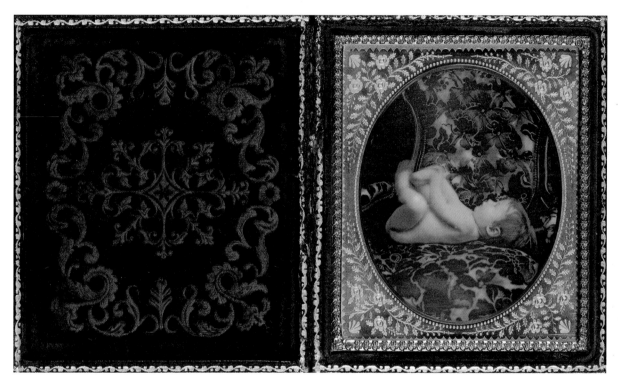

1　**Unknown Maker**, *Baby on Sofa*, ca. 1855

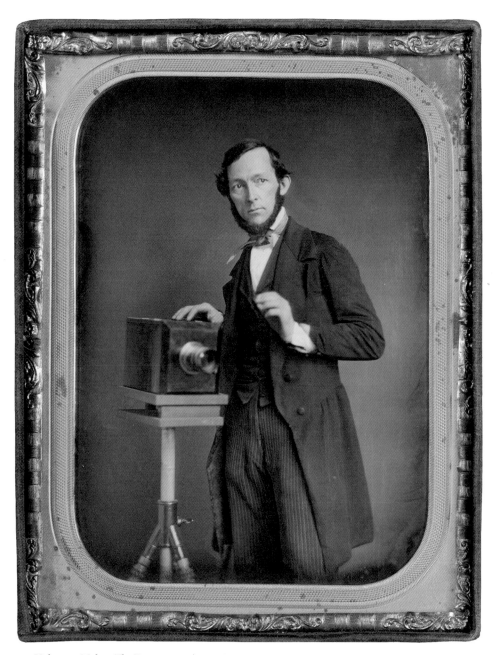

2 **Unknown Maker**, *The Daguerreotypist*, ca. 1850

The Hallmark Photographic Collection

at The Nelson-Atkins Museum of Art

The Origins of American Photography

1839–1885

FROM DAGUERREOTYPE TO DRY-PLATE

Keith F. Davis

With contributions by Jane L. Aspinwall

Director's Foreword by Marc F. Wilson

Hall Family Foundation

in association with

The Nelson-Atkins Museum of Art

Distributed by Yale University Press,

New Haven and London

The Origins of American Photography
FROM DAGUERREOTYPE TO DRY-PLATE, 1839–1885

Published to accompany the exhibition
Developing Greatness: The Origins of American Photography, 1839-1885;
From Daguerreotype to Dry-Plate
at The Nelson-Atkins Museum of Art, June 9–December 30, 2007

Production: Rich S. Vaughn

Design: Malcolm Grear Designers, Providence, Rhode Island

Digital Photography and Tritone Separations: Thomas Palmer, Newport, Rhode Island

Color Separations and Printing: Dr. Cantz'sche Druckerei, Ostfildern, Germany

ISBN: 978-0-300-12286-2

Library of Congress Control Number: 2007933240

Hall Family Foundation
P.O. Box 419580, MD 323
Kansas City, Missouri 64141-6580

The Nelson-Atkins Museum of Art
4525 Oak Street
Kansas City, Missouri 64111
www.nelson-atkins.org

Distributed by
Yale University Press
302 Temple Street
P.O. Box 209040
New Haven, Connecticut 06520-9040
www.yalebooks.com

TABLE OF CONTENTS

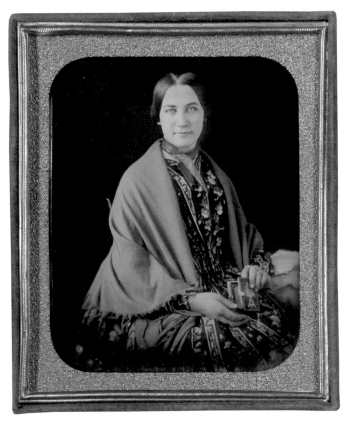

3 **Unknown Maker**, *Woman Holding Half-Open Daguerreotype Case*, ca. 1850

Director's Foreword

This volume and the exhibition it accompanies, *Developing Greatness: The Origins of American Photography, 1839-1885,* inaugurate a new era for photography in the great region served by Kansas City's Nelson-Atkins Museum of Art.

Both celebrate the establishment of one of America's major holdings of photography, the Hallmark Photographic Collection at the Nelson-Atkins Museum of Art, a public treasure housed and exhibited in handsome galleries in the new Bloch Building. Generously donated in its entirety to the Museum in late 2005 by Hallmark Cards, Inc., this collection is the basis for what will become one of the nation's most active programs in photography.

This collection began in 1964 with the acquisition of 141 prints by Harry Callahan. Many other acquisitions and exhibitions followed in the next forty years, particularly after a young curator—Keith F. Davis—was hired in 1979 to oversee the collection. Thanks to the uniquely enlightened support of Hallmark Chairman Donald J. Hall, the collection grew from fewer than 700 prints in 1979 to about 6,500 at the time it was donated to the Nelson-Atkins. The collection was always intended to be used for the enjoyment of art enthusiasts and for scholarship. With the collection now part of the Museum—and Mr. Davis installed as our Curator of Photography—these aims will be pursued with new vigor.

With this exhibition and book, the Nelson-Atkins, our co-publisher the Hall Family Foundation, and our distribution partner Yale University Press, hope to cast new light on the riches of early American photography. For those who visit the exhibition in Kansas City, where it is on display from June 9 through December 30, 2007, this book will serve as a ready reference, a distillation of thorough scholarship that complements and enlarges the experience of the works on display. The viewer is likely to come away in wonder at the power of the medium itself, a miraculous invention of optics, chemistry, and art capable of producing with relative ease and economy an astonishing range of images.

From its modest beginning in 1839, American photography almost immediately became central to the nation's cultural life. The medium was rooted in everyday realities and Americans embraced it wholeheartedly. It was as though a fledgling nation had for the first time found an image of itself that rang true. Within a short time, the medium was applied to many other subjects of interest and importance, from the wonders of the natural world to the horrors of war. As both exhibition and book make clear, by 1885 photography had transformed Americans' sense of themselves and their world. Our sensibilities would never again be the same.

Mr. Davis's selection of images reveals his deep understanding of the richness of photography in its first four and a half decades in America. He has created a remarkably thorough picture of the formative years of the medium, drawn entirely from the collection he has developed. This clearly has been a labor of love and of enthusiastic discovery. Anyone perusing the following pages will surely marvel at the deftness with which he has combined detailed information about key personalities, technical advances, and the currents of cultural history with the remarkable visual testimony of the works themselves.

A book of this scale can hardly be produced without the able assistance of many, foremost among them Jane L. Aspinwall, the Museum's Assistant Curator of Photography. She worked with Mr. Davis on this project from its very inception and—in addition to authoring the catalogue section—contributed to every other facet as well. Both benefited from the tireless work of Chelsea Schlievert, Photography Department Assistant. Invaluable help was provided by the Museum's various divisions, including Conservation and Collections Management, Curatorial, Design, Education, as well as our Spencer Art Reference Library. Deep thanks go to all.

This important work is a direct reflection of the values and standards of the Hall Family Foundation, its Board of Directors, and, in particular, its President, William A. Hall. None of this would have happened without the unstinting generosity of the Hall Family Foundation.

MARC F. WILSON
Menefee D. and Mary Louise Blackwell Director/CEO
The Nelson-Atkins Museum of Art

Preface and Acknowledgments

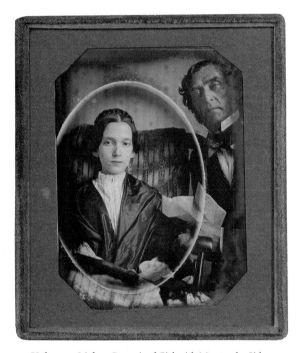

4 **Unknown Maker**, *Portrait of Girl with Man to the Side with Letter*, ca. 1850

The years from 1839 to 1885 mark the first generation in American photography, from the introduction of the daguerreotype to the dominance of the dry-plate technology and the rise of amateur practitioners. This was a time of astonishing enterprise and invention. These years are vital to any larger understanding of photography's history: all the future possibilities of the medium were explored in its foundational period.

Through intuition and experimentation, the first generation of photographers established a new visual language. They learned not only to record the world, but to make *pictures* of an entirely new kind. Photographs were produced not so much *by* a machine (the camera) as *with* it: every photograph represented a union of some aspect of worldly fact with a complex amalgam of individual skills, judgments, and ideas. Photographers knew all too well that the process was far from automatic; faced with the same subject, no two operators would make identical images. While founded on scientific principles—the laws of optics and chemistry—photography was clearly an art unto itself. It required a refined understanding of materials and procedures, a sensitivity to the nuances of light and chiaroscuro, and an innate feeling for pictorial structure. The photographic process was demanding, yet surprisingly flexible; objective in spirit, it could be bent to a variety of interpretive and expressive ends. Photographers understood clearly that their pictures were different from—were transformations of—the subjects they recorded. The best photographers understood this transformative process and used it with precision and purpose. The art of photography was born with the process itself; it remains a challenge and a fascination to this day.

Photography was hailed as one of the wonders of the age for both its astonishing veracity and its endless utility. Almost immediately, the process became deeply woven into the fabric of everyday life. This was the era of photographic professionalism. As a result of both technical and economic factors, almost all practitioners used the medium to earn a living. Although individual photographers differed widely in skill, ambition, and originality, their shared professionalism made photography a reasonably unified practice. The result of this collective effort is a remarkable record of both the facts and the spirit of the age. Many of the photographs of this era are memorable on strictly aesthetic grounds, as rare and original pictorial

artifacts. They are also profoundly human documents: evocations of real lives, emotions, and ideas.

The Origins of American Photography aims to present a fresh and comprehensive overview of these formative decades. It also serves as a guide to the highlights of a key component of the overall photography collection at The Nelson-Atkins Museum of Art. This volume has been published to accompany a major exhibition, "Developing Greatness: The Origins of American Photography, 1839-1885." Deliberately, however, its scope extends well beyond the contents of "Developing Greatness": this book includes roughly twice the number of works presented in the exhibition. It is our hope that this text will remain of value to both general readers and photography specialists long after our show has closed.

This volume gives equal importance to pictures and words. With 606 high-quality reproductions, this is a richly visual book. The great achievement in this era is found, first and foremost, in the pictures themselves. By their sheer number, these pictures illuminate the larger visual themes and genres of the time; their expressive subtleties stem from the imaginations of the photographers who made them. While thematic categories may be described generically, the best photographs defy simple categorization: they are wondrously one-of-a-kind creations.

The texts in this volume support and enlarge our understanding of the pictures. My narrative provides an historical overview, combining a focus on photographic matters with an interest in selected currents of social and intellectual history. The first four chapters take varying perspectives on the daguerreian era, from 1839 to about 1860. The following four chapters examine specific topics in the history of early American paper photography, from the early 1850s to 1885. This text is indebted to the fine scholarship of recent decades, but can only represent an individual perspective on the subject. The catalogue section by Jane L. Aspinwall provides physical and technical information on the photographs, as well as data on their makers and subjects. This material is the product of several years of dedicated and original research.

This union of pictures and texts aims to enrich and expand our understanding of early American photography. Some of the photographs in this volume are so well known as to be iconic; many others are published here for the first time. As the number and significance of these recent discoveries indicates, this history is an exciting work in progress.

Much remains to be learned about this history, in part, because so much was allowed to be forgotten. Living memory of the years 1839 to 1885 was fading rapidly by the turn of the twentieth century and few considered the history of early photography worthy of even casual study. A gradual process of historical reclamation began in the early 1930s, when Robert Taft, a professor of chemistry at the University of Kansas, became interested in the pioneering generation of American photography. Finding no serious studies of the subject, he set out to make one himself. Taft corresponded with the few "old-timers" who were still alive (including William Henry Jackson, who died in 1942 at the age of ninety-nine) and with the descendants and associates of others. This personal information, combined with his meticulous reading of newspapers and photographic journals, resulted in Taft's landmark study *Photography and the American Scene: A Social History, 1839-1889*, published in 1938. Seventy years later, this text remains essential both for the originality and precision of Taft's research and for his effort to suggest the medium's place in American cultural life.

Another pioneering text, Beaumont Newhall's *Photography 1839-1937*, appeared in 1937. Published as the catalogue to a large exhibition at the Museum of Modern Art, this was the first version of Newhall's venerable *History of Photography* (editions of 1938, 1949, 1964, and 1982). While he maintained a catholic interest in the overall history of the medium, Newhall's book *The Daguerreotype in America* (1961) made a vital contribution to the historiography of early American photography. A decade later, Richard Rudisill's *Mirror Image: The Influence of the Daguerreotype on American Society* (1971), based on a deep understanding of the literary and intellectual context of the time, further advanced scholarship of the subject.

Appreciation of this period flourished in the following decades, beginning with the publication of such noteworthy studies as *Era of Exploration: The Rise of Landscape Photography in the American West, 1860-1885* (1975) by Weston J. Naef and James N. Wood; Harold Francis Pfister's *Facing the Light: Historic American Portrait Daguerreotypes* (1978); William Welling's detailed chronicle *Photography in America: The Formative Years, 1839-1900* (1978); and *The American Daguerreo-*

type (1981) by Floyd Rinhart and Marion Rinhart. Beginning in these years, monographs were published on a host of important figures, including Southworth & Hawes, Carleton E. Watkins, Edward Anthony, Timothy O'Sullivan, William Henry Jackson, Whipple & Black, George N. Barnard, and Alexander Gardner.

Beginning in 1989, the American daguerreotype became the subject of vigorous scholarly attention. Two notable books appeared that year: *American Daguerreotypes from the Matthew R. Isenburg Collection*, with an essay by Alan Trachtenberg, and *The Daguerreotype: A Sesquicentennial Celebration*, the first of several collections of essays edited by John Wood. The Daguerreian Society, founded in 1988, provided a lively forum for the collecting and study of daguerreotypes and its annual journal (first published in 1990) made invaluable contributions to the subject. Other important books also appeared in this period, including *The Daguerreotype: Nineteenth-Century Technology and Modern Science* (1991) by M. Susan Barger and William B. White; Dolores A. Kilgo's *Likeness and Landscape: Thomas M. Easterly and the Art of the Daguerreotype* (1994); *Secrets of the Dark Chamber: The Art of the American Daguerreotype* (1995) by Merry A. Foresta and John Wood; and *The Silver Canvas: Daguerreotype Masterpieces from the J. Paul Getty Museum* (1998) by Bates Lowry and Isabel Barrett Lowry.

This continuing scholarship has greatly enriched our understanding of nineteenth-century American photography. It has also served to illuminate the remaining gaps in our historical knowledge: for every figure from this period deemed worthy of a book or catalogue, at least three or four equally deserving names could be mentioned. By its nature, this scholarship highlights the need for periodic overviews of the era—synoptic evaluations that combine a general grasp of current scholarship with fresh research and a new selection of images. This was accomplished with considerable success in the 1991 book *Photography in Nineteenth-Century America,* edited by Martha A. Sandweiss. The work of six scholars, this volume examined its subject from a corresponding number of viewpoints. In the intervening sixteen years, no other volume has attempted to cover this large subject in comparable depth. The present work strives to do just that: to provide a new template for the appreciation of early American photography as a whole.

The initial idea for this book began a dozen years ago, following the publication of *An American Century of Photography: From Dry-Plate to Digital, The Hallmark Photographic Collection* (1994), and the tour of a large exhibition of the same name. That project, marking the thirtieth anniversary of the founding of the Hallmark Photographic Collection, surveyed American work of the modern era, from 1885 to the present. The show traveled widely and the book sold out in a matter of months. Given the collection's continued growth, a decision was made not to reprint the 1994 volume. Instead, after several years of further work, a substantially revised and enlarged second edition of the book was published in 1999.

In early 1995, a major new initiative was begun: the expansion of the Hallmark Photographic Collection to encompass American work from 1839 to 1885. It was clear at the time that this was an area of prime acquisition opportunity. Important works were becoming rarer every year, but American photographs had not yet reached the prices of early European works of comparable quality. American daguerreotypes were of particular interest. The private market was gaining momentum and, thanks to the Daguerreian Society, a new sense of collective identity was forming among enthusiasts and scholars. Despite this rising interest, important works were both available and—all things considered—fairly priced.

This new endeavor was officially begun in February 1995 with the acquisition of two works by Charles D. Fredricks: the magnificent print of his Broadway studio [287] and a whole-plate daguerreotype of Recife, Brazil [86]. Through quiet but determined effort, many more prints and daguerreotypes were purchased in the following years. Our goal was straightforward: to assemble a collection of photographs from 1839 to 1885 to complement our rich holding of post-1885 work, and to thus complete our coverage of the entire span of American photography. Further, we aimed to create a holding that would significantly enlarge our aesthetic and historical understanding of the subject. Some of these works were by recognized names and touched familiar historical bases. Many others were by anonymous practitioners and were previously unknown or unpublished.

In late 2005, the 6,500-piece Hallmark Photographic Collection was transferred in full to the Nelson-Atkins. This marked the end of its forty-one-year history as a corporate collection and the start of an exciting new chapter in its public and scholarly use. This change in status altered few earlier priorities, but it accelerated the pace of our work. At the urging of chief curator Deborah Emont Scott, and with the endorsement of director Marc F. Wilson, this project in early American photography (which we anticipated completing in about 2010) was chosen as one of two featured exhibitions to open the museum's spectacular new Bloch Building in June 2007. In fact, this date marked the debut not only of a vastly enlarged museum, but of its new photography department. Appropriately, then, this volume and its companion exhibition celebrate not the end of an old program, but the birth of an exciting new one.

We are grateful to the many individuals and institutions that helped in the making of this book. Beginning in 1995, this new area of collecting demanded a correspondingly new expertise. My understanding of early American photography was enriched by several remarkably knowledgeable people, beginning with George R. Rinhart and Grant B. Romer. A collector of extraordinary experience, Mr. Rinhart taught me much about this period and guided many important works into our collection. I remain deeply grateful for his friendship and trust. Mr. Romer, a pioneer of modern daguerreian scholarship, was similarly inspiring and helpful.

I visited a number of private collectors, all of whom instructed me by their example: Stephen N. Anaya, William B. Becker, Ralph Bova, John Cameron, John Delph, Gary W. Ewer, Greg French, Victor Germack, Neil Goldblatt, Nicholas M. and Marilyn A. Graver, Matthew R. Isenburg, George M. Kemp, David LaPlaca, Richard A. Look, R. Bruce Lundberg, Yann and Lynn Maillet, Joan Murray, Jan Schimmelman, Robert Harshorn Shimshak, Kathryn Schwemley, Fred Spira, Alan Trachtenberg, Leonard A. Walle, Larry J. West, George S. Whiteley IV, Julian Wolff, John Wood, Harvey Zucker, and others. Modern practitioners of the daguerreotype—Kenneth Nelson, Irving Pobboravsky, Mike Robinson, Robert Shlaer, and Jerry Spagnoli—provided their own insights and revelations. And, of course, dealers such as Joseph Bellows, John Boring, David B. Chow, Joseph Dasta, Keith de Lellis, Gary Edwards, Terry Etherton, Jeffrey Fraenkel, Charles A. Hartman, Paul M. Hertzmann, Charles Isaacs, Ken Jacobson, Hans P. Kraus, Jr., Kevin and Karen Kunz, Larry Gottheim, Mack Lee, Michael Lehr, Ezra Mack, John N. McWilliams, Michael D. Medhurst, Alex Novak, Janos Novomeszky, Graham

Pilecki, Jill Quasha, Richard T. Rosenthal, Richard Rydell, William L. Schaeffer, Charles Schwartz, Andrew Smith, Dan and Mary Solomon, John Staszyn, Stephen White, Chester Urban, Christopher Wahren, Dennis A. Waters, and others, supplied a steady stream of acquisition possibilities.

Over several years, research was conducted at a number of museums and historical societies. These include the Library Company, the Free Library of Philadelphia, and the Historical Society of Pennsylvania, all in Philadelphia; the Boston Athanaeum, Massachusetts Historical Society, Boston Public Library, and Museum of Fine Arts, in Boston; Harvard Observatory, Harvard University Archives, and the Historical Collections Department of Baker Library, Harvard Business School, all in Cambridge, Massachusetts; and the Newburyport Historical Society, in Newburyport, Massachusetts. Productive visits were also made to the Beinecke Library, Yale University; New-York Historical Society; New York Public Library; Gilman Paper Company, New York; Metropolitan Museum of Art; George Eastman House, Rochester; Library of Congress, Washington, D.C.; Chrysler Museum, Norfolk, Virginia; The Historic New Orleans Collection; Cincinnati Historical Society; Cleveland Art Museum; Western Reserve Historical Society, Cleveland; Chicago Historical Society; Art Institute of Chicago; Missouri Historical Society, St. Louis; Kansas State Historical Society, Topeka; Union Pacific Railroad Archives, Council Bluffs, Iowa; Colorado Historical Society, Denver; Oregon Historical Society, Portland; the J. Paul Getty Museum, Los Angeles; the Wilson Centre for Photography, London; and the Bibliothéque de L'Institut de France, Paris. My sincere thanks to the many staff members at these institutions who helped us, including Bret Abbott, Linda Bailey, Gordon Baldwin, Will Graves, Violet Hamilton, Tom Hinson, Leslie Hunt, Brooks Johnson, Karen Lightner, Brenda S. Mainwaring, Paul Martineau, Leigh Moran, Weston J. Naef, Scott Nason, Sally Pierce, Aaron Schmidt, Catharina Slautterback, Duane R. Sneddeker, Joe Struble, Sarah Weatherwax, Jay Williamson, and David Wooters. In various ways, Denise B. Bethel, Wes Cowan, John S. Craig, Frank DiMauro, Dr. Hans W. Gummersbach, Françoise Heilbrun, Matthew R. Isenburg, James S. Jensen, Daile Kaplan, Tim Lindholm, Stephen Longmire, Bates Lowry, Christopher Mahoney, Carl Mautz, Keith McElroy, Mark Osterman, Jeff Rosenheim, Thomas Southall, Will Stapp, Mark White, Glenn Willumson, Daniel Wolf, and Del Zogg also provided assistance and advice.

A few people deserve special thanks for their assistance and for their genuine enthusiasm for our project. Jill Quasha went out of her way to help us see the work of J. B. Greene, in Paris. In Boston, Chris Steele generously provided access to his voluminous files on early photography in Massachusetts. In both New York and Philadelphia, Sandra Markham provided invaluable advice and research assistance. Leonard and Jean Walle were wonderfully hospitable, introducing me not only to their remarkable collection, but to other holdings and archives in Michigan. George and Sue Whiteley were equally generous with their time and guest room. Gary W. Ewer was extraordinarily helpful. He was an endless source of references, documentation, and insights and provided encouragement when it was most needed. He gave us far more information that we could actually use, but he ensured that our scholarly bar was set high. We cannot thank him enough. Mr. Ewer, Kenneth Nelson, Mike Robinson, Grant B. Romer, and Bob Zeller all provided helpful comments on early drafts of several chapters of my text. My wife, Trish Davis, "volunteered" to read every page of this text and improved them all. The late Janos Novomeszky and John Delph were both enormously helpful in the early stages of this project, and both are greatly missed.

For their expert work in conserving or preparing some of the works in this book, our thanks go to Thomas Edmondson, Grant B. Romer, George S. Whiteley IV, and Tim Ward. Several on the staff of the Nelson-Atkins helped directly with the preparation of this book, including Margaret Conrads, John Lamberton, Gaylord Torrence, Roberta Wagener, Jeff Weidman, and Toni Wood. Chapter six of this book is based on an essay published in *Photography in Nineteenth-Century America* (1991). I am very grateful to the Amon Carter Museum and to John Rohrbach, the museum's senior curator of photographs, for permission to use the title and some passages of this original essay.

My deep thanks to this book's production team for their commitment to excellence. The photographic imaging and separations are by Thomas Palmer, Newport, Rhode Island; the elegant design is the work of Malcolm Grear Designers, Providence, Rhode Island; and the printing was done by Dr. Cantz'sche Druckerei, Ostfildern, Germany. All did remarkable work. Particular thanks go to Pat Appleton of Malcolm Grear Designers and to Klaus Prokop of Cantz for their deep personal involvement in this project. I am enormously grateful to Rich Vaughn for his graphics expertise and his invaluable help in guiding this production to completion. Thanks, too, to Shawn Pollock for her help with an endless number of details. I also appreciate the superb professional assistance of editor Elizabeth Smith and indexer Lindsey Buscher. Finally, we appreciate the enthusiasm for this project of our distribution partner, Yale University Press, and editor Patricia J. Fidler.

The small staff of the museum's photography department labored tirelessly on this exhibition and book. Jane L. Aspinwall, Assistant Curator, Photography, worked with me from the moment in 2004 when this project was officially approved and scheduled. We worked seamlessly as co-curators of the exhibition. She authored the Catalogue of this book, a distillation of her years of dedicated research. In truth, her scholarship informs every page of this volume; my text benefited greatly from her findings, corrections, and cautions. I could not have asked for a more dedicated or professional curatorial partner. Chelsea Schlievert, Department Assistant, Photography, was critical to the success of this effort. With unflappable professionalism, Chelsea made our new department run smoothly, while helping with nearly every facet of this project. She has our undying thanks and our admiration.

Finally, we thank director Marc F. Wilson for his warm foreword to this book and for his support of the museum's new photography program. Thanks, too, to chief curator Deborah Emont Scott for her steadfast support of this book and the accompanying exhibition. As always, I thank David Strout for inaugurating the Hallmark Photographic Collection in 1964, and for taking a chance on a young photo-historian in 1979. The assistance of Terri R. Maybee, Karen Beckett, and Tracy M. Foster of the Hall Family Foundation is greatly appreciated. I am deeply grateful to William A. Hall, President, Hall Family Foundation, for more than twenty years of trust, support, good sense, and guidance. And, once again, I thank Donald J. Hall, Chairman of the Board, Hallmark Cards, Inc., for his unparalleled commitment and vision. None of this could have been accomplished without his confidence and support.

K. F. D.

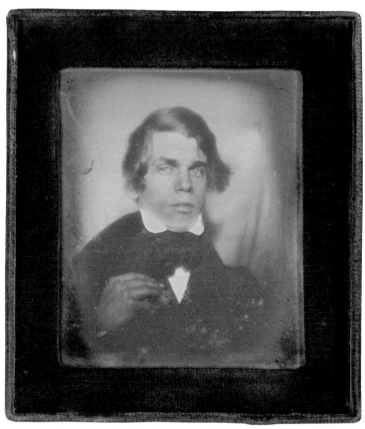

5 Henry E. Insley, *Self-Portrait*, ca. 1839

CHAPTER I The Pioneering Generation: 1839-1843

Wonderful wonder of wonders!!…The real black art of true magic arises and cries avaunt. All nature shall paint herself—fields, rivers, trees, houses, plains, mountains, cities, shall all paint themselves at a bidding, and at a few moments' notice… Here is a revolution in art.[1]

These enthusiastic lines appeared in one of the first American accounts of photography—an article from the April 13, 1839, edition of the *New-Yorker* titled "New Discovery in the Fine Arts." The hyperbole is understandable. The daguerreotype image was astonishing and immediately became the subject of wide cultural interest. Men of science were intrigued by its technical and chemical intricacies. The public was excited by its potential to mechanize—or automate—the picture-making process. Artists and writers were fascinated by its representational and philosophical implications—the radically new standard of visual truth it seemed so obviously to embody. The daguerreotype hit American shores with the force of a cultural hurricane; it swept away a familiar set of pictorial assumptions and practices, and established new ones in their place.

Ideas and Inventions

Photography resulted from the union of two historical paths of inquiry: first, an understanding of light, optics, and the means of forming virtual images; and second, the chemical knowledge to register and preserve these images. The first path involved the use, beginning in the Renaissance, of the camera obscura (from the Latin, meaning *dark room* or *dark chamber*).[2] The camera obscura was a simple device—typically, a box with a lens on one side, an internal 45-degree mirror, and a pane of frosted glass on which the lens-formed image could be viewed and traced on translucent paper. By the seventeenth century, this "camera" possessed the key features of the modern photographic camera: lens, focusing mechanism, and viewing or imaging surface.

For at least a handful of investigators, the camera obscura triggered a seemingly natural question: could its glowing images be captured and made permanent? The power of sunlight to effect physical changes had long been understood—as, for example, in the phenomena of light turning vegetation green and the tanning of human skin. In the eighteenth century, the light-sensitivity of various chemical compounds was discovered. In 1727, Johann Heinrich Schulze found that a solution of silver nitrate darkened on exposure to sunlight.[3] Several decades later, Karl Wilhelm Scheele explored the light-sensitivity of silver chloride and other substances. In 1777, Scheele founded the discipline of photochemistry by publishing the first comprehensive book on the chemical effects of light.[4] By about 1800, at least two English experimenters—Thomas Wedgwood and Sir Humphry Davy—had attempted to make images on chemically sensitized sheets of paper. They failed only because they had no way to preserve their delicate shadow-impressions—their images continued to darken, even when viewed strictly by candlelight, until finally vanishing into blackness.

Photography was not invented before the early nineteenth century for good reason: the process depended on chemical knowledge that did not exist earlier. The light-sensitive emulsions of most photographic processes involve the use of halogens—a class of highly reactive elements that combine with metals to produce a salt. The primary halogens—fluorine, chlorine, bromine, and iodine—are all corrosive, toxic substances.[5] The last three have played a particularly key role in photography. In the early nineteenth century, all were relatively recent discoveries. None could be found in a pure state in nature; all were isolated from compounds found in sea water and natural brine wells. A pale green gas, chlorine was discovered in 1774 by Karl Wilhelm Scheele but only identified as an element (and named) in 1810 by Sir Humphry Davy. Bromine, a volatile red liquid, was discovered in 1826, but not produced in quantity until about 1860. The discovery of iodine was announced in 1813. It is a dark gray or purple-black solid that sublimes at room temperature into a purple-pink gas. Iodine was found as a result of military research—a by-product of the production of saltpeter (a component of gunpowder) from the residue of seaweed. Iodine is the least reactive of the halogens, but forms compounds with many substances. These halogens, used individually and in concert, made photography practical.

After the tantalizing failures of Wedgwood and Davy, it was Joseph Nicéphore Niépce, a reclusive inventor in the village of Chalon-sur-Saône, in central France, who made the first permanent photographs a quarter-century later.[6] In addition to a variety of other

pursuits, Niépce (with his brother Claude) became interested in the then-new process of lithography in 1813. This work stemmed, in part, from their desire to win one of the financial premiums for improvements in lithography offered every year by the Société d'Encouragement des Arts et Métiers.[7]

Within a few years, Niépce's work took an important turn. Intrigued by the idea of replicating images directly, without the intervention of the artist's hand, he began experimenting in 1816 with several light-sensitive compounds. A brilliant and persistent experimenter, Niépce tested various photosensitive emulsions on surfaces of paper, stone, glass, and metal. His first successes involved making photographic copies of engravings. After oiling these engravings to render them translucent, he placed them in direct sunlight in contact with his prepared surface. The results were "negative" images that, after being etched in acid, could be used as engraving plates.

By 1824, Niépce had made an image from nature in his camera obscura. His curious process involved coating a surface—at first a limestone slab, later a pewter plate—with a layer of bitumen of Judea, or asphaltum, a mineral resin known to harden on exposure to light. After a lengthy exposure in the camera, Niépce rinsed his image in oil of lavender. The areas of the bitumen that had received the most light were hardened and remained intact; the areas that received the least exposure were washed away. In about 1827, he used this technique to create the earliest extant photograph: a view from a back window of his house, looking over the roof of his barn to the landscape beyond. Niépce's remarkable process—which he called heliography—produced images that were minutely detailed and permanent, if very faint in tone. The practicality of the process was another matter: his plates required exposures of about four or five days.[8]

It is notable that, to promote this work, Niépce journeyed to London rather than to Paris. His brother Claude had resided in England for several years, attempting to market their earlier invention, the *pyréolophore*, a boat with an internal combustion engine. To anyone hoping to profit from a new device or technology, English patent law was far more accommodating than French law. In France, photography was deemed a manifestation of nature, and not a patentable discovery. This fact shaped the early history of photography in several ways.[9] Niépce showed his heliographs to various figures in London and gave one of them—the famous 1827 view from his window—to Francis Bauer, a fellow of the Royal Society.[10] Ultimately, however, nothing came of these efforts and Niépce returned home.

The man who introduced photography to the world—the Parisian Louis-Jacques Mandé Daguerre—began his investigations independently of Niépce. Unlike the reclusive Niépce, Daguerre was a public figure. Trained as an architect's apprentice, stage designer, and artist, he had worked as a scene painter for the Paris Opera. Fascinated by the creation and orchestration of large-scale theatrical illusions, Daguerre opened one of the great entertainment sensations of the era in 1822.[11] Daguerre's Diorama was a mesmerizing virtual spectacle. In a small rotating theater, two large, realistically painted canvases, each about 45 x 72 feet in size, were passed slowly before the seated spectators. Through a clever arrangement of skylights and mirrors, these paintings could be illuminated from either front or back, creating the visual sensation of changes in time and weather—a shift from day to night, for example, or from fair weather to storm.[12]

Daguerre's attempts to fix the images of the camera obscura, which probably began in the early 1820s, grew logically from this illusionistic endeavor. On hearing of Niépce's research in 1826, he wrote the older man a letter of introduction. They met in 1827 and entered into partnership two years later. Their goal was to perfect a commercially viable process, with the profits to be shared equally. Before Niépce's untimely death in 1833, they explored a variety of approaches and achieved significant progress. Their physautotype process, which has only recently been described and understood, was perfected by the summer of 1832.[13] This technique used a silver plate covered with a light-sensitive layer of resin. Exposure in the camera produced a latent or invisible image which was revealed by the action of a chemical solvent—the fumes of a petroleum substance akin to kerosene. While Niépce's heliographs required four or five days' exposure in the camera, physautotypes could be made with three to eight hours' exposure. The resulting images have far stronger tones than the pale heliograph, and bear a striking resemblance to Daguerre's subsequent process.[14]

Continuing after Niépce's death, Daguerre pursued an approach that had intrigued them both: sensitizing the silver plate directly with the fumes of iodine. The result was a new and radically superior process: the daguerreotype. This technique used a copper plate, coated with a thin layer of silver that was buffed and polished to a mirror-like sheen. After sensitization, the plate was exposed in the camera for about three to twenty minutes. The latent image was then developed with the vapors of heated mercury. The combined use of iodine as a sensitizing agent and mercury as a developer yielded far shorter exposure times than any earlier technique.

Daguerre began sharing his results with a few friends in the summer of 1835, but two major objectives—the desire to further perfect the process and the hope to profit from it—prompted him to keep all technical details to himself for the next four years.[15] In 1837—the date of his oldest extant plate—Daguerre found a way to permanently fix his images, using a warm solution of salt dissolved in water.[16] He immediately tried to sell rights to the process. Given the restrictions of French patent law, Daguerre realized that his invention could not be registered and protected in his native country. Failing to interest various foreign governments in his secret, he turned to a public subscription scheme. After years of secrecy, Daguerre now actively sought public notice. As the historians Helmut and Alison Gernsheim have written, Daguerre "attracted all the attention he could by driving around Paris with the bulky apparatus weighing 50 kg on a cart, photographing public buildings and monuments." However, this strategy also failed, since few were willing to pay a substantial sum for instructions to be revealed only at an uncertain future date.[17]

After several uneasy months, Daguerre was saved by the scientific community. By the beginning of 1839, he had secured the backing of François Arago, a leading figure in the French Academy of Sciences. Recognizing the importance of Daguerre's work, Arago pressed the French government to purchase all rights to the process, in order to give it to the world at large. The cultural prestige of this magnanimous gesture, Arago argued, would far outweigh the modest investment.[18] Arago began his campaign with a dramatic presentation at the January 7, 1839, meeting of the Academy of Sciences. Without releasing the actual details of the process, Arago described Daguerre's research and the astonishing quality of his pictures. The political process thus set in motion culminated seven months later, on August 19, 1839, with the public revelation of the details of the technique.

The January 7 session of the Academy of Sciences triggered a flurry of activity in both France and England. Press reports stimulated French public interest in Daguerre's process—ensuring, as Arago

had hoped, general support for the government's purchase. These reports prodded Hippolyte Bayard, a minor official in the French Ministry of Finance, to begin his own photographic experiments. In a remarkably short time, Bayard invented a process entirely his own—a technique for making direct-positive paper prints in the camera. Hoping to secure Arago's support (and, of course, his own government stipend), Bayard mounted a public exhibition of his pictures on July 14, the national holiday. However, the scientific and political establishments apparently believed that one new process was enough, and Bayard was effectively ignored.

In England, William Henry Fox Talbot was stunned to receive word of the January 7 session of the Academy of Sciences. Educated at Cambridge, Talbot was a man of considerable learning and ability—a scientist, classical scholar, botanist, mathematician, and linguist.[19] In early 1834, he had also begun researching the problem of photography. By the summer of 1835, he had succeeded in making permanent photographic images in the camera obscura using paper sensitized with a solution of silver chloride and fixed in a bath of potassium iodide (replaced soon after by a solution of common table salt).

It is entirely to Talbot's credit that he—unlike other early researchers—came to recognize the value of the photographic negative. While the processes of Niépce, Daguerre, and Bayard all produced one-of-a-kind direct-positive images (like the twentieth-century Polaroid), Talbot realized that the negative could be contact-printed to similar sheets of sensitized paper to produce identical positive prints in quantity. Although photography's first success lay primarily in the direct-positive process of the daguerreotype, negative/positive processes would achieve near-absolute dominance by 1860. This dominance could hardly have been predicted in 1839, however, as Talbot's prints were distinctly inferior in detail and brilliance to the daguerreotype. Talbot's use of paper for both his negatives and prints meant that fine details were obscured by the fibrous structure of the paper itself. Further, compared to Daguerre's process, the tonal range of Talbot's images was limited and his exposures were long.

Talbot continued to refine his process after 1835, but without urgency. In fact, he only returned seriously to his photographic work in November 1838, with the intention of summarizing his findings for an upcoming meeting of the Royal Society. The events in Paris of January 7 came as a genuine shock to him. Seeking to place what he had accomplished on public record, Talbot sent samples of his 1835 work to the January 25, 1839, meeting of the Royal Institution in London. Six days later, he traveled to London to read a paper— "Some Account of the Art of Photogenic Drawing"—before the Royal Society. The precise details of his process were given in a communication read at the Royal Society meeting of February 21.

The race for historical priority and prestige was on—a race between nations as much as individuals. Confident of the superiority of the daguerreotype, Arago invited leading British scientists to come to Paris to view Daguerre's plates. A group of learned men— including Talbot's friend, scientist Sir John Herschel—went to Paris in May. They were overwhelmed by the beauty and detail of the daguerreotype. Talbot could not have been happy to read Herschel's enthusiastic endorsement of the Frenchman's pictures: "It is hardly saying too much to call them miraculous… Every gradation of light & shade is given with a softness & fidelity which sets all painting at an immeasurable distance. His *times* are also very short. On a bright day 3 m[inutes] suffices…"[20] By every meaningful measure—

precision, tonal range, beauty, and speed—the French process was clearly superior to the British one.[21]

Daguerre's official recognition was not long in coming. Between mid-June and early August, Arago's bill stipulating the terms of purchase (life annuities for both Daguerre and his former partner's son and heir, Isidore Niépce) was hurried through official channels and signed into law. On the afternoon of August 19, the long-awaited event took place: the public release of the details of Daguerre's process. The setting was most distinguished—a joint meeting of the Academy of Sciences and the Academy of Fine Arts, held at the Institute of France, across the Seine from the Louvre. The place was jammed; the auditorium was full of artists and scientists, and the plaza was mobbed with curious citizens. After underscoring the historical import of the day's events, Arago provided a step-by-step description of the technique.

Everyone in attendance was excited by the revelation of Daguerre's secret, although many were dismayed by its complexity. Their concerns were assuaged by a promotional campaign that included the release for general purchase of an official instruction manual and a camera outfit.[22] Both sold out almost immediately. Daguerre's manual was quickly translated into English, German, Swedish, and Spanish; ultimately, it would be issued in more than thirty editions and summaries.[23] To ease concerns over the difficulty of his process, Daguerre himself gave weekly demonstrations. The French public responded with unbounded enthusiasm. The excitement spread internationally as reports of the August 19 meeting—and then copies or summaries of Daguerre's manual—began arriving in foreign cities.

Photography had been released into the world, but its meaning and potentials were not at all clear. How would it ultimately be used? What would be its impact on traditional forms of picture making? Was it an art?—and, if so, what kind of art? Given the complexity of photography's genealogy, the answers to these questions could be only vaguely imagined.[24] By 1839, photography had been invented at least three times by men with distinctly different backgrounds, values, and motivations.[25] Niépce was a reclusive genius who began his work in a quest to replicate images automatically. Talbot was a scientist and humanist—a man of letters and connections—with an interest in both the chemical and artistic aspects of the process. Daguerre was a gifted inventor who also happened to be a commercial artist and a master showman and illusionist. Each man began his photographic investigations as an intellectual challenge, but each hoped to profit from his labors.[26] Early photography was a rich amalgam of ideas and influences. It united, in varying degrees, the worlds of science, technology, commerce, and art, with some hint of the more shadowy realms of alchemy and magic. All these currents may be traced in its subsequent history.

The Daguerreotype in America: 1839

General reports on the processes of both Daguerre and Talbot began filtering across the Atlantic in the months following the January 7 session of the French Academy of Sciences. This flow of information resulted in a few isolated photographic experiments, beginning in the spring of 1839, and a growing number of more sucessful ventures in the autumn of that year.

The earliest American photographic experiments took place in the academic community. In his informative volume *Photography in America: The Formative Years, 1839-1900*, William Welling reports two

such instances from April or May 1839. Harvard students Edward Everett Hale and Samuel Longfellow "repeated Talbot's experiments at once," while John Locke—a professor of chemistry and pharmacy in Cincinnati—exhibited paper photographs in a local bookstore.[27] When success with the daguerreotype was achieved months later, it was centered in New York, Philadelphia, and Boston, with isolated experiments elsewhere.[28]

Although the painter and inventor Samuel F. B. Morse cannot be credited with the first published report of the daguerreotype in America—which appeared at least as early as February 23, 1839—he played a crucial role in its early history.[29] Some years earlier, in fact, Morse may have been the first American to attempt to preserve the images of the camera obscura. This work, variously dated to either ca. 1810-12 or ca. 1821-23, took place while Morse was living in New Haven, Connecticut, during his studies at Yale University or while working there as a sculptor and portrait painter.[30] In the period between these dates, Morse received a thorough artistic training in London, befriended some of the leading artists of his day, and continued the chemical and mechanical experiments he had begun as an undergraduate.

Morse's proto-photographic work in New Haven was aided by his friendship with Professor Benjamin Silliman, Yale's first chair in chemistry and natural history. Silliman had a thorough understanding of chemistry as well as a personal acquaintance with leading figures in Britain's proto-photographic world, including Sir Humphry Davy. It was in this context that Morse, using a camera obscura, later claimed he "was able to produce different degrees of shade on paper, dipped into a solution of nitrate of silver…but, finding that light produced dark, and dark light, I presumed the production of a true image to be impracticable, and gave up the attempt."[31] Morse turned his attention to other things—including his experiments with the telegraph, an invention hailed as one of the technological marvels of the age.

Morse traveled to Europe in 1838 to promote his telegraph. He was in Paris in the spring of 1839, when both his invention and the daguerreotype were the talk of the town. In early March, Morse initiated a meeting with Daguerre. While the Frenchman naturally withheld the details of his technique, he showed examples of his work. Morse excitedly penned a letter to his brothers—newspaper editors in New York—describing what he had seen (and giving the tantalizing report, cited above, of his own earlier research). Morse's letter appeared in the April 20, 1839, edition of the *New-York Observer*, and was reprinted in other American publications.[32] It included a description of the daguerreotype's physical appearance and astonishing precision:

> They are produced on a metallic surface, the principal pieces about 7 inches by 5, and they resemble aquatint engravings; for they are in simple chiaro oscuro, and not in colors. But the exquisite minuteness of the delineation cannot be conceived. No painting or engraving ever approached it. For example: In a view up the street, a distant sign would be perceived, and the eye could just discern that there were lines of letters upon it, but so minute as not to be read with the naked eye. By the assistance of a powerful lens, which magnified 50 times, applied to the delineation, every letter was clearly and distinctly legible, and so also were the minutest breaks and lines in the walls of the buildings; and the pavements of the street. The effect of the lens upon the picture was in a great degree like that of the telescope in nature.[33]

Portions of Morse's letter were cited, along with considerable information on Talbot's photogenic drawing technique, in the May 1839 issue of the *United States Magazine and Democratic Review*.[34]

For the details of Daguerre's process, the United States—like the rest of the world—had to await reports of Arago's August 19 presentation.[35] While the precise timing and details remain unclear, it appears that these summaries took about four weeks to reach New York.[36] Arago's presentation was first noted in the American press in the September 23, 1839, edition of the *New-York Evening Post*. Within days, other descriptions of the process appeared in Philadelphia, Washington, D.C., and Baltimore papers.[37]

More detailed reports and copies of Daguerre's manual quickly followed. The October 26, 1839, issue of the *Albion* included a concise description of the process.[38] A translation of Daguerre's manual, with diagrams of the required equipment, appeared in the November 2 issue of the *New-York Observer*.[39] At roughly the same time, another translation of Daguerre's text, by Professor John Frazer of the University of Pennsylvania, appeared in the November 1839 issue of the *Journal of the Franklin Institute*.[40] It is clear, therefore, that residents of the major cities had enough knowledge to begin experimenting with the process by the end of September, and that detailed accounts became widely available in early November.

In New York, a few crude daguerreotypes were made almost immediately. Credit for the first successful American daguerreotype goes to D. W. Seager, an English-born physician, who produced an architectural view of New York on September 26 or 27, 1839. By September 30, this plate was displayed in the shop of James R. Chilton, a physician, chemist, and pharmacist, at 263 Broadway. (Chilton himself experimented with the daguerreotype and became a supplier to the daguerreian trade.) Seager delivered public lectures on the process in New York, beginning on October 5, before fading out of the historical record.[41]

At about the time that Seager produced his first plate, other New Yorkers—including Samuel Morse, John W. Draper, Charles E. West, George W. Prosch, and Henry E. Insley—were also experimenting with the process. Only a few days after Seager's initial success, Morse—then an instructor at New York University—made a successful fifteen-minute exposure of the Unitarian Church from a third-story window of the university. Morse then turned to the problem of portraiture and, as he later claimed, made plates of figures standing in direct sunlight, with their eyes closed, with exposures ranging from ten to twenty minutes.[42] As an adjunct to these experiments, Morse became one of the first teachers of the daguerreotype. Many of his early students (who paid the substantial fee of $25 to $50 for lessons) went on to distinguished careers in the profession.

In late September 1839, Dr. John W. Draper, a professor of chemistry at New York University, also began experiments with the process. Having earlier explored the light-sensitivity of silver iodide and silver bromide, Draper grasped immediately the importance of Daguerre's discovery.[43] As it happened, Morse and Draper had offices in the same building and the two joined forces upon discovering their mutual interest in photography. Dr. Charles E. West, an acquaintance of Morse and Draper, and a fellow educator, also worked with the process in the fall of 1839.[44]

The most remarkable early work in the American daguerreotype was achieved by the team of Alexander S. Wolcott and John Johnson.[45] Wolcott was a manufacturer of instruments and dental supplies, with an expertise in optics. Johnson was trained as a watchmaker

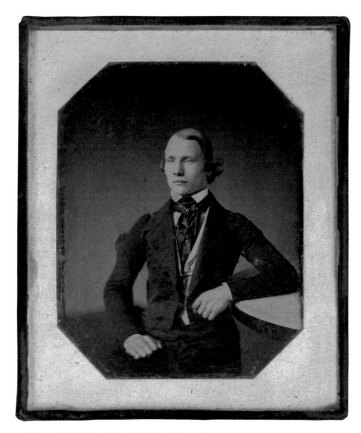

6 **Henry E. Insley,** *George W. Prosch*, ca. 1843-44

but also had experience in science and chemistry.[46] Johnson showed Wolcott a summary of Daguerre's process on the morning of October 6 (a date that suggests Johnson may have attended Seager's lecture the previous day).[47] Within minutes, Wolcott conceived of a new camera design based on the principle of the reflecting (or Newtonian) telescope. In place of a characteristically small lens, Wolcott's camera employed a 1¼-inch-diameter concave mirror. Used in conjunction with miniature daguerreotype plates (about ⅜-inch square), this combination produced somewhat shorter exposures than the standard camera obscura lenses of the day. The result (reputedly made on the afternoon of the same day!) was almost certainly the first photographic portrait in history, a profile view of Johnson standing in front of a window.[48]

It is important to note that while other pioneers began by making the easiest views—typically, records of buildings from upper-story windows—Wolcott and Johnson's very first plate was a portrait: the Holy Grail of 1839 daguerreotypists. With ease, it would appear, the pair began significantly ahead of their rivals—and maintained that advantage for some time. In the following weeks, the men conducted an intensive investigation of the mechanical and chemical aspects of the process. They collaborated with Henry Fitz, Jr., a skilled telescope maker, to replace their original camera with a larger model with a 7-inch mirror. This improved light-gathering ability allowed them to cut exposure times markedly, and to make larger plates (about 2 x 2 ½ inches). They also explored ways to increase the chemical sensitivity of their plates.

While Wolcott and Johnson worked on their own, George W. Prosch [6] produced cameras for Morse, Draper, and West. A manufacturer and retailer of "philosophical instruments," Prosch became one of the very first American suppliers of daguerreian goods and equipment. As early as November 2, 1839, a leading New York newspaper carried the following notice:

> The whole apparatus, including the camera obscura, iodine box, mercury box, thermometer, funnel, caps, lamps, troughs, stands, frames, silver plates & c., may be obtained of Mr. G. W. Prosch, philosophical instrument maker, 140 Nassau St., who is ready, we understand, to deliver the instrument complete for the sum of forty dollars… The lenses for the camera are made in the best manner by J. G. Wolf, 86 Nassau St., and the chemical ingredients, iodine, hyposulfite, & c., by J. R. Chilton, chemist, Broadway.[49]

Prosch's interest in the process was shared by his brother-in-law, Henry E. Insley, a broom-maker in the Bowery.[50] Prosch and Insley were both closely associated with Morse, from whom they received their first instructions. Together, the brothers-in-law experimented with the process in the autumn of 1839. They achieved considerable success, particularly in the making of portraits.[51] In fact, Insley was among the first Americans to be portrayed in the daguerreotype. This striking image [5], taken outdoors in direct sunlight, was almost certainly made in late 1839 or very early in 1840. This date suggests that it was produced in collaboration with Prosch or with both Prosch and Morse.

In Philadelphia, the early use of the daguerreotype followed a similar pattern of association with a characteristic set of interests: chemistry, optics, the making of precision instruments, and art.[52] If anything, Philadelphia possessed an even richer scientific and intellectual tradition than New York. Many members of the prestigious Franklin Institute—named for Benjamin Franklin—were interested in photography. As a result, the September issue of the Institute's *Journal* contained a summary of Daguerre's process, abstracted by Alexander Dallas Bache, the president of Girard College and a leading member of the local scientific community.[53]

The first Philadelphian to make a successful daguerreotype, Joseph Saxton, was representative of the city's intellectual elite: he was described as "a cultured man of genius."[54] Trained in jewelry making and engraving, Saxton invented a host of mechanical devices, including clocks and electromagnetic machines. After his election to the Franklin Institute he traveled to England, where he met such noted scientists as Michael Faraday. On his return to Philadelphia, Saxton became constructor and curator of the precision weighing devices at the U.S. Mint. With this technical expertise, Saxton had no trouble assembling a simple camera and making a daguerreotype view—on about October 16, 1839—from his window at the Mint.[55]

In his later summary of this period, the daguerreotypist and early historian of American photography Marcus A. Root suggested that a dozen or more other Philadelphians worked with the daguerreotype in the weeks after Saxton's success.[56] Not surprisingly, most of these men came from the ranks of the city's academic, medical, and technological elite. These figures included Walter R. Johnson, a Harvard graduate and professor of natural philosophy at the Franklin Institute; Dr. Paul Beck Goddard, of the University of Pennsylvania's chemistry department; Dr. J. E. Parker and Dr. Wildman, both dentists; William G. Mason, an engraver skilled in working with metal plates; and Robert Cornelius.[57]

Of this remarkable group, the most talented may have been Cornelius.[58] Trained in chemistry and drawing, Cornelius was then working in his father's business, which specialized in the manufacture

of silver-plated metal ware and brass lamps and chandeliers. At an early point in his experiments (presumably just after October 16), Joseph Saxton asked the young Cornelius if he could apply his expertise with metals to the manufacture of daguerreotype plates. Excited by Saxton's example, Cornelius took up the process himself. He assembled a camera in the family workshop, purchased a lens from the city's leading optician, John McAllister, Jr., and by late October or November had made his famous self-portrait—the earliest such image in existence.[59]

By early December, Cornelius had joined forces with Dr. Paul Beck Goddard to improve the process. Almost immediately Goddard suggested the use of bromine as an "accelerator" to increase the sensitivity of daguerreotype plates.[60] While Daguerre's original technique used a single sensitizing agent, Goddard's two-step process (iodine followed by bromine or, very soon after, by a combination of halogens) would soon become standard practice. The value of this improvement was clear. The daguerreotype's commercial viability lay in portraiture, which could only become practical with reduced exposure times. Given the economic worth of this secret, Cornelius and Goddard guarded it jealously, while quietly buying all the bromine they could find.

There was activity elsewhere in the United States in late 1839, although this has not been fully documented.[61] In his 1864 history, Marcus A. Root noted merely that "in 1839, Professor Grant…and Mr. Davis, of Boston, Massachusetts, made daguerreotypes on the third day after the discovery was published in Boston."[62] Notably, Dr. Henry Coit Perkins, in Newburyport, Massachusetts, made successful daguerreotype views of his town no later than the first week of November 1839. Perkins had a brilliant and versatile mind; a Harvard graduate, he was a physician with an interest in paleontology, astronomy, optics, and engraving. His surviving daguerreotypes are larger than extant plates by any other American of the period and reveal a confident vision. Perkins stuck with the process for at least several months, delivering a public lecture on the subject on February 20, 1840, in Newburyport.[63] Charles Avery, a professor of chemistry and natural philosophy at Hamilton College, in Clinton, New York, was another important early practitioner. After seeing a display of daguerreotypes in New York in late 1839, Avery turned to his friend Samuel Morse for instruction. Avery promoted the new medium in his chemistry lectures at Hamilton and gave private instruction in the process.[64] In Baltimore, daguerreotypes of street scenes were made by James Green and Thomas Phillips in late October 1839.[65] As far away as Wheeling, West Virginia, a Mr. Mathers was working with the process before the end of the year.[66]

Beyond the Laboratory: 1840

The daguerreian experiments of late 1839 were made predominantly by men from the realms of science and technology. Most of these figures were intrigued to see *if* they could make a daguerreotype image. All the evidence suggests that, once having done so, most returned to their previous pursuits. For them, Daguerre's process was fundamentally a curiosity, an intellectual challenge. While others conducted experiments in the next year or two for similarly personal reasons, the nature of the daguerreian enterprise was rapidly shifting and expanding. The purely intellectual challenge of the process never entirely disappeared, but it became subordinate to entrepreneurial and commercial motives. Instead of seeking merely to make a few

images of passable quality, nearly all daguerreotypists from 1840 on sought the skills to make consistently good ones. With their eyes firmly on the business possibilities of the new technology, their primary interest lay in portraiture.

This practical and professional outlook was epitomized by Wolcott and Johnson. While most others in 1839 tinkered with the daguerreotype, Wolcott and Johnson had a nearly visionary understanding of its ultimate practicality and utility. They received the first photographic patent in the United States—for Wolcott's mirror camera design, granted on May 8, 1840—and laid the groundwork for an international network of businesses.[67]

The world's first commercial daguerreotype studio was opened by Wolcott and Johnson in New York. Their first space—a trial operation in Wolcott's residence at 52 First Street—was functioning by the first week of February 1840, with Henry Fitz, Jr., as the camera operator.[68] By the middle of March, they had taken rooms in the Granite Building, at the corner of Broadway and Chambers Street. This was an ideal location: they were in the heart of the city's commercial district, and the structure's height and orientation provided maximum access to daylight.[69] The new gallery featured a system of moveable mirrors outside the taking room window that allowed them to flood the area with a powerful side light. This arrangement, in combination with the light-gathering power of their improved mirror camera, permitted Wolcott and Johnson to make portraits with exposure times of about three to five minutes. Their ninth-plate likenesses were cased and sold for the significant sum of $5 each.[70] This operation received much attention from the other daguerreian pioneers; it was reported that Morse, Chilton, Prosch, Cornelius, and others came to study their techniques.

Wolcott and Johnson's ambition is revealed in the range of their activities in 1840. Astute in both technology and business matters, they did much to shape the future course of the profession. In their quest for better plates, they prompted the Scovill Company—a venerable metal-working concern in Waterbury, Connecticut—to begin the commercial production of daguerreotype plates. In the summer, they established branch operations in Baltimore, under Fitz's direction, and in Washington, D.C.

Most remarkably, even before selling their first commercial portrait, Wolcott and Johnson began laying the foundation for an international business. In early February 1840, the pair sent Johnson's father, William S. Johnson, to England to patent the mirror camera and to secure backing for its commercial use. The senior Johnson entered into an agreement with Richard Beard, a businessman and entrepreneur.[71] After paying fees to Daguerre for the right to use his process in England, the new business was established under Beard's name in August.[72] A period of intensive preparation began, with many trials and experiments. John Frederick Goddard, a local lecturer in optics and natural philosophy, was hired to help perfect the chemical manipulations. Johnson left New York in October 1840 to join the London operation and Wolcott followed in the summer of 1841. The official opening of the Beard gallery, at the prestigious Royal Polytechnic Institution at 309 Regent Street, took place on March 23, 1841, and the business was immediately successful.

Wolcott and Johnson stayed in England for several years, improving and expanding the operation.[73] Particular progress was made in 1841 in refining the proportion and sequence of halogens to increase plate sensitivity. The resulting chemical formulation was marketed for years as "Wolcott's Mixture." Beginning in the summer of 1841,

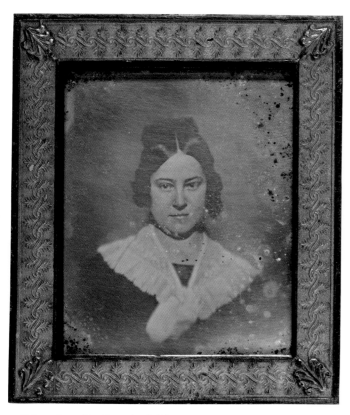

7 **Robert Cornelius**, *Portrait of a Woman*, ca. 1840

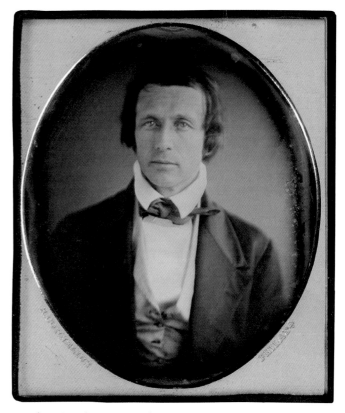

8 **Robert Cornelius**, *Portrait of a Man*, ca. 1841

branch galleries were opened in Plymouth, Bristol, Cheltenham, Liverpool, Nottingham, and other English cities.[74]

Following the model of Wolcott and Johnson, Morse and Draper opened their own portrait studio in New York in the spring of 1840.[75] As Morse recalled in 1855, "soon after we commenced together to take portraits," the pair set up a studio on the roof of their building at New York University. This was, from the beginning, a commercial enterprise: "As our experiments had caused us considerable expense, we made a charge to those that sat to us to defray this expense."[76]

The pair had a good run of business, despite their painfully long exposure times. In July 1840, Draper noted that exposures in direct sunlight ranged from twenty to ninety seconds, while portraits taken by diffused light required five to seven minutes. Neither choice was entirely satisfactory. As Draper noted of the gentle indirect light, "The advantages…which might be supposed to accrue from the features being more composed, and of a more natural aspect, are more than counterbalanced by the difficulty of retaining them so long in one constant mode of expression." A happy medium was achieved by adopting Wolcott and Johnson's technique of arranging mirrors to direct light into the studio. With this approach, Draper achieved exposures of forty seconds to two minutes.[77] Since portraits were most practical in sunny conditions, overcast days were usually devoted to giving instructions in the art.[78] When Draper left at the end of the summer to return to teaching, Morse continued in the business for several more months by himself.[79]

The firm of Insley and Prosch opened New York's third professional daguerreian studio, on the corner of Broadway and Liberty Street, in the summer of 1840. Their first customer was their friend and fellow daguerreotypist Dr. Charles E. West.[80] They, too, followed the example of Wolcott and Johnson by using mirrors to bounce sunlight into the studio.[81] The intensity of this illumination was made slightly more tolerable to sitters by the interposition of a sheet

of blue-tinted glass, which passed only the wavelengths of light to which the daguerreotype plate was most sensitive. Insley and Prosch closed this gallery at the end of the summer of 1840 when the weather turned cooler and the days shorter. The next year, operating now on his own, Insley opened a new gallery at Broadway and Cedar.

In Philadelphia, Cornelius and Goddard continued to perfect their still-secret bromine process, which eventually allowed indoor portraits to be made with exposure times of about ten to sixty seconds.[82] Spurred by his visit to Wolcott and Johnson's New York establishment, Cornelius opened for business on May 6, 1840, with Goddard as a silent partner.[83] His first sitter was the optician John McAllister, Jr., who supplied lenses to a generation of Philadelphia photographers.[84] Cornelius went on to make portraits of his family, friends, and scientific colleagues, as well as the paying public. Most of his earliest plates are simple head-and-shoulders depictions made in strong, direct light. These were typically presented in decorative brass frames made at the Cornelius lamp factory [7].

Cornelius operated this studio through the summer of 1840 and reopened in a new location in June 1841. The portraits from this second phase of Cornelius's business are more accomplished in style—the lighting is more nuanced and the poses more relaxed. Instead of the earlier brass frames, these portraits were presented in the leather-over-wood miniature cases that were quickly becoming standard in the profession [8]. This second studio lasted little more than a year, as Cornelius returned full-time to the family's lamp business after 1842.[85]

A visiting Frenchman, François Gouraud, played a key role in the growth of the profession in America. He might even be considered the "Johnny Appleseed" of early American photography: the profession grew, in large measure, from his many exhibitions, lectures, and demonstrations of 1839-40. Gouraud was in New York by late November 1839, acting as the sole American agent for Giroux & Co., the

Parisian firm holding the rights to sell Daguerre's official apparatus and materials.[86] Gouraud's reputation was enhanced by his close association with Daguerre: he had studied with the inventor and his collection of views included some by the master himself.[87]

Gouraud began his promotional campaign in early December 1839. On December 4, he gave an invitation-only preview exhibition of his plates to a select group of New Yorkers. Six days later, he opened a public exhibition at 57 Broadway, in the heart of the city's commercial district.[88] The public was both enthralled by the works on display and astonished at their values (they carried price tags ranging from $40 to $500 each).

The plates in Gouraud's collection were clearly of a higher quality than any made to that time by Americans. Many New Yorkers immediately paid for lessons, while men like Seager, Morse, Draper, and Chilton met with him in hopes of refining their skills. As it turned out, Gouraud greatly disappointed this latter group. In a public letter, Seager called the Frenchman a swindler and an imposter. Morse, incensed that Gouraud claimed to have taught him everything he knew about the process, stated bluntly that the visiting impresario had "revealed nothing to me which, on experiment, I have not proved either frivolous or useless."[89]

Despite these squabbles, Gouraud worked aggressively to promote both the daguerreotype and himself. He visited Philadelphia in January 1840 to meet the city's daguerreotypists. Back in New York, he advertised that he would deliver two one-hour lectures each day (with scheduled presentations in French and Spanish). His first lecture, on February 5, attracted some 120 gentlemen and ladies and resulted in a fine plate of the view from the lecture hall window.

In early March, Gouraud journeyed to Boston, where he set up his exhibition and gave more lectures and demonstrations.[90] His first talk, on March 27, was limited in advance to 500 people and quickly sold out. He gave three more presentations in the following week (all at the prestigious Masonic Temple), then moved on to the cities of Salem and Providence. Toward the end of May, Gouraud received from France a collection of some 200 daguerreotypes, including views of Paris, Rome, and Athens. These were shown in Boston in early June. At that time, Gouraud was advertising his services as a portraitist; he was set up in the Hall of the Boston Historical Society, offering "ordinary size" portraits at $5 each.[91] After this, however, his photographic trail vanishes. Gouraud's next appearance in the historical record is in 1844, as an itinerant instructor in "Phreno-Mnemotechny, or, The Art of Memory."[92] He died in Brooklyn in 1846, at the age of thirty-nine.[93]

In the course of his abbreviated photographic career, Gouraud showed fine daguerreotypes to thousands of viewers and demonstrated the process to many hundreds more. Gouraud's audiences in Boston included curious amateurs such as Francis Calley Gray, Edward Everett Hale, and Samuel Bemis, as well as several young men who would go on to become leaders in the new profession.[94]

Samuel Bemis was the most remarkable of these early amateur practitioners. Trained as a watchmaker, he became a skilled and successful dentist.[95] Bemis attended one of Gouraud's lectures in Boston and bought a complete daguerreian outfit. His first plates—architectural views of the city—were made in April 1840. Over the following year or so, Bemis produced the first body of landscape photographs in America: a series of whole-plate views of the White Mountains of New Hampshire. Bemis was a member of the Natural History Society in Boston and an avid hiker and climber. It was

natural, therefore, that he chose to make views of the rugged New England landscape. Bemis made about three dozen plates in all, most in and around Crawford Notch, on the eastern side of New Hampshire. However, he also carried his equipment to the western side of the state to photograph around Franconia Notch [9]. This daguerreotype—presented in his characteristic plain wood frame—depicts Lafayette House, the first hotel in the region.[96]

By the spring of 1840, residents of other American cities were being introduced to the process. The first recorded daguerreotypes in New Orleans were the work of Jules Lion, a black, French-born painter and lithographer. Lion opened an exhibition of his plates (probably all city views) on March 15, 1840, with an admission charge of $1.[97] The first daguerreotype made in South Carolina—a portrait by William H. Ellet—was probably produced in May 1840.[98] The first daguerreotype seen in Pittsburgh may have been the one noted in a local newspaper of May 20, 1840.[99] By the summer of 1840, itinerant practitioners were starting to be seen in New England and the more settled areas west of the Hudson. Before the end of the year, a number of notable pioneers were set up in full-time professional practice, including Henry Fitz, Jr., in Baltimore, John Plumbe in Boston, Jeremiah Gurney in New York, and Ezekiel C. Hawkins in Cincinnati.

In 1840, the economic potential of the daguerreotype was becoming clear. Equipment and supplies that had earlier been improvised or imported at great expense were increasingly available from local manufacturers and retailers. By early 1840, the Scovill firm had solved various technical problems in plate-making and was able to compete with French manufacturers. Their business grew steadily, and Scovill remained the leading American producer of plates throughout the daguerreian era.[100] Joseph Corduan, of New York, may have been the first American to manufacture daguerreotype plates; he went on to produce fine plates under the firm name Corduan and Perkins. A corresponding market arose for lenses, processing equipment and chemicals, image cases, and—ultimately—all the other items needed to run a professional studio. George W. Prosch was the first of several Americans to sell improved cameras of domestic design and manufacture.[101] As early as February 1840, Prosch was advertising his complete line of daguerreotype equipment and supplies as far away as South Carolina.[102]

The Foundation of a Profession: 1841-43

The field grew steadily in the early 1840s, propelled by continuing improvements. Lenses were made faster (that is, capable of casting brighter images) and sharper. Cameras were made lighter and more versatile. Exposure times were reduced—and the quality of the resultant images improved—by several technical innovations.

Daguerreotypists learned to make more richly toned images through improved methods of preparing, sensitizing, and finishing their plates. In 1839-40, following Daguerre's original formulation, plates were typically cleaned and polished—using a fine pumice powder, olive oil (then called "sweet oil"), and balls of cotton wool—with relatively casual, circular strokes. By late 1840, it was apparent that plates had smoother surfaces and stronger tones if they were polished with lateral rather than circular strokes, and finished with a delicate buff. In addition to these aesthetic qualities, perfectly prepared plates allowed somewhat shorter exposure times.

By the end of 1841, halogens other than chlorine were put into use to further shorten exposures. The most common of these substances

9 **Samuel Bemis**, *Lafayette House, Franconia Notch, New Hampshire*, ca. 1840

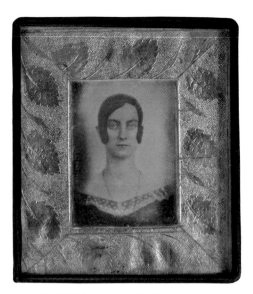

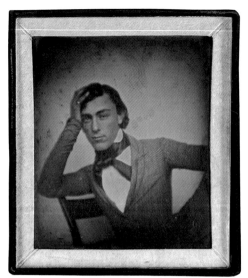

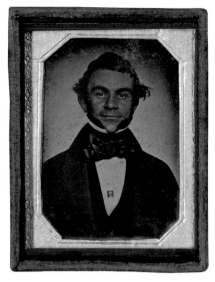

10 **Smith & Hale**, *Portrait of a Woman*, ca. 1841

11 **Hawkins & Todd**, *Portrait of a Man*, September 16, 1841

12 **W. & F. Langenheim**, *Portrait of a Man*, February 12, 1842

—known generically as "accelerators" or "quick stuff"—was bromine. At about the same time, it was discovered that "gilding" improved the contrast and stability of the image. In this step—after the image had been developed, fixed, and washed—a solution of gold chloride was gently heated on the surface of the plate. As the liquid bubbled into gas, the gold chloride formed a chemical bond with the image-bearing silver. As a result of these improvements, plate sensitivity was markedly increased (by some reports, by a factor of twenty), and the characteristically weak images of the pre-gilding era were replaced by rich and brilliant ones.

Although it took a few years for these improvements to be fully understood and adopted, the art of daguerreian portraiture improved markedly between 1841 and 1843.[103] This increased sophistication is documented in the following six works. These images range in date from ca. 1841 to ca. 1843, with two firmly dated examples in between. Physically, they are entirely characteristic of this early period: all are relatively small plates, presented with paper mats and in simple cases.

In addition to its unusually wide paper mat, the first of these [10] has all the hallmarks of the earliest commercial portraits: a faint, flat image (typical of an ungilded plate), a stern and unimaginative pose, and the use of overall "blast" lighting, resulting in an image without sculptural modeling or tonal nuance. It is important to note that this method of illumination was a result of both stylistic choice and technical necessity. There was an honored painterly tradition of smoothly radiant faces without any hint of shadow. In the quest for the "essential" reality of the sitter, this approach was logical; shadows, after all, are the most fleeting and transitory of effects. In addition, of course, the effort to shorten exposure times drove the earliest daguerreotypists to flood their sitting rooms with as much light as their subjects could stand. However, the goal was always an enveloping horizontal illumination rather than a harsh, overhead light.

As the second of these works [11] reveals, by mid-1841 the better portraitists were achieving more relaxed and lively poses, while continuing to employ a version of "blast" illumination. The first plate made for a customer by the Langenheim brothers, of Philadelphia, shows a further advance [12]. While stolidly posed, the sitter's

bemused half smile conveys a new sense of intimacy and animation. This portrait would also have been notable for being made in mid-winter, when the available daylight was near its annual minimum.

The fourth and fifth plates in this series [13, 14] demonstrate an increasingly subtle use of light. Instead of flooding their subjects with illumination, photographers began exploring the use of chiaroscuro (literally: *light* plus *dark*). Photographers understood that the art of portraiture lay not in the simple quantity of light employed, but in its quality—its distribution and modulation. The maker of the final plate in this sequence [15] not only posed and illuminated his subject with care, but employed an elaborate painted studio backdrop. This work represents a distinctly refined and ambitious approach to the early art of daguerreian portraiture.

While many of these portraits cannot be precisely dated, this sequence traces the general direction of technical and stylistic change in this period.[104] As these six plates suggest, the problem of portraiture shifted in the first years of the 1840s from technical considerations alone to primarily aesthetic concerns. Daguerreotype portraits became increasingly relaxed, natural, and flattering as photographers came to understand the nuances of lighting and pose. With this evolution, the daguerreotype moved from the era of the mechanical "likeness" to the age of the true portrait.

As the process became increasingly refined, daguerreotypists became at once more skilled and more numerous. A growing number of big-city galleries was open for business and a small army of itinerant daguerreotypists plied their trade in more remote parts of the country. A telling commentary appeared in a newspaper of February 24, 1843—a humorous perspective on the two most prevalent occupations in an economically depressed era.

I presume you would like to know who makes money in New York in these "Jeremiad" times. I can hear but two classes—*the beggars* and the *takers of likenesses by daguerreotype*… With the late twin increase of poverty and pity, the beggars of New York have correspondingly increased… *Daguerreotyping,* which is now done for a dollar and a half, is the next most profitable vocation. It will soon be difficult to find man or woman who has not his likeness done by the sun…[105]

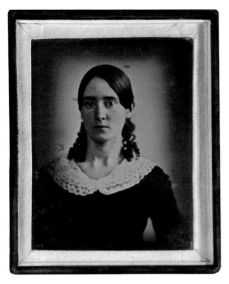
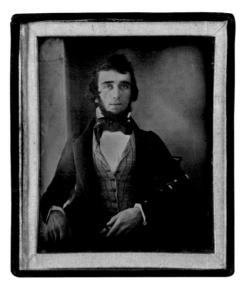
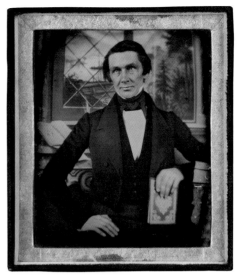

13 **Unknown Maker**, *Portrait of a Woman*, ca. 1842

14 **Unknown Maker**, *Man with Clarinet*, ca. 1842-43

15 **Unknown Maker**, *Rev. Charles Jones of Rome, New York*, ca. 1842-43

Case Studies:
Southworth & Hawes and John Plumbe

In its first years, the daguerreotype posed a professional challenge at once enticing and uncertain. Many young Americans were drawn to it in the hopes of making money. Not surprisingly, a high percentage of them failed. It was never easy to make a living as a daguerreotypist. In the early years, when competition was negligible, the process was difficult and often crude. As the technique became refined and standardized, competition increased dramatically.

The medium's pioneering professionals embodied a wide range of skills and experiences, and took differing attitudes toward the discipline itself. Something of these differences may be suggested in brief case studies of two important early firms: the businesses of Southworth & Hawes, in Boston, and of John Plumbe, who began in Boston and went on to open franchise operations in other cities.

Albert Sands Southworth, the younger partner in the famed firm of Southworth & Hawes, was a twenty-eight-year-old pharmacist in Cabotville, Massachusetts, when the daguerreotype reached America in the fall of 1839.[106] He was soon contacted by Joseph Pennell, a former schoolmate living in New York City, with an excited description of the new process. Southworth visited New York, was introduced by Pennell to Samuel Morse, and eagerly agreed to join his friend "in business for the purpose of making likenesses."[107] In May 1840 Southworth reported to his sister: "My mind has been in one constant state of agitation and study… Suffice it to say, that I can NOW make a PERFECT picture in one hours time, and that would take a painter weeks to draw… We doubt but that in less than a month, we shall be able to take portraits and miniatures to perfection."[108] Progress was not achieved quite that quickly; in the spring of 1841, the partners were still struggling to pay off the money they had borrowed to set up business. Seeking a more lucrative market, they moved in 1841 from Cabotville to Boston, where they rented rooms in the city's most fashionable commercial district. Two years later, in an effort to increase his patronage by the city's wealthiest families, Southworth moved across the street to a larger studio space. At this time, he took on a new partner: Josiah Hawes, a self-taught portrait painter turned daguerreotypist.[109]

Southworth & Hawes went on to operate a prestigious and respected studio throughout the daguerreian era. Their business was a reflection of their personalities and values. Southworth & Hawes aimed their services at Boston's upper crust: they made a beautiful and expensive product for a refined, status-conscious clientele. Their customers included the city's most distinguished families, the business and political elite, and the intelligentsia—prominent clergymen, writers, artists, and performers. The partners charged the highest rates in Boston—for plates of comparable size, their prices were typically two or three times higher than their local rivals'. Even as increased competition forced the price of daguerreotypes downward, Southworth & Hawes resisted the trend and maintained their high rates. Further, while most daguerreotypists worked in the more affordable sixth- and quarter-plate sizes, Southworth & Hawes became renowned for their mastery of the expensive whole-plate format. Great innovators and experimenters, they also prided themselves on making images of distinctly uncommon subjects (such as clouds) and under seemingly impossible conditions (for example, a series of early medical operations utilizing ether).[110]

In their advertising, Southworth & Hawes emphasized the quality and refinement—the artistry—of their work. In 1851 the pair announced: "We are proud to acknowledge the compliments and patronage of the best artists, amateurs, and judges of Art in Boston and vicinity… Our past conduct and experience we offer to them, to the public, and to all, as a pledge that *we will excel. Our customers shall have the best of work.* We will deserve and claim by right the name of our establishment, 'The Artists' Daguerreotype Rooms.'"[111]

The team lived up to this ambitious rhetoric. Their plates were more mellow in tone than the work of their competitors, their sitters more pleasingly posed and illuminated, and their finished works larger and more elegantly presented. A key artistic idea—the role of the unique hand and eye of the creator—was critical to the studio's approach. Southworth & Hawes never employed "operators": they gave their full and personal attention to every sitter. While it was

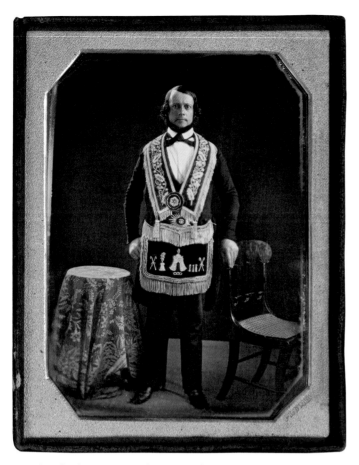

16 **John Plumbe**, *Man Dressed in Fraternal Apron*, ca. 1844

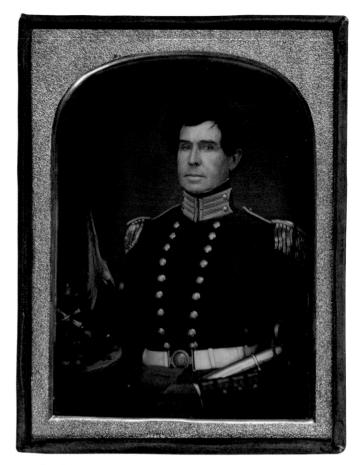

17 **John Plumbe**, *Mexican War Officer*, ca. 1846-48

common practice for daguerreian studios to employ some form of division of labor, including trained technicians to pose and photograph each sitter, Southworth & Hawes treated their "brand name" with the utmost seriousness. They took great pride in the fact that every plate from their studio was truly their work.

Both Southworth and Hawes had a deep and personal devotion to the medium. Although Southworth left the studio business in the early 1860s, he continued to list himself as a "Photographist"; his specialty in later life was the forensic use of photography to analyze handwriting. He was a respected figure in the National Photographic Association and gave several eloquent talks at national meetings. Hawes continued working quietly as a professional photographer until his death in 1901. His careful guardianship of a large collection of studio plates ensured that the Southworth & Hawes firm is now the best documented and most celebrated of all the great daguerreian enterprises.

John Plumbe was born in Wales and came to the United States as a child with his parents.[112] He worked as an apprentice civil engineer as a teenager, developing his love for the then-new railroad. In the early 1830s, Plumbe worked on the construction of the nation's first interstate rail line between Petersburg, Virginia, and Garysburg, North Carolina. Following his parents to Dubuque, in the Wisconsin Territory, Plumbe worked in real estate while advocating the visionary concept of a transcontinental railroad. Plumbe happened to be in Boston in the spring of 1840, promoting his railroad scheme, while François Gouraud was lecturing on the daguerreotype. Putting his railroad dreams temporarily on hold, Plumbe threw himself into

the new art. His first professional appearance as a daguerreotypist, in December 1840, was at Harrington's New Museum in Boston, an entertainment emporium that also featured phrenological readings and appearances by a "giant," a tattooed man, and gymnasts.[113]

From the beginning, Plumbe thought big. He aimed to establish not merely one business, but a chain operation. By mid-1841, he had established galleries in Exeter, New Hampshire; Salem, Massachusetts; and Dubuque.[114] Plumbe established a gallery in Philadelphia in 1842, and four more in 1843, in Albany, Saratoga Springs, Baltimore, and New York City.

Plumbe's New York City address—in the heart of the commercial district, at 251 Broadway—became his flagship location. This operation was phenomenally successful. A later writer recalled that this operation employed "twelve operators and Mrs. Thomas, an artist," and made "400 to 500 pictures a day at from $3 to $8 each."[115] Plumbe also ran an import and manufacturing business for cameras, chemicals, and daguerreian supplies from this address. In addition, he gave instruction to many who would become renowned in the field, including the Shew brothers, Ezra Chase, and Samuel Masury.[116] By 1845, Plumbe's business had grown to include twenty-five galleries, ranging from Portland, Maine, to Washington, D.C., Richmond, Cincinnati, Louisville, New Orleans, and St. Louis, and even overseas, in Liverpool and Paris. By this time, Plumbe's photographic empire provided "employment and support" for nearly 500 persons.[117]

The keys to Plumbe's business were brand-name recognition and the economies of scale. Daguerreotypes from his establishments carried the "Plumbe" credit regardless of their actual makers. Plumbe

employed some first-rate daguerreotypists—Gabriel Harrison, for example, began his professional career in Plumbe's New York studio. While many of Plumbe's other operators are now little known, he clearly had an eye for talent. Overall, the work that left his various studios was of fine quality [16, 17, 18]. Plumbe kept his expenses to a minimum by standardizing his equipment and materials and purchasing his supplies in bulk. He advertised nationally and he made certain that most of his galleries were accessible by rail. Like any astute businessman, he adapted with the times. As increased competition drove prices down, Plumbe dropped his rates accordingly, seeking to make his profit from the volume of his production.

Ever the promoter, Plumbe helped establish the daguerreian waiting room as a public attraction. Fascinated by celebrity, Plumbe appointed his waiting rooms with daguerreotypes of statesmen, artists, performers, and other notables.[118] While these images might have been available for sale, their primary purpose was to elevate the tone of the business and to entice potential customers.

Plumbe knew the advantages of maintaining a high profile. He exhibited his work in trade and manufacturers' fairs and was often rewarded with the top prize. In 1846, he made daguerreotypes of all the major federal buildings and monuments in Washington, D.C., for display in his gallery in that city. Also in 1846, he began collaborating with the printmaker Thomas Doney to have mezzotint engravings of prominent men made from his daguerreotypes for inclusion in the *United States Magazine and Democratic Review*. In subsequent years, low-cost lithographic versions of Plumbe's celebrity portraits were made by several printmakers, including Nathaniel Currier, for popular sale.[119] In late 1846, Plumbe set up his own National Publishing Company to increase the circulation of his most significant portraits. Plumbe's press issued a variety of books as well as his own periodicals, the *Popular Magazine* and the short-lived *Plumbeian*.

By 1847, however, Plumbe was overextended and his empire was crumbling. He ceased his publication efforts to refocus his attention on his portrait studios. By 1848, these too were in trouble; one by one, they were closed or sold. In 1849, Plumbe ceased all direct management of his galleries to go to California. After further unrewarded efforts to promote a transcontinental rail line, he returned to Dubuque in 1854. Sick and impoverished, he committed suicide three years later.

The professional examples of Southworth & Hawes and John Plumbe suggest something of the variety of ideas and issues at play in this era. Some daguerreotypists were passionately devoted to the medium. For others, it was simply a livelihood—an opportunity rather than a calling. Some took genuine pleasure in exploring the nuances of the process—the challenge of making "perfect" plates and fresh, innovative images. Others cared only to achieve a consistently good, standardized product. Aesthetic issues were a primary concern for some, a matter of secondary importance for others.

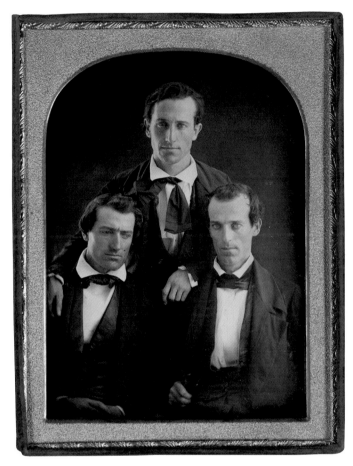

18 **John Plumbe**, *The Raymond Triplets*, ca. 1845-48

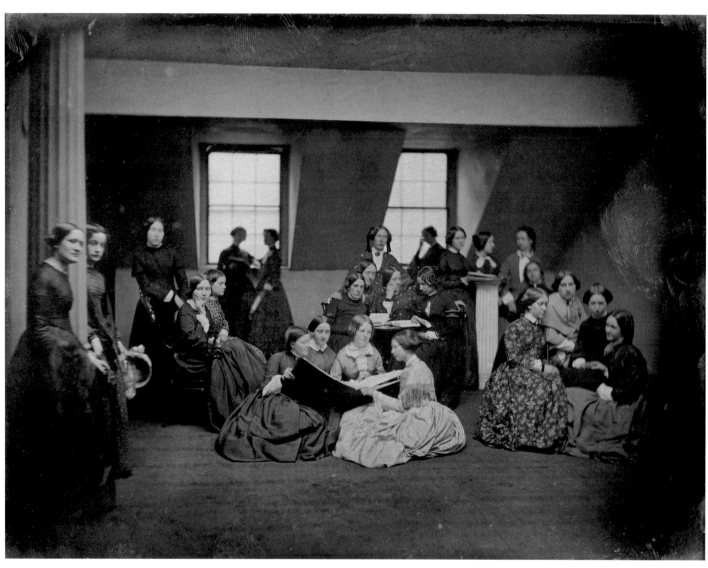

19 **Southworth & Hawes**, *Students from the Emerson School for Girls*, ca. 1850-55

CHAPTER II # Leaders in the Profession:
A Regional Survey

The true achievement of the American daguerreotype lies in the full spectrum of what was accomplished with the process—from the most artistic plates to the most generic, from works by the most celebrated studios to those by an army of now-forgotten practitioners. This volume includes examples from across this spectrum, from daguerreian masterpieces to more journeyman or characteristic images. Exceptional works bear a particular relation to the historical "rule": they are either perfect realizations of that rule, or radical deviations from it. Characteristic images, by contrast, fit comfortably within the accepted standards of the era—they are the pictures that daguerreotypists aimed to make on a consistent basis. Our understanding of the American daguerreotype rests on taking both categories into account. Exceptional works mark the technical and conceptual limits of the medium; characteristic works speak to shared values and abilities.

A significant act of imagination is required to fully appreciate the art of the daguerreotype. A majority of all the daguerreotypes ever made have been discarded or lost. It hardly matters—and certainly could never be proven—whether it is 90 percent or 60 percent of this original production that is now gone. Lost daguerreotypes constitute a potent aspect of today's daguerreian lore—they represent a kind of pictorial Atlantis. In 1850-51, for example, Robert H. Vance created 300 whole-plate views of California's cities, gold fields, American Indian communities, and missions, as well as scenes on the ocean route to California, along the west coast of South and Central America.[1] Displayed to great acclaim in New York City in October 1851, these were subsequently purchased by John H. Fitzgibbon and moved to St. Louis. After 1857, they vanish from the historical record. Other large bodies of expeditionary daguerreotypes have suffered a similar fate. None of John Wesley Jones's reputed 1,500 views, made between California and the Missouri River in 1850-51, are now known. The painter and daguerreotypist John Mix Stanley made portraits of Indians in the Far West in 1853; all are now lost. In his work for the 1853-54 expedition of John C. Frémont, Solomon Nunes Carvalho made some 300 views in the western plains and Rocky Mountains; only one of these may now be extant.[2] Only a few of the approximately 400 plates by Eliphalet Brown, Jr., produced as part of the 1852-54 Japan expedition of Commodore Matthew C. Perry, are now known.[3] Many other more modest examples of lost daguerreotypes could be cited. For example, a steamboat explosion in 1853 cost the now little-remembered daguerreotypist N. S. Bennett, of Washington, D.C., an irreplaceable box with a whole-plate daguerreotype of Henry Clay, "the last picture ever taken from life of the great Statesman," a "fine likeness of the Florida warrior Billy Bow Legs," and "a valuable collection of likenesses of the Rocky Mountain tribes of Indians."[4]

These losses have continued more or less steadily in the intervening century and a half. Most of this destruction has been the result of everyday acts of carelessness or neglect. Until relatively recently, daguerreotypes were viewed as simple historical artifacts with little aesthetic or financial value. As a result, until the later decades of the twentieth century, daguerreotypes were typically saved for what or who they depicted, rather than for any intrinsic significance as photographs. Under these conditions, millions of daguerreotype plates have vanished—discarded or simply lost through neglect.

Furthermore, many plates survive in less than pristine condition. Knowing that silver naturally tarnishes on contact with the atmosphere, daguerreotypists protected their plates in nearly air-tight packages (the tape-sealed unit of plate, mat, and cover glass, inserted into a leather or thermoplastic case). Over time, however, as these seals have failed, glass has decomposed, and the sealed packages have been taken apart, the daguerreotypes have suffered from accelerated tarnishing, as well as from surface debris, scratches, and wipes. Given their propensity to tarnish, some plates have been cleaned several times over the decades. No method of removing tarnish is without risk, and the tones of many daguerreotypes have been compromised —in some cases severely—by over-cleaning.

The ultimate message of this history is regrettably simple: most of the best plates from the daguerreian era cannot now be seen in anything like their original condition or, indeed, at all. Given the remarkable diversity and quality of the plates that *have* survived, we can only marvel at the brilliance of this original achievement.

As so many of the attributions and titles in this book suggest, the daguerreotypes now extant often come to us as mysteries. A great majority were created as family mementos. The identity and meaning of their subjects was self-evident to the people for whom they were made. However, such private meanings become increasingly obscure with each passing year. The evidence of antique shops and

flea markets suggests that familial memory extends back, on average, only about three generations. After this time, family photographs typically become historical orphans, destined for the trash heap, the flea market, or, on rare occasions, the auction house. As a result of this human process of moving, sorting, and forgetting, relatively few daguerreotypes today are accompanied by the basic facts of origin, subject, or prior ownership.

Only a fraction of American daguerreotypes—something between 5 and 10 percent—bears the name of its maker. We must assume that, given a choice, customers rarely wanted the studio's name emblazoned on their portraits. Such names and logos were probably viewed as advertising—signs of commerce on personal mementos. When they appear, these identifying marks are usually imprinted on the brass mat or on the facing velvet pad. Less frequently, they may be found on the exterior of the case, written or inscribed on the back of the plate, on scraps of paper, or—in the rarest examples —on the image itself.[5] In other instances, attributions of varying reliability may be based on the evidence of a characteristic posing chair, backdrop, or tablecloth.

There was no professional standard for indicating the authorship of finished daguerreotypes. Some studios put their identifying mark on a high percentage of their works—the early chain of Plumbe operations, for example, as well as the studios of Rufus Anson, in New York, and Charles Williamson, in Brooklyn. Identified works by several notable daguerreotypists—including Jeremiah Gurney and the operations of Samuel and Marcus Root—are known today in at least moderate quantity. A few daguerreotypists—most prominently, Rensselaer E. Churchill, of Albany—took this notion of authorship to its artistic extreme by autographing their plates with a stylus. Conversely, other now-famous businesses—including the Boston firm of Southworth & Hawes—appear to have deliberately left their plates, mats, and cases unmarked.[6] Southworth & Hawes's reticence was a form of elitism—they felt, with some justification, that their style and presentation alone distinguished their works from all others.

In truth, most leading studios of the period prided themselves on having an identifiable aesthetic—a result of favored poses, characteristic backgrounds or props, the use of larger plates or hand-coloring, and the style and quality of the cases. By the early 1850s, this notion of individual studio style was taken for granted, and an astute professional of the period could easily have distinguished a work by Whipple from one by Southworth & Hawes, a Gurney from a Brady, a Root from a Langenheim.

Today, the clarity of these differences is much harder to appreciate. In part, we are simply less sensitive to the creative choices embodied in each work. In addition, we have few large groups of firmly identified daguerreotypes to illuminate the aesthetic of individual studios —both characteristic stylistic traits and the range and frequency of deviations from these favored approaches. There are, thankfully, a few notable exceptions to this rule, including the approximately 2,000 firmly attributed plates by Southworth & Hawes, and the more than 600 examples by Thomas M. Easterly.[7]

This problem of style is complicated by the nature of the daguerreotype business. While small-town operators or elite practitioners like Southworth & Hawes may have made all their images themselves, the typical large-city studio employed one or more operators to make pictures. Although these operators would have been thoroughly trained in their employers' technique and approach, each would inevitably bring something of themselves to the final image. Furthermore,

nearly every studio—from large to small—produced a broad range of work for an equally broad public. This production ranged from large, elegantly conceived portraits for the wealthiest customers to small, formulaic likenesses for those of more modest means. In addition, studios typically provided all the other services demanded by their customers, from the making of postmortems to the production of daguerreian jewelry. As a result, the output of most studios was distinctly heterogeneous.

Further, responding to the needs of their customers, daguerreotypists routinely borrowed, bought, and copied plates made by others. These copies were often of superb, like-original quality. If these second-generation images now carry any maker's mark, it is that of the copyist rather than the original photographer. In addition to examples of their own work, many studio reception rooms exhibited plates of notable faces or scenes by other makers. Sometimes, these plates changed hands several times. In a letter of 1851, for example, the Meade Brothers noted that they had sold daguerreotypes of celebrities to one studio, which promptly sold them to yet another, where they were placed on display.[8] These reception room exhibits were understood not strictly as promotions of what any single studio could accomplish, but as demonstrations of the beauty and potential of the daguerreotype itself.

The authorial implications of this practice of borrowing and copying plates were usually straightforward. In 1852, for example, John A. Whipple exhibited a five-plate panorama of San Francisco, but he had never visited California and his acquisition of this work was reported in the Boston press.[9] In other cases (including, surely, many yet to be discovered), this practice led to inevitable confusions over authorship. For example, while Southworth & Hawes employed no operators in their Boston studio, they were known—on at least a few occasions—to have copied and shown the work of others. In 1848, they received a sixth-plate portrait of General Zachary Taylor from a studio in New Orleans; this was copied to whole-plate size and exhibited in their reception room.[10] More significantly, there has long been question about the authorship of the views of Niagara —the falls, river, and suspension bridge—that ended up in the Southworth & Hawes studio collection [c-37, c-38]. The scholarly consensus now is that these are almost certainly the work of Platt D. Babbitt, the daguerreotypist who effectively owned the "franchise" for making views at Niagara Falls. There is no record that either Southworth or Hawes visited Niagara, but there is clear evidence that the pair received plates in trade from Babbitt.[11]

As a result of these factors, the output (and the residue) of any single studio would probably lack the aesthetic unity typical of a "fine" artist. This is to be expected, since the daguerreotype was an *applied* art; studios were in the business of serving the needs and tastes of their customers. Nonetheless, there is a clear aesthetic—or, more correctly, a set of overlapping aesthetics—in the American daguerreotype.

The artistic ambition of a respected studio would have been most apparent in its largest, most expensive productions. Half- and whole-plate portraits were not made casually—each represented a major expenditure by the customer and a corresponding technical effort by the photographer. In a large studio with multiple operators, it is safe to assume that plates of this size were made by the most talented photographers. As a result, it is in these larger plates that we find the most conscious and considered aesthetic statements of the period. These same traits are often evident in plates of smaller size, but with less consistency or precision. It is for exactly this reason that we

might look to the most routine productions—the basic sixth-plate portrait—for an indication of the overall standards of a large studio.

The fact that we cannot make solid attributions of authorship for more than a fraction of existing daguerreotypes leads us naturally to the idea of a "collective" style or aesthetic. The emphasis here is on commonalities: the basic characteristics and potentials of the process, the shared ideas and values of the period, and the classic genres or themes. Despite its usefulness, however, this notion of a collective style is a product of historical necessity—as much a result of what we do *not* know as of what we *do*.

Most of the thousands of men and women who worked as daguerreotypists in America are now historical footnotes.[12] This is to be expected: most were of merely adequate talent, with no larger ambition than to earn a living. This does not rule out the possibility, of course, that many of their works may deserve to be remembered and celebrated. On the other hand, the leading figures in the profession fully deserve a more formal historical recognition. Their names were known nationally and even internationally, and their efforts helped define both the potentials of the medium and the nature of the profession.

The business of the daguerreotype was a complex economic ecology: a network of people and studios engaged in a struggle—variously cooperative and competitive—for resources. Some practitioners were successful and grew large; others achieved an acceptable, middling level of financial stability. A significant number were ultimately unsuited for the business and failed.

Daguerreotypists worked where there was money to be made; each required a population of reasonable size (or a steady stream of visitors) to prosper. Daguerreotype studios were prevalent in major cities—where they were often clustered in the heart of the commercial district—and spread more thinly in the provinces. This entrepreneurial system provided a niche for a variety of talents. Daguerreotypists who were introverted, moderately well organized, and merely competent with the process might get by in small-town practice, where they faced little competition. By contrast, the most successful city daguerreotypists were almost invariably the ones with the best overall combination of technical knowledge, business acumen, and interpersonal skills. Thus, by acknowledging the field's leading figures, we at least begin the process of recognizing the range of qualities that led to success in the profession.

The regional history of the daguerreotype was a direct reflection of the nation's overall economic growth. In 1840, New York, Boston, and Philadelphia were the country's leading financial, industrial, transportation, and cultural hubs. The profession began in these places and radiated outward with the flow of population, commerce, and communication.

Boston and Vicinity

A leading port, Boston had long served as a point of intellectual and commercial contact with Europe. The city grew steadily in the daguerreian era: from a population of 93,400 in 1840, to 136,900 in 1850, and 177,800 in 1860. In this period, it ranked between third and fifth in population among American cities, roughly comparable in size with Baltimore, New Orleans, and Philadelphia.

One of the best-managed cities in the nation, Boston exuded an air of prosperous refinement.[13] While much smaller than its bustling Empire State rival, it boasted a richer and more homogenous population. In fact, in the early 1840s, Boston had the highest per capita wealth of any city in America. It weathered the effects of the Panic of 1837 far better than New York: between 1840 and 1850, Boston's per capita wealth grew from $961 to $1,297, while New York's fell from $806 to $555.[14] Boston's fiscal soundness encouraged the flourishing of the daguerreian profession. Four galleries were in operation in 1841, six in 1842, sixteen in 1846, and forty-three in 1850.[15] The city's relative wealth, conservatism, and social homogeneity helped shape the nature of the resulting pictures.

The best-remembered Boston firm—Southworth & Hawes—was intimately identified with the city's social elite. The studio was on Tremont Row, in the heart of the most fashionable commercial district. Many of the city's prominent families lived nearby, around Pemberton Square.[16] While most other studios sought the broadest clientele possible, Southworth & Hawes emphasized quality, taste, and artistry. They specialized in the expensive whole-plate format and fought all pressures to lower prices.[17]

The Southworth & Hawes style that we now consider characteristic was achieved over time, a result of technical refinement and aesthetic choice. As Marcus Aurelius Root observed, Southworth & Hawes had a style "peculiar to themselves; presenting beautiful effects of light and shade, and giving depth and roundness together with a wonderful softness or mellowness." This aesthetic was based on a nearly unsurpassed technical mastery. Their plates had "an exquisitely pure, fine, level surface…entirely free from waves, bends and dents,—in short, as nearly perfect, as is perhaps possible."[18]

As the contemporary daguerreian practitioner and scholar Mike Robinson has demonstrated, the "wonderful softness or mellowness" of Southworth & Hawes's plates was a result of their attention to every step of the process. This effort began with plate preparation: as Southworth noted, "The finer the polish, the more delicate the picture."[19] The partners augmented the silver layer of their plates through electroplating, and used a polishing device of their own invention to ensure the best finish. In sensitizing, they employed a distinctive combination of bromine and iodine in the second step.[20]

Southworth & Hawes were masters of light and employed their entire studio space—along with various baffles, scrims, and reflectors—to make best use of the day's illumination. While strong light was needed to reduce exposure times for some subjects—children and large groups, for example—the firm preferred a softer illumination for most others. Further, Southworth & Hawes made selected use of the "white" or "illuminated" camera to open shadow tones and mute extremes of contrast. In this technique, the interior of the camera was painted white to increase internal reflections. These extraneous light rays effectively added a small overall exposure to the dark tones of the image, smoothing and lowering the contrast of the final picture.[21] In addition, they carefully manipulated the focus of their lens, rendering at least a few portraits (usually of women) with a quasi-impressionistic softness. Finally, they were careful to develop their plates over mercury heated to no more than 70 degrees Celsius (158 Fahrenheit); at higher temperatures, images had greater contrast and tended to take on a granular appearance in the dark tones. Characteristically, this approach resulted in plates with "an exquisitely fine surface, opalescent pink whites, beautiful clear shadows, and an overall soft and mellow tone."[22] At times, these images were rendered even more delicate (and painterly) through the addition of hand-coloring, as seen in this exquisite portrait of Hawes's daughter, Alice Mary Hawes [20].

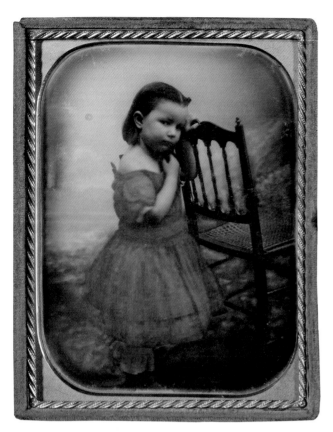

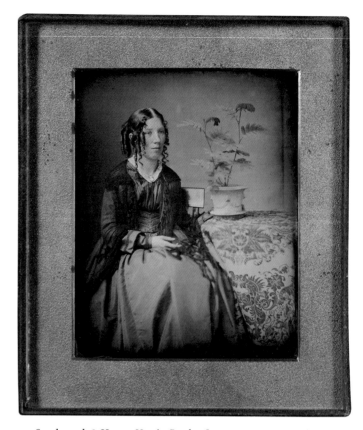

20 **Southworth & Hawes**, *Alice Mary Hawes*, ca. 1853-55 21 **Southworth & Hawes**, *Harriet Beecher Stowe*, ca. 1843-45

The evolution of Southworth & Hawes's style may be seen in three of their finest photographs of women: an engagingly direct portrait of Harriet Beecher Stowe from about 1843-45 [**21**], and two masterful works of several years later [**19, 22**]. The Stowe portrait—made after she first came to national renown as a writer, but before the international fame of *Uncle Tom's Cabin* (1852)—is characteristic of at least some portion of the studio's early plates. It is of medium size—a quarter-plate—and lacks the overt idealization of some of their later works.

The two later works, both whole plates with the "soft and mellow" tones described above, reveal a more polished and ambitious artistic approach. *The Letter* (originally one half of a stereo pair) is an elegant depiction of two young women sharing a communiqué. The women are arranged to show both their faces and costumes to advantage. The visual space around them heightens the mood of both physical intimacy and emotional sympathy: the out-of-focus elements in the background suggest an upscale parlor while remaining appropriately subordinate to the figures.

Students from the Emerson School for Girls is a logistical and artistic tour-de-force. This plate depicts the long axis (and full width and height) of the Southworth & Hawes studio—a perspective demanded by the size of the group. Instead of simply recording these twenty-five figures in close formation, the team made a genuine *composition* by orchestrating them in clusters across the pictorial space. There are eight distinct groupings of between one and five women reading, talking, or simply lost in thought. The image is a veritable catalogue of poses and glances; each figure conveys a distinct identity, yet all are unified by the formal logic of the composition. Above all, this image conveys a subtle sense of its own artful status as a *picture*: two standing figures on the left bracket a pillar, nearly mirror reflections of one another, while the fourth figure

from the left enlarges the mood of self-contained perfection by looking coolly and steadily out of the picture at us.

Southworth & Hawes recorded many distinguished sitters, ranging from local figures such as Daniel Webster, Charles Sumner, Henry Wadsworth Longfellow, and Ralph Waldo Emerson, to visiting celebrities such as Louis Kossuth, Lola Montez, and Jenny Lind. They also produced extraordinary pictures outside the studio, including views of Boston streets and buildings, ships in dry dock, and monuments in Mount Auburn Cemetery. A remarkable series of whole plates, made ca. 1846-47, records various reenactments of an important event in the history of medicine: the first surgical use of ether.[23]

Southworth & Hawes explored the boundaries of the medium in both technical and aesthetic terms. They were pioneers in making very large daguerreotypes, up to 13 ½ x 16 ½ inches in size.[24] They were also early proponents of stereoscopic photography. When seen in a simple viewing device, these paired images—typically made with a twin-lens camera to simulate the separation of the human eyes—provide a remarkable illusion of three-dimensional space. Stereo daguerreotypes came to popular attention at the 1851 Crystal Palace exposition in London, and the technique was used widely in France and England for portraits, urban views, and artistic studies.[25]

While the stereo daguerreotype never achieved a comparable degree of acceptance in the United States, several Americans made notable efforts with it. By early 1852, Southworth & Hawes had designed and built a unique viewing device, the Grand Parlor and Gallery Stereoscope. As scholar Grant B. Romer has written, this table-top viewer was "in concept, a console-style visual entertainment center, the 1850s equivalent of the cabinet television that entered the parlors of American homes in the 1950s."[26] Designed for stereo pairs of whole-plate daguerreotypes, this viewer provided a stunning visual experience. Southworth & Hawes created a special body of work in

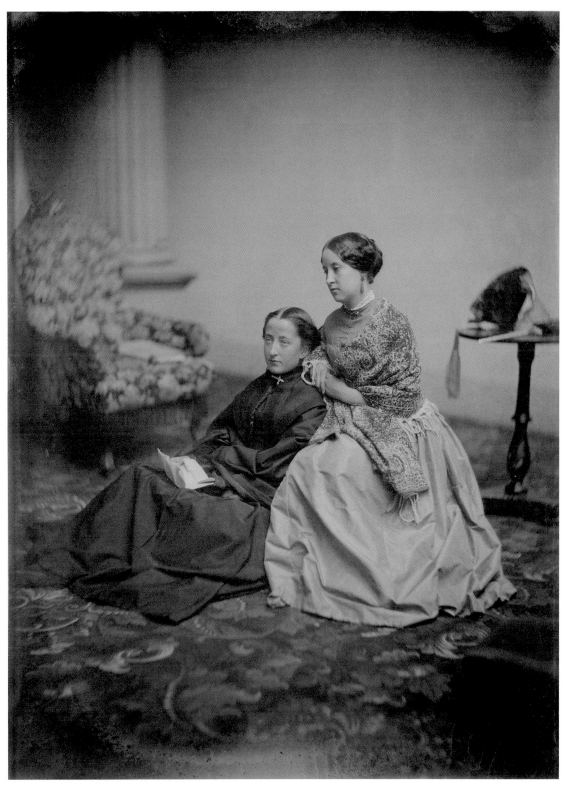

22 **Southworth & Hawes**, *The Letter*, ca. 1850

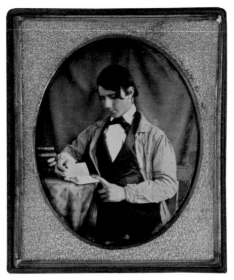

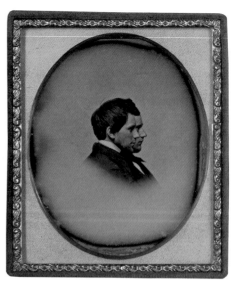

23 **Southworth & Hawes**, *Frost on a Window*, ca. 1850

24 **John A. Whipple**, *Self-Portrait, Reading Book in Lab Coat*, ca. 1842-43

25 **John A. Whipple**, *Self-Portrait with Brother, Frank Whipple, in Double Profile*, ca. 1847

this format (including *The Letter*), and charged visitors twenty-five cents for a single viewing session or fifty cents for a "season ticket." It is known that two other leading daguerreotypists (Alexander Hesler, in Chicago, and Platt D. Babbitt, at Niagara Falls) purchased similar models from them.[27] Babbitt may have covered part of this expense by trading stereo images made in and around the falls.

The views that Southworth & Hawes made (or acquired) for their Grand Parlor and Gallery Stereoscope stand slightly apart from their usual commissioned portraits. Given the device's public nature, Grand Parlor views would have been made to serve an aesthetic, rather than primarily utilitarian, function. They were intended to promote the gallery's renown and to demonstrate the quality and originality of Southworth & Hawes's work.[28]

The full range of Southworth & Hawes's creative vision had not been fully appreciated until 1999, when a previously unknown trove of about 240 daguerreotypes was sold at auction.[29] This group included two radically unusual views—pictures of fleeting natural effects that could only have been made for experimental and aesthetic purposes. One is a whole-plate view of luminous clouds above a silhouetted roofline.[30] The other [23] is a sixth-plate close-up of frost on a window. These daguerreotypes explore the patterns of nature on vastly different scales. While a handful of other—primarily European— photographic cloud studies may be found from this era, the subject was otherwise unexplored in the American daguerreotype. Nothing comparable to the frost study is known by any other photographer of the period.

Today, these images strike us as prototypically modern, suggesting a conceptual link to such classic twentieth-century artists as Alfred Stieglitz, Edward Weston, and Minor White. These images suggest something important about Southworth & Hawes's attitude toward photography. While they used the medium to earn a living, they actively explored the nature and potentials of the process itself. In a way that the 1960s-70s street photographer Garry Winogrand might have appreciated—he famously said, "I photograph to see what things look like photographed"—they were fascinated by the challenge of conceiving and making *pictures*.[31] The most informed observers of the day understood the firm's uniqueness. As James Wallace Black— himself a leading Boston photographer of the 1850s—noted in 1877,

Southworth & Hawes "made some of the most exquisite results— only the profession had not the cultivation to appreciate them."[32]

Southworth & Hawes occupy a unique place in photographic history. For reasons of both intention and chance, far more attributed plates have survived from their studio than from any other firm of the period.[33] This visual archive is supplemented by an equally unusual quantity of business records and correspondence. After more than thirty years of scholarship and appreciation, we have a richer understanding of Southworth & Hawes—as personalities, entrepreneurs, and artists—than of any of their peers.[34] This poses an interpretive challenge: to better assess the ways in which Southworth & Hawes were representative of the American daguerreian profession and the ways in which they were atypical or unique. This task remains uncompleted, since it requires a deeper understanding of the work of other leading studios than has been achieved thus far.

Fortunately, a substantial (if considerably smaller) body of work by John Adams Whipple, Southworth & Hawes's leading competitor in Boston, also survives. Mechanically inclined, with an interest in chemistry, Whipple appears to have experimented with the daguerreotype in late 1839. For several years, he earned his livelihood in the chemical end of the daguerreian business. In an early self-portrait [24] Whipple recorded himself in his lab coat, reading. By 1844, he had moved full-time from the chemical laboratory to the studio. While he worked for a few years in partnership with Albert Litch, and later with James Wallace Black, most of his daguerreotypes were produced under his business name alone.[35] Whipple was located on Washington Street, the city's main commercial thoroughfare.[36] He developed close links to lithographers, engravers, and publishers: his views and portraits of notable subjects were reproduced on music sheet covers, in the pages of illustrated newspapers such as *Gleason's Pictorial*, and as fine copper-plate engravings.[37]

Whipple was personable, reliable, talented, and—as a result— successful.[38] His business style was more populist than that of Southworth & Hawes. While the latter took what one historian has described as an "elegant but conservative approach" to their business, Whipple actively promoted his technical innovations (including his use of steam power to polish his plates and to cool his studio), and

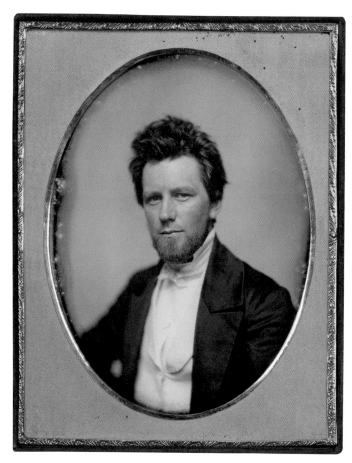

26 **John A. Whipple**, *Self-Portrait*, ca. 1850

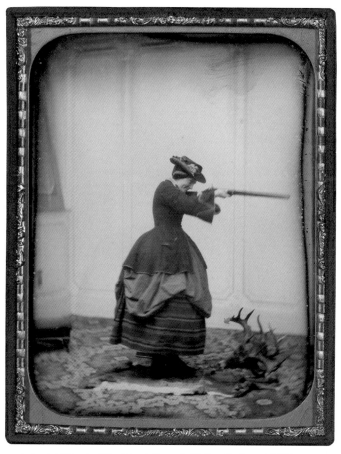

27 **John A. Whipple**, *Ellen Harris Young in Riding Clothes, with Rifle*, ca. 1849

his skills with both group portraits and oversize daguerreotypes.[39] One of Whipple's surviving mammoth-plate (or double whole-plate) daguerreotypes depicts the family of his wife, Elizabeth Mann Whipple [C-1]. Whipple used various strategies to keep his name in the public eye. In 1850, he organized an elaborate evening program of entertainment at the Tremont Temple. This extravaganza, "Whipple's Grand Optical Exhibition of the Dissolving Views," consisted of projected lantern slides of foreign views, insects and microscopic creatures, and a life-size projection of Jenny Lind, all accompanied by music and song.[40] This democratic appeal was also reflected in Whipple's rates; in an indirect reference to his competitors on Tremont Row, he advertised "Prices reasonable."[41]

In 1849, Whipple patented a process for what he termed "crayon daguerreotypes." These were made by photographing a subject's head through an oval opening in a large white card. The card was kept in motion during the exposure, yielding a pleasingly soft cameo effect around the head—the tones in the face and shoulders were normally strong, fading to a creamy white around the periphery of the image. These vignetted portraits were popular and other daguerreotypists produced their own versions of this simple technique.[42]

Whipple also made technical and scientific contributions to the process. He was one of the first to try to take daguerreotypes at night by artificial light and, beginning in 1846, he experimented with making views through a microscope.[43] Most notably, in 1850-52, he produced an important series of astronomical images of the moon, Jupiter, various stars, and a partial solar eclipse. These daguerreotypes—about seventy in all—were made through the telescope at Harvard Observatory.[44] Finally, Whipple was a pioneer in the introduction of paper photography in the United States. He began

experimenting with paper processes as early as 1844, and in 1850 patented his "crystalotype" process for making prints from albumen-coated glass negatives.

Whipple's existing plates, most in the sixth- to half-plate formats, reveal refined technical skills, graceful poses, and a consistently sensitive use of light.[45] In addition to photographing celebrities such as Daniel Webster [C-2], Horatio Greenough [C-3], Jenny Lind, and President Millard Fillmore, he recorded Boston's middle- and upper-class citizens. The quality and originality of his work in the studio is seen in an important group of self-portraits and family images. The best-known image of Whipple himself has long been a lithographic portrait from 1851, based on a now-lost daguerreotype.[46] A recently discovered self-portrait [26] appears to be a close variant of this 1851 view, probably made in the same sitting. This flawless half-plate presents Whipple at his professional best, relaxed and dignified. A less conventional approach is seen in two unusual double-profile portraits of Whipple juxtaposed with his brother, Frank [25], and with his wife, Elizabeth [C-4].

Whipple's inventiveness is also evident in two portraits of Ellen Harris Young, the wife of New York governor John Young.[47] These half-plates could hardly be more different in concept. The first [C-5] depicts Mrs. Young in a standard, if distinguished, pose. The second [27] is far less conventional: with a slight smile on her face, she stands on a hunting trophy with a rifle to her shoulder. This is a distinctly modern vision of female athleticism and self-confidence; this Mrs. Young is no stereotypical Victorian woman. The novelty of this portrait underscores an important aspect of the engagement in the studio between photographer and subject. While many portraits were orchestrated entirely by the photographer, others were true

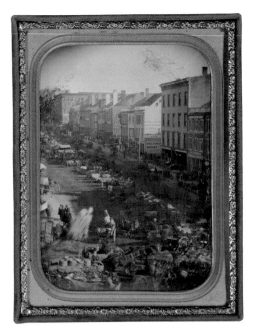

28 **George K. Warren**, *Lowell, Massachusetts, Market Day*, ca. 1850

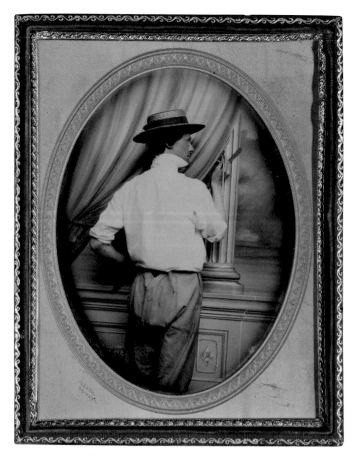

29 **Russell A. Miller**, *Painter and Backdrop*, ca. 1855

collaborations. It seems probable that this portrait began as Mrs. Young's idea, which was then realized by Whipple.

Other notable daguerreotypists worked in or around Boston, under their own names and in various partnerships. The careers of the earliest practitioners tended to be fleeting. Three of these—T. H. Darling, John S. F. Huddleston, and the team of Smith & Hale — operated at 62 Milk Street, 123 Washington Street, and 2 Milk Street, respectively, in the summer of 1841.[48] Another pioneering figure, Marcus Ormsbee [c-6], took over Darling's old studio in 1842. Ormsbee partnered with George M. Silsbee, who subsequently collaborated with Samuel Masury. Loyal M. Ives, a portrait painter and daguerreotypist, partnered with Lorenzo G. Chase; both later worked independently [c-7]. Chase appears to have been particularly active: in 1849, he claimed to have already "executed 40,000 likenesses."[49]

The interpersonal dynamics of the profession are reflected in the business and partnership relationships among the major figures, as well as in their physical proximity. In Boston, the profession was centered on a few blocks of Washington Street. Whipple began as a chemist at 20 Washington before establishing his venerable daguerreotype studio at 96 Washington. Both Luther Holman Hale and Benjamin French, the region's leading supplier of daguerreotype equipment and materials, were for many years at 109 Washington.[50] Loyal M. Ives was a few doors away at 142 Washington, with Lorenzo Chase at 173 Washington. No fewer than six daguerreian firms were located at 257 Washington over the years, with another four rotating through the 258½ address. Other notable studios were located a few minutes' walk from Washington Street on Tremont Row and on Court, Milk, and Winter streets.[51]

Daguerreotypists in other Massachusetts communities—such as George Kendall Warren and Russell A. Miller, both of Lowell—made regular trips into Boston for supplies and other business dealings. Best known today for his paper photographs from the 1860s and 1870s, Warren was an accomplished daguerreotypist. Though badly scratched, his view of downtown Lowell is one of the most dynamic American urban views known today [28]. Russell A. Miller's half-plate study of a painter depicted in the act of painting a *trompe l'oeil* backdrop is one of the genuine masterpieces of this era [29]. It

is an image about image-making itself—a sly celebration of the art of pictorial illusion. Sadly, little is known by or about Miller beyond this single work.[52]

Ultimately, Boston's professional influence extended throughout New England, from Providence and Newport, Rhode Island, to Portland and Bangor, Maine [c-8].[53] As the center of the New England economy, the city provided a hub for the comings and goings of the region's daguerreotypists.[54] Marcus Ormsbee, for example, conducted business in both Boston and Portland, Maine. Samuel Masury learned the process at Plumbe's gallery in Boston and went on to operate studios in Salem, Massachusetts, and Providence, Rhode Island, before returning to the city full-time.

Philadelphia and Vicinity

Each of the leading cities of this era had a distinct character. Philadelphia was the urban expression of Pennsylvania, the Quaker State. The Quakers were pacifists and social progressives. In the decades before the Civil War, Philadelphia played an important role in the causes of abolition, temperance, penal reform, and women's rights. Philadelphia had one of the most prominent communities of free blacks in the nation and was a major terminus for the Underground Railroad.

Philadelphia rivaled New York in population, wealth, and foreign trade until about 1795; after that, the gap between the two widened steadily.[55] In the national censuses of 1830, 1840, and 1850, Philadelphia ranked third or fourth in population—roughly equivalent to Baltimore, Boston, and New Orleans—as it expanded from about 80,000 residents to 121,000. The city leapt in size in 1854, with the incorporation of over two dozen surrounding municipalities. It increased in area from 2 to 129 square miles, and had an official

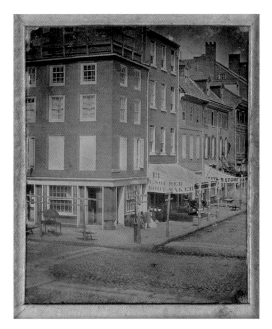

30 **William G. Mason** (attrib.), *View of Northeast Corner of Chestnut and Second Streets, Philadelphia*, ca. 1842-43

population in 1860 of just over 565,000. Although Philadelphia continued to fall behind New York in foreign trade, by the 1840s it was the nation's most industrialized city. It became a center for textiles and for the manufacture of a variety of heavy machines, including ships, steam engines, and locomotives.[56]

Philadelphia had a uniquely rich cultural and intellectual tradition. Benjamin Franklin was instrumental in starting both the Library Company (1731) and the American Philosophical Society (1743). The Franklin Institute, founded in 1824, encouraged scientific and technological progress. Early attention was also paid to high culture, with the founding in 1805 of the Pennsylvania Academy of Fine Arts. Spurred by visions of cultural greatness, the Greek Revival movement in architecture began in Philadelphia with Benjamin Henry Latrobe's Bank of Pennsylvania (1801). As Latrobe himself noted, "The days of Greece may be revived in the woods of America, and Philadelphia become the Athens of the Western world."[57]

It was in this intellectual and commercial context that Philadelphia's daguerreian profession flourished. The city's major daguerreotypists were headquartered on Chestnut Street, most between the addresses of 100 and 216. This section of Chestnut Street was daguerreotyped in remarkable detail. The result is an unsurpassed photographic record of a major American city in the 1840s.[58]

Some of this work was encouraged or commissioned by John McAllister, Jr., the city's leading optician and an avid antiquarian. McAllister was deeply involved in the history of the American daguerreotype: he sold Robert Cornelius his first lens and was proud to be Cornelius's first customer on the opening day of his studio, May 6, 1840. The McAllister firm went on to supply nearly all the other Philadelphia daguerreotypists of the 1840s and 1850s. By the early 1840s John McAllister, wealthy and semi-retired, was devoting most of his energy to his antiquarian interests. He had a passion for the history of both the city and the nation, and collected a broad range of artifacts, including photographs.[59]

While the authorship of some of this work is uncertain, William G. Mason has been credited with some of the earliest Philadelphia city views. These were made between 1842 and 1845, possibly in collaboration with William Y. McAllister, the eldest son of John

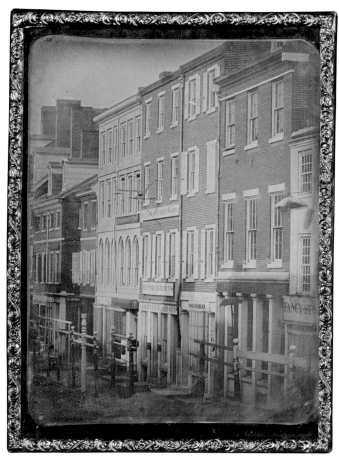

31 **William G. Mason** (attrib.), *View of North Side of Chestnut Street, Philadelphia*, ca. 1843-45

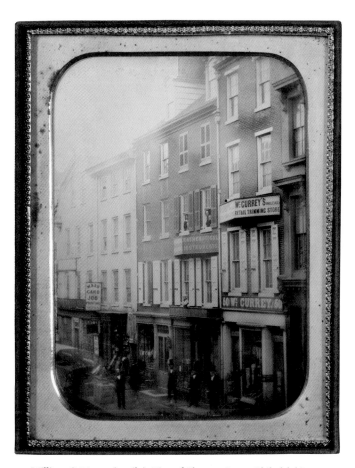

32 **William G. Mason** (attrib.), *View of Chestnut Street, Philadelphia (McAllister's Optical Shop)*, ca. 1853

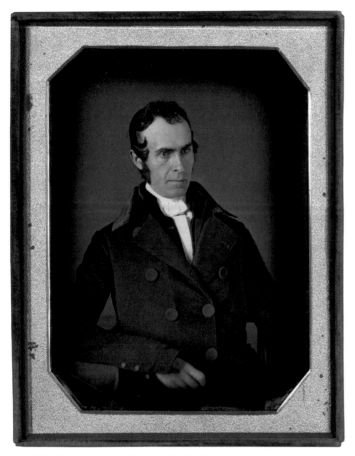

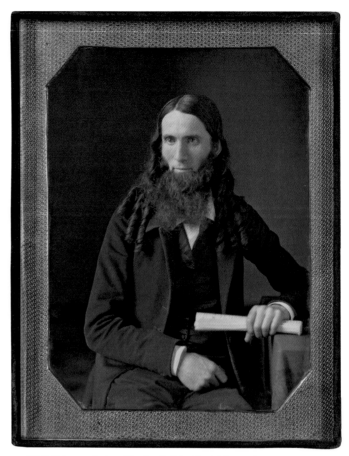

33 **W. & F. Langenheim**, *John Greenleaf Whittier*, ca. 1843-45

34 **W. & F. Langenheim**, *Charles Calistus Burleigh*, ca. 1843-45

McAllister. Mason, an engraver and amateur daguerreotypist, had his business next door to the McAllister & Son shop at 48 Chestnut Street. It is likely that Mason worked at John McAllister's request and with the assistance of his son.

Two of these views [**30, 31**] were made from approximately the same location. The smaller (and slightly earlier) plate presents the view diagonally to the northeast, across Chestnut and Second streets.[60] The second represents a 90-degree shift in camera orientation: the view northwest along the north side of Chestnut. This block was of particular interest to Mason: at least three other views of it are known.[61] Appropriately, the third and largest of the works reproduced here depicts the McAllister shop, with John McAllister himself posed at the doorway [**32**]. This structure, at 48 Chestnut, was the firm's address through the first fifteen years of the daguerreian era; in December 1854, McAllister & Son moved to new quarters further down Chestnut Street. In addition to the McAllister marquee, this view records two family members or employees looking out the third-floor windows and the firm's sculptural trademark—a gilded bust of Benjamin Franklin (the inventor of bifocal glasses) above the entrance.[62]

Following the pioneering efforts of Robert Cornelius, the brothers William and Frederick Langenheim opened one of the city's earliest studios in 1842 [**12**]. Born in Germany, the Langenheims came to photography by rather circuitous routes. William studied law in Germany before arriving in the United States in 1834 [**c-9, c-10**]. Moving to southwest Texas, as part of a new immigrant community, he fought with Sam Houston's Texas Army in 1835 and was captured by Santa Anna's Mexican troops. After nearly a year in captivity, he went to New Orleans, where he joined the U.S. Army, then engaged in conflict

with the Seminole Indians. After immigrating to the U.S. in 1840, his brother Frederick Langenheim worked as a newspaperman for a German-language publication. Joining together in Philadelphia, the two formed a partnership that lasted until William's death in 1874.

The Langenheims were visited by many notable sitters, including the poet John Greenleaf Whittier [**33**]; the abolitionist, reformer, and journalist Charles Calistus Burleigh [**34**]; and Thomas Ustick Walter, the architect of the United States Capitol [**c-11**]. These plates reveal the brothers' technical skills and understanding of the subtleties of lighting and posing. On occasion, the Langenheims used an uncommon masking technique—chemically etching the background of a portrait in order to produce an iridescent, painterly tone [**c-12**]. They were pioneers in other aspects of the medium, including paper photography and stereographic work.

Another daguerreian pioneer, Samuel Broadbent, worked for many years in Philadelphia. The son of a portrait painter, Broadbent practiced that trade for at least a decade before learning the daguerreotype from Samuel F. B. Morse in 1840-41.[63] Broadbent traveled widely in the 1840s, making portraits from Savannah, Georgia, to Hartford, Connecticut. By 1851, he had settled in Philadelphia, where he remained until his death in 1880. Broadbent's noted sitters included Lucretia Mott, the famed abolitionist and advocate of women's rights [**35**]. He made something of a specialty of stereo portraits [**c-13**], producing at least as many works in this format as any other studio of the period. This work also reveals one of Broadbent's trademarks: his elaborate painted backdrops.

Samuel Van Loan and John Jabez Edwin Mayall were also early practitioners in Philadelphia. Both were born in England. Mayall came to Philadelphia in about 1842; after working with John Johnson

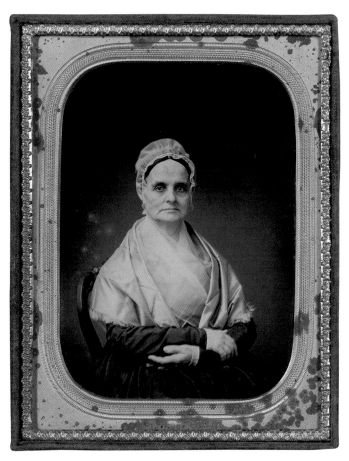

35 **Samuel Broadbent**, *Lucretia Mott*, ca. 1855

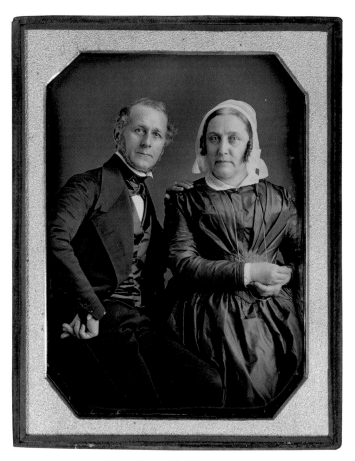

36 **Van Loan & Mayall**, *Husband and Wife*, ca. 1845-46

in Manchester, England, Van Loan arrived in 1844.[64] The two joined in partnership, at 140 Chestnut Street, under the name Van Loan & Mayall [36]. After Mayall left in 1846 for London, Van Loan continued on his own and in other partnerships [C-14, C-15].

Other prominent early members of the Philadelphia daguerreian community included David C. Collins, Montgomery P. Simons, James E. McClees, Washington L. Germon, Marcus A. Root, and Frederick De Bourg Richards. Many of these men were linked by the bonds of friendship and partnership.

While David Collins's career has not been fully documented, he may have entered the profession as early as 1842. He worked in partnership with Marcus A. Root in 1845 and later with his brother, Thomas P. Collins [C-16]. A remarkable still life [37], dated 1842, is tentatively attributed to him. The artistry of this work — directly indebted to a rich tradition in European painting — is unparalleled in this early period of the American daguerreotype. The Collins brothers' skills were also demonstrated in an impressive panorama of six half-plates, made in about 1846, of the Fairmount Water Works on the Schuylkill River.[65]

Montgomery P. Simons began in 1842-43 as a case manufacturer and a distributor of daguerreian supplies.[66] It is unknown when he actually began making daguerreotypes, but this might have been as early as 1842.[67] In the fall of 1845, he was in business with Thomas P. Collins at 100 Chestnut Street; by 1846, he was on his own at 120 Chestnut. After several years in Philadelphia, he worked in Richmond, Virginia, from 1851 to 1857, before returning to the Quaker City.[68] Simons won numerous awards in the exhibitions of his day and made portraits of such renowned figures as Henry Clay, Daniel Webster, and Jefferson Davis. A dedicated writer, he contributed

37 **David C. Collins** (attrib.), *Dog "Albus,"* September 1842

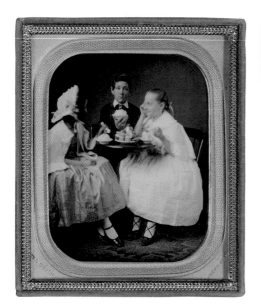

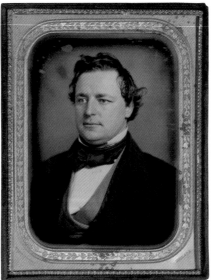

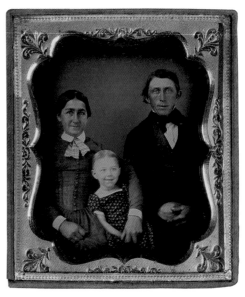

38 **Washington L. Germon**, *The Ice-Cream Party*, ca. 1855

39 **Frederick De Bourg Richards**, *Portrait of a Man*, ca. 1850

40 **William Stroud**, *Smiling Family*, ca. 1855

essays to the photographic journals of the day and published three technical manuals.

Simons had a distinctive style. He preferred larger and often odd-size plates: both the works reproduced here [93, c-17] are three-quarter plates. Simons's daguerreotypes suggest an unusual depth of psychological insight. Indeed, perhaps more than any other photographer of his day, Simons aimed at representing the inner, emotional life of his sitters. This exploration reached a culmination in his extraordinary "Passions" series of 1853, made in Richmond at the request of an artist acquaintance, William Hubbard, and a wealthy local patron, Mann Satterwaite Valentine II. The twenty-seven surviving plates depict the two men enacting a variety of emotional states—including revenge, hate, fear, despair, pride, and humility—for the camera.[69] At once scientific and theatrical, these plates have no equal in early American photography.

James E. McClees got his start in 1844 as an assistant to Simons. He then joined in a successful partnership with Washington L. Germon, from about 1846 until 1855. They produced elegant work, often delicately hand-colored [c-18]. After the end of their partnership, both men continued on their own. This whimsical plate by Germon [38] depicts a children's ice-cream party, a distinctly unusual subject.

Marcus Aurelius Root was one of the most influential figures of the daguerreian era—a fine photographer and an important writer and historian.[70] He contributed many essays to the photographic journals of the day, and his book *The Camera and the Pencil* (1864) is an essential period text. Root studied painting with Thomas Sully and taught penmanship before learning the daguerreotype process from Robert Cornelius. After traveling through the South, he returned to Philadelphia to work with David Collins. In 1846, he purchased the studio of John J. E. Mayall, when the latter moved to London.

Root was both ambitious and successful. He claimed to have produced a total of 4,500 daguerreotypes from July 1846 to June 1847, and 7,500 in the following twelve months—an increase from about fifteen to twenty-five sittings a day.[71] By 1849, he had expanded to New York City, where he opened a gallery managed by his younger brother, Samuel Root. In the early 1850s, he opened branch businesses in Washington, D.C., Boston, and St. Louis.[72] During this

time, Root employed George S. Cook as the chief operator of his Philadelphia studio.[73]

Root produced a wide variety of work, including Philadelphia street scenes; portraits of celebrities such as Henry Clay, Daniel Webster, Tom Thumb, and Jenny Lind; and artistic and narrative studies. The latter works bore such intriguing titles as *The Young Artist's First Effort* and *The Puzzled Pupil*.[74] Root also worked in the mammoth-plate format, made images through the microscope, and recorded a solar eclipse through a telescope.[75] An atypical plate [c-19] suggests something of the range of his work, as well as his close contacts with the artistic community. In his essays, Root presented a voice of idealism and progress: he advocated high standards, fraternal good will, and the moral importance of art.[76]

Frederick De Bourg Richards was a landscape painter in New York before turning to the daguerreotype.[77] Significantly, he exhibited paintings throughout his lifetime; his effort to balance the two activities appears without parallel in American daguerreotypy. Richards's daguerreotype studio was in operation by late 1846, when he photographed Daniel Webster. He subsequently achieved considerable recognition for his portrait of Jenny Lind, made during her 1850 visit to Philadelphia, and for his images of other celebrities, including Henry Clay, Edwin Forrest, and Lola Montez. Richards's portrait style, as seen in this half-plate of an unidentified man [39], was direct, dignified, and relaxed. He worked successfully in the mammoth-plate format, was a pioneer in making stereo daguerreotypes [c-20], and was among the first Americans to turn to paper photography in the early 1850s.

Philadelphia was the focus of daguerreian activity throughout eastern Pennsylvania. A number of capable operators worked in this region, including William Stroud of Norristown. What Stroud's works lack in self-conscious artistry, they make up for in endearing immediacy [40].

Glenalvon J. Goodridge, based for many years in York, Pennsylvania, was one of the most notable African American daguerreotypists.[78] Goodridge's father was a mulatto freedman and a prosperous entrepreneur. The son had much of his father's enterprise: he learned the daguerreotype process at about the age of seventeen and

was open for business in York by 1847. Goodridge produced simple, unembellished work [C-21], and enjoyed a loyal clientele. The premium he won in October 1856 for the best ambrotypes at the York County Fair would appear to make him the first African American photographer to win a competitive prize.[79]

The Philadelphia daguerreian community also had a major influence in nearby Wilmington, Delaware.[80] Many of the major Philadelphia practitioners—including Simons, Root, and McClees & Germon—advertised in the Wilmington newspapers. Broadbent operated a studio there for two years, from 1849 to 1851, before moving to Philadelphia. In addition to running a successful business there, Broadbent trained at least two of the city's leading practitioners, Ellwood Garrett and Benjamin Betts.

New York City and State

As the nation's commercial and financial hub, New York was also the center of the daguerreotype profession. It had more studios, more talented and influential daguerreotypists, and a greater volume of business than any other city. It also had a distinctive character: vital, competitive, innovative, and diverse.

Since the first official census, in 1790, New York had been the nation's largest urban area. From a population of just over 33,000 in that year, New York grew rapidly: the city and its suburbs included roughly 400,000 people in 1840; 650,000 in 1850; and over a million in 1860.[81] The surrounding regions (Jersey City, Newark, and Elizabeth, New Jersey, for example) grew at an even faster rate, giving rise to a regional industrial network centered on lower Manhattan. In the city proper, investment in manufacturing increased more than fivefold between 1840 and 1860, resulting in a corresponding spurt in new businesses.[82]

New York's growth was neither steady nor predictable, however. The frenzied boom times of the 1820s and early 1830s came to a sudden end with the Panic of 1837. The effects of this recession—deflation, failed businesses, shrinking fortunes, and a sharp downturn in business and residential construction—lasted at least eight years. From about 1845 to 1857, the city again grew rapidly in size, wealth, and influence. This expansion was further fueled by the influx of California gold beginning in 1849. In the years 1851-54 alone, some $175 million in gold bullion poured into New York's financial markets; as one result of this golden windfall, the value of the city's imports and exports doubled between 1849 and 1854.[83] This giddy growth was tempered by a brief recession in the winter of 1854-55 and a more serious downturn in the fall of 1857.

New York's population was distinctly heterogeneous. Between 1840 and 1855, some 68 percent of immigrants to the United States came through the city, and many stayed. Between 1845 and 1855, New York's population grew by 70 percent, but the number of foreign-born residents grew at twice that rate.[84] This influx of newcomers contributed to the city's dramatic inequalities. In 1845, when the city could claim at least ten millionaires, the journalist Horace Greeley estimated that fully two-thirds of New York residents subsisted on a dollar a week.[85] While this sobering estimate came at the end of a serious recession, comparable extremes of wealth and poverty existed throughout the boom years of the late 1840s and early 1850s.

New York was a dynamic contradiction: a place of luxury and squalor, order and chaos. In addition to its high culture, New York was pulsing with the turmoil of ethnic unrest, labor protests, gang hooliganism, and rising levels of street crime. The vices of gambling, drunkenness, and prostitution were distressingly visible, even in the better parts of the city.[86] By the mid-1850s, many of the most comfortable New Yorkers worried that the social order had simply collapsed.[87] In some respects, the city was a vision of the nation's own conflicted future—a preview of both the benefits and the dislocations of modernization.

New York's daguerreian community was correspondingly large and diverse. In 1850 there were some 71 daguerreotype studios in New York.[88] In 1853, at the peak of the daguerreotype business in America, New York and Brooklyn were home to about 100 studios, which employed about 250 men, women, and boys. Of the estimated 3 million daguerreotypes produced that year in the United States, a significant portion were made in New York.[89]

Compared to the studios in Boston, those in New York had both more wealthy patrons and more lower-middle-class ones. While there was at least as much demand as in Boston for elite work, there was even more for cheap daguerreotypes. The business climate in Boston was relatively genteel and conservative; New York's was more ruthlessly competitive. The result was a broader range of work in New York—from the finest whole plates to the most banal twenty-five-cent ninth-plates—and, by the early 1850s, a veritable war between elite operations and the city's low-rent "picture factories."

In the daguerreian era of the 1840s and 1850s, New York's energy was exemplified by Broadway. The city's primary north-south thoroughfare, Broadway ran from Bowling Green, at the lower tip of Manhattan, up to the fashionable City Hall Park and beyond. As early as 1786, lower Broadway had been called "the center of residence in the fashionable world."[90] With the growth of the early nineteenth century, Broadway was transformed from an elite residential area to the city's commercial hub. Mansions were replaced by hotels, shops, and places of amusement. In 1841, for example, the ever-astute P. T. Barnum opened his American Museum in the heart of this area, on Broadway at Ann Street.

By the late 1840s, Broadway was filled with elegant shops selling all manner of goods: clothing, hats, shoes, jewelry, perfume, home furnishings, toys, books, wine, and paintings.[91] This commercial abundance was epitomized in the department store of Alexander T. Stewart. Opened in 1846, at Broadway and Chambers Street, Stewart's five-story Marble Palace offered a dazzling array of products. Stewart paid great attention to the *spectacle* of commerce. His store was large, airy, and opulent; his clerks were handsome and well-dressed; and he kept his name in the public eye by advertising aggressively and by staging fashion shows to promote the newest styles.[92] His store was not simply a place to buy goods—it was a sensory and entertainment experience in itself. Stewart's runaway success inspired many imitators.

By the early 1850s, Broadway was *the* destination for businessmen, shoppers, strollers, and visitors. As recounted in a recent history of the city in this era,

> The street became an extension of the stores, a stage for the fashion conscious. Hundreds of people "spend their lives in sauntering through Broadway during fashionable hours seeing and being seen," the *Tribune* observed. Most were smartly dressed women, all ribbons and silks and Parisian fashions, who formed "one sheet of bright, quivering colors," though men were also in evidence, conservatively dressed businessmen as well as dandies with hornlike mustaches, kid gloves, thin trouser legs, and patent leather shoes.

At night the effect was almost magical as gas lamps and illuminated store windows captured the streams of pedestrians in their glow and the colored lamps and omnibuses transformed Broadway into a river of light.[93]

The elite New York daguerreotype studios were an integral facet of Broadway's social and commercial milieu.[94] At various times, for example, Mathew B. Brady did business at the 187, 205-07, 359, 643, and 785 addresses; Martin M. Lawrence was located at 152, 203, 303, and 381; Alexander Beckers at 201, 264, and 411; Jeremiah Gurney at 189, 349, and 707; Meade Brothers at 233 and 285; Abraham Bogardus at 363; Charles D. Fredricks at 349, 585, 588, and 770; and Rufus Anson at 589 and 633. Many of these studios were in close proximity to one another. In 1851, for example, no fewer than seven daguerreotypists —Powelson & Co., James Brown, N. G. Burgess, Jeremiah Gurney, Beckers & Piard, M. M. Lawrence, and Brady—were located between 177 and 205 Broadway. Like other fashionable businesses, these studios tended to move northward over the years, following the city's development. The sequential moves of Brady's galleries, from 205-07 Broadway in 1844 to 785 Broadway in 1860, was characteristic of this shift in the city's commercial center of gravity.[95]

Given this business context, the elite New York studios were not simply places in which to be photographed: they were aesthetic experiences in their own right. As in Stewart's Marble Palace, visitors expected to be entertained, inspired, and uplifted in a carefully crafted realm of luxury and refinement. Similarly, the owners of the leading studios were seen not merely as photographers, but as entrepreneurs, taste makers, and even showmen.

These qualities were exemplified in the figure of Mathew B. Brady. Well known in his lifetime, Brady remains a kind of mythic character today, by far the most recognizable photographic name of the nineteenth century. Brady was a talented and ambitious figure with a knack for publicity. Something of his personality is suggested in a cryptic R. G. Dun credit report from 1852, which observed that Brady "likes to live a pretty fast life and spends his money freely," but that he "deals honorably [and] is worthy of all confidence…"[96] In 1858, the *American Phrenological Journal* published a reading of Brady's "phrenological character" that one suspects was drawn as much from personal acquaintance as from the contours of his skull.

You have a temperament indicating a high degree of the mental or nervous, in conjunction with a wiry toughness of body, indicative of great propelling power and physical energy and activity. These conditions, combined, produce intensity of emotion, depth and strength of feeling, and a disposition to be continuously employed. You are living too much on your nerves, and need a great amount of sleep to recuperate your constitution, and to quiet your brain and nervous system; but you are tough, and will wear a long time, provided you take ordinary care of yourself.[97]

Born in upstate New York, Brady was plagued by poor eyesight from an early age. He arrived in New York City as a teenager in about 1839, where he met Samuel Morse and possibly worked as a clerk in A. T. Stewart's department store.[98] He first appears in the New York business directories as a manufacturer of cases for jewelry, portrait miniatures, and surgical instruments.[99] By early 1844, Brady had opened his first daguerreotype gallery at 205-07 Broadway. Limited by his faulty vision, Brady probably spent little time behind the camera. Instead, he devoted his energy to promoting and expanding his business. He exhibited in the competitions of the day and began an ambitious effort to make, collect, and publish portraits of

the era's leading figures. In March 1853, he opened a second and more lavish gallery at 359 Broadway—one praised as the finest in the city.[100] After years of exploring the Washington, D.C., market, he opened a gallery there in 1858 under the management of Alexander Gardner, a Scottish immigrant who had worked for him in New York since 1856.

Fascinated by fame and power, Brady himself contributed significantly to the modern cult of celebrity. As historian Mary Panzer has observed, "From the very first, Brady defined his quest for famous faces in explicitly political terms."[101] In February 1849, he traveled to Washington, D.C., to photograph president-elect Zachary Taylor, the members of his cabinet, and other notables gathered in the city for Taylor's inauguration. Within a year, Brady's collection of celebrities had grown to include, in the words of a contemporary critic,

almost every man of distinction among our countrymen…and every member of the U.S. Senate for a considerable number of years past; all the Judges of the Supreme Court, most of the members of the lower House of Congress, nearly all the foreign ambassadors, the generals of the army, the commodores of the navy, the governors of the state and nearly all those men who have acquired influence in the departments of literature, science, and public life…[102]

Within a few years, Brady's portrait collection was the best of its kind in the nation. From Daniel Webster, Henry Clay, and John C. Calhoun, to Thomas Cole, Jenny Lind, and P. T. Barnum, Brady recorded the face of American political and artistic culture. In addition to being displayed in his New York studio, many of these images were placed before the public in various forms of reproduction—as fine lithographs, as woodcuts in the illustrated papers, and as inexpensive cartes-de-visite.

Brady took great pride in his work. As he stated in 1853, "During the several years I have been devoted to the Daguerreian Art, it has been my constant labor to perfect it and elevate it. The results have been that the prize of excellence has been accorded to my pictures at the World's Fair in London, the Crystal Palace in New York and wherever exhibited on either side of the Atlantic."[103] While the Brady galleries produced their share of routine sixth-plate portraits, he actively sought the patronage of the wealthy and powerful. A superb half-plate portrait of an unidentified boy [41] suggests the technical and aesthetic care given to the studio's more expensive productions. Perhaps just as importantly, this portrait suggests something about his favored customers: this young sitter, exuding a palpable sense of self-confidence and authority, seems a perfect representative of the city's ruling elite.

Jeremiah Gurney, one of Brady's chief competitors, was a man of very different temperament. While Brady was a *bon vivant*, with many irons in the fire, Gurney was quieter, more modest, and more prudent. Gurney enjoyed consistent success in the daguerreian era and his business continued long after Brady's went bankrupt. Gurney was well-liked by his peers and played a leading role in the first professional group of the era, the American Daguerre Association.

Trained as a jeweler, Gurney took up the daguerreotype in 1840, at the age of about twenty-eight, after receiving instruction from Samuel Morse. Unlike Brady, Gurney was intimately involved in all aspects of his business. As an advertising bill of 1852 or earlier stated, "Mr. G. attends personally to his sitters, and no picture is allowed to leave his gallery, unless it is perfectly satisfactory."[104] While the size of his operation naturally required that he employ operators, these men were highly skilled.[105] In 1853, for example, he hired Solomon

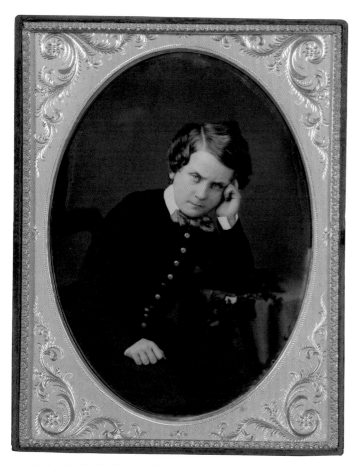

41 **Mathew B. Brady**, *Portrait of a Boy*, ca. 1850

Nunes Carvalho [C-22], an experienced professional who had previously operated galleries in Baltimore, Charleston, and Washington, D.C., and who subsequently went on the arduous 1853-54 western survey of Colonel John C. Frémont.

Gurney moved less often than most of his competitors. He occupied rooms at 189 Broadway from 1840 to 1852, before refurbishing Jesse Whitehurst's fire-damaged gallery at 349 Broadway, on the corner of Leonard Street. Under Gurney's ownership this became one of the city's most elegant studios. The reception room featured a vast array of portraits—daguerreotypes, paintings, and paper photographs—of celebrities and everyday New Yorkers. In 1853-55, Gurney partnered with Charles D. Fredricks, who had an expertise in the new paper process. While Gurney devoted his time to his 349 Broadway space, Fredricks ran an operation in Paris under both their names [C-23]. Gurney remained at this address until 1858, when he moved further north to 707 Broadway.

Gurney excelled with large daguerreotypes. His gallery was known for its flawless whole plates and he produced some of the finest mammoth-plate daguerreotypes in the country.[106] In 1851, there was a vogue for oversize work among the leading New York studios. At that year's Fair of the American Institute, several daguerreotypists —Gurney, Marcus and Samuel Root, Jesse Whitehurst, and George S. Cook—all displayed work in this size, with Gurney's 11 x 13-inch plates clearly the best of all.[107] Sadly, few mammoth plates by any of these studios are known today.

Gurney's daguerreotypes are nearly all formal portraits, made in the studio.[108] If he made any outdoor views, for example, they remain unknown today. The clothing and demeanor of his sitters underscore the fact that Gurney ran an elite business. He had a corresponding technical and pictorial aesthetic: his images are dignified, graceful, and serene. He favored a soft, enveloping light and used plain, mid-value backgrounds to emphasize the luminous, silvery tones of the daguerreotype plate itself. His images are both optically sharp and warm in feeling—precise, but never harsh. Above all, Gurney's portraits reveal an exquisite sensitivity to both the ease of his sitters and the harmony of the overall composition.

Three plates from Gurney's 349 Broadway studio (ca. 1852-58) demonstrate the variety and quality of his work. The first of these [42] is an occupational portrait, a relatively unusual genre for Gurney. The compositional simplicity of this image is appropriate to its masculine, functional subject. These are businessmen and this is an efficient, businesslike depiction. Gurney's *Family Group* [43], on the other hand, is a masterpiece of relaxed intimacy. Each figure is presented at his or her best, while the unity of the ensemble is conveyed in the interlocking rhythm of figures and gestures.

The third work from this era [44] is in a category all its own— an image of flawless perfection that suggests a consciously allegorical or symbolic impulse. This young girl is at once physically real and a vision of angelic grace; this image has an "ideal" purity that rivals the era's finest achievements in marble. Something of this perfection is also evident in this late sixth-plate [C-24]. This portrait of a confident and presumably privileged child stands as a quiet summation of Gurney's mastery of the daguerreotype. The plate is technically faultless; the pose simple, yet dignified; the subject relaxed, engaged, and thoughtful; the coloring precise and restrained.

The brothers Marcus and Samuel Root produced work for a similarly elite audience. Expanding beyond his original location in Philadelphia, Marcus A. Root trained his younger brother and opened a space in New York in 1849. A larger gallery, opened in 1851 at 363 Broadway under the names of M. A. Root and S. Root, was one of the most lavish in the city.[109] This portrait [45] is technically perfect, beautifully illuminated, and elegantly composed. The variety of work from the Root gallery is suggested in a curious pair of plates: views of the same white-coated figure drinking from a flask and posed with a pointer [C-25, C-26]. Clearly not traditional portraits, these appear to have been made for narrative or theatrical purposes, possibly as studies for illustrations in woodcut or engraving.

If Brady, Gurney, and Root typified the upper echelon of New York studios, Rufus Anson aimed at a more populist market. A relative latecomer to the profession, Anson was in business by 1851 at 633 Broadway, somewhat north of the most fashionable addresses of the day.[110] With a few years' experience, he moved to 589 Broadway, two doors from the larger gallery of Charles D. Fredricks [287].

From the beginning, Anson sought a varied clientele. His operation was sufficiently upscale to attract a number of famous sitters. One of them was Marietta Alboni, an imposing Italian opera singer (and rival to Jenny Lind) who toured the United States to great acclaim in 1852-53 [C-27]. Judging by the finest extant examples, Anson's work compared favorably with the productions of the most elite studios [C-28, 46, 47]. In addition to daguerreotypes of this quality, the Anson studio released many routine pictures—typified by generic poses and lighting—in the smaller formats. This was Anson's bread-and-butter production, and he proudly advertised his ability to make quarter-plates for only fifty cents each. Not surprisingly, Anson is rarely mentioned—and then usually in unfavorable terms—in the photographic literature of the period. In 1853, the editor of *Humphrey's Journal* referred to him disdainfully as "the

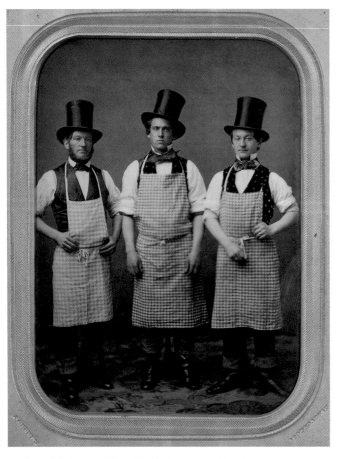

42 **Jeremiah Gurney**, *Three Men in Aprons*, ca. 1852-58

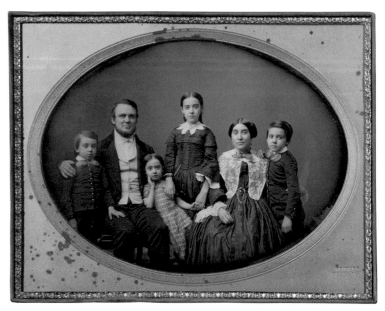

43 **Jeremiah Gurney**, *Family Group*, ca. 1852-58

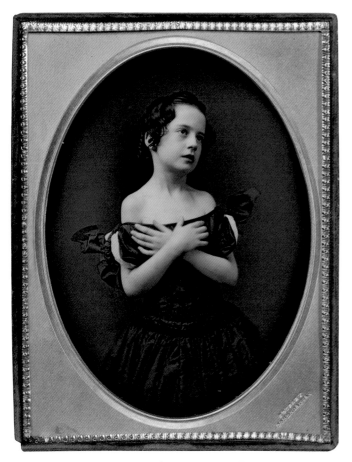

44 **Jeremiah Gurney**, *Young Girl with Arms Crossed*, ca. 1852-58

45 **Samuel Root**, *The Doty Sisters*, ca. 1852-54

46 **Rufus Anson**, *Family Group with Boy Holding Rooster*, ca. 1853-55

47 **Rufus Anson**, *Standing Man with Musket*, ca. 1853-55

fifty cent (medium) man," while Anson himself promised that his half-dollar productions were "warranted equal in quality and size to those that cost $2 and $3 elsewhere."[111]

Although he was clearly not one of the fraternity's elite, Anson's work was vastly superior to that of the cut-rate "picture factories" in the city. He struck a happy and profitable medium: good value for the dollar for a predominantly middle-class market. In truth, the high quality of much of his work was a reflection of the field's accumulated expertise by the early 1850s. While few at this time hoped to make consistently perfect daguerreotypes, many could routinely make very good ones.

The profession in New York included many other experienced figures. Henry E. Insley, one of the field's pioneers, worked as a daguerreotypist through at least 1859. His skills are evident in a group of family images [c-29, c-30] and a whole-plate self-portrait [c-31]. Jonas M. Edwards [48], a student of Samuel F. B. Morse, began in late 1841 in Richmond, Virginia. In 1843, in collaboration with Edward Anthony, Edwards opened galleries in Washington, D.C., and then in New York City. Their popular New York studio was one of the first, in early 1843, to perfect the art of hand-coloring daguerreotypes. Unfortunately, Edwards died only a few years later —a victim, one writer speculated, of his "intense application" to the business.[112] Victor Piard, who began as an assistant in the Anthony, Edwards & Co. gallery in Washington, D.C., worked in New York for several years in partnership with Alexander Beckers, a former

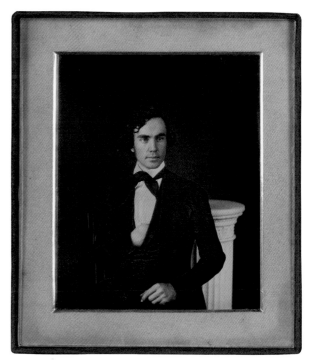

48 **Anthony Edwards, & Co.**, *Portrait of Jonas M. Edwards*, ca. 1845

49 **Abraham Bogardus**, *Man Reading, with Woman*, ca. 1850

associate of the Langenheims.[113] From its opening in 1849, the Beckers & Piard studio was a dependable operation that produced a typically broad range of images [C-32, C-33].

After beginning in the profession in Albany, in 1842, Charles R. Meade and Henry W. M. Meade established one of the most respected New York studios.[114] The Meade Brothers business, for many years at 233 Broadway, was a favorite of the city's well-to-do. For example, this young sitter [C-34] was the daughter of Moses Sperry Beach, the owner of the *New York Sun*. The Meades were enterprising artists and businessmen. In 1846, they sent daguerreotypes of Niagara Falls to the King of France and the Emperor of Russia, garnering much praise and publicity as a result. The brothers made independent tours of Europe in the late 1840s. On his trip, in 1848, Charles Meade visited Daguerre and was granted the rare privilege of making portraits of the inventor by his own process.[115] Their studio featured one of the finest displays of daguerreotypes in the city, with about 1,000 plates on view, including portraits of celebrities, views of foreign cities, and some 12 x 16 ½-inch plates.[116]

Martin M. Lawrence turned from watchmaking to daguerreotyping in about 1842. He ran a successful gallery on Broadway for many years [C-35], won numerous awards, and enjoyed the respect of his peers. His was the first biographical profile to be featured in the *Photographic Art-Journal*, in 1851.[117] The new gallery he opened in 1853, at 381 Broadway, was one of the city's most luxurious; it featured two posing rooms, each with 16-foot ceilings and 12 x 15-foot skylights.[118] Like Gurney, Lawrence put considerable effort into the production of oversize daguerreotypes, 13 x 17-inches in size, for display in the leading exhibitions. These grand plates, often depicting symbolic or allegorical subjects, were the work of his chief operator at the time, Gabriel Harrison. A man of high standards and

quiet demeanor, Lawrence stated: "I prefer to write my own advertisements on well-prepared and polished plates."[119]

The son of a farmer, Abraham Bogardus came from upstate New York. After working in the dry-goods business, he learned the daguerreotype process from George W. Prosch and opened his own studio in 1846. For many years, Bogardus was at Barclay and Greenwich streets, a few blocks west of Broadway, where he ran a lively and profitable business.[120] As *Humphrey's Journal* observed in 1855, "though a little more democratic in his locality, [Bogardus] is keeping full pace with his more aristocratic competitor, in the daily net profits of his establishment."[121] Bogardus recorded his share of rich and famous subjects, as well as many thousands of middle-class New Yorkers. This unusual image [49], a miniature masterpiece of emotion and psychology, suggests the quality of his vision.

Bogardus was a warm, witty man with high standards and a genuine devotion to his craft. He loved daguerreotypes and was making them at least as late as 1869, nearly a decade after most others had dropped the process.[122] In later years, he wrote extensively on the subject.[123] In 1884, he stated simply: "I have yet to see the picture made with a camera equal to the daguerreotype."[124]

Brooklyn—by 1850 the seventh largest city in America—had its own daguerreian community. Charles H. Williamson, a native of Scotland, arrived in 1851. A photographer of great refinement, Williamson was also an "excellent painter in watercolors" and probably made the finest hand-colored daguerreotypes in the nation.[125] These have a distinctly painterly quality [50], suggesting some debt to the British daguerreotype style. However, while British portraits were often heavily colored, Williamson used pigment with great sensitivity.

One of the most original photographers of the daguerreian era, Gabriel Harrison came from a wealthy and artistically inclined family. His father, "a man of classical education," was an expert in the engraving of banknotes.[126] His sisters and brother were all involved in music, while Harrison was fascinated by elocution, the stage, and art. Active in politics from an early age, he was also an outspoken abolitionist. Harrison was a man of great passion and idealism who threw himself completely into his chosen causes.

Harrison entered the daguerreotype business in 1844 as an assistant in John Plumbe's New York studio. His talent was immediately apparent: in 1845, two of his plates won prizes at the Washington Fair. One was a portrait of former president Martin Van Buren. The other —a poetic image of Harrison's son George Washington Harrison embracing a bust portrait of his namesake, George Washington— was an early example of the ideal or allegorical work that became Harrison's artistic hallmark.

From 1849 to 1852, Harrison worked as the chief operator in Martin M. Lawrence's studio. In this period, he continued making ideal images—often in the daunting mammoth-plate format— inspired by motifs from art history and the theater. One of his most famous oversize plates—*Past, Present, and Future*, a moody view of three women representing the stages of life—won a bronze medal at the 1851 Crystal Palace exhibition in London. Using his own children as protagonists, Harrison went on to make artistic plates with titles such as *The Infant Saviour; Mary Magdalene; Young America;* and *Helia, or the Genius of Daguerreotyping*. These patriotic, religious, and symbolic works—in the terminology of the day, "descriptive daguerreotypes" or "compositions"—occupy an important place in photographic history. They were pioneering examples of a purely aesthetic approach—one that aimed to elevate the medium above

50 **Charles H. Williamson**, *Young Woman in Blue Dress*, ca. 1851

51 **Gabriel Harrison**, *Viola Harrison*, ca. 1856-58

52 **Samuel L. Walker**, *Man with Hat*, ca. 1853

its merely utilitarian applications. Such images represented a critical early salvo in what would be a long historical battle: the fight for photography's status as art.

By 1851, a sympathetic writer noted that Harrison "is now almost universally known as the *Poet Daguerrean*."[127] Capitalizing on this recognition, Harrison opened his own gallery in 1852 in partnership with George Hill, a fellow painter and theater enthusiast. This lavish studio, like Williamson's, was on Fulton Street, Brooklyn's equivalent of Broadway. Harrison enjoyed the patronage of the area's "most fashionable and wealthy" citizens.[128] He was particularly esteemed in the artistic community: it was Harrison's jaunty portrait of Walt Whitman, for example, that served as the basis for the engraved frontispiece of the first edition of *Leaves of Grass* (1855). A portrait of Harrison's daughter Viola [51] suggests the eloquent simplicity of his daily studio work.

In addition to his labors behind the camera, Harrison served as an important voice for the profession's elite. In essays such as "The Dignity of Our Art," he underscored the need for high standards, knowledge, and taste.[129] Harrison's photographic career did not continue long past the daguerreian era. In later life, he worked in the theater, wrote plays and books, and taught acting and elocution. Something of his character is suggested in a biographic sketch written in 1874, in which he stated: "Don't try to make a great man of me. Avoid that nonsense. I only hope to stand remembered as a good one."[130]

The influence of New York's daguerreian community was felt for hundreds of miles. The Hudson River and Erie Canal facilitated the inexpensive transportation of people, supplies, and correspondence to and from the upper and western regions of the state. The pace of this movement increased markedly with the extension of rail lines in the 1840s and early 1850s. As a result, daguerreotypists in Poughkeepsie, Albany, Troy, Schenectady, Utica, Syracuse, Oswego, Rochester, and Buffalo all maintained links with their peers in Manhattan and Brooklyn.

Many talented men worked in these upstate communities.[131] Samuel L. Walker, who began in the profession in about 1843, ran a successful gallery in Poughkeepsie for many years.[132] In addition to the fine quality of his studio work, he was active in teaching the

53 **Rensselaer E. Churchill**, *Two Children*, ca. 1850-55

54 **Donald McDonnell**, *Indian Chief Maungwudaus, Upper Canada*, ca. 1850–51

55 **Oliver B. Evans**, *Four Children in Costume*, ca. 1853

technique.[133] Walker was a man of varied and colorful interests. He was, for example, a devout believer in the teachings of a pair of "Psycho-Magnetic Physicians" of the day. Walker's obituary notice described him somewhat cryptically as "a man of great artistic taste, and fervent love for his profession, withal possessing some eccentricities that made him a marked man."[134] Walker's unconventionality is suggested nicely in this playful "portrait" [52].

Rensselaer E. Churchill, one of the leading figures in Albany, produced some of the most beautiful and distinctive work of the period [53, C-36]. The pride he took in his plates is underscored by the fact that he etched his signature directly on the surface of his images. This unusual practice implies an entirely modern notion of authorship. Only about two dozen daguerreotypists were known to have signed their plates, and none did so more frequently than Churchill.[135]

Further west, D. D. T. Davie ran the leading gallery in Utica. Having taken up the daguerreotype in 1846, he was active in the professional associations of the 1850s. He published a short-lived monthly journal, the *Scientific Daguerrean*, beginning in January 1853, and later wrote a reminiscence titled *Secrets of the Dark Chamber* (1870).[136] George N. Barnard, who also entered the field in 1846, operated successful studios in Oswego and Syracuse. While his studio portraits are entirely competent, Barnard is best remembered today for more unusual works. His dramatic views of an Oswego mill fire of July 5, 1853, are among the earliest photographs in America of a newsworthy event.[137] Further, like Gabriel Harrison, Barnard advocated the production of purely artistic works. His whole-plate daguerreotype *Woodsawyer, Nooning*—a genre scene of a veteran woodsman and a young boy resting at lunch—received an honorable mention in

the 1853 Anthony Prize competition. Edward T. Whitney, who began as a jeweler, learned the daguerreotype process in 1844 from Martin M. Lawrence, in New York. After moving to Rochester, Whitney ran the city's leading studio from about 1846 through the end of the daguerreian era.

Several notable daguerreotypists were based in Buffalo, at the western terminus of the Erie Canal, and in nearby Niagara Falls. This was a popular tourist destination; by the late 1830s, "doing the falls" was seen as the culmination of an American Grand Tour. Its popularity was only accelerated by the completion of a railroad line to Niagara in 1842. By 1850, the falls were attracting more than 60,000 visitors per year.[138]

The leading studios in Buffalo included those of Donald McDonnell and Oliver B. Evans. Both are known today for relatively few identified works.[139] McDonnell entered the profession in about 1848. In addition to his portrait work—carried out in a lavish studio at 194 Main Street—he sold daguerreian supplies.[140] McDonnell's technical and artistic skill is demonstrated in a remarkable half-plate portrait of Indian Chief Maungwudaus [54]. A comparable level of aesthetic sophistication is evident in Oliver B. Evans's whole-plate portrait of four wealthy children in costume [55].

Today, Platt D. Babbitt is the best-remembered daguerreotypist from this region. Although rarely mentioned in the photographic literature of the day, Babbitt ran a unique and successful operation.[141] He held sole rights to photograph at the pavilion in front of Point View (later Prospect Point), the best viewing position on the American side of Niagara Falls.[142] A riveting example of the natural sublime, this cataract was an enormously popular tourist attraction —a sight at once exhilarating and terrifying, humbling and uplifting. Babbitt specialized in whole-plate views of groups of spectators, seen from behind, awestruck by the relentless cataract [56]. He also photographed in the off-season and away from his jealously guarded spot at Prospect Point. He was fascinated by the falls in winter [C-37] and by the new suspension bridge—designed by John Augustus Roebling and completed in March 1855—across the river [C-38].[143]

On July 19, 1853, Babbitt made his most haunting and heartbreaking image—a record of a young man named Samuel Avery clinging to a snagged log just above the lip of the falls [57]. The previous evening, Avery had been rowing on the river with friends.

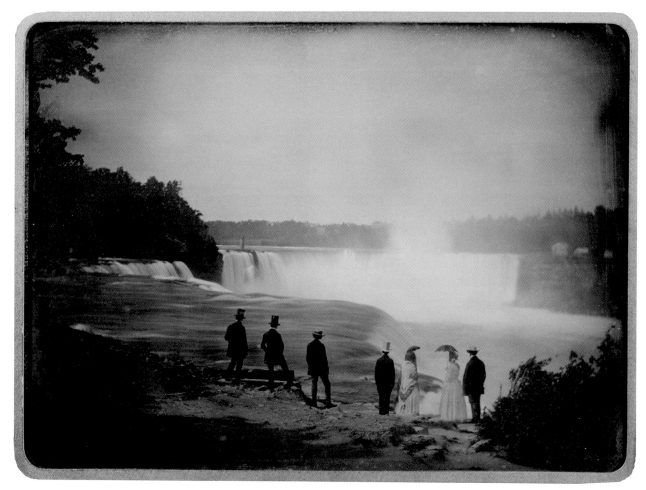

56 **Platt D. Babbitt**, *Group at Niagara Falls*, ca. 1853

57 **Platt D. Babbitt**, *Avery Stranded, Niagara*, July 19, 1853

Their boat was caught by the current and smashed on rocks. His companions were instantly swept over the brink, but Avery was lucky enough to catch hold of a snagged log. After he was spotted the next morning, a series of rescue efforts was made. On the final attempt, a boat was lowered to him by rope. Avery was able to climb in, but the vessel capsized, throwing him into the water. Within seconds, he was swept over the falls to his death.[144] The story was covered in newspapers nationwide and even inspired a poem by William Dean Howells.[145] Taken within days of George N. Barnard's views of the Oswego mill fire, Babbitt's daguerreotype is one of the most important early American photographs of a newsworthy event. He made several copies of this remarkable image but it is unknown how many were sold.

The iconic appeal of Niagara made it a natural subject for daguerreotypists. McDonnell made visits from Buffalo and numerous others—including Thomas Easterly, the Langenheims, Meade Brothers, and Jesse Whitehurst—came to photograph the falls.[146]

The South

Practitioners set up studios in every major city in the South and itinerants traveled hundreds of miles on the roads and rivers of the region. While the volume of this trade would never rival that of the more densely populated North, a significant number of daguerreotypists worked there.

Historically, the American South has been defined as the territory below the Mason-Dixon Line, marked by the southern border of Pennsylvania and the western edge of Delaware. By this measure, Baltimore was the northernmost Southern city. A major port, Baltimore was one of the nation's most important urban areas in the early nineteenth century. It ranked second in population in 1830, 1840, and 1850, and fourth in 1860.

Henry Fitz, Jr., opened one of the nation's first daguerreotype studios in Baltimore in the summer of 1840.[147] Others followed in relatively short order, typically on Baltimore Street, the city's commercial center. In late 1843, John Plumbe opened one of his branch operations there. This studio, managed by Jacob Shew (who later went to California), was for four years the city's most successful daguerreotype business. Other talented practitioners worked in Baltimore before moving elsewhere: Chauncey Barnes and Harvey S. Marks both went to Alabama, for example, while the partners Charles Fontayne and William S. Porter moved to Cincinnati. Solomon Nunes Carvalho, who began in business in Baltimore in July 1849, made successive moves to Washington, D.C., Charleston, and New York, before accompanying John C. Frémont's fifth and last western expedition in 1853.[148]

Jesse H. Whitehurst not only ran one of the best studios in Baltimore, he was the region's leading daguerreian entrepreneur. Born in Princess Anne County, Virginia, Whitehurst demonstrated artistic and mechanical skills at an early age. After learning the daguerreotype process in 1843, he opened a string of studios throughout the upper South—in Norfolk, Richmond, Baltimore, Lynchburg, Petersburg, Washington, D.C., and Wilmington—and in New York City.[149] This was a massive enterprise: Whitehurst's galleries reportedly produced a total of 60,000 daguerreotypes in his first six years of operation.[150] By 1851, he claimed to be making 30,000 plates annually.[151]

Whitehurst obviously had no personal hand in the great majority of the works that bear his name. His galleries were managed by such

58 **Jesse Whitehurst**, *Mother and Daughter*, ca. 1850-55

capable figures as the brothers Julian and Lucian Vannerson. While some of Whitehurst's operators were paid employees, others appear to have worked more independently, as co-owners or franchisees of their galleries. To further complicate the matter of authorship, a few galleries continued to carry the Whitehurst name for years after he sold his interest in them.

The Whitehurst studios produced work of consistently high quality, often in larger plates [58]. Whitehurst's work is also distinguished by his frequent use of the "rotary background" technique. In this process, a revolving-drum backdrop behind the sitter produced a featureless mid-toned background. As one of Whitehurst's advertisements noted, the technique "gives an airy and living appearance to the picture."[152] Whitehurst was recognized in the exhibitions of the day for his views of Niagara Falls, his portrait of Jenny Lind, and other works.

Washington, D.C., presented a market of moderate interest to daguerreotypists. The nation's capital was reliably full—except in the sweltering summer—of political leaders, military officers, and visiting dignitaries. Otherwise, however, it had a relatively modest resident population; in the national censuses of 1840, 1850, and 1860, it ranked thirteenth, eighteenth, and fourteenth in size. The first itinerant arrived in the city in March 1840, followed by a few other little-remembered operators.[153] During the congressional sessions of 1842-43 and 1843-44, Edward Anthony and Jonas M. Edwards set up an extended operation in the city to make portraits of prominent statesmen. Philip Haas undertook a similar project before moving to New York in 1844, while Mathew B. Brady came from New York some time later in pursuit of the same quarry. The first permanent daguerreotype studio in the city was opened by John Plumbe in late

59 **George S. Cook**, *Boy with Book*, ca. 1849-50

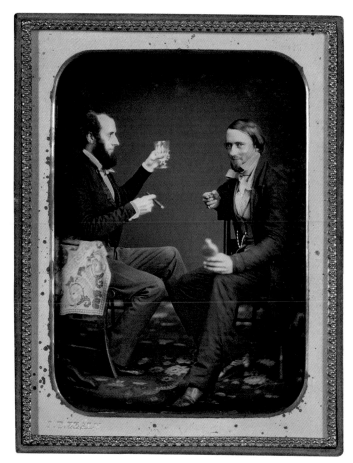

60 **J. T. Zealy**, *The Toast*, ca. 1850

1844. In addition to making portraits, Plumbe produced a set of half-plates in 1846 of the Capitol, White House, Patent Office, and similar structures.[154] Others set up temporary operations or branch galleries in Washington, including Solomon Nunes Carvalho, Marcus A. Root, Jesse Whitehurst, and James E. McClees. Julian Vannerson worked in the city for many years, first as the manager of Whitehurst's operation and then in partnership with McClees.

In Richmond, Virginia, one of the best galleries was owned by William A. Pratt. Whitehurst had a significant operation in that city, and Montgomery P. Simons worked there for about six years after leaving Philadelphia in 1851.

Charleston, South Carolina, was a significant center of daguerreian activity. Charleston had been an important port since its founding in 1670 and by the mid-eighteenth century it was famous for its aristocratic luxury and high culture. At the end of that century, Charleston's fortunes began a slow decline. The city ranked fourth in population in 1790 but slipped to tenth in 1840 and to fifteenth in 1850. Of course, this population was significantly different in composition from that of any Northern city. In 1840, 45 percent of the South Carolina population was white; 53.5 percent were slaves; and 1.4 percent were free African Americans.

As a result of Charleston's wealth, and its appeal as a winter resort, the city was visited regularly by Northern daguerreotypists.[155] Many familiar names worked there on a temporary basis, including Jesse Whitehurst, Samuel Broadbent, and Montgomery P. Simons. One of the city's leading daguerreotypists, George S. Cook, arrived in 1849. While he expanded his activities beyond Charleston (working for periods in Philadelphia, New York, and Chicago), Cook was a fixture in the city for most of the next three decades. One of his most memorable portraits [59] depicts a free black youth. The legal and social status of this young man is conveyed in his fine clothing and in the book he holds (a sign of literacy). Other notable Charleston daguerreotypists included a Mrs. Fletcher, the first woman (in 1842) to operate a studio in South Carolina, and Charles L'Homdieu,

whose operation of 1847 has been described as the first "established" gallery in the city.[156]

The leading daguerreotypist in the state capital, Columbia, was the rather mysterious J. T. Zealy. Little is known of Zealy's background or training. However, his relatively few identified works, and comments about him in the photographic press, prove that Zealy was a photographer of real talent. His quarter-plate *The Toast* [60], is a masterpiece of spirited camaraderie, made with a memorable sense of spontaneity and sly humor.

The body of work for which Zealy is now best known is of a markedly different nature. In 1850, he was commissioned to photograph slaves on a plantation outside Columbia for Harvard professor Louis Agassiz. Agassiz intended to use these images to bolster his theory of "separate creation," the idea that the world's various races did not share a common ancestor.[157] Many Southerners embraced this theory in the belief that it provided "scientific" proof of racial inequality, and thus a justification for slavery. While Zealy made the requested images, it is to his credit that the resulting plates transcend any simple notion of racial types. Using the lessons of lighting and pose that he applied to Columbia's upper class, he illuminated the essential humanity of his enslaved subjects. Rediscovered in 1976, these unforgettable plates have received considerable attention in recent decades.[158]

New Orleans was the heart of the Deep South. One of the world's busiest ports, the city was a lively mixture of Creoles, native-born Americans, and recent immigrants from Ireland, Germany, and elsewhere in Europe. In 1840, New Orleans was the nation's third largest city, with a population of just over 100,000. By 1850, it had over 116,000 people and ranked fifth.

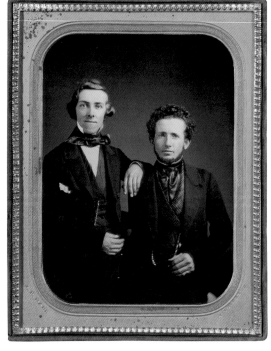

61 **Ezekiel Hawkins** (attrib.), *The* Jacob Strader *at Wharf, Cincinnati,* ca. 1853

62 **James P. Ball,** *Two Men,* ca. 1855

Residents of New Orleans viewed daguerreotypes for the first time on March 15, 1840.[159] The maker of these views was Jules Lion, a black painter, lithographer, and daguerreian pioneer. John Plumbe set up a branch gallery in the city, and Marcus A. Root, George S. Cook, and Ezekiel Hawkins were among those who worked there briefly, but established their reputations elsewhere. The best resident daguerreotypists included James Maguire, who worked in the city from 1842 until his death in 1851, and Edward Jacobs, who plied his trade from 1844 through the end of the daguerreian era [c-39]. In 1847, while employed by E. White and Co., Jacobs made a highly praised portrait of General Zachary Taylor, the hero of the Mexican-American War and future president of the United States.

With the natural growth of population and commerce in the region, a network of daguerreotypists soon took shape throughout the Deep South.[160]

The West

In the early nineteenth century, the population of the United States expanded rapidly into the great inland territory known as "The West." This included what is now termed the Midwest and upper South: from western New York State and the diagonal barrier of the Appalachian Mountains westward to the Mississippi River and beyond. This vast region was settled in waves.[161] By 1800, settlers had moved from western New York to northern Ohio, the upper Ohio River valley, and parts of Kentucky and Tennessee. After the War of 1812, Indiana and Illinois were increasingly settled as the steamboat opened the interior waterways to travel and commerce. Yet another surge of settlers began in the 1830s, with the great canals, the beginning of railroad travel, the start of a system of national roads, and the removal of most of the native Indian populations.

By 1850, the outer limit of white settlement constituted a broad arc from Green Bay, Wisconsin, southward to the "Permanent Indian Frontier" along the western boundary of Missouri and Arkansas.[162]

Despite its vast size, this region was linked together—and joined to the East—by an impressive system of transportation. As D. W. Meinig has observed, "By the late 1850s the entire national population—excepting only the Far West and Texas—was within six days' travel of New York City or Philadelphia, a remarkable compression of the operational distance-scale of the nation."[163]

The cities of this region grew quickly. Much of the traffic into the West followed the two great waterways: the Ohio River (from Pittsburgh downstream to the Mississippi) and the Erie Canal–Great Lakes system (west from Albany, through Buffalo, to Cleveland, Detroit, Milwaukee, and Chicago). Cincinnati, which held a strategic position on the Ohio River, was the most important of the western settlements. In 1820, it already had a population of nearly 10,000 and ranked fourteenth in size nationwide. By 1850, it ranked sixth, with a population of 115,000. By 1860, eight of the twenty-one largest American cities were in this trans-Appalachian region. Cincinnati and St. Louis ranked seventh and eighth in size, with nearly identical populations of about 161,000, followed by Chicago (ninth), Louisville (twelfth), Pittsburgh (seventeenth), Detroit (nineteenth), Milwaukee (twentieth), and Cleveland (twenty-first).

Cincinnati prospered with the boom in steamboat travel beginning in the 1820s. By the 1850s, it was one of the largest manufacturing centers in the country, known for butchering and meat packing, metal products, furniture, and riverboats. In addition to its status as the largest of the region's cities, Cincinnati was also the most cultured: the "Athens of the West." Thanks to the predominance of German settlers, Cincinnati developed into a lively center for music, theater, and the visual arts.[164] This creative climate was enriched by a steady stream of visitors—artists, performers, and entrepreneurs—in transit up and down the Ohio River.

Cincinnati's first daguerreotypist, Ezekiel C. Hawkins, came to photography after a lengthy career as an artist.[165] He claimed to have taken up the daguerreotype in the fall of 1840, after receiving a letter from Samuel Morse outlining the process.[166] Hawkins was an

outgoing and enterprising man. He spent years creating a collection of daguerreotype portraits of the region's pioneers—a visual archive that was largely destroyed in an 1851 studio fire.[167] His gallery, one of the most lavish in the region, was decorated with his photographs and with sculptures by Joel Tanner Hart, one of the region's most noted artists. Hawkins was an accomplished teacher and lecturer on photography, and an early advocate of the paper process.[168]

Unfortunately, few identified works by Hawkins are known. This half-plate daguerreotype [61] is tentatively attributed to him.[169] It depicts a magnificent vessel named for its owner, the head of the Strader Steamboat Company in Cincinnati. Put into service in 1853 as a passenger and mail packet steamer, running between Cincinnati and Louisville, the *Jacob Strader* was the largest boat (at 347 feet long) on the Ohio River. It was also one of the most elegant: its 306-foot-long cabin had beautiful chandeliers, full-length mirrors, and a $1,000 piano.[170] This view shows it at wharf, along the river bank east of the city center. This is an image of progress and prosperity: the houses are of recent construction; the air is filled with the steam and smoke of enterprise; and the ship stands as a symbol of both engineering and commercial success.

Cincinnati was one of the era's most photogenic cities. The opposite bank of the river, at Newport, Kentucky, provided a panoramic vista of the waterway, the commercial heart of the city, and the surrounding residential areas. The most remarkable daguerreotype view of this scene was made in 1848 by the local team of Charles Fontayne and William Southgate Porter. Composed of eight flawless whole plates, this work was a technical and artistic tour-de-force. Widely celebrated in its day, this panorama received prizes at exhibitions in Philadelphia and Baltimore and was acclaimed at the 1851 London Crystal Palace exhibition.[171]

While other Cincinnati daguerreotypists made outdoor views, their primary business naturally was in portraiture. This sixth-plate [c-40] is a relatively early work by Fontayne, made before Porter arrived in 1848 to resume their previous partnership. Thomas Faris, who began in the profession in 1841, was also an accomplished portraitist. This image, made after a partnership with Hawkins, depicts two solemn children—posed before an elaborate painted backdrop—holding an open daguerreotype of a man [c-41].

James P. Ball's "Great Daguerreian Gallery of the West" produced some of the finest work in the region. The leading African American daguerreotypist of his era, Ball worked as an itinerant in Virginia and Ohio before opening his lavish Cincinnati gallery in 1847.[172] Located in the most fashionable part of town, Ball catered to a middle- and upper-class clientele and made elegantly direct portraits [62, c-42].

Outside Cincinnati, the state's second largest concentration of daguerreian talent was in Cleveland. Theodatus Garlick is credited with making the first daguerreotype in that city. Garlick was a man of many talents. Originally a blacksmith and tombstone carver, he became a physician and surgeon, a sculptor, and an avid outdoorsman—a dedicated fisherman and the father of modern fish farming. While his work with the daguerreotype was relatively brief, Garlick operated a public studio for a time in 1841.

Following Garlick's lead, several capable practitioners made Cleveland their home. Charles E. Johnson had entered the profession in 1841, in Binghamton, New York. After a peripatetic start, he settled in Cleveland for several years, from 1849 to 1853, before leaving for San Francisco. In this time, Johnson met James F. Ryder in Ithaca,

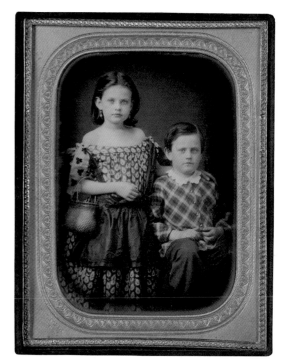

63 **William C. North**, *Josephine and Eugene Gray, Children of Joseph W. Gray*, ca. 1850

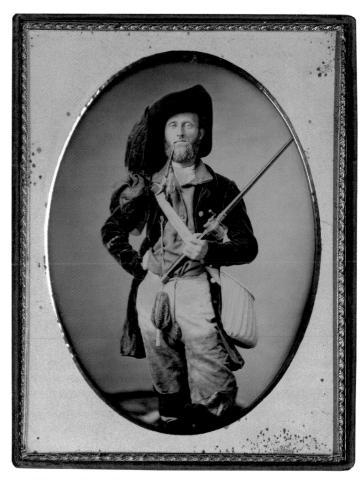

64 **William C. North**, *The Fisherman*, ca. 1850

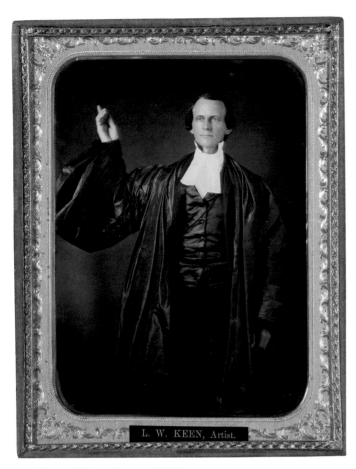

65 **Lilbern W. Keen**, *Reverend W. M. Steel*, ca. 1860

For example, Lilbern W. Keen is one of the many daguerreotypists to have gone almost entirely unmentioned in standard histories. Keen was based in Jonesborough, Tennessee, but traveled occasionally; this work [65] was taken in Decatur, Illinois. Here, he records Reverend Steel in the dramatic pose of a classical leader or orator.

Daguerreotypists were scarcer in the late-blooming settlements of the region. Chicago was a city of very modest size through the 1840s and into the early 1850s. In the census of 1850, it ranked twenty-fourth in size nationally, with a population of about 30,000. A few of the notable Chicago practitioners include E. D. Gage, who was in operation by 1844; John Frederick von Schneidau, who opened for business in 1849 and was credited with the first American daguerreotype portrait of Jenny Lind; and William G. Chamberlain, who worked in Chicago from 1852 to 1856 before moving to Denver.

The greatest photographic activity at the edge of the frontier lay along the region's main thoroughfares: the great rivers. The first daguerreotypist in present-day Minnesota appears to have been Sarah Judd.[177] She worked from 1848 to 1850 in Stillwater, east of St. Paul on the St. Croix River. In 1850, there was only one other active photographer in the state: William H. Jarvis, who worked as both a daguerreotypist and a dentist in St. Paul. Ultimately, this area around the St. Anthony Falls was home to five daguerreotypists in the 1850s. The best of this group was Joel E. Whitney. Whitney opened his first studio in 1851 and—after seeking advice from the more experienced Alexander Hesler—he achieved a reputation for good and stylish work. In 1853, Whitney advertised that he had "just returned from New York, with the largest and most magnificent assortment of Daguerreotype goods, ever offered to the people of Minnesota."[178] In addition to his work in the studio, Whitney daguerreotyped Minnesota scenery, including both the St. Anthony and the Minnehaha falls.

Whitney's mentor, Alexander Hesler, was one of the most respected daguerreotypists in the country. Hesler was a man of many virtues: he was warm and generous, entrepreneurial in spirit, technically innovative, and artistically inclined. He contributed letters and articles to the photographic journals and showed regularly in the exhibitions of the day. Hesler led a restless, productive life.[179] Born in Montreal, he grew up in Vermont and moved with his family to Racine, Wisconsin, in 1833. After learning the daguerreotype process in Buffalo, he set up professional practice in Madison, Wisconsin, in 1847. By 1849, he had arrived in the Mississippi River town of Galena, Illinois. He worked in Galena for most of the next five years before relocating to Chicago in late 1854.

Hesler made several photographic excursions up the Mississippi River to St. Paul. On the first, in the summer of 1851, he recorded all the river towns between Galena and St. Paul, and made views of such natural attractions as the St. Anthony Falls.[180] His friendship with Whitney began at this time. In August 1852, Hesler returned to St. Paul and, assisted by Whitney, undertook a daylong daguerreotyping marathon. With Whitney preparing and developing plates in a portable dark tent, Hesler made over eighty scenic images along the river, at Minnehaha Falls, and from a bluff overlooking St. Paul. Ever the efficient businessman, Hesler exposed nearly thirty plates of Minnehaha Falls alone on this excursion. One of these was given to a friend in Galena, who sent it to poet Henry Wadsworth Longfellow. This daguerreotype served as at least partial inspiration for Longfellow's popular poem "The Song of Hiawatha" (1855). In Galena, Hesler also produced superb whole plates of the city, the river, and its steamboats.

New York, and convinced Ryder to come to Cleveland to manage his studio. Shortly later, Ryder established his own business in the city, which became one of the region's most venerable.[173]

On the evidence of his surviving work, William C. North was Cleveland's finest daguerreian talent. After working briefly in Boston, and then in Oberlin, Ohio, North moved to Cleveland in about 1850.[174] He ran this business through the remainder of the decade, probably with the assistance of his nephew Walter C. North. The elite nature of North's customers is suggested in a quarter-plate of the children of Joseph Gray, the editor of the Cleveland *Plain Dealer* [63]. North's masterpiece is this exquisite half-plate portrait of a fisherman [64]. This work has all the hallmarks of a "show piece." Technically perfect, it depicts a special American type: the outdoorsman as artist and dandy. Given the surpassing quality of this work, it is appropriate that its subject may be the city's daguerreian pioneer himself, Theodatus Garlick.

Elsewhere in Ohio, Albert Bisbee—the author of *The History and Practice of Daguerreotyping* (1853)—was the best-known figure in Dayton.[175] Bisbee's most celebrated work—a six-plate panorama of Cincinnati—was presented in the 1853 New York Crystal Palace exhibition. Samuel Dwight Humphrey worked in Columbus for at least two years, from 1846 to 1848, before going to New York, where he began publishing the *Daguerreian Journal* in 1850. Alexander B. Weeks, an experienced operator and longtime associate of Jeremiah Gurney, operated a gallery in Toledo in the mid-1850s.

Experienced daguerreotypists were at work beyond Ohio, from the states of Michigan, Indiana, and Kentucky to the Mississippi River settlements of Memphis, St. Louis, and St. Paul.[176] On their best days, many of these operators produced beautiful and memorable images.

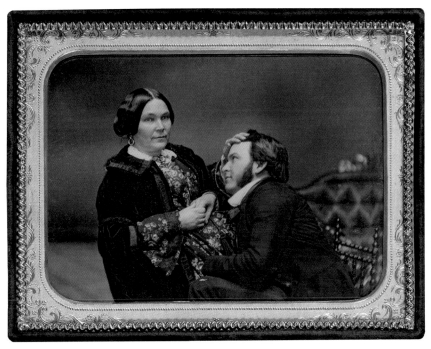

66 **Alexander Hesler**, *Man and Woman*, ca. 1855-59

67 **Alexander Hesler**, *Quadruple Portrait of James Duncan Graham, Sr.*, ca. 1855-59

The variety of Hesler's work is suggested in the prize-winning group of plates he sent to the 1853 Crystal Palace exhibition in New York. These included three views of the St. Anthony Falls, a panoramic series of Galena and the river, a whole-plate genre scene titled *Driving a Bargain* [278], and at least one plate from a series "illustrating character and passion."[181] Hesler's artistic studies were widely admired. Two of these works—including *Driving a Bargain*—were reproduced as salt-print facsimiles as the frontispieces to the April and September 1854 issues of the *Photographic and Fine Art Journal*.

Hesler's portraits were equally esteemed. After he won the gold medal for the best daguerreotypes at the Fair of the Chicago Mechanic's Institute in 1853, a critic observed that his "thorough understanding of the means and method of producing a good Daguerreotype is shown in the rich heavy tone of his pictures. But the position and arrangement of his subjects show the genuine artist. They are all relieved from that vacant…look, which is the bane of common daguerreotypes."[182] As this work from his Galena period demonstrates [c-43], Hesler depicted his subjects not only as dignified, but as possessing a genuine emotional and psychological depth. These qualities are evident in a distinctly unusual work from his Chicago studio [66] that may be related to his earlier project to illustrate "character and passion." Finally, Hesler made at least a few quadruple portraits, using an in-camera mask to make four exposures on a single plate [67]. This work has a distinctly modern feeling—instead of one "true" likeness, we are given a slightly disorienting sequence of perspectives.

While Hesler's writings are saturated with the idealism characteristic of his day, they were honest and deeply felt. In 1853, he wrote:

> In making likenesses and pictures we should have some other aim in view besides the mere paltry gain in dollars and cents, and the mere gratification of the present. We *should remember* that we are *working* for *future generations*—that after we have passed off this busy scene of bustle and strife, our *works will live* and our influence be felt, in proportion to the good we have done.[183]

Downriver, St. Louis had the most remarkable community of American daguerreotypists outside New York, Boston, and Philadelphia. Due to its key position on the Mississippi, near the junctions of the Illinois and Missouri rivers, St. Louis grew rapidly. In 1840, it ranked twenty-fourth in size nationally, with nearly 16,500 people. By 1850, it had leaped to a rank of eighth and a population of almost 78,000. Ten years later, it was still eighth, but its population had more than doubled.

In 1854, there were sixteen studios in the city doing an annual combined business of at least $75,000.[184] The members of this fraternity ranged from dependable professionals such as John J. Outley and William H. Tilford to major figures such as John H. Fitzgibbon, Enoch Long, and Thomas M. Easterly. Outley and Tilford both produced consistent work for a middle-class clientele. When Fitzgibbon was establishing his elite credentials by advertising "I want it to be distinctly understood, that I take no Pictures less than Three Dollars, or higher than Forty," Outley's offerings were priced from $1 to $10.[185] As a result of this combination of price and quality, Outley's studio was the busiest in the city. More rustic in feeling than his most characteristic work, this full-figure portrait [c-44] is indicative of his inventive eye. Tilford served as an assistant and partner to Fitzgibbon in the early 1850s before opening his own daguerreotype studio and supply house [c-45].

John H. Fitzgibbon enjoyed a long and respected career. Born in London, he came to the United States with his family at a young age. After his apprenticeship to a saddle maker, Fitzgibbon moved to Lynchburg, Virginia, where he managed a hotel. He took up the daguerreotype in 1841 and relocated to St. Louis in 1846. Fitzgibbon's images were widely exhibited and praised; he contributed essays to the photographic press, and he was elected to high posts in several professional associations. Fitzgibbon's reputation ensured that most visiting celebrities came to his studio. This plate [68] of Jenny Lind was made during her visit to St. Louis in March 1851 in the national tour organized by P. T. Barnum.[186]

68 **John H. Fitzgibbon**, *Jenny Lind*, 1851

69 **Enoch Long**, *Three Girls*, ca. 1850

Fitzgibbon was also active outside the studio. He traveled up the Mississippi to establish a temporary studio as early as 1847, and he made several photographic expeditions into the country south and west of St. Louis. In 1854, he journeyed through southern Missouri, northwestern Arkansas, and the Indiana Nations territory of present-day northeastern Oklahoma.[187] Advertising ahead of himself to drum up business, he stopped in ten communities in thirty-two days. As the first "picture man" many of his subjects had ever seen, Fitzgibbon made a healthy profit selling likenesses.

Fitzgibbon's gallery was the most lavish in the region—an astonishing showcase of the daguerreian art. In 1853 Fitzgibbon purchased and subsequently exhibited the Vance collection of 300 whole-plate views of California and South America.[188] As a writer of the day observed, his gallery featured "the finest and most extensive collection of pictures…to be found in the World."[189] In 1854, the *Photographic Art-Journal* noted:

> We recently visited Fitzgibbon's gallery, which is so much talked about, and were surprised at the immense collection of pictures that this establishment contains. Mr. F. has done all that a lover of his art could do to make his gallery attractive. There can be seen portraits of all the notables who have visited St. Louis during the last seven years, including distinguished statesmen, divines, Indian chiefs, belles of the West, landscapes, &c., &c. It is only at this gallery that pictures are taken on mammoth sized plates.[190]

Although Fitzgibbon was noted for his portraits of Indians, few of these plates are known today.[191] Fewer yet of his landscapes or mammoth-plate works appear to have survived.

In 1857, Fitzgibbon used many of these images to create a spectacle titled "Fitzgibbon's Panorama of Kansas and the Indian Nations." Following an entertainment fad of the time, this was a long, scroll-like painting (covering some 12,000 square feet of canvas) that was slowly unrolled in front of a seated audience to provide a virtual journey. Based on Fitzgibbon's daguerreotypes, this monumental work was created by a talented St. Louis painter, Carl Wimer, who had been trained at the Düsseldorf Academy. In addition to scenes related to the civil strife in Kansas, the panorama included many vignettes of the landscape and peoples along the upper Missouri River. The centerpiece of the work was a "great scene of the Laying Down of Arms, by 2700 Border Ruffians, to Governor Geary," in which all the primary faces were allegedly based on daguerreotypes.[192] Fitzgibbon accompanied his touring panorama to New England in early 1857, where it played briefly in Boston and apparently in a few other towns in the region. However, it subsequently disappeared from the historical record and almost certainly failed to repay Fitzgibbon's investment.[193]

The brothers Horatio H. Long and Enoch Long learned the daguerreotype process in 1842 under the tutelage of Robert Cornelius, in Philadelphia. They worked in partnership until Horatio's death in 1851, first in Augusta, Georgia, and then as itinerants from Alabama to New Hampshire. They moved to St. Louis in 1846 and quickly established a national reputation.[194] The Longs had high standards and pointedly advertised "No catch-penny pictures taken at this gallery."[195]

This remarkable portrait of three children—two white, one black—was made at a time of heated debate over slavery [69]. The original intention of Long's portrait was undoubtedly straightforward: to

70 **Thomas M. Easterly**, *Man with Elephant*, ca. 1850

depict the two young children of a wealthy local family with their attendant, the child of a household slave or African American caretaker. The resulting picture is activated by a deep set of tensions—between white and black, foreground and background, daylight and shadow. While the intended hierarchy is clear—the white children are of primary importance, with the African American behind and subordinate—the black youth utterly dominates the picture. The well-dressed white children become almost cardboard thin; the gravity of the picture is centered in the stolid, shadowy figure behind them. It is a challenging vision of the American "family" of the late antebellum era, suggesting nothing less than the nation's guilty conscience—its original sin of slavery and racial inequality.

Thomas M. Easterly was more than simply another leading St. Louis daguerreotypist. In some respects, he was the most extraordinary American daguerreotypist of all. While he achieved only a regional reputation in his day, his work is now recognized as radically original. Easterly had ambitions with the daguerreotype, and a devotion to it, that were unsurpassed by any of his peers.

Born in Vermont, Easterly worked in the 1830s and early 1840s as a traveling instructor of writing, calligraphy, and pen-making.[196] He took up the daguerreotype sometime in the early 1840s in New York State. After a foray to New Orleans, and then to Vermont, he moved west in 1845. He worked as an itinerant in Illinois, Iowa, and Missouri, making a leisurely excursion up the Missouri River as far as Liberty and Kansas City. By March 1847, he had settled in St. Louis.

Easterly's studio work was simple and unembellished [c-46]. He used few props and no painted backdrops; his portraits are clear, dignified, and direct. What truly distinguishes Easterly's vision is the work he made beyond the standard portrait. Some sense of his unconventionality is conveyed in a gallery advertisement of 1851: "Likenesses of Distinguished Statesmen, Eminent Divines, Prominent Citizens, Indian Chiefs, and Notorious Robbers and Murderers. Also Beautiful Landscapes, Perfect Clouds, and a bona fide streak of lightning, taken on the night of June 18th, 1847."[197] Easterly had his share of famous sitters, from performers such as Julia Dean, Jenny Lind, and Lola Montez, to local clergymen such as William Greenleaf Eliot, and the touring spiritualist sisters Margaret and Kate Fox. His Indian portraits—elegantly hand-colored plates of Sauk and Fox tribe members, made in 1847—are on a par with Fitzgibbon's masterful Indian images of a few years later.[198] Easterly's technical expertise is apparent in his nighttime view of a bolt of lightning and in his ability to record clouds.

Most remarkably, Easterly produced many outdoor views. Over an extended period, he lovingly documented the changing face of St. Louis and its environs. In addition to scenic views around the outskirts of the city, he recorded streets and residences, shops and factories, ferry boats and locomotives, buildings ruined by fire and new ones under construction. Easterly had an historian's eye. He was particularly attentive to the bittersweet cost of progress—the relentless destruction of the city's primeval or picturesque past in the name of improvement. For example, he recorded the leveling of an ancient Indian earth mound, one of the old city's most prominent landmarks, and the draining and filling of Chouteau's Pond, a formerly idyllic area that had become a polluted eyesore.[199]

Easterly's versatility is demonstrated in a surprising quarter-plate of a man with a young elephant [70]. While this daguerreotype

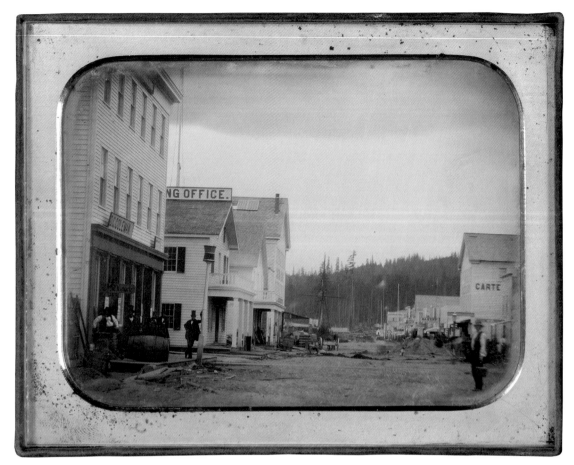

71 **Joseph Buchtel** (attrib.), *Front Street, Portland, Oregon,* ca. 1852

comes without supporting information, it may have been made during a visit of the "Great and Only Show," the traveling circus troupe of Dan Rice. This show, which made the first of several visits to St. Louis in 1848, had many feature attractions, including "Empress," the largest elephant in America prior to P. T. Barnum's "Jumbo."[200] The adolescent animal depicted here might have been the offspring of "Empress" or another of Rice's elephants. The unusual subject of this daguerreotype, and its snapshot-like immediacy, underscores the radical individuality of Easterly's vision.

California and the Pacific Coast

In the 1850s most of the territories of the Far West, along the Pacific coast, were in the earliest stages of economic development. As a result, only a handful of communities had the population and wealth to support the daguerrian trade.

The first daguerreotypist in Portland, Oregon, was Matthew K. Smith, who worked briefly in the city in 1851 before leaving for Honolulu and turning to the newspaper business. After him, Leland H. Wakefield, Joseph Buchtel, and Denny H. Hendee opened daguerreotype studios in Portland between 1852 and 1853. Buchtel had an unusual professional life. In the beginning of his career, he worked seasonally as both a daguerreotypist and as a deck hand on the steamships that plied the upper Willamette River; later he was a sheriff and a firefighter. While his authorship is not conclusive, it was probably Buchtel who made this important early view of Portland's Front Street [71] in about 1853.[201] Elsewhere in the region, Peter Britt

was in business by 1853 in Jacksonville; in 1854, Phillip F. Castleman opened Eugene's first daguerreotype studio and Samuel Holmes was in business in Olympia (Washington Territory). Other daguerreotypists practiced in Salem, The Dalles, and Oregon City.

The greatest daguerrian activity along the Pacific coast was in San Francisco and the boom towns of the nearby mining region. This area was transformed by the discovery of gold in 1848. San Francisco went from a quiet outpost of 400 residents in early 1847 to a city of 20,000 by the end of 1849. Few of these new arrivals had a permanent stake in the area; nearly everyone was in transit, hunting and scheming. Many photographers emulated this restless, opportunistic model by managing studios in two or more places at once, and by making regular forays into the backcountry. The sheer number of existing Gold Rush daguerreotypes proves that the "forty-niners" provided an eager and profitable market. Despite the difficulties of working in the field, the high quality of these plates testifies to the skill of their makers.

Although few daguerreotypists made much of a mark in San Francisco prior to 1850, many studios opened in the next few years.[202] The earliest operations tended to be part-time or short-lived. In 1850, for example, Julia Shannon began advertising her services as both a daguerreotypist and a midwife. Sterling C. McIntyre, a dentist and daguerreotypist, arrived in San Francisco in 1850 from Tallahassee, Florida. He produced a beautiful five-plate panorama of the city but moved soon after to Nevada City, California, where he appears to have returned to dentistry.

Frederick Coombs is one of the most colorful characters in daguerreian history. Before turning to the camera, he was a phrenologist

72 **Jacob Shew**, *Portrait of a Standing Girl*, ca. 1856-58

73 **James M. Ford** (attrib.), *Dentist and Patient*, ca. 1852-54

and a proponent of the curative powers of electricity. His career in photography began in 1845 in the Illinois area: he worked in Springfield, St. Louis, Alton, and Chicago before arriving in San Francisco in early 1850. Coombs was accomplished both in the studio [c-47] and outside it (he made at least one panorama and several individual views of San Francisco). However, his business was plagued by one of the most common dangers of the day: fire. In the course of one year (on May 4 and June 14, 1850, and May 4, 1851) he was burned out of three studios.[203]

In 1852, Coombs traveled back east to promote the Golden State with his own portable museum of curiosities: daguerreotype views, wildflowers, nuggets of gold, and a California wildcat. He presented these attractions in cities from Milwaukee to New York. From this time on, Coombs himself became increasingly a curiosity. Dressed in colonial garb as either George Washington or Benjamin Franklin [c-48], Coombs survived on the street by selling photographs of himself to passersby, and by giving impromptu lectures on a wide variety of topics.[204]

The careers of brothers Benjamin Pierce Batchelder and Perez Mann Batchelder were more conventional. Originally from Massachusetts, the Batchelders began their daguerreotype business in California in 1851, in Sonora. Using a studio on wheels, they operated throughout the gold-mining region. Isaac W. Baker, who learned the process from the Batchelders, worked for some time in their mobile studio.[205]

The brothers Jacob Shew and William Shew were also active in this region. Jacob Shew began in the profession in about 1843, managing John Plumbe's Baltimore gallery. He went to California in

1849 with the intention of becoming a miner, but soon turned back to the daguerreotype. In the mid-1850s, he worked in San Francisco on his own, in various partnerships, and in the studio of James M. Ford, before moving to Sacramento [72]. William Shew had begun supervising John Plumbe's Boston operation in 1841. In addition to establishing a gallery in San Francisco in 1851, he worked throughout the region in a wheeled Daguerreian Saloon.

James M. Ford worked as a daguerreotypist in Sacramento before moving to San Francisco in 1852. He was one of the first in the region to offer portraits in the stereoscopic format.[206] Ford's skill in the studio is suggested in this beautifully posed occupational image of a dentist and patient [73]—a work originally created in stereo.[207] No occupational portrait could be more flattering: an offending tooth has evidently been removed cleanly, efficiently, and without pain. Ford's own business ran somewhat less smoothly: after initial success, he suffered a serious financial setback in 1854. He went on to open a new gallery in San Jose in 1855, where he employed a young operator named Carleton Watkins.

George H. Johnson did as much work in the gold regions as any daguerreotypist. He opened a studio in Sacramento in July 1849, but moved to improved quarters in 1850 [266], a clear sign that his business was prospering. Johnson made regular trips into the gold fields, producing many strong images—often in the half- or whole-plate sizes—of mining towns [267], encampments, claims, and sluices. As an extension of this work, a Sacramento newspaper noted in 1851 that he was also "taking views of the various blocks and stores of this city, and is ready to give our citizens a perfect counterpart of their dwellings, or places of business, at a moderate price."[208] In 1852,

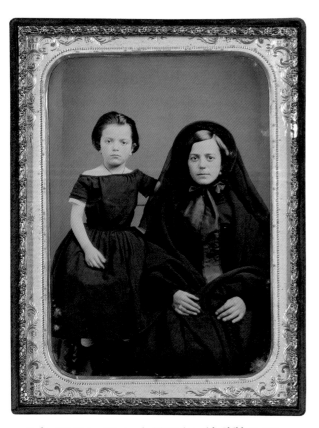

74 **Robert H. Vance**, *Woman in Mourning with Child*, ca. 1855

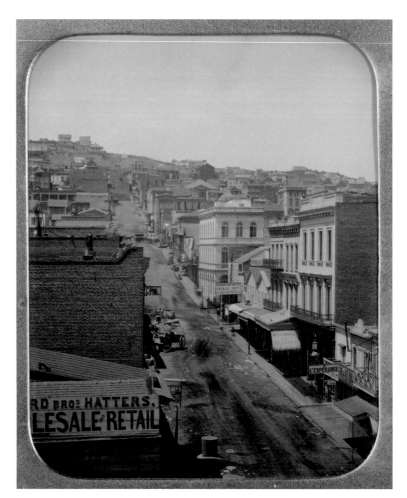

75 **Robert H. Vance**, *View of Sacramento Street, San Francisco*, ca. 1854-56 (detail)

Johnson moved from Sacramento to San Francisco, where he opened the first of several studios.

Robert H. Vance was not only Johnson's prime competitor in San Francisco—he was the most accomplished and enterprising daguerreotypist in the region.[209] Born in Maine, Vance learned the daguerreotype process in 1845 and worked in New England before embarking in 1846 for South America. From 1847 to 1850 he was based in Valparaiso, Chile.

Upon arriving in San Francisco in late 1850, Vance began a massive documentary project. Working with whole plates, he made many images of San Francisco (both single views and panoramas) and an exhaustive record of the gold country. This collection was created with amazing speed. By September 1851, Vance was in New York with his 300 whole-plate views. These were exhibited at 349 Broadway, above Whitehurst's gallery, for an admission fee of twenty-five cents for a single visit and fifty cents for a season ticket.[210] Vance's exhibition was acclaimed, but not profitable. In 1853, these works were sold twice, first to Jeremiah Gurney and then to John H. Fitzgibbon. They were exhibited in Fitzgibbon's St. Louis studio until 1857, when they disappear from the historical record—the greatest single lost treasure of early American photography.[211]

Upon returning to San Francisco in early 1852, Vance resumed his successful operation in that city and opened new spaces in Marysville and Sacramento. By the end of the decade, he was a man of significant wealth.[212] A wide range of sitters came to Vance's San Francisco studio, from the city's best families to the roughest

frontiersmen. Vance's skill in routine portraiture is demonstrated in this somber portrait of a mother in mourning dress, with her young daughter [74].

Given his vast experience working outdoors, it was also natural that Vance documented San Francisco itself. This stereo view, looking up Sacramento Street [75], presents a minutely detailed vision of the city's commercial heart. The view appears to have been made from the roof of the building in which Vance had his studio [c-49]—a perspective he used on more than one occasion.[213] This whole plate [76] depicts a bunting-draped building at Sacramento and Sansome streets, one block from Vance's gallery. The "Great Man" commemorated here had the unusual name of James King of William. King of William, a muckraking journalist and editor of the *San Francisco Evening Bulletin*, was a spirited foe of local corruption. Incensed by one of his editorials, a rival editor and politician shot King of William outside his office. As the wounded man clung to life for a few days, his supporters demonstrated in the street. Upon his death, a group of citizens—members of a self-appointed Committee of Vigilance—removed the assassin from the sheriff's office and lynched him. One of the owners of this building—the office of Smiley, Yerkes & Co., auctioneers and commission merchants—was a charter member of the Committee of Vigilance. This daguerreotype commemorates both the loss of an important civic figure and, by implication, the power of frontier justice. This plate is one of at least two exposures that Vance made of the subject; he also made several views of the street demonstrations by King of William's supporters.[214]

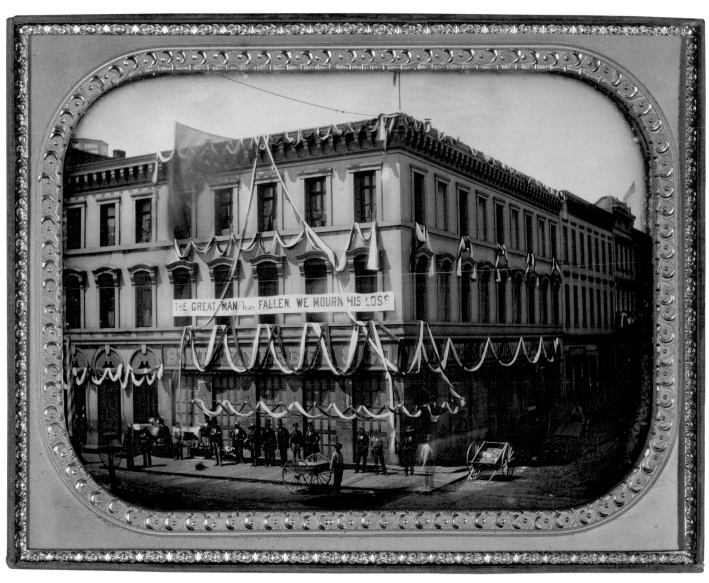

76 **Robert H. Vance**, *"The Great Man Has Fallen," San Francisco*, May 1856

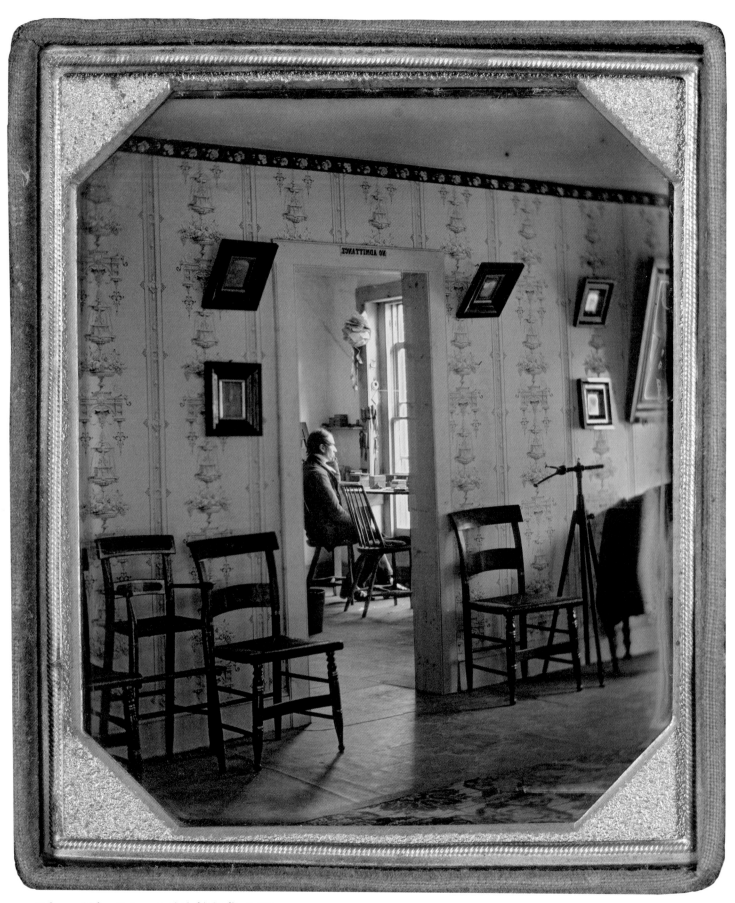

77 **Unknown Maker**, *Daguerreotypist in his Studio*, ca. 1850

CHAPTER III Being a Daguerreotypist

A New Profession

The daguerreotype had something in common with the California Gold Rush. In both cases an exciting discovery resulted in great public interest and, for many, the adventure of a new pursuit. Both were risky propositions, with success far from guaranteed. Gold mining required back-breaking labor and a good deal of luck; the daguerreotype demanded patience, discipline, and skill.

Near the end of his long life, the pioneering photographer James F. Ryder looked back wryly on the profession's early years:

Along in the forties many daguerreotype men styled themselves "professor," and their titles were seldom questioned. It was but a step from the anvil or the sawmill to the camera. The new business of likeness-taking was admitted to be a genteel calling, enveloped in a haze of mystery and a smattering of science. The dark room where the plates were prepared was dignified by some of the more pretentious as the laboratory. A "No Admittance" door, always carefully closed by "the professor" on entering or emerging, naturally impressed the uninitiated as something out of the usual, and when he came out carrying a little holder to his sitter and from it drawing a thin slide, revealing from under it the likeness just taken, it was no unreasonable stretch of credulity to recognize in the man something of a scientist and a professor.[1]

As a young man working in a book-printing office in upstate New York, Ryder had been introduced to the process in 1847 by a "Professor Brightly," a distinguished if somewhat worn and rumpled newcomer to the village. Ryder continued:

He had taught cross-roads school in the country, had a smattering knowledge of and had lectured upon phrenology and biology. The new art of daguerreotypy attracted his attention and had been gathered in as another force with which to do battle in the struggle for fame and dollars. His habit of brushing with his hand the already stiff front hair in an upward direction rather emphasized its standing and his dignity. His manner was genial, meant to impress the person in his presence that, although a professor, he did not choose to seclude himself in his superior knowledge to the exclusion of his surroundings. He was a sun that could afford to shine upon other and lesser planets without dimming its own luster. In a friendly way he had felt my bumps, found ideality prominent, color good, form excellent, and assured me that I was a promising subject and would make a mark as a daguerreotypist. He knew I had a little money which he wished to lure from my pockets into those trousers of his with the baggy knees. He flattered me and I succumbed: that's how it happened that I took to the camera.

After paying for lessons and equipment, Ryder learned the trade as the "professor's" apprentice. The limitations of his mentor's knowledge quickly became apparent, however. "In our work repeated trial was the rule—we would try and try again without knowing the cause of failure. Many a day did I work blindly and almost hopelessly, pitying my outraged sitters, and pitying myself in my despair and helplessness."[2] Real facility came slowly and with considerable effort. Ryder observed: "In the first two years of my practice I repeatedly paid for methods and processes from those in advance of me, considering it better policy than digging it out myself." The results were predictably mixed. One of Ryder's instructors stressed the benefit of polishing plates with a moist buff, for example, while the next placed all his faith in a completely dry buff.[3]

Ryder soon gained enough skill to run the studio when Professor Brightly ventured into the countryside to lecture on his other topics of interest. "These lecture outings were productive of advantage to the business in daguerreotypes. He made acquaintances who came in for likenesses and in turn the picture business played into the hands of the lecture field. We were not accused of driving a 'trust' or 'a combine,' but photography, phrenology, and biology were all handled from our headquarters, at 137 Owego Street, over J. M. Heggies' harness store, Ithaca, New York." Ryder observed that this eclectic mix of activities was not unusual. "It was no uncommon thing to find watch repairers, dentists, and other styles of business folk to carry daguerreotypy 'on the side.' I have known blacksmiths and cobblers double up with it, so it was possible to have a horse shod, your boots tapped, a tooth pulled or a likeness taken by the same man; verily, a man—a daguerreotype man, in his time, played many parts."[4]

This colorful reminiscence suggests the aura of mystery that surrounded the daguerreotype process; the entrepreneurial energies

of at least some of its practitioners; the attendant cloud of hype, enticement, and promotion; and—implicitly at least—the less-than-perfect quality of many of the resulting images.

While undeniably true, Ryder's story needs to be understood in context. He was writing from the perspective of a village operator with a relatively unsophisticated clientele and little competition. The lengthy trial-and-error process he described, and the casual production of daguerreotypes "on the side" by the likes of blacksmiths and cobblers, would have been considerably more common in small towns than in cities. One suspects that the daguerreotype could be treated profitably as a part-time occupation only in areas with a resident population too small to support a full-time practitioner.

As community size increased, market forces inevitably expanded the supply of work. Competition among daguerreotypists resulted in a stratification of the market, from cheap images by the least talented makers to expensive plates by the most capable. While the average work in provincial areas may have been of unpredictable quality in the late 1840s, this was far less true of the output of city studios. In major urban areas the process reached a high degree of excellence relatively early—certainly by 1845—and this quality was further refined through the end of the daguerreian era.

This range of technical and artistic achievement was accomplished by daguerreotypists of varied backgrounds, inclinations, and skills. As Ryder noted, at least some practitioners had been blacksmiths and cobblers. For example, the peripatetic daguerreotypist John W. Bear, known as the "Buckeye Blacksmith," had indeed begun his professional life at the forge.[5] Despite the apparently mundane nature of such occupations, it is well to remember that blacksmiths and cobblers were artisan-entrepreneurs with at least basic social and business skills. Whatever success such men achieved with the daguerreotype would have been due more to these general aptitudes than to their competence in hammering iron or in mending shoes. Whether from the ranks of the laboring classes or from higher up the social scale, the leading American daguerreotypists were men of intelligence, ambition, manual dexterity, artistic sensitivity, and business acumen. Americans from nearly every walk of life may have tried the daguerreotype, but real success required a relatively uncommon set of aptitudes and skills.

More than a few of the best daguerreotypists had experience or formal training in the visual arts. Josiah Johnson Hawes, Solomon Nunes Carvalho, George S. Cook, Samuel Broadbent, Thomas Faris, Ezekiel Hawkins, and Frederick De Bourg Richards, among others, had all worked as landscape or portrait painters before turning to the camera. Marcus A. Root had studied painting before becoming a teacher of penmanship, and then a daguerreotypist. Mathew B. Brady claimed to have received lessons at the beginning of his career from the painter William Page. Other daguerreotypists came from relatively technical backgrounds in art-related industries. Eliphalet Brown, Jr., had been an artist and lithographer; Washington L. Germon was apprenticed to a steel engraver before working in the card-engraving business; and Philip Haas had worked as a lithographer and a publisher of prints.

Many daguerreotypists with backgrounds outside the realm of the visual arts possessed an aptitude for precise, disciplined work. After growing up on a farm, Israel B. Webster was apprenticed to a tinsmith. Jeremiah Gurney and Edward Tomkins Whitney had both begun as jewelers. Mathew B. Brady and Montgomery P. Simons both manufactured fine cases (for jewelry, painted miniatures, and

daguerreotypes) before turning to the camera. John Plumbe and John Frederick von Schneidau had worked as civil engineers and surveyors. John H. Fitzgibbon had been apprenticed to a saddler and ran a hotel for five years before taking up the daguerreotype. Other daguerreotypists had white-collar business experience: Joel E. Whitney had been a merchant miller, Abraham Bogardus worked in New York City in the dry-goods business, and Charles D. Fredricks had experience in a Wall Street banking house.

A handful of daguerreotypists traced utterly individual career trajectories. Levi L. Hill was apprenticed to a printer before becoming a Baptist pastor, a photographer, and the self-proclaimed inventor of a process for making daguerreotypes in natural color.[6] Gabriel Harrison was trained as a printer, and played an active role in the theatrical world throughout his life—he taught elocution and acting; wrote, produced, and acted in various plays; and wrote books on the history of drama. Finally, Frederick C. Coombs was an inventor, author, promoter, itinerant professor of phrenology and electricity, and legendary eccentric.

While the great majority of American daguerreotypists were white men, there were notable exceptions to this general rule. Several free black men enjoyed successful careers as photographers. James P. Ball, the most renowned of this group, ran a large studio in Cincinnati, a center of antislavery activism and a key link in the Underground Railroad.[7] Ball learned the process from another black daguerreotypist, John B. Bailey, of Boston. Other notable African American daguerreotypists included Jules Lion, in New Orleans; Augustus Washington, of Hartford, Connecticut; and Glenalvon J. Goodridge, of York, Pennsylvania.[8] While none of these men reached easy or quick success, their work appears to have been widely accepted on its intrinsic merits: contemporary commentaries include few mentions of race. It was widely agreed, for example, that Ball's studio was one of the finest in the region. Judging by the evidence of his surviving plates, he catered to a largely middle-class and white clientele.

Women also played a visible role in the daguerreian business. The daguerreotype was one of a handful of occupations considered suitable for ladies—in part, because it was typically light, indoor labor. Many women worked as assistants, colorists, and receptionists in studios owned by men (to whom they were often related by birth or marriage). A modest additional number—probably a few dozen in all—owned and operated their own studios.[9] While contemporary accounts do not suggest that these women were treated with overt prejudice, it is also clear that few of them made more than a marginal living with the camera. Most were in business for relatively brief periods and none achieved any unusual success or recognition. This remarkable ambrotype depicts a female operator at work [78]; sadly, her name remains unknown.

One of the earliest of these professional women was a Mrs. Davis who—based on her advertisements of December 1843—was perhaps the first daguerreotypist in Houston, Texas.[10] In 1845-46, Sarah Holland struggled to make a living with the process in various communities in Massachusetts and New Hampshire. Julia Shannon worked as both a daguerreotypist and midwife in San Francisco in 1850-51.[11] Sarah Judd operated a studio in Stillwater, Minnesota, from 1848 to 1850. In the early 1850s, Sally Hewes worked as an operator for, or a partner with, Samuel Broadbent, in Philadelphia.[12] Marcella W. Barnes, active as early as 1852, made daguerreotypes in the states of New York, Michigan, and Wisconsin. Originally trained as a teacher, Julia Ann Rudolph worked in 1852-55 as an operator in

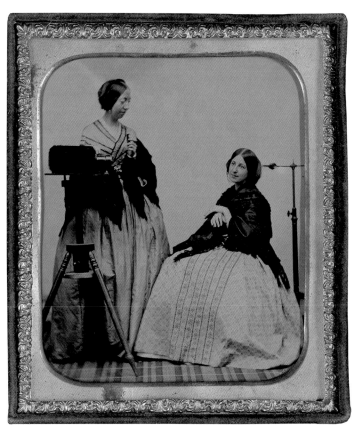

78 **Unknown Maker**, *Woman Daguerreotypist with Camera and Sitter*, ca. 1855 79 **Charlotte Prosch**, *Portrait of a Standing Child*, ca. 1851

D. D. T. Davie's studio in Utica, New York, before opening her own gallery in Nevada City, California.[13]

Charlotte Prosch, the sister of George W. Prosch, enjoyed one of the longest careers as a female daguerreotypist. Originally listed as a dressmaker, she began advertising her skills as a daguerreotypist in 1845 in New York City. She moved to Newark, New Jersey, in about 1847, where she opened a studio near her brother on Broad Street [**79**]. She married in 1853 and continued making daguerreotypes as "Mrs. Day, formerly Miss Prosch," through the end of the decade.

Secrets of the Dark Chamber

While the basic steps of the daguerreotype process were not complicated, genuine success was a matter of experience and judgment.[14] Mediocre daguerreotypists followed published instructions by rote, used the cheapest materials, and were casual or inconsistent in technique. The best practitioners had studio secrets for nearly every step of the process, were meticulous about their tools and chemicals, and precise in their procedures. These elevated skills went hand in hand with an understanding of the daguerreian syntax—its expressive flexibility and nuances. The process could be shaped to meet the requirements of a given subject or condition of light, and it could be used to convey a personal aesthetic.

The daguerreotype image is produced on a thin sheet of silver-coated copper.[15] Daguerreotype plates were manufactured by specialized metal-working concerns and purchased wholesale, typically in lots of a dozen. Most plates were made by the so-called Sheffield (or clad plate) process, pioneered in Sheffield, England, in the mid-1700s for the manufacture of silver-plated tableware.[16] In this technique, a wafer of silver was fused in an oven to a thicker ingot of copper. This composite block was then rolled into a thin sheet composed of a layer of copper topped by a much thinner surface of silver.

In the 1840s, electroplating or galvanizing (the use of an electric current to deposit silver on a copper surface immersed in a conducting fluid) came into general use as an alternative to the Sheffield process. However, from the mid-1840s on, most daguerreotypists continued to use clad plates, which they often galvanized or re-silvered to improve the existing silver layer.[17] In 1848, for example, a Philadelphia newspaper reported that "the plates used by our best daguerreotypists are all re-silvered, with one or two additional coatings." This writer noted that the local daguerreotypist Marcus A. Root "keeps two or three men the year round employed entirely at this business of re-silvering, which adds about one half to the original cost of the plates."[18]

This added silver made buffing easier and exposure times shorter, while adding visibly to the beauty of the finished image. In at least a few instances, daguerreotypists prepared their finest plates by buffing and galvanizing each one up to three times before sensitizing them for exposure.[19] As Warren Thompson noted in 1851: "It is well known by almost all experienced operators that silver deposited by the galvanic process is highly favorable for daguerreotypes, the whites being much less liable to solarize and the darks more transparent and perfect in their details. Almost all the best operators in America for the past five years have galvanized their plates themselves."[20] In addition, this technique had an economic advantage: while a standard plate might be sensitized, exposed, processed, and then wiped clean a maximum of two or three times (if it had not been gilded), re-silvered plates could be used many times.

Daguerreotype plates were distinguished primarily by their dimension. The standard unit of measure originated from Daguerre's

"whole plate," 6 ½ x 8 ½ inches in size. The dimensions of smaller plates are: half-plate, 4 ¼ x 5 ½ inches; quarter-plate, 3 ¼ x 4 ¼ inches; and sixth-plate, 2 ¾ x 3 ¼ inches. The cheapest images were produced as ninth-plates (2 x 2 ½ inches) and sixteenth-plates (1⅜ x 1⅝ inches). Since the expense of a finished daguerreotype was based primarily on size, most were made in the relatively affordable sixth- and quarter-plate formats.[21] A few studios, such as that of Southworth & Hawes, specialized in the luxurious whole-plate format. While daguerreotypes were sometimes taken in even grander formats, the difficulty of the process seemed to increase exponentially with plate size.[22]

Regardless of their final size, daguerreotype plates were further distinguished by the relative thicknesses of the silver and copper layers. A typical 1/40 plate, for example, carried a silver layer one-fortieth the thickness of the copper support. On average, it was better to have more silver rather than less, and beginning daguerreotypists were advised to practice their technique on 1/20 plates, which could stand several tries. With experience came the ability to work consistently with thinly coated, and thus less expensive, plates.

For years French daguerreotype plates were distinctly superior to those of American manufacture. Through the 1840s, the leading plates in the American market were imported from two Parisian manufacturers, Charles Christofle and Alex Gaudin.[23] The most popular American plates of the period were produced by the J. M. L. and W. H. Scovill Company, in Waterbury, Connecticut. As manufacturing techniques improved and overall production volume grew, wholesale costs dropped. By 1850, a dozen French sixth-plates cost about $2, while a similar quantity of American plates could be had for approximately $1.40. Scovill's product improved steadily, and after about 1850 was at least as good as the French import.

Once the daguerreotypist had plates in hand, the first step was to clean and polish them to remove all surface impurities.[24] As pointed out by Samuel D. Humphrey in his *American Hand Book of the Daguerreotype* (1858), this step—seemingly the most routine—was actually the one "in which operators fail more often than all others."[25] Once the plate was safely secured face up in a wood vise, Humphrey recommended dusting the surface with a fine rotten stone, and adding a few drops of a solution of water and alcohol. The photographer then used a square of clean Canton flannel or prepared cotton to rub this abrasive paste over the plate in a smooth, circular pattern. "The motion of the hand should be brisk and free, not hurried, and the pressure about equal to that of a pound weight."[26] This damp polishing was followed by a second step with a dry square of flannel and an even lighter dusting of rotten stone. It was critical that the plate be polished evenly and that it never be touched directly by the hand. When successfully completed, "the plate should now exhibit a bright, clear, uniform surface, with a strong metallic luster."[27]

Every step of the process was subject to experimentation and modification. Departing from Humphrey's technique, for example, D. D. T. Davie tried at least three different wetting solutions— alcohol with ammonia, alcohol alone, and distilled water—with surprisingly varied results. Davie reported: "The first [solution] pleased me much the best. The portrait was, comparatively speaking, round as an apple, and clear and beautiful as life. The lights and shades were beautifully blended and defined, giving a fine perspective, and the tone rich, mellow, and agreeable."[28] These were exactly the qualities the daguerreotypist strove to achieve in his finished image.

Plate preparation continued with the two-step buffing stage, which turned the smoothed surface to a brilliant, mirror-perfect finish.[29] Two (or sometimes three) buffs, made from the best deerskin, were used to apply powdered rouge followed by lampblack. While some photographers came to employ rotary devices to speed the cleaning and buffing processes, many continued to do this delicate step by hand, with the taut buckskin secured to a wooden paddle.[30] The buffing operation was done with a relatively light pressure and "a free, easy, horizontal motion."[31] The second buff was the most critical—the softest buckskin and a minute quantity of the finest abrasive (and sometimes none at all) were employed to bring the plate to a pristine finish. Great care had to be used to keep all dust (which could leave visible scratches) off the surface. As the process reached its conclusion, hand pressure was steadily decreased until the buff was merely gliding across the plate. The goal was a "surface of such exquisite polish as to be itself invisible, like the surface of a mirror."[32]

Everything depended on this step: well-buffed plates not only produced richer tones, but allowed faster exposure times in the camera.[33] The beautifully buffed plate carried a minutely fine pattern of parallel marks that were invisible (or nearly so) to the naked eye. As each daguerreotype was intended to be viewed by side illumination, the final buffing pattern had to be in the lateral dimension of the finished plate in order to minimize the scatter of reflected light. Thus, the orientation of the desired photograph—whether vertical or horizontal—had to be determined before the buff was begun.

Successful buffing depended on a precise method. The buffs had to be stored carefully overnight and brushed and cleaned every morning. When in use, buffs needed to be kept perfectly dry (typically, by heating them gently at the studio stove), but not allowed to become too hot. The heat of the buff had a marked effect on the quality of the finished daguerreotype: Alexander Hesler noted a 75 percent reduction in exposure time due solely to an adjustment in the quality and temperature of the buffing step.[34] New buffs took time to break in, but once they absorbed the ideal patina of rouge, they were used as long as practicable.

Next, the plate was made light-sensitive. This was done in a dimly illuminated (but not entirely dark) space, allowing the daguerreotypist to inspect the plate during the process. While Daguerre's original instructions called for a single sensitizing agent (iodine), daguerreotypists routinely used additional chemicals after 1841. The first coating box contained a small quantity of iodine crystals. The second was sprinkled with a "quickstuff" or "accelerator" powder, composed of bromine, chlorine, or fluorine, either singly or in combination. The exact composition of quickstuff varied from one studio to the next, and formulas were often jealously guarded. Instruction manuals gave various recipes for accelerators, and more than a dozen ready-made compounds could be ordered from wholesale suppliers.[35] Nearly all the chemicals in the daguerreian processing room— chlorine, iodine, bromine, potassium cyanide, and mercury—were toxic. Many daguerreotypists felt their ill effects, and a few died.[36] To keep unhealthful vapors to a minimum, each coating box was constructed with a nearly air-tight sliding lid. By this means, a daguerreotype plate could be put face down in an opening in the lid, smoothly moved into place over the chemical fumes, and with equal ease removed from contact with the sensitizing agent.

The full sensitizing process involved three steps: iodine, "quickstuff," and iodine again.[37] The timing of these steps could only be determined by experience: everything depended on the ambient temperature and humidity, and the strength of the chemicals on

that day. In addition, daguerreotypists learned that they could alter the speed, tone, and contrast of their plates by varying the duration of each step. A longer time over the bromine accelerator shortened the exposure time in the camera. This only worked to a particular point of maximum sensitivity, however; beyond this, additional bromine dulled the image.[38] The final exposure to iodine had a great effect on the contrast of the plate. A short exposure produced higher contrast; longer exposure resulted in softer tones. By carefully managing these steps, the daguerreotypist could custom-sensitize the plate—a dull, overcast day, for example, called for a short final exposure to iodine.[39]

Only those who have personally witnessed it can fully grasp the chromatic beauty of the sensitizing process.[40] The plate is inspected periodically during its initial exposure to iodine (a process that typically required between twenty and ninety seconds.) As the iodine reacts with the silver surface to form a light-sensitive silver iodide, the plate goes through a very precise cycle of colors: from a light yellow to vivid yellow, followed by orange, a light rosy pink, a deeper rose red, purple, steel blue, and green. At this point, the plate seems colorless and, with continued exposure to iodine, begins the color cycle again. The quality of the final daguerreotype is determined by the precise point in this cycle at which the plate is shifted from iodine to bromine.

Typically, a plate was sensitized over iodine to a deep yellow color. It was then given just enough bromine to bring it to a delicate rosy tint. As Samuel D. Humphrey wrote in 1858:

> Experience proves that the common impressions, iodized to a *rather light yellow gold tint*, and brought by the bromine to a *very light rose color*, have their whites very intense, and their deep shades very black. It is also known that if you employ a thicker coating of iodine, and apply upon it a proportionate tint of bromine, so as to obtain a *deep rose tint*, delineations will be less marked, and the image have a softer tone. This effect has been obvious to every one who has practiced the art. Thus I may observe that the light coatings produce strong contrast of light and shade, and that this contrast grows gradually less, until in the very heavy coatings it almost wholly disappears. From this it will readily be perceived that the middle shades are the ones to be desired for representing the harmonious blending of the lights and shades.

Humphrey summarized the matter in these words: "We see that the light coating produces a very sharp but shallow impression; while the other extreme gives a deep but very dull one."[41] The photographer aimed for the aesthetic "sweet spot" between these imperfect extremes.

To further complicate matters, plate sensitization was affected by the ambient conditions.[42] Daguerreian work was ideally performed at about 70 to 75 degrees Fahrenheit, in relatively dry air (about 40 to 55 percent relative humidity). At significantly higher or lower temperatures plate sensitization (in particular, the first iodine step) proceeded too quickly or slowly. Under dry conditions, dust and static electricity were major problems. High humidity was even worse: extreme atmospheric moisture could literally erase the plate's latent image. In the quest for a stable working environment, every daguerreotype studio used a stove year round: for heat in the winter, and to help dry the sultry summer air. In addition to these atmospheric variables, daguerreotypists found that the fumes of turpentine, paint, and other commercial chemicals adversely affected the sensitization process.[43]

The final exposure to iodine, done in near-total darkness, rendered the plate light-sensitive. This was a relatively straightforward step, done by time rather than by inspection. The plate was then placed in a plate holder and taken to the camera for exposure.

The sensitivity or "speed" of a daguerreotype plate varied depending on the care with which it had been prepared and sensitized. The other key concern, of course, was the quantity and quality of studio illumination. Given these variables, from about the mid-1840s on, daguerreotypes required something on the order of three to thirty seconds of exposure in the camera, with most probably made in the range of six to twenty seconds. By modern terminology, the daguerreotype plate had a sensitivity of about ASA 0.05 or 0.10.[44] Daguerreotypists came up with various techniques to improve sensitivity. For example, Alexander Hesler found that he could increase the speed of his plates by sensitizing them with iodine in the normal manner, and then storing them in the dark for two or three weeks before finishing the sensitization process and exposing them. Speed could also be increased by charging the plates with static electricity on warm, dry days.[45]

The daguerreotype's alchemical aura stems in part from the central role of mercury in the process. A liquid metal, mercury is a strange substance with a colorful history. Aristotle called it "liquid silver" and it has also long been known as quicksilver.[46] Mercury fascinated the alchemists, and it was used in medicine from the medieval era into the twentieth century. Today, it is employed in the manufacture of various industrial products and insecticides. Mercury has a dangerous allure: both its poisonous effects and its affinity for (or ability to amalgamate with) gold and silver have long been known. It must have been considered somehow appropriate that the "magic" of the daguerreotype depended, at least in part, on one of nature's most enigmatic substances. Indeed, the "mercurial" nature of the substance found some parallel in the daguerreotype's own tendency for fickleness and unpredictability.

The invisible or latent image on an exposed daguerreotype plate was made visible ("developed") by the action of the vapors of heated mercury. The mercury pot—typically an inverted, truncated pyramid of cast iron—was mounted on a short stand. The flame of an alcohol or spirit lamp, placed below the pot, maintained a temperature of about 175 degrees Fahrenheit. In subdued light, the exposed plate was taken out of the plate holder and positioned face down over the mercury.

Development times typically varied from two to four minutes, depending on the temperature of the mercury and the sensitivity of the plate. The outside weather also affected development times. As Humphrey stated in 1858: "It is well known to the experienced Daguerreotypist, that different atmospheres have a decided effect upon the mercury in developing the Daguerreotype... In summer, on cloudy and stormy days, mercurial vapors rise more readily and quickly than in the temperature of autumn or winter."[47] If the daguerreotypist was uncertain about these variables, he could make quick visual checks of the plate to gauge its progress.

Correct development was a matter of experience. The final image was seriously degraded by either under- or over-development: the first produced a shallow and indistinct picture; the second, one that was chalky and granular. As Humphrey put it: "Just the right quantity of mercury leaves the impression of a transparent, pearly white tone... To mercurialize with exactness is a nice point."[48] To underscore the "exactness" of the process, Humphrey described his experiment to test the reaction of identically sensitized and exposed plates to varying development times. This test confirmed how quickly the developing

plate moved at first toward, and then away from, the ideal palette of tones. Humphrey described the quality of the resulting images:

1 minute, ashy and flat; no shadows; linen, deep blue.

1 ½ minute, coarse and spongy; shadows, muddy; drapery, dirty reddish brown.

2 minutes, shallow or watery; shadows, yellowish; drapery, brown.

2 ¼ minutes, soft; face, scarcely white; shadows, neutral; drapery, fine dark brown linen somewhat blue.

2 ½ minutes, clear and pearly; shadows, clear and positive, of a purple tint; drapery, jet black, with the dark shades slightly frosted with mercury.

2 ¾ to 3 minutes, hard and chalky; shadows, harsh; drapery, roughened, and misty with excess of mercury.[49]

While the slight frosting in the shadows was not ideal, Humphrey's 2 ½ minute test plate was decidedly superior to those developed even fifteen seconds more or less.

Once developed, the image was fixed in a solution of hyposulfite of soda in water (or "hypo") to remove any remaining light-sensitive silver halides. This and all subsequent steps could be done in daylight. Following the fixer bath, the plate was rinsed briefly in fresh water to remove any residual chemicals. At this stage, the daguerreotypist examined his plate closely to decide whether it would be finished or wiped clean for reuse. In standard portrait studio practice, this decision was made in consultation with the customer, who was only expected to pay for images that met with his or her approval.

The final processing step was the gilding operation. The plate was placed face up on a perfectly level metal stand. The gilding solution —gold chloride dissolved in a weak hypo bath—was poured directly on the plate, heated by a flame held below. Dexterity was required: the precise amount of gilding solution, poured quickly and smoothly onto the plate, filled the entire area to a visible depth (the fluid is held on the plate by its own surface tension). Moving the flame steadily back and forth under the plate, the daguerreotypist watched the image change under the thin layer of liquid, as the gold precipitated out of solution to bond with the silver image. In addition to deepening and strengthening the tones of the image, the added gold made the surface somewhat more durable—more resistant to wipes and abrasions.

While gilding was accomplished in a few minutes, the plate went through significant changes in this time. As Humphrey wrote:

It is not unfrequent that the surface assumes a dark, cloudy appearance. This is generally the best sign that the gilding will bring out the impression with the greatest degree of distinctness. Soon, the clouds gradually begin to disappear, and, "like a thing of life" stands forth the image, clothed with all the brilliancy and clearness that the combined efforts of nature and art can produce.[50]

When the plate reached its ideal tonality, the flame was removed, the remaining gilding solution poured off, and the image rinsed in fresh water. Then came the critical step of drying the plate. This had to be done carefully in order to avoid leaving water marks on the brilliant surface. Humphrey recommended gripping the plate on one corner with pliers, holding it horizontal, and heating the back with a flame while blowing gently downward to speed the removal of all remaining moisture.

Once dried, daguerreotype plates were often colored by brushing or stippling dry powdered pigment directly onto the surface.[51] Most typically, a few selected areas were colored: cheeks, or a shirt or dress.

Jewelry was often stippled gold, and glistening highlights could be added by carefully pricking the surface of the plate with a pin or awl.[52] The evidence of surviving plates suggests that a relatively high percentage were originally given some tinting. Applied color was a matter of individual taste—the photographer's and, more importantly, the customer's. Pigment was usually applied in a minimal and understated fashion; heavy color was widely viewed as garish or as an attempt to hide technical deficiencies. As Humphrey caustically observed:

Of all the so-called improvements in the Daguerreotype, the coloring is the least worthy of notice. Yet the operator is often, in fact most generally, called upon to hide an excellent specimen under *paint*. I can conceive of nothing more perfect in a Daguerreotype than a finely-developed image, with clearness of lights and shadows, possessing the lively tone resulting from good gilding. Such pictures, however, are not always had, and then color may perform the part of hiding the imperfections."[53]

Despite this condemnation, some studios specialized in colored daguerreotypes and made consistently tasteful and elegant images.

The final steps involved the protection and presentation of the plate. This work was typically done by a window, in a space adjacent to the posing room but protected by a "No Admittance" sign [77]. A three-part package of plate, mat, and cover glass was used, with this ensemble sealed tightly around the perimeter with tape. The mats on very early plates were often made of paper. Stamped brass mats came into use by about 1843, with the complete package contained in a thin brass retainer. This unit was then pressed into a case that could be closed tightly with hook-and-eye clasps. These cases —manufactured in wood and leather, velvet, mother-of-pearl, papier-mâché, tortoiseshell, pressed paper, and eventually in cast thermoplastic resin—came in standard sizes and were decorated with a seemingly endless variety of designs.[54] In addition to showcasing the finished daguerreotype as an easily portable keepsake, this package buffered the plate from contact with air (to slow the natural tendency of silver to tarnish) and protected the image surface from rubs and scratches. The great majority of daguerreotypes were originally issued in such cases; a smaller number were presented in wood or thermoplastic wall frames.

At Work

The daguerreotypist's professional life was centered in the studio, which functioned as workshop, office, and exhibition hall [80]. Small town studios were typically compact, plain, and sparsely staffed. These rural daguerreotypists typically worked alone or with the assistance of a single family member or apprentice. The biggest galleries in New York City, on the other hand, might be staffed by eight or ten employees, each with a specialized role. These large firms had a reception room and gallery, a ladies' parlor, one or two posing rooms, a darkroom, a finishing room, and an office.

In any multistory block of commercial buildings, daguerreian studios usually occupied the top levels. While light for the operating room was sometimes admitted through side windows, the best studios were almost always located on the uppermost floor, beneath a glass skylight. Visitors entered these galleries from the street through a doorway decorated with enticements—press clippings, testimonials, and examples of the work produced upstairs. After climbing one or two flights of stairs, customers entered the reception room, where

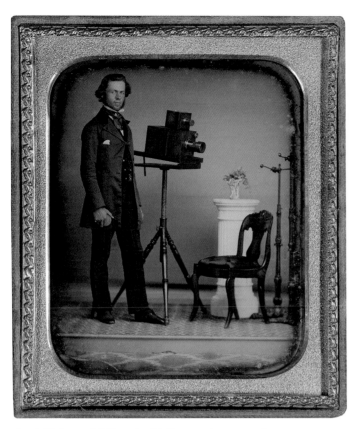

80　**A. H. Boyce**, *Self-Portrait with Cameras*, August 30, 1855

they were welcomed and made aware of the studio's services. Most metropolitan studios offered a wide range of work, from affordable sixth-plates to expensive whole plates, with the option of hand-coloring adding further to the cost. Customers also could choose from a selection of cases, ranging from plain leather to luxurious mother-of-pearl. These differences carried clear social meaning: expensive daguerreotypes were symbols of wealth and taste.

As the most public of the daguerreotype studio's spaces, the reception room was designed to encourage customers to elevate their taste, to dig a little deeper into their pockets, and to invest more generously in their daguerreian keepsakes. In the largest studios, the reception rooms were veritable art galleries, filled not only with examples of the firm's own photographs, but with other works of art and fine furnishings and accessories.

By the early 1850s, the major urban studios competed with each other, in part, through the luxury of their operations. The finest studios of all—in New York City—were described in detail in the press of the day. In 1852, for example, Gabriel Harrison opened a new gallery on Fulton Street in Brooklyn. The photographic press proclaimed his new space to be "superior to any other we have seen." Harrison's studio had a 10-foot-wide entrance and doors of "brilliant stained glass." His exhibition room was 45 feet long, 25 feet wide, and 14 feet high, octagonal in shape, and painted in white and gold. It was lighted by a large oblong skylight of ground glass, which filled the room with a beautifully soft and flattering light. Harrison's operating room, 50 x 30 feet in size, was "frescoed in a quiet, subdued tint." Harrison's sitters were placed below a skylight reputed to be the largest in the world. Containing over 250 square feet of fine English white plate glass, it was canted at an angle of 35 degrees and oriented to the northeast. This was judged "the best position for a light to prevent abrupt shadows under the eyes, nose, and chin" and

allowed the production of portraits with smooth, flattering tones. Harrison's ladies' dressing room, adjacent to the operating room, was 15 feet square and "fitted up in the most chaste and beautiful style with salmon color and marble top furniture."[55]

In 1853, Martin M. Lawrence and Mathew B. Brady both opened lavish new studios on Broadway. Lawrence's studio boasted a 25 x 40-foot reception room "furnished with rich, heavy Brussels carpet," a six-branch chandelier suspended from a frescoed ceiling, elegantly papered walls, lace curtains, and rosewood furniture upholstered in green velvet. On the wall, Lawrence displayed prize-winning examples of his work on a gilt-bordered velvet panel. A 25-foot-square ladies' parlor was nearby. Two flights up, Lawrence had two operating rooms, each 25 x 30 feet in size with 16-foot ceilings and skylights measuring 12 x 15 feet. These spaces were connected to his rooms below by a dumbwaiter and speaking tube.[56]

Brady's new studio at 350 Broadway was arranged in similar style. Its centerpiece was a luxurious 26 x 40-foot reception room:

> The floors are carpeted with superior velvet tapestry, highly colored and of a large and appropriate pattern. The walls are covered with satin and gold paper. The ceiling frescoed, and in the center is suspended a six-light gilt and enameled chandelier, with prismatic drops that throw their enlivening colors in abundant profusion. The light through the windows is softened by passing the meshes of the most costly needleworked lace curtains, or intercepted, if occasion requires, by shades commensurate with the gayest of palaces, while the golden cornices, and festooned damasks indicate that Art dictated their arrangement. The harmony is not the least disturbed by the superb rosewood furniture—tete-à-tetes, reception and easy chairs, and marble-top tables, all of which are multiplied by mirrors from ceiling to floor. Suspended on the walls, we find Daguerreotypes of Presidents, Generals, Kings, Queens, Noblemen—and *more nobler men*—men and women of all nations and professions.[57]

Such opulence was not limited to New York City. In Cincinnati, for example, James Presley Ball's Great Daguerreian Gallery of the West drew many admiring visitors and the attention of the national press. Ball's gallery had a reception room measuring 20 x 40 feet, with nearly 200 framed photographs of prominent citizens and such luminaries as Jenny Lind and P. T. Barnum. Paintings by Robert Duncanson, a black Cincinnati artist, were on view, as well as sculptures representing the goddesses of Poetry, Music, Science, Religion, and Purity. The room was filled with fine furniture, two large mirrors, and a piano; the walls were covered by expensive gold-leaf wallpaper. As reported in *Gleason's Pictorial*, it was a scene of "elegance and beauty," presided over by a proprietor who was "the very essence of politeness."[58]

In 1853, the daguerreotypist and writer Marcus A. Root made rather specific suggestions on the outfitting of a successful studio's reception room. First, he recommended "books sufficiently various to interest the majority, at least, of all comers." It was important that these not be "bulky, grave, or abstract works," but volumes conducive to "awaking the better moods" of those waiting to sit for the camera. Secondly, he recommended "on the tables, and in portfolios, an ample variety of the finest engravings, prints, & c." together with "curiosities of different kinds," including medals, coins, vases, urns, and perhaps a medieval tapestry.

It was necessary that everything in the room be carefully selected and arranged to produce in the sitter "a genial, elevated tone of sentiment and emotion." Root emphasized that the furniture should be well made and tasteful, with "every article shaped and finished in

accordance with our best conceptions of beauty and grace." The space should be filled with works of art: framed photographs, paintings, prints, and busts and statues of marble or plaster. It was necessary for all these works to depict ideal or notable subjects: beautiful women, handsome men, and uplifting historical or allegorical motifs. Finally, he recommended adorning the room with "several cages of singing-birds" since "the notes of these charming little creatures, their beautiful forms and plumage, and their graceful movements and pretty ways are to nearly all persons exceedingly agreeable." The ultimate aim, he emphasized, was to "have the heliographic rooms a temple of beauty and grandeur."[59]

Daguerreotypists were at the mercy of the weather, the season, and the flow of customers. Light overcast skies produced the best illumination for daguerreotypes, while few were made on rainy days. As every daguerreotypist knew, the quality and intensity of daylight varied markedly throughout the year. The business was notably seasonal, with its slowest times in the depths of winter and the middle of summer. In the winter, the preferred operating hours were from 10:00 a.m. to 2:00 p.m. Daylight was abundant in the summer—resulting in productive hours from about 9:00 a.m. to 5:00 p.m.—but the accompanying heat and humidity were less than ideal. Most daguerreotypists would have picked late spring and early fall as their ideal working months—periods of moderate temperatures and ample, mellow light.

The dispiriting dullness of the off-season affected all studios, albeit in varying degrees. The slowdown would have been worst in the most northern and provincial studios, where business could sometimes drop almost to nothing. This is conveyed with painful clarity in the 1852 diary of Tallmadge Elwell, a little-known and rather luckless daguerreotypist in the settlement of St. Anthony Falls (now Minneapolis), in the Minnesota Territory. A few representative passages give some sense of the unsettlingly "feast-or-famine" nature of his business.

> Nov. 8th. Nothing in the Daguerreotype line today…
>
> Nov. 9th. A room full of folks all day, crowded to a greater extent than ever before, so that four or five were turned away without being supplied with miniatures…
>
> Nov. 10th. Very much of a wintry day and snowed in the afternoon and evening. Nothing done in the picture line…
>
> Nov. 11th. Chored and fussed around considerably but made no money…
>
> Nov. 12th. A beautiful day and very light in consequence of a heavy fall of snow the night previous. Had the pleasure of taking three very good pictures…
>
> Nov. 15th. Fine weather for taking pictures but done nothing at it except to retake one of a mother and child. I find that there is by far too much of the time when I am unprepared to operate successfully owing to the multitude of trifling inconveniences that I am not always careful to avoid…
>
> Nov. 16th. A pleasant day and very favourable for taking pictures. Took one of a lumberman…
>
> Nov. 18th. Took two pictures, but could not successfully use my buff wheel…
>
> Nov. 19th. Weather mild and agreeable. Took but one picture…
>
> Nov. 24th. A mild and thawing day. Nothing done in the picture line…
>
> Nov. 25th. No money earned and no applicants for pictures…[60]

While big-city studios rarely sank to this level of near-inactivity, all practitioners were affected by the vicissitudes of season and climate.

The daguerreotypist began each day well before the first customers were admitted. In cooler months, he would begin by firing up the stove to warm the studio. In the darkroom, the sensitizing boxes and mercury pot needed to be brought to their working temperatures. The primary morning task was the preparation of plates—cleaning, buffing, and sensitizing. On normal working days, the larger daguerreotype studios probably prepared dozens of plates in advance by running them through the first (iodine) sensitizing step. These could be used throughout the day; when a customer arrived, it was a simple matter to complete the sensitization process.[61]

As customers trickled in, the work of the studio began in earnest: making visitors feel at ease, explaining services and prices, advising on dress and pose, making the actual exposure, the approval of the final image, its presentation in a case or frame, and the receipt of payment. Each day, this cycle would be repeated at least several times in the smaller studios and dozens of times in the larger ones. There was a desired rhythm to this daily flow of customers. For reasons of both light and temperament, daguerreotypists encouraged that babies and children be photographed early in the day. As George N. Barnard advertised in 1847: "The best time for children is from 9 o'clock in the morning to 1 in the afternoon—all others from 9 to 5."[62]

Daguerreotype portraits were made in the operating or posing room. Small studios would typically have a single operating room of modest size; larger studios had one or two of more generous dimension. The operating room's utility was directly related to its size and shape. Whereas individual head-and-shoulder portraits could be made in close quarters, larger working spaces were required for full-length depictions or group portraits. Moreover, the higher the ceiling, the more control the daguerreotypist had over the illumination from the skylight. Scrims and white baffles were used to soften and direct this overhead light.

The largest studios had operating rooms of roughly 25 x 40 feet and this space was used astutely.[63] From the evidence of their surviving plates, for example, we know that Southworth & Hawes used every square foot of their operating room. They preferred certain alcoves for individual portraits, while using longer perspectives for group shots [19]. Through the use of movable walls and decorative columns, they created a surprising variety of posing environments within this space. In addition to regularly rearranging these architectural elements—and couches, chairs, and end tables—the pair relocated their camera and tripod between sittings (or even between sequential exposures of the same subject). As the sun traced its daily path overhead, their camera-to-subject axis tended to pivot around the center of the room, in accordance with the changing angle of illumination. The best daguerreotypists were engaged in a continuous dance with daylight—accommodating themselves to its direction and quality to put it to best pictorial use.

While portraiture constituted the bread-and-butter work of nearly every daguerreotypist, most were adept at other uses of the camera. These applications included copy work—making daguerreotypes of other daguerreotypes or, on occasion, of prints, paintings, and even three-dimensional objects (e.g., works of sculpture). One suspects that at least some of this work was held aside for slow, overcast days: with inanimate subjects, it scarcely mattered how long the exposures took. Some photographers also advertised their skills in making daguerreian jewelry: small daguerreotypes inserted into buttons, brooches, pendants, pins, necklaces, bracelets, watch fobs, lockets, rings, earrings, stickpins, and other personal items.[64] Many

of these images would have been copies (typically, greatly reduced) of existing photographs. With some regularity, daguerreotypists also made pictures outside the studio of a new house or store, a prize horse and carriage, or similar subjects.

At the end of the afternoon, the daguerreotypist would put the finishing touches on the day's work. The reception room would be swept, dusted, and readied for the next day. In the evening, the photographer might spend time repairing equipment, mixing chemistry, or simply tinkering and experimenting. The next morning, the cycle would begin again.

A Contentious Fraternity

Daguerreotypists were members of a notoriously fractious professional "family." They were a diverse group, varying widely in knowledge, skill, and ambition. Village practitioners, the owners of the most elite city galleries, and the cheap "fifty-cent men" in urban low-rent districts occupied distinctly different professional and social realms. What unity the daguerreian community enjoyed was the result of the bonds of friendship, employment, and partnership.

The most valued employees in the larger daguerreotype studios were the operators, the men (and a few women) who directed the actual making of portraits. A number of notable daguerreotypists gained their experience as operators. Victor Piard had begun in this capacity for the firm of Anthony, Edwards & Co., while Alexander Beckers was similarly employed by the Langenheim brothers. James E. McClees and Washington L. Germon both worked for Montgomery P. Simons, and Gabriel Harrison served as chief operator for both John Plumbe and Martin M. Lawrence. James Brown, after working as Mathew B. Brady's chief operator, opened his own gallery in New York in 1848.

The steady movement of studio personnel resulted in a fluid network of partnerships and affiliations. In the mid-1840s, David C. Collins had partnerships with both Marcus Root and Montgomery Simons. The brothers Marcus and Samuel Root worked both separately and jointly, as did McClees and Germon, Jeremiah Gurney and Charles D. Fredricks, Samuel Van Loan and John Jabez Edwin Mayall, Ezekiel Hawkins and Thomas Faris, Victor Piard and Alexander Beckers, and others. A chart of the comings and goings of the most notable operators of the era, as well as of the business relationships between studio owners, would reveal a complex map of personal and professional links.

By 1850, the field was large enough to warrant the publication of professional manuals and journals. Several key instruction manuals were published in this period, including Samuel D. Humphrey's *A System of Photography* (1849), Henry Hunt Snelling's *History and Practice of the Art of Photography* (1849), and Levi L. Hill's *Treatise on Daguerreotype* (1850).[65] Most notably, two independent photography journals appeared within two months of each other in the winter of 1850-51. These journals served an enormously valuable function: they provided a forum for discussion and debate for an increasingly diverse and far-flung profession. For historians today, they are essential reading.

The world's first periodical devoted strictly to photography appeared on November 1, 1850, with the title *The Daguerreian Journal: Devoted to the Daguerreian and Photogenic Art. Also, embracing the Sciences, Arts, and Literature.* Issued twice a month, this publication —which continued after 1851 as *Humphrey's Journal*—was the brainchild of Samuel D. Humphrey, an experienced daguerreotypist and author. Based in upstate New York, Humphrey had traveled as an itinerant in the late 1840s as far afield as Connecticut, North Carolina, and Ohio.[66] He moved to New York City in 1850, where he started the *Daguerreian Journal*.

Worried about the status and progress of the field, Humphrey tirelessly promoted high standards, the free exchange of information, and the collective benefits of a kind of guild solidarity. He was instrumental in founding the American Daguerre Association in 1851, the first national organization dedicated to promoting and elevating the profession. In addition to editing his journal, Humphrey produced a second manual, *American Hand Book of the Daguerreotype*, issued in five editions between 1853 and 1858. His *Practical Manual on the Collodion Process* (1856) was issued in three editions. Humphrey's professional interests shifted in 1857-58, when he began studies for a medical degree, and he sold his journal in 1859.

Humphrey's monopoly in photographic journals was short-lived: the first monthly issue of the *Photographic Art-Journal*, edited by Henry Hunt Snelling, appeared in January 1851. Snelling's journal ran under this name until the end of 1853 and then as the *Photographic and Fine Art Journal* from 1854 to 1860.

Unlike Humphrey, Snelling was not a practicing daguerreotypist; he had a business background and worked as sales manager for the nation's largest photographic supply house, E. Anthony and Company, in New York. Snelling was a man of considerable energy: from the end of 1850 through 1857, he edited his monthly journal while maintaining his full-time position with Anthony. In addition to his 1849 book (largely a compilation of data from other sources), Snelling published *A Dictionary of the Photographic Art* (1854). He eventually sold his journal and retired from photography in 1857.[67]

Together, these journals gave the growing field a sense of collective identity. By Humphrey's estimate, there were no fewer than 10,000 daguerreotypists in 1850; perhaps as many as a third of them ultimately subscribed to one or both of these publications.[68] The journals were written for serious, intelligent professionals—men with ambition and ideals. Each issue was varied in content, with coverage of practical concerns, science and technology, the fine arts, and personal information. Many articles were reprinted from other publications; others were written by the editors or by subscribers. Both editors used their columns to express pointed opinions on the state of the art.

The first issue of the *Daguerreian Journal* included articles on the science of the daguerreotype and the aesthetics of sculpture, an analysis of the "Effect of Atmospheric Electricity upon the Wires of the Magnetic Telegraph," a report on a "Visit to the Art Union," and brief notices on daguerreotypists and their activities. The last page included a "Daguerreian Artists' Register," a list of the daguerreotypists—from Brady in New York to Frederick Coombs in San Francisco—that, one presumes, were paid subscribers.

Similarly, the first issue of Snelling's journal included lengthy essays on "The Art of Photography," and "Researches on Light," as well as advice on the preparation and buffing of plates, a report on American art unions, poetry, and more. Snelling lavishly highlighted the leading figures in the profession. His first six issues included handsome lithographic portraits and biographical sketches of Mathew B. Brady, Martin M. Lawrence, Gabriel Harrison, Augustus Morand, George S. Cook, and Luther Holman Hale. Scores of other names were mentioned—and implicitly endorsed—in every issue.

In their first editorials, Humphrey and Snelling gave strikingly similar rationales for their efforts. Both emphasized the importance of

inquiry and improvement, the sharing of information, and high standards. The profession's problems, in Humphrey's eyes, lay primarily in the public taste for cheap pictures and the cut-rate competitors that served this demand. He asserted that all daguerreotypists bore some responsibility for this state of affairs.

> We are grieved that the art we have so long practiced, and held in such high estimation is looked upon by many as unworthy of the notice and patronage of the public… A lack of pride among Daguerreians is one of the greatest disadvantages our art labors under. Many care not what may be their reputation as artists so long as they put a few dollars into their pockets. This is decidedly wrong, for one poor picture will do more injury than ten good ones can repair. Let every artist strive for a good reputation by honoring his profession…[69]

For his part, Snelling acknowledged the merits of Humphrey's effort and shared his concerns about the state of the profession. Snelling lamented the debilitating effects of petty rivalries, the inclination to serve the lowest common denominator of public taste, and a lack of any larger collective vision. He wrote: "There is nothing that will serve to dissipate the petty jealousies too prevalent among artists, or banish that malevolent aspersion of talent so prominent in newspaper advertisements [by the least reputable daguerreotypists], as a union of the profession in one great philosophical body."[70]

Both journals aimed to encourage this hoped-for "union of the profession."[71] The goal was something based on two prominent models of the time: the craft or guild associations of urban workers that had begun forming in the 1830s, and the art unions of the 1840s and early 1850s. Trade associations were protective in nature—a means of establishing professional standards, wages, and working hours.[72] The art union movement, on the other hand, was a complex amalgam of business, populism, idealism, and gambling—a means of improving society by democratizing art. The Art-Union of London, begun in 1837, provided the model for many subsequent variations on the theme.[73]

The American Art-Union, founded in New York in 1839, grew into an ambitious program to purchase and distribute works of art. The group solicited thousands of members, who joined for a modest annual fee. This money was used to purchase original works of art. At the end of each year, these paintings were awarded by lottery—a $5 investment gave each member the chance to own an original work by the likes of Thomas Cole, Asher B. Durand, Jasper Cropsey, and George Caleb Bingham. In addition, engravings of the most acclaimed paintings were produced in quantity and sent to all members.

Before it collapsed in the early 1850s from financial and legal embarrassments, the American Art-Union achieved remarkable success in raising the reputation of American painters and in placing art in thousands of homes. American daguerreotypists followed the Art-Union closely and both journals reported on it regularly. In 1850, some eighty-four daguerreotypists were members of the Art-Union: their association with the group underscored their artistic credentials and the annual engravings would have been a standard part of their reception room displays.[74]

Several attempts were made to form regional or national professional associations in the early 1850s. The first such idea, dating from the fall of 1848, came from D. D. T. Davie, of Utica, New York. After conversations with his professional peers, Davie scheduled a meeting in Syracuse, on July 12, 1851, of the New York State Photographic Association. This was attended by about thirty upstate studio owners, from Albany to Buffalo. Only three days later, a separate meeting of New York City daguerreotypists led to the establishment of the American Heliographic Association. Upon hearing of the death of the inventor of the daguerreotype, this group changed its name to the American Daguerre Association. By the fall of that year, the association claimed 131 members in cities across the country. In August 1851, another regional group—the loosely knit Daguerreotypists of New York and Brooklyn—was convened.[75]

These groups were both idealistic and elitist. Composed of elected members only, they made two basic demands: that members demonstrate "high moral and artistic standing" and that they not make "low priced pictures."[76] The union of these two concerns—artistic and financial—was clearly conveyed in the preamble and resolutions of the New York State group:

> Whereas, the Daguerreotype likeness, when properly executed, is more faithful to nature than any other style of portraits; and whereas, many imposters are flooding our country with caricatures at a much less price than a good picture can be afforded for, thereby not only robbing their patrons, but degrading this most beautiful art, and what is worse those who are competent to practice the art successfully—those who would improve and go on from one improvement to another until the last victory was achieved; and whereas, these men are held in poverty and disparagement by the mere catchpennies who hold themselves up to the world as artists, when they are not—And whereas the increased demand for the best miniatures that can be taken calls for a fair compensation for the same, in order that operators may be encouraged to use still greater effort in trying to excel in this most beautiful art. Therefore—[77]

It was resolved that a committee be appointed to draft a constitution and bylaws; that "we do all in our power for the advancement of the art, and each other in the study of the same, and bury forever all feelings of envy and jealousy which have hitherto existed"; and, in order to choke off the rise of "catchpenny" operators, to discourage "giving instructions to any but those whose natural talents and moral standing qualify them for successfully practicing the art."[78] Finally, the group stressed the need for a national standard of prices to forbid the making of any portrait for "less than One dollar and Fifty Cents."[79]

While these sentiments might have been shared by nearly all leading daguerreotypists, the group's tactics were open to question. At the first meeting of New York and Brooklyn daguerreotypists, on August 8, at Brady's gallery, Gabriel Harrison criticized the idea of a "Secret Society"—a reference to the self-selected membership. If the daguerreotype was genuinely democratic in nature, he asked, why were these proposed associations not equally accommodating? "If we are to have a society for the good of *all*, why not invite all to come in? Why not invite the fifty cent man as well as the dollar or two dollar man? Let the corner stone of the institution be democratic. With such we will have union! Union is strength! And with strength we must prosper."[80]

Harrison's questions pointed up an awkward truth. The high ideals of art, democracy, and taste could not provide the glue to hold this fractious community together. While the rhetoric of these groups focused on matters of status—a cultural respect for the daguerreotype and its leading practitioners—the overriding issues were economic. In simple fact, the most elegant and progressive studios depended on stable retail prices and healthy profit margins. However, this price structure was under increasing pressure from production-line studios. These cheap galleries, serving a frugal and

relatively undemanding clientele, had no interest in any uniform (i.e., higher) price structure.

In this climate, economic self-interest was interpreted as evidence of dubious character. Snelling wrote with bitter exasperation in May 1852 of the continued disinterest in technical and aesthetic refinement demonstrated by many practitioners:

> The fact is the larger portion of those daguerreotypists who decry theoretical knowledge are either too lazy to devote two or three hours a day—an amount of time they all have at their disposal—or they prefer spending the money that would enable them to obtain it in the billiard room, the drinking house, or upon women. This we know to be a matter of fact in many instances. Without the ambition to raise them above the common horde, they plod along in groveling ignorance of every thing pertaining to their art except a mere mechanical process that enables them to get a shadow they call a daguerreotype.[81]

By the time he penned these angry lines, Snelling was well aware that no association of daguerreotypists could be genuinely effective. In fact, within about a year all these groups were essentially defunct.

The Daguerreian Economy

Daguerreotyping was first and foremost a commercial activity, a means of earning a livelihood. With few exceptions, daguerreotypists were typical small businessmen of the day. The great majority were artisan-entrepreneurs with much in common with the other independent tradesmen—shopkeepers, millers, coopers, cabinetmakers, bookbinders—of their communities. Daguerreotypists typically owned their tools, rented their working quarters, and had no more than one or two others on the payroll. They earned enough to support themselves and their families, but had little expectation of becoming rich. By the standards of the day, even the largest studios in New York were enterprises of relatively modest scale.

The heyday of the daguerreotype, from about 1843 to 1857, coincided with a period of sustained economic growth. The United States suffered a deep depression from 1837 to the mid-1840s. Financial indicators began to turn upward again in 1843, and a general prosperity returned in 1846 due to the stimulus of the Mexican War. The economy performed robustly over the next decade. This boom lasted until 1857, when a Wall Street panic spread to Europe, producing the first truly international market crash. While cheaper photographic techniques had been introduced in the early 1850s, the daguerreotype maintained its cultural dominance as long as prosperity lasted. With the financial retreat of 1857, however, the daguerreotype rapidly lost ground. The depression not only hastened the process's end, it decimated a field that was viewed by some as distinctly overcrowded.[82]

In this era, everything was in flux; many things were possible, but nothing was guaranteed.[83] The keywords were enterprise, progress, and risk. Americans' willingness to try new ventures (and the hype and bravado that often went with them) was the stuff of both legend and parody. In an 1858 letter to *Humphrey's Journal*, the daguerreotypist Franklin B. Gage provided a colorful caricature of some of the least capable in his own profession.

> In England a man is obliged to serve seven years before he can acquire a trade; but, in this country, any one is considered qualified to carry on any kind of business that happens to strike his fancy. To-day you will find the Yankee taking daguerreotypes; to-morrow he has turned painter; on the third day he is tending grocery; dealing out candy to the babies for one cent a stick. On the fourth day he is building a ship to be driven by double and twisted gas and gammon; if he gets the ship done before the close of the day he will get a patent and bleed the unsophisticated… On the fifth day he has invented a stove that will certainly astonish the natives, and will save about *five quarters* of the wood used. On the sixth day he has turned politician… When the seventh day comes round he has turned preacher, and you will find him dealing out salvation by the shilling's worth to the gaping multitude. Thus ends one week of a Yankee's life. The next is highly diversified with something else; and so it goes on to the end of his days. When he dies we are astonished, on summing up what he has accomplished, to find that it is *just nothing!*[84]

Something of this daring and adaptability was characteristic of the daguerreian field as a whole. Many daguerreotypists were ready and willing to go wherever there was money to be made. The career of George S. Cook provides a useful case study. Born in Connecticut, Cook moved to the South at an early age. He learned the daguerreotype process in New Orleans in 1843, where he worked professionally for two years. In 1845, he traveled to New York to acquire better equipment. He then embarked on a 3,000-mile itinerant odyssey to Pittsburgh, then down the Ohio River to St. Louis, Nashville, and various communities in Mississippi, Alabama, and Georgia. At each stop, Cook set up operation for a few days, weeks, or months, making portraits until local demand inevitably fell off. He finally arrived in Charleston, South Carolina, in 1849, where he established a more permanent studio. In 1851 he was hired to oversee Brady's New York gallery during the owner's extended trip to Europe. He returned to Charleston in 1852, where he remained relatively fixed for some years.[85]

Many daguerreotypists worked more or less continuously as itinerants; others, based in fixed studios, made road trips during the slow summer months. By the 1840s, itinerancy was common practice: rural communities were visited regularly by traveling preachers, lecturers, musicians, peddlers, and portrait painters.[86] Many beginning daguerreotypists worked as full-time itinerants. The practice held numerous benefits for those struggling to master the process or with thin wallets: their customers were relatively unsophisticated, and they were not required to pay regular rent on gallery space.[87]

Some notable figures began as itinerants. Thomas M. Easterly, for example, worked in Vermont, Iowa, and western Missouri before establishing a gallery in St. Louis in 1847. James F. Ryder learned his craft as an itinerant in western New York State, Pennsylvania, and Ohio before settling in Cleveland in the mid-1850s. John H. Fitzgibbon was one of the most notable studio-based daguerreotypists to make extended summer excursions. In 1846, he traveled to Cincinnati and St. Louis, recording "Picturesque scenes and Indian country." In the summer of 1854, after he had established a permanent studio in St. Louis, he went through the Indian territory of southwest Missouri, visiting ten settlements in thirty-two days. He claimed to have been the first daguerreotypist in the region and earned excellent money: an average of $100 a day.[88]

Itinerants varied considerably in talent and sophistication. The poorest worked in primitive conditions in hotel rooms or other rented spaces. As historian Beaumont Newhall has described, "All of the needed apparatus, including a tripod and a headrest to clamp on the back of a chair, could be packed into a small trunk. Any well-lighted room would serve as a studio, and a blanket across the corner of the room could serve as a darkroom."[89] By contrast, the most prosperous itinerants traveled in fully equipped studios: horse-drawn

81 **Unknown Maker**, *Traveling Daguerreian Studio*, ca. 1850

82 **Joseph R. Gorgas**, *Gorgas's Floating Daguerreian Gallery*, ca. 1856

wagons or, in a few instances, riverboats. Wheeled "daguerreotype saloons" were making the rounds of rural New England by the mid-1840s; by 1852, no fewer than four such wagons, headquartered in Syracuse, were servicing the populace of central New York State.[90] In 1853, in the nearby town of Lockport, New York, two enterprising daguerreotypists spent the enormous sum of $1,200 to build a lavish wheeled studio "28 feet long, 11 feet wide and 9 feet high, with a beautiful skylight and tastefully furnished."[91]

It is this or a similarly elaborate vehicle that is recorded in this lively sixth-plate daguerreotype [81]. Here, a prosperous figure stands proudly in front of a new mobile studio, surrounded by an entourage of workmen and companions. This studio had both a sidelight and a skylight and was painted to ensure maximum visibility.

In the mid-1850s, John R. Gorgas spent three years plying the Ohio and Mississippi rivers in a floating gallery [82]. In a later reminiscence, he called this period "the happiest of my life, with a handsome boat 65 feet long, well appointed, a good cook, with flute, violin and guitar, had a jolly time, did not need advertising, and never did any Sunday work."[92] As the daguerreotype era shaded into the age of the ambrotype and tintype, itinerants continued to travel the nation's roads and rivers. This half-plate ambrotype [83] records a traveling studio in what appears to be a distinctly provincial setting.

This entrepreneurial energy is also seen in the regional and even international reach of the daguerreian business. Several daguerreotypists, including John Plumbe, operated chains of galleries. By 1851, Jesse Whitehurst's seven galleries employed a total of thirty-three people.[93] After opening a gallery in Philadelphia, Marcus Root formed satellite operations with various partners in Mobile, New Orleans, St. Louis, New York, and Washington, D.C. From his initial gallery

83 **Unknown Maker**, *Traveling Ambrotype Studio*, ca. 1860

in Memphis, Thomas Jefferson Dobyns—a landowner reputed to be "the wealthiest daguerreotypist in America"—established branch businesses in Louisville, Nashville, New Orleans, St. Louis, Vicksburg, Cincinnati, and New York.[94]

Beginning with the pioneering work of Wolcott and Johnson, American daguerreotypists were an integral part of an international economy. There was steady travel and communication across the Atlantic. Several notable American practitioners had taken up the process in Europe or chose to work there. Philip Haas began his career in Paris before settling in New York.[95] John Jabez Edwin Mayall came from England to work in Philadelphia in partnership with Samuel Van Loan. In 1846, he returned to England, setting up a highly successful practice in London that specialized in the "American style" daguerreotype.[96] Mayall's name remained familiar to the American community in these years, and his efforts were regularly reported in the photographic journals. Warren Thompson, another early Philadelphia practitioner, ran a studio in Paris in the late 1840s and early 1850s. Thompson excelled in the production of stereographic portraits, a format more popular in England and France than in the United States [84]. William Hardy Kent, an Englishman who worked in New York before relocating to London, also became known for his stereo portraits [85]. Another New Yorker, Charles D. Fredricks, operated a studio in Paris for about six months in 1853.

In addition to this personal and professional commerce with Europe, American daguerreotypists were active in other parts of the world. In 1854, for example, Thomas Glaister established a branch operation of the Meade Brothers studio in Melbourne, Australia.[97]

Latin and South America provided the largest overseas market for American daguerreotypists. As the historian Abel Alexander has noted:

"The first wave [of daguerreotypists in the region] was European, with the French soon followed by the English, Germans, Italians, and Swiss. The Europeans were quickly followed by the Americans, who had in their favor geographic proximity…"[98] The first practitioners in Rio de Janeiro, Brazil, included Augustus Morand and his partner James E. Smith, who set up a temporary studio in December 1842.[99] In addition to making portraits of the city's elite, Morand attracted the patronage of the Emperor. Over a period of almost five months, Morand made daguerreotype portraits of the royal family, copies of paintings in their collection, and views of the scenery around the Imperial residence.[100]

While he is best known today for his New York studio of the late 1850s, Charles D. Fredricks began his photographic career in South America. In 1843, he was the first daguerreotypist to visit the Venezuelan port of Angostura (present-day Ciudad Bolivar), where he earned a healthy profit photographing the city's elite. With regular visits back to New York for supplies, Fredricks spent most of the next nine years in South America. He worked his way across the continent, setting up temporary studios from Belem, Brazil, to Buenos Aires, Argentina.[101] In mid-1851, he arrived with his partner, Alexander B. Weeks, in the coastal city of Recife, Brazil. The pair stayed there for about four months, making portraits of the locals as well as a series of whole plates of the city and harbor [86]. These plates were marked "Electrotypo," an apparent reference to Fredricks's use of galvanizing to increase their speed and tonal richness.

In early 1852, Fredricks went from Recife to Montevideo and then to Buenos Aires. In the Argentine capital he found at least ten daguerreotypists—nearly all itinerants like himself—set up for business. He stayed in Buenos Aires through the end of 1852, making portraits and whole-plate views of the city. Fredricks's attention was

84 **Warren Thompson**, *Portrait of a Boy with Toy Rifle*, ca. 1854-56

85 **William Hardy Kent**, *Alice Abadam and Child*, 1856

subsequently directed elsewhere: a short-lived studio in Paris, a major operation in New York, and regular winter stays in Havana, Cuba, where he maintained a satellite operation into the 1860s.[102]

American daguerreotypists also worked on the Pacific side of South America. For example, at least two Americans set up notable businesses in Lima, Peru. Arthur Terry, of New York, ran a studio there from 1848 to 1852, when he was succeeded by Benjamin Franklin Pease. While Pease's earlier history is unclear, he probably honed his daguerreian skills in New York City, perhaps in association with Jeremiah Gurney.[103] Pease enjoyed a near monopoly in Lima through the end of the decade. One of his most remarkable works, a half-plate from the mid-1850s, stands as a powerful symbol of the structure of Peruvian society [87]. In this work, a haughty, aristocratic young boy with a riding stick is flanked by two dark-skinned servant women. The women wear fine shawls, indicating the wealth of the family they serve. In the words of historian Keith McElroy, this is an "archetype of Limean society"—a comfortable, self-assured culture founded on rigid notions of class and race.[104]

The earliest American photographers in Chile included the brothers Charles and Jacob Ward, who established a portrait studio in Santiago in 1844. Robert H. Vance, who took up the daguerreotype in New England in 1845-46, arrived in Chile in early 1847. Based primarily in the bustling port city of Valparaiso, he also worked in Santiago and made periodic trips to other parts of the country. In mid-1850, after spending about two and a half years in Chile, Vance set sail for San Francisco, with stops along the way to photograph in Peru, Panama, and Mexico.[105] Other Americans worked in Central America: William Fitzgibbon, of St. Louis, for example, was one of the leading practitioners in Guatemala in the 1850s.[106] After operating in New Orleans in the 1840s, H. Whittemore made views throughout the Caribbean—in Bermuda, Nassau, and Trinidad—and in South America.[107]

This geographical dispersion was both a result and a reflection of the growing number of daguerreotypists in the United States. With the booming economy, the field expanded rapidly in the late 1840s and early 1850s. Between 1845 and 1850, the number of studios in Boston grew from 9 to 43.[108] By the fall of 1850, Samuel D. Humphrey reported that 71 daguerreotype studios were operating in New York City. These businesses employed a total of 127 operators (including owners), 11 ladies, and 46 boys. By his conservative estimate, the operators earned $10 per week, the ladies about $5, and the boys approximately $1.[109] The field boomed in the next few years. In mid-1853, the *New York Daily Tribune* reported that the 100 or more daguerreian studios in New York and Brooklyn together provided employment for about 250 men, women, and boys.[110] Comparable increases were seen in other American cities.

By 1853, it was estimated that "there cannot be less than 3,000,000 daguerreotypes taken annually in the United States." New York City had significantly more studios than any other, followed by Boston, Philadelphia, and Baltimore.[111] This network of galleries was linked to supporting industries that produced plates, chemicals, cameras, cases, and other studio equipment.[112] By 1853, this nationwide daguerreian economy employed some 13,000 to 17,000 persons nationwide.[113]

The economic efficiencies of scale ensure that, with an increase in the volume of production, the unit cost of any manufactured thing tends to fall. In 1840, the simplest daguerreotype portrait cost $5; a dozen years later, plates of comparable size (and superior quality) could be had for fifty cents. Several factors conspired in this era to drive prices down: the increasing volume of manufacture, the steadily dropping costs of transportation, and increased competition in all aspects of the business. This trend was a distinctly mixed blessing. Daguerreotypists were able to purchase supplies at gradually declining prices. However, they felt a corresponding pressure to lower the cost of their own products, just as public taste was demanding increasingly ornate studios. As a result, it took greater efficiencies to earn the same amount of money per day. As long as the business continued to expand, this formula could be made to work. However, once the market reached saturation, consumer tastes shifted, or the economy weakened, this was a recipe for crisis.

Despite these pressures, the early 1850s were great years for American daguerreotypists. As Snelling wrote in an October 1853 editorial, "Daguerreotypists generally are not only doing remarkably fine business, but remarkably fine work. No era in the history of daguerreotyping has produced so many exquisite gems of the daguerreotype art as the present; and the almost universal desire for improvement, gives evidence of a better appreciation of the art."[114] Thanks to technical improvements, and their accumulated years of experience, the better daguerreotypists were able to produce more plates—and of higher quality—than ever before. For example, D. D. T. Davie reported in mid-1853 that the use of machinery to clean and buff his plates gave better results—and in one-eighth the time—than the older hand method. These savings allowed him to cut overhead expenses significantly: "I am now alone in my manipulations, except what assistance I get from a lady pupil; I am making as many pictures as I was three years ago, when I employed three assistants, the average of my work is much better, and it is produced with decidedly more ease…" Noting equal improvements in his housekeeping and accounting practices, Davie wrote optimistically: "My matters are all moving on like clock-work. I look around me and among others of my brothers in art in similar circumstances and I feel contented and happy."[115]

The great challenge for leading studios was to maintain a profitable price structure. In his correspondence of 1853, Davie reported prices that would have been the envy of his colleagues. After accounting for all the variables that went into the price of a daguerreotype portrait, Davie reported: "I am getting an average of $2.53 for my ⅙ sizes and less including lockets; $4.35 for ¼ sizes; $8.25 for ½; and $15 for full sizes; this estimate includes groups as well as single portraits."[116]

Given even a moderate number of daily customers, these prices would have yielded a healthy profit. While some of the provincial studios—like Tallmadge Elwell's sluggish operation in Minnesota—could struggle to earn $20 a week, the leading city operations could make that much every hour or two.[117] In January 1852, Jeremiah Gurney informed Henry Hunt Snelling that he had received $120 "for pictures taken the day previous, entirely by himself, before three o'clock, and this too at a dull season."[118] Similarly, Samuel D. Humphrey reported finding no fewer than twenty-three customers one day waiting to sit for Abraham Bogardus's camera.[119]

Inevitably, the downward pressure on daguerreotype prices increased the divide between leading studios and cut-rate operators. The former put an emphasis on quality: personalized attention, technical perfection, and expensive finishing treatments. The latter emphasized quantity: small plates, stock poses, and cheap cases.

In New York City, Reese and Company, at 289 Broadway, pioneered a production-line system in 1852. Using a strict division of labor, the firm claimed to have produced up to 400 finished portraits

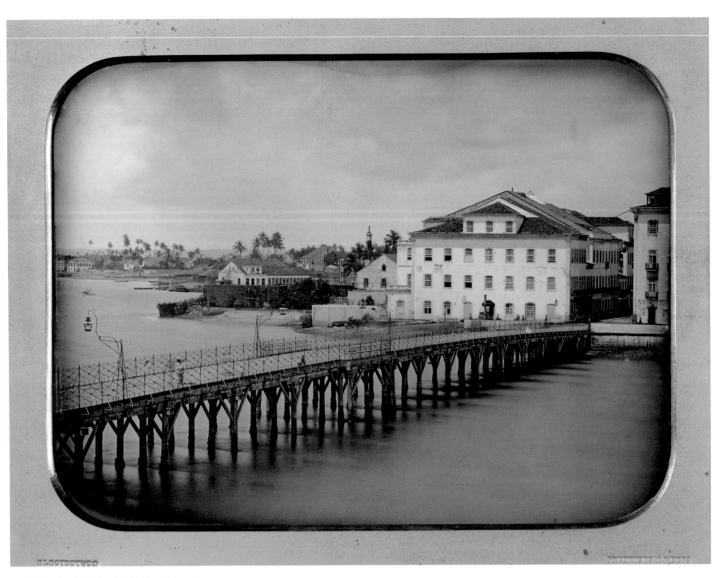

86 **Fredricks & Weeks**, *Recife, Brazil*, ca. 1853

in a day.[120] While Reese specialized in twenty-five- and fifty-cent portraits (sixteenth- and ninth-plates, respectively), he also offered work in the half-plate size at up to $10.[121] Silas A. Holmes ran one of the most notorious (and successful) of these "Two-Shilling" operations.[122] For the Christmas season of 1854, he advertised "Gift Daguerreotypes, 25 cents, $1, and $5, or $9.50 per dozen, taken by machinery…," and boasted that he was making up to 600 portraits daily.[123] Within a few weeks, Holmes had added a "wholesale department" to his operation and was offering to take portraits "for $20 per hundred."[124] Based on the evidence of Holmes's own portrait [c-50] one suspects that the great majority of his plates were made in the smallest sizes. Rufus Anson, on the other hand, made a more diversified product. He was set up to make elegant larger plates for the wealthier customers [46, 47] as well as the best fifty-cent sixth-plates in New York — "colored, and in a nice case, with preserver — twice the size others make for fifty cents."[125] The cost of the smallest daguerreotypes fell enough that they were given away as promotional novelties. In late 1853, for example, at least one company advertised "Daguerreotype Hats" — a free likeness with the purchase of every new derby or bowler.[126]

Leading studio owners vehemently protested this trend toward cheap, generic work. A few operations — most notably Southworth & Hawes — simply refused to lower prices. They continued to serve an elite, but steadily shrinking clientele. Most leading daguerreotypists, such as Mathew B. Brady, tried to have it both ways. In 1854, Brady proudly asserted his high standards: "I wish to vindicate true art, and leave the community to decide whether it is best to encourage real excellence or its opposite; to preserve and perfect an art, or permit it to degenerate by inferiority or materials which must correspond with the meanness of price."[127] However, at about the same time, he advertised "new arrangements" at his gallery allowing the production of "better pictures…from 50 cents to $1, than have ever been made before at these prices."[128]

Daguerreotypists employed a great variety of strategies to increase their name recognition, customer count, and profits. Southworth & Hawes promoted their Grand Parlor and Gallery Stereoscope as a fashionable mode of public entertainment. Similarly, John Adams Whipple staged magic lantern shows of "dissolving views" of photographs and photographic copies of noted works of art. At least a few daguerreotypists attempted to copy the American Art-Union's elaborate lottery scheme. In 1854, for example, it was reported that Jesse Whitehurst was "trying the plan of giving Daguerreotypes with farms." Apparently, Whitehurst envisioned making 30,000 daguerreotypes at $3 each, with properties going to the winning ticket holders.[129] A number of leading studios made advertising cards and tokens as

promotional souvenirs. "Daguerrerian notes"—slyly designed to resemble legal currency—were also issued as a form of credit for future purchases at the gallery [c-51].

Such schemes aside, most daguerreotypists accommodated themselves to this market with the utmost pragmatism—by changing with it. As paper prints and the ambrotype (both products of the wet-plate collodion technique) became increasingly popular, photographers adopted these techniques. The recession of 1857 accelerated this shift away from the expensive and "old-fashioned" daguerreotype. After the early 1860s, public demand for the process had all but disappeared.

Exhibitions and Competitions

Daguerreotypes enjoyed a high public visibility in the 1840s and 1850s. They were seen not only in the intimate realm of the family parlor, but also in public exhibitions. In the home, daguerreotypes held personal meaning for an intimate circle of viewers. In public exhibitions, they were seen by many more people and in a more disinterested way. In this context, it was clearly the craftsmanship or artistry of the daguerreotype that was being celebrated. Daguerreotypes were shown publicly in the reception rooms of portrait studios and at trade fairs and expositions. These venues shaped the potential meanings of the medium in distinct but overlapping ways.

Every major daguerreotype gallery had a prominent exhibition space. Daguerreotypes were presented in a context of luxury and refinement, surrounded by expensive furnishings, works of art, and other emblems of high culture. These exhibitions were entertaining and educational. In addition to giving visitors an opportunity for quiet contemplation, they provided a rich lesson in the art of the daguerreotype. Associating the daguerreotype with more traditional forms of fine art underscored the photograph's own aesthetic qualities and its status as a deliberately conceived and crafted *picture*. In sum, these commercial exhibitions presented the daguerreotype as both new and useful, technically advanced and aesthetically refined.

Daguerreotypes were also exhibited in regional, national, and international fairs and expositions. These ranged from the largely agricultural displays of county fairs to the era's greatest showcase of technical and commercial progress, London's famed 1851 Great Exhibition of the Works of Industry of All Nations, or "Crystal Palace." As this diversity of venues suggests, the meaning of these displays spanned a broad spectrum, from demonstrations of local enterprise to symbols of global technological progress.

In the United States, daguerreotypes were included in a host of annual exhibitions devoted to the advancement of technology, science, and art. Sponsored most typically by "mechanic" organizations, these exhibits were part of an educational effort that included the establishment of research libraries, the publication of journals, and the collection of artifacts.[130] One of the earliest of these groups, the Massachusetts Charitable Mechanic Association, was founded in 1795 by master mechanics. The organization's 1847 fair, held at Boston's Faneuil Hall and Quincy Market, had more than 1,600 exhibits and attracted about 70,000 visitors.[131] The American Institute of the City of New York, founded in 1828, took on a broad mission of national improvement. The organization was divided into four departments —Agriculture, Commerce, Manufacturing, and the Arts—each of which was represented in the group's annual fairs. The American Institute's twenty-third fair, in 1850, had over 2,000 entrants, with exhibits ranging from agricultural tools to works of art. In Philadelphia, the

87 Benjamin Franklin Pease, *El Patroncito*, ca. 1853-55

Franklin Institute gave awards and premiums in over thirty categories —from Cotton Goods to Surgical and Dental Instruments—in their annual American Manufacturers exhibitions. This model was followed by a host of state and regional exhibitions, from the Maryland Institute Fair to the Illinois Mechanics Fair.

The progressive agenda of these organizations and fairs reflected a basic cultural optimism as well as a belief in the symbolic unity of these varied endeavors. Mechanical innovation and artistic refinement were understood to stem from the same (or at least parallel and related) human capacities. Better plows and rifles, more refined household furnishings, and fine works of art all spoke to society's steady climb up the ladder of civilization. Technical and creative achievement was equated with national character and virtue. Indeed, for many, this constantly elevating enterprise carried spiritual meaning.[132]

While most daguerreotypists benefited from these exhibitions, they did not view them uncritically. Given their size and the haste with which they were assembled, these displays were usually cramped and cluttered. For some, the categorization of the daguerreotype was equally frustrating: most commonly, it was classed as a technology rather than as an art. In the 1847 Massachusetts Charitable Mechanic Fair, daguerreotypes were grouped with other "conveniences of civilized life" and exhibited near "labor-saving washing machines."[133] In New York's 1853 Crystal Palace exhibition, daguerreotypes were placed in Class 10—"Philosophical Instruments, and Products resulting from their use"—which included astronomical and surveying instruments, a Fresnel lens, electric telegraphs, a planetarium and globes, watches and clocks, surgical instruments, and more.[134] Less typically, daguerreotypes were presented in the Fine Arts category of the Franklin Institute's 1847 exhibition, with examples of engraving, painting, stucco work, and ornamental penmanship. However, after

listing the merits of these daguerreotypes, this show's official catalogue noted that "the judges do not consider this department as strictly belonging to the Fine Arts…"[135]

In fact, these exhibitions celebrated the daguerreotype as both a mechanical and an aesthetic achievement. The first was reflected in the usual organizational categories; the second in the awarding of medals and prizes. Daguerreotypists competed eagerly for these prizes and cited them prominently in their advertisements. The two most important exhibitions of the era were the 1851 London Crystal Palace exhibition and its 1853 New York namesake. American daguerreotypists played a key role in both exhibitions.

London's Great Exhibition of 1851, held in the boldly modern Crystal Palace structure in Hyde Park, was the single most famous exhibition of the nineteenth century. Conceived by Queen Victoria's husband, Prince Albert, the exhibition celebrated Great Britain's economic and industrial might. It was an international showcase with submissions from two dozen countries. The Great Exhibition lived up to its name: in all, over 6 million visitors came to see the 13,000 objects on view.

The display of photographs included 772 images from six countries.[136] Photographers from the United States, Great Britain, and France submitted the majority of these works. Notably, all three prize medals went to Americans. The winners were John Adams Whipple, for his daguerreotype of the moon; Martin M. Lawrence, for the oversize allegorical work *Past, Present, and Future* (by his operator Gabriel Harrison); and Mathew B. Brady, for his portraits of celebrated Americans.

The triumph of American daguerreotypists in London was a point of cultural pride. Beyond the individual honors accorded Whipple, Lawrence, and Brady, viewers were struck by the overall quality and variety of the American installation. Exquisite portraits were shown by Oliver Evans, of Buffalo; C. C. Harrison, of New York; W. A. Pratt, of Richmond; and Whipple. With their portraits, the Meade Brothers showed at least one artistic work—an allegorical study of the four continents.[137] The American display also included Fontayne & Porter's masterful eight-plate panorama of the Cincinnati waterfront, and twelve plates of Niagara Falls by Jesse Whitehurst. Finally, the Langenheim Brothers showed paper prints (Talbotypes) of views of Philadelphia.

The success of the London fair inspired a group of New Yorkers to host a similar event. Everything was based on the London model, including the building itself. The New York Crystal Palace, an iron and glass structure erected on the present-day site of Bryant Park, opened on July 14, 1853. The fair announced American economic and technological power to the world. In the midst of heated debates over slavery and the Union, it also aimed to cement a national sense of purpose and identity.

The New York fair—officially, the Exhibition of the Industry of All Nations—was an amazing spectacle.[138] Its Crystal Palace, a glittering octagonal structure, spanned two city blocks. The outer skin was composed of 15,000 sheets of enameled glass; at the center of the building was a vast 100-foot-diameter dome that rose to a breathtaking 125 feet. The radical design of the building (following Joseph Paxton's London original) provided an exhilarating sense of openness and light: the structure's weight was carried by slender ribs of iron rather than by thick stone or masonry walls.

The fair was broadly international. Of the more than 5,000 exhibitors, roughly half came from twenty-three foreign countries, with Britain, Germany, and France leading the way. An astonishing array of items was on view, from an extensive mineralogical collection to a great variety of new devices and technologies, from rock drills to telegraphs.[139] The fair also included a large display of sculptures and a separate gallery for paintings.[140]

Photography was one of the great strengths of the American section. As Horace Greeley stated in the exhibition's official report, "If there be any one department in the whole building which is peculiarly American, and in which the country shines preeminent, it is in that of Daguerreotypes…"[141] A total of twenty-nine entrants showed daguerreotypes; two more were represented by paper prints, with another two displaying daguerreian cameras and equipment.[142]

While some of these works had been previously exhibited in London, the display was larger and even more impressive than the 1851 showing. Portraits dominated the displays of Mathew B. Brady, Samuel Root, Marcus Root, Jeremiah Gurney, William C. North, Masury & Silsbee, Enoch Long, and Charles H. Williamson. John H. Fitzgibbon's submissions included portraits of Jenny Lind, Louis Kossuth, and several Indian warriors. Artistic and allegorical works were in greater abundance than in 1851. The award-winning plate from the London exhibition—Gabriel Harrison's *Past, Present, and Future*—was again on display.[143] The ambition of this work was matched by Philip Haas's whole plate of a man reading a newspaper at home; several plates by Alexander Hesler, including *Driving a Bargain*, a genre scene set in a blacksmith's shop [278]; a series by Meade Brothers illustrating Shakespeare's "Seven Ages of Man"; and new allegorical works by Harrison on plates up to 15 x 18 inches in size.[144] For at least one critic, the finest work in the display was Albert Bisbee's six-plate panorama of Cincinnati.[145] Other outdoor views were presented by Hesler (three images of St. Anthony Falls and a panorama of Galena, Illinois), Joel E. Whitney (St. Anthony Falls), and Jesse Whitehurst (ten Niagara Falls views). John Adams Whipple exhibited two of his celebrated astronomical daguerreotypes—one of the moon and another of sunspots. Paper photographs were shown by three entrants: Whipple, Marcus Root, and Ezekiel Hawkins.[146]

Ultimately, the judges awarded one silver medal, seven bronze medals, and ten honorable mentions. The top award went to Whipple for his paper photographs. Brady, Hesler, Lawrence, and Samuel Root were among those receiving bronze medals. The honorable mentions included Fitzgibbon, Gurney, Harrison & Hill, Long, Meade Brothers, North, Marcus Root, and Whitehurst.[147]

Daguerreian awards reached their high-water mark in 1853. The most anticipated prize in the field—sponsored by Edward T. Anthony, owner of the leading photographic supply house—was awarded in November of that year. The idea for the Anthony Prize had been percolating for some time. It began in the spring of 1851 as a $500 premium for "the most important improvement in practical photography" introduced that year. Despite the selection of a prestigious jury—the daguerreian pioneers Samuel F. B. Morse and Professor John Draper, and the noted architect and engineer James Renwick, of Columbia University—the idea generated little interest among daguerreotypists and no awards were made.[148]

Anthony reconsidered his approach, and by the end of 1852 the emphasis had shifted from technical concerns to aesthetics. Daguerreotypists were given a year—until November 1, 1853—to submit work in competition for a $500 ornamental pitcher. This trophy would go to the maker of the best group of four daguerreotypes, one each in the whole-, two-thirds-, half-, and quarter-plate sizes.[149]

Ten daguerreotypists submitted the requisite four works. After careful consideration, the judges gave the top prize to Jeremiah Gurney. Second prize—a pair of goblets—went to Samuel Root. Gabriel Harrison, Alexander Hesler, George N. Barnard, George K. Warren, and James Brown all received honorable mentions.[150]

Few of their fellow professionals would have quibbled over the recognition of these men. Nonetheless, the jurors' decision spurred a pointed critique from Snelling in the *Photographic and Fine Art Journal*:

> We trust that it will not be deemed out of place to say a few words in regard to the pictures contributed. Of the whole forty daguerreotypes, but two were compositions—all the rest were portraits—a class of pictures rendered more easy to perfect, on account of the continued practice, and consequently apt experience of the manipulator. We therefore look upon the man who can step aside from the beaten track, and produce an artistic composition, worthy of honorable mention, superior to him who can simply produce a perfect portrait…. We must also express our astonishment that men whose talents are so fully equal to the attempt, should neglect this opportunity for giving to the world specimens of their skill in composition; there is no merit in these men taking a good portrait; their reputations were fully established in this branch. We are grievously disappointed in the result of Mr. Anthony's generous movement for the elevation of the art.[151]

Snelling ignored the work of the top prize winners to praise two men—Harrison and Barnard—who had received honorable mentions. Snelling applauded the fact that only these entrants had ventured beyond the familiar realm of studio portraiture to make "compositions" or artistic studies. All four of Harrison's works— *Young America; Helia, or the Genius of Daguerreotyping; The Infant Saviour Bearing the Cross;* and *Mary Magdalene*—were in this vein. Barnard's whole plate, titled *Woodsawyer, Nooning*, depicted an old woodsman and his son resting at their noon meal [277]. Snelling's admiration for Barnard's genre study was evident: the frontispiece of that issue of the journal was a paper-print copy of the image.

Snelling's complaint raised a familiar set of questions. Was photography fundamentally a technology or an art? Did its ultimate importance lie in the realm of fact or in the domain of ideas? Was the camera merely a "handmaiden" to the established arts or an art in its own right? Did its highest utility lie in satisfying a commercial need or in informing and elevating public taste?

The Language of Light: Commerce and Art

American daguerreotypists worked in a complex climate of pragmatism and idealism. All of them faced the mundane realities of commercial practice; some also had clear artistic and cultural ambitions. In large measure, the vitality of the American daguerreotype stems from this fundamental tension between the real and the ideal, practice and theory.

The elements of this quest were spelled out in the literature of the period. While the vocabulary of the 1850s can seem sentimental and formulaic to today's ears, these terms and concepts reflect the values of the day. In this regard, George N. Barnard's essay "Taste" may be taken as a usefully representative document. Originally drafted as a paper to be read before a meeting of the New York State Daguerreian Association, "Taste" was published in the May 1855 issue of the *Photographic and Fine Art Journal*. While Barnard was notably eloquent, his ideas were not original. The thoughts he expressed had a long cultural lineage and were familiar to and shared by his fellow photographers.

> Realizing as I do the necessity of elevating the standard of our profession…the time has arrived when it should be rescued from the hands of quacks and charlatans, and…firmly established as a philosophic and scientific pursuit, ministering to the necessities of mankind…

> To be a true Daguerreotypist requires talents of no ordinary character—he should unite virtues and gifts, seldom attainable in their highest rank in the same person, he should be a skillful chemist, profound in natural philosophy, at least that portion embracing the laws of light and the theory of color, and last but not least he should be a cultivated artist…

> From the time of the discovery of the art until a later period the attention of all talented and educated Daguerreans has been almost exclusively engaged in pushing the invention to perfection… And well has the assiduity of our Photographist been rewarded. The art owes scarcely less to the artists of America than to the inventors Messrs. Daguerre and Niepce; for what they conceived in the incipient germ has been cultivated and perfected in America, until American pictures have obtained renown as far as any knowledge of the art extends. Something may be claimed for the natural advantages of our country but their chief excellence must be attributed to the perfection attained by the high skill and superior knowledge of American genius…

> This perfection of manipulatory skill being attained, it is time that Photographists should turn their attention to the knowledge and cultivation of the principles of artistic science, and thus elevate their profession above the merely chemical….

> These…are not the production of accident, but the result of the application of fixed principles; and the attainment of a knowledge of these principles on which are founded a correct taste and artistic skill…

> Without the attainment of this knowledge the Photographist is left to the guidance of his own uncultivated, or perhaps perverted ideas, or falls a victim to the Juggernaut of vitiated public taste.

> "Public Taste," says Ruskin, "as far as it is the encourager and supporter of Art has been the same in all ages. A fitful and vasicating current of vague impression, perpetually liable to change, subject to epidemic desires and agitated by infectious passion, the slave of fashion and the fool of fancy, but yet always distinguishing with singular clear sightedness between that which is best, and that which is worst…; never failing to distinguish that which is produced by *intellect* and that which *is not*…"

> Still fluctuating as taste is, varied though it may be by national education, physical inequalities or in different ages, there are certain well defined laws which, if correctly understood and strictly adhered to, give to the work an intrinsic excellence recognized in all ages, and the violation of which sink the high minded artist into the mere mechanical slave.

> And it is these laws which I would have the Photographist make his unceasing care and study; the practice of them lie all along his path, and in every picture evidence may be given of something nobler than the mere copyist, [something] of the intellectual, cultivated, artistic operator.

> Nor do I mention the consideration of these duties to discourage the zealous, energetic operator…but would encourage him in view of the difficulties already surmounted to persevere and place our art upon that high and ennobling position, when a true Daguerreotypist shall be considered by the world—not as he now is, merely

the mechanical operator with the camera—but the talented artist and educated and devoted man of science.

How little, alas!, does the world know of the toil, the study, the self devotion, the high scientific attainments already expended and now enlisted in the ranks of the Daguerreans. The patient investigation, the devotion, the tireless energy which in any other profession would have made the name of the zealot world renowned, is as it were buried from public appreciation by its very utility to the same public…

What immense aid has not the art of painting and engraving received from the Daguerrean process? How has the multiplication of pictures among the people increased owing to its intervention?…

How much does the multiplication of pictures tend to enlighten and unite the Human family! Read and understood by the infant and the aged; scattered from the hovel of the poor to the palace of the great, it extends a humanizing influence wherever it goes.

And how much of that influence is due to the perfectors of the process…?

Still the Daguerrean must not be satisfied while it yet remains to him to perfect himself in the acquisition of a correct standard of Taste. The acquisition of the graces which unite the True with the Harmonious and Beautiful…

[Fine daguerreotype portraits can] have an intrinsic value even after the name and history is lost. There is a portrait of Martin Engelbrecht, by Van Dyck in the Dresden gallery, of whose history and character everything is lost, and as the beholder stands and admires that noble and almost breathing face he sighs to learn that all that is known is the name upon the back and the signature of the artist. Why is that picture so valuable, so much admired, deprived as it is of all collateral subjects of interest? Solely on account of its own merits; by the soul of intellect stamped upon the canvass by the genius of the Master.

Such genius would I introduce into the art of photography; a genius which discriminates to the mind of the observer between the cultivated and the uncultivated Daguerrean.

In portraiture this cultivation is shown in the depth and power of light and shade; in placing the sitter in the most judicious position, relieving sharp features, emboldening round ones, revealing with exquisite grace the beauties of the elegant form, hiding with adroit skill the inelegancies of the clumsier; varying the light with various complexions, subduing, emboldening, changeful as the sunbeams, but as beautiful in all.

Are these results attainable by every vulgar mind, or does not the art of the Daguerrean receive an additional luster from the skill and cultivation which enables him to produce such pleasing pictures at will? Some one remarked to Gilbert Stuart that he thought the prices for his portraits enormous, considering the limited time it took to make them. "Consider my dear sir," said the artist, "that I have been thirty years in learning how to do it."

Such is the spirit I would hope to see diffused among our artists; the desire not only of grasping the great truths of science and by their agency fastening the shadows as they fall upon the polished plate. But I would see science wedded to Art, with Truth and Beauty as their Handmaids and our profession soaring above the merely mechanical position which it now holds, aspire to a place among the higher branches of employment and the Daguerrean ranked as he deserves among the noble, intellectual and humanizing employments of the age.[152]

On one level, these words were transparently self-serving and self-congratulatory: a group of like-minded professionals praising themselves for their dedication, skill, and cultural importance. In addition, as previously noted, Barnard's comments were part of a larger effort to keep prices high through a form of guild solidarity. Beyond these obvious ambitions, however, his talk touched on a key set of themes: the nature and potentials of the medium itself, the personal traits of the ideal daguerreotypist, the importance of art, and the power of the aesthetic to remake both the self and society.

Barnard's comments were founded on an implicit celebration of the process itself. A shining example of intellectual progress, photography was richly multifaceted in meaning. Through its use of the lens, the camera had much in common with such scientific tools as the telescope and microscope. These optical devices were at once objective and disorienting—they amplified our perception of the real by collapsing space and altering our perception of scale. At the same time, the daguerreotype reeked of alchemy—it was, in some unexplainable way, about the transmutation of vapors into visions, reality into illusion.

These mystical associations were amplified by the cultural legacy of the reflective surface at the heart of the process. As the "Mirror with a Memory," the daguerreotype tapped into the complex associations—moral, representational, and allegorical—of the mirror in Western thought.[153] The mirror lends itself to both truth-telling and trickery, self-knowledge and vanity; it is as varied in potential meanings as the uses to which it may be put.

Just as importantly, photography was based on light and vision: the transformative chemical power of sunshine and the power of sight. Light was a fundamental phenomenon of nature, the subject of (and a critical tool in) the most advanced research of the day. At the same time, light and vision carried rich symbolic meaning. In the history of both faith and philosophy, light was synonymous with perception, understanding, virtue, and presence. In Genesis, the cosmos is "without form and void" until the creation of light—which, in being judged "good," gives coherence to all that follows. In Plato's famous image of the prisoners in the cave, from the *Republic*, human ignorance (a domain of dim, flickering shadows) is contrasted with an ideal realm of factual and spiritual awareness (the almost painful brilliance of daylight).[154]

Variations of such phrases as "divine light" or the "light of reason" are found throughout the history of Western thought. These metaphors carried a powerful duality: vision, the most direct product of light, was both an act and an idea. Indeed, it is but a small semantic move from *sight* to *insight*, *vision* to *visionary*, *image* to *imagination*, *light* to *enlightenment*. This duality had particular resonance in antebellum America—an era that formed its own, unique synthesis of Enlightenment and Romantic ideas.

From the European tradition of Enlightenment—*l'age des lumieres* and the *Aufklärung*—American thought derived a clear set of principles. These included a radical notion of individuality and the celebration of personal initiative; the rejection of aristocratic privilege in favor of a more egalitarian social structure; a celebration of reason and science; a faith in universal laws of nature and human character; the separation of church and state; a rejection of superstitions of all kinds; and an acceptance of the new commercial civilization and its values. Above all, the Enlightenment believed in progress—human and social perfectibility.

On the other hand, the Romantic reaction to Enlightenment values, in the late eighteenth and early nineteenth centuries, stressed the limits of human reason and the values of emotion and intuition.

While the Enlightenment valued science, the Romantics celebrated Art and Genius. While Enlightenment thinkers believed in a universal human condition, Romantic thinkers emphasized cultural particularity—the unique traditions and traits of various "races" or groups. Fearing the tyranny of ungrounded reason or theory, they stressed the lessons of history, the value of custom and tradition. Importantly, however, Romantic thinkers underscored the Enlightenment's emphasis on the individual.[155]

In absorbing and transforming these intellectual traditions, Americans raised individuality to a high level of importance. What mattered most were personal abilities, choices, and actions. Capitalism was founded on the idea of individual enterprise, open markets, and free trade. Democracy rested on the principle of individual equality and worth. Similarly, the religious currents of the day emphasized personal revelation over official church dogma.

In an age seemingly liberated from the bonds of tradition and decree, the highest values were to be found in the human heart: in the collective reservoir of public sentiment and taste. This was a double-edged sword, of course, as Barnard underscored with a quotation from the English critic John Ruskin. Public taste—like human character itself—was a tangle of contradictions. Nonetheless, through discipline and effort, timeless truths could be gleaned from the messy contradictions and temporary passions of everyday life.

It was this deep ocean of shared sentiment that daguerreotypists sought to tap. All of them were in the business of creating optimal likenesses. These images circulated by the millions throughout society as tangible expressions of a personal and cultural ideal. Leading practitioners believed firmly that fine daguerreotypes contributed to this elevating project, while bad ones played to the public's worst inclinations. As a leading daguerreotypist observed in 1852, poor daguerreotypes were an inevitable result of the public's "mania for *cheapness.*" He asked:

> Who can estimate the mischief and wrong perpetuated by thus corrupting and poisoning the popular taste at its very spring?... The daguerrean art, by producing pictures at a rate so comparatively low, as to bring them within the reach of all, would have been the precise instrumentality requisite for developing the sense of beauty and educating the artistic taste of our whole extended people.[156]

These ideas could only have been expressed in an era that remained optimistic about the essential goodness of human nature and the inevitability of social progress.

As a result of these varied conceptual threads, the daguerreotype held a clear political meaning. Less expensive than even the poorest work in oil, the daguerreotype was both advanced and democratic. In this populist climate it was a sign of social progress that fine and instructive works were now being brought "within the reach of all." The daguerreotype was the perfect medium for a young nation dedicated to the principles of pragmatism, opportunity, and improvement. The daguerreotype served a vital dual purpose: it was both an example of, and a means toward, this new society. It was thus doubly appropriate that the daguerreotype recorded the face of America—an awe-inspiring vision of unity-in-diversity, of national pride, dignity, and grace.

Attitudes toward the daguerreotype were, in part, a reflection of attitudes toward the character of the nation itself. American daguerreotypists were engaged in a complex cultural project of "civilizing the machine," in the words of scholar John F. Kasson.[157] This involved both celebrating technology and humanizing it—enjoying the daily benefits of modern invention and commerce while fighting the mechanization of the soul. On the positive side, technology stood for a spectrum of virtues: progress, regularity, harmony, and efficiency. Machines united the truths of nature—universal forces and laws— with the power of human reason, all in the name of a better future.

As a result, an appreciation for the spare beauty of mechanical efficiency arose in the 1840s and 1850s.[158] For example, an ambitious essay on the "Development of Nationality in American Art," in the *Photographic Art-Journal*, observed that the most representative American enterprises—such as shipbuilding—united the skills of both the artist and the artisan. "It is a generally acknowledged fact, that in beauty of form, the American ships are the first in the world… [T]he laws of structural beauty are dependent on a demand for a fitness to the use designed, as well as on abstract beauty of form… simplicity is an important component of beauty." For this unnamed essayist, the aesthetic spirit of the time could only be an expression of its progressive energies. A national aesthetic "does not consist in the establishing of academies or of new rules and canons, nor in new systems of color or light and shade, but in the expression of new thoughts…"[159] Thus, this essay advised American artists to ignore the legacy (or burden) of the artistic past: "There is no necessity to go back, we have everything in this, our day, necessary for its art. Let us express the present in its own terms…" There should be no "deference to false ideals, classicalism, or any other ism except naturalism."[160] And, of course, in many respects, the daguerreotype was the epitome of naturalism.

At the same time, few Americans could truly ignore the legacy of the past or the social prestige of the established arts. Barnard's essay explicitly holds up acclaimed painters as models for his ideal daguerreotypist, and the literature of the day is filled with references to "timeless" principles and values. The larger task was to separate these timeless verities from the social history of European art: its undemocratic association with wealth, power, and idle luxury. While Americans had long been suspicious of the fine arts as a symbol of Old World elitism, by the 1840s the virtues of the aesthetic—of "cultivation" and "taste"—were widely accepted.[161] In essence, the aesthetic was expressed in a peculiarly American dialect: it was naturalized, democratized, and spiritualized. Truth was equated with beauty; aesthetic judgment was seen as a universal human capacity; and art was viewed as a bridge between the realms of matter and spirit.

Inevitably, the daguerreotype was fitted into this complex conceptual framework. It was seen as a radically new kind of art, but one that might serve many of the same cultural ends as the older disciplines. The daguerreotype was both a business and an art—a combination of science and craft, requiring both technical knowledge and aesthetic judgment. It was the perfect expression of the entrepreneurial and democratic spirit of the age, and a means by which the image and taste of the people might be represented, shared, and —ultimately—elevated. It was a technology in the service of ideas— a means of both depicting and transforming the American character.

88 **Unknown Maker**, *Sarah Creighton, Julia Maria, and Harriet Cutler Peet,* ca. 1846-48

89 **Unknown Maker**, *Sarah Creighton, Julia Maria, and Harriet Cutler Peet,* ca. 1855

CHAPTER IV The Face of a Nation

The most prolific American daguerreotypist was "Unknown Maker." Somewhat less than 10 percent of the plates in existence today bear some form of maker's mark. For the rest, any guesses as to possible authorship can only be based on clues within the image itself (a characteristic backdrop, tablecloth, or posing chair, for example) or on the physical package of the work. This chronic lack of information pushes us inevitably toward the notion of a "collective vision." While useful, this concept should not be construed either too literally or too narrowly. Daguerreotypes were produced along a lengthy aesthetic and stylistic continuum, from the most primitive and functional at one end to the most sophisticated and artistic at the other. Far from being determined by a single operative idea, this work was the result of a rich spectrum of ambitions and abilities.

In contrast to the earlier focus on leaders in the profession, this section presents a thematic overview of works that are typically not maker marked. A brief suggestion of the history and importance of portraiture is followed by a discussion of the key genres of the American daguerreotype. The emphasis here is primarily visual—a reminder that, although the categories of daguerreian production may be considered generic, the objects are stubbornly one-of-a-kind creations.

The Cultural Importance of Portraiture

The Portrait Tradition

The style and presentation of daguerreotype portraits owed a considerable debt to existing aesthetic standards and commercial practices, including those of the painted miniature. Although the daguerreotype represented a radical break from the portrait miniature, the two techniques satisfied a common cultural need. Many of the posing conventions of the daguerreotype were drawn from this earlier tradition, and the finished objects are similar in size and presentation. Early daguerreotypes were even placed in cases originally manufactured to hold painted miniatures. The daguerreotype altered and enlarged an existing cultural practice rather than creating an entirely new one.

There was a rich history of portraiture in America before photography.[1] In the colonial era, painted portraits owed much to the British

tradition and were a clear sign of wealth and privilege. Nevertheless, even the Calvinist authorities, who frowned on religious images, encouraged the making and display of portraits.[2] After the American Revolution, the market for portraits grew well beyond society's upper crust as the upper-middle class—merchants, physicians, lawyers, clergymen, manufacturers, and others—commissioned likenesses of themselves and their families. The increasing demand was part of a growing consumer culture as well as a new expression of identity, "an act of self-assertion and cultural aspiration."[3]

The most ambitious portraits had a dual purpose: to convey a "true likeness" and to suggest something of the subject's character and history. These portraits served as both an accurate record of appearance and an idealized summary of a life. The play between these requirements engaged the memory and imagination of each viewer. In his influential 1725 treatise, *An Essay on the Theory of Painting*, Jonathan Richardson wrote:

> The Picture of an absent Relation or Friend, helps to keep up those Sentiments which frequently languish by Absence and may be instrumental to maintain, and sometimes augment Friendship, and Paternal, Filial, and Conjugal Love, and Duty. Upon the sight of a Portrait, the character, and master-strokes of the history of the person it represents are apt to flow in upon the mind, and to be the subject of conversation: so that to sit for one's Picture is to have an Abstract of one's life written, and published, and ourselves thus consigned to Honour or Infamy.[4]

This was a heavy burden of meaning, which paintings conveyed with varying degrees of success. Nonetheless, this idealism flavored the cultural meaning of portraiture throughout the daguerreian era.

With the increased demand for painted portraits, the profession's economic base widened significantly. Many practitioners entered the field and customers were offered renderings of varying quality and price. Upper-middle-class clients typically paid $10 to $20 for painted portraits, the equivalent of a week's wages for a country clergyman in the 1830s.[5] At the most elite end of the scale, portraits could cost $100 or more—the equivalent of half a year's income for a typical farm laborer. There was an obvious difference between works by self-taught itinerants and the finest academic portraits. Cheap paintings were simple in both content and technique: generic head-and-shoulder renderings without fine detail or dimensional modeling.

The most expensive portraits were more carefully conceived and finished: a full-length depiction with details of dress and environment, for example, or an elaborate group portrait.

While the most formal portraits were rendered in large size and in oil, a market developed for simpler painted miniatures, pastels, and silhouette and profile renderings. In the late eighteenth and early nineteenth centuries, portrait miniatures were made in oil or watercolor on surfaces of copper, ivory, enamel, or vellum. The finest examples were highly prized and sometimes as expensive as full-sized portraits in oil.[6] The cheapest portraits were silhouettes and profiles on paper, typically priced at two for twenty-five cents.[7] These inexpensive techniques put portraiture within the reach of even working-class citizens.[8]

The low cost of these works was made possible, in part, by mechanical innovation. By the late eighteenth century, American portraitists were regularly using the camera obscura, as well as both the pantograph (to copy, reduce, or enlarge an existing flat design) and the physiognotrace (to create life-size profiles and silhouettes).[9] While these devices were disdained by some elite artists, their application democratized portraiture by multiplying the number of finished renderings and speeding their production. Physiognotrace operators set themselves up in business in museums, art galleries, taverns, coffee houses, and jewelry and fancy goods shops.[10] Others worked as itinerants, plying their skills from town to town.[11] Like the daguerreotypists that followed them, these enterprising men and women demonstrated a wide range of ability.

The central themes of daguerreian portraiture may be found in this pre-photographic era. Portrait painting began as a relatively elite practice but was transformed by the forces of republicanism, technology, and the competitive marketplace. As elite painters prospered, the popular demand for likenesses provided opportunities for less-experienced artists. An economic hierarchy naturally developed. Artists who made large, expensive paintings were never in direct competition with the makers of profiles and silhouettes: they inhabited different professional worlds. Finally, as a reflection of the pragmatic American spirit, many of these portraitists happily embraced mechanical innovations—including the daguerreotype itself—to aid their work.

After its experimental stage of 1839-40, the daguerreotype caused radical changes in portraiture. It dramatically raised the standard of representational "truth": even daguerreotypists of marginal skill could capture likenesses as accurate as those of the finest painters. As a result, most painters and miniaturists of anything less than the upper rank were put out of business. Notably, however, elite painters were little affected by the daguerreotype.[12] Their expensive renderings occupied a distinct economic niche and were understood to have meanings beyond the merely representational. Americans of the day would have agreed that the daguerreotype was better suited to conveying actual physical appearance than the deeper "history of a person" posited by Jonathan Richardson. However, it was precisely these larger truths that motivated the leading daguerreotypists. The camera made the production of recognizable likenesses easy; the challenge was to make images that, like the finest hand-rendered portraits, transcended physical description alone.

Daguerreian portraiture was informed by a range of visual influences, from the high traditions of academic painting and the marble portrait bust to the simplest folk-art paintings [90] and the imagery of popular prints. However, the portrait miniature provided the most direct model for the daguerreotype. Physically, the two have

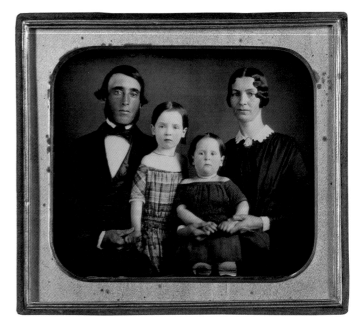

90 **Unknown Maker**, *Family of Four*, ca. 1847-50

much in common: similar in size, they were also matted and cased in nearly identical ways. Both techniques produced intimate and highly detailed images intended to be viewed in the hand. Both have pellucid image surfaces without the weight and texture of oil paint: the pearly luminescence of a miniature on ivory suggests something of the daguerreotype's smoothness and brilliance. Finally, the typical poses of painted miniatures—from simple head-and-shoulders representations to full-figure and group depictions—were routinely replicated in the daguerreian studio.

The finest miniature painters conveyed a memorable sense of presence and character, visual fact and inner depth. This level of achievement took unusual skill, however. Less talented painters produced flat, generic likenesses with too little factual grit to suggest a living being. By comparison, the most ordinary daguerreotypes accomplished that basic task with ease.

A comparison is instructive: painted miniatures and a daguerreotype of the same subjects, a Dr. and Mrs. Thomas Epps Wilson, from North Carolina [91-93]. The painted depictions are of moderately high caliber: they convey a clear sense of "likeness," but little of character. On the other hand, Montgomery P. Simons's three-quarter plate is all nuance and psychological depth—beginning with the young wife's hint of melancholy and the husband's dry reserve. The young wife is seated slightly forward of her spouse; she looks away from him at the camera, while he glances sidelong toward her. A complex psychological space is created: observer and observed are squeezed tightly together, while remaining distinctly "apart." The dark and generous surrounding space emphasizes their physical presence, from head to ankle, while hinting at this emotional constraint. Ultimately, this couple is vastly more *real*—both physically and emotionally—in the daguerreotype than in their painted miniatures.

Of course, as a generic comparison of the merits of painted miniatures and daguerreotypes, this example is not entirely fair. These miniatures are by an unknown artist of good ability, while Simons was a daguerreotypist of exceptional talent. Nonetheless, this comparison highlights something of the difference between the techniques. Dollar for dollar, customers had good reason to expect vastly superior results from photographers than from painters. It

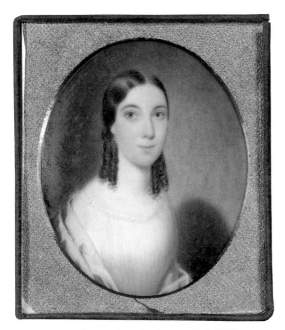

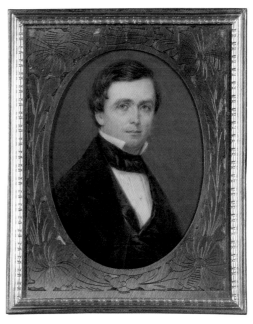

91 **Unknown Maker**, *Portrait of Janet Mitchel Wilson*, ca. 1845

92 **Unknown Maker**, *Portrait of Thomas Epps Wilson*, ca. 1845

also suggests that, in the right hands, the daguerreotype was capable of far more than a simple likeness.

While the cultural prestige of painting ensured a continuing market for elite hand-rendered portraits, most Americans happily embraced the new process. In 1927, historian Harry B. Wehle observed: "The [painted] miniature in the presence of the photograph was like a bird before a snake: it was fascinated—even to the fatal point of imitation—and then it was swallowed."[13] The daguerreotype did not kill the miniature outright. Miniature painting accommodated itself to Daguerre's process and ultimately outlived it. Miniaturists happily worked from daguerreotypes—using them as studies or source material—and then became adept at painting over photographs.[14] The associations of the miniature—its "aura of aristocratic lineage and timeless beauty"—ensured that it would survive for some time in an elite economic niche. Indeed, a handful of miniature painters found abundant work through the end of the nineteenth century, long after photographers had discarded their sensitizing boxes and mercury pots.[15] By that time, of course, subsequent photographic technologies had returned the painted portrait to its original economic niche: the choice of a small, but wealthy clientele.

Illustrious Americans

From at least the time of the American Revolution, Americans sought a sense of collective identity in the achievements of their most notable citizens.[16] Too young to have a genuine history, the new nation sought a form of "civic spirituality" in the example of its military, political, and religious leaders.[17] The effort to create a literary and visual "National Portrait Gallery" began early and was repeated by many.

In the first half of the nineteenth century, Americans suffered from a "Biographical Mania."[18] George Washington was the subject of a number of biographies, including Parson Weems's *Life of George Washington* (1808), which set the standard for an enduring, if uncritical, popular study of a celebrated life. This was followed by narratives of many more individual lives and collections of biographical profiles. This trend reached its peak in the daguerreian era: at least ten times more biographies by and about Americans were published

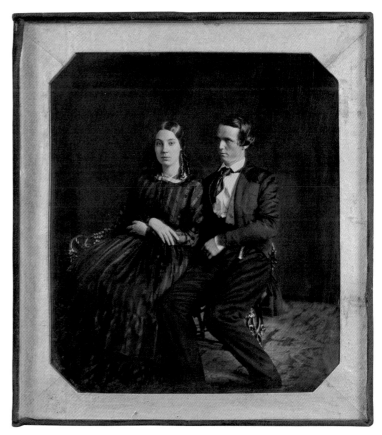

93 **Montgomery P. Simons**, *Thomas Epps Wilson and Janet Mitchel Wilson*, ca. 1847

from 1840 to 1860 than from 1800 to 1820.[19] One of the defining achievements of the era was Jared Spark's twenty-five-volume *Library of American Biography* (1834-48), the first definitive national biography based on documentary evidence.[20]

The nature of this writing evolved considerably in these years. Nationalistic and didactic, the earlier biographies aimed to edify and inspire the reader. This idealism is suggested in "Uses of Great Men," the lead essay of Ralph Waldo Emerson's *Representative Men: Seven Lectures* (1850):

> It is natural to believe in great men… Nature seems to exist for the excellent. The world is upheld by the veracity of good men. They make the earth wholesome. They who lived with them, found life glad and nutritious. Life is sweet and tolerable only in our belief in such society… We call our children and our lands by their names, their names are wrought into the verbs of language, their works and effigies are in our houses, and every circumstance of the day recalls an anecdote of them.[21]

The contemplation of the good and great was understood to be naturally elevating: it improved individual character and strengthened a collective sense of identity.

This civic and republican emphasis was modified by the forces of democracy, individualism, and the free market. The earlier focus on the virtuous, the patriotic, and the pious broadened to include the prosperous. Between 1830 and 1860, many biographies appeared of merchants, "mechanics," and other self-made men. The didactic impulse remained—these studies underscored the virtues of industry, persistence, and temperance—but the terms of success were now broadened to include social and commercial achievement.

A more inclusive vision of the biographical subject developed accordingly. Studies such as *Women of the American Revolution* (1848-50) and *The Colored Patriots of the American Revolution* (1855) expanded the perspective of earlier historians. In addition to captains of industry, more humble tradesmen were honored in studies such as *Lives of Distinguished Shoemakers* (1849).[22] By the 1850s, the American public was given access to an astonishing range of published lives, from reverential studies of leaders to breathless accounts of criminals and rogues. The result was a more complex notion of what it meant to be famous—and to be American.

Pictures and works of art had an important place in this new culture of biography and celebrity. As early as 1780, the artist Charles Willson Peale began collecting portraits of Revolutionary War heroes. In the 1820s, sculptor John Brouwere began assembling a collection of plaster portrait busts of American leaders and heroes.[23] The spread of printmaking in the early nineteenth century helped democratize this taste for patriotic images. Beginning in the late 1810s, several illustrated projects were undertaken, including Joseph Delaplaine's *Repository of the Lives and Portraits of Distinguished American Characters* (1816-18), John and Joseph Sanderson's *Biography of the Signers to the Declaration of Independence* (1820-27), James B. Longacre and James Herring's *National Portrait Gallery of Distinguished Americans* (1833-39), and William H. Brown's *Portrait Gallery of Distinguished American Citizens* (1845).[24] These were lavish, arduous, and generally unprofitable ventures. Many other such works followed, with only the cheapest achieving any real success. The lesson was relatively clear: images intended for a mass audience had to be priced accordingly.

While deluxe illustrated volumes rarely turned a profit, a strong market developed for individual portrait prints. As historian Wendy Reaves has observed, "The lithographed likeness was the parlor ornament, souvenir, T-shirt, and bumper sticker of its day. Every group wanted its portrait-emblems—the congregation, its minister; the cause, its martyr; the organization, its spokesman; the audience, its idol."[25] These were made in prodigious numbers. In 1849, for example, it was reported that a leading firm in Hartford, Connecticut, was making 3,000 to 4,000 prints per day, with sales to date of "more than 100,000" of its best-selling design (a portrait of Washington).[26]

Beginning in the early 1840s, daguerreotypists attempted to cover this same nationalistic and commercial ground, an effort that led to a close alliance between photography studios and the printing industry.[27] Edward Anthony was the first photographer-entrepreneur to explore this market. With his partner, Jonas M. Edwards, and operator, Victor Piard, Anthony worked extensively in Washington, D.C., between 1842 and 1844. The firm made portraits of every member of Congress and of dozens of other national figures, from Samuel F. B. Morse to John J. Audubon. This project had official sanction: Senator Thomas Hart Benton allowed the team to set up their camera in a Senate committee room. Anthony offered free portraits to his sitters for the right to sell copies of the plates he retained. This collection was presented in Anthony's "National Miniature Gallery," at 247 Broadway in New York. This display, which comprised almost 400 portraits by 1844, was the first large collection of photographs of American notables.[28]

In addition to selling copy daguerreotypes of these plates, Anthony produced and marketed print facsimiles. In fact, most of Anthony's profit from this venture appears to have come from the sale of individual engravings and the inclusion of his images in the *United States Magazine and Democratic Review*. This work culminated with the production of a 32 x 40-inch mezzotint engraving titled *The United States Senate Chamber*, depicting Henry Clay delivering his farewell address. This elaborate group portrait—the work of artist James Whitehorne and engraver Thomas Doney—included the faces of ninety-seven persons, all based on daguerreotypes. Published in at least two versions, in 1846 and 1847, it appears to have been relatively popular.[29] After changing hands several times, most of Anthony's original daguerreotypes were destroyed in a fire in 1852.[30]

This pattern of collecting notable portraits, putting them on public display, and marketing print facsimiles was followed by other daguerreotypists. John Plumbe clearly recognized the value of nationalistic subjects. In 1846, he began a project to daguerreotype all the major federal buildings and monuments in Washington, D.C., and to exhibit them in his gallery in that city. In the same year, he began collaborating with engraver Thomas Doney to make mezzotint prints of his portraits of statesmen; many of these were included in the *United States Magazine and Democratic Review*. Plumbe worked with several printmakers, including Nathaniel Currier, to sell lithographic versions of his celebrity images.[31] In 1846, Plumbe set up his own National Publishing Company to increase the circulation of his most significant images. The subjects of his lithographic portraits—which were typically called "Plumbeotypes"—included former presidents John Quincy Adams and Martin Van Buren, and senators John Calhoun and Sam Houston.

Mathew B. Brady was attracted to political power and the aura of celebrity from the start of his career. In 1849, when he traveled to Washington, D.C., for the presidential inauguration, Brady announced his intention to establish a gallery of portraits "of every

distinguished American now living."[32] By 1850 the display in his New York gallery was acclaimed as the finest of its kind. He wasted no time exploring the market for lithographic prints from these daguerreotypes: in 1849, he published a print of President Zachary Taylor and his cabinet drawn by the artist and lithographer Francis D'Avignon. This collaboration resulted in an official partnership between Brady and D'Avignon in 1850, and the start of an ambitious twenty-four-part subscription series titled *The Gallery of Illustrious Americans*, with lithographic portraits of Taylor, John C. Calhoun, Daniel Webster, Henry Clay, John C. Frémont, John James Audubon, and others.[33] Despite its high quality, the work was a financial failure; only twelve lithographs were issued, and the partnership between Brady and D'Avignon did not survive the year.[34]

While these grandiose projects appeared destined to fail, there was a natural and productive alliance between the daguerreotype studio and the print industry in the late 1840s and 1850s. For example, the prolific lithographer Albert Newsam, of Philadelphia, made prints from daguerreotype portraits by many of the city's leading studios, including those of Robert Cornelius, Montgomery P. Simons, the Langenheims, the Collins brothers, Marcus and Samuel Root, McClees & Germon, Samuel Van Loan, and Samuel Broadbent.[35] In addition to his work with Brady, Francis D'Avignon made portrait prints based on daguerreotypes by Jeremiah Gurney, Martin M. Lawrence, Philip Haas, Meade Brothers, Samuel Root, Augustus Morand, and others.[36] D'Avignon also made the lithographic portraits of daguerreotypists used by Snelling as frontispieces to various issues of the *Photographic and Fine Art Journal*.[37]

Daguerreotypists responded directly to this popular fascination with celebrities. Every leading studio was a public portrait gallery. In addition to oil paintings and prints of famous personalities, reception rooms typically featured daguerreotypes of local, national, and international notables. The plates of regional figures would have been the work of the gallery in which they were displayed. For example, William A. Pratt, of Richmond, achieved considerable attention for his portrait of the Virginia governor and other "distinguished men of that State."[38] Figures of national or international renown were often represented in plates that had been purchased or copied.

Leading daguerreotypists vied for the prestige of having celebrities sit for them. In the course of her lengthy American tour of 1850-51, for example, Jenny Lind posed for an uncounted number of daguerreotypists, from Mathew B. Brady and Samuel Root in New York, to John H. Fitzgibbon [68] and Enoch Long in St. Louis. These photographers proudly displayed the resulting plates in their own studios and made copies to sell. The price of these copy plates followed the law of supply and demand. At the beginning of Lind's tour, daguerreotypists were reportedly charging up to $25 for her likeness.[39] By its end, Frederick De Bourg Richards was advertising copies of his most acclaimed exposure of the singer at considerably more reasonable prices: sixth-plates at $2, quarter-plates at $4, and half-plates at $6 apiece.[40]

Daguerreotypists and celebrities came to a mutually beneficial understanding. In exchange for an hour of their time and a portrait or two to take with them, personalities like Jenny Lind garnered local publicity and goodwill. The chosen daguerreotypists gained bragging rights over their less-favored local rivals and stood to profit from the sale of their images.

On at least a few occasions, however, the frenzy of this ritual became unseemly. Louis Kossuth, the famed Hungarian nationalist, was besieged by requests from daguerreotypists during his tour of the United States in 1851-52. Kossuth agreed to sit for some, but turned many more away—an action applauded by the editor of *Humphrey's Journal*:

> We must give nine cheers for Louis Kossuth—and why? Because he has more respect for the Daguerreotype art than many of the Daguerreians themselves! In other words, he said No to a horde of supplicating Photographers, whose minds were intent to make a few almighty dollars, even at the sacrifice of that high character which should hold sway over every disciple of DAGUERRE. It is obvious to every individual that may be called upon, and urged to sit for a portrait, that it is to make capital of, and we feel much pleased with the Hungarian Governor's answer—"I am fearful it is for a speculation, to which I cannot consent."
>
> … It is no uncommon saying by our first men, that they "wish there was no such discovery as Daguerre's," for it is so annoying that it is impossible to go to New York, Boston, or Philadelphia without being tormented by a dozen invitations to sit for a Daguerreotype likeness—this we heard from a gentleman who, during a stay of a single day in this city, received no less than TWENTY-ONE "very polite invitations" to allow the *artist* "the gratifying pleasure of adding a portrait of his most honorable sir to their collection."[41]

Of course, few subjects expressed Kossuth's qualms about the public traffic in these images. The result was a steady circulation of likenesses of nearly everyone of public interest. In addition to the portraits of noted subjects reproduced in an earlier chapter, "Leaders in the Profession," the following unattributed works underscore the varieties of antebellum celebrity.

A career soldier, Zachary Taylor [94] came to national prominence for his role in the Mexican War. Chosen by the Whig party as its presidential candidate in 1848, "Old Rough and Ready" defeated the Democratic nominee, Lewis Cass. Taylor's tenure as president was short and stormy: his cabinet was beset by scandal and the nation was torn by the debate over slavery. Despite his own status as a Southerner (and a slave-holder), Taylor was an ardent nationalist and faced down a threat of secession in early 1850. He died suddenly in July of that year, succeeded by his vice president, Millard Fillmore. The extant daguerreotypes of Taylor all appear to date between about 1847 and 1850. This may be a copy plate of one of the earliest of these depictions, made ca. 1847-48.[42]

The political career of Charles Sumner was spurred by the abolitionist fervor of the early 1850s. A Harvard-trained scholar, Sumner was cultured and dignified—he stood over six feet tall and exuded a sense of aristocratic grandeur tinged with melancholy. He was a highly polarizing figure: he rallied Northern activists to the abolitionist cause and enraged Southerners. Sumner's most provocative speeches, on May 19 and 20, 1856, resulted in a personal attack on the floor of the Senate by Representative Preston Brooks of South Carolina [C-101]. Brooks beat Sumner savagely on the head and shoulders with a gutta-percha cane, making him an immediate martyr to the Northern cause. While the maker of this half-plate [95] has not been established, it could well have been either Southworth & Hawes or John A. Whipple.[43]

Few understood the power of the photograph as well as Frederick Douglass, the brilliant and charismatic advocate of African American rights. Douglass was one of the most photogenic figures of the age: he had a commanding physical presence, majestic features, and a penetrating gaze. He enthusiastically embraced the objectivity of the

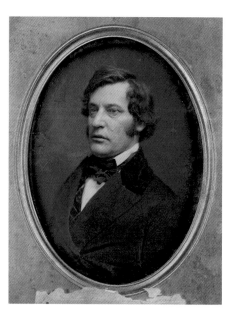

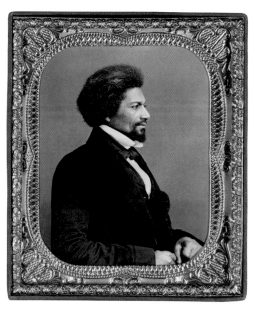

94 **Unknown Maker**, *Zachary Taylor*, ca. 1847-48

95 **Unknown Maker**, *Charles Sumner*, ca. 1854

96 **Unknown Maker**, *Profile Portrait of Frederick Douglass*, ca. 1858

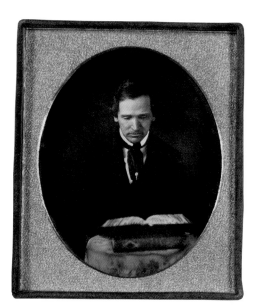

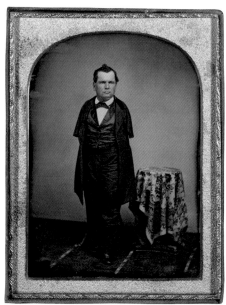

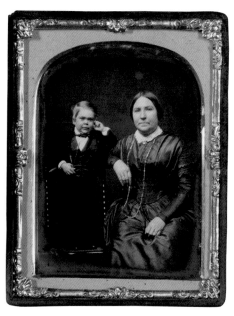

97 **Unknown Maker**, *Elihu Burritt Reading*, ca. 1845

98 **Unknown Maker**, *Saunders K. G. Nellis*, ca. 1850

99 **Unknown Maker**, *Tom Thumb and his Mother*, ca. 1850-55

daguerreotype—he saw it as a natural tool of social justice, a means of defeating prejudices and misconceptions.[44] He said: "Poets, prophets, and reformers are all picture makers—and this ability is the secret of their power and of their achievements. They see what ought to be by the reflection of what is, and endeavor to remove the contradiction." On another occasion, he ventured that "the moral and social influence of pictures" was more important to the quality of national culture than "the making of its laws."[45] Douglass found the clarity and affordability of such images inherently liberating. On a depiction of Hiram Revels, the first African American senator, he observed: "Pictures come not with slavery and oppression, but with liberty, fair play, leisure, and refinement."[46] Accordingly, Douglass used photographs of himself to project a new image of African American strength and sophistication. This previously unrecorded sixth-plate [96] represents him in an iconic profile view.

Elihu Burritt was a uniquely American type: the working-class scholar. The son of a shoemaker, Burritt was employed for years as a blacksmith. Intelligent and idealistic, he was hungry to learn. He taught himself several languages—according to legend, he studied Greek grammar while working at the forge—and became a noted writer and public speaker. Burritt was devoted to the causes of abolition, temperance, world peace, self-culture, and the dignity of the working man. This depiction, showing him in thoughtful study, captures the essence of the man [97].

At the other end of the spectrum of celebrity were the novelty acts and "freaks" of P. T. Barnum. The greatest showman of the nineteenth century, Barnum dazzled his audiences with oddities, animals, illusions, and performers. On any given day, visitors to his American Museum saw ropedancers and glassblowers, ventriloquists and jugglers, trained chickens and a 20-foot python, and much more.[47] Barnum's enterprise was both new and deeply American: entertainment as spectacle in an age of advertising and mass media.

Barnum's attractions ranged from the high culture of Jenny Lind to, in his own words, "all that is monstrous, scaly, strange and queer."[48] Born without arms, Saunders K. G. Nellis [98], had developed an astonishing facility with his feet and toes: he could load and fire a pistol, shoot a bow and arrow, wind a watch, play musical instruments, and cut silhouette portraits. Charles Sherwood Stratton joined Barnum at the age of only four, in 1842, when he took the stage name Tom Thumb. By the time of his 1844 European tour, he was an international celebrity. Tom entertained his audiences in amusing skits dressed as characters such as Hercules and Napoleon. This portrait with his mother [99] presents him as a sober and prosperous young man rather than as any one of his stage characters.

Many of Barnum's exhibits were purely sensational: they veered far from any genteel notion of education and moral betterment. However, subjects such as Mr. Nellis and Tom Thumb embodied important aspects of the ideology of uplift. These young men were understood to have overcome handicaps to achieve social and financial success. As untraditional as their careers might have been, their lives confirmed an American faith in self-improvement.

Pictures and Things: The Human Artifact

The daguerreotype portrait had deep cultural meaning. It drew on the traditional associations of elite portraiture while exemplifying the new virtues of democracy, individualism, and the entrepreneurial economy. Daguerreotype portraits were understood both factually

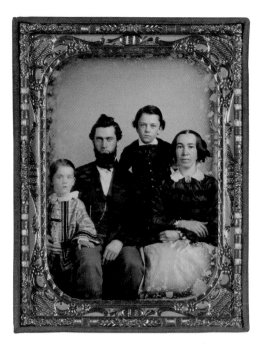

100 **John A. Keenan**, *Family Group with Wife Wearing Daguerreotype Pin of Husband*, ca. 1855

and symbolically, as records of the present and as mementos for future generations. They commemorated lives and were themselves an integral part of daily life.

Given their moderate cost, it was not uncommon for daguerreotypes to be made of a person or family at reasonably regular intervals. Some photographers emphasized this time-keeping function by employing a consistent compositional structure. For example, two quarter-plates, made roughly seven or eight years apart, depict three sisters in precisely the same arrangement [88, 89]. These images register both change and continuity: children have grown into women, but the matching compositions speak to the constancy of familial bonds.

The great majority of daguerreotype portraits were family pictures, intended to be kept and viewed in the home. Most were understood as deeply personal artifacts—talismans as much as mere representations. The personal meaning of these pictures was underscored in many ways, including a sometimes literal connection to the body. Daguerreotypes were routinely used in jewelry.[49] Images of small size (often reduced copy plates) were incorporated into bracelets, buttons, earrings, necklaces, pendants, pins, stickpins, rings, and lockets. These were not articles of everyday use, but were worn on "dressy" occasions. This daguerreotype depicts a family group in which the wife wears a daguerreotype pin of her husband [100].

An even more intimate union of body and emblem was achieved in the daguerreian-era fad for the decorative use of human hair.[50] It was not uncommon for daguerreotype pins or brooches to include locks of their subject's hair. The emotional weight of the image was thus powerfully augmented: the virtual presence conjured by the photograph was amplified by the aura of the bodily fragment. Hair is both delicate and enduring: a happy metaphor for a subject who might well be distant or deceased. More elaborately, daguerreotype portraits were affixed to bracelets woven from the hair of their subjects [C-52]. These, too, were viewed as commemorative objects to be worn on special occasions [C-53].

These practices were part of a larger, conceptual aspect of daguerreian portraiture: the play between the virtual and the physical,

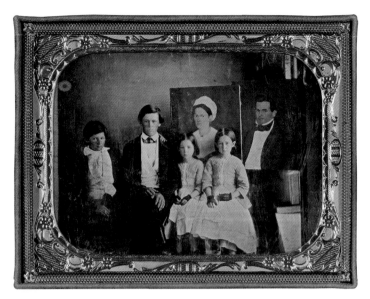

101 **Unknown Maker**, *Family Group (children with painting of parents)*, ca. 1855

102 **Unknown Maker**, *Man Posed with Painting*, ca. 1850

103 **Unknown Maker**, *Man and Woman with Painting of Man*, ca. 1850

image and reality. What did these pictures mean to viewers? How were they understood to "represent" their subjects? A particular category of daguerreotype portraits—subjects posed with painted likenesses—may provide a few partial answers [101-103]. These photographs present a curious representational realm: reality and image are combined in a new and ontologically more complex representation. These daguerreotypes record the interaction between living subjects and pictures. Significantly, the relationship we perceive *within* these daguerreotype images is recapitulated in the experience we have looking at them. In both cases, we are profoundly aware of the picture as an inanimate artifact: life becomes still-life, a perceptual moment is frozen in pictorial amber.

Some may be tempted to describe these images as "naive," as if the subjects within the frame did not understand the difference between people and pictures. But this would be both false and unfair. The people depicted here were fully aware of their engagement in two intimately related acts—extending the life of existing representations and collaborating in the production of new ones. Instead of a naiveté about the nature and meaning of pictures, these images suggest a rich and generous understanding.

It became relatively common for daguerreotypes themselves to be included in daguerreotype portraits [104-106]. With endlessly varied inflections, these images convey a dual message. On one hand, the absent person is represented symbolically—given fresh and relatively lasting pictorial life. On the other, we as viewers are reminded of the memorial function of every daguerreotype; the people honoring the memory of departed family members are now themselves long dead.

Ultimately, this genre of the picture-within-a-picture reminds us of the conceptual and emotional complexity at the heart of daguerreian portraiture. Daguerreotypes were bound up in a deeply personal process of remembrance and association. Far from simple records of fact, they had aspects of the talisman, emblem, or icon—images saturated with memory and meaning.

High and Low: The Aesthetics of Portraiture

Practically speaking, to be a daguerreotypist was to be a portraitist. Portraiture was the heart and soul of the profession and most daguerreotypists did little else. After a basic mastery of technical manipulations, a photographer's most important skills lay in lighting and posing his subjects. The most ambitious practitioners used this knowledge to suggest qualities beyond the obvious—something of character, spirit, and the Ideal.

Daguerreotypists were masters of a new technique, but they worked in a traditional pictorial discipline. Portraiture had a long and honored history, beginning with the example of the Greeks and Romans. Historically, portraits served a variety of functions, including the representation of claims to immortality, the display of social status, and the assertion of power. In the service of these aims, portrait painting developed a sophisticated visual and symbolic rhetoric. The full-length standing portrait was identified with sovereigns, for example, while other social positions, "such as the high-ranking cleric, the military leader, the prince, the scholar, and the beautiful woman, became associated with distinctive portrait formats, attributes and even pictorial languages."[51] Painters developed a representational vocabulary to convey all manner of personal qualities, from dignity, privilege, and authority to devotion, wit, and melancholy.

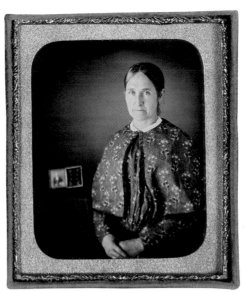

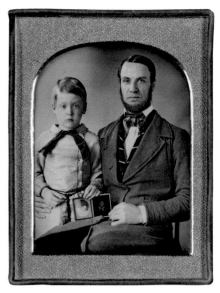

104 **Unknown Maker,** *Jerusha Forbes Holding a Daguerreotype*, ca. 1848-50

105 **Unknown Maker,** *Woman with Daguerreotype of her Husband*, ca. 1850

106 **Unknown Maker,** *Father and Son with Postmortem Daguerreotype*, ca. 1850

Everything in this pictorial world—stance, gesture, gaze, costume, props—had significance.

Certainly, there were daguerreotypists who gave little thought to such matters, aiming simply to make pictures that would sell. However, many practitioners did absorb elements of these artistic traditions, both consciously and intuitively. Earlier styles and formats, such as the medallion or cameo profile, were reiterated precisely in the daguerreotype studio [**107**]. Likewise, certain poses paid clear artistic homage to classical prototypes. For example, Lilbern W. Keen's portrait of Reverend Steel [**65**] directly recalls the motif of the Roman commander or orator.[52]

More subtly, photographers developed different approaches for common sixth-plate portraits than for half- or whole plates of their wealthiest subjects. The latter images drew from the symbolic rhetoric of elite or aristocratic painted portraits. These larger daguerreotype plates often showed more of the sitters' figures (three-quarter-length views instead of simple head-and-shoulder depictions, for example) and were more complexly orchestrated, with a greater emphasis on props and pictorial space itself [**108**].

Most importantly, daguerreotypists did not merely inherit this representational code: they transformed it. In effect, the camera loosened, flattened, and democratized the symbolic language of the painted portrait. The subjects of inexpensive plates could be portrayed in full-length standing poses, if they so desired. Rural families could be recorded in front of elegant painted backdrops, and an illiterate child could be depicted in the pose of the scholar, with one hand on a thick tome. Traditional representational codes were further eroded by the daguerreotype's inherent objectivity. The most elegant lighting and props could not disguise the fact that some wealthy men were physically unimposing, while the commanding presence of a tailor, blacksmith, or slave might be conveyed in even the simplest studio arrangement. The daguerreotype could be orchestrated to reflect notions of social status—but only within the limits of the process itself. The daguerreotype had the democratic virtue of reflecting every subject with equal brilliance.

Beyond such transformations of an inherited representational code, the new visual language of the camera produced images of unprecedented candor and spontaneity [**C-54, 109-111**]. Images such

107 **Unknown Maker,** *Young Woman in Profile*, ca. 1850

as these are difficult to imagine in painted form—they are too casual and quirky. These were made possible by the rapidity of the photographic process, the relatively low cost of the finished plates, and their makers' pragmatic, no-frills approach. Many of these aesthetically "raw" images were made of the youngest subjects: infants and children presented a notorious challenge to daguerreotypists. In the case of the youngest babies, photographers preferred their subjects asleep [**112**] or rendered immobile as artfully as possible [**113**].

Children slightly older than this could present an even greater problem because they were both more active and more fearful. In this vein, there is a genre of daguerreian portraits with no painterly parallel: the child with a hidden or intruding parent [**114-117**]. The impetus for these images is clear: some children could only be coaxed into posing by the comforting presence of a parent.

These often whimsical pictures underscore the difference between photography and painting. These are purely photographic: they record what was there to be seen. While comparable events may well have occurred in painters' studios, it is inconceivable that artists would have chosen to record such odd or extraneous details.

108 **Unknown Maker**, *Three Children at a Table*, ca. 1843-45

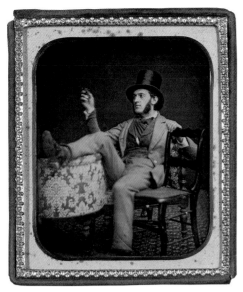

109 **Unknown Maker**, *Man in Casual Pose*, ca. 1850

110 **Unknown Maker**, *Woman with Two Shy Children*, ca. 1850

111 **Unknown Maker**, *Boy and Dog*, ca. 1850

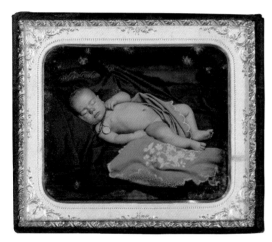

112 **Unknown Maker**, *Sleeping Baby*, ca. 1855

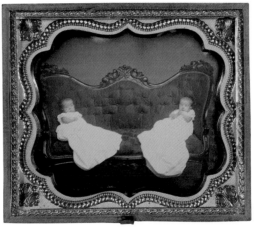

113 **Unknown Maker**, *Twin Babies in Christening Gowns*, ca. 1855

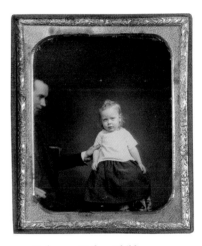

114 **Unknown Maker**, *Child (father reaching into frame)*, ca. 1850

115 **Unknown Maker**, *Portrait of a Girl (father at edge of frame)*, ca. 1855

116 **Unknown Maker**, *The Human Head Clamp*, ca. 1850

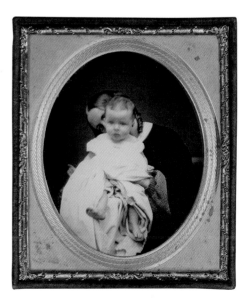

117 **Unknown Maker**, *Baby with Hiding Mother*, ca. 1855

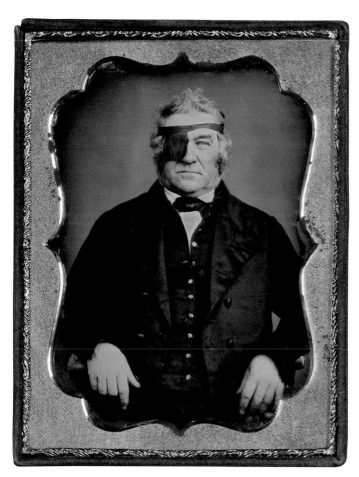

118 **Unknown Maker**, *Portrait of Obed Hussey*, ca. 1850

119 **Unknown Maker**, *Girl Showing Pantaloons*, ca. 1850-55

Painting is a synthetic enterprise, while photography deals with factual contingencies. These images, at once amusing and "modern," remind us of a basic virtue of the lens: its inability to impose value judgments. Such judgments were the responsibility of the photographer and—while we now embrace the "primitive" charms of such pictures—it is well to remember that the daguerreotypist's characteristic impulse was to rise above such "merely" optical records.

The portraitist's most immediate tasks lay in lighting and posing his subjects. The mechanics of lighting involved moving the camera and posing chair around the studio space, and adjusting reflectors and overhead baffles in order to take best advantage of the day's light. The goal was a clear, mellow light—one that both defined and caressed the sitter. As Marcus A. Root noted in *The Camera and the Pencil*,

> Care should be used that the light be not brilliant or dazzling, but mild and soft, as well as clear, and so falling as to make well-defined, transparent shadows, especially under the brows, nose and chin. The "high lights" should be distinctly located on the forehead, nose, cheeks, and chin; and broad, flat lights and shadows avoided. The high lights, the shadows, and the middle tints should be, especially on the face, in perfect harmony.[53]

This ideal of tonal harmony, from transparent shadows to luminous highlights, was reiterated by every major figure of the day. In 1852, Albert S. Southworth observed: "Shadows as well as lights are required to represent forms, not in patches of black on white, but transparent, gradually softening and blending lights in a warm, mellow tone, giving forms and features in proper proportion."[54]

The next step, posing, held the potential for a nearly endless range of interpretive and stylistic choices [118-121]. Was the subject to be recorded in a simple head-and-shoulders likeness or a broader three-quarter or standing pose? What constituted the "identity" to be recorded: the face alone or the entire figure? How much emphasis was to be placed on costume or the particularities of glance and gesture? Did the subject have a better side? How could appealing features be emphasized and less attractive ones minimized? How could the subject be coaxed into helping create an alert and vibrant likeness rather than a dull and inert one? The answers to such questions could only be found in the individual eye and the judgment of the daguerreotypist.

Beyond a consideration of the face and figure, daguerreotypists often employed props to enliven the image or to suggest something of the sitter's character. Every studio had such basic props as end tables, books, and vases of flowers. Some of the best portraits of children include what might well have been the subjects' own toys [122-124]. In other instances, props were used in ways that strike us today as either incongruous [125] or mysterious [126]. Is the image of the man with a model ship an "occupational" portrait? Was he a model maker or sea captain, or is the object simply evidence of a hobby? The daguerreotype alone cannot tell us.

While every sitter presented problems to be solved, the task became more complex with groups. With multiple subjects, the photographer sought to accomplish at least three things: to record each person at their best, to convey a sense of connection or sympathy between them, and to create a unified pictorial whole. This was a true test of a daguerreotypist's ability. Various solutions to the problem of the paired portrait are illustrated in the four works reproduced here. One [128] is a relaxed and spontaneous image of a brother and sister standing at a window. The domestic nature of the setting nicely underscores the naturalness of their embrace. The second work is

120 **Unknown Maker**, *Dr. Rowland Greene*, ca. 1850-55

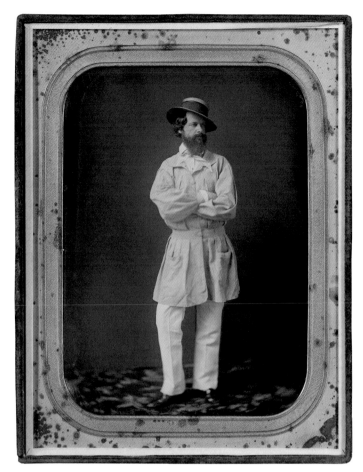

121 **Unknown Maker**, *Standing Artist*, ca. 1850

an unusually poetic pose [**127**]; arms entwined, these sisters appear deeply lost in thought. The result is a particularly successful union of fact and spirit, the real and the ideal. A flawless half-plate [**C-55**] presents a haunting view of a seated woman and standing child. There are no props or background details to distract from the essence of the image—faces, body language, and dress. Another half-plate, at once charming and visually dynamic, makes brilliant use of a studio prop [**129**].

This mesmerizing portrayal of two young sisters [**130**] is one of the most sublime portraits of the daguerreian era. The mood is one of poetic introspection: the girls are united by physical proximity, but they look past one another and occupy distinctly individual mental realms. The figures convey a brooding thoughtfulness; the image's theatrical air only emphasizes this state of intense inwardness. Curiously, this image has at least as much in common with later aesthetic currents—the allegorical work of Julia Margaret Cameron in the 1860s and 1870s, for example, or of the Pictorialists in the first decade of the twentieth century—as with any genre of daguerreian work.

Every daguerreotypist had the ability to deal with larger groups, but some did so more often and more imaginatively than others. Southworth & Hawes, Jeremiah Gurney, and Montgomery P. Simons, for example, all made superb renditions of families and groups. One of the most remarkable group portraits of this era [**131**] depicts six women—probably sisters or members of an extended family. The composition is as intuitive as a jazz solo and as solid as a stone wall. No two figures are posed identically: each leans, glances, and connects with her companions in a distinctive way. The result is a poetic balance of both individual and collective identity.

The most ambitious daguerreotypists sought to make likenesses that were more than simply objectively true. They sought a Platonic, ideal likeness in each sitter: the suggestion of a universal human beauty or grace. On one level, this might be regarded merely as an effort to flatter. Indeed, some recent historians have been dismissively critical of what they view as the vacuous "sentimental ideal" of this era.[55] Historically and conceptually, however, the roots of this desire for beauty, harmony, and grace run deep.

Given the currency of such Platonic ideas, it is not surprising that American culture of this period was heavily indebted to the classical tradition. Britain had become enthralled by Greek art and society in the late eighteenth century, and this enthusiasm made its way across the Atlantic.[56] In American architecture, a devotion to neoclassicism turned into a full-blown Greek Revival by about 1820. In the following decades, classical culture exerted a marked influence on many facets of American society, from higher education to popular fashion.[57]

This enthusiasm for Hellenism included a new reverence for Greek sculpture. In 1755, Johann Joachim Winckelmann—the father of modern art history—published *Reflections on the Imitation of Greek Works in Painting and Sculpture*. This influential text set the tone for much of the artistic discussion of the early nineteenth century. Winckelmann's argument for the timeless value of Greek sculpture was founded on Platonic principles.[58]

> In the masterpieces of Greek art, connoisseurs and imitators find not only nature at its most beautiful but also something beyond nature, namely certain ideal forms of its beauty, which…come from images created by the mind alone…

122 **Unknown Maker**, *Girl with Doll*, ca. 1848-50

123 **Unknown Maker**, *Boy with Bow and Arrow*, ca. 1846-48

124 **Unknown Maker**, *Child with Building Blocks ("The Master Builder")*, ca. 1850

125 **Unknown Maker**, *Young Boy at Table with Marble Statue*, ca. 1850

126 **Unknown Maker**, *Man with Model Ship*, ca. 1850

127 **Unknown Maker,** *Two Girls,* ca. 1850-55

128 **Unknown Maker,** *Fitzhugh and Helen Ludlow,* ca. 1846-48

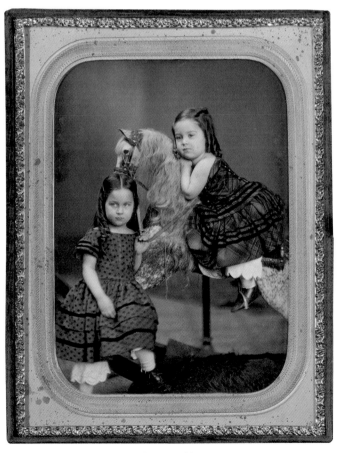

129 **Unknown Maker,** *Two Girls on a Hobby Horse,* ca. 1850

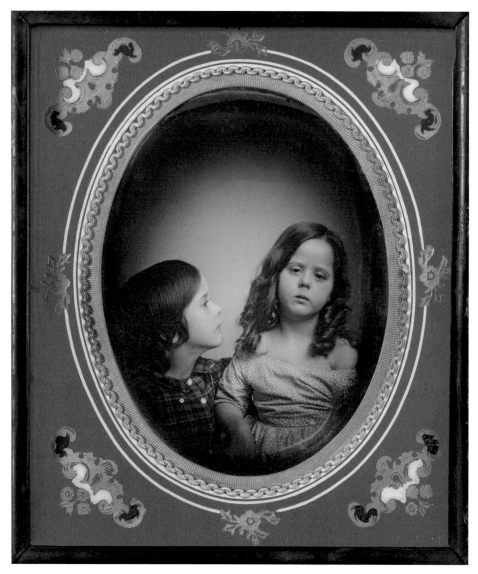

130 **Unknown Maker**, *Portrait of Two Girls*, ca. 1855

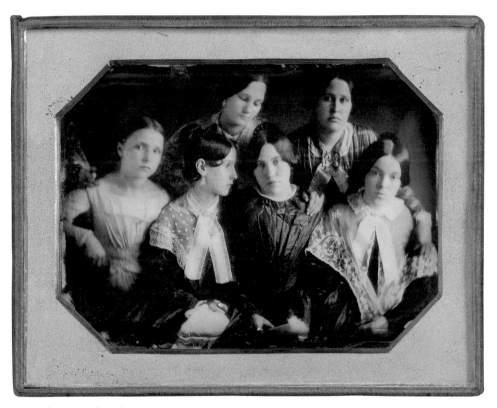

131 **Unknown Maker**, *Six Women*, ca. 1845

The highest law recognized by Greek artists was "to create a just resemblance and at the same time a more handsome one"; it assumes of necessity that their goal was a more beautiful and more perfect nature…

Sensual nature provided the artist with all that nature could give; ideal beauty provided him with sublimity—from the one he took the human element, from the other the divine.

Winckelmann emphasized that great art—as a "more perfect nature"—was superior in instructive power to the jumbled confusion of worldly fact. It was far easier, he felt, to recognize the necessary unity and harmony of great truths in art than in nature. These truths carried the potential for a new understanding of the self. Given this sublime goal, it was natural that Winckelmann celebrated Greek sculpture for its perfection and emotional reserve.

> The general and most distinctive characteristics of the Greek masterpieces are…a noble simplicity and quiet grandeur, both in posture and expression. Just as the depths of the sea always remain calm however much the surface may rage, so does the expression of the figures of the Greeks reveal a great and composed soul even in the midst of passion…
>
> The more tranquil the state of the body the more capable it is of portraying the true character of the soul. In all positions too removed from this tranquility, the soul is not in its most essential condition, but in one that is agitated and forced. A soul is more apparent and distinctive when seen in violent passion, but is great and noble when seen in a state of unity and calm.

These qualities were abundantly evident in the art most directly influenced by this classical tradition: portrait busts and neoclassic allegorical sculpture. The American embrace of this work was part of an international fashion. The French sculptor Jean-Antoine Houdon (1741-1828), for example, was famous throughout Europe and America for his portrait busts and mythic figures.[59] Britain had a rich tradition of such works in marble and bronze, which had a direct influence on American tastes.[60] By the 1840s, American sculpture was dominated by this preference for elegantly finished "ideal" subjects. In addition to his famous *Greek Slave* (1851), for example, Hiram Powers also created works such as *Eve Tempted* (1842), *The Fisher Boy* (ca. 1849), *America* (1848-50), and *California* (1858).[61]

These sculptural traditions influenced the daguerreian portrait aesthetic as much as any two-dimensional artistic works. Many of the leading daguerreotype studios had copies of such sculptures in their waiting rooms, and some used them as posing accessories [125]. The ostensibly timeless and ideal nature of these works set a corresponding model for photographic portraiture: one of high technical polish, expressive reticence, unity, and harmony. Through careful study of portrait busts, daguerreotypists learned to consider the heads of their subjects "in the round," to find the best point of view and the most sympathetic angle of light. Finally, the elegant finish of a marble or bronze bust had a connection with the carefully buffed and polished surface of the daguerreotype plate. Both had a kind of transcendent perfection.

Ideal beauty was understood to include the virtues of balance, unity, and harmony. This notion of wholeness had many facets: psychological, physiological, philosophical, moral, and spiritual. In his influential text, *On the Aesthetic Education of Man* (1794), Friedrich Schiller argued that ideal Beauty could heal the divide between matter and spirit: "Through Beauty the sensuous man is led to form and to thought; through Beauty the spiritual man is brought

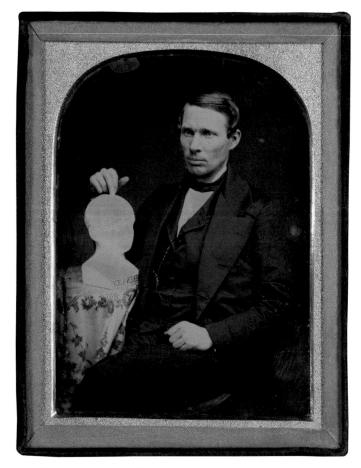

132 **Unknown Maker**, *The Phrenologist*, ca. 1850-55

back to matter and restored to the world of sense."[62] This notion of Beauty's recuperative power was a central concern of the Romantic and Idealist thinking of the era.

In the United States, by the 1830s, Ralph Waldo Emerson was emphasizing the need for a poetic, all-embracing vision. As he famously wrote in the essay "Nature": "Every natural fact is a symbol of some spiritual fact."[63] For Emerson, the coherence of the self corresponded to one's experience of the world. In a critique of modern commercial society, and the growing demand for specialized skills and knowledge, Emerson wrote: "The reason why the world lacks unity, and lies broken and in heaps, is, because man is disunited with himself." Emerson sought an ideal unity in self-reliance and a new sense of psychic wholeness.[64]

This concept of the balanced and unified self had deep spiritual significance. A central theme in the tangled history of American theological thought in this era was the quest for order, union, and correspondence. This involved the hoped-for synthesis of science and scripture, the powers of reason and the insights of faith.[65] This unity was understood to be the mark of genuine spiritual awareness: the organic unity of the self, and the identification of that self with the entire realm of creation. The state of "grace" that believers sought was, in part, one of complete openness and transparency— a selfless, virtuous, and radically simple way of being. To be pure, enlightened, and purged of complicating tensions and distractions was, by definition, to be *graceful*.

This idea was given powerful expression in the so-called sciences of physiognomy and phrenology, beginning in the late eighteenth century.[66] Physiognomy gained widespread popular interest with the publication in 1775 of the first volume of Johann Caspar Lavater's

Physiognomische Fragmente. His thesis was simple: character and appearance were intimately connected; physical perfection provided visible expression of moral excellence. For Lavater, the face and body consisted of natural "signs" that reflected moral character. As stated in a maxim of the day, "Virtue makes one more beautiful, vice more ugly."[67] The goal of each individual was thus to strive to become a Beautiful Soul—a virtuous, harmonious, and happy person.[68] While physiognomy enjoyed little intellectual credibility after about 1800, it lingered in the cultural consciousness as a spiritual and ethical concept.[69]

Phrenology also began in the late eighteenth century as an outgrowth of physiognomy. It was first codified by Franz Joseph Gall, an anatomist, physiologist, and physician working in Vienna. Gall deduced that the bumps and contours of the skull were evidence of twenty-seven cerebral "organs," from the attributes of affection, pride, and vanity to the propensities for poetical and metaphysical thought. Phrenology was the science of reading individual character in these cranial undulations [132]. Phrenology was broadly influential in the United States during the daguerreian era—for some as an objective science, for most others as a general set of assumptions about human nature. The New York publishing firm of Fowler and Wells did much to serve this interest [C-56]. The firm published numerous titles on the subject, the monthly *American Phrenological Journal,* and self-help books on mesmerism, the hydropathic water cure, and other interests of the day.

The cultural interest in physiognomy and phrenology influenced daguerreian portraiture. Photographers strove to evoke the spiritual identity of their sitters: in the structure of the head (and particularly of the forehead and brow) they saw evidence of temperament and character. Sitters desired harmonious and idealized likenesses not simply because they were flattering, but because they spoke to these deeper matters. Like true religious piety, one could not become a Beautiful Soul without striving—by purging the lesser aspects of the self. A critical step toward this spiritual ideal involved bringing body and mind into balance—the achievement of a natural grace. The aim of daguerreian portraitists was similarly two-fold: a perfect melding of body and spirit, reality and potential. All of this involved taste, training, and discipline: the photographer's, in his refinement of taste and technique; and the subject's, in his or her perfection of character.

While daguerreotypists developed a repertoire of standard posing and lighting arrangements, it is mistaken to assume that the characteristically calm, harmonious, and somber nature of these images is a reflection of nothing more than an empty "sentimental ideal." The inclination of daguerreian portraiture was toward a deep reading of identity. This notion of the self was not simply about the physical body or a single moment of existence—it was about one's spiritual identity and destiny.[70] To an important degree, sitters in the daguerreian period sought likenesses that united their real and ideal "selves." In striving to look their best in pictures, they also sought to emphasize their better inclinations. The subtext of most daguerreotype portraits was the quest by subject and photographer together not only to record a physical being, but to suggest a higher identity. To pose for the camera was, for many subjects, to set themselves a spiritual goal—to imagine the soul they hoped to become.

Here, the exceptions prove the general rule. Today, a common question about early portraiture is: "Why didn't anyone smile?" In fact, of course, smiling subjects were recorded, albeit in very small number [133, 134]. The rarity of these daguerreian smilers has often

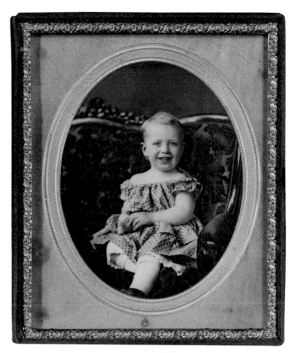

133 **Unknown Maker,** *Smiling Child,* ca. 1850

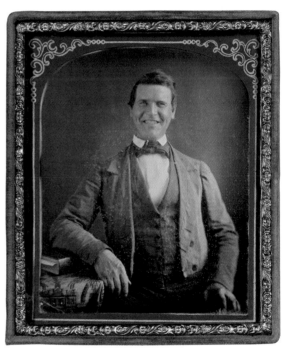

134 **Unknown Maker,** *Smiling Man,* ca. 1845-48

been explained as a result of the process's lengthy exposures. This technical answer can only be partly true, however, since it is entirely possible to hold a smile for five or ten seconds.

In this regard, cultural convention was more important than exposure times. The typical portrait was serious business: a record of the self, in the richest sense, intended for posterity. Antebellum Americans knew that this was best conveyed in a state of calm dignity, relaxed and attentive. This was the true self—the self that transcended the particularities of the passing moment and the temporary gesture. The smile, as an occasional and transitory expression, had no connection with this deeper self. Furthermore, the smile carried as many negative associations as positive ones. While it was charming for a baby to be recorded with a happy expression, it was far less appropriate for an adult to be portrayed that way. The polite smile could

be seen as a simple reflex gesture, a social mask.[71] There can be a fine line between a smile and a smirk. On the face of an adult, the smile or grin could be interpreted as a sign of desire, deceit, irreverence, or disrespect. For all these reasons, adults chose not to smile in daguerreotype portraits because it was unserious and unbecoming, not because lengthy exposures made it difficult.

Daguerreian Genres and Themes

The American daguerreotype after 1840 was an almost exclusively professional enterprise. While some wealthy amateurs used the technique in England and France, Samuel Bemis presents a distinctly lonely (and brief) example of the serious nonprofessional in America. The difficulty and expense of the process, and the lack of a European-style tradition of the amateur artist-connoisseur, made this commercial exclusivity almost inevitable. There were at least two consequences of this fact. First, genuinely poor plates were made in relatively small number: daguerreotypists either achieved a basic level of professional ability fairly rapidly or they quit. Second, all American daguerreotypes came out of a commercial context. The vast majority of plates were commissioned by and sold directly to individual customers. A far smaller number were made by those same professionals for personal, experimental, or artistic purposes.

The professional nature of the daguerreotype put natural limits on the breadth of its applications. Daguerreotypists were in business to make pictures people would buy. Anything else—such as Southworth & Hawes's *Frost on a Window* [23]—was made on the daguerreotypist's own time and at his own expense. Even for photographers so inclined, the demands of a successful practice left relatively little time for strictly personal uses of the medium. (In truth, there was no obvious line between the personal and the professional: all good daguerreotypists put their full creative effort into their commercial work.)

With these constraints acknowledged, the range of American daguerreian production is nevertheless remarkable. While most of these images were made in studios, daguerreotypists demonstrated a genuine gift for invention—for nearly endless variations on a few basic genres and poses. Daguerreotypes may logically be discussed in thematic categories, but no two plates are actually the same. In addition to this studio production, daguerreotypists took their cameras outdoors to record city views, landscapes, the activities in Gold Rush country, and more. The result is an astonishingly rich record of American people, places, and enterprise.

The Occupational Daguerreotype

The daguerreian era was one of enormous economic expansion, driven by the power of individual ambition and initiative. Compared to the aristocratic culture of Europe, relatively few American families enjoyed inherited wealth. Most Americans—nearly all men, and many women—had to earn a living, and they typically worked hard. Many had distinctly fluid careers, moving with little hesitation from one occupation to another. The industrialization of the American economy was only beginning in the daguerreian era. In rural areas, most people were farmers. Towns were populated by a characteristic assortment of artisans, shopkeepers, and white-collar professionals—from blacksmiths, bakers, and carpenters to pharmacists, jewelers, and lawyers. The larger cities, with vastly greater concentrations of capital, had a correspondingly greater number of occupations and workers.[72] Sooner or later, most of these people came to a daguerreotype studio to sit for a portrait.

An occupational portrait records a sitter with some evidence of their profession, trade, skill, or interest.[73] The telling detail may be distinctive clothing, as in the case of a soldier or a member of a fraternal group. In other instances, it is an object—a musical instrument or a medical kit, for example. The liveliest occupational daguerreotypes present their subjects enacting some aspect of their daily routine. As these images demonstrate, personal identity was intimately connected with one's place in the social and economic matrix: what one *did* was central to who one *was*.

Similar images were made in Europe, but the occupational daguerreotype was characteristically American. The young nation perceived itself as a land of freedom and opportunity, with success a matter of talent and hard work. What a person did was less important than the fact that it was done well and by choice. In stark contrast to the unproductive leisure of Europe's aristocracy and the miserable poverty of its underclass, Americans embraced work as the path to economic security and social respectability. Honest labor held personal and nationalistic meaning: it represented self-reliance, enterprise, improvement, and an optimism about the future.

Skilled labor was not simply a product of the American experience; it was part of its identity. In 1853, artist Thomas Crawford was commissioned to design a sculptural relief for the pediment above the Senate portico. This work, titled *Progress of Civilization,* depicts "America" as a neoclassic figure flanked by realistic depictions of national "types." On one side is the past: American Indians and a woodsman with an axe laboring to conquer the wilderness. The other side shows the present: a soldier, merchant, schoolteacher, and mechanic, all engaged in constructive effort.[74] In sitting for their own occupational portraits, Americans were—on some intuitive level—taking their own symbolic place in this great collective narrative.

Music played an important role in the lives of antebellum Americans. Like the popular arts of oratory, handwriting, and drawing, music represented a sign of cultural refinement. Many families had pianos or other instruments at home and entertained themselves in song. In addition, every city had at least one theater or concert hall in which touring professionals regularly performed. Images of musicians are among the most common of occupational daguerreotypes [137, 138, C-57, C-58]. These range from simple renditions of a sitter with an instrument to more complex simulations of performers in action. Two of the finest works of this genre [135, 136] depict a man at a piano and a woman with a guitar. Both are moody, evocative portrayals.

Readers and writers constitute another familiar category of occupationals. Many subjects were photographed holding books, newspapers, or letters.[75] The routine use of the book as a prop was a reflection of its cultural significance: literacy was probably the single most important factor in achieving social and financial success. Books represented the life of the mind; newspapers, an engagement with business, politics, and the other currents of public life; letters, the enduring bonds of friendship and family.[76] In various ways, all these works [139-141, C-59, C-60] celebrate the personal and social importance of the written word.

Military and fraternal images were also made in significant number [142-147, C-61, C-62, C-63]. In these works, the uniforms

135 **Unknown Maker**, *The Pianist*, ca. 1850

136 **Unknown Maker**, *Woman with Guitar*, ca. 1850

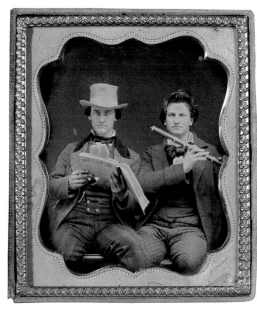

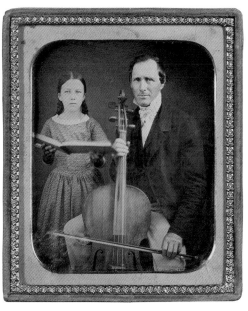

137 **Unknown Maker**, *J. S. Boyd and Mr. Strandley with Flute and Sheet Music*, ca. 1850

138 **Unknown Maker**, *Cellist and Girl*, ca. 1850

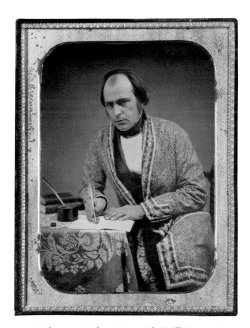

139 **Unknown Maker**, *Man with Quill Pen*, ca. 1850

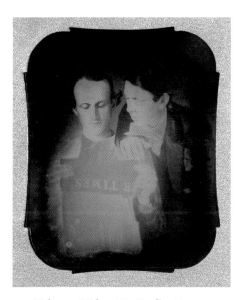

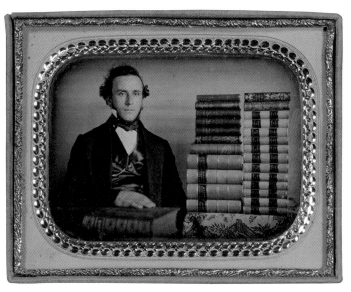

140 **Unknown Maker**, *Men Reading Newspaper*, ca. 1843-45

141 **Unknown Maker**, *Man with Books*, ca. 1850

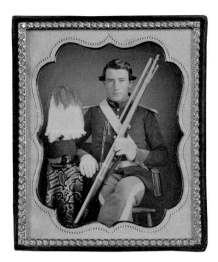

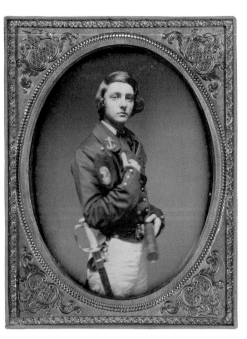

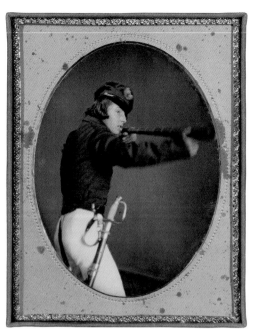

142 **Unknown Maker**, *Henry B. Webbert*, November 20, 1855

143 **Unknown Maker**, *James Duncan Graham, Jr., Holding Telescope*, ca. 1857

144 **Unknown Maker**, *James Duncan Graham, Jr., with Outstretched Telescope*, ca. 1857

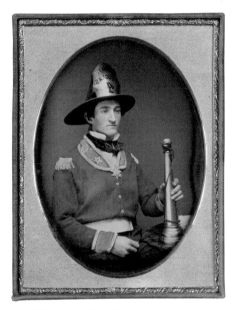

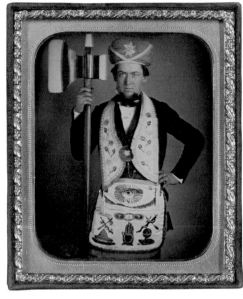

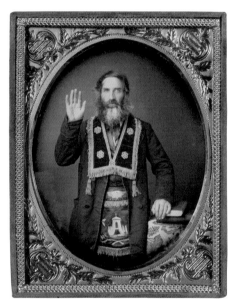

145 **Unknown Maker**, *Fireman*, ca. 1855

146 **Unknown Maker**, *Odd Fellow with Ceremonial Axe*, ca. 1850

147 **Benjamin F. Reimer**, *Odd Fellow Taking Oath*, ca. 1855

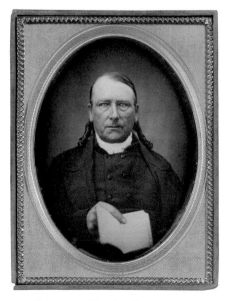

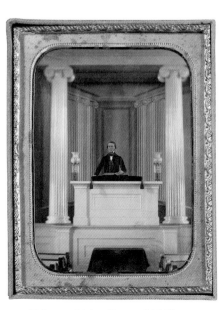

148 **Unknown Maker**, *Preacher*, ca. 1855

149 **Unknown Maker**, *Reverend McKinney in his Pulpit*, ca. 1850

150 **Robert H. Vance** (attrib.), *Pharmacist (or Chemist)*, ca. 1850-55

151 **Unknown Maker**, *Dentist with Tools and Set of False Teeth*, ca. 1855

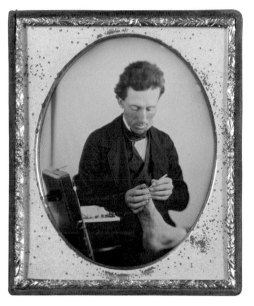

152 **Unknown Maker**, *Surgeon with Scalpel and Equipment*, ca. 1850

153 **Unknown Maker**, *Dr. Kenison, Chiropodist*, ca. 1852-53

154 **Unknown Maker**, *Man with Skulls*, ca. 1850

155 **Unknown Maker**, *The Mesmerist*, ca. 1850

156 **Unknown Maker**, *Artist with Palette Knife, Maul Stick, and Paint Brush*, ca. 1850

157 **Unknown Maker**, *Man with Leopard Skin*, ca. 1855

158 **Unknown Maker**, *Clown*, ca. 1850-55

provide clear occupational identifiers. In addition, the photographers and sitters often made creative use of hats, rifles, and other objects. In the first of a pair of portraits of James Duncan Graham, Jr., for example, the young officer holds a telescope at his side [143]. In the more unusual second pose, he readies the instrument for use [144].

Religious figures could usually be distinguished by dress. Preachers were often depicted with one hand firmly on the Bible [148]. Less commonly, they were commemorated in their role as public orators [65]. Rarest of all, at least one was recorded in a true environmental portrait, standing in the pulpit of his church [149].

In the antebellum decades, the health and medical sciences included a variety of disciplines, from pharmacy and dentistry to the pseudo-sciences of phrenology and mesmerism. In a plate that may have been made by Robert H. Vance, a pharmacist or chemist poses proudly with the tools of his trade [150]. Accustomed to making house calls, dentists carried their equipment in portable cases. These made compelling props in the daguerreotypist's studio [151, c-64]. A slightly more improvised set of objects—including scalpels and a human skull—was brought to the studio by a surgeon [152]. Most unusual of all, a chiropodist, or foot specialist, had himself recorded tending a patient's toenails [153].

This enigmatic image of a man with a collection of skulls [154] probably depicts a medical doctor or a phrenologist. There can be no question about the subject of this image [132], perhaps the most iconic photograph of an American phrenologist. He is posed with the trademark phrenological bust, with his finger positioned somewhere between the zones of "Self-Esteem" and "Reverence." A mesmerist or psychic healer is probably the subject of this image [155]. Now largely forgotten, mesmerism played an interesting role in the early history of hypnosis and of modern psychology.[77]

The freewheeling economy provided many opportunities for enterprising Americans. Some earned their livelihood in the public realm as artists and performers. The vast American appetite for diversions and amusements created a market for all manner of talents, from painters and musicians to clowns and comics.[78] The occupations depicted here [156-160, c-65, c-66] include landscape painter, circus performer or actor, tightrope walker, clown, dancer, black-face minstrel, and pugilist.

Most Americans earned their living in less colorful ways, as artisans, shopkeepers, and "mechanics" of various kinds. A broad spectrum of small trades is represented in the following group, from blacksmith, baker, and tailor to silversmith, surveyor, and cartographer [161-173, c-67–c-73]. These images are characterized by a wide variety of poses, gestures, and accompanying props. They provide a cross-section of American labor, from some of the least-skilled employments to some of the most demanding.

Rough outdoorsmen also came into the studio to pose. The culture of hunting and the frontier is reflected in four images of men with rifles [174-176, c-74]. The lively study of three Cape Cod duck hunters is unusual, in part, for the early painted decoys in the foreground [176].

Outdoor and environmental occupationals are uncommon [177, 178]. This image of a man picking pears is distinctly curious. The white cloth, held in place by a background assistant, serves to isolate the tree and foreground man from the visual confusion of the surrounding space. Given its apparently didactic nature, this daguerreotype might have been made as a study for a lithograph or engraving.

This whole-plate butcher shop scene is both a technical and a conceptual masterpiece [179]. It was taken under the most difficult lighting conditions. The interior of the shop is in shadow, while beams of sunlight—passing through windows behind the camera—create abstract patterns in the lower part of the image. Despite the long exposure and shallow depth of field, this image presents a detailed inventory of a bustling enterprise. Butchers are posed at their chopping blocks, customers wait attentively, and carcasses hang from the ceiling.

Ethnicity and Race

Antebellum America was a nation of many tongues and traditions. The number of foreign arrivals began increasing dramatically in the 1830s, when it averaged about 60,000 per year. These numbers peaked in 1854, when nearly 428,000 entered the country. Pushed out of Europe by famine, economic stagnation, and political turmoil, nearly 3 million immigrants came to the United States between 1845 and 1854. Many were from Ireland and Germany, and most of these were Roman Catholic. This transformation of the nation's formerly Protestant and native-born population produced tensions in the social fabric. Ethnic and religious rivalries developed, crime rates rose, the number of poor increased, and labor riots broke out in several cities. Despite these conflicts, most European immigrants eventually felt accepted in their new land, and went about the business of living. Indeed, some portion of them continued to take at least ceremonial pride in their cultural heritage [180].

The same could never be said about the experience of Africans and American Indians. In 1850, there were about 3.2 million slaves and 435,000 free blacks in the United States—in all, about 16 percent of the population.[79] The institution of slavery rested on a deep cultural belief in racial inequality: the assumed superiority of the white or Caucasian "race" above all others. Southern slaveholders held such beliefs proudly, and few Northern abolitionists were entirely free of racial prejudice. As a result, free blacks faced great difficulties, with rigid restrictions on where they could live and how they could earn a living. Nonetheless, the lives of these free blacks—in both the South and the North—were vastly better than those of their enslaved cousins. Communities of literate and successful free black citizens arose in New York, Philadelphia, and Boston in the North, and in Baltimore, Alexandria, Richmond, Charleston, New Orleans, St. Louis, and other cities in the slave states.

Black subjects are not uncommon in the American daguerreotype, but they were represented less often than their 16 percent share of the national population. Relatively few enslaved subjects were recorded and the best known of these images were commisioned as "types"—clinical, anthropological specimens—rather than as portraits.[80] However, at least a handful of slaves were recorded in something resembling the conventional portrait. This image, for example, depicts a slave of a wealthy Virginia Plantation family [181]. Commissioned by the owning family, it remained in the hands of various generations of descendents for nearly 150 years, until the late 1990s. This history underscores the fact that slaves were sometimes thought of not only as property, but as members of the extended "family."

These images remain charged and unsettling today. We are aware that this man was a possession, and that he had little or no voice in the decision to be recorded. His physical reticence speaks volumes: he was clearly unpracticed in the art of presenting himself to the camera. However, it is more than mere cliché to observe

159 **Unknown Maker**, *Tightrope Walker*, ca. 1855

160 **Unknown Maker**, *Black-Face Minstrel*, ca. 1850

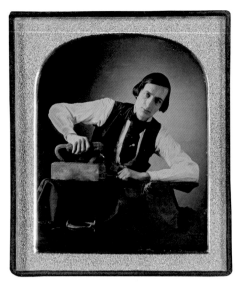

161 **Unknown Maker**, *Tailor Ironing*, ca. 1848

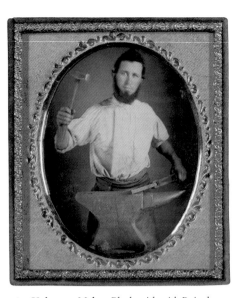

162 **Unknown Maker**, *Blacksmith with Raised Hammer*, ca. 1850

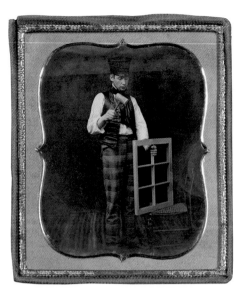

163 **Unknown Maker**, *Window Maker*, ca. 1850

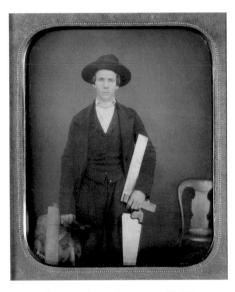

164 **Unknown Maker**, *Carpenter with T-Square and Saw*, ca. 1850

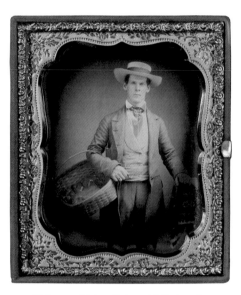

165 **Unknown Maker**, *Baker with Basket of Buns*, ca. 1850

166 **Unknown Maker**, *Delivery Boy with Parcel*, ca. 1850

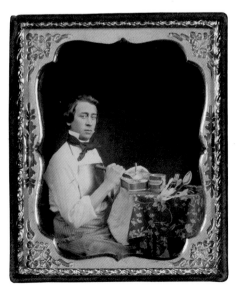

167 **Unknown Maker**, *Silversmith*, ca. 1850

168 **B. Barbour**, *Jas. D. Robey, Calligrapher, Suncook, New Hampshire*, 1854

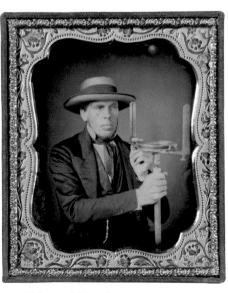

169 **Unknown Maker**, *Surveyor*, ca. 1855

170 **Unknown Maker**, *Two Musical Instrument Repairmen and Young Boy*, ca. 1845-48

171 **Unknown Maker**, *Man with Hammer and Nail*, ca. 1850

172 **Unknown Maker**, *Woman Ironing*, ca. 1850-55

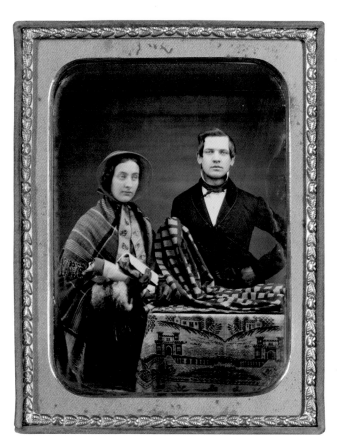

173 **Unknown Maker**, *Fabric Salesman*, ca. 1850

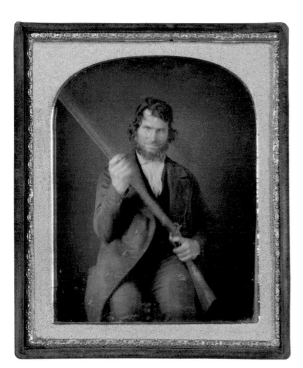

174 **Unknown Maker**, *Mountain Man with Rifle*, ca. 1850

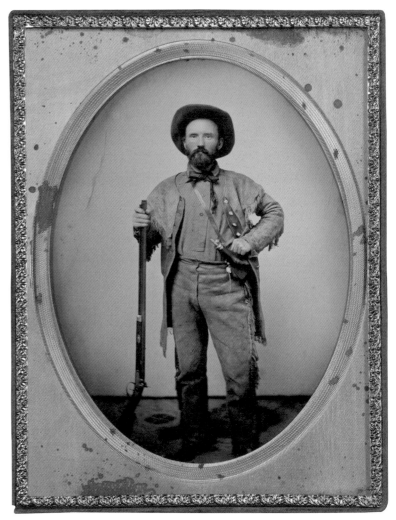

175 **Unknown Maker**, *The Frontiersman*, ca. 1856

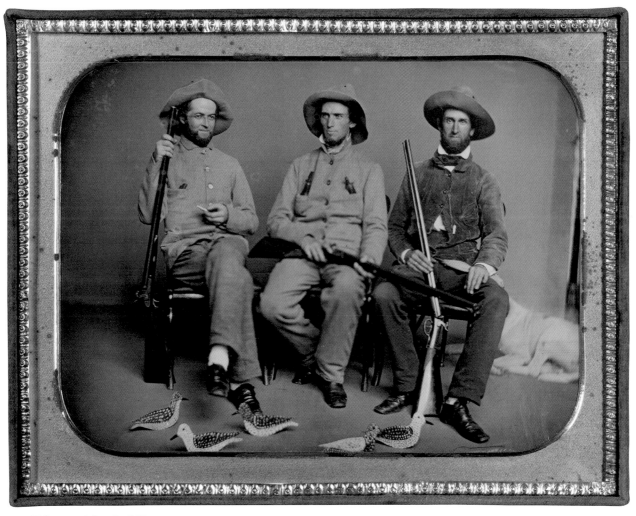

176 **Unknown Maker**, *Duck Hunters*, ca. 1850

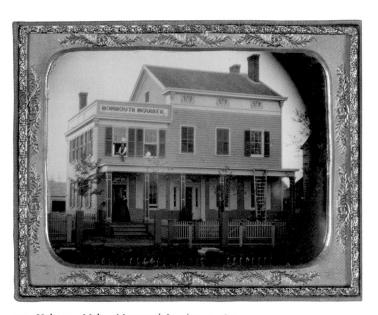

177 **Unknown Maker,** *Monmouth Inquirer,* ca. 1855

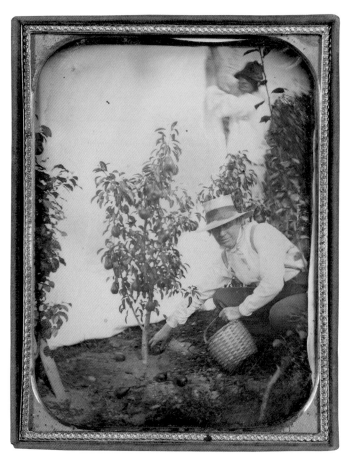

178 **Unknown Maker,** *Man Picking Pears,* ca. 1850

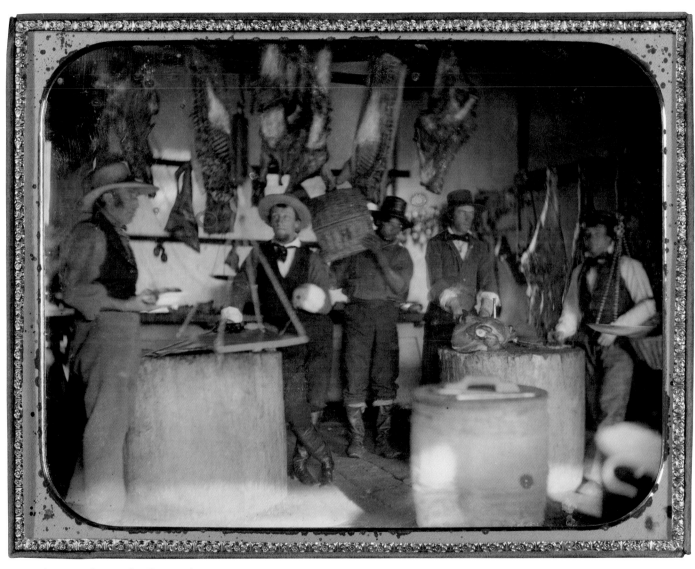

179 **Unknown Maker**, *Butcher Shop Interior*, ca. 1850

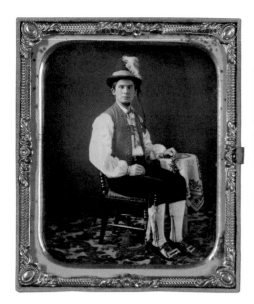

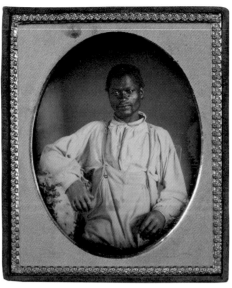

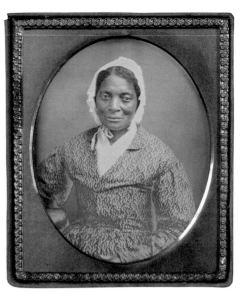

180 **Unknown Maker**, *Man Wearing Plumed Hat and Ethnic Dress*, ca. 1855

181 **Unknown Maker**, *Virginia Plantation Slave*, ca. 1850

182 **Unknown Maker**, *Portrait of a Woman*, ca. 1850

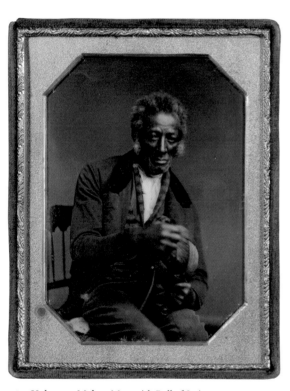

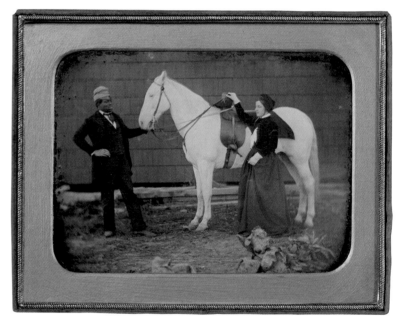

184 **Unknown Maker**, *Woman with Horse and Groom*, ca. 1850

183 **Unknown Maker**, *Man with Ball of String*, ca. 1850

that—despite the inhumanity of this man's legal status and treatment—this image conveys some basic sense of personhood.

In many cases, visual evidence alone cannot reveal whether the black man or woman in a daguerreotype was enslaved or free. The most successful free blacks could easily have afforded portraits of themselves and their loved ones, and that may be what is represented in works such as these [182, 183]. One surmises that this groom's fine outfit and confident pose mark him as a free man [184]. This remains an educated guess; what is indisputable is his role in service to the woman with the radiantly white horse.

The unequal relationship between whites and blacks lies at the heart of one of the most poignant genres in the daguerreotype: images of white children with black attendants. Ideas of racial difference,

authority, and power are central to these images. A handful of these daguerreotypes are explicit depictions of servitude [185]. More typically, however, African Americans are posed in nurturing roles, as trusted caretakers [C-75, C-76]. The finest of these works carry a nearly heartbreaking emotional charge [186, 187].

American Indians were daguerreotyped on far fewer occasions than American blacks, in part because they played a less visible role in the white economy. By the daguerreian era, the Native American populations had already endured a long and deadly history at the hands of white Americans. Felled by disease, and repeatedly displaced in officially sanctioned land grabs, American Indians had declined sharply in number since the seventeenth century. Following the historical and ethnographic interest of artists such as George Catlin,

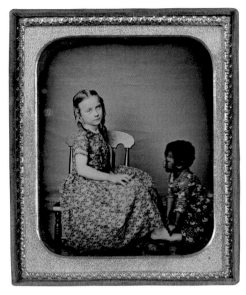

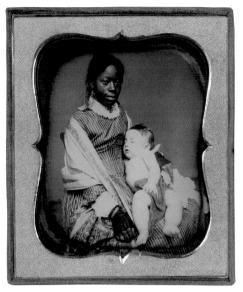

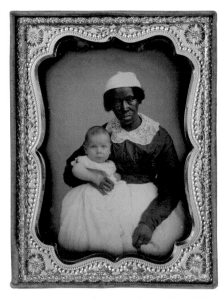

185 **Unknown Maker**, *Young Girl with Attendant*, ca. 1850

186 **Unknown Maker**, *Caretaker with Child*, ca. 1850

187 **Unknown Maker**, *Attendant with Child*, ca. 1855

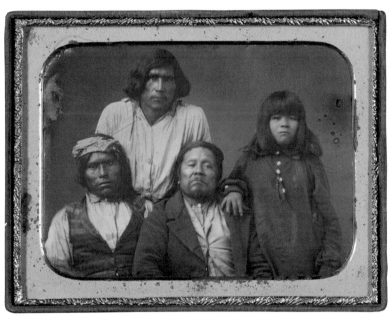

188 **Unknown Maker**, *Unidentified Native Americans*, ca. 1850

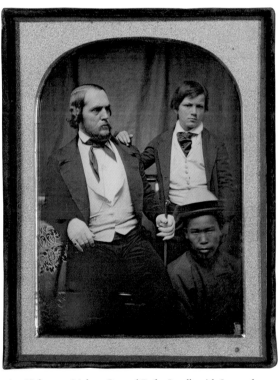

189 **Unknown Maker**, *General Rufus Ingalls with Son and Servant*, ca. 1855

beginning in the late 1840s a few daguerreotypists made concerted efforts to record important Indian subjects. In St. Louis, both Thomas M. Easterly and John H. Fitzgibbon made superb daguerreotypes of Indian chiefs and warriors.[81] In Buffalo, New York, Donald McDonnell made at least one study of comparable quality [54]. These are elegantly posed and finished works, portraying their subjects in ceremonial dress. As uncommon as these may be, images of Indians in everyday dress are rarer still [188]. This plate depicts what is certainly a frontier scene: four casually dressed Indians who appear to have just stepped in off the street.

On the other side of the continent, the Chinese began arriving in California after the discovery of gold in 1848. They typically saw themselves as visitors; most intended to return to China after a few

years with what they earned as laborers, miners, cooks, waiters, and servants. This influx was rapid. In 1850, there were only about 1,000 Chinese in the entire United States; in 1852 alone, 20,000 entered California.[82] While many of these were headed to the gold fields, a distinctive Chinese community quickly took root in San Francisco.

Two daguerreotypes of white men with Chinese servants present very different messages about the relationship between the races. In one [190], the standing servant dominates the scene; his subservient status is clear, but he is recorded with dignity. In the other [189], the servant is squeezed awkwardly into a lower corner of the image as a compositional afterthought. The servant's shadowy presence suggests something important about the racial attitudes of the day: these "others" were present everywhere, but remained at the margins

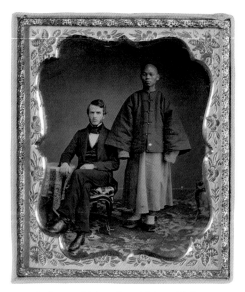

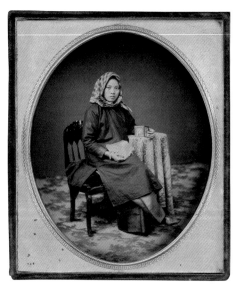

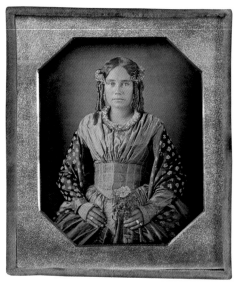

190 **Unknown Maker**, *Seated Man with Servant*, ca. 1855

191 **Unknown Maker**, *Chinese Woman with Open Daguerreotype*, ca. 1850

192 **Unknown Maker**, *Young Woman with Floral Necklace*, ca. 1846-48

of society. Conversely, this image of a Chinese woman [**191**] appears to have been commissioned by the subject herself; if she is subservient to anyone, it is not apparent in this self-confident likeness.

The identity of this elegant young woman [**192**] remains a mystery. She may be of Pacific island origin, but this has not been established with any degree of confidence.

Memorial and Postmortem Images

As two recent scholars have observed, "Nineteenth century Americans mourned well."[83] Indeed, to most twentieth-century tastes, the Victorians mourned entirely too well. Their rituals of bereavement have long been seen as excessive, morbid, and sentimental. As in so many other matters, however, this modern dismissal is not entirely warranted. Social attitudes toward death have changed enormously in the last 150 years. What was once public ritual has been banished to the private realm or, in fact, effectively denied. In the nineteenth century, death was a visible fact of community life; most people died at home, surrounded by family and friends. Funerals were important community events, and the rituals of remembrance were elaborate [**193**].

The period from about 1830 to 1860 produced a distinctive new style of mourning, a logical expression of a larger movement toward refinement and the symbolic orchestration of emotion.[84] This attitude toward death and mourning was the result of many factors—religious, philosophical, and aesthetic. The rural cemetery movement—an extension of the era's interest in gardens and the picturesque landscape—began in the 1830s, with the establishment of Mount Auburn (1831) in Cambridge, Laurel Hill (1836) in Philadelphia, and Green-Wood (1838) in Brooklyn. These cemeteries, and the others that followed, were both fashionable burial grounds and places of quiet reflection for the living. As noted at the time, they represented "a school of both religion and philosophy."[85]

While artists created postmortem and memorial likenesses before the invention of photography, the camera significantly expanded the practice. Many daguerreotypists promoted their ability to record the dead. One suspects that this was relatively lucrative and easy work—with a surcharge for the house call and no danger of a likeness being

193 **Unknown Maker**, *Eugenia Nye Memorial*, 1850

ruined by an unsteady sitter. Daguerreotypists aimed to represent the dead with grace and dignity—dressed in their finest clothes and laid out on a bed or settee as if asleep. The goal was a memorial likeness, a record in death that would extend memory of the subject in the living.

The harshness of everyday life was underscored by periodic health scares; in 1849, for example, the nation was ravaged by one of several cholera epidemics of the era. These outbreaks were deadly and terrifying; thousands died, and the medical community could do little to help. The most vulnerable people were the weakest—infants and the elderly—and death often came quickly. In such cases, a postmortem image might well have been the only photographic

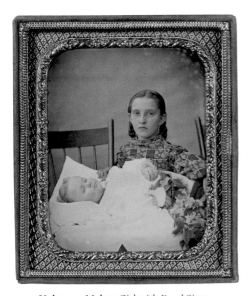

194 **Unknown Maker**, *Girl with Dead Sister*, ca. 1855

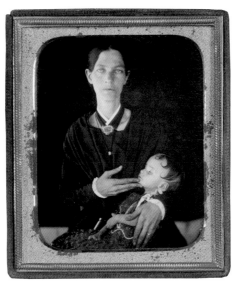

195 **Unknown Maker**, *Mother with Dead Child*, ca. 1850

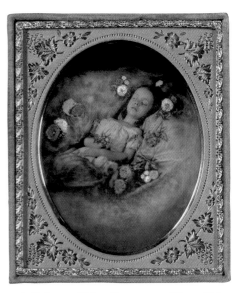

196 **Unknown Maker**, *Postmortem of Young Girl*, ca. 1855

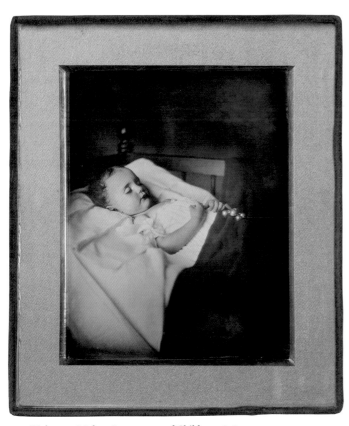

197 Unknown Maker, *Postmortem of Child*, ca. 1848

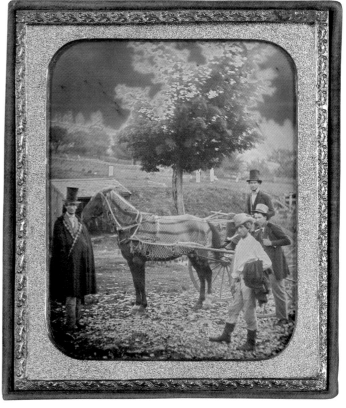

198 **Unknown Maker**, *Undertakers and Grave Diggers in Cemetery*, ca. 1850

likeness ever made of that individual. The fear of sudden death lent real power to the photographer's familiar slogan: "Secure the Shadow ere the Substance Fade."

The dead of all ages were photographed, but the most poignant postmortems depict infants and children. Child mortality rates were high, and many families suffered the loss of one or more sons or daughters. These young victims were sometimes photographed with a grieving family member [**194, 195**]. In other cases, the child was recorded alone, arranged in a state of peaceful repose [**196, 197**, c-77].

Death provided regular business not only for daguerreotypists, but for undertakers and grave diggers—the apparent subjects of this unusual image [**198**].

The American Scene

As we have seen, the daguerreotype was applied to a great variety of subjects beyond the routine portrait and the most familiar categories of the occupational. While some of these images may be considered permutations of the idea of the occupational, others fit no larger template. These latter are often narrative pictures: they record people interacting with one another or presenting signs and symbols of various kinds. While some of their meanings seem clear today, others have become irretrievably mysterious.

Americans were avid gamers and gamblers. They embraced competitive sports and they loved to wager.[86] The result was an extensive

199 **Unknown Maker**, *Two Men Playing Cards*, ca. 1848

200 **Unknown Maker**, *Two Men Playing Dominoes*, ca. 1850

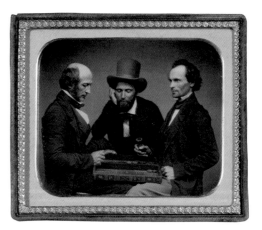

201 **Unknown Maker**, *Three Men Playing Backgammon*, ca. 1850

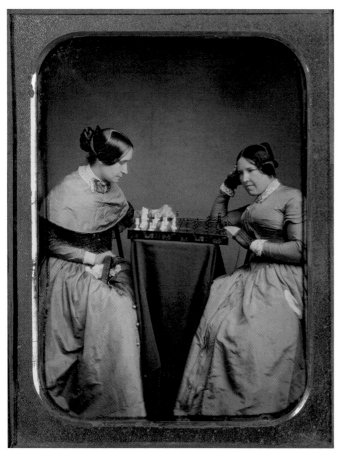

202 **Unknown Maker**, *Elizabeth Sewall Willis Wells and Mrs. Phineas Wells Playing Chess*, ca. 1848-50

tavern culture of card-playing, board games, and similar amusements —a largely male realm of drink and camaraderie. Daguerreotypes of men playing cards, backgammon, dominoes, and chess together [**199-201, c-78**] all speak to the importance of fraternal bonds. Some of these pastimes were also appropriate for the parlor, as revealed in this unusual view of women playing chess [**202**].

Tavern culture could be both seductive and dangerous. As part of a larger climate of reform and moral improvement, public crusades were mounted against the evils of gambling and drink. The temperance movement attracted thousands to the cause of self-control, discipline, and respectability. These two plates would appear to stem

from this movement [**203, 204**]. The first depicts a man pouring a glass of water—a confirmation of sobriety. The second records a man seated at a table, holding a book (the Bible?) and pointing heavenward. On the table beside him is what appears to be a tightly corked carafe of wine. This image reads as a statement of sobriety: while temptation is close at hand, the young man has the faith and willpower to resist it.

The work of this period is rich with narratives. These two images are overtly patriotic [**205, 206**]. In one, a mother and daughter contemplate a print of George Washington; in the other, a young girl poses with a flag. It was not uncommon for subjects to pose for the camera in costume or in a theatrical or symbolic role [**207-211, c-79**]. Informed by the tradition of the amateur theatrical and *tableau vivant*, antebellum Americans enjoyed playing with notions of identity and representation. These resulting images are at once true and false— recreations of the self in the knowing guise of symbol and allegory.

The daguerreotype was well suited to the evocation of interpersonal warmth. More than a few daguerreotypists could convey love and friendship with a compelling sense of spontaneity and immediacy [**212, c-80**]. Both men and women were portrayed in such images.[87] For example, this pair of quarter-plates [**215, 216**], made minutes apart, evoke sequential moments of good-spirited camaraderie. This quarter-plate [**213**] captures with almost crackling energy the devil-may-care spirit of a group of four young men. Another remarkably spontaneous work [**214**] preserves a characteristic boyish gesture. This is a most unusual portrayal: an evocation of brotherly teasing and rivalry.

A few daguerreotypes were made in an even more intimate style. This image of a woman brushing her hair [**217**] is not erotic in the French tradition of photographic nudes and academic studies, but it is a distinctly private subject. Clothed in a camisole, this woman is represented in the act of readying herself to be seen in public. The genesis of this image can only be guessed. Might this be the photographer's wife? Was this woman particularly proud of her hair? Less mysterious, but perhaps surprising to modern taste, are the handful of known daguerreotypes of nursing mothers [**218**].

Some daguerreotypes were created as messages to be exchanged between lovers [**219, 220**]. The first shows a young man pointing at a bouquet of flowers. We presume that his message is essentially "This is for you," and that this sentiment was conveyed by sending

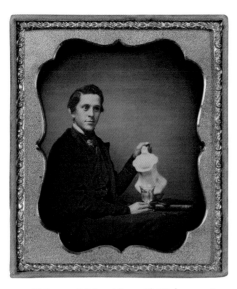

203 **Unknown Maker**, *Man with Pitcher*, ca. 1855

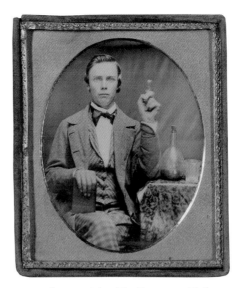

204 **Unknown Maker**, *The Temperance Pledge*, ca. 1848-50

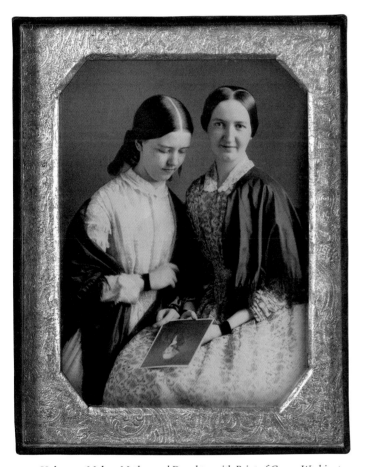

205 **Unknown Maker**, *Mother and Daughter with Print of George Washington*, ca. 1845-48

206 **Unknown Maker**, *Child with American Flag*, ca. 1854-56

the daguerreotype through the mail. The second image could almost have been sent by return post. A young woman holds a daguerreotype case tightly in one hand; with the other, she displays a Valentine heart to the viewer. It is telling that these deeply personal messages were created in the context of the commercial daguerreotype studio. We are reminded that sitters always had the ability to direct the making of their likenesses.

A host of other private narratives were staged for the camera, from the relatively obvious to the distinctly ambiguous. One presumes that this letter [221] carried news from a distant loved one. On the other hand, the meaning of Lord Byron's poem, "The Hebrew

Melodies," to this mournful pair [222] can only be guessed. This woman's sheaf of wheat [223] carried clear symbolic meaning in the nineteenth century. In religious terms, wheat represented the good and the fruitful; politically, it suggested the promise and bounty of the nation. At weddings, it was customary to throw wheat at the newlyweds to ensure prosperity and fertility. However, it is uncertain which of these interpretations apply here, or for whom the good wishes were intended.

Some images are even more oblique in meaning [224]. Is this gold miner pointing to his companion's new hat or to the heavens? Equally mysterious objects, gestures, and interactions [225-228,

207 **Unknown Maker**, *Child with Drum*, ca. 1855

208 **Rufus Anson**, *Girl Dressed as Little Red Riding Hood*, ca. 1850

209 **Unknown Maker**, *Standing Boy with Powder Horn and Toy Sword*, ca. 1855

210 **Unknown Maker**, *Man in Colonial Costume*, ca. 1850

211 **Unknown Maker**, *Young Woman Adorned with Floral Garlands*, ca. 1850

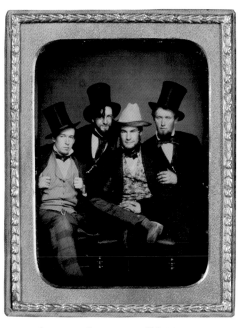

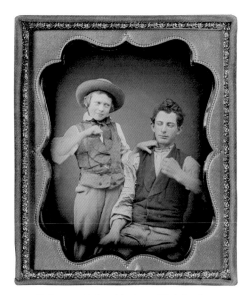

212 **Unknown Maker**, *The Adlard Sisters*, ca. 1855 213 **Unknown Maker**, *Four Devilish Men*, ca. 1850 214 **Unknown Maker**, *Two Boys "Fighting,"* ca. 1850

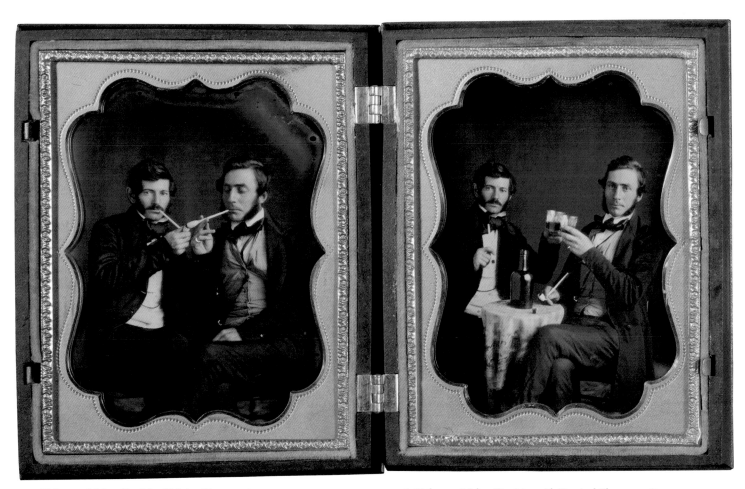

215 **Unknown Maker**, *Two Men Lighting Pipes*, ca. 1850-55 216 **Unknown Maker**, *Two Men with Upraised Glasses*, ca. 1850-55

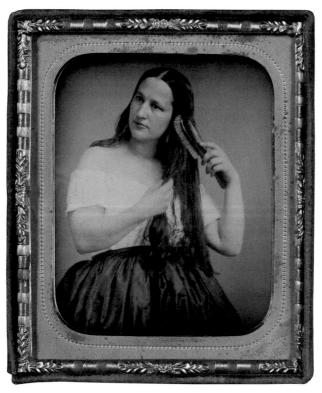

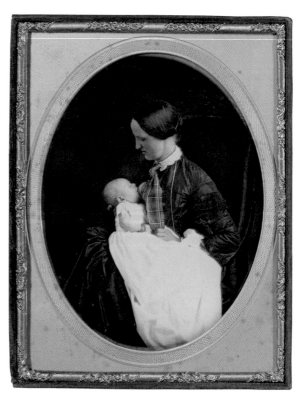

217 **Unknown Maker**, *Woman Brushing her Hair*, ca. 1850-55

218 **Unknown Maker**, *Mother Nursing Baby*, ca. 1850

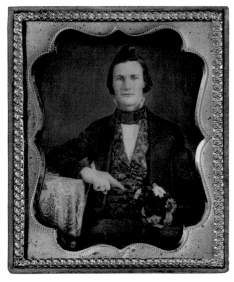

219 **Unknown Maker**, *Man Pointing at Bouquet of Flowers*, ca. 1850

220 **Unknown Maker**, *Woman with Love Token and Daguerreotype*, ca. 1850

221 **Unknown Maker**, *Group of Four Reading a Letter*, ca. 1850

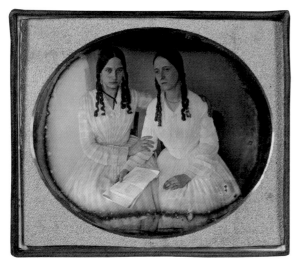

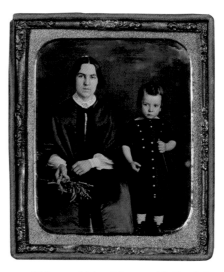

222 **Unknown Maker**, *Women with Poem by Lord Byron*, ca. 1848

223 **Unknown Maker**, *Woman with Sheaf of Wheat*, ca. 1855

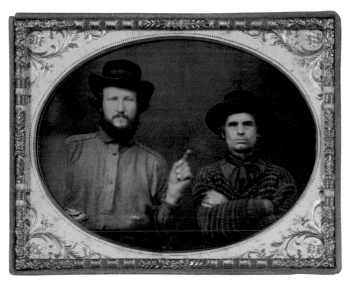

224 **Unknown Maker**, *Two Gold Miners, One Pointing*, ca. 1855

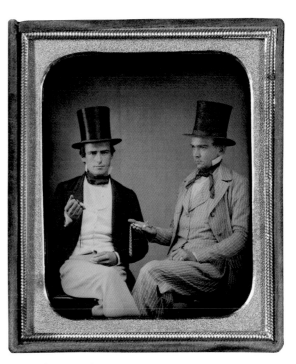

225 **Unknown Maker**, *Two Men with Watches*, ca. 1855

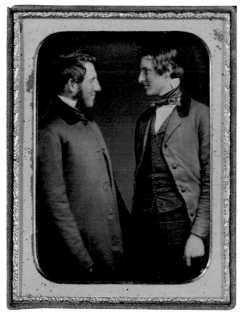

226 **Unknown Maker**, *Two Men Holding Hands*, ca. 1850

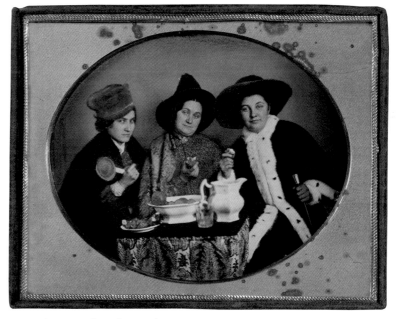

227 **Unknown Maker**, *Three Lively Women*, ca. 1850

228 **Unknown Maker**, *Man Seated Casually in Chair*, ca. 1855

229 **Unknown Maker**, *Cat by Window*, ca. 1850

230 **Unknown Maker**, *Sleeping Cat on a Table*, ca. 1850-55

231 **Unknown Maker**, *Dog on Wooden Bench*, ca. 1850

232 **Unknown Maker**, *Two Dogs on Rug*, ca. 1855

233 **Unknown Maker**, *Seated Woman with Parrot*, ca. 1850

234 **Unknown Maker**, *Lizzie Barber with her Bird*, ca. 1850

236 **Unknown Maker**, *Two Clocks*, ca. 1850

235 **Unknown Maker**, *Girl with Lamb*, ca. 1855

237　**Unknown Maker**, *Howell, Michigan (quiet street with dog)*, ca. 1854

C-81–C-83] remind us that daguerreotypes were made for very specific and personal reasons. To view them today is, in essence, to overhear tantalizing fragments of intimate, long-lost conversations.

Americans paid for pictures of the people, things, and places that they cared about and wanted to remember. Not surprisingly, pets and animals were recorded with some frequency. These subjects presented a notorious challenge to photographers: cats, dogs, and other animals could hardly be talked into posing a particular way, or for a specific duration. With skill and patience, however, remarkable success was possible [229-235, C-84, C-86]. It was vastly easier, of course, to record inanimate objects [236, C-87]. The first of these daguerreotypes was probably made in the name of commerce—for the sample case of a manufacturer or salesman—while the second served an antiquarian interest.

Outdoor Views

While the great majority of daguerreotypes were made in studios, many photographers were adept at working outdoors.[88] Views of cities and villages were made with some regularity, usually at the request of a customer. Less commonly, such scenes were made on the photographer's own initiative, as a test of new plates or to add novel images to a reception room display. It is easy to imagine a daguerreotypist testing his plates and chemistry on this quiet morning view from his studio window [237]. Similarly, this work [238] might be explained as a response to the technical challenge of recording clouds and snow. In other instances, views of villages and cities were made that united documentary and aesthetic concerns [239, 240, C-88].

Daguerreotypists also recorded the life of the street: the tent of a traveling circus or religious revival, groups posed beside new shops, and the comings and goings of merchants and travelers [241-243, C-89, C-90]. The street was the necessary setting for documents

of new vehicles and animals [244, 245]. This image [246] is a double portrait twice over, a record of the handsome white horses as well as of the women who ride them.

Daguerreotypists were often commissioned to document homesteads. This unusual image [247] records the first stage of a barn raising. This study of a simple prairie house [249] is distinguished, in part, by the photographer's skill in rendering clouds. Another kind of artistry is evident in this elegantly picturesque rural scene [248]. While it was not uncommon for rural families to be recorded outside, in front of their homes and barns, few posed with this much energy and invention [C-91]. This view of an outdoor picnic [C-92] is notable, in part, for the sheer number of people included.

Subjects of engineering and industrial interest were also recorded [250-252]. In addition, daguerreotypists also accompanied several of the surveying or scientific expeditions of the era. Unfortunately, next to nothing is known about this intriguing image [C-93], which appears to be a record of such a party.

The market for scenic daguerreotypes was spurred by two factors: the rise of tourism and the nationalistic symbolism of the landscape. As the epitome of the Romantic landscape sensibility, waterfalls were universally popular subjects. They were breathtaking reminders of Nature's power and a stimulus to the deepest personal meditations. Waterfalls were a kind of sensory vortex: they drew the spectator's attention with almost magnetic power, and served as a perceptual focus for everything within sight. As the painter Thomas Cole noted, waterfalls conveyed

> The beautiful but apparently incongruous idea of fixedness and motion—a single existence in which we perceive unceasing change and everlasting duration. The waterfall may be called the voice of the landscape, for, unlike the rocks and woods which utter sounds as the passive instruments played on by the elements, the waterfall strikes its own chords, and rocks and mountains re-echo in rich unison.[89]

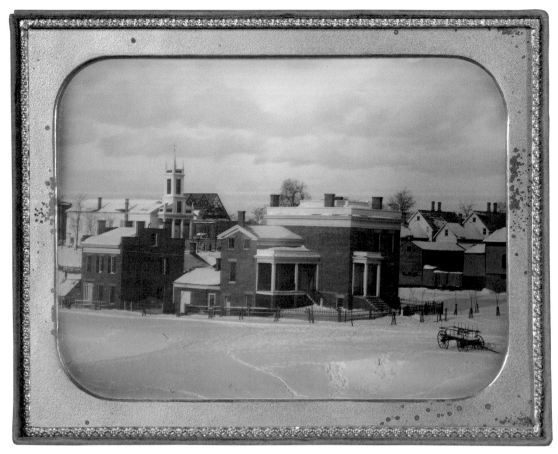

238 **Unknown Maker**, *Town in Snow*, ca. 1850

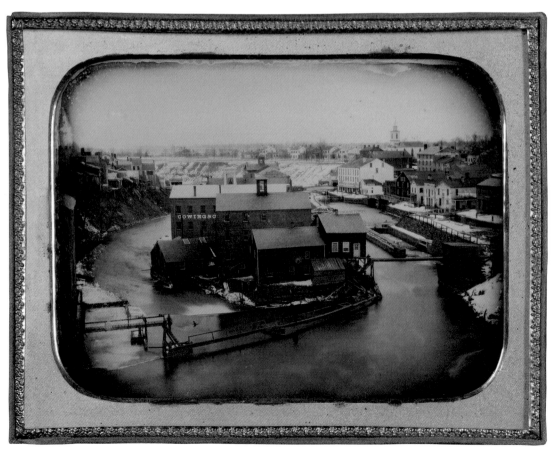

239 **Unknown Maker**, *Cowing & Co., Seneca Falls, New York*, ca. 1850-55

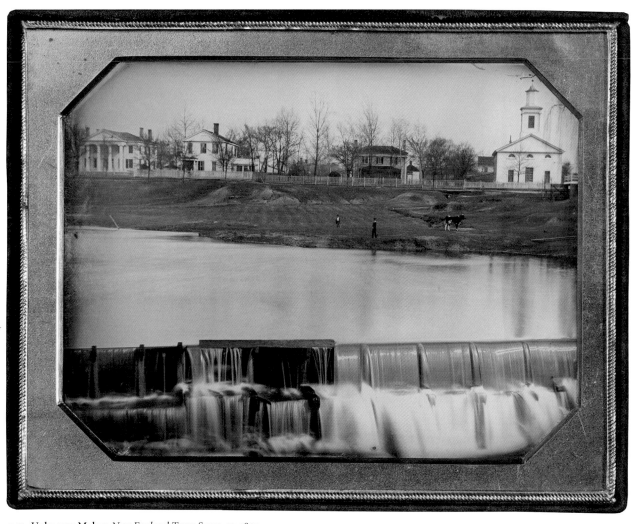

240 **Unknown Maker**, *New England Town Scene*, ca. 1850

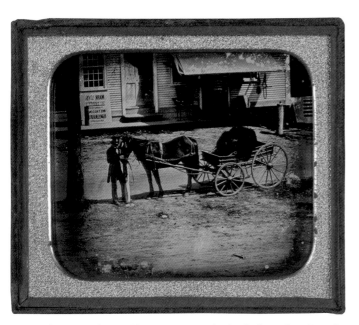

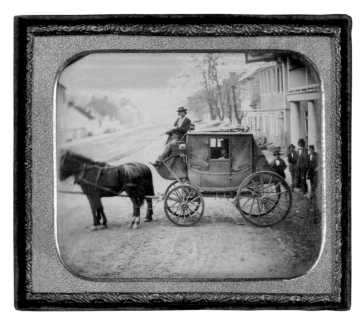

241 **Unknown Maker**, *Maiden Lane, New York City (in front of Mark Levy's store)*, ca. 1843

242 **Unknown Maker**, *Stagecoach*, ca. 1850

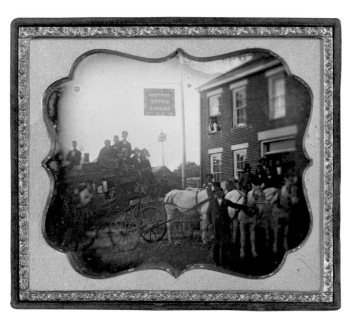

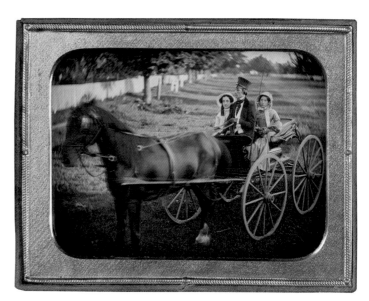

244 **Unknown Maker**, *Three People in Carriage*, ca. 1850

243 **Unknown Maker**, *Stagecoach Scene*, ca. 1850

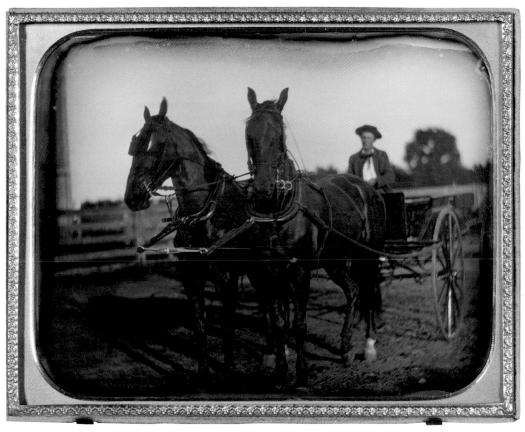

245 **Unknown Maker**, *Horse-Drawn Wagon*, ca. 1855

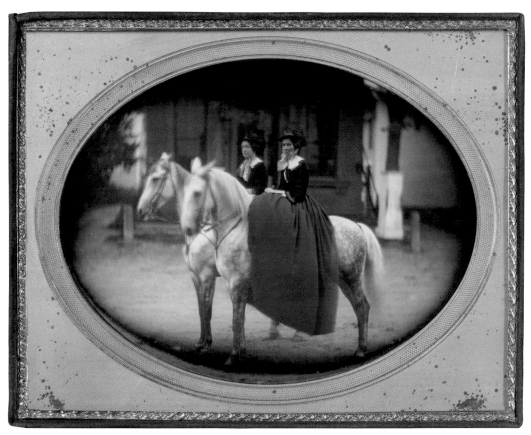

246 **Unknown Maker**, *Two Women on Horseback*, ca. 1850-55

247 **Unknown Maker**, *Barn Raising*, ca. 1850

248 **Unknown Maker**, *Rural Homestead*, ca. 1855

249 **Unknown Maker**, *House on Prairie*, ca. 1855

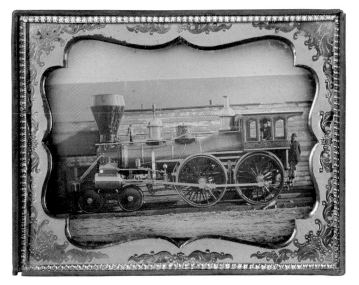

250 **Unknown Maker**, *Locomotive (Adams Express)*, ca. 1850

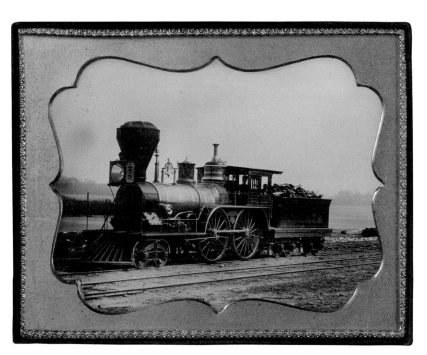

251 **Unknown Maker**, *Locomotive*, ca. 1855

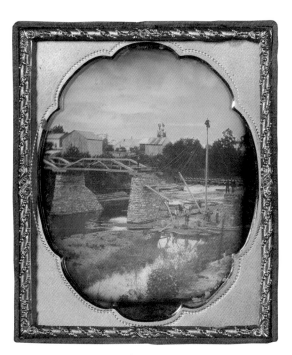

252 **Unknown Maker**, *Bridge Construction*, ca. 1850

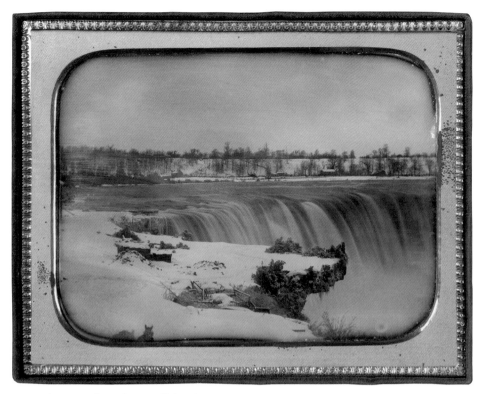

254 **Joel E. Whitney** (attrib.), *Minnehaha Falls*, ca. 1855

253 **Unknown Maker**, *Niagara Falls in Winter*, ca. 1850

255 **Unknown Maker**, *St. Anthony's Falls*, ca. 1850

Niagara Falls had become a major tourist attraction by the late 1830s. It was the most frequently photographed landscape motif of the daguerreian era—the subject of many hundreds of plates [253]. A host of smaller falls were also recorded, including St. Anthony's Falls, in St. Paul, and the nearby Minnehaha Falls [254, 255]. This view of St. Anthony's Falls employs a vertical format to record both the falls and the surrounding landscape.

Gold and the West

Gold was discovered on the morning of January 24, 1848, on John Sutter's property near the juncture of the American and Sacramento rivers, northeast of Sacramento, California. A Swiss immigrant, Sutter was the wealthiest Anglo resident in this sparsely populated region. He kept cattle, sheep, and horses, and—in January 1848—was constructing a sawmill on the South Fork of the American River. The gold discovered at this site by his employee, James W. Marshall, would transform both the region and the nation.

Gold became a national obsession.[90] By summer, gold fever had spread throughout California and northern Mexico. In June, it was reported that three-quarters of the houses in San Francisco had been abandoned; most able-bodied men, from blacksmiths to lawyers, had gone to the gold fields.[91] The frenzy grew in the fall and early winter of that year, as stories of fantastic riches appeared in newspapers across the country.[92] The result was the greatest mass migration in the young nation's history. By sea or by land, some 80,000 people made their way to California in 1849. By 1854, the region had gained about 300,000 new residents.[93]

All of these new arrivals hoped to strike it rich. By 1855, some $300 million in gold had been pulled from the California soil, enormously enriching the local and national economies. At a time when skilled artisans earned $1.50 for a typical day's work, many miners were making $16—and the more fortunate, $25 to $35—a day.[94] This tremendous wealth created wild inflation in the local economy. Mark Twain jokingly wrote of barbers charging $1,000 for a haircut—which miners "happily paid…, knowing that we would make it up tomorrow."[95] Twain's exaggeration was based on reality: successful miners paid a premium for the things they needed and for the luxuries or amusements they desired. In this male-dominated world of adventure and risk, money became both all-important and curiously unimportant. One miner wrote in the fall of 1849: "Fortunes are lost and won in five minutes. 36,000 dollars was risked upon the turn of a single card, and *lost…* Money is *nothing* here; the tables groan under millions in gold and silver."[96]

This prodigious wealth explains the remarkable number and quality of surviving Gold Rush daguerreotypes. Many miners sat for portraits in San Francisco, on their way to or from the gold fields [256, c-94]. As a tangible demonstration of their good fortune, some posed proudly with a nugget or sample of ore [257]. The most remarkable images were made in the mining region itself. Itinerant photographers found a ready market for views of miners, and of their encampments and mining operations [258-260].

These images are rich in information. They document changes in mining technology, from relatively small sluicing operations to the industrial approaches of quartz mining and hydraulic mining [261-264]. These larger-scale operations involved the use of great quantities of water. In quartz mining, water was used to separate flecks of gold from tons of crushed rock; in hydraulic mining,

256 **Unknown Maker**, *Gold Miner*, ca. 1850

257 **James M. Ford**, *Miner with Gold Ore*, ca. 1855

137

258 **Unknown Maker**, *Gold Miner in Front of Tent*, ca. 1850

259 **Unknown Maker**, *Gold-Mining Scene (camp)*, ca. 1850-55

260 **Unknown Maker**, *Gold-Mining Scene (landscape view)*, ca. 1850-55

261 **Unknown Maker**, *Gold Mining, North Fork, American River*, ca. 1850-55

262 **Unknown Maker**, *Gold Miners with Sluice*, ca. 1850

263 **Unknown Maker**, *Gold-Mining Landscape*, ca. 1855

264 **William Shew**, *Michigan Bluff, Placer County, California*, ca. 1855

265 **Unknown Maker**, *El Dorado County, California*, ca. 1855

266 **George H. Johnson**, *Johnson's Studio, Sacramento, California*, ca. 1850-55

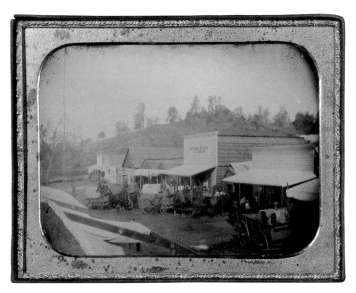

267 **George H. Johnson**, *Mining Town*, ca. 1850-52

mining settlements throughout the region [267]. Individual merchants commissioned numerous such studies by Johnson or his competitors [c-95, c-96].

The frenzy of the Gold Rush produced a distinctive culture of hard labor and extravagant riches. This rough-and-tumble world was the stuff of legend, and it gave rise to its share of exaggerations and fables. Captain Harry Love (in the center of this image [270]) was one of the most notable figures of the era. After serving as a Texas Ranger, Love came to California to seek his fortune. He failed as a miner, but his success as a bounty hunter resulted in his appointment in 1853 to head the California State Rangers.

Love was given the task—and the promise of a substantial reward—of apprehending Joaquin Murrieta, the leader of a band known as "The Five Joaquins." Depending on one's point of view, Murrieta was either a vicious criminal or a Mexican patriot.[99] He was accused of rustling, murder, and robbery, but some considered him the "Mexican Robin Hood." While the facts remain murky, Love and his rangers claimed to have found and killed Murrieta and "Three-Fingered Jack," his second in command. Murrieta's head and Jack's hand were cut off, preserved in jars, and brought to the governor in Sacramento. After these grisly relics were judged authentic, Love and his men received their reward. In the following months, the head and hand were exhibited in Mariposa, Stockton, San Francisco, and other communities, for the edification (at $1 each) of the populace. This recently discovered daguerreotype records Love with his chief officers. It was almost certainly made at the moment of their greatest fame, when they arrived in Sacramento with the trophies of their manhunt.

The West contained many valuable resources to be hunted and exploited. For example, the virgin forests of the Pacific coast provided nearly endless opportunities for loggers. This beautifully composed plate [268] records a sawmill with a mound of logs in the foreground, and a settlement in the distance. This bold view [269] also appears to document a logging operation somewhere on the Pacific coast.

high-pressure streams of water eroded entire hillsides. To satisfy this need, a vast network of canals, ditches, and aqueducts was constructed throughout gold country. By 1852, water companies had been established to construct lengthy flumes to carry water from mountain streams down to the mining operations.[97] This plate [265] probably records the leaders of one of these construction teams, with assorted family members, posing before a new flume.

The wealth from the gold fields triggered an explosive growth in the region's towns and cities. Many enterprising figures—from blacksmiths to bankers—settled in Sacramento, Stockton, and other formerly quiet towns. The success of these artisans and merchants provided yet more work for daguerreotypists.[98] George H. Johnson, perhaps the most prolific photographer of the gold country, rode the crest of this economic wave. He recorded his own studio in the commercial heart of Sacramento in this image [266] and documented

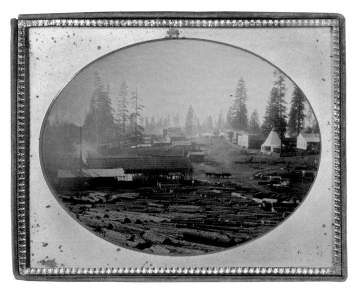

268 **Unknown Maker**, *Lumber Town*, ca. 1850-55

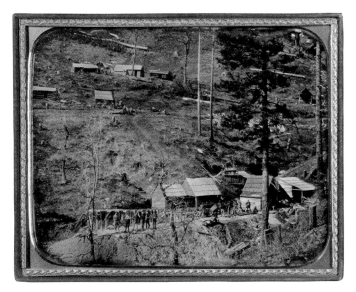

269 **Unknown Maker**, *Logging Scene*, ca. 1850-55

143

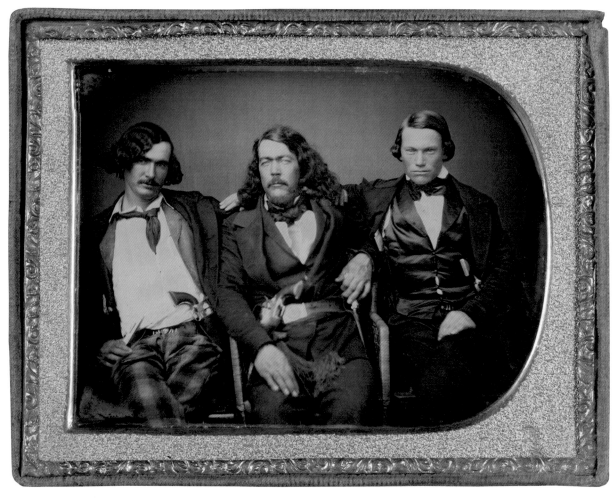

270 **Unknown Maker**, *Captain Harry Love and California Rangers*, ca. 1853

Comic, Allegorical, and Artistic Works

A critical aspect of daguerrian practice is revealed in the rarest works: images made for comic, experimental, or purely artistic purposes. Some daguerreotypists took genuine pleasure in exploring what could be done with the process beyond the demands of routine portraiture. A few of these images were undoubtedly made at the request of a customer. The odd nature of such requests required a correspondingly imaginative response by the photographer. In other instances, photographers made unusual images on their own initiative. Thus, while some of these uncommon plates left the studio with customers, most were probably exhibited as conversation pieces in the photographer's reception room display. In this context, funny, surprising, or purely aesthetic images served as a form of advertising. Reported around town, these novel plates helped attract visitors to the studio.

These unusual works fit no single conceptual category or genre. Some are the result of technical manipulations—such as the making of two exposures on a single plate [271]. To produce this "playing-card" image, the photographer made one partially masked exposure, rotated the plate 180 degrees, and then made a second one. This multiple-exposure technique has a profoundly modern feeling—it is an approach associated with the "New Vision" avant-garde of the 1920s and the work of artistic photographers such as Harry Callahan in the 1940s and 1950s. Clearly, however, this fascination for the camera's inherent optical and mechanical capabilities was not a twentieth-century invention.

A more radical variation of this double-exposure technique is demonstrated in this image of a "two-headed" man [272]. Henry Insley was one of the most prominent figures to explore such effects. An article in *Humphrey's Journal* in early 1854 described several of Insley's daguerrian novelties. These included "a boy with two heads," a plate identical in concept to the work reproduced here.

> This specimen awakens sympathy in nearly every one who looks upon it, as it is almost impossible to imagine so perfect a delusion. This…was produced by the boy first leaning his head on one side, and then changing its position to the other, without moving the body in the least; thus he is represented with two heads, both facing the same way.

Insley was also credited with a more complex double exposure: an image of a man holding a drinking glass and pouring from a pitcher with what appear to be his two right arms. Like the "two-headed" boy, this effect was achieved by having the subject hold one pose for the first half of the exposure, and another for the remaining time. In a variation on this idea, explored by daguerreotypists such as John H. Fitzgibbon, composite portraits were created by carefully making two or more exposures on a single plate. Through this technique, people who had not been to the studio at the same time could be portrayed together, or a single figure could be depicted standing beside himself.[100]

Such peculiarly photographic effects run counter to most of our presumptions about Victorian visual taste. However, as the historian David S. Reynolds has illuminated, this pious and pragmatic culture had a powerfully "subversive imagination."[101] In addition to its impolite humor, erotic and sensationalist literature, and spiritualist enthusiasms, American culture embraced the pleasures of "artful deception."[102] In the realms of art and entertainment, these deceptions included *trompe l'oeil* painting, theatrical experiences like the

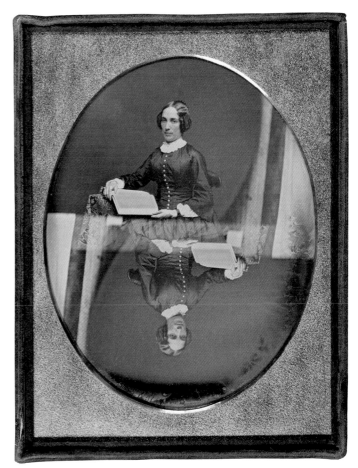

271 **Unknown Maker**, *Double Portrait*, ca. 1846-50

272 **Unknown Maker**, *"Two-Headed" Man*, ca. 1855

273 **Unknown Maker**, *Man with Violin Wearing Woman's Hat*, ca. 1850

274 **Unknown Maker**, *Comic Dentist*, ca. 1850

Diorama, Barnum's frauds and exaggerations, and a colorful fraternity of illusionists, magicians, and tricksters. In part, images such as the "two-headed" man represent the daguerreian equivalent of a magician's sleight-of-hand: the "fraud" is playful rather than malicious. The appeal lies in the "impossible" nature of the act and in the skill of the performance. In addition, however, such images also represent a subversion of the era's accepted standards—realist and idealist alike.

The simplest novelty images of the era are straightforwardly comic [273, 274]. While they vary considerably in the complexity of the joke being enacted, these are typically parodies, inversions, or exaggerations of everyday appearance or behavior. A somber violinist poses—absurdly—with a fancy woman's hat. The pulling of a tooth suggests an act in a burlesque skit.

Americans had a natural love of humor.[103] In part, their wit was a reflection of the egalitarian impulses of the age—and the corresponding interest in what Ralph Waldo Emerson called "the near, the low, [and] the common."[104] Humor is an expression of vernacular culture, a "bottom-up" social phenomenon. It is based on the creative potential of pastiche, imitation, and parody, and reflects a fluidity of values, identities, and truths. By the 1830s, American humor had taken on nationalistic importance. In that decade, the first purely comic almanacs were published and larger-than-life backwoods literary characters—from Davy Crockett to Nimrod Wildfire—achieved wide popularity.[105] In the daguerreian era, comic performers and burlesque troupes toured throughout the land.

Another form of artistic daguerreotype was known as the "composition"—a carefully posed study of ideal, symbolic, or narrative appeal. The most famous examples of this type were Gabriel Harrison's works of the early 1850s, such as *The Infant Saviour* and *Young America*. A few others made similar works. This plate [275] was perhaps inspired by Harrison's example: a depiction of a nude child with a paintbrush, palette, and maul stick. It is a charmingly naive picture. The work's elevated theme—"The Spirit of Art"—is tempered by its jerry-rigged improvisation. The child, elevated on a stack of books,

is positioned somewhat precariously on a fabric-draped chair. There is no painting or easel in sight; the young subject is steadied by a maul stick, which rests in turn on a highchair. What might have been rendered in paint as an inspiring (if familiar) allegory is here simple playacting. Something of the same ambition is seen in this work [276]. Daguerreotypes such as these testify to the expressive ambitions of at least some photographers and to the popular taste for theater and the *tableau vivant*.

More refined "compositions" were made by such noted figures as George N. Barnard [277] and Alexander Hesler [278]. While the original daguerreotypes are now lost, these images survive today as paper-print copies. These works are artistic variations on the occupational portrait. Most importantly, both tell stories—of the virtue of labor and of the wisdom handed down from one generation to the next.[106]

The story of the Hesler image was recorded in an essay in the *Photographic and Fine Art Journal*.[107] The adult subject, a friend of Hesler's in Galena, Illinois, was portrayed as an embodiment of the character of the enterprising American westerner. Born in Massachusetts, he worked as a blacksmith for five or six years; seeking to improve himself, he went to Missouri to attend college. With a degree in hand, he resumed his former trade in Galena. Widely respected in the community, in 1853 he took on the additional duties of justice of the peace. This image is rich in both anecdote and allegory. As the essayist in the *Photographic and Fine Art Journal* noted, this work was intended "to represent the youth, the strength and the enterprise and intelligence of the mighty West… In the boy with the horseshoe (which he is trying to sell), we have the youth and enterprise; and in muscular man and hardy employment, we have the strength of a nation."[108]

Audiences of the day would have easily understood such works. In tandem with the democratic values of the Jacksonians and the "Young America" movement, artistic scenes of everyday life came to wide popularity in the late 1830s and 1840s.[109] As part of a larger

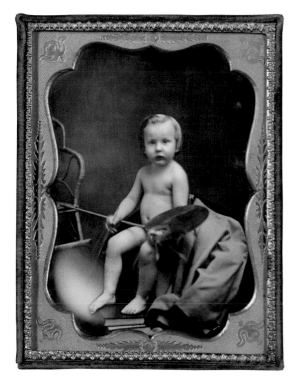

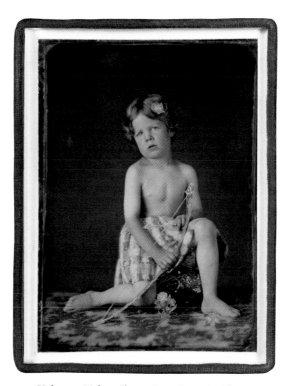

275 **Unknown Maker**, *Child with Brush and Palette*, ca. 1850 276 **Unknown Maker**, *Chester Lunn, Jr., as Cupid*, ca. 1850

quest for a truly national art, genre painters embraced the rhythms and incidents of daily life. Ralph Waldo Emerson noted in his essay on art that the challenge and opportunity for American artists was to "find beauty and holiness in new and necessary facts, in the field and road-side, in the shop and mill."[110]

The canvases of William Sidney Mount provided a clear model for these daguerreotypes. One of the leading genre painters of the day, Mount's first two major successes were *Bargaining for a Horse* (1835) and *Farmers Nooning* (1836). Both paintings reached a broad public in the form of engraved copies. While neither Barnard nor Hesler imitated these paintings directly, they were undoubtedly inspired by the work of Mount and his peers.[111]

More remarkable yet is a daguerreian masterpiece of street children playing marbles [**279**]. This is an explicitly artistic work, clearly intended as an exhibition piece. It is a wonderfully dynamic image: at least a dozen figures are depicted shooting marbles, cheering, fighting, or watching the action. This immediacy is heightened by the work's documentary flavor; all the visible evidence suggests that we are being shown real street kids, outdoors, on an actual sidewalk. By comparison, all the other "compositions" discussed above were clearly made in the studio.

This work can be fruitfully compared with genre paintings of street kids of the 1840s and early 1850s.[112] Typically, the newsboys, bootblacks, and street urchins of these paintings are portrayed in static poses and with a sentimental or moralizing tone. There is little celebration of the raucous energy of the street in these paintings; rather, the focus is on social specimens, or "types."[113] By contrast, the boys in this daguerreotype are distinctly individual and animated. They are depicted as completely within their own "world"; there is no indication that that they are being presented for either judgment or pity. Despite its imperfect condition, this plate represents the highest achievement of this genre of the daguerreian art.

Young boys are also depicted in two highly refined works of the 1840s. The first [**280**] records a barefoot boy, lost in thought, with

277 **George N. Barnard**, *Woodsawyer, Nooning*, 1853

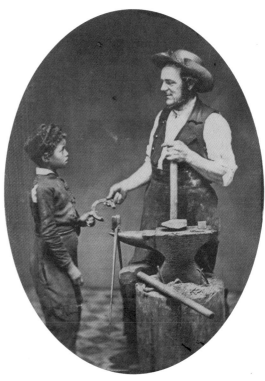

278 **Alexander Hesler**, *Driving a Bargain*, 1853

279 **Unknown Maker**, *Boys Playing Marbles*, ca. 1850-52

280 **Unknown Maker**, *Boy on Bench with Book*, ca. 1843-47

281 **Unknown Maker**, *Boy with Hammer and Books*, ca. 1843-46

open books on his lap. Everything suggests that this is a narrative and symbolic motif: a country youth, bored by his studies, caught in the act of daydreaming. This was a distinctly American subject— a suggestion of both the life of the imagination and the lure of the rough-and-tumble outside world.[114] This charming portrait of a boy with a younger brother [281] suggests a similar departure from routine portraiture. Here, the central figure—fresh-faced and well-dressed —prominently displays an armful of books and a heavy mason's hammer. The message seems clear: in this land of opportunity and progress, the keys to success are knowledge and a willingness to work.

Some daguerreotypes deviate wildly from the norms of routine portraiture for reasons that can only be guessed. This bizarre image [282] depicts a *trompe l'oeil* painting (of a child peering from beneath a curtain) and a table-top arrangement of a chess board and a daguerreotype case. The mood of this work—its ominous air of *absence*—suggests that it was intended to serve a memorial function. However its subject remains unclear. We are presented not with the components of an obvious narrative, but simply with objects: a haunting virtual likeness, an interrupted chess game, and an unseen photograph.

It is tempting to view this picture as a self-reflexive meditation on the mysteries of representation. This work deliberately blurs the line between things and images, space and surface. The *trompe l'oeil* nature of the background painting is both masked and amplified by the limits of the daguerreotype image itself. All four edges of the painting are hidden—one by the table and three by the daguerreotype's mat. The table—positioned at exactly the level a standing child would encounter it—occupies a real space that the viewer is perceptually inclined to extend into the virtual realm of the painting. As a result of this sly composition, one is encouraged to read the painting as a three-dimensional, "from life" representation, even while knowing full well that it is not. The closed daguerreotype case is appropriately enigmatic. The case contains an image, but one that remains forever unseen and unknown. The chess board suggests a rich network of ideas: precise rules, strategic thought, risk, and improvisation. It is a "world" unto itself, with both strict laws and many potential moves. Photography is a discipline of similar complexity and creative potential, at once rule-bound and wondrously open-ended.

These musings may have nothing to do with the actual making of this plate. Nevertheless, one wonders how the conceptual depths of picture making could be suggested with any richer ambiguity than this. If this image had been made in 1930, it could be comfortably described as "surrealist." As a work of about 1850, it expands our appreciation for the art of the daguerreotype precisely to the degree that it defies easy explanation.

The most profoundly artistic daguerreotypes may be those that hold a mirror to the process itself. Whether as a result of experimentation, casual play, or intentional parody, a small but important number of such self-reflexive images were made. This is one of the most startling of these images [283]. An adolescent boy, perched on the back of a chair, makes an absurd face at the camera. This daguerreotype is wholly transgressive in intention: it willfully violates every rule of "good" portraiture. The subject is *not* relaxed, thoughtful, dignified, and serious—he is awkward and ludicrous. The antithesis of the Beautiful Soul, he is instead the very embodiment of the era's "subversive imagination."

It is entirely fair to ask why this image was made. Perhaps it was theatrical in nature—a depiction of a character from a play or comic skit of the day. It is possible that it stemmed from a personal project like Montgomery P. Simons's "Passions" series—an evocation, we might speculate, of the state of "Incredulity," "Astonishment," or "Surprise." Or perhaps it was made on a creative lark, as a conversation piece for a daguerreotypist's studio display. While all these reasons are possible, none can yet be proven. What remains is the fact of the work itself, in all its absurd and confounding glory.

The following two images comment wittily on the rituals and logistics of the daguerreotype portrait. The first [284] depicts four hunters with their rifles and small prey. Both the dress of these subjects and the simplicity of the composition suggest that this daguerreotype was made by a provincial or itinerant artist. Nonetheless, it is doubtful that any city operator achieved a more pointed send-up of the artifice of the studio process. The hunter on the far right holds a stuffed owl on his lap. The owl, mounted on a display stand, is positioned so that its head backs into a miniature headstand. The joke is deliberate: the bird's headstand is turned sideways, displayed fully to the camera. These backwoodsmen are clearly not as simple or somber as we first assumed. The stuffed owl, held "secure" in its headrest, mimics their own condition, as specimens pinned awkwardly in place for the camera. An irreverent philosophical question comes to mind: Which art is closer in kind to photography—painting or taxidermy? This work is at once a portrait and an anti-portrait: a group likeness that pokes fun at the artful deceptions of likeness making.

While the hunters are engaged in conceptual slapstick, this image [285] engages in a more cerebral deconstruction of the rituals of the portrait studio. This precisely orchestrated group portrait depicts the absent-minded moments of preparation *before* actually posing for

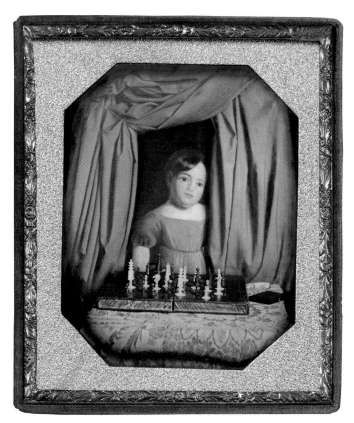

282 **Unknown Maker**, *Painting of Young Girl with Chess Board (surreal still life)*, ca. 1848-50

149

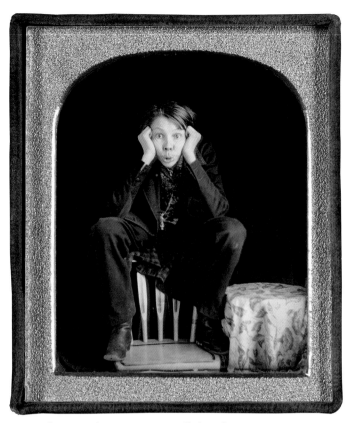

283 **Unknown Maker**, *Young Man on Chair Back*, ca. 1850

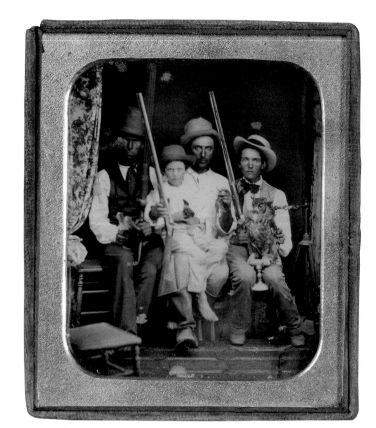

284 **Unknown Maker**, *Hunters with Owl*, ca. 1850

the camera. Four people are shown readying themselves to be photographed: the central figure nonchalantly reads a letter; a man, glancing at the same letter, has his hair tended by the woman on the right. In the lower left corner, a kneeling figure waves her finger toward the camera as if to say to the photographer: "Not yet! We're not ready!" This astonishing work is the visual equivalent of a linguistic paradox: *This sentence is false.* As a carefully planned representation of an unplanned moment, it both is and is not a "real" portrait.

This image is playfully theatrical, but its conceptual weight cannot be ignored. While exceptionally rare, it points up a critical facet of American daguerreian practice. Every competent photographer understood the technical possibilities of the process and the tastes of the public. In addition, the best practitioners had fertile visual imaginations—a curiosity about the nature and potentials of the photographic image. As a result, some small but vital part of their output consisted of images made for their own pleasure and edification. These "outlier" images played a critical role in defining the grammar and syntax of a new pictorial language.

End of an Era

The daguerreotype was pushed aside at its artistic zenith. By the mid-1850s, every practitioner of any reputation at all had the skill to make consistently good plates. The best operators were able to make superb ones on a regular basis. It was this facility—and the warmth with which nearly all first loves are remembered—that made it so difficult for some daguerreotypists to give up the technique. The most accomplished practitioners were deeply proud of what they could do with the process: they considered themselves not merely artisans, but artists and connoisseurs [286]. Economic realities were

unforgiving, however. By the end of 1854, demand for the daguerreotype had slackened.[115] By 1860, the process was a minor facet of most studio operations or had been dropped completely.

A few devoted practitioners fought to maintain interest in the process. In early 1859, for example, Samuel D. Humphrey published an essay extolling the virtues of the daguerreotype, "the most perfect and reliable of all pictures."

> The frail and fading Ambrotype is often sold, by unprincipled operators, for a Daguerreotype, and thus the unsuspecting public are defrauded and led to condemn the most beautiful pictures which it is possible to produce. The soft finish and delicate definition of a Daguerreotype has never yet been equalled by any other style of picture produced by actinic agency, while for durability we have no proof of any other impression being permanent. There can be no question, that if the public were fully posted as to the real worth of Daguerre's discovery, his process would be the only one that would meet with favor at their hands. If the operators would hold fast to this process, and recommend no other, they would greatly enhance the value of their art and improve the somewhat shaken confidence which now exists with regard to it.
>
> Whenever we hear a person decrying the old Daguerreotype we look upon him as one who cannot make a good picture by that process, which, by the way, is far more difficult than most of the others, and hence the reason for its being so much neglected of late. We do not believe that any experienced and successful Daguerreotype operator can be found who will not lift up his voice in favor of his old art…. We again repeat what we have said many times before to all our friends: Procure a Daguerreotype in preference to any other style of picture![116]

After the late 1850s, the process was kept alive by the patronage of older and wealthier customers. In New York, in 1862, the studios

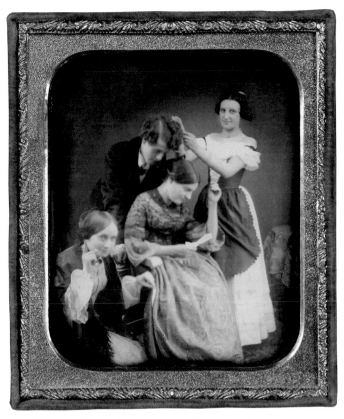

285 **Unknown Maker**, *Preparing for the Camera*, ca. 1850

of Anson, Bogardus, Gurney, and Williamson were all reported to be doing a "good trade" with the process.[117] In early 1864, a report on "Photography in Boston" noted:

> Mr. Whipple maintains his ancient fame, and keeps his old establishment at 96 Washington Street. Probably more daguerreotypes are taken by him than by all the rest of New England operators. Nothing has ever surpassed a *good* daguerreotype in delicacy, clearness, and permanency, and in and about Boston there are enough who believe so to afford liberal patronage to a first-class gallery. Mr. Ormsbee also takes daguerreotypes, and perhaps one or two others.[118]

Inevitably, however, as this older clientele disappeared, the daguerreotype went from a marginal practice to an unsustainable one.

Thomas M. Easterly was perhaps the most dogged devotee of the technique. Refusing to take up the newer glass and paper process, Easterly made daguerreotypes until at least the early 1870s.[119] At his death in 1882, he was regarded as a remarkable figure—if a distinctly odd and stubborn one—from a long-distant era.

Death of T. M. Easterly

One of the oldest Daguerreotypists of the country, at the age of seventy-three years. Mr. Easterly, strange to say, never was a photographer; believing in letting well enough alone, he never would embark in the photographing business, but stuck to Daguerreotyping to the last. In fact, we may say he was starved out of the business, for it left him in poor health and pocket. Some years ago he became paralyzed, and of late suffered a great deal. He was truly a faithful follower of Daguerre, and one of its most competent and worthy artists.[120]

Easterly was deeply disappointed by the public's reluctance to "let well enough alone"—its preference for cheaper, easier, and more flexible processes. The daguerreotype could not compete with these new techniques: its only virtue was perfection.

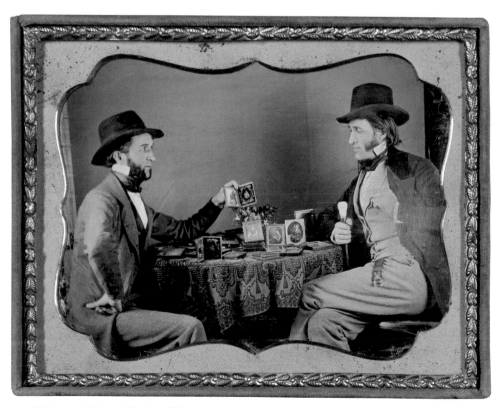

286 **Unknown Maker**, *A Showing of Daguerreotypes*, ca. 1850

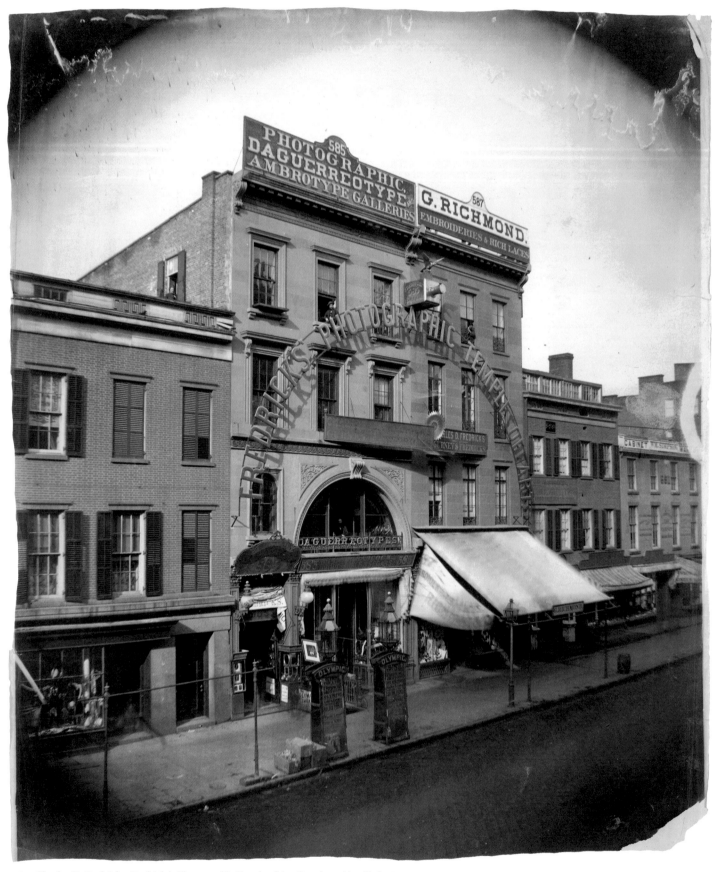

287 **Charles D. Fredricks**, *Fredricks's Photographic Temple of Art, Broadway, New York*, 1857

CHAPTER V The Rise of Paper Photography

The late 1850s was a time of pluralism and change in the photographic world. While photographers of 1850 would have easily grasped the symbolic significance of Charles D. Fredricks's public façade in 1857 [**287**], his backroom operations would have surprised them. A telling detail of this image is the sign at the top of his building with the words

PHOTOGRAPHIC,

DAGUERREOTYPE and

AMBROTYPE GALLERIES

By 1857, the task of professional photographers had grown considerably more complex than it had been only a few years earlier. The daguerreotype, still the technique of choice for many customers, was now merely one of several options. "Photograph" was now broadly understood to mean a *paper* photograph made from a wet-collodion glass negative. Paper prints had obvious advantages over the daguerreotype, beginning with the fact that any number of identical examples could be made from a single negative.

Customers could also choose an ambrotype portrait. Like the daguerreotype, the ambrotype was a unique, direct-positive image presented under a mat in a small case. However, unlike the earlier technique, the ambrotype image was on glass rather than a plate of silver-coated copper. The ambrotype was in fact an offshoot of the "photographic" process: an under-exposed wet-collodion negative that, when backed with black paper or lacquer, appeared as a dusky-toned positive. Its advantages over the daguerreotype were two-fold: it was cheaper and, lacking the earlier technique's highly reflective surface, easier to view.

Another variation of the wet-collodion process—most commonly known as the tintype, but also termed the melainotype or ferrotype—was also available. This technique, invented in 1856 by Hamilton L. Smith, of Gambier, Ohio, was the cheapest and simplest of all.[1] The tintype was essentially an ambrotype on metal instead of glass. A thin sheet of iron was lacquered with black varnish, sensitized with a wet-collodion emulsion, exposed in the camera, and processed in the normal manner. The dark varnish substrate allowed the direct camera image (technically, a negative) to read as a dull-toned positive. Tintypes were so inexpensive—and, typically, so artless—that few major studios advertised them. However, the process was as durable as the objects themselves, and the production of tintypes continued well into the twentieth century.

As this variety of techniques suggests, photography was at an important technological and aesthetic crossroads in the late 1850s. Two fundamental approaches were in competition—the daguerreotype and the various permutations of the wet-collodion process—with only one destined to survive. The beauty of the older technique was well known; the aesthetic and commercial potential of the newer one was yet to be fully grasped. By 1857, however, one thing was certain: "daguerreotypy" could no longer be used as a synonym for "photography." Indeed, some were beginning to suspect that the future of photography might not include the daguerreotype at all. The story of this technological evolution begins in Europe, where the new process was first and most rigorously explored.

Paper and Glass in Europe

Daguerre's daguerreotype and Talbot's paper-negative technique were announced to the world simultaneously in 1839. Both were practiced for about twenty years. But there the similarity ends. Radically different in principle, these techniques had correspondingly distinct histories. The daguerreotype achieved early dominance and was used around the world. Talbot's calotype process was slower to capture the public's attention and was adopted by far fewer photographers. Critically, however, Talbot's concept of a unique photographic *negative* from which a potentially unlimited number of *positive* paper prints could be made would determine the course of photography until the turn of the twenty-first century.

Patent restrictions had much to do with the spread—and inhibition—of both processes. In purchasing the daguerreotype from its inventor in July 1839, the French government made it freely available to the world, except—as it turned out—in Britain, where Daguerre quietly registered a patent.[2] Talbot, in turn, took out patents for the calotype in Britain, France, and the United States. Talbot's claims, coupled with the broad public preference for the daguerreotype, ensured that his process would see very limited use through the 1840s outside his own efforts. The most noted calotypists of this period included the team of David Octavius Hill and Robert Adamson, in Edinburgh, Scotland. Most of the British licensees were gentlemen-

amateurs of Talbot's social class who made relatively modest numbers of images for personal, artistic, and historical reasons.[3]

The calotype process was based on the production of a paper negative. Once processed, fixed, and dried, this calotype negative was placed in the sun in direct contact with a freshly sensitized sheet of paper. The action of sunlight, passing through the negative to strike the emulsion on the paper below, produced a positive "salt print" or Talbotype. With care, any number of reasonably identical prints could be produced from a single negative. Salt prints have a characteristic beauty: depending on processing and toning, they range from reddish brown to purplish brown in color. They also have a visible granular structure since the image is created by light passing through the fibrous structure of the negative.

By its nature, this process fell well short of the daguerreotype's astonishing brilliance and precision. Instead, the aesthetic of the calotype rested on the softer effects of atmosphere and chiaroscuro. Calotypists learned to emphasize broad masses of tone and texture, a more compressed contrast range, and the graphic logic of the overall composition. Given the relative simplicity of the process and the cheapness of paper, calotype photographers tended to work in larger sizes than most daguerreotypists. For all these reasons, photographs from calotype negatives seemed more allied to traditional forms of the graphic arts—drawings and engravings—than to the microscopic realism of the daguerreotype. As a result, the leading calotypists on both sides of the English Channel were men with artistic rather than strictly commercial inclinations.[4]

Paper photography gained new interest in France beginning in 1847, thanks to Louis-Désiré Blanquart-Evrard, a cloth merchant and amateur photographer in Lille. After learning Talbot's process in 1844, Blanquart-Evrard worked assiduously to improve it. He found that faster exposures could be achieved if the negatives were exposed while still damp, and he devised better techniques for developing and fixing his prints. Talbot protested this work as a violation of his patent, but the French government ignored his claims. Blanquart-Evrard was free to establish a commercial printmaking operation and paper photography flourished in France.[5]

Further improvements came in short order. Many calotypists had routinely waxed their negatives after they had been exposed and processed to make them more transparent for printing. A leading French calotypist, Gustave Le Gray, struck upon the idea of waxing his sheets of paper at the beginning of this process, before sensitization. Le Gray's waxed-paper negatives were used dry—in fact, they could be kept for up to two weeks before exposure with no detrimental effects. This freed photographers to travel considerable distances without the burden of their chemicals and trays. Also, the negative's smooth surface produced prints with finer detail and an increased subtlety of tone.[6] After Le Gray published his results in late 1851, the dry waxed-paper technique was widely adopted.

The ultimate degree of pictorial transparency depended on negatives of glass rather than of paper.[7] In 1848, Abel Niépce de Saint-Victor, a young relative of Nicéphore Niépce, introduced a glass-plate process using albumen (the whites of eggs). The albumen dried to a hard, transparent coating which was then sensitized in the appropriate chemical baths. This process yielded crisp detail but it was never widely adopted since the emulsion was significantly slower than paper-negative techniques.

A pivotal breakthrough came in 1851 with the work of the British photographer and researcher Frederick Scott Archer. Instead of albumen, Archer coated glass plates with collodion, a viscous fluid produced by dissolving guncotton (an explosive composed of cotton steeped in nitric and sulfuric acids) in alcohol and ether. Originally developed for medical purposes—to bind wounds and surgical incisions—collodion dried to a tough, transparent, and colorless film. Although collodion worked well for the production of glass-plate negatives, it had minor drawbacks. Considerable dexterity was required to apply the sticky fluid to glass sheets of often substantial size. Collodion could not be simply brushed on the glass: it had to be flowed, steadily and evenly, from the top to the bottom, with the photographer manipulating the plate in his hands to allow gravity to do its work. Further, the collodion emulsion was most sensitive to light before it dried. Universally used while damp, the process became known as the "wet-collodion" technique.

Because the collodion negative had to be exposed and processed before it dried, photographers were required to bring all their processing chemistry and trays with them into the field. Many traveled with a portable dark tent; a few, such as Roger Fenton in the Crimea, used a custom-designed photographic wagon pulled by a horse or mule. Photographers accepted these inconveniences for the new clarity and increased sensitivity of the wet-collodion negative.

The photographic papers of the era went through a corresponding transition.[8] Salt prints were made by saturating a sheet of fine writing paper in a solution of ordinary salt (sodium chloride) and then coating it on one side with a solution of silver nitrate. This chemistry permeates the paper. As a result, the photographic image is held within the structure of the paper itself and has a naturally matte appearance. In the 1850s, photographers began modifying this simple formula. To improve the clarity and richness of their prints, they often coated or "sized" the surface of their papers with starch or gelatin. These sizing materials also affected the color of the final image. In addition, print color could be modified by toning; gold chloride, for example, shifted the hue of salt prints from reddish-brown to purple. Finally, some of these prints were waxed or varnished, lending a slight sheen to the surface.

Albumen had proved impractical for the production of negatives but, as introduced by Blanquart-Evrard in 1850, it was ideal for the coating of photographic paper. The whites of eggs were beaten to a froth and then allowed to settle back into liquid form. Sheets of paper were floated carefully on this solution (so that only one side was coated) and hung to dry. Once sensitized in baths of silver nitrate, albumen paper was printed out by exposure to the sun in direct contact with a negative. The albumen layer is hard and smooth and lies on the surface of the supporting paper. As a result, the albumen print has a glossy surface and a bolder tonal range than the typical salt print. Nearly all albumen prints were gold toned, resulting in an image color ranging from warm purple-brown to cool blue-black. Together, the wet-plate collodion negative and albumen print processes dominated the practice of photography for about thirty years, from the mid-1850s to the mid-1880s.

An extraordinary body of paper photographs was created in the 1850s, primarily in England and France, by these various techniques—paper and glass, dry and wet, salt and albumen.[9] This work was, in part, the product of a rich peer-group dialogue on the art of photography. These collegial exchanges took a variety of forms: the organization of photographic societies, the establishment of annual exhibitions, the founding of professional journals, and the formalizing of photographic instruction.[10] In Paris, for example,

the Société Héliographique was founded in 1851, and succeeded in 1854 by the Société Française de Photographie (which remains in existence today). In 1853, the Photographic Society (later the Royal Photographic Society) was organized in London. Each of these societies published journals: *La Lumière*, the *Bulletin* of the Société de Française de Photographie, and the *Journal of the Photographic Society*. Beginning with the 1851 Crystal Palace exhibition in London, photographic exhibitions were held regularly in both countries, and in studios such as that of Gustave Le Gray, in Paris, practitioners were instructed in the newest techniques.[11]

The leaders of this photographic "golden age" have become familiar names in our history books. In France, in addition to Le Gray, these figures included Charles Nègre, Henri le Secq, Charles Marville, and Edouard Baldus. Based in Paris, these artist-photographers traveled extensively to record France's architectural patrimony for the 1851 Mission héliographique, an ambitious government-sponsored documentary project.[12] Other remarkable photographers—including Maxime Du Camp, Auguste Salzmann, John B. Greene, and Felix Teynard—made photographs of scientific and archaeological interest in the Middle East. Roger Fenton was the finest photographer in Britain at this time; his best-known works, documenting British forces at the Crimea, were produced in 1855. Many other British photographers created important bodies of work, from Benjamin Brecknell Turner's rustic idylls to the studies of India by John Murray and Linnaeus Tripe.

Gustave Le Gray provided an important model for the professional paper photographer of the era. He made portraits in his Paris studio, had a steady stream of students, and received prestigious official commissions.[13] In addition, Le Gray made his own artistic work, including forest studies at Fontainebleau and, beginning in 1856, his celebrated seascapes. Le Gray was a professional in a distinctly artistic and aristocratic manner—he was a man of some renown, a teacher, an innovator, and an *auteur*.

The aesthetic impulse was central to all the work created by Le Gray and his peers, even when the pictures were made for ostensibly documentary purposes. Similarly, art played a key role in the productions of Blanquart-Evrard's printing establishment. Blanquart-Evrard's aim was both educational and aesthetic: he sought to elevate public taste and to enlarge the public's access to worthy pictures. In the introductory remarks to his first portfolio, *Album photographique de l'artiste et de l'amateur* (1851), he noted: "The publishers have one desire, that their publications be granted useful entry into the artist's studio and the cabinet of the amateur. They will be happy to see them find a place in the home, delighting the family in its leisure hours as well as promoting a taste for the fine arts."[14] Between 1851 and 1855, Blanquart-Evrard published lavish albums of original photographic prints. The subjects of these portfolios ranged from reproductions of paintings, statuary, and monuments, to collections of landscapes, city views, and archaeological studies.

French photography of this era was founded on a clearly articulated aesthetic theory. Formulated during the heyday of the paper negative, "the theory of sacrifices" emphasized the pictorial strengths of the calotype process. Further, it distinguished this visual language from the radically different—and putatively "commercial"—aesthetic of the daguerreotype. Le Gray expressed it concisely: "The artistic beauty of a photographic print consists nearly always in the sacrifice of certain details; by varying the focus, the exposure time, the artist can make the most of one part or sacrifice another to

288 **Leavitt Hunt**, *Grand Hall and Obelisk, Karnak*, 1851

produce powerful effects of light and shadow…"[15] The central concern lay in the vigorous orchestration of form and tone rather than in precise description. From an aesthetic point of view, it was far better to suggest the mass and texture of a tree than to depict every leaf. This kind of aesthetic photograph was always the expression of a personal viewpoint, a subjective interpretation of reality.

The marked difference between the daguerreotype and the calotype processes had a parallel in the artistic debates of the day. There was a tension in French painting between the examples of Jean-Auguste-Dominique Ingres and his younger rival Eugène Delacroix. The first stood for line, form, reason, and description; the second for color, energy, passion, and suggestion. The dominant photographic technologies of the day were fitted into this conceptual dichotomy. The daguerreotype fell into the first, more conservative camp, while the calotype was viewed as an artist's medium—malleable, expressive, and suggestive. The terms of the debate did not change greatly with the transition from paper to glass negatives: the same ideas of aesthetic effect were in play throughout the period. Ultimately, it was the paper photograph itself—with its connections to the traditions of drawing and printmaking—that was granted such aesthetic status in the 1850s.

These attitudes ran deeper in Europe than in the New World. For Americans, photography remained an almost exclusively commercial enterprise. Lacking an aristocratic leisure class, America had no tradition similar to the French or British gentleman-amateur artist and connoisseur. This social fact, combined with the burden of license fees for Talbot's process, greatly impeded the rise of paper photography in America. But two Americans—both based in Europe—did play a significant role in the history of the calotype. Both used the process to record archaeological ruins in the Middle East: Leavitt Hunt, one of the least known of these expeditionary photographers, and John B. Greene, arguably the greatest of them.[16]

Leavitt Hunt grew up in a wealthy and talented family. One brother became a painter; another was an influential architect. After the family moved to Europe in 1843, Hunt traveled the continent. He studied philology and law, and became "thoroughly versed in half a

289 **John B. Greene**, *Medinet Habou, Entrée de la Seconde Cour*, 1854

290 **John B. Greene**, *Abu Simbel*, ca. 1854-56

291 **John B. Greene**, *Vue du Portique de Luxor*, 1854

score of languages."[17] He also became proficient with the calotype process. Accompanied by a sculptor friend from Cincinnati, Hunt made a photographic excursion up the Nile in the winter of 1851-52 [288]. He then continued as far north as Lebanon, Baalbek, and Damascus before returning to Germany. Back in Berlin, Hunt's many photographs were of interest to the famed Prussian naturalist Baron Alexander von Humboldt, who reportedly showed them to the King of Prussia.[18]

While Hunt was a good photographer, John B. Greene was a genuinely great one. The son of a Boston banker residing in Paris, Greene apparently spent all of his life in France.[19] Greene developed an early interest in both photography and archaeology: he was a founding member of the Société Française de Photographie and also belonged to the Société Asiatique. Greene learned photography from Le Gray and adopted the master's waxed-paper negative technique.[20] His three trips to the Middle East, between 1853 and 1856, were apparently all self-financed.[21] His first trip to Egypt, from the fall of 1853 to early 1854, yielded a group of over 200 waxed-paper negatives. Ninety-four of these were printed by Blanquart-Evrard and issued in an exquisite 1854 album titled *Le Nil, Monuments, Paysages, Explorations Photographiques*.[22] Greene returned to Egypt later that year to conduct excavations at Medinet-Habou, Thebes.[23] After a visit to Algeria, Greene went back to Egypt for a third time in 1856. However, his health had suffered and he died later that year in Cairo at the age of only twenty-four.

Greene understood the calotype aesthetic perfectly and produced images that are by turns bold, dynamic, and minimal. In his study of a sun-drenched wall and shadowed doorway at Medinet-Habou [289], the mass of the structure is played off against the hieroglyphic carvings on its outer surface. Greene conveys the rich mystery of the past: the hieroglyphs are clearly described, but their meaning—like the interior of the structure itself—is far from obvious. Whereas Greene's vision here is one of foursquare solidity, his view of Abu Simbel employs diagonals to evoke a sense of energy and instability [290]. Here, the colossal figures appear to be at once emerging from, and sinking into, a heaving, shifting landscape. Although it depicts ancient and weighty things, this image is about mutability rather than stasis. Finally, in his distant view of Luxor [291], Greene emphasizes the seemingly endless expanse of sky and sand. The majestic ruins and lone palm tree occupy a mere fraction of the pictorial space; the result is an almost existential comment on the smallness of man's works in the face of nature and eternity. Ultimately, Greene's photographs are about the mute mystery of human artifacts and the awesome depth of historical and time.

Paper Photography in America

From the early months of 1839, a handful of Americans experimented with paper photography. One of the most notable of these was Josiah Parsons Cooke, a brilliant young man who went on to teach mathematics and chemistry at Harvard University [C-97]. Cooke began experiments with Talbot's process in 1842 as a fifteen-year-old Harvard student. By 1844, he had produced successful calotype negatives and salt-print positives of views from his dormitory window.[24]

By this time, however, it was abundantly clear that American tastes favored the daguerreotype. As a result, no use of paper photography in the continental United States in the 1840s or 1850s came remotely close to the achievements of Greene and his European peers.

American photographers were all experienced with the daguerreotype; they understood the process and loved its exquisite detail and brilliant tones. By comparison, the calotype—with its longer exposures and muted chiaroscuro—was seen as distinctly inferior.

The failure of the calotype in America was not for any lack of promotional effort.[25] In 1849, the Langenheim Brothers made a major investment in Talbot's process. They approached the inventor with a proposal to act as his American agents; in turn, Talbot offered an outright sale of his American patent rights. The Langenheims agreed and spent much of 1849 and 1850 promoting the technique to fellow professionals. As part of this effort, they made more than 100 scenic images in a series titled "Views in North America." Ultimately, the Langenheims found few photographers willing to pay $30 for the right to work on paper. After recouping only a fraction of their initial payment to Talbot, they were forced to back out of their agreement.[26]

Despite the Langenheims' costly failure, the paper photograph was destined for success after the introduction of the wet-collodion glass-negative process. John A. Whipple, in Boston, and Ezekiel Hawkins, in Cincinnati, were among the earliest American professionals to commit themselves to making paper prints from glass negatives.

Whipple began experimenting with glass negatives as early as 1844.[27] After failing in his attempts to use dried milk as a binding vehicle, he was inspired in 1848 by the work of Abel Niépce de Saint-Victor to use albumen.[28] The glass-negative technique that Whipple patented in 1850 used a combination of albumen and honey (which apparently increased the sensitivity of the emulsion). Whipple called this process "crystalotypy" and his paper prints "crystalotypes" in recognition of the technique's crystal clarity. Whipple showed his crystalotypes in the fall of 1850, and won an award, at one of the annual Mechanics' exhibitions in Boston. At about this time, James Wallace Black began working with him to improve and promote the process.[29]

Over the next few years, Whipple and Black worked with the technique themselves [292] while striving to sell licenses for its use to other professionals. In 1852, Whipple reached an agreement with

292 **Whipple & Black**, *Dartmouth Crew, Connecticut River, Hanover, New Hampshire*, ca. 1859

the Root studio in New York: crystalotypes were placed on display there and Black visited to give instructions in both the albumen and collodion negative processes.[30] James E. McClees came to Boston in 1854 to learn the process and paid $250 for the right to practice it in Philadelphia.[31] Whipple and Black emphasized one of the technique's greatest advantages: its reproducibility. Starting with its April 1853 issue, the *Photographic Art-Journal* began a regular use of crystalotype prints as frontispiece illustrations. These included architectural views, studies of sculpture, and copies of noted daguerreotypes.

Ezekiel Hawkins may have been the first in the world—in 1847—to make collodion glass negatives.[32] He was certainly deeply involved in making paper photographs by mid-1851.[33] He worked variously with both paper and glass negatives and called his positive prints "solographs." Like Whipple, Hawkins produced prints in some quantity to be tipped onto the pages of journals. For example, the first issue of the short-lived *Western Art Journal* (January 1855) included three original Hawkins solographs: a view of a local high school, a portrait, and a study of the steamer *Jacob Strader*.[34]

The regular use of Whipple's prints in the *Photographic Art-Journal* pointed up the value of editorial promotion. The journal's editor, Henry Hunt Snelling, was a strong advocate of paper photography. In the July 1852 issue of his journal, Snelling combined American and European perspectives on the new process—emphasizing both potential profit and elite taste: "Those…who first introduce the paper process to the public in our large cities, will undoubtedly make money, for there are very few men of taste who would not prefer the beautifully bold, warm toned and mezzotint-like photograph, to the cold, semi-distinct and glaring daguerreotype."[35] In later issues, Snelling published many articles on the technique and aesthetics of paper photography, often by leading British and French authorities. For example, the first of several essays by Gustave Le Gray appeared in the August 1852 issue of the *Photographic Art-Journal*.[36]

By the end of 1852, Snelling proclaimed that "a new era has dawned upon photography":

> The paper processes have been brought to such a degree of excellence, that the minds, not only of our daguerreans but of the public, are turned to them with a degree of attention of the most absorbing nature. A large number of our first artists have already commenced the practice of the art, and many others are making enquiries preparatory to entering the field…We anticipated this result months ago.

Snelling viewed the coming transition to paper photography as a way of elevating the profession. Citing the "ruinously low prices to which daguerreotypes have fallen" due to competition from a "horde" of mediocre practitioners, Snelling looked to the new process to raise both professional profits and public taste. In his mind, paper photography was beyond the ability of ordinary operators; it required "far more talent and scientific knowledge" than the ubiquitous daguerreotype.[37]

Snelling's cheerleading had some real effect: in 1852-53, there was a marked increase in the use of paper photography in America. By this time, a number of Americans had visited London and Paris and had seen fine paper work first-hand. Examples of European paper photographs were also available in New York. By late 1852, for example, Snelling was offering photographs by Blanquart-Evrard for $4 apiece.[38] In the summer of 1853, a group of Blanquart-Evrard prints was exhibited at the New York Crystal Palace exhibition.[39] By the end of that year, the Anthony firm was importing fine paper photo-

293 **Victor Prevost**, *The Commonwealth*, ca. 1854

graphs from a leading London publisher.[40] This traffic in significant European photographs grew steadily. In 1855, for example, Frederick De Bourg Richards brought back from Europe several landscapes by Roger Fenton and a collection of architectural photographs by James Anderson, of Rome, which he exhibited at the Pennsylvania Academy of Fine Arts.[41] In 1856, Jeremiah Gurney wrote glowingly of Roger Fenton's Crimean photographs.[42]

Personal expertise, as well as prints, traveled across the Atlantic. Before coming to New York in 1848, Victor Prevost had studied alongside Gustave Le Gray and Roger Fenton in Paris, in the studio of painter Paul Delaroche. Prevost worked with the calotype process until 1853, when he returned briefly to Paris to learn the waxed-paper process from Le Gray. Prevost opened a studio devoted to paper photography in early 1854 and made more extensive outdoor use of the technique [**293**] than any other New Yorker.[43] He received critical praise, but could not compete with the larger studios. In about 1855, Prevost went to work for Charles D. Fredricks, who himself had learned the collodion process in Paris in 1853.[44]

By the early months of 1854, other leading American galleries were working with the glass-negative and paper-print techniques. In New York City, these included the studios of Gurney, Root, Lawrence, Haas, and Brady, and in Rochester, the business of Whitney & Denny.[45] In addition to that of Whipple & Black, fine paper work was being done in Boston by Masury & Silsbee. Frederick De Bourg Richards and James E. McClees were among the leading paper photographers in Philadelphia. Jesse Whitehurst's operations in Baltimore and Washington were also producing fine work on paper. In the West, Porter & Hoag in Cincinnati, Alexander Hesler in Galena, John Frederick von Schneidau in Chicago, and John H. Fitzgibbon in St. Louis were also finding success with the new technique.

As 1854 passed into 1855 and 1856, photographers turned increasingly to these processes. This was a transition in stages, guided by economic realities. To begin with, there was the matter of price. Unless a customer requested numerous prints from the same negative, paper photographs were at least as expensive as daguerreotypes. In 1855, for example, McClees's prices for plain (unpainted) salt prints, 4 x 5-inches in size, were $3.50 for the first print and fifty cents for each subsequent impression. The prices for 8 x 10-inch prints were $10 and $1.50, respectively.[46] When a sixth-plate daguerreotype could be purchased for fifty cents or a dollar, paper portraits were clearly

aimed at upscale customers. Second, there was the problem of fading. While daguerreotypes tarnished and were susceptible to physical degradation, they did not fade. Paper prints were far less light-fast—a problem known all too well to Talbot himself. Beginning in the early 1840s, considerable effort was devoted to this issue. For example, by carefully maintaining his chemical baths and washing his prints generously, Blanquart-Evrard produced photographs of admirable permanence. However, this care was harder to achieve in the more improvised, low-production-volume environment of the typical American studio of the 1850s. As a result, the instability of paper prints became a topic of general discussion. *Humphrey's Journal*, for example, ran a series of articles on the matter beginning in December 1855.[47]

Given these issues, many studios found that the most profitable use of the wet-collodion technique lay in the production of ambrotypes rather than paper prints. The ambrotype was fashionable for a relatively short time, from 1855 to the early 1860s, but it speeded the general adoption of the wet-collodion process independent of the matter of paper photography.[48]

Antebellum America on Paper: Picture, View, and Likeness

The full achievement of early American paper photography is hard to gauge: the surviving works are too few and scattered. It is obvious that the artistic merit of this work falls well short of the high standard set in Britain and France. However, it is equally apparent that significant work was created by at least a few dozen American photographers. The works to be discussed here are divided into three categories: images inspired by the European aesthetic tradition, urban views, and portraits.

As noted above, there is little in American paper photography of the 1850s to match the overtly pictorial ambition of British and French work. The leading British amateurs made landscapes and studies of rural life deeply indebted to the tradition of the picturesque. French photographers were powerfully shaped by their academic training in painting and drawing. This aesthetic impulse comprises a minor but fascinating current in early American paper photography. A perfect example of this approach may be seen in a work of June 1854 by Frederick De Bourg Richards and John Betts [294]. Richards was man of considerable artistic ability, with a deep appreciation for European culture and art.[49] This picturesque and nostalgic scene clearly reflects those interests. Chosen as the frontispiece for the October 1854 issue of the *Photographic and Fine Art Journal*, this became one of the best-known examples of a purely pictorial application of early American paper photography.

A bolder and even more remarkable work by Samuel Masury [295] should be viewed in this context. Masury went to Paris in 1855 to study with the Bisson Frères (the brothers Louise-Auguste and Auguste-Rosalie Bisson), who were famed for their majestic wet-collodion architectural work. In the French capital, he learned much about both technique and aesthetics.[50] Upon his return to Boston, Masury photographed the estate of Charles Greeley Loring. This composition strikes a beautiful balance between nature and culture —the tree and barn, landscape and "improvements," are presented in graceful harmony. On its simplest level, this image provides a visual inventory of Loring's prized horses and livestock: their names are

written carefully on the mount. Beyond this documentary function, Masury gives pictorial form to the Jeffersonian ideal: a cultured existence lived in harmony with nature.

This theme of a landscape transformed by human effort is underscored in an exquisite salt print from the late 1850s [296]. This unusual genre scene records a group of spectators in their Sunday best watching professional stump pullers at work. As mundane as the task might now appear, this labor had deep cultural importance. Land was "improved" in the transition from forest to field; cleared acreage was productive and profitable in ways that wooded tracts were not. The camera's rather distant perspective provides a sense of geographic context, implying the expanse of tillable land beyond the picture's edges. The fine dress of the onlookers marks this as an event of importance while suggesting that they themselves have risen above physical toil. Finally, the subtly undulating band of figures in the picture's mid-ground echoes the welcoming contours of the land itself.

Another carefully choreographed outdoor group portrait [297] records the members of a scientific expedition in early 1857. Organized by the Lyceum of Natural History of Williams College, this group spent about two months exploring the coast of Florida, gathering specimens of flora and fauna. This photograph was made on the Williams College campus shortly after the party's return, in front of an evergreen decorated with their collection of Spanish moss. Standing proudly in their field gear, the explorers display their trophies to the camera.

The paper process allowed photographs to be issued in albums. A pioneering work in this regard was George R. Fardon's *San Francisco Album*, a series of about thirty-two salt prints from wet-collodion negatives.[51] Issued in the fall of 1856, the *San Francisco Album* was the first published compilation of photographs of an American city. Created primarily for the purpose of civic boosterism, Fardon's album was evidently sold on a subscription basis to wealthy businessmen and property owners.[52] His photographs record important commercial and civic buildings, churches, views of the bay, and—appropriately, given the chronic threat of fire—a number of the city's volunteer fire companies. Fardon's views represent San Francisco as booming, progressive, and safe.

One of Fardon's finest photographs [298] shows the view north along Kearny Street toward Telegraph Hill. In his extended exposure, people blur into invisibility and a fluttering awning turns to mist. The economic dynamism of the place is unmistakable, however. Kearny Street is a forest of advertising signs—for painting, hardware, Catholic books, tin ware, watches, hats, daguerreotypes, saddles, and much more. Equally important, Fardon records the gradual replacement of smaller and earlier wooden buildings with fine new structures of brick and stone.

While Fardon's work was the first of its kind issued in book form, photographers in other cities were recording their communities on paper. In Boston, both Whipple and Southworth & Hawes made urban views. This unusually large work [c-98] appears similar to identified works by the latter studio. In New York, Victor Prevost produced an extensive series of urban views by 1854, but his hopes to have these issued in book form were unrealized. Another superb group of New York views, from about 1855, have been attributed to either Silas A. Holmes or Charles D. Fredricks.[53] In 1857, Henry Hunt Snelling, the editor of the *Photographic and Fine Art Journal*, offered his readers prints of city scenes made from 18 x 22-inch mammoth-plate negatives.[54] Philadelphia was equally well recorded on paper:

294 **Richards & Betts**, *Old Barley Mill, Brandywine River*, June 1854

295 **Samuel Masury**, *On the Loring Estate*, ca. 1856

296 **Unknown Maker**, *Stump-Pulling Scene*, ca. 1857

297 **Unknown Maker**, *Lyceum of Natural History of Williams College (Florida Expedition Group)*, 1857

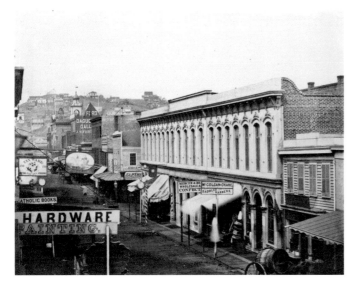

298 **George R. Fardon**, *Kearny Street, San Francisco*, ca. 1855-56

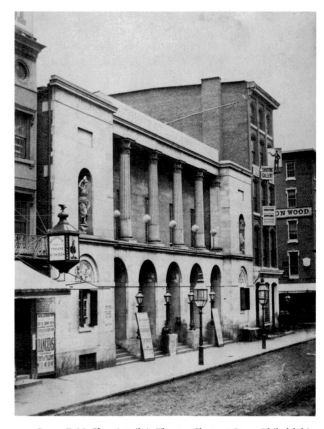

300 **James E. McClees** (attrib.), *Theater, Chestnut Street, Philadelphia*, ca. 1854

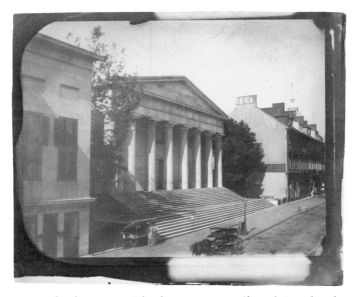

299 **Frederick De Bourg Richards**, *Customs House (formerly Second Bank of the United States), Philadelphia*, ca. 1857-59

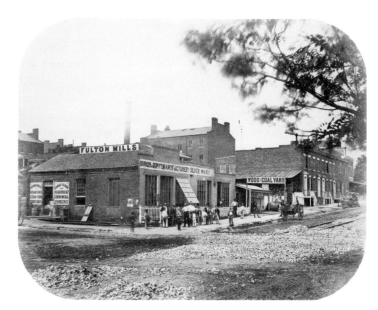

301 **Williams & Outley**, *Street Scene, St. Louis*, ca. 1859-60

both Frederick De Bourg Richards [**299, c-99**] and James E. McClees [**300**] undertook surveys of important streets and structures. This view of Cincinnati [**c-100**] may have been by the city's leading proponent of paper photography, Ezekiel Hawkins, although proof of his authorship is lacking. From the top of its new courthouse, Alexander Hesler made an eleven-plate, 360-degree panorama of Chicago in 1858.[55] In St. Louis, Williams & Outley used a camera of at least 12 x 15-inch format to record the rapidly changing face of the city [**301**]. In New Orleans, J. D. Edwards created a significant body of work on paper. This masterful view [**302**] records the economic lifeblood of the antebellum South: bales of cotton ready for shipment to the North and to Europe.

The most daring urban view of this period—and the first successful aerial photograph in America—was made on October 13, 1860, by James Wallace Black.[56] It was a genuine challenge to squeeze a camera, tripod, and dark tent into the basket of a balloon, and then to coat, expose, and develop a wet-collodion negative while swaying

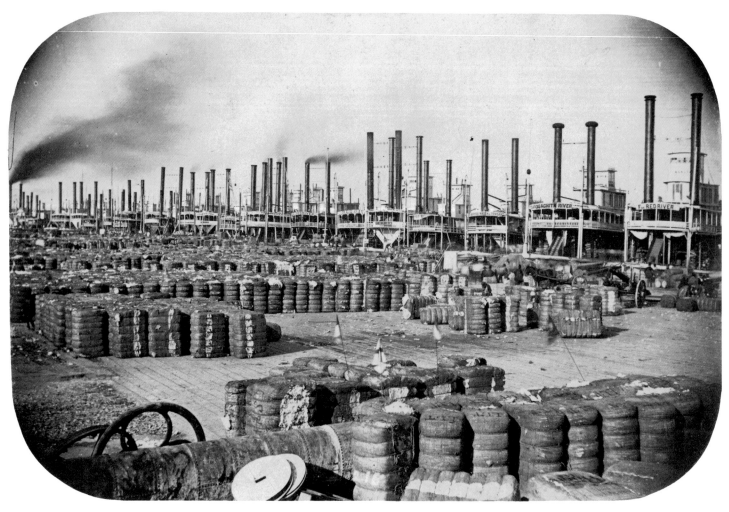

302 **J. D. Edwards**, *Steamships at Cotton Wharf, New Orleans*, ca. 1857-60

aloft. Although the feat had been accomplished two years earlier by
the renowned French photographer Nadar, it had never been done in
America. In collaboration with the balloonist Samuel King, Black went
up twice. The first ascent, on August 16, 1860, over Providence, was a
photographic failure.[57] The second attempt, in a balloon tethered 1,200
feet above Boston Common on October 13, 1860, was successful. Six
negatives were exposed and the print from the best of them [303]
was widely acclaimed. This view of Boston's commercial heart is
quintessentially modern: a familiar subject made radically new
through a novel and disorienting point of view.

The single most important American urban paper photograph
of the 1850s may well be Fredricks's majestic view of his studio on
Broadway, in New York City, ca. 1857 [287]. This untrimmed print
reveals the full image captured by Fredricks's large wet-collodion
negative, as well as flaws in the coating and a few fingerprints. The
vignetting in all four corners suggests that a short-focus lens was
used to capture the widest possible view of the building and its sur-
roundings. While this image reveals a good portion of a city block,
it is clearly—and proudly—a "portrait" of a single business.

From 1854 to 1856, Fredricks worked in partnership with Gurney
at 349 Broadway. Fredricks opened a lavish new gallery under his
own name in August 1856. His location at 585 Broadway, near the
corner of Broadway and Prince Street, put him in the heart of the

303 **Black & Batcheleder**, *Boston as the Eagle and Wild Goose See It*, 1860

city's most fashionable district. The luxurious Metropolitan Hotel was across the street and the area was filled with theaters and upscale shops. The renovation of Fredricks's property appears to have taken about six months, but by the spring of 1857 the details evident in this photograph were in place.[58]

This image documents the public face of Fredricks's business. At the top of the structure, a large sign reads PHOTOGRAPHIC, / DAGUERREOTYPE and / AMBROTYPE GALLERIES. A sign in the center of the façade announces the new status of the business:

CHARLES D. FREDRICKS

LATE

GURNEY & FREDRICKS

Fredricks himself looks out the second-floor window, while his employees stand at windows on the third and fourth floors. The gentlemen's entrance to the gallery, at the 585 address, is decorated with framed daguerreotypes and paper prints. The ladies' entrance, at 587 Broadway, is shaded by an awning.[59]

The symbolic rhetoric on view is equally interesting. On the building's façade, arranged in a towering arc, letters about four feet tall spell out FREDRICKS' PHOTOGRAPHIC TEMPLE OF ART. In the center of the structure is a vertical arrangement of icons: an eagle, a camera, and the sun.[60] Together, these words and representations suggest photography's rich social and conceptual meaning. The phrase "Photographic Temple of Art" unites the ideas of fact, spirit, and invention. It suggests associations with ancient and sacred sites, great museums, and the dignity of art. The sculptural icons are indications of patriotism (the eagle as a symbol of national pride and independence), science and technology (the camera), and the forces of nature (sunlight as both beautiful and life-sustaining).

What did it mean for a business to promote itself so boldly as a "Photographic Temple of Art?" To some degree, of course, this was viewed as promotional hype. In part, the phrase was a direct jab at Fredricks's former partner, Jeremiah Gurney, who described his own operation as a "Photographic Palace of Art." These crasser motives aside, the phrase would not have been effective if it did not "ring true" on some level. To grasp the ways in which this rhetoric did strike an intellectual or emotional chord with mid-century Americans would be to understand a vital but deeply elusive aspect of the cultural mind.

Fredricks's remarkable photograph reminds us that portraiture remained the profession's primary task. The shift from the daguerreotype to the ambrotype and paper photograph resulted in significant changes in darkroom and finishing procedures. The new process allowed faster exposures in the studio, and allowed the production of much larger photographs. Otherwise, however, this shift in technique produced no corresponding pictorial advance. In fact, the conventions of lighting and posing became increasingly standardized with the waning of the daguerreotype, possibly as a result of a larger trend to streamline studio procedures. Few portraits after the mid-1850s can match the subtlety, invention, and immediacy of the best work from the preceding fifteen years.

While paper prints may not have represented a great aesthetic advance, they vastly extended the public circulation of original photographs. In the daguerreotype period, a sitting with a celebrity such as Jenny Lind might have resulted in three or four finished plates. With some labor, copy daguerreotypes of the best of these originals could be made and sold. The paper photograph, on the other hand, allowed a nearly unlimited number of prints to be made

304 **Jesse Whitehurst** (attrib.), *James Buchanan*, 1856

from a single negative. This potential only encouraged the already growing market for celebrity images.

As a result, nearly everyone of any renown was photographed by the wet-collodion process. James Buchanan was the first American President (1857-61) to be extensively recorded on paper [**304**]. At about the time of Buchanan's inauguration, his successor was photographed in Chicago by Alexander Hesler [**305**]. This unconventional likeness—the so-called "Tousled Hair Portrait"—depicts the Abraham Lincoln known to his friends and associates, a forceful presence and a man without pretense. Apparently, Lincoln himself mussed his hair for this portrait, stating that his friends would not recognize him too finely groomed.[61] A lengthy parade of other notables passed through the photographic studios of the day, from political figures [**306, c-101, c-102**] to adventurers [**307**], artists [**c-103**], and ambassadors [**308**]. Many of these photographs were produced in quantity for public sale; others appeared in engraved facsimile in the illustrated newspapers of the day.

In addition to serving as the basis for engravings in the illustrated papers, original paper prints were included in a handful of American books of the period. William Henry Fox Talbot's *Pencil of Nature* (1844-46), the first photographically illustrated publication, had demonstrated the reproductive potential of the negative/positive process. Potential was one thing; the practical considerations of cost and labor turned out to be quite another, and none of these books was issued in great quantity. Two early publications were *Homes of American Statesmen* (1854) and *Remarks on Some Fossil Impressions in the Sandstone Rocks of Connecticut River* (1854), which contained a single salt print apiece by John A. Whipple and George M. Silsbee, respectively. Frederick De Bourg Richard's travel narrative,

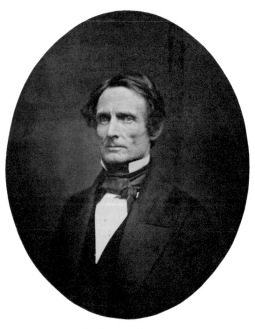

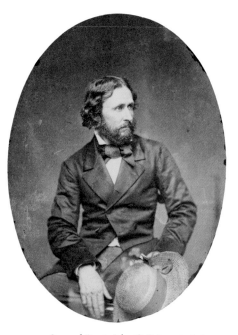

305 **Alexander Hesler**, *Abraham Lincoln*, 1857 306 **Jesse Whitehurst**, *Jefferson Davis*, ca. 1857 307 **Samuel Root**, *John C. Frémont*, 1856

308 **Charles D. Fredricks**, *Tateishi Onojirō Noriyuki*, 1860

DUMB-BELL CHARTS IN THE BACKGROUND.

| GEORGIE. | EDWIN. | HAMIL. | GRUBB. | ORVILLE. | NEDDIE |
| | | ABRAM. | | JAMES. | |

309 **Frederick Gutekunst,** *Dumb-Bell Charts in the Background (Group at Pennsylvania Training School for Feeble-Minded Children),* ca. 1858

Random Sketches, or, What I Saw in Europe (1857), included three salt prints.[62] A considerably larger effort was made by D. D. T. Davie, who produced the *Photographic Senatorial Album of the Empire State, 1858-59* (1859), with thirty-five original salt-print portraits.

One of the most remarkable of these pioneering volumes is Isaac Newton Kerlin's *The Mind Unveiled, or: a brief history of twenty-two imbecile children* (1858). The first photographically illustrated medical book in America—with up to seven salt prints by Frederick Gutekunst—this volume documented the work of the Philadelphia Training School for Feeble-Minded Children. Gutekunst photographed these children (all finely dressed for the camera) in a variety of characteristic activities [309]. Few of these volumes were issued, and individual copies reveal considerable variation in the number and sequence of the photographic plates.

Paper prints could be made in large size as well as (theoretically) in large number. For the elite galleries of the time, the most significant innovation was the "Imperial" format. These oversize portraits, typically made from 21 x 17-inch negatives, became a specialty of the Brady studio in about 1855.[63] Other photographers followed this example; Meade Brothers, for instance, gave the name "Excelsior Photograph" to pictures of this size. The poses and compositions of these portraits tend to be simple—typically, the subject is presented in formal dress, either standing or sitting, with a minimum of studio props. In some cases, the final prints were retouched with India ink, giving them a painterly quality. The finished prints convey a feeling of dignity and stature, as seen in this portrait of Moses Grinnell, a wealthy New York City merchant and civic leader [310]. This was portraiture for the wealthiest clients: the price of a single print ranged from $50 to $500 (the equivalent today of roughly $1,000 to $10,000).

While the handwork on Imperial portraits tended to be subtle and monochromatic, the matte surface of the salt print invited the artist's brush. Not coincidentally, the late 1850s saw a vogue for photographs retouched in India ink, watercolor, or crayon, or painted over completely in oil. Many leading studios kept a professional artist

on staff to do this work. Such handwork added prestige to the finished portrait, and customers paid accordingly. In the 8 x 10-inch size, James E. McClees charged $10 for the first "plain" print, $15 for "tinted" impressions, and $25 for the same "finely finished" in either watercolor or India ink.[64] Advertisements of the time suggest that a significant portion of these hand-painted works were paper copies of old daguerreotype portraits enlarged up to "life size." This copying and enlarging process typically resulted in a marked loss of sharpness; as a masking technique, handwork was thus all the more appropriate.

While most leading studios disdained any excessive use of pigment, smaller studios happily indulged the public's taste for eye-popping color. This work [311], by an unnamed photographer in Peoria, Illinois, is a fine example of a heavily hand-painted print. While characteristic of a larger genre, this work is distinguished by the careful rendering of the floor tiles and distant landscape scene.

At present, the era of the American salt print remains little known and imperfectly documented. A tantalizing hint of the riches of this period was provided in 1997, when an album of over 200 salt prints came to light in California. It was rapidly disassembled and the location of many of these prints is now uncertain. It was determined that the album had been compiled between about 1853 and 1858 by John R. Johnston, a painter, sculptor, and singer.[65] A native of Cincinnati, Johnston studied art there and, in the winter of 1847-48, in Baltimore. In the late 1840s and early 1850s, he assisted with the painting of large panoramas in Cincinnati and St. Louis. He also achieved success painting portraits and theater backdrops. He then became involved in photography. By 1855, Johnston was coloring paper photographs for Ezekiel Hawkins and other photographers. In 1856, he moved to Baltimore, where he continued to paint while "supplementing his income by tinting photographs."[66] He established a close working relationship with Jesse Whitehurst and was associated with as many as four of Whitehurst's studios as an artist.[67]

As a result of his many professional contacts—from the greater Washington-Philadelphia region down the Ohio River valley as far

310 **Mathew B. Brady**, *Moses H. Grinnell*, ca. 1858

311 **Unknown Maker**, *Susan M. Davis*, 1865

west as St. Louis—Johnston assembled a large and varied collection of prints. It is easy to surmise that this group included works by the Whitehurst studio and by Hawkins. Other prints in the group are known to have been made by the Brady studio, James E. McClees, John Wood, George K. Warren, and Albert Park. The album contained a number of family pictures—portraits of Johnston himself, and his wife and daughter—as well as portraits of performers and celebrities, from Edwin Forrest to Jefferson Davis [306] and the Kansas Investigating Committee [C-102]. The album also included likenesses of photographers: a group portrait of the Whitehurst studio staff (including Johnston) and portraits (or self-portraits) of Washington Peale, Albert G. Park [C-104], and Charles Waldack [C-105]. Views of Cincinnati [C-100], Lexington, Nashville, Baltimore, and Philadelphia were included, as well as such rare subjects as the 1857 inauguration of President Buchanan. There were also paper-print copies of now-lost daguerreotypes, including Alexander Hesler's *Driving a Bargain* [278].

New Formats: The Stereograph and Carte-de-Visite

By 1860, it was clear that Henry Hunt Snelling had been at least half right in his predictions of 1852. The rise of glass and paper did represent a genuinely new era in American photography. After twenty years, the once-dominant daguerreotype was rapidly disappearing. However, Snelling was wrong in his assumption that the wet-collodion and paper-print processes would primarily serve the cause of the nation's most refined practitioners. The Imperial portrait, promoted by Brady and his elite peers, was too expensive to achieve broad popularity. Instead, the most important new formats of the late 1850s—the stereograph and the carte-de-visite—were small and inexpensive. Following their introduction in Europe, both achieved enormous popularity in America.

The stereograph is based on the principle of binocular vision. The two human eyes take slightly variant perspectives on the world and send correspondingly different messages to the brain. These overlapping perspectives create our sense of space and distance. Made with a twin-lens camera, stereographic images are viewed in a lenticular device that allows the virtual images to completely fill the viewer's perceptual field. The result is a compelling, if slightly curious, sense of visual depth in which objects appear as flat cut-outs occupying discrete planes in space.

Stereo photographs were made on an experimental basis in the 1840s, but achieved broad notice at the 1851 Crystal Palace exhibition in London.[68] A market for stereographs developed in the following years, first in Europe and then in the United States. At first, vacationing Americans brought stereo photographs and viewers back from Europe. By 1852, imported stereographs were being sold by the New York publishing firm D. Appleton Company and a number of leading Americans—including Brady, Gurney, and Beckers & Piard—were working with the technique.[69] Frederick De Bourg Richards, in Philadelphia, was one of the format's most devoted practitioners; by 1852, he was manufacturing and selling an improved viewer of his own design.[70]

These early views were produced in several ways—as daguerreotypes, glass transparencies, and paper prints. In 1853, John F. Mascher, of Philadelphia, patented a self-contained viewer/case for stereo daguerreotypes.[71] Despite the utility of Mascher's device, stereo daguerreotypes were made in relatively small number. The Langenheims

led in the production of glass and paper stereographs. Their first effort to make stereo transparencies in 1850—albumen glass negatives printed as glass positives—found little success. By 1854, they had shifted to the wet-collodion process for both their positive glass transparencies and their paper prints. The result was an impressive number of views on both glass and paper, issued in 1854-55 in such series as "Philadelphia and Environs," "The City of Washington," "Baltimore," "Niagara Falls," and "Beauties of the Hudson River." James E. McClees was publishing paper stereographs by 1855, and the D. Appleton Company began issuing original views a year later. After Oliver Wendell Holmes invented an improved stereo viewer in 1859, the format soared in popularity. By late 1860, no fewer than 200 American photographers were producing stereographs on either paper or glass.[72]

While the stereograph soon became an accepted part of American cultural life, its perceptual and pictorial uniqueness should not be overlooked.[73] The stereograph challenged previous assumptions about human vision and required photographers to think about pictures in a new way. The creation of stereo images actually predated the announcement of photography. Sir Charles Wheatstone, a distinguished British physicist and inventor, first demonstrated the principle of the stereoscope in 1838. Wheatstone's device used mirrors, set at a 90-degree angle, to present the reflections of two perspectival drawings to the viewer (one drawing per eye). While the drawings were flat, they combined to create the illusion of a three-dimensional form. Wheatstone's experiment proved the importance of binocular vision to the perception of depth. It also opened an intriguing gap between perception and reality: the space seen in Wheatstone's device was virtual, not physical.

This discovery stimulated interest in the science and theory of perception, and contributed to the nascent field of experimental psychology. As a result of the questions raised by Wheatstone's stereoscope, this field paid considerable attention to the physiological and subjective aspects of depth perception. These factors were underscored by Wheatstone's description of the "pseudoscope," a device in which perspective views were reversed (the right eye sees the image intended for the left eye, and vice versa). In this curious arrangement, depth is turned inside out: convex objects appear concave, and background and foreground are reversed.[74]

All this amounted to much more than a simple parlor trick. As Laura Schiavo has noted, "By introducing the body and its productive capacities into the story, the stereoscope contested the idea that vision could be represented geometrically—the basis for Renaissance perspective… Disputes surrounding the stereoscope had clear implications for metaphysical and philosophical discussions about the nature of knowing and the role of the body in perception."[75] Perception could no longer be understood as a simple encounter with reality—it was a subjective and synthetic process.

Photographers realized that the stereo image was inherently about space. As a result, practitioners learned to view the world both graphically and spatially—as a sequence of planes of visual incident. On the simplest level, this involved the inclusion of foreground or framing details to most effectively "shape" the space of a landscape scene. On a more refined level, photographers found that space itself could be manipulated by varying the separation of the lenses of their cameras. The separation of the human eyes—about 2½ inches—only provides "true" depth perception of objects relatively close at hand. Landscape photographers found that they could

312 E. Anthony, *The Burning of Cyrus W. Field's Warehouse in New York*, 1859

313 E. Anthony & Co., *Looking up Broadway from the Corner of Grand Street*, ca. 1860

enhance the spatial illusion of distant scenes by widening the gap between their lenses, from a "normal" distance of 2 ½ inches up to several feet or more. This "hyperstereo" effect was known by 1851 and became an established technique.[76]

Following on the heels of the stereograph, the carte-de-visite enjoyed a similar boom in popularity beginning in 1860-61.[77] This format—the size of a visiting card—came to prominence in Paris in 1854 through the efforts of André-Adolph-Eugene Disderi.[78] The carte-de-visite (or "card photograph," as it was often called), is a small albumen print on a sturdy paper mount. Typically, the prints are about 2 ⅛ x 3 ½ inches in size, while the mounts measure 2 ½ x 4 inches. These images were easy to make in quantity. Using multi-lens cameras, photographers made either four or eight separate exposures on a single wet-collodion negative. Each print from one of these negatives yielded a corresponding number of card portraits. Sold by the dozen, cartes-de-visite were shared with friends and saved in albums. The craze for card photographs triggered an accompanying fad for fancy albums; no fewer than fifteen patents were issued in 1861-65 for photographic albums.[79] The family album became a requisite part of nearly every parlor in America—a treasured repository of miniature faces and scenes.

The popularity of the carte-de-visite affected the sale of all other photographs. Attempts to revive the daguerreotype in the early 1860s were fruitless. The ambrotype declined in popularity and the sale of stereographs, which had boomed in 1859-60, also slowed.[80] A report from May 1863 may be taken as typical of the day: "In Boston, as in every other city and town in this country, the card photograph has for the past two years been in universal demand, almost to the complete exclusion of every other style of photographic portraiture, and has in fact produced a revolution in the photographic business."[81]

This revolution had several facets. The carte-de-visite further democratized the production and consumption of portraits: they were cheaper than any earlier style or format. Produced in enormous quantity, they spurred a vastly increased social circulation of photographic images. Families now routinely possessed card photographs not only of themselves, but of political leaders, celebrities, and depictions of distant places and events.

Stylistically, the carte-de-visite represented a further step away from the nuanced artistry of the daguerreotype. Card photographs were too small to convey the subtleties of costume or expression that were characteristic of the earlier process. In addition, the low-cost/high-volume nature of this business required photographers to pose and illuminate their subjects in efficient, formulaic ways. The

card photograph was by its nature, a cooler, more emotionally neutral form of depiction than the earlier process. While the daguerreotype had been the quintessential family likeness—a one-of-a-kind image typically held within the context of the immediate family—the carte-de-visite had a more perfunctory and public function.

Edward Anthony clearly grasped the economic meaning of this revolution in photography. Recognizing the vast market for inexpensive photographs, he created a tightly integrated business for the creation, production, and distribution of both stereographs and cartes-de-visite. Anthony had learned the daguerreotype process in early 1840 from Samuel F. B. Morse.[82] He opened his first studio and daguerreian supply concern about a year later, in the winter of 1840-41.[83] By 1844, he was a wholesale supplier of daguerreotype plates, cases, chemicals, and cameras, and all the other equipment needed by a professional operation.[84] Just as he understood the value of goods in bulk, Anthony grasped the commercial value of inexpensive photographs in quantity.

By 1858, Anthony was importing European stereographs for both wholesale and retail sale. With the introduction of Oliver Wendell Holmes's improved stereoscope in 1859, Anthony began producing his own stereo photographs. By the summer of that year, he had published 175 original views of scenes in and around New York City. Within months, his offerings had grown to include dramatic records of newsworthy events [312].[85]

Some of these 1859-60 views were all the more remarkable for having been taken with "instantaneous" exposures of roughly one-fortieth of a second.[86] Many of these stereographs depict Broadway, often from the upper floors of Anthony's own business.[87] These images [313] were notably new in American photography.[88] For the first time, the camera captured the energy and congestion of the city—sidewalks full of pedestrians and streets jammed with horse-drawn vehicles. These images depicted a world at once physically familiar and pictorially strange. Viewers marveled at the odd and varied postures of pedestrians in these split-second exposures: the camera revealed the "simple" act of walking to be surprisingly complex. As a noted writer of the day observed, "No artist would have dared to draw a walking figure in attitudes like some of these."[89]

The Anthony firm quickly became the leading producer and distributor of both stereographs and cartes-de-visite. Anthony patented one of the earliest American carte-de-visite albums in 1861, and did much to ensure the standardization of the format across the industry. By 1873, the firm had a trade list of over 11,000 of its own stereographs, with hundreds more by other makers.

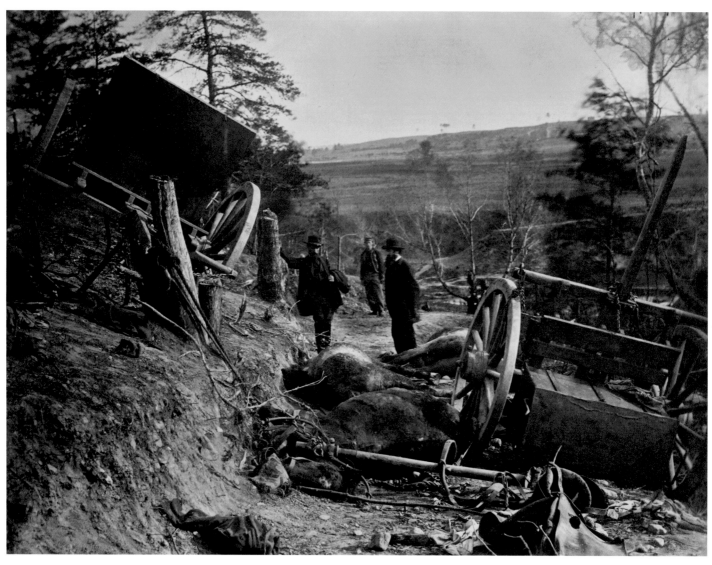

314 **Andrew J. Russell**, *Fredericksburg: Rebel Caisson Destroyed by Federal Shells*, May 3, 1863

CHAPTER VI "A Terrible Distinctness": Photography of the Civil War Era, 1861-1865

Nearly a century and a half after its conclusion, the Civil War remains uniquely compelling to Americans.[1] The importance of the conflict derives in part from its overwhelming scale. The war saw some 10,455 military actions, from the huge battles of Antietam and Gettysburg to thousands of smaller skirmishes, raids, and occupations scattered over some eighteen states and territories.[2] From a national population of 31.4 million in 1860, some 2.1 million men served in the Union Army, while 800,000 joined in the defense of the Confederacy. Of these 2.9 million, just over one-third were casualties and 623,000 died. Bullets and disease claimed as many American lives between 1861 and 1865 as in all other wars combined.[3]

The conflict lasted four years—from the shelling of Fort Sumter on April 12, 1861, to the surrender at Appomattox on April 9, 1865—but the roots and ramifications of the war dominated decades of American history. The issue of slavery had been the cause of heated regional debate through the 1840s and 1850s, and the trauma of Reconstruction shaped the South for generations. In addition to ending slavery and preserving the Union, the war set the future course of the American nation. The South had represented a distinct way of life: a rural, agricultural, labor-intensive culture founded on a belief in racial inequality, a central government of limited power, and the traditional values of family, hierarchy, and patriarchy. The North was rapidly developing into an urban, capitalist, competitive, and industrial society, with an increasingly strong central government. The war was, in part, a clash between these contrasting visions of America.

The Civil War represented a watershed in the history of warfare. In 1861, traditional ideals of martial heroism collided headlong with the brutal reality of anonymous killing on a previously unimagined scale. The Civil War was the first major conflict to demonstrate the lethal consequences of industrial technology and mass production. This war saw the first extensive use of rifled muskets, explosive shells, ironclad vessels, and naval mines. It marked the first sustained use of railroads to move and supply troops in the field, and of observation balloons and the telegraph. It also introduced crude prototypes of the machine gun, submarine, hand grenade, and rocket —all of which would have their most deadly impact in future conflicts.

These new technologies reshaped the rules and strategies of war.[4] The rifled musket, for example, had a far greater range and accuracy than earlier smooth-bores. It expanded the "killing zone" of the battlefield, doomed the time-honored heroics of the open frontal assault, and made field fortifications essential. This pragmatic respect for defensive action challenged the traditional military emphasis on offense. In the Atlanta Campaign, for example, the advance of General William T. Sherman's troops rested largely on repeated flanking moves to threaten the enemy's lines of supply and communication, rather than on direct tests of strength.

As part of the Civil War's radical modernity, photography played an unprecedented role. Although the camera had been used to document aspects of the Mexican-American War (1846-48), the Second Burma War (1852-53), and the Crimean War (1854-55), the Civil War was recorded in a wholly new manner. More than 3,000 individual photographers made war-related images.[5] While the great majority of these were studio portraits, a still considerable number of photographers made portraits and group scenes in the field. Dozens of cameramen made battlefield views and other images of official military interest. These photographs permeated American culture. In fact, the Civil War has been described as the first "living room war"—one brought home to viewers in the form of mass-produced cartes-de-visite and stereographs, and as wood engravings derived from photographs in the pages of *Harper's Weekly* and *Frank Leslie's Illustrated*.[6]

Tintypes, ambrotypes, and carte-de-visite portraits of individual soldiers compose the majority of Civil War photographs. With few exceptions, these are unremarkable in form or visual sophistication. Another large category of Civil War photographs includes mass-produced stereographs and cartes-de-visite of politicians, military leaders, and war scenes. Large-format group portraits also exist in some quantity. Views of military bridges, buildings, vessels, and equipment constitute a smaller category of images, while battlefield photographs are the rarest of all.

Despite the camera's apparent ubiquity, it is important to remember that many aspects of the war went largely or even entirely unrecorded. For example, photographs of actual fighting were made on only a few occasions—most memorably by Andrew J. Russell, at Fredericksburg on May 3, 1863, and by George S. Cook in Charleston harbor on September 8, 1863.[7] These are both distant views, made within the sound of cannon and gunfire, but without any of the visual drama of the most famous twentieth-century war photographs.

These rare images underscore a general rule: Civil War photographers were typically kept at a healthy distance from combat. In

part, the absence of photographers from both the heat and the after-math of battle was a result of their heavy equipment and relatively slow process. It was also a reflection of the basic factors of time and distance: very few battles took place with photographers near at hand and ready to work. Further, the logistics of travel made it impossible for many cameramen to arrive at the scene of an engagement sooner than two or three days after the end of fighting. This typically meant that there was little to be recorded: after a major engagement, the dead were usually buried within about two days by the forces holding the ground, and the armies had moved on. As a result, despite the notoriety of photographs of Civil War dead, such powerful scenes were recorded on only seven occasions in four years of conflict.[8]

The documentation of the war was enormously one-sided. Confederate photographers such as J. D. Edwards and the team of Osborn & Durbec were active in the early months of the conflict. However, these activities were all but ended by the Union blockade of Southern ports and the resulting economic crisis: commodities became scarce and prices skyrocketed. On January 1, 1862, *Humphrey's Journal* noted with only slight exaggeration that "the Photographic Art down South has completely died out in consequence of the war. The miserable rebels are shut up like a rat in a hole." As a result of the blockade, Confederate photographers had "nothing to work with, and nobody to work for."[9] As a recent historian has noted, "Confederate field photography almost ceased to exist after 1861."[10]

This inevitably partial record has shaped the collective memory of the war in curious ways. The people or incidents that were not photographed typically have a less-specific historical "reality" than those that were pictured often and well. Conversely, the renown of a thing or event can be artificially elevated by the number and quality of its representations. For example, the *Dictator*, a massive 13-inch mortar, remains well known because of several impressive photographs made in the fall of 1864 [315]. In truth, however, the *Dictator* had only minor historical significance; it saw limited action in the siege of Petersburg and appears to have spent the final six months of the war in storage.[11]

A Mass Market for Pictures

In 1860, 3,154 Americans were working as photographers.[12] In the previous few years, these men (and a few women) had witnessed rapid changes in their profession. The daguerreotype had gone almost entirely out of fashion, replaced largely by the paper-print processes, including the inexpensive stereograph and carte-de-visite formats.

A mass audience for photographs had begun to take shape on the eve of the Civil War. The start of war in 1861 only increased the importance of this market. No firm was better prepared to supply this growing national demand than the Anthony Company. Early in 1861, Edward Anthony signed a contract with Mathew B. Brady—with whom he had previously enjoyed a close professional relation-ship—to mass-produce and distribute cartes-de-visite from Brady's collection of portraits. Brady received about $4,000, and the new copy-negatives became the property of Anthony.[13] The Anthony firm acquired similar collections from other sources; later in 1861, for example, it purchased many negatives from George S. Cook in Charleston, South Carolina.[14]

The tense months leading up to war provided a lucrative market for images of newsworthy subjects. On February 8, 1861, during the standoff between the Federal defenders of Fort Sumter and the

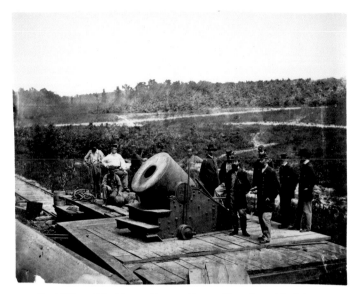

315 **David Knox**, *The Mortar* Dictator, *Front of Petersburg, Virginia*, October 1864

Confederates blockading Charleston harbor, George S. Cook went to the fort to photograph its commander, Major Robert Anderson. Cook immediately sold the negative to Anthony, who issued a humorous advertisement for likenesses of this Northern hero under the banner headline: "MAJOR ANDERSON TAKEN!"[15] As the nation's attention remained focused on Fort Sumter through the middle of April, Anthony printed up to 1,000 copies per day of the Anderson portrait.[16]

The first photographs of the war itself, made immediately after the withdrawal of Union forces from Fort Sumter on the morning of April 15, were also created for popular sale. Beginning on that day, photographer Alma A. Pelot, an employee of Charleston studio owner Jesse H. Bolles, recorded several subjects related to the siege of Fort Sumter.[17] One of these was the Confederate Floating Battery, a heavily reinforced barge with four large cannons that had played a key role in the bombardment of the fort [316]. Bolles promoted these views in ads in the Charleston newspaper, but their current rarity suggests that few were sold.

In April 1862, Coleman Sellers—a skilled engineer, amateur photographer, and American correspondent for the *British Journal of Photography*—reported from New York:

> Card pictures are all the rage, and there are many novelties in the way of card albums. Mr. E. Anthony tells me that. . . they are now printing 100 sheets of paper each day, producing 3600 card pictures. The ones that sell best are soldiers and popular statesmen; but literary and theatrical characters are in demand, as are also small copies of engravings… One curious circumstance…is that in many of the cities of the northern slave states, where there is said to be a strong union feeling, portraits of the southern generals are very much more in demand than are those of the union army.

Sellers further noted that, even at the frantic pace of 3,600 images per day, the firm remained "behindhand in supplying some orders."[18]

The Anthony firm issued periodic catalogues of both their stereoscopic and card photographs. These covered a broad range of subjects, from picturesque regional scenes to views of Japan, the Danube River, and Cuba, and copies of engravings and statuary.[19] The firm's November 1862 catalogue listed war views from Brady's negatives. Cartes-de-visite at twenty-five cents each were available

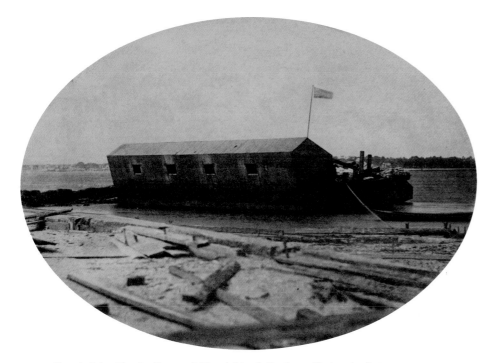

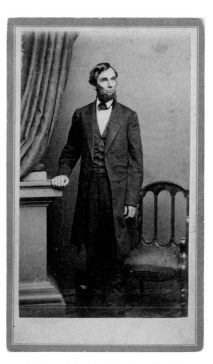

316 **Alma A. Pelot**, *Floating Battery, Sullivan's Island, Charleston Harbor*, April 1861 317 **Mathew B. Brady**, *Abraham Lincoln*, 1863

of various aspects of the conflict, including scenes at Washington, Manassas, and Bull Run; encampments and groups near Yorktown; the Antietam battlefield; and portraits of President Lincoln [**317**] and leading generals. Many of these images were also issued in the stereo format. Anthony published about 2,000 Civil War stereographs in all, including about 900 from Brady negatives.[20] In addition to these smaller-format views, Anthony distributed larger Brady prints under the collective title "Incidents of the War." Although Brady rarely gave individual credit to his photographers, he insisted that all views published from his negatives bear the "Brady & Co." imprint.[21] Other leading studios—including those of Jeremiah Gurney, Charles D. Fredricks, Frederick Gutekunst, and John Carbutt—issued carte-de-visite portraits of military leaders and statesmen.[22] The market for these inexpensive photographs, in the North at least, remained strong throughout the conflict.

The sale of these photographs was part of a larger popular market for pictures. Commercial lithography, which came into its own as a profession in America in the 1820s, was in its heyday in the 1860s.[23] During the war, lithographers and engravers supplemented their output of genre scenes, art reproductions, and religious subjects with prints of military leaders, battles, ships, and patriotic allegories.[24] Some of these scenes were derived from eyewitness sketches; others were more loosely based on verbal reports. This was typically a time-sensitive business. Generals Ambrose E. Burnside and George G. Meade, for example, were but two of the Union's military leaders who rose quickly to fame, only to subsequently drift out of public favor.[25] Accordingly, publishers moved with considerable speed in the production and distribution of new offerings.

Printmakers and photographers were both competitors and collaborators. Some engraved or lithographed portraits were based on photographs; in other cases, prints were copied by the camera and issued as cartes-de-visite. As Coleman Sellers observed:

> A curious race is being run between the engravers and photographers in the publication of portraits of prominent men. Before the advent of card-pictures our generals and popular statesmen were

either illustrated by expensive engravings or cheap coloured lithographs. The photographed card-portrait called for a smaller and a cheaper engraving to compete with it. Soon some very good copper-plate vignette heads were produced, and sold for about one-half the retail price of the photographs. These are now being copied by second-rate photographers, and sold to the retail dealers at about twenty for one dollar. What will be the ultimate effect of this competition on the art is hard to tell. It results now in the masses being furnished with plenty of good pictures at a low rate.[26]

Some photographers were employed full-time copying engravings, a business described in mid-1863 as "very brisk."[27]

The common cause of photographers and printmakers is revealed in their treatment of the war's first martyr: Colonel Ephraim Elmer Ellsworth. Ellsworth was famous even before the war, when he led an elegantly costumed volunteer company called the U.S. Zouave Cadets.[28] His Zouave Cadets toured the North, accompanied by a brass band, to demonstrate their marching and acrobatic skills. When the war broke out, Ellsworth formed a company of New York Fire Department Zouaves. On May 24, 1861, he led his men across the Potomac to Alexandria, Virginia, the northernmost edge of rebel territory. With no Confederate troops in sight, Ellsworth stormed to the top of the Marshall House, an inn on King Street, to cut down a large rebel flag. As he came downstairs with his trophy, Ellsworth was shot dead by the building's owner. The innkeeper, in turn, was killed by Francis E. Brownell, one of Ellsworth's men. A correspondent from the *New York Tribune* had been by Ellsworth's side during the whole episode and other reporters soon arrived on the scene. All were affected by the pathos of the event. Ellsworth's idealism and dashing style and the deep political symbolism of the flag combined to make a powerful narrative. He was given a memorial service in the East Room of the White House (he had known Lincoln before the war) and his story was published throughout the land.

Lithographers and engravers responded to this event with alacrity. The first prints appeared within a week of his death and poured from the nation's presses for months. As two leading historians of

318　Mathew B. Brady/E. Anthony & Co., *Ellsworth Memorial*, 1861

the subject have noted, "more than eighty pictures appeared in all—dignified portraits based on photographs, action scenes re-creating his death, and lithographed covers for funeral dirges and requiem marches."[29] Photographers naturally followed suit. The *Ellsworth Memorial* [318], with photographs copyrighted by Brady and Anthony, takes an efficiently didactic approach to the subject. Composed of a circular image of the Marshall House and studio portraits of Ellsworth and his "avenger" Brownell, this memorial provides both visual and narrative symmetry. The images represent patriotism, perfidy, and retribution; we are shown the protagonists and the stage for the opening scene of a great national drama.

Photography and the Illustrated Press

The American appetite for pictures developed in tandem with a larger revolution in communications. A truly national press arose in the 1850s and, inspired by the *Illustrated London News*, several American publications began featuring pictures.[30] Frank Leslie was central to this development. Born in England, Leslie gained invaluable experience as an engraver for the *Illustrated London News* before arriving in New York in 1848. He worked briefly for *Gleason's Pictorial Drawing-Room Companion*, started in Boston in 1851, and for the New York *Illustrated News*, which debuted on January 1, 1853. His weekly, *Frank Leslie's Illustrated Newspaper,* begun in December 1855, was the nation's first broadly successful illustrated paper. This was followed in January 1857 by its closest rival, *Harper's Weekly.* Both papers featured wood engravings—often derived from photographs—of a variety of newsworthy subjects. By 1860, the illustrated weekly newspaper had become a staple of American life.

The war stimulated a dramatic increase in newspaper circulation. Editors sent an unprecedented number of reporters into the field: the *New York Herald*, for example, had 63 correspondents in various theaters of the war and spent nearly $1 million covering the conflict. Some 500 writers, including representatives of leading European papers, reported on the war from a Northern perspective.[31] A corresponding effort went into its pictorial documentation. The illustrated papers purchased freelance work and employed such noted sketch artists as Alfred Waud, William Waud, Theodore R. Davis,

Edwin Forbes, Thomas Nast, James Taylor, and Winslow Homer. These resourceful artists accompanied the Northern armies through the most important campaigns and sent back thousands of sketches for publication.[32] These papers also reproduced hundreds of portraits from photographs by Brady, Anthony, and other firms, and a smaller number of battlefield views engraved from photographs.[33]

Photographers and sketch artists knew each other well and crossed paths repeatedly in the field. Alfred Waud, for example, rode to Bull Run with Brady. He visited Manassas in March 1862, when George N. Barnard and James F. Gibson were in the area, and was photographed by Timothy O'Sullivan at Norfolk, in early 1862, and at Gettysburg, in July 1863. O'Sullivan and Theodore R. Davis both recorded the activities of Federal forces near Savannah, Georgia, in early 1862. Davis and Barnard were also well acquainted through their shared experiences in the war's eastern and western theaters. Many factors reinforced these links, including Alexander Gardner's prewar experience as a newspaper editor and Brady's conscious emulation of the press's organization (he later said: "I had men in all parts of the army, like a rich newspaper").[34]

While the illustrated papers made extensive use of original photographs, it was a laborious and expensive process to translate them into ink-on-paper reproductions. First, the photograph had to be sketched (in reverse) in pencil on the end grain of blocks of extremely fine-grain wood. Turkish boxwood, "nearly as hard as flint," was the engraver's favorite surface.[35] With these pencil sketches as a guide, the blocks were then hand-carved to create a relief printing matrix. The photographic engravings in the early issues of *Leslie's* or *Harper's* were thus doubly removed—by sketch artist and by engraver—from the optical precision of the source photograph.

Photographic technology itself became part of this process in the late 1850s, with the introduction of the photography-on-wood technique. In this method, a photographic image was printed directly onto the sensitized surface of the printing block, which was then cut as usual by hand. By replacing one manual step of the process with a mechanical one, this technique brought a new standard of visual accuracy to the printed page. This hybrid technique—part photography, part handwork—dominated until the era of halftone reproductions began in the late 1880s. The photography-on-wood process attracted such noted professionals as George N. Barnard, who devoted much effort to the technique in 1857-58.[36]

Despite this improvement, much time and labor was still required to turn a photograph into a wood engraving. For example, images of the September 17, 1862, battle of Antietam appeared in three consecutive issues of *Harper's Weekly*, beginning with four sketches by field artists on October 4. The next issue, dated October 11, included four more sketches by Alfred Waud and a map of the battleground. It was only in its publication of October 18 that *Harper's Weekly* printed photographically derived pictures of the battlefield. These were presented in a dramatic double-spread of eight engravings from the photographs made by Alexander Gardner on September 19-22. A similar delay occurred in 1863, when Brady's images from the Gettysburg battlefield appeared in *Harper's Weekly* nearly five weeks after they had been taken.

This translation of original photographs to printed engravings often produced disappointing results. The endless detail of the photograph—its factual transparency—was impossible to convey in a manually rendered image: the crude syntax of the relief printing block flattened the infinite particularities of the photograph into a weight-

less screen of dots and lines. Further, engravers inevitably altered or rearranged the data of the photograph to "improve" it—to make it simpler or more picturesque. Such manipulation represented a further move away from the gritty specificity of the original image.

Brady, Gardner, and the Aesthetics of War

By the onset of the war, Edward Anthony had established a successful system for the mass-production and distribution of inexpensive photographs. The illustrated newspapers provided a lucrative national forum for an enormous variety of newsworthy images. Together, these markets provided the economic foundation for the war's unprecedented photographic coverage. Mathew B. Brady and Alexander Gardner—working both jointly and apart—are critical figures in this story.

Brady played a central role in Civil War photography.[37] His importance does not stem from any direct handling of the camera. Instead, Brady helped conceive the project of documenting the war and, through his gallery in Washington, D.C., direct the activities of photographers in the field. With connections to the Anthony firm and the illustrated newspapers, he was involved in the mass-production, sale, and reproduction of an enormous number of war-related photographs. Dynamic and brave, Brady went repeatedly to the front, often with his photographic team. While there is no evidence that Brady ever made a single exposure himself, there can be little doubt that he personally guided the making of photographs on numerous occasions.

Ultimately, Brady's war effort must be understood as a business venture, albeit one of deep personal interest. Given his investment in the personalities and news of the day, it was natural for him to embrace the challenge of representing the most newsworthy chapter of the nation's history.[38] In this effort, the Brady gallery functioned somewhat like the picture agencies and news services of the twentieth century: it commissioned, gathered, and sold images.

It is difficult to separate Brady's efforts in the early period of the war from those of his trusted studio manager, Alexander Gardner.[39] Born in Scotland, Gardner was apprenticed to a Glasgow jeweler from 1835 to 1842 before working as a journalist and as the editor of the *Glasgow Sentinel*. Widely read, Gardner wrote essays on science, art, and social problems.[40] An interest in chemistry led him to take up photography, first as an amateur and then professionally. By 1848, he was involved in planning a utopian community in the United States and many of his relatives subsequently settled in a "cooperative society" in Iowa. Gardner arrived in New York in 1856, but instead of following his family to Iowa, he began working for Brady.

In addition to his photographic talents, Gardner had an aptitude for business. In February 1858 he was chosen to direct Brady's new gallery in Washington, D.C., which he operated with considerable autonomy and success. Notably, it was Gardner who arranged Brady's distribution relationship with the Anthony firm. While it appears that Brady initially paid little attention to the carte-de-visite, Gardner clearly recognized its commercial potential.[41] By mid-1860, Gardner's staff in Washington included his brother, James Gardner, as well as Timothy O'Sullivan and James F. Gibson. George N. Barnard and Jacob F. Coonley were among the other New York-based photographers associated with Anthony and Brady.

Gardner showed great initiative in putting photographers in the field, coordinating their efforts, and finding profitable outlets for their pictures. Brady was a frequent presence in the Washington

319 **Mathew B. Brady**, *Camp Sprague, 1st Rhode Island Regiment*, 1861

gallery, but he had little hand in its day-to-day operation. It has been suggested that Gardner deserves credit for "conceiving the idea" of a broad photographic coverage of the war, while Brady—as the owner of the business and Gardner's employer—was responsible for organizing this effort.[42] It was Brady, for example, who approached General Winfield Scott and President Lincoln to gain permission for photographers to accompany Union troops into the field. Ultimately, it is probably impossible to precisely distinguish their roles in this historic enterprise. It may be enough to say that Brady and Gardner did it together.[43]

From the first months of 1861, Washington was buzzing with political and military activity. Lincoln was inaugurated on March 4 and Fort Sumter fell five weeks later. The new president issued a call for 75,000 volunteers on April 14 and for 42,000 more on May 3. Naturally, Brady was drawn to Washington by this activity. As thousands of newly enlisted troops poured into the city, many came to his gallery to sit for portraits. In turn, Brady's photographers—and others—worked in the large encampments around the city. For example, in service to both Anthony and Brady, George N. Barnard produced a series of group portraits of the New York Seventh Militia in May 1861 at Camp Cameron, a forty-acre encampment just outside the city.[44] These camp photographs have a relaxed and innocent air. None of these soldiers had yet seen combat. Indeed, few expected the war to last more than a few weeks and many Northerners believed that "a lady's thimble would hold all the blood to be shed" in the conflict.[45] Many of these newly minted soldiers undoubtedly saw their service as a kind of fraternal adventure.[46]

In addition to overseeing some of the more prestigious portrait sessions in his gallery, Brady almost certainly visited these camps. The earliest Union volunteer regiments were derived largely from Brady's own social sphere—professional men and the sons of privilege—and he had close personal connections with officers of the New York Seventh Militia. One of the most important, but least known, aspects of Brady's Civil War work is a series of views produced in these camps between about May and August 1861. These were made with relatively large negatives (about 12 x 15 inches in size) and issued under the collective title "Brady's Incidents of the War."[47] Each of these images presents a carefully orchestrated tableau of figures. Some are conventional group portraits [319]; others are artful simulations of characteristic events or activities [c-106, c-107]. Many of these views are peopled landscapes rather than traditional

portraits: figures are usually presented in the mid-ground, with considerable attention given to the surrounding space.

This rare series suggests what the war meant before it truly *was* war—before these troops had been shocked by the blood and death of combat. These images are calm and ceremonial; they evoke the martial decorum of an earlier age.[48] The physical scale and careful artistry of these photographs reflects a notable aesthetic ambition. The series bears clear evidence of Brady's creative vision: it is easy to imagine him orchestrating the scenes to be recorded and directing the work of his assistants.

Brady made numerous visits to the front, often in the company of his photographers. These trips began with the war's first engagement at Bull Run. With hundreds of other civilians, Brady watched the July 21, 1861, battle from a distance of a mile or two. When the expected Northern victory turned instead into a panicked rout, Brady was caught up in a chaotic and exhausting twenty-five-mile trek back to Washington. It appears that no photographs were made that day, although Brady later claimed otherwise.[49] Over the following years, his presence near the front was documented in a number of photographs. In the last months of 1862, for example, he traveled through the eastern theater of the war, from Harper's Ferry to General Burnside's camp near the Rappahannock River, in Virginia.[50] He was at the battlefield of Gettysburg about two weeks after the engagement of July 1-4, 1863. His trips in the final year of the conflict took him to Petersburg and Cold Harbor, Virginia, in June 1864. Unfortunately, however, the full extent of Brady's field trips can only be guessed.[51]

Never one to avoid publicity, Brady was happy to be pictured as a friend and confidant of leading Union officers [320]. In other cases, his visual presence is more subtle and his location more perilous. As part of a project to record the infantry corps commanders of the Army of the Potomac, Brady was at the front near Petersburg on June 20 and 21, 1864.[52] In addition to making group portraits of officers, Brady and his team ventured to the foremost Union line to take views of soldiers standing guard. Although it was a quiet day, these pictures convey a tense immediacy that is rare in Civil War photography. The most evocative of these images [322] was made only about a half mile from the Confederate lines. Standing figures are splayed across the elongated space of the picture plane: they are conscious of the camera's presence but are not posed in any traditional way. The apparent spontaneity of these figures only adds to the image's veracity. Inconspicuous nearly to the point of invisibility, Brady stands against the nearest point of the defensive wall: his straw hat is visible just in front of the left-most figure.

The Brady teams traveled in specially equipped photographic wagons [321] in which wet-collodion plates could be coated, sensitized, and developed.[53] These photographers typically worked with at least two cameras: one to make negatives of approximately 7 x 9 inches in size, and a smaller one to make stereo negatives. Stereo images served double duty in the marketplace. A print from a full stereo negative could be used to make one finished stereograph, or—in significantly trimmed form—two essentially identical carte-de-visite prints. This choice in the finishing process ensured maximum economic return from each image, and a large percentage of Brady's photographs were issued in these smaller formats. Many of these negatives were forwarded to the Anthonys in New York to be printed, mounted, and distributed.

Brady's success in documenting the conflict was, in large measure, a result of Gardner's direction. Intelligent and fair, Gardner was also

meticulously organized, "a man of great system and much firmness in maintaining and carrying forward his plans."[54] In addition to working in the field himself, Gardner directed the efforts of Timothy O'Sullivan, George N. Barnard, James F. Gibson, William R. Pywell, and others. This team covered a large area. O'Sullivan, for example, photographed Union-occupied areas along the southeast coast from December 1861 to May 1862. In South Carolina (Port Royal Island, Hilton Head Island, and Beaufort) he recorded troops on parade, bridges, forts, and residences; further south, he photographed the ruins of Fort Pulaski, Georgia. Returning north, he worked at Manassas in July 1862 before accompanying Union troops to Warrenton and Culpeper, Virginia. He then made views at Cedar Mountain, near Manassas, Virginia, shortly after the engagement there of August 9, 1862.

Gardner broke with Brady sometime in late 1862 or early 1863, taking the most experienced photographers with him.[55] Brady's operation suffered from these losses: significantly fewer images were issued under Brady's name in 1863 and 1864, although the Brady & Co. output increased in 1865 following a new distribution agreement with Anthony.[56] After Gardner's departure, Brady's photographic teams included David B. Woodbury, Silas Holmes, E. T. Whitney, and Anthony Berger.[57] It may be impossible to arrive at a definitive list of the men who worked in the field for Brady. He is known to have purchased some negatives from independent operators, and some "Brady" cameramen were probably on the Anthony payroll.

Alexander Gardner apparently left his full-time duties in the Brady gallery in 1862 to become the official photographer of General George McClellan's Army of the Potomac. Given the honorary rank of captain, Gardner may have served on a freelance basis.[58] In this period, he specialized in the photographic duplication of maps and drawings for the army's topographic engineers. He also worked extensively in the field in the fall of 1862, and Brady published his views of Warrenton, Antietam, and Aquia Creek. When Lincoln demoted McClellan in November of that year, Gardner returned to private practice in Washington, although he continued to bill himself as "Photographer to the Army of the Potomac." By the spring of 1863 he had severed all ties with Brady and established his own studio [c-108]. He reclaimed many of the war views made during his tenure with Brady, perhaps in lieu of unpaid wages or other obligations. Renowned for his kindly nature and liberal wages, Gardner easily attracted the best of Brady's former employees.

Gardner was soon promoting his own series of war views. In September 1863 he issued a twenty-eight-page catalogue listing 568 images. Folio-size prints (7 x 9 inches) were available for $1.50 each, while stereographs and album cards sold for fifty cents and twenty-five cents, respectively.[59] Beginning in about early 1865, Gardner used the Washington firm of Philp and Solomons to publish these views, which were distributed by Anthony and also available by mail from Gardner's gallery. His catalogue, unlike similar listings of the period, gives his photographers individual credit for their views.

The work produced by Brady and Gardner—both jointly and independently—covered a broad range of subjects and was issued in several formats. Their photographers strove to record as many of the conflict's leading people, places, and events as possible. Many of these photographs are environmental portraits: some reveal the aesthetic of the studio group portrait [323], while others are more improvised and personal [c-109]. Topographic images were also made, with varying degrees of artistry [324]. A view of a Union

320 **Mathew B. Brady**, *Maj. Gen. Burnside and Brady the Artist, Head Quarters of the Army of the Potomac, Near Richmond, Virginia*, 1863

321 **Mathew B. Brady**, *Brady's Photographic Wagon*, ca. 1862

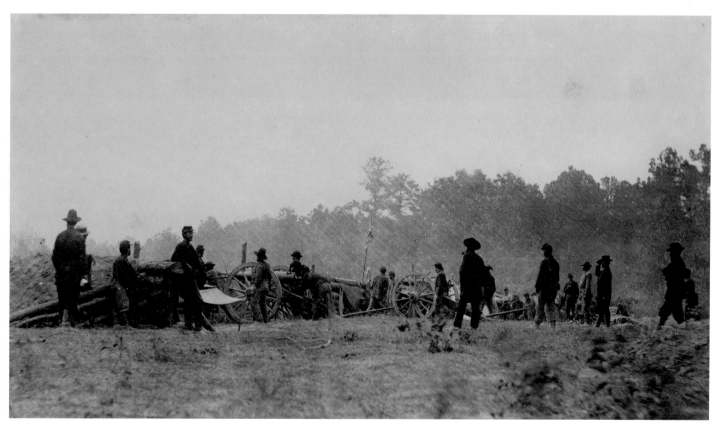

322 **Mathew B. Brady**, *Jones's 11th Massachusetts Battery, before Petersburg*, June 21, 1864

323 **Alexander Gardner**, *President Lincoln and General McClellan at Antietam*, 1862

324 **Mathew B. Brady** (attrib.), *Winter Camp, Army of the Potomac*, ca. 1862

325 **Unknown Maker,** *Camp near Darnestown, Maryland; General Banks's Division, Best's Battery,* 1862

326 **David Woodbury**, *Military Bridge across the Chickahominy, Virginia*, 1862

327 **Egbert Guy Fowx** (attrib.), *On the James River*, ca. 1862

encampment near Darnestown, Maryland [325], for example, suggests an awareness of Roger Fenton's Crimean photographs of 1855.[60] In David Woodbury's view of troops on a military bridge [326], the nominal subjects are subordinated entirely to the surrounding landscape—a vast and dangerous swamp. The aesthetic impulse is also evident in this picturesque view of Union ships and docks on the James River [327]. Another work, perhaps by the same photographer, documents the ability of military engineers to reshape the landscape [c-110]. The themes of engineering and technology are common in this work. Many Civil War photographs are variations on the theme of the occupational: depictions of soldiers with the tools of war [c-111]. In other instances, photographers documented military tools or devices [328] with a specificity that would have served analytical or instructional purposes.

The photographic depiction of the war reached a new level at the battle of Antietam in September 1862. This was a pivotal episode of the conflict—the war's first major engagement on Northern soil and, with 23,000 casualties, the single bloodiest day in American history. The armies fought to a draw on September 17 and spent the next day in a tense standoff. On the evening of September 18 and the morning of September 19, General Lee's army quietly withdrew across the Potomac River. While President Lincoln was dismayed by General McClellan's refusal to pursue the retreating Confederates, the Union achieved a strategic victory. Lee's attempt to invade the North was thwarted and, in holding their ground, Federal forces gave Lincoln the opportunity to announce the abolition of slavery in the South.

Alexander Gardner was in close proximity to the battle of Antietam and began work on September 19 as soon as it was clear that Confederate forces had withdrawn.[61] With the assistance of James F. Gibson, he photographed on the battlefield through September 22 with both a large format and a stereo camera [329]. Their gritty images, the first American photographs of battle dead, attracted unprecedented interest from the public and press.[62]

Coinciding with the publication of wood engravings of some of these images in *Harper's Weekly*, Brady opened a display of photographs in his New York gallery.[63] The exhibition created a sensation. On October 20, 1862, the *New York Times* ran a lengthy and sensitive review of the display.

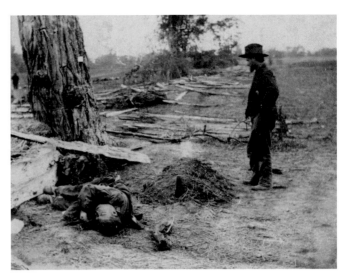

329 **Alexander Gardner and James F. Gibson**, *A Contrast! Federal Buried, Rebel Unburied, Antietam*, 1862

We recognize the battle-field as a reality, but it stands as a remote one. It is like a funeral next door. The crape on the bell-pull tells there is a death in the house, and in the close carriage that rolls away with muffled wheels you know there rides a woman to whom the world is very dark now… But it is very different when the hearse stops at your own door, and the corpse is carried out over your own threshold…

Mr. BRADY has done something to bring home to us the terrible reality and earnestness of war. If he has not brought bodies and laid them in our dooryards and along the streets, he has done something very like it. At the door of his gallery hangs a little placard, "The Dead of Antietam." Crowds of people are constantly going up the stairs; follow them, and you find them bending over photographic views of that fearful battle-field, taken immediately after the action. Of all objects of horror one would think the battle-field should stand preeminent, that it should bear away the palm of repulsiveness. But, on the contrary, there is a terrible fascination about it that draws one near these pictures, and makes him loth to leave them. You will see hushed, reverend groups standing around these weird copies of carnage, bending down to look in the pale faces of the dead, chained by the strange spell that dwells in dead men's eyes…

The ground whereon they lie is torn by shot and shell, the grass is trampled down by the tread of hot, hurrying feet, and little rivulets that can scarcely be of water are trickling along the earth like tears over a mother's face. It is a bleak, barren plain and above it bends an ashen sullen sky.

These pictures have a terrible distinctness. By the aid of the magnifying glass, the very features of the slain may be distinguished.[64]

In these photographs, the faces and postures of the dead were shockingly expressive. With mouths agape and limbs crumpled in strange positions, these corpses did not conform to traditional notions of gallantry and heroism. The stark ugliness of death challenged comfortable beliefs in the meaning of military sacrifice. Appropriately enough, it was often difficult in these photographs to distinguish Confederate from Union dead.

Engravings of these images in *Harper's Weekly* were accompanied by a text testifying to the "wonderfully lifelike" quality of the originals: "Minute as are the features of the dead, and unrecognizable by the naked eye, you can, by bringing a magnifying glass to bear on them, identify not merely the general outline, but actual

328 **Timothy O'Sullivan**, *Canvas Pontoon Boat*, ca. 1864

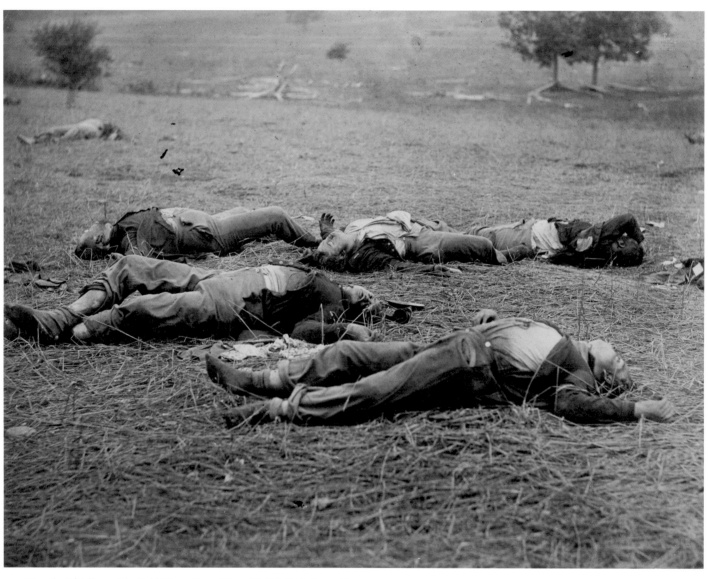

330 **Timothy O'Sullivan**, *The Field Where General Reynolds Fell, Gettysburg*, 1863

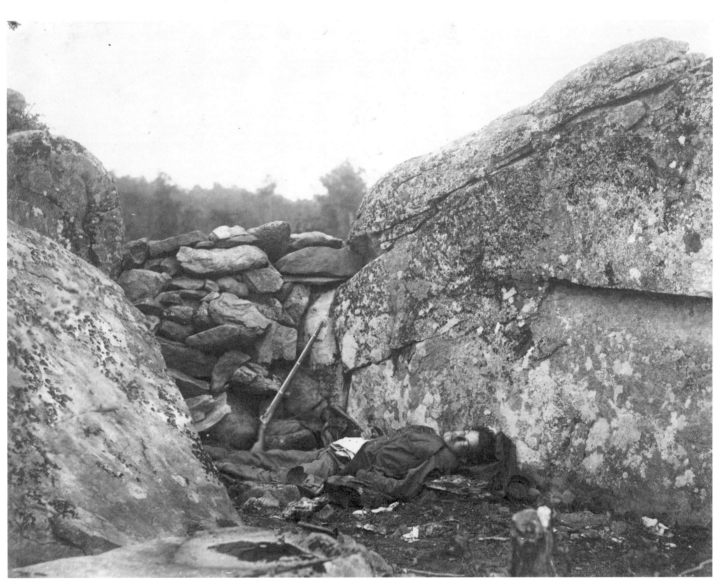

331 **Timothy O'Sullivan**, *Home of a Rebel Sharp-Shooter at Battle of Gettysburg*, 1863

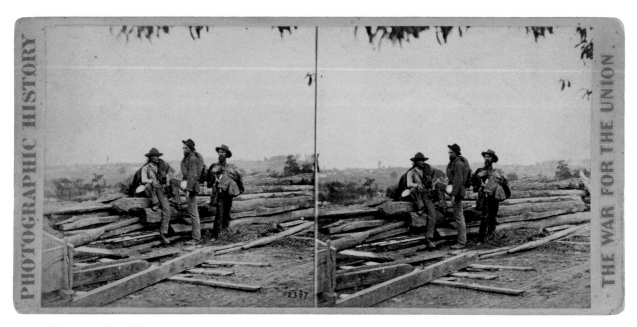

332　**Mathew B. Brady,** *Rebel Prisoners, Gettysburg,* 1863

expression."[65] However, little of this detail was contained in the published illustrations. In the pages of *Harper's Weekly,* these images were moving but not shocking; the facts held full emotional weight only in the original photographs.

In July 1863, Gardner and his men made an equally famous series after the battle of Gettysburg.[66] This engagement, which lasted from July 1 to July 4, 1863, was the decisive turning point of the war. After the setback at Antietam, Confederate forces had won victories at Fredericksburg (December 1862) and Chancellorsville, Virginia (May 1863). Encouraged by these successes, General Lee determined to again take the war to the North. Union forces were vulnerable and a Southern win at Gettysburg might have been fatal to the North. The engagement began on July 1 and grew in intensity as both sides gained reinforcements. The battle raged late in the afternoon of July 2 and most of July 3. No fighting took place on July 4, and by the next morning the Confederate forces had withdrawn. Together, the opposing armies suffered a total of 51,000 dead, wounded, captured, or missing.

The first photographers to arrive on the scene were Alexander Gardner, James F. Gibson, and Timothy O'Sullivan. Gardner and his men probably reached Gettysburg late on July 5, and photographed intensively over the next four days.[67] As Union burial parties cleaned up the carnage, the trio concentrated on areas still littered with bodies. After the reception of their studies of the dead at Antietam, it is not surprising that Gardner's team devoted fully 75 percent of their plates to the same subject here. Most of the corpses they found were Confederate; the rarer Union bodies were recorded in a characteristically gritty view [**330**].[68] Here, and at other locations, Gardner and his men explored various compositional possibilities by recording clusters of bodies from two or more vantage points.

Gardner's men then moved to an area of large rocks known as Devil's Den, where they made one of the war's most famous images.[69] The team found a single Confederate corpse, lying on open ground, which they photographed at least four times. Worried that the work of the burial parties was rapidly reducing the number of such subjects, the photographers then "re-used" the body. They rolled the corpse onto a blanket and hauled it to a more photogenic spot about seventy yards away. A rifle—which may have been carried by Gardner as a prop—was placed artfully beside the body. Two exposures were

made of this new arrangement. One of them, credited to Timothy O'Sullivan, has become an icon of Civil War photography [**331**].

The staged nature of this image was first widely noted by William Frassanito in his 1975 book *Gettysburg: A Journey in Time.*[70] This information challenged more than a few assumptions about Civil War photography in particular, and about nineteenth-century "documentary" practice in general. It became clear that this historical icon was the result of a willfully fictional process. The earliest prints of this image, issued on Gardner's "Incidents of the War" mount, identified the dead Confederate as a sharpshooter. In fact, the soldier had almost certainly been a regular infantryman and the rifle beside him was not a sharpshooter's. Later, when Gardner included this image in his 1866 album, *Gardner's Photographic Sketch Book of the War,* it was accompanied by an entirely imaginary narrative evoking the pathos of the dying soldier's thoughts and visions.

This revelation of the image's constructed nature prompted some to label it a fraud, and to view it as proof that photographs *only* tell artful "lies." Less frequently noted was the fact that Frassanito's revelation was based on close examination of all the known photographs from this series. The *truth* of Gardner's putative "lie" was there to be found in the collective evidence of the photographs themselves. Photographers may "lie," but the pictures do not; the difference is critically important.[71]

These insights on *Rebel Sharp-Shooter* helped erode any simple notion that Civil War photographs could be viewed as self-evident vehicles of historical fact. But these insights did not diminish the value or trustworthiness of the picture; rather, they enlarged, enriched, and complicated our understanding of the truths that photographs can illuminate. Gardner's arranged photograph is a profoundly revealing document of the ideas and emotions of a cultural moment. It places physical facts in the service of a powerfully resonant narrative: a story of sacrifice and honor, and of the tragedy of dying young, alone, and far from home. The story is clear. Here is where the *Rebel Sharp-Shooter* stood; this is the rifle he used; here is where he died. The crumpled figure is at once singular and generic: an unnamed individual who stands for the thousands who died there and, by extension, on all the war's killing fields. In some instances, the truth of a photograph may have at least as much in common with great

works of the imagination—the novel *The Red Badge of Courage*, for example—as with any journalist's report or official document. As a result of Frassanito's revelations, Civil War photography as a whole has come to be recognized as more varied in nature, richer in meaning, and more fundamentally aesthetic than previously thought.[72]

Ultimately, Gardner's *Rebel Sharp-Shooter* serves an enormously useful function: it illuminates the complexity of nineteenth-century thinking about the meaning and purpose of pictures. Of Gardner's work at Gettysburg, this image stands alone as a grossly staged scene. The other photographs from this series (despite some questionable captions) would hold up to nearly any modern definition of documentary practice. Thus, while Gardner saw his work at Gettysburg as primarily the collecting of visual facts, he took the opportunity to make at least one picture that was explicitly about ideas. This latter approach—overtly synthetic, expressive, and narrative—was central to the visual vocabulary of the era: it was the aesthetic of popular paintings, prints, and engravings. In its day, *Rebel Sharp-Shooter* was a thoroughly "mainstream" image—one that was understood fully by its intended audience, the general public. In creating work for more specialized audiences—military engineers, for example—such interpretive latitude would have been neither desired nor accepted.

The complexity of visual history is underscored by comparing Gardner's results at Gettysburg with those of Brady.[73] Brady and his team arrived at the battlefield on about July 15, some six days after Gardner's men had finished. By this time, the area had been completely cleared of corpses and any equipment of value. Brady was pictured standing in an empty field, and the team made a stereograph of Confederate prisoners [332]. Otherwise, the team found little evidence of battle to record. However, at this remove from the fighting, Brady had knowledge that Gardner's men did not: an understanding of the nuances of the battle and of the strategic importance of individual sites. In this regard, Brady benefited from his late arrival, and his Gettysburg views reached a mass audience well before Gardner's. Wood engravings of Brady's views appeared in *Harper's Weekly* within weeks, while Gardner's did not enjoy this exposure until 1865.[74]

As the work of Brady and Gardner makes clear, there was a marked shift in the overall nature of Civil War photography in the first years of the war. Many of the earliest images—such as Brady's camp scenes of mid-1861—are calm, ordered, and celebratory. In 1862 and 1863, with Gardner's stark views of the dead at Antietam and Gettysburg, war photography entered a different and resolutely unromantic age. Notably, a similar evolution may be traced in the engravings of the war in the illustrated papers of the period.[75]

Photography and the Military

There were two distinct networks of military photography: one catering to the soldiers themselves and another in official service to the military establishment. The first was highly entrepreneurial and decentralized; the second was elite and tightly organized. These two networks produced radically different sorts of pictures.

Many photographers profited from the vast market for portraits of individual servicemen. The war was a bonanza for Northern photographers; indeed, for many, business had never been better. On February 1, 1862, Coleman Sellers noted, "with the professional operators the war has been quite a source of profit."[76] Many soldiers sat repeatedly for portraits—before leaving home, in the various cities and villages through which they passed, and in the semi-permanent encampments in which they were stationed. In May 1862, Sellers noted that one enterprising photographer "has been for some time driving a brisk business at the camps below Washington" making ambrotypes and stereographs. This photographer reportedly made $50 per day in ambrotypes alone: "The soldiers are very good customers as long as their money holds out."[77] In the major cities, photographers were equally busy. Sellers reported that "photography, in a business point of view, has been benefited by our troubles. The dealers in photographic stock and instruments are at their wits' end to meet their orders, and all the galleries are crowded with visitors."[78]

The Union encampments attracted their own legions of photographers. Many freelance portraitists visited the Union camp at Brandy Station, Virginia, between December 1863 and May 1864, when it was at its busiest. Over 300 photographers worked in and around the Army of the Potomac as it moved throughout eastern Virginia, Maryland, and southern Pennsylvania.[79] The three Bergstresser brothers, from Pennsylvania, stayed with this army for over two years, producing up to 160 portraits a day at a dollar apiece.[80] Apparently in an effort to regulate this activity, each division of the Army of the Potomac officially assigned or approved photographers.[81] In all, about 1,000 civilian cameramen may have worked in and around Federal camps during the war.[82]

Some photographers traveled considerable distances to ply their trade. G. H. Houghton, of Brattleboro, Vermont, accompanied troops in the Army of the Potomac's 1862 Peninsula Campaign.[83] In 1862-63, Henry P. Moore of Concord, New Hampshire, operated a gallery at Hilton Head, South Carolina, where a regiment of New Hampshire troops was stationed. In addition to taking portraits, Moore recorded buildings, vessels, island scenery, and the local population of former slaves [333]. Issued after he returned to Concord, some of these images drew international notice.[84]

In several instances, soldiers who had been photographers in civilian life set up temporary studios in their camps. In the early months of the war, troops in one camp of the Army of the Potomac established a small weekly newspaper, a temperance league, various singing clubs, and

> a photograph establishment, with all the modern appliances of this wonderful art, operated by practical artists who are members of the regiment. The design is to have not only the whole regiment

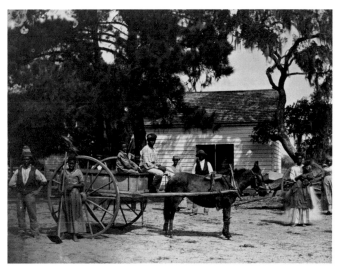

333 **Henry P. Moore**, *"Gwine to da Field" (Hopkinson Plantation, Edisto Island, South Carolina)*, 1862

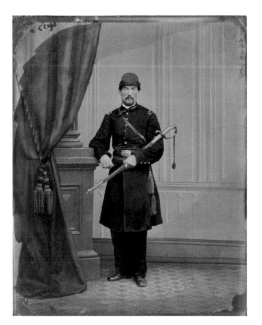

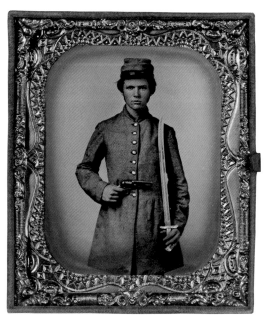

334 **F. S. Keeler**, *Union Officer*, ca. 1861-65

335 **Unknown Maker**, *Confederate Private with '49 Colt Pistol and Sword Bayonet*, ca. 1861-64

336 **L. Seebohm & Co.**, *Civil War Soldiers in "Combat,"* ca. 1865

photographed but also each individual member, together with the camp, its connected objects and scenery, with incidents and places on the march, thus obtaining a living history of the campaign for future use.[85]

Some itinerant photographers managed to carry all their equipment on horseback. In March 1862, Sellers noted: "Photography is following the army south, and very many good operators are finding employment in portraiture in the camp, while at the same time occasionally very interesting camp scenes reach us. One of the camp photographers tells me that his dark box folds up so as to be readily carried on horseback, and he finds no trouble in managing his various solutions in the field."[86] Sellers also observed that "the majority of the pictures made for soldiers in camp, or as they pass through any town, are ambrotypes. This is because their movements are too uncertain to allow for the delay of paper pictures; besides many of them have a liking for the fancy cases in which their portraits are enclosed—and, in addition to all this, they are so cheap."[87]

Most of the resulting portraits are generically simple: three-quarter or full-length standing poses, sometimes with pistols, rifles, or knives displayed prominently [**334, 335**]. The most unusual of these images include staged scenes of combat [**336**], comic portraits, and drinking and card-playing tableaux.

The official military hierarchy represented a critically important market for Civil War photographs. The army's enthusiasm for photography reflected the training that leading officers were given at West Point. The program of the United States Military Academy at West Point influenced the documentation of the Civil War as well as the nature of the conflict itself. From its inception in 1802, the Academy had been under the direction of the army's Corps of Engineers. As a result, the curriculum focused on the practice of civil engineering, with related courses in mathematics, chemistry, natural philosophy (mechanics, optics, and astronomy), mineralogy, and geology. The Academy's program in this period aimed "to produce engineers capable of military command, rather than officers with engineering skills," and upon graduation, the best students almost invariably entered the Army Corps of Engineers.[88]

Prior to 1860, the War Department used its engineering expertise to undertake a variety of projects across the nation, from surveys of potential canal and rail routes to the construction of lighthouses and post offices. The elite Corps of Topographic Engineers (officially founded in 1838 and merged back into the Corps of Engineers in 1863) was instrumental in mapping the nation's lakes and rivers, establishing the national boundaries, and exploring the West.[89] All of these activities depended on the precise visual information conveyed in maps, sketches, diagrams, and photographs.

Further, the curriculum of the military academy sought to unite technical knowledge with the tastes of the gentleman. Cadets studied French, drawing, and ethics, and were encouraged to take a broad interest in music and the visual arts.[90] Accomplished professionals taught courses in mechanical, figure, and topographic drawing. One of these instructors, the painter Robert Walter Weir, was a friend of such noted artists as Horatio Greenough, Washington Irving, Samuel F. B. Morse, Washington Allston, and Rembrandt Peale.[91] Many students—including future generals Samuel P. Heintzelman and Montgomery C. Meigs—enjoyed these classes and produced drawings of superb quality.[92] No sharp division was perceived between the fine and applied arts: it was accepted that pictures could be (and indeed, should be) both informative and beautiful. This synthesis of technical and aesthetic concerns helps explain the visual quality of much of the work commissioned by the military.

An important, if distinctly mundane, application of military photography lay in copy work: the replication of maps and documents. It required far less time and money to make copies of hand-drawn maps with the camera than with the lithographic press. The working method was simple [**337**]. Original renderings were tacked flat to a vertical surface—usually an exterior wall in direct daylight—and photographed with a large-format camera. These negatives (often 18 x 22 inches in size) were then sun-printed in the normal manner, in contact with a sheet of albumen paper, to make positive copies. Unusually large maps were photographed in sections and pieced together. This photo-copying process allowed for rapid updating. When new information was added to the topographer's

337 **Alexander Gardner**, *Making Maps, Photographic Establishment, Headquarters, Army of the Potomac*, ca. 1863

338 **George N. Barnard**, *View from Rebel Works Southeast of Atlanta*, 1864

339 **George N. Barnard**, *Gen. Sherman's Men Destroying the Railroad, Before the Evacuation of Atlanta, Georgia*, 1864

original drawing, a fresh negative could be made in a few minutes, and prints from it in a few hours. In an even more basic method, photo copies could be made without a camera: the original drawing, on translucent or oiled paper, was printed in contact with albumen paper to make same-size negative copies.

Some noted photographers devoted considerable effort to this work. Alexander Gardner was employed in 1862 by the Department of Topographic Engineers attached to General McClellan's Army of the Potomac. George N. Barnard probably assisted Gardner in this work and was subsequently hired by the Department of Engineers to perform similar duties in Nashville.[93] Other government photographers made duplicates of official renderings and drawings. At the U.S. Treasury Department, Lewis E. Walker was "constantly busy" copying drawings and maps for the Office of the Architect and other federal departments.[94] Further, it was reported in early 1864 that "all the Northern engineering establishments building engines for the navy worked from photographic copies of the chief engineer's drawings."[95]

The Department of Engineers also used the camera in more conventional ways to record rail lines, bridges, warehouses, and fortifications. George N. Barnard was the most important civilian photographer employed by the Union Army's western branch, the Military Division of the Mississippi.[96] While based in Nashville in early 1864, he copied maps and worked in the field documenting the work of military engineers. He also made panoramic landscape views to assist topographers in the preparation of maps. Barnard relocated to Atlanta after the city was taken by General Sherman's forces. There, in the late summer of 1864, he documented both the old Confederate defenses and the new Union fortifications around the city.[97] One of these images of Union troops occupying a former Confederate fort includes Barnard's own wagon, processing tent, and bottles of chemicals [338]. With his stereo camera, Barnard also recorded the frenzied destruction that occurred just before Sherman's forces left the city for their March to the Sea [339].

The Bureau of U.S. Military Railroads also commissioned many photographs. Between April 1862 and September 1863 this department was headed by General Herman Haupt, an 1835 graduate of

West Point. Before the war, Haupt researched the principles of bridge design and published several books on the subject.[98] Secretary of War Edwin Stanton called Haupt to Washington in early 1862 to reconstruct the Richmond, Fredericksburg, and Potomac Railroad and to impose order on the Union's overall rail system. Haupt succeeded on both counts: he brought the trains closer to schedule and his men constructed bridges and laid track with astonishing efficiency.[99]

Haupt's research and instructional interests constituted a vital aspect of his wartime service. He began working on the manuscript for *Military Bridges*, a lengthy practical guide for staff officers, in January 1863. Between their other assignments, his men conducted engineering experiments involving the assembly of bridges and floating docks and warehouses, as well as tests of techniques to construct, repair, and destroy rail lines.

To document the varied labors of his men [340], Haupt located a camera and detailed the services of artist Andrew J. Russell, a captain in the 141st New York Volunteers. Russell was transferred to Haupt's headquarters in Alexandria, Virginia, in February 1863.[100] In addition to his photographic assignments, Russell served as "acting Quartermaster for the Military Railroad Construction Corps, ordnance officer of the military railroads, and occasional painter of railroad cars and engines."[101] Russell hired Baltimore photographer Egbert Guy Fowx for three months to instruct him in the wet-collodion process and to assist him in the field. Russell paid Fowx's salary from his own pocket, receiving only his regular captain's pay for these varied labors.[102] Russell apparently agreed to these terms with the understanding that he would retain possession of at least some of his negatives.

In addition to recording Haupt's engineering experiments at Alexandria, Russell journeyed farther afield to test his wet-collodion skills and to record subjects of more general military interest. The flaws in the coating of this plate [C-112] suggest that it was made early in his photographic apprenticeship. Russell's skills improved quickly, and within weeks he was recording train wrecks, temporary bridge trestles [341], and similar subjects. He accompanied Haupt to the battlefield of Fredericksburg on May 3, 1863, where, from a safe distance, he recorded the smoke of the engagement.[103] Russell arrived

on the battlefield soon after the cessation of fighting—probably within an hour or two. Working quickly, he made his famous images of the Confederate dead behind the stone wall at Marye's Heights and of General Haupt examining an exploded artillery wagon [314]. Russell continued this work through the summer of 1865, making many large-format views in and around Alexandria, on the James and Potomac rivers, and in Washington, D.C. In the weeks after the end of war, he worked in the ruined cities of Petersburg and Richmond.[104]

Haupt liberally distributed Russell's photographs. By the end of Russell's first year of service with the Bureau of Military Railroads, nearly 6,000 prints had been produced and distributed, with orders for another 3,000 remaining to be filled. Groups of prints were delivered to President Lincoln, the secretaries of War and the Treasury, the "Admiral of [the] Russian fleet," and many leading generals.[105] Haupt dispersed these photographs for both political and instructional ends: to ensure continued support for his work and to promote new techniques in military engineering.

The U.S. Army Military Medical Department also made extensive use of photography.[106] This department helped create and maintain a network of hospitals, ambulance corps, and rehabilitation camps. Like their counterparts in other branches of the military, medical officers carefully documented the nature of this new war and the effectiveness of their techniques in coping with its demands. War injuries were officially classified into two categories: "Surgical" (the result of wounds suffered in combat) and "Medical" (diseases and other environmental maladies). To aid these analytical efforts, the Surgeon General of the Medical Department established the Army Medical Museum in 1862 to collect and study "all specimens of morbid anatomy, surgical or medical, which may be regarded as valuable; together with projectiles and foreign bodies removed, and such other matters as may prove of interest in the study of military medicine or surgery."[107] The commissioning and collecting of photographs was an important part of this effort. A photographer accompanied the museum's first curator, Dr. John Hill Brinton, on his visits to field hospitals, and Brinton's successor, Dr. George Alexander Otis, oversaw the production of more photographs. Physicians in outlying hospitals regularly contributed "photographic representations of extraordinary injuries . . . operations or peculiar amputations."[108] These images were often the work of local civilian photographers and typically in the carte-de-visite format.

The Museum's own photographic department was headed by William Bell. In 1866, the editor of the *Philadelphia Photographer* described Bell's operation:

A nicely arranged and convenient atelier adjoins the Museum, and all the conveniences of a well-regulated, first-rate gallery are there. . . . [T]he principal work of the photographer is to photograph shattered bones, broken skulls, and living subjects, before and after surgical operations have been performed on them. Of course, all these subjects were created by the war… These bones are photographed principally to aid the engraver in making wood-cuts for the illustrations of works upon army surgery. We were shown some photographs of the wounded, before and after operations had been performed on them, and certainly photography is the only medium by which surgery could so plainly make known its handiwork. We saw a picture of one poor fellow as he came from the field, with his face almost torn asunder by a shell. After surgery had exercised its skill upon him, he was again photographed, and looked much better than any one could be expected to look with his lower jaw gone. We passed hastily through the Museum of mounted bones and shattered limbs. . .[109]

340 **Andrew J. Russell**, *U.S. Military Railroad Wood Yard*, April 1863

341 **Andrew J. Russell**, *Locomotive on Trestle*, ca. 1863

When Bell left Washington in 1872 to accompany Lieutenant George Wheeler's survey to Utah and Arizona his duties were assumed by his assistant, Edward J. Ward.

The Medical Museum's staff remained active after the war. Typically, wounded soldiers were photographed at the time of their original treatment and again in the late 1860s and 1870s as physicians monitored their condition. Some of these photographs were used as proof of disability for pension applications. Selections of these images were presented in various official summaries and reports. The seven-volume *Photographic Catalogue of the Surgical Section of the Army Medical Museum*, begun in 1865, contained detailed case histories and fifty tipped-in albumen prints, 4 x 6 inches in size or larger. The monumental *Medical and Surgical History of the War of the Rebellion*, issued in six volumes between 1870 and 1888, contained thousands of engravings derived from photographs, photomechanical illustrations by the heliotype process, and a few tipped-in woodburytype prints.[110]

These photographs present their subjects in an appropriately clinical manner. Unlike any other genre of Civil War photography, medical views are characterized by close perspectives. The result is an odd pictorial combination of emotional detachment and an unnerving physical intimacy, and a vision of formal (and often physical)

342 **William Bell**, *Successful Excision of the Head of the Humerus*, 1864

343 **William Bell**, *Recovery After a Penetrating Gunshot Wound of the Abdomen…*, 1865

fragmentation [**342, 343**]. The strangeness of these images—for laymen, at least—is compounded by the arcane terminology of many of the titles.

Medical photographers produced a wide range of work, from records of hospitals to studies of surgeons and embalmers in action [**c-113**]. They also developed the field of photomicrography: at Douglas Hospital in Washington, D.C., doctors were achieving magnifications of 7,000 power by 1864.[111] Photographer J. J. Woodward, of the Army Medical Museum, produced a fascinating series of photomicrographs of human tissue and of microscopic pests [**c-114**].

Montgomery C. Meigs was perhaps the most enthusiastic patron of military photography. In 1853, Meigs was placed in charge of two prestigious projects: the extension of the national Capitol and the construction of the Washington Aqueduct.[112] By the late 1850s, he had also become an avid amateur photographer, and formed friendships with such noted figures as Coleman Sellers, the Anthony brothers, and Alexander Gardner.[113]

Named Quartermaster General of the U.S. Army in June 1861, Meigs performed a difficult job brilliantly. His department was responsible for the procurement, transport, and storage of an unprecedented quantity of essential items, from food and shoes to horses and wagons. This was a new war, with new logistical demands: a 100,000-man army in enemy territory required 600 tons of supplies a day. Meigs oversaw the expenditure of $1.5 billion, nearly half the total direct cost of the Union's war effort.[114] As an advisor to the Secretary of War on overall strategy, he had a uniquely broad technical and logistical understanding of the entire war effort.[115] Meigs was fascinated by photographs documenting this

massive enterprise: he collected them from various sources and commissioned others himself.

Despite the demands of his official duties, Meigs kept abreast of the photographs forwarded to Washington by various departments of the military. In April 1864, for example, he saw the views of Chattanooga that George N. Barnard had made for the Department of Engineers. Meigs found these images "interesting and beautiful" and wrote General Sherman in Nashville to inquire about Barnard's more recent photographs of that city and Knoxville. He requested two sets of each group, "one for my office and one for myself."[116] Meigs was so impressed by these prints that he requested permission for Barnard to take time from his normal duties to photograph for the Quartermaster's Department.

Meigs directed the work of at least four other photographers in 1864-65: Andrew J. Russell, Jacob F. Coonley, Samuel A. Cooley, and Thomas C. Roche. Coonley and Roche's services were obtained through the Anthony firm, and Russell's through the Bureau of Military Railroads. Cooley appears to have corresponded directly with the Quartermaster General. Following Meigs's instructions, these photographers documented the works of the Quartermaster's Department: bridges, railroad trestles, boats, barracks, warehouses, hospitals, and more. Intended for internal use and official files, these images were typically not seen by the general public. While his name is seldom mentioned in histories of the subject, Meigs was the military's single most important patron of photography.

By contrast to this activity on the Union side, Confederate military photography was almost nonexistent. Andrew Jackson Riddle was one of the few Southern photographers known to have been

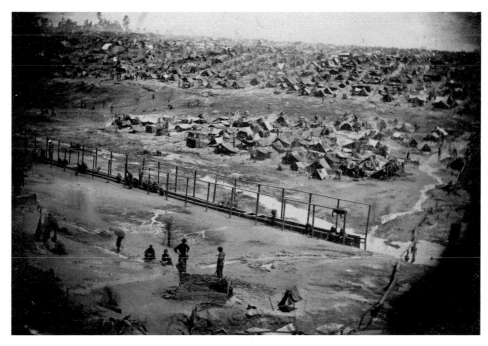

344 **Andrew Jackson Riddle**, *Andersonville Prison, Georgia. Bird's Eye View; Gathering Roots to Boil Coffee; 33,000 Prisoners in Bastille*, August 17, 1864

345 **Albert J. Beals**, Dictator, *Under Construction*, 1863

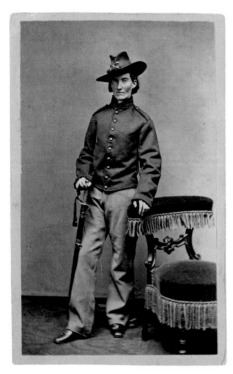

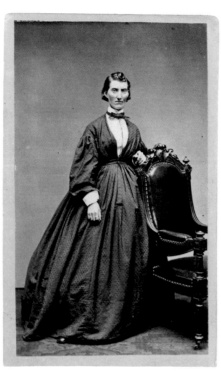

346 **Samuel Masury**, *Frances L. Clayton Dressed as Cavalryman*, ca. 1865

347 **Samuel Masury**, *Frances L. Clayton*, ca. 1865

348 **Mathew B. Brady**, *Major Pauline Cushman Souvenir*, ca. 1865

349 **John Carbutt**, *The Brave Defenders of Our Country*, 1863

350 **Unknown Maker**, *Sojourner Truth*, 1864

on the military payroll.[117] Riddle began photographing maps in Richmond, Virginia, soon after the start of hostilities. By 1864, he had moved to Macon, Georgia, where he billed himself as "Chief Photographer, Division of the West." In addition to his map-copying work, Riddle made an extraordinary series of views of Andersonville prison in August 1864. Although they were produced with the cooperation of the camp's commander, these views have a strangely surreptitious quality. Made from the top of the prison's outer wall, the images are oddly canted and vignetted; there is little evidence that Riddle's subjects were aware of his camera. The resulting images are genuinely shocking: they record thousands of prisoners in a septic squalor [344]. This image, for example, depicts an open latrine only steps from prisoners' tents. It is surprising that Riddle was allowed to make such revealing pictures.[118] It is even more surprising that he was allowed to sell them publicly. While it is probable that very few were sold during the years of the war itself, by the 1880s these views had become highly desired by Northern veterans.[119]

End Game: Victory, Trauma, and the War of Memory

After Gettysburg, the tide of war turned inexorably in the Union's favor. Despite horrific casualties and occasional setbacks on the battlefield, the size, wealth, and industrial capacity of the North made the war's outcome all but inevitable. While General Ulysses S. Grant fought Confederate forces to a standstill in the Virginia Campaigns of 1864-65, General William T. Sherman made dramatic progress in the western theater. His occupation of Atlanta, on September 2, 1864, raised Northern morale and contributed significantly to President Lincoln's reelection two months later.

The Union mood during this period was one of patriotism and weary determination. Many photographs reached the public in these final years, from celebrations of engineering might [345] to political allegories [C-115]. The first of these views, documenting a Union ironclad vessel being readied for launch, is an image of contrasts: this dark and dirty workshop has given birth to a vessel as sleek and lethal as a white shark. The second is purely symbolic: a youthful Liberty, holding Old Glory, standing calmly triumphant on an enemy flag.

Portraits of notable personalities continued to find an eager market. For example, Frances Clayton achieved some renown for serving in the Union Army for nearly two years disguised as a man [346, 347]. Apparently, Clayton's secret was protected by her propensity for chewing tobacco, spitting, and swearing. Her ruse was discovered only after she was wounded and sent to a hospital.[120] Pauline Cushman, a professional actress, became famous for another form of deception. She worked as a spy for the Union Army in Tennessee, carrying messages behind enemy lines and reporting on the strength of Confederate forces. After she was captured, and narrowly escaped execution, President Lincoln awarded her an honorary major's commission in thanks for her service. For some years thereafter, Cushman toured the country under the guidance of P. T. Barnum, lecturing on her exploits. It was said that her story became more thrilling and dangerous with each retelling. Brady photographed Cushman in various poses and costumes. Eight of these portraits, together with one of Barnum, were copied and issued as a special carte-de-visite "souvenir" [348].

Photographs were an integral part of the charitable Sanitary Fairs held in the major cities of the North from the fall of 1863 through early 1865.[121] With all proceeds going to the war effort, photographs were among the many items offered for sale. One of the

351 **Myron H. Kimball**, *Wilson Chinn, a Branded Slave from Louisiana*, 1863

352 **Charles Paxon**, *Our Protection: Rosa, Charley, Rebecca*, 1864

most remarkable of these works, by Chicago photographer John Carbutt [349], was sold at the nation's first Sanitary Fair, which opened in that city on October 27, 1863. Carbutt's carte-de-visite commemorates the sacrifice of Union soldiers with an unforgettable combination of artistry and blunt realism. In other cases, photographs were made of the *tableaux vivants*, or living pictures, that were part of the fairs' entertainment [C-116].

A few entrepreneurial individuals commissioned photographs to support their own reform and charitable causes. One of the most famous of these figures, Sojourner Truth [350], was active in the abolition, women's rights, and temperance movements. She was particularly concerned about the plight of escaped and—after 1863—emancipated slaves. During the Civil War, she served in Washington, D.C., as a nurse and aide to the African American refugees who gathered there. After the war, she worked to create jobs for former slaves. This portrait, which she registered for copyright in 1864, represents a savvy understanding of the economy of celebrity. Sojourner Truth controlled and profited from the public circulation of her likenesses; printed on the face of this carte are the words "I Sell the Shadow to Support the Substance."

One of the most curious bodies of Civil War work—the emancipated slave series of 1863-64—was also made for charitable purposes.[122] After the Union Army occupied New Orleans in May 1861, military officials were charged with maintaining order. As part of this effort, General Nathaniel Banks, Commander of the Division of the Gulf, instituted the first free public schools in Louisiana. These schools had high symbolic value but were chronically low on funds. To promote their essential work, a publicity tour of the North was begun in late 1863 in coordination with the American Missionary Association and the National Freedman's Relief Association. A group of eight students—most without any visible trace of "black" skin—and three adults were brought to New York and Philadelphia to sit for portraits in several studios. The resulting images range from depictions of the inhumane treatment of adult slaves [351] to demonstrations of patriotism [352]. Most of the profit from the sale of these photographs went to the Freedman's Relief Association.[123]

These photographs speak to both the power of the abolitionist idea and to underlying perceptions of racial difference. These children had been designated as slaves by the "one-drop rule," which held that any African heritage made one "black." However, these children were chosen for their promotional role in the North because it was expected that young white faces would generate more sympathy than young black ones. As historian Kathleen Collins has noted:

> These visual mementoes remain as evidence of a social reform campaign which was widely discussed and supported among abolitionists at the time… Now, among Northern collections large and small may be found these enigmatic portraits of Caucasian-featured children who, because of their "whiteness," could stimulate their Northern benefactors to contribute to the future of a race to which these children found themselves arbitrarily confined.[124]

The end of the war brought both elation and sorrow to an exhausted nation. After the numbing duration of the conflict, the events of the spring of 1865 occurred in rapid and bewildering succession: Lincoln's second inaugural on March 4 [353], the occupation of Richmond and Petersburg on April 3, the surrender at Appomattox on April 9, the shooting of the President on April 14 and his death early the next day, Lincoln's mourning procession in the capital on April 19, the departure of his funeral train on April 21 for the solemn

1,700-mile journey back to Illinois [354], the death of the assassin John Wilkes Booth on April 26, the start of the trial of the Lincoln conspirators on May 9, the capture of Confederate President Jefferson Davis on May 10, and the grand review of the Army of the Potomac in Washington on May 23.

Copyright records for the Washington, D.C., district court reveal the photographic community's timely response to these events. On April 13, Brady registered three panoramic views of the ruins of Richmond, as well as portraits of the leading Confederate generals: Robert E. Lee, Joseph E. Johnson, and Thomas J. "Stonewall" Jackson. (Once the war was over, the trade in such portraits was apparently considered a matter of objective history rather than the celebration of unpatriotic foes.) On May 1, Brady registered a portrait of President Andrew Johnson and seven depictions of the soldier credited with shooting John Wilkes Booth. On May 17, Alexander Gardner copyrighted three portraits of Johnson, two of Lincoln, and several of a Lincoln conspirator. In June, at least two firms registered interior views of the courthouse in which the conspirators were being tried.[125] Not surprisingly, the nation's photographers gave enormous attention to Lincoln's death and funeral. On May 22, 1865, Coleman Sellers noted with only slight exaggeration:

> During the past month the whole labour of photographers has been in one direction—the collection and reproduction of portraits of Mr. Lincoln, and pictures of the localities and incidents connected first with the fearful tragedy itself, and then with the sublime spectacle of the funeral train passing over a route of more than a thousand miles to the final resting place… In each city photographers have been reaping rich harvests from their pictorial representations of the funeral cars and instantaneous pictures of the various processions.[126]

This period was climaxed by the trial of the Lincoln conspirators, which was exhaustively reported in the nation's newspapers. After seven weeks of testimony and deliberation, the end came quickly. The proceedings concluded on June 29. The verdict was given to the defendants on July 6, and they were hanged the next day in the courtyard of the Old Arsenal Penitentiary, Washington, D.C. Alexander Gardner was given special permission to record the execution. Choosing their vantage points carefully, he and Timothy O'Sullivan operated a stereo and a 7 x 9-inch camera, respectively.[127] The deliberate pace of events allowed them to make an unprecedented sequence of views: at least five large plates (three reproduced here [355, 356, 357]) and three stereos. While this series appears to have been made primarily for the Secret Service and the government, prints were also sold to the general public.[128]

This was a period of homecoming and somber commemoration across the nation. Some of the most moving photographs record the return of soldiers to civilian life. A simple carte-de-visite presents a scene reenacted in countless households: a returning veteran, still in uniform, gravely tells his tale to friends and family [358]. A number of the war's leading military figures had themselves recorded in similarly transitional roles: they are in military dress but are depicted as husbands and fathers. One of the most remarkable of these portraits, by John Carbutt, depicts a haunted William T. Sherman embracing his young son in a gesture at once tender and tentative [360].

As veterans returned home, their fallen comrades were honored in countless ceremonies. Monuments to the Union dead at the battles of First (July 21, 1861) and Second (August 29, 1862) Bull Run were dedicated on June 10-11, 1865. The ceremony consisted of a religious service, a hymn, a military parade, and a rifle salute, followed by

353 **Unknown Maker**, *Abraham Lincoln's Second Inauguration*, March 4, 1865

354 **Unknown Maker**, *Lincoln's Catafalque, New York*, 1865

355 **Alexander Gardner**, *Scaffold for Lincoln Conspirators*, 1865

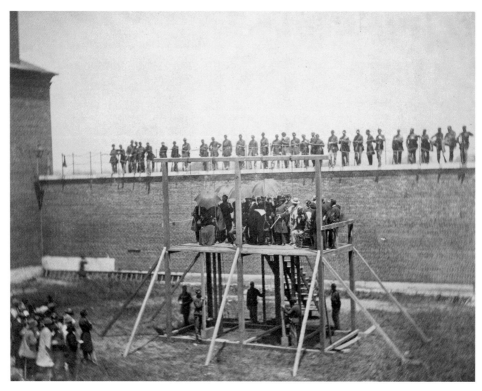

356 **Alexander Gardner**, *Reading the Death Warrant*, 1865

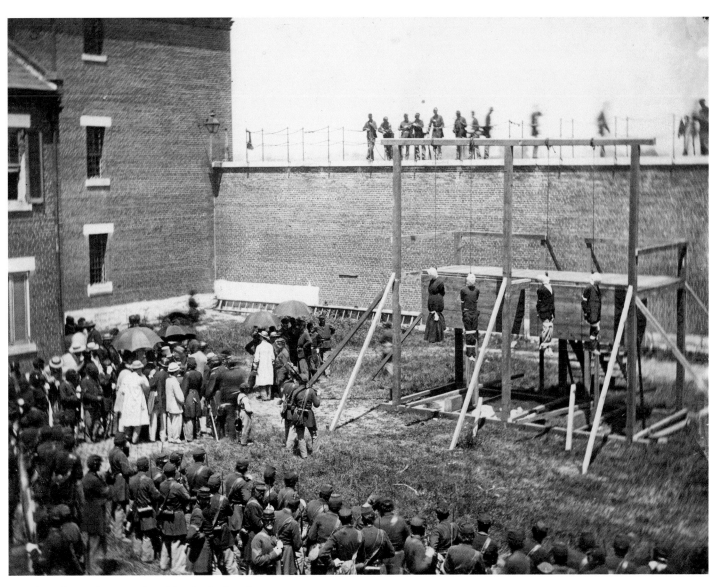

357 **Alexander Gardner**, *Hanging of the Lincoln Conspirators*, 1865

358 M. Witt, *The Soldier's Return*, 1865

formal addresses by Judge Abram B. Olin, of the District of Columbia Supreme Court, and Generals Wilcox, Heintzelman, and Farnsworth. Alexander Gardner was among those who had come from Washington, D.C., for the day's events. In addition to photographing the monuments themselves, he made at least one distinctly unconventional image [359] of the spectators (and speakers to follow) listening to Judge Olin's remarks.[129]

The process of keeping the war alive in memory began on the day the South surrendered, and photographers played a critical role in this collective act of remembrance and commemoration. The erection of monuments began within weeks of Appomattox, and a seemingly endless number of histories, memoirs, and biographies poured from

the nation's presses. Veterans of the war formed associations to maintain ties and share memories. Reunions were held by individual batteries, regiments, and even entire armies; specialized groups such as the Union Ex-Prisoners of War and the Signal Corps Society were also established. The Grand Army of the Republic, an umbrella organization open to all who served in the Union Army, held its first national convention in 1866 and reached a peak membership of over 400,000 in 1890. Other important national groups, such as the Military Order of the Loyal Legion of the United States, were established. Civil War reunions were held annually through 1951, when three ancient Confederate veterans gathered in Richmond for the last time.[130]

Contrary to what has become a kind of photo-historical fable, public interest in Civil War photographs remained strong in the years after the war. For example, the Anthonys' "War for the Union" stereographs, first issued in 1865 and reprinted steadily for years, appear to have been highly successful. In fact, these cards were priced higher than other Anthony sets, an indication of the depth of this market.[131]

In addition to this broad audience for moderately priced images, an elite clientele existed for limited-edition works. These collectors were typically men of wealth and social position who had participated in the conflict. Within eighteen months of the war's conclusion, this specialized audience provided the market for two lavish photographic volumes: Alexander Gardner's *Photographic Sketch Book of the War* and George N. Barnard's *Photographic Views of Sherman's Campaign*. Both were sold by subscription — by soliciting advance commitments prior to publication. The editions would be limited to something between 100 and 200 copies each, with sales guaranteed for perhaps half this number before the actual labor of

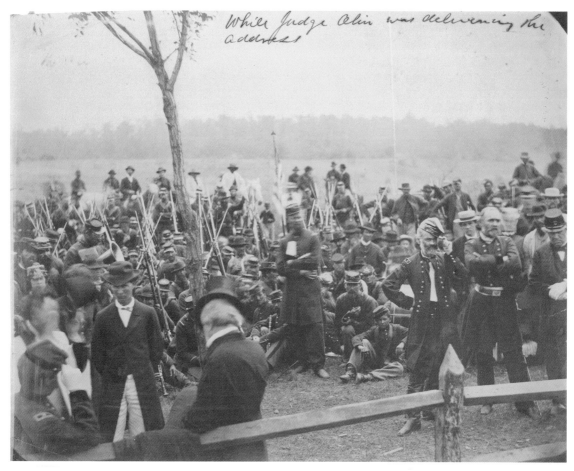

359 **Alexander Gardner**, *While Judge Olin was Delivering the Address*, June 11, 1865

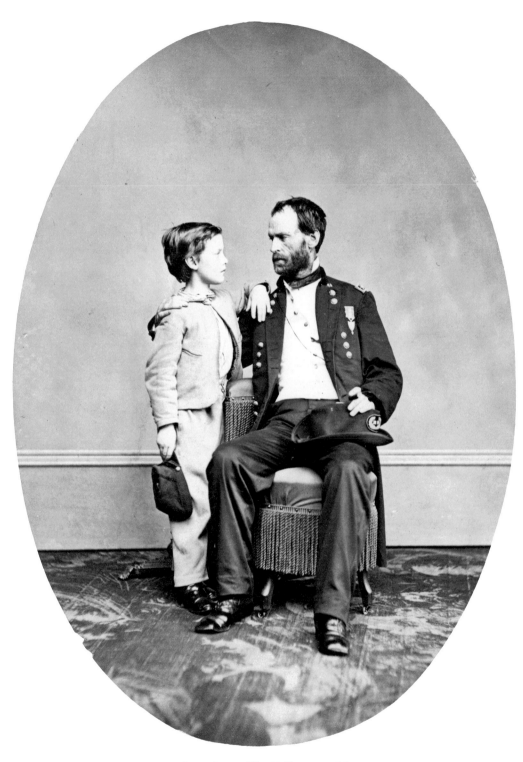

360 **John Carbutt,** *William T. Sherman and Son,* 1865

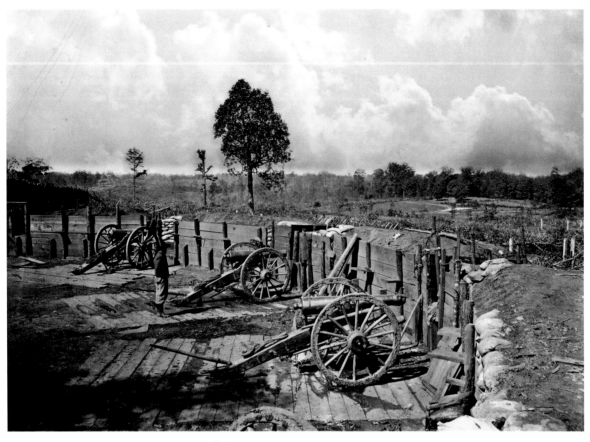

361 **George N. Barnard**, *Rebel Works in Front of Atlanta, No. 2*, 1864

creating the volumes was started. Although some twentieth-century historians have described these volumes as financial failures, this was almost certainly not the case.

Gardner's Photographic Sketch Book of the War, a lavish two-volume work, appeared at the end of January 1866 at a price of $150 (comparable to about $3,000 today). Each of the 200 copies contained 100 original albumen prints. Because of his special relationship with the Army of the Potomac, Gardner's survey was limited to the eastern theater of the war, with primary attention given to the campaigns in Virginia and Maryland. The plates in the *Sketch Book*, each credited to both photographer and printer, are organized in roughly chronological sequence. The first image shows the Marshall House, where Ellsworth was killed in May 1861; the last records the dedication of the monument at Bull Run in June 1865. Choosing from the many hundreds of war negatives made under his direction, Gardner created a clear and powerful visual narrative.

Each of these 100 photographs is paired with a lengthy text explaining the historical importance of the scene depicted, with anecdotes and poetic musings to enlarge the picture's meaning. For example, a tranquil photograph of an army encampment at Culpeper, Virginia, is accompanied by a text bristling with action: "the pulsations of battle . . . have throbbed through its streets, Cedar Mountain, blazing with conflict, looked down upon it, and Grant . . . shook its spires with the roar of his guns."[132] Similarly, the text for a static image of parked wagons suggests the "lively times [of] harness-sewers working to distraction, and blacksmiths punishing their anvils day and night."[133] This is already a retrospective vision of the conflict — one infused by the warm glow of memory.

In this context, the lyric narrative accompanying Gardner's *Home of a Rebel Sharp-Shooter* [331] feels appropriate.[134] After a quick review of the battle of Gettysburg, and a description of the sharpshooter's lair, Gardner's text becomes increasingly poetic:

> The sharpshooter had evidently been wounded in the head by a fragment of shell which had exploded over him, and had laid down upon his blanket to await death. There was no means of judging how long he had lived after receiving his wound, but the disordered clothing shows that his sufferings must have been intense. Was he delirious with agony, or did death come slowly to his relief, while memories of home grew dearer as the field of carnage faded before him? What visions, of loved ones far away, may have hovered above his stony pillow! What familiar voices may he not have heard, like whispers beneath the roar of battle, as his eyes grew heavy in their long, last sleep![135]

This text was representative of the cultural need to find meaning in loss. As the historian Alice Fahs has written, "Hundreds of popular songs and poems during the war grappled with the fact of mass, anonymous death by creating idealized deaths for soldiers. While numerous poems sought to aestheticize the dead body of the soldier or the site of his death, far more poems and songs gave voice to dying soldiers' thoughts."[136] A year after the war ended, most Northerners reading Gardner's words would have understood exactly what "documentary" value they possessed. The dead young man in this picture had come to be seen less as an enemy than as an American; the spot where he fell was national hallowed ground.

The complexity of Gardner's volume derives in large part from this rich and deliberate pairing of pictures with words. Each *Sketch Book* photograph documents with unimpeachable precision the particularities of a specific site. The accompanying text provides a larger framework of fact, anecdote, speculation, and judgment. This com-

362 **George N. Barnard**, *Scene of General McPherson's Death*, 1864 or 1866

363 **George N. Barnard**, *Battleground of Resaca, No. 2*, 1866

bination of the visual and literary evokes a remarkable narrative movement in time and space. Events before and after the photographed moment are suggested, as well as geographic spaces beyond the frame of the image. The *Sketch Book* represents a powerful union of words and pictures, revealing Gardner's deep understanding of both.

George N. Barnard's decision to produce his *Photographic Views of Sherman's Campaign* was undoubtedly influenced by the reception of his colleague's work.[137] Within weeks of the *Sketch Book*'s release, Barnard began work on an album devoted to General William T. Sherman's celebrated campaign. Barnard had anticipated this opportunity, having earlier secured permission to keep many of the 12 x 15-inch negatives he made in 1864-65. To supplement these views, he made a trip to the South in the spring of 1866, retracing Sherman's route from Nashville to Atlanta, Savannah, and Charleston. Back in New York, Barnard spent the summer and early fall printing between 100 and 150 copies each of the album's 61 photographs. Each album also included several official campaign maps and a small volume of historical text written by his journalist friend Theodore R. Davis.[138] Barnard's large (20-pound) volume was completed in November 1866 and was priced at $100 per copy (about $2,000 today).

Oddly, the title of this work only approximates the subjects depicted. The album opens with a postwar studio portrait of Sherman and his generals borrowed from Mathew B. Brady.[139] This is followed by fifteen plates depicting scenes in Nashville and Chattanooga associated more directly with the 1863 campaigns of General Ulysses S. Grant. Album plate 17 represents the first new territory covered in Sherman's move toward Atlanta after he took over as head of the Military Division of the Mississippi. Subsequent images document in geographical sequence the battlegrounds of Resaca, New Hope Church, Kennesaw Mountain, and Atlanta. Eight plates are devoted to the defensive works around Atlanta and the city itself. Notably, Barnard did not record the most infamous aspect of Sherman's campaign, the March to the Sea. The reasons for this omission involve both the logistical difficulties of photographing in transit, and Barnard's personal distaste for the acts of theft and violence perpetrated by Sherman's "bummers."[140] The album concludes with photographs of Savannah, Columbia, and Charleston.

Sherman's Campaign contains views of scarred battlefields, ruined buildings, scenic landscapes, and bridges, trenches, and forts. Beyond his rendition of such places and things, Barnard presents a complex meditation on history, memory, and aesthetics.[141] He clearly intended his volume as a synthesis of information and art. During the war, he had made objectively "straight" prints from his negatives. In 1866, however, he used a cumbersome double-printing technique to add billowing clouds to skies that had been previously blank [361]. These clouds added nothing of documentary value to his pictures: their sole function was aesthetic.

The brooding artistry of Barnard's album is exemplified in one of its most famous plates, the *Scene of General McPherson's Death* [362]. General James Birdseye McPherson, who died in a skirmish on the outskirts of Atlanta on July 22, 1864, was one of the youngest, most talented, and most beloved of Union generals. As soon as Atlanta was safely occupied by Union forces, Barnard made the first of at least two attempts to commemorate this site. As in the case of Gardner's *Rebel Sharp-Shooter*, Barnard actively shaped this scene for his camera. He pulled offending foliage out of the lens's view, arranged the

horse's skull and bones on the ground, and even painted over some distracting graffiti on the central tree.[142]

This image pays homage to an honored theme in history painting: the depiction of the dying military hero. In a classic example of this genre, Benjamin West's *Death of General Wolf* (1770), the gallant young general expires in the company of his faithful retinue. While Barnard's photograph stems from this elevated tradition, it is—by the nature of both the medium and Barnard's own sensibility—radically different in effect. Most obviously, it is eerily empty of human presence. Barnard eschews theatrical action or overt sentiment for the melancholy associations of a few scattered pieces of evidence. This photograph is a constructed meditation on memory and loss, a memento mori. Like his album as a whole, this photograph is imbued with a haunting sense of absence: an absence of people, of action, and of moral certainty.

Barnard's album draws particular conceptual strength from its interweaving of uniquely American themes: the sacred beauty of the landscape and a sense of cultural identity as revealed in a layering of historical incident. Many at the time believed that the war had finally conferred on the nation a much-needed pantheon of national heroes, dramatic narratives, and grand ideals.[143] At the same time, its bitterness and bloodshed had resulted in a profound loss of cultural innocence and optimism. In images of blasted trees and denuded ground, Barnard suggests this complex and bittersweet new cultural maturity [363]. His silent landscapes suggest fierce battles, mangled bodies, and deep passions. There is nothing remotely triumphant in these pictures; a disquieting moral ambiguity underlies them all. Barnard believed deeply in the war's purpose, but was shocked by its savagery. This moral anguish is implicit in his work.

It is difficult to grasp fully the ways in which Civil War photographs were appreciated in their time. The war had been so overwhelming and traumatic that unadorned "facts" could not begin to explain its meaning. Despite (or perhaps because of) their apparent specificity, war photographs were effortlessly woven into a complex communal narrative. The inherent truthfulness of the photograph was universally accepted. The "terrible distinctness" of images of the dead at Antietam, for example, was painfully apparent to all. On viewing stereographs of these scenes, Oliver Wendell Holmes confessed that "it was so nearly like visiting the battlefield to look over these views, that all the emotions excited by the actual sight of the stained and sordid scene. . . came back to us, and we buried them in the recesses of our cabinet as we would have buried the mutilated remains of the dead they too vividly represented."[144]

At the same time, critics and viewers of the 1860s looked to photographs for more than facts alone. For some, the camera's highest value lay in its ability to stimulate thoughts and emotions—to promote understanding, empathy, and moral insight. Photographs did more than simply present evidence; they allowed viewers to establish emotional connections to the events of the recent past and to each other. Photographs of the dead at Gettysburg, for example, were seen to suggest both the agony of individual deaths and the lives of grieving families. A full understanding of the meaning of death could begin with the stimulus of the photograph but, because "broken hearts cannot be photographed," could only be completed in the imagination of each viewer.[145] Civil War photographers understood this instinctively.

364 **Timothy O'Sullivan**, *Desert Sand Hills near Sink of Carson, Nevada*, 1868

CHAPTER VII — Nature and Culture: Scenic, Topographic, and Promotional Views

The United States grew enormously in the first two-thirds of the nineteenth century. The Louisiana Purchase of 1803 added 828,000 square miles of land west of the Mississippi River. Between 1845 and 1853, a vast area of formerly Mexican territory—including most of the present-day states of Texas, New Mexico, Arizona, Utah, Nevada, and California—was gained by annexation, cession, and purchase. In 1846, the British gave up the Oregon Territory (the current states of Oregon, Washington, and Idaho). This continental expansion culminated with the purchase of Alaska from Russia in 1867.

This dramatic territorial enlargement accelerated an ongoing process of exploration, exploitation, and settlement. The first whites to enter these territories were typically hunters and trappers. They were followed by mapping and geological parties and by the first trickle of westward pioneers. The Santa Fe Trail opened in 1821 as a trade route. Beginning in the early 1840s, a growing number of settlers went west on the Santa Fe, Oregon, and California trails. The Mormons, the largest single group of immigrants in this period, reached the Great Salt Lake in 1847. Miners and engineers came next. In addition to the California Gold Rush, which began in 1848, other great mineral "rushes" occurred in this era, from the discovery of gold and silver in Arizona, Nevada, and Colorado in 1858-59, to the copper-mining operations in Montana in the 1880s. Numerous railroad surveys were made in the 1850s, but intensive construction was delayed by the Civil War.

The West was settled unevenly and in waves. The California Gold Rush spurred a leapfrogging effect. There was a sudden influx into central California and elsewhere along the Pacific Coast, but the Great Plains and Rocky Mountains remained sparsely settled until after the Civil War. Nonetheless, this vast region was opened at a relentless pace: an overland stage route was completed in 1858 and the transcontinental rail line was finished in 1869. By 1883, the bison, a great symbol of the untamed West, was essentially extinct. The 1890 U.S. Census confirmed that the frontier was officially closed: the American nation was now "settled" from coast to coast.

In the course of this process of occupation and exploitation, the native populations were decimated, uprooted, and marginalized. For example, California had about 150,000 native people in 1845, but only 25,000 in 1856.[1] Over the following decades, the combined effects of disease, murder, broken treaties, and outright theft were catastrophic. The Battle of Little Big Horn, in 1876, marked a final, short-lived, victory for the Lakota people. In 1881, a weary and emaciated group led by Lakota warrior Sitting Bull surrendered to an army outpost in a remote corner of the Dakota Territory. Within a few years, all significant resistance had ended and the remnants of the many North American tribes were sequestered onto ever-shrinking reservations.[2]

The Art of Landscape

This physical transformation of the United States—relentless and often ruthless—was accompanied by a fresh appreciation for the national landscape. This new aesthetic taste was the result of many factors—economic, patriotic, religious, artistic, and scientific. The idea of Manifest Destiny, the traditions of the picturesque and the sublime, the concept of the wilderness as a kind of primeval Paradise, the contemporary fashion for painted panoramas, and the popular fascination with geology all contributed to this new taste for landscape.[3] The land had as many meanings as Americans had reasons to look at it. In the words of art historian Barbara Novak, "Nature's text, like the Bible, could be interpreted with Protestant independence."[4] Depending on one's point of view, the land could represent youth and fertility; independence, industry, and social accord; self-denial, awe, and transcendence; human frailty and mortality.

This new attitude developed in tandem with the rise of modern tourism. Although leisure travel had been an established practice in Europe for decades, tourism's development in the United States began in the 1820s and 1830s. The transportation revolution of this time—by road, river, canal, and railroad—made vacation and sightseeing trips both fashionable and easy. An American version of the European "Grand Tour" arose—an itinerary that was at once pleasurable and instructive. The key destinations on this circuit included Niagara Falls, the Connecticut and Hudson river valleys, the Catskill and Adirondack regions of central New York State, and the White Mountains of New Hampshire.

Artists made these same journeys and marveled at the same sights. For example, Thomas Cole's famous painting *View from Mount Holyoke, Northampton, Massachusetts, after a Thunderstorm (The*

Oxbow), of 1836, represents the view from one of the most popular vantage points along the Connecticut River valley. Cole, considered the father of a national school of landscape art, also painted in the White Mountains and the Catskills and wrote the influential "Essay on American Scenery" (1835).[5] His work combined a love of real places with a deeply moral and symbolic vision. Drawing from European artistic traditions, his landscapes are allegories and parables: meditations on the most profound matters of spirit and history. Cole's *Course of Empire*, a series of five large paintings made between 1834 and 1836, warned of the "natural" cycle of human civilizations, from "The Savage State" and "The Pastoral or Arcadian State" to "The Consummation of Empire," "Destruction," and "Desolation." In part, this series underscored the superiority of spiritual values to worldly ambition and wealth.

Cole's influence extended well beyond his death in 1848. His paintings were viewed as expressions of national character and destiny. As a contemporary admirer, the diarist Philip Hone, observed: "I think every American is bound to prove his love of country by admiring Cole."[6] While the artists that followed typically had a more empirical and naturalistic vision, Cole's example informed the greatest generation of American landscape artists.[7] As Cole's most prominent student, Frederic Edwin Church, assured his teacher in 1844, "I pursue [landscape painting] not as a source of gain or merely as an amusement, I trust I have higher aims than these."[8] Such lofty aims are seen in the achievements of the Hudson River and Luminist schools of painting—specifically, in the work of artists such as Church, Asher B. Durand, John Frederick Kensett, Martin Johnson Heade, Jasper Francis Cropsey, Fitz Hugh Lane, and Albert Bierstadt.[9] These artists depicted the beauty of relatively familiar scenes—the Hudson and Connecticut river valleys, for example—as well as the more exotic wonders of the West, South America, and the Arctic.

American landscape paintings of this period varied considerably in size, subject, and effect. Some artists created works of intimate size and of local or pastoral subjects. For example, Kensett and Heade were known, respectively, for their quiet views of New England beaches and salt marshes. While they worked in various sizes, both were particularly accomplished in works ranging from about 20 to 36 inches in width. The mood of these paintings is appropriately personal: they are characterized by a pellucid clarity and meditative stillness. In addition to their larger, more polished canvases, most of these painters worked in the rapid and direct medium of the oil sketch. Characteristically modest in size, these were typically made "from nature," outdoors, in a single sitting. As a result, oil sketches have something of a "snapshot" veracity; they provide a relatively empirical impression of a specific place or of a fleeting condition of light and atmosphere. While oil sketches were often used as studies for larger paintings, they were also exhibited as finished works of art.[10]

At the other end of the scale, painters such as Church and Bierstadt became famous for very large canvases. Church's *The Icebergs* (1861) measures 64 x 112 inches, while Bierstadt's *Storm in the Rocky Mountains—Mt. Rosalie* (1866) is even larger, at 83 x 142 inches. In the tradition of the diorama and the painted panoramas of the day, these spectacular paintings were displayed to the paying public in carefully orchestrated solo installations.[11] Influenced by the tradition of history painting, these were rendered on a scale commensurate with the sublimity of their subjects. Everything about these works was big, including the profits that could be realized. In 1859, Church was paid $10,000 for *The Heart of the Andes*, a record for an American

painting, and he probably made just as much from the admission fees collected during the work's multi-city tour. This staggering price was soon eclipsed by sales of his own newer paintings and by others by Albert Bierstadt. In the mid-1860s, Bierstadt reportedly sold several works for between $20,000 and $25,000 each.[12]

The appeal of these large works derived, in part, from the novelty of their subjects. In search of exotic scenes, artists became adventurers and travelers. Church made trips to South America in 1853 and 1857 and to the Middle East in 1868. Bierstadt went to Switzerland in 1856, and made the first of several trips to the West in 1859 with the railway survey expedition of Colonel Frederick W. Lander. In 1863, he spent nearly two months in the Yosemite Valley and then toured the Pacific Northwest. The painter Thomas Moran first visited the West in 1871 as part of the U.S. Geological and Geographical Survey of the Territories, led by Ferdinand V. Hayden. He made many more western trips, including a visit to Yosemite in 1872 and to the Grand Canyon in 1873.

This quest for distant and sublime subjects was exemplified by the work of William Bradford, a painter from New Bedford, Massachusetts. Inspired by his friend Albert Bierstadt, Bradford developed a reputation for his marine studies in the late 1850s. The appeal of the austere northern waters prompted Bradford to make a series of voyages along the Labrador Coast. Beginning in 1861, he made return visits there nearly every summer through the end of the decade. Bradford's expeditions, composed primarily of the wealthy adventurers who underwrote the trips, became increasingly elaborate affairs. He advertised that these excursions would "present great attractions for naturalists and men of science, as well as sportsmen and lovers of adventurous travel."[13] Bradford also brought several party members along at his own expense, including three photographers from James W. Black's firm in Boston: George Critcherson in 1863, William H. Pierce in 1864, and John L. Dunmore in 1867.[14] Bradford directed the production of their views, which he used (with his many sketches) as studies for paintings produced later in the studio.

Bradford's photographic effort culminated in his seventh and final Arctic expedition of 1869. This voyage, on a 325-ton icebreaker named *The Panther*, lasted three months and covered 5,000 nautical miles, including a sometimes harrowing 100-mile trip into the ice pack of Melville Bay, Greenland. Bradford brought two experienced photographers on this trip: Dunmore and Critcherson. Using cameras of up to about 12 x 16 inches in size, the pair made between 300 and 400 negatives of the ocean, towering icebergs and glaciers, polar bears, the midnight sun, native peoples and their dwellings, and the *Panther* itself [**365, 366**].[15] In 1873, Bradford issued 141 of these views—accompanied by a colorful and informative narrative—in an album titled *The Arctic Regions: Illustrated with Photographs Taken on an Art Expedition to Greenland*.[16] This was a massive work, measuring 25 x 21 inches overall with 76 elephant-folio-size pages of text and photographs. Its announced edition size of 300 copies required the production of 42,300 original albumen prints.

The photographs of *The Arctic Regions* were of interest to a varied audience, from artists, ethnologists, and scientists to sportsmen and adventurers. This breadth of appeal was characteristic of nearly all the important bodies of landscape or expeditionary photographs of the period. None were narrowly conceived; all were intended to serve a variety of interests and needs.

Photography played a central role in nineteenth-century landscape depiction. Artists such as Bradford were not only aided by the camera but commissioned new works. Beginning in the late 1850s,

365 **Dunmore & Critcherson**, *No. 98. Castle Berg in Melville Bay over two hundred feet high.*
The Figure, which is some seventy-five feet from the Base, gives an object to compare with the Berg.
The ice in the foreground is about eighteen inches in thickness, 1869

366 **Dunmore & Critcherson**, *No. 83. Hunting by Steam in Melville Bay, The Party After a*
Day's Sport Killing Six Polar Bears within the Twenty-Four Hours, 1869

photographs of picturesque landscapes were sold to the public in considerable quantity. The most ambitious photographers, such as Carleton E. Watkins, worked with self-consciously artistic intentions and appealed to a more elite audience.

Inevitably, the landscape photographs of this era reflected the nature and potentials of the medium itself. Photographs were monochromatic and—compared with most paintings—of small size. Since lenses have an inherently limited depth of field, it was difficult when working with the largest cameras to capture close and distant objects in equally sharp focus. Further, the sensitivity of the wet-collodion emulsion made it nearly impossible to record the full tonal range of a sunlit scene—to capture detail in both ground and sky in a single exposure. As a result, most photographers let their skies go blank, treating them as a purely graphic element of the composition. Photographers may have been influenced by the traditions and motifs of landscape painting, but they understood that landscape photography held its own challenges and possibilities. The photographer's encounter with the landscape was inevitably shaped by existing pictorial conventions and assumptions, but it was never fully determined by them. Indeed, in many respects, the photographic landscape was something entirely new.

The Eastern Landscape: Scenic and Topographic Views

While a relative handful of scenic daguerreotypes were made in the United States, the advent of the glass-negative and paper-print processes spurred a dramatic increase in landscape photography. As long as they could be made and sold cheaply, landscape pictures (like portraits of celebrities) had a broad public appeal. Whether viewed as works of art, as souvenirs of travel, or as tasteful parlor accessories, mass-produced scenic photographs played a central role in the era's traffic in images. It is significant both that the majority of scenic photographs were issued as stereographs, and that most stereographs were scenic views.[17] These two genres were intimately allied: the stereo format allowed such photographs to be sold in series—comprising a virtual journey or itinerary—and the illusion of three-dimensionality provided a visual experience that no painting could duplicate.

Scenic and topographic views were among the first stereographs produced in the country. In the winter of 1854-55, the Langenheims began issuing both glass and paper stereographs with series titles including "Philadelphia and Environs," "Baltimore," "Pittsburgh," "Niagara Falls," "The White Mountains," and "Beauties of the Hudson River."[18] By 1862, the Anthony firm had a huge number of such views in stock. These included such standard subjects as Niagara, the White Mountains, the Hudson River valley, the Catskills, and California, as well as more narrowly focused subjects, such as "The Picturesque on the Pennsylvania Central R. R.," and "A Ramble through the Southern Tier on the Route of the Erie Rail Road."[19] In the coming years, hundreds of American photographers followed this model by making and publishing stereographs of regional scenes.[20]

Scenic and landscape photographs were quite common as stereographs, but far rarer as large-format views. Americans happily bought stereographs of such subjects, but resisted paying the price of larger prints. In 1883, Wisconsin photographer Henry H. Bennett wrote to Eadweard Muybridge to apologize for the scarcity of his large-plate views: "I am mortified that they are no better and more

of them, but my attention has been almost wholly to stereo work, there being no sale here for any other class of views up to the present time."[21] Relatively few large-format landscape views were sold to the general public; typically, they were made for elite collectors, for personal and artistic reasons, or as scientific or historical documents.

The first significant body of large-format landscape photographs on paper was made by James W. Black in 1854.[22] Black was in partnership with John A. Whipple at the time, helping promote Whipple's "crystalotype" paper process. Black's trek to the woods of New Hampshire was probably conceived to demonstrate the versatility of this new technique. He ultimately made at least thirty-five views, 8 ½ x 11 inches in size, ranging from expansive vistas of fields and farms to tightly cropped views of trees and rocks.[23] While the best of these have a striking directness, it is apparent that the series served as a test—technically and aesthetically—of Black's skills. He is not known to have done further work in this vein.

Franklin White, a resident of Lancaster, New Hampshire, also made early views of the White Mountains. White had experience as a daguerreotypist before he learned the new glass-negative and paper-print processes in 1854.[24] He had an experimental bent and developed a method of preparing his negatives so that they remained sensitive for several days.[25] With this "dry" technique, White made a series of views in about 1858-59 of the area around Mount Washington and in the Franconia Range. These pictures are somewhat primitive in technique and, like Black's earlier series, aesthetically simple.[26] This image [c-117] is memorable for its stark, unromantic sensibility—an entirely photographic, rather than painterly, vision.

Another significant body of landscape photographs was made at about the same time by William James Stillman, a journalist, art critic, and aspiring painter. Stillman founded the *Crayon* in 1855, the most influential American art journal of the period. He had an impressive circle of friends and influences, including the philosopher and essayist Ralph Waldo Emerson, the scientist Louis Agassiz, and the British art critic John Ruskin. After taking lessons in photography from James W. Black, Stillman produced a series of landscape views in the Adirondacks in the summer of 1859. A small folio of sixteen of these prints—made by Whipple & Black in Boston—was given to members of the Adirondack Club.[27] Stillman's photographs are modest in size and quiet in effect; they focus on the play of light through the forest and on details of tree trunks and fallen logs.

Ultimately, Stillman found his ideal subject in the historical topography of Europe. In Athens, Greece, he made intensive photographic surveys of the Acropolis in 1869 and 1882. Both visits resulted in powerful and elegant images [**367**]. These photographs are a perfect resolution of Stillman's interest in art history and his desire to make art himself.

The most significant eastern landscape work of this era was produced in the White Mountains by the Bierstadt Brothers. Based in New Bedford, Massachusetts, the Bierstadts were perhaps the most accomplished landscapists of the prewar era. The older brothers, Charles and Edward, had become photographers by 1859. The youngest brother, Albert, had studied art in Europe and was soon to become one of the nation's leading landscape painters. In 1859, all three went to the Rocky Mountains with an expedition headed by Colonel Frederick W. Lander. Ostensibly organized to build roads, the Lander party included a "full corps of artists."[28] In addition to Albert's sketches and paintings, the brothers made stereographs of scenery and Indians.[29]

367 **William James Stillman**, *Eastern Portico of the Parthenon, View Looking Northward and Showing Mount Parnes in the Extreme Distance*, ca. 1869

368 **Bierstadt Brothers**, *The Cathedral, White Mountains, New Hampshire*, ca. 1860

369 **John Moran**, *Tropical Scenery, Isthmus of Darien, Panama*, 1871

Upon returning to Massachusetts, the trio produced an important group of White Mountain photographs, ranging from stereographs to views of nearly mammoth-plate size [**368, c-118**]. Although Albert did not operate a camera, this was a collaborative effort.[30] A laudatory notice on this work in the *Crayon* concluded: "The plates are of large size and are remarkably effective. The artistic taste of Mr. Albert Bierstadt, who selected the points of view, is apparent in them. No better photographs have been published in this country."[31] This praise was deserved: the Bierstadt views have a greater aesthetic assurance than any other eastern landscape work of the antebellum era. The photographic partnership between Charles and Edward continued until 1867. Edward then went to New York City, where he entered the printing and publishing business, while Charles continued as a photographer at Niagara Falls.[32]

John Moran, of Philadelphia, is a rare example of the American artist-connoisseur: his photography was motivated primarily by aesthetic rather than commercial concerns. Moran came from a family of artists—his brothers Edward and Thomas were among the most successful landscape painters of the time—and he kept abreast of artistic theory and criticism.[33] Moran's landscape photographs embody a clear set of principles: a close attention to the details of nature, based in part on the theories of British critic John Ruskin, and a respect for the camera's descriptive precision.[34] Moran's photographs of the postwar years are intimate in feeling,

ranging from picturesque landscape views [**c-119**] to tightly framed details of bushes and trees.

The botanical specificity of these latter views is echoed in some of the work Moran produced in 1871 as part of the Darien Survey. Organized by the U.S. Navy under the direction of Commodore Thomas O. Selfridge, Jr., this survey investigated the feasibility of constructing a canal across the Isthmus of Darien, Panama. Given the engineering capabilities of the day, Selfridge's report was not encouraging. Suitably, in Moran's most powerful photographs [**369**], the luxuriant jungle growth appears as impenetrable as a brick wall.

While the commercial market for large-format landscape views was always limited, a few photographers made a specialty of this work. In Minneapolis, Joel E. Whitney's devotion to the St. Anthony and Minnehaha falls [**370, 371, c-120**] continued from the daguerreian era into the wet-collodion period. As this pair of Minnehaha views demonstrates, Whitney visited this venerable attraction throughout the year. From his start in photography in 1865, Henry H. Bennett, based in Wisconsin Dells, Wisconsin, recorded the beauty of that region in every format, from stereographs to mammoth-plate panoramas. Seneca Ray Stoddard, in Glens Falls, New York, became similarly identified with the idyllic landscape of the Adirondacks [**372**].[35] A number of photographers, including George K. Barker and Herman F. Nielson [**373**], served the perennial market for views of Niagara Falls. A dramatic view of a landslide by the little-known

370 **Joel E. Whitney**, *Minnehaha Falls in Summer*, ca. 1865

371 **Joel E. Whitney**, *Minnehaha Falls in Winter*, ca. 1865

372 **Seneca Ray Stoddard**, *Untitled (Adirondacks Landscape)*, ca. 1870

373 **Herman F. Nielson**, *Niagara Falls*, ca. 1880

374 **Thomas H. Johnson**, *Honesdale, Pennsylvania (panorama, sections 1-4)*, ca. 1870

375 **Henry P. Bosse**, *From Bluff at Fountain City, Wisconsin, Looking Downstream*, 1885

376 **Henry P. Bosse**, *Riverfront, Burlington, Iowa*, 1885

Boston photographer David Butterfield is a rare example of New England mammoth-plate work [C-121]. Butterfield's photograph was a kind of spot-news reportage: it was registered for copyright only eleven days after the event it recorded.

Other photographers worked in a topographic mode, producing information-rich images for specialized markets. This four-plate panorama of Honesdale [374], a town in northeast Pennsylvania, was created by Thomas H. Johnson for a small-edition album titled *Views of the Delaware and Hudson Canal and Gravity Railroad*, of ca. 1870. Johnson recorded the overall operation of the Delaware and Hudson Canal Company, including its machine shops, rail lines, and canals. Honesdale was the firm's base of operation, where coal was transferred from gravity railroad cars to canal barges. In the tradition of nineteenth-century urban views, Johnson used an elevated perspective to achieve a sense of cartographic objectivity.[36]

Henry Peter Bosse's cyanotypes [375, 376] were created in the course of his duties as a mapmaker with the U.S. Army Corps of Engineers. Bosse worked closely with Montgomery Meigs, the son of the great patron of Civil War photography, and a photographer himself.[37] Between 1883 and 1893, Bosse made hundreds of large-format views on the upper Mississippi River, from St. Paul to St. Louis. These record canals, levees, bridges, and boatyards as well as communities and scenes along the river. Bosse often used a distant or elevated view to convey a larger sense of context: the position of settlements along the river and of the waterway in the surrounding landscape. Like so many Civil War photographs made under the auspices of military engineers, Bosse's photographs had a double virtue: they were both useful and beautiful.

Yosemite and Carleton E. Watkins

Following its "discovery" in 1851, Yosemite became the most celebrated symbol of the grandeur and beauty of the American West—the frontier equivalent of Niagara Falls.[38] In March 1851, a detachment of soldiers from the Mariposa Battalion entered the Yosemite Valley under orders to round up Indians who had not gone voluntarily to a reservation on the Fresno River. The soldiers were astounded by the visual drama of the place: a valley about seven miles long, three-quarters of a mile wide, and over 3,000 feet deep, with towering waterfalls and huge formations of naked granite. As word of the place spread, entrepreneurs, writers, and artists soon came to savor Yosemite's sublime, cathedral-like aura.

The first party of tourists, organized by the writer and publisher James Mason Hutchings, arrived in July 1855. Hutchings's description of Yosemite's "wild and sublime grandeur" appeared in the *Mariposa Gazette* and was reprinted in other journals.[39] Within a year, the first trail and hotel were constructed. While travel was difficult and accommodations remained primitive for some time, a steady stream of tourists began arriving in the summer of 1856.

The first visual interpretations of Yosemite appeared in short order. The artist Thomas Ayres had been among that first group of tourists in the summer of 1855. Hutchings produced several printed versions of Ayres's drawings in the following months: a lithograph titled *The Yo-Semite Falls* and four engravings in the July 1856 issue of *Hutchings' California Magazine*. Ayres returned to the valley in 1856 for a more extensive tour; the results of this visit were apparently shown in New York in 1857.[40] In the following years, many other artists came to paint the valley, including Alfred Bierstadt.

In 1859, Hutchings brought the first photographer, Charles L. Weed, to Yosemite. Weed was a talented and experienced figure.[41] In addition to serving as the managing junior partner of Robert H. Vance's ambrotype gallery in Sacramento, in 1858, Weed became adept at wet-collodion fieldwork. In the fall of that year, he made a series of views of the gold-mining operations and settlements along the Middle Fork of the American River. He moved to San Francisco in the following spring to assist with—and then to run—Vance's gallery there. In June, Hutchings engaged Weed to photograph Yosemite for his *California Magazine*. Weed took two cameras: one to make 10 x 14-inch negatives, and another for stereo views. His first plate depicted the central feature of the valley: the 2,500-foot-high Yosemite Falls.[42] Weed produced at least twenty large-format and forty stereo negatives on this trip. To today's eyes, these 1859

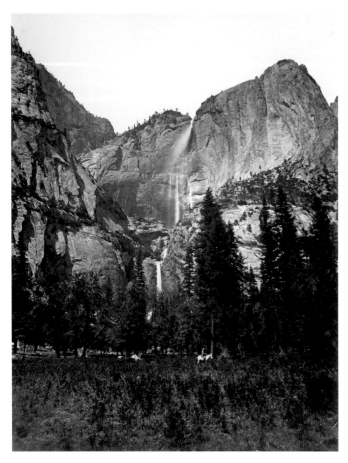

377 **Charles L. Weed**, *The Yo-Semite Fall, 2,634 Feet High, Yosemite Valley, Mariposa County, California*, ca. 1864

views are rather static and unimaginative; indeed, one influential recent study has described them as "primitive."[43] Nonetheless, when exhibited in Vance's gallery two months later, the photographs won rave reviews in the press.[44]

In about 1864, working for the firm of Lawrence and Houseworth, Weed made an extended trip through eastern California and the Nevada Territory with a 17 x 21-inch mammoth-plate camera.[45] This trip included a stay in Yosemite, where he made at least thirty large views and many stereographs. On this visit, Weed made new photographs of many of the subjects he had recorded in 1859. This group included a view of Yosemite Falls [377], made from a slightly different camera position than the one used earlier.[46] In addition to his larger plate size, Weed's vision had grown more discerning in the intervening five years. While some of the photographs from this second visit have a blunt directness reminiscent of his work in 1859, others are more gracefully choreographed.[47]

Upon his return to San Francisco, Weed's views were displayed at the Lawrence and Houseworth store on Montgomery Street. The mammoth-plate views were priced at $3.00 apiece ($4.00 in a "fine black walnut frame"), while stereographs sold for $4.50 per dozen (or $6.00 hand-colored).[48] Although Weed received almost no direct credit for this work, the pictures were widely admired. He displayed his large prints at the 1864 Mechanics' Institute Exposition in San Francisco, and Lawrence and Houseworth sent many of them to the 1867 International Exposition in Paris.[49]

This exhibition activity suggests that Yosemite views enjoyed a slightly different status than most other landscape photographs: they were of greater public interest and held significant potential for profit. As a result, a competition for visual and commercial supremacy

arose among three key photographers. Prodded by Weed's work of 1859, Carleton E. Watkins made an astonishingly productive visit to Yosemite in 1861 with an 18 x 22-inch mammoth-plate camera. (This work influenced Weed to return in 1864 with a camera of equivalent size.) Watkins went back to Yosemite in 1865 and 1866 to firmly claim the subject as his own. Eadweard Muybridge visited Yosemite for the first time in 1867 with a small 5 ½ x 8 ½-inch camera; for his second trip, in 1872, he also moved up to the 18 x 22-inch format. The work of these three defined Yosemite as a photographic subject for years to come.

Carleton E. Watkins was the greatest photographer of the nineteenth-century American West.[50] In a generation-long career, he produced work of unprecedented quality and consistency from British Columbia to the Mexican border, and as far east as Utah and Montana. Watkins arrived in California in 1851, from Oneonta, New York. After working as a clerk and a carpenter, he learned the daguerreotype process in 1854 in the employ of Robert H. Vance. By 1858, after a stint managing James M. Ford's gallery in San Jose, Watkins was adept at large-format outdoor wet-collodion work. In the coming years, Watkins became closely identified with the majesty of the Yosemite Valley: he traveled there numerous times between 1861 and 1881, and these trips resulted in many of his most memorable images.

Watkins's first visit to Yosemite, in the summer of 1861, resulted in a stunning group of thirty mammoth plates and 100 stereo negatives [378, 380]. While the public took little notice of this work, Watkins's prints were admired by such influential figures as Ralph Waldo Emerson and Oliver Wendell Holmes. These photographs were displayed at Goupil's Art Gallery in New York City in December 1862, and influenced Congress to pass the Yosemite Bill in June 1864 to protect the valley from development.[51] Watkins produced more superb views in Yosemite in the summers of 1865 and 1866, and again in 1872, 1875, 1878, and 1881 [379, C-122].

The photographs Watkins made at Yosemite in 1861 are generally considered to be the most personal and lyrical he created there, but all are united by a distinctive vision. Watkins's pictures are at once bold and subtle: the graphic strength of his images is matched by a richness of tone and a delicacy of detail. He used his big negatives to full advantage, rendering his subjects in the most evocative light and with perfect sharpness. To this end, he often started work in the early morning, before temperatures rose and the wind picked up. Watkins's perfection was noted by critics of the time. In an 1865 article praising these works, the editor of the *Philadelphia Photographer* observed: "We never saw trees that were more successfully photographed. There seems to have been no wind, and the very best kind of light."[52] Watkins recorded water, foliage, rock, and atmosphere with unprecedented sophistication. The result is a body of work of unmatched visual intelligence.

The personal nature of Watkins's work may be best grasped in a comparison with that of his rival, Eadweard Muybridge. One of the most colorful characters in the history of photography, Muybridge was born in England as Edward James Muggeridge. After changing his name and occupation several times, he emerged as a landscape photographer in 1867 in San Francisco. His visit to Yosemite that year netted a fine group of medium-format views. In a series of return visits in 1872, Muybridge made forty-five mammoth-plate negatives [381, 382], thirty-six whole-plate views, and nearly 400 stereographs.[53] This work was encouraged by artist friends in San Francisco and motivated by the hope of professional recognition and

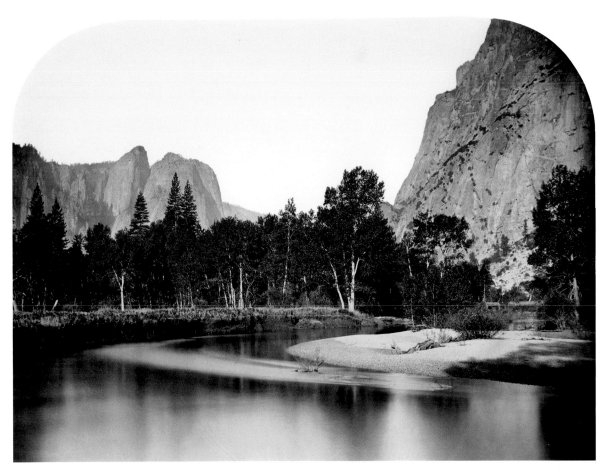

378 **Carleton E. Watkins**, *View from Camp Grove, Yosemite*, 1861

379 **Carleton E. Watkins**, *View on the Merced, Yosemite*, ca. 1872

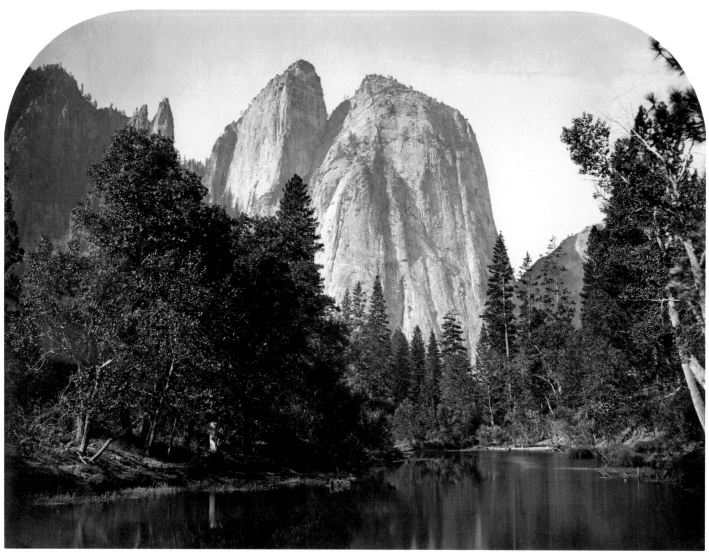

380 **Carleton E. Watkins,** *Cathedral Rocks, Yosemite,* 1861

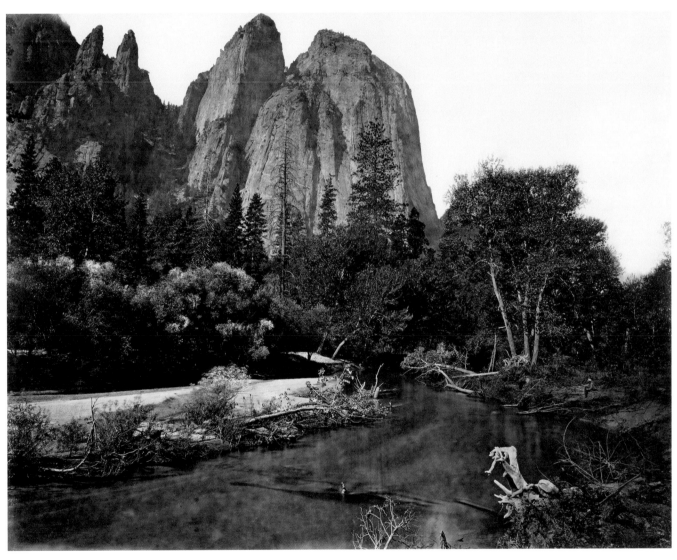

381 **Eadweard Muybridge**, *Cathedral Rocks, Valley of the Yosemite, 2,600 Feet High*, 1872

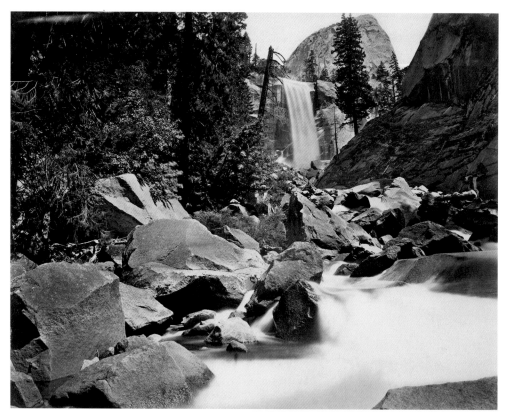

382 **Eadweard Muybridge**, *Pi-Wi-Ack, Valley of the Yosemite*, 1872

profit. As a result, Muybridge worked with considerable aesthetic ambition and daring.

Watkins's 1861 *Cathedral Rocks* is an elegantly resolved graphic play of tone and texture [380]. Muybridge's 1872 view of this motif [381] is more complexly orchestrated, with an entirely different emphasis on space. In contrast to Watkins's classicism, Muybridge's photograph is almost Baroque in its visual tensions. The order of Watkins's picture rests, in part, on his simple foreground: the smooth tones of the glassy water establish a tranquil compositional foundation. Muybridge, on the other hand, puts considerable emphasis on the stark, gnarled branches in his immediate foreground. As a result of this bold near-far spatial play, Muybridge creates a stage of visual incident that is at once expansive and animated. Watkins depicts this site as silent, sublime, and uplifting; through Muybridge's eyes, it is dynamic and mysterious.

Of these three photographers, only Watkins continued to work steadily as a landscapist. Weed left San Francisco in early 1865 on a five-year trip to oversee businesses in Honolulu and Hong Kong. The exact nature of his photographic work after his return to California remains unclear.[54] Muybridge's career after 1872 is the stuff of legend. In 1873, he made stereographs of sites associated with the Modoc Indian War in northern California and continued up the coast to make views in Oregon. In 1874, he discovered that his young wife was having an affair; incensed, Muybridge shot and killed the offending man. After a sensational trial, he was acquitted on grounds of insanity and immediately left on an extended photographic excursion to Central America. On his return to San Francisco, he made several remarkable 360-degree panoramas of the city from the top of Nob Hill. Muybridge's later years were devoted to his celebrated photographic studies of human and animal locomotion. This work began under the auspices of California governor Leland Stanford and was continued at the University of Pennsylvania, in Philadelphia. Muybridge lectured internationally on this work in the late 1880s and 1890s and played a significant role in the development of the modern motion picture.

In contrast to the astonishing highs and lows of Muybridge's life, Watkins's later career was one of quiet dedication and chronic financial struggle. Watkins worked ceaselessly, making views on his own initiative and for a handful of patrons. He received several commissions from mining corporations, including an 1863 assignment to record the New Almaden quicksilver (mercury) mines near San Jose [383]. In the next few years, he also began productive relationships with the California State Geological Survey and the Central Pacific Railroad. In 1867, he journeyed to Oregon, where he made at least fifty-nine mammoth plates of Portland, Mt. Hood, and scenes along the Columbia River [384].

Watkins was a brilliant photographer but a poor businessman. In about 1875, he suffered a severe financial crisis, losing his gallery and his entire stock of negatives to a competitor, Isaiah W. Taber.[55] In the following years, Watkins was forced to compete with his own past, as Taber marketed fresh prints from Watkins's old negatives. Watkins immediately set out to rebuild his inventory of views in his "New Series" work. He traveled and photographed until he was simply too old to continue. In the 1890s, his family was essentially destitute and he was going blind. In the spring of 1906, the curator of a local museum visited Watkins and was amazed at the quantity of historically important work he held. A deal was arranged with the aim of moving the most significant items to safe storage on April 22. The great San Francisco earthquake occurred on April 18, 1906, destroying everything Watkins had worked so hard to preserve. He died, broken and forgotten, in 1916. The rediscovery of his work began, finally, in the early 1970s.[56]

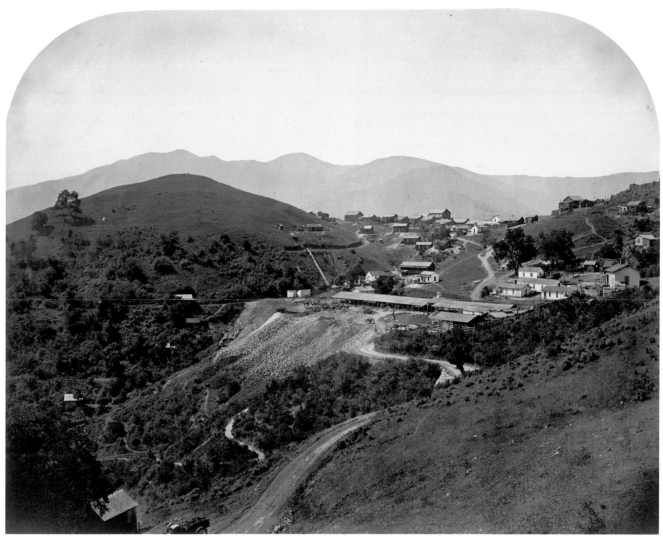

383 **Carleton E. Watkins**, *The First View of the Mine, View Looking South, New Almaden*, 1863

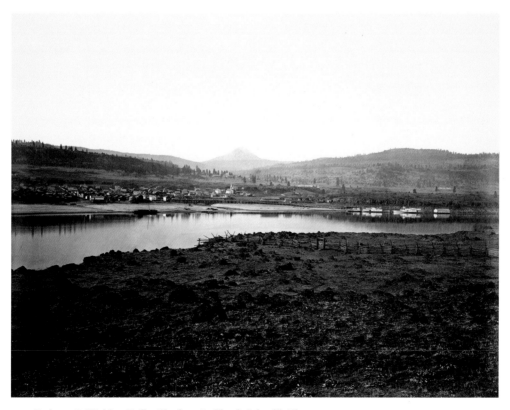

384 **Carleton E. Watkins**, *Dalles City from Rockland, Columbia River*, 1867

385 **Unknown Maker**, *Pennsylvania Railroad Engine*, 1868

386 **William T. Purviance**, *Emigrant Train, West Philadelphia*, ca. 1870

The Push West: Troops, Tracks, and Treaties

The opening of the American West—its exploration and occupation by whites—began slowly in the early decades of the nineteenth century. It gathered speed in the 1840s and 1850s, was temporarily slowed by the Civil War, and then gained an irresistible momentum after 1865. The "winning" of the West was a complex phenomenon, the result of many thousands of individuals and a variety of political and economic interests. The U.S. Army played a major role in the region. In addition to maintaining law and order, the army functioned as the equivalent of a department of public works; it determined boundaries, created maps, constructed wagon roads, and looked after similarly essential tasks.[57] Business interests—particularly those of the railroads—also played a critical role. The extension of rail lines across the region promised riches not only for individual investors, but for the nation as a whole. Finally, the resident peoples of the region represented an evolving subject of interest: from a military and scientific concern to a political and moral one. The leading photographers negotiated these various interests as a matter of course.

The Louisiana Purchase of 1803 started an official process of exploration, mapping, and fact-gathering in the West. This began as a series of small and intermittent efforts: the 1803-06 expedition of Lewis and Clark in the Pacific Northwest; Zebulon M. Pike's

Southwest expedition of 1807; and Major Stephen H. Long's exploration of the Great Plains in 1819-20.[58] The pace of this effort accelerated significantly in the 1830s and again in the 1840s. Beginning in 1842, the U. S. Topographical Engineers oversaw many western expeditions with the mandate to map the territories, scout for possible wagon or railroad routes, and to determine the agricultural and mineral resources of the region. These early expeditions typically collected information broadly, if rather unsystematically. For example, Colonel John C. Frémont went west numerous times, beginning in 1838. Mapping was typically his highest priority, but Frémont also collected botanical samples and meteorological data, and made notes on the appearance, habits, and distribution of the Indian tribes he encountered.

The documentary value of pictures was recognized early on. The Long expedition included two artists—Samuel Seymour, who devoted himself to topographic renderings, and Titian Ramsey Peale, who sketched geological details and insects, birds, and animals. Examples of their work were included in Long's official report and presented to the public in a museum exhibition.[59] By the early 1840s, printed illustrations became an expected supplement to official reports, and nearly every expedition had an artist or draftsman on staff.[60]

Although the camera was applied to this documentary project as soon as it was available, the results were decidedly imperfect. The daguerreotype presented a profound technical challenge in remote areas. Further, in order to be rendered useful as an illustration in a published text, the one-of-a-kind daguerreotype image had to be redrawn on a lithography stone or engraving block. In these techniques, much of the photograph's characteristic detail was inevitably lost. Frequently, this process also resulted in the loss of the daguerreotype itself. As a consequence, there is an extensive history of failed attempts to make expeditionary daguerreotypes and, even more tragically, of collections of plates being lost or discarded once their initial informational function had been served.[61] By their nature, paper photographs—made in multiple from wet-collodion negatives—were vastly more appropriate for this work than daguerreotypes.

The western expeditions of the antebellum era culminated in the production in 1855-60 of the *Pacific Railroad Reports,* a compilation of the results of the official surveys to that date. Comprising seventeen volumes, this massive work included maps and hundreds of illustrations of the topography, flora and fauna, and Indians of the West.[62] Unfortunately, it was poorly organized; as historian William H. Goetzmann has observed, the *Pacific Railroad Reports* "were a little like the country they were intended to describe: trackless, forbidding, and often nearly incomprehensible."[63]

The Civil War brought the government surveys nearly to a halt. After 1865, the surveys began again in significantly new form. Before the war, they had been led by soldiers; afterwards, professional scientists held increasingly important positions. In the earlier period, the camera had served a distinctly peripheral role in the documentation of the West; after 1865, it held a central place in this project.

As the title of the *Pacific Railroad Reports* indicates, the prewar western surveys were powerfully motivated by the search for a transcontinental rail route. Beginning in the early 1830s, rail lines were steadily laid down across the United States, at first along the eastern seaboard and then progressively further into the continent.[64] The result was a revolution in transportation, communication, and commerce. Most significantly, the railroad changed how people thought; by annihilating the former constraints of time and space, rail travel

387　**James F. Ryder**, *Station, Atlantic & Great Western Railway*, 1862

388　**James F. Ryder**, *Bridge, Atlantic & Great Western Railway*, 1862

was deemed a triumph of culture over nature. The railroad became a key symbol of national character and a recurrent motif in art.[65] New locomotives were routinely documented by photographers [385] and several publishers issued series of stereographs of the scenery along particular lines of track. Much of this work was done in partnership with, or in the employment of, the rail companies. In an effort to promote their lines and increase business, many railroad companies established relationships with photographers. In 1867, for example, William T. Purviance became the official photographer of the Pennsylvania Central Railroad. His large-format views [386] were issued in a series titled "Pennsylvania Railroad Scenery."

Railroads were big and costly businesses. A rail line held the promise of vast profits, but it was enormously expensive to build and entrepreneurs were in constant search of investment money. The earliest large-format photographic survey of an American railroad appears to have been undertaken specifically for the purpose of raising capital.[66] In early 1862, the Cleveland photographer James F. Ryder was commissioned by the Atlantic & Great Western Railway to record two major segments of their line: from Salamanca, New York, to Akron, Ohio, and from Meadville to Oil City, Pennsylvania. The owners of the Atlantic & Great Western wanted to extend their reach from Newburgh, New York, all the way to St. Louis. Since the Civil War had absorbed nearly all domestic investments, the railroad sought funds from investors in England. As the project's chief engineer told Ryder, "purchasers of shares could feel a greater sense of actuality from seeing photographs rather than from drawings upon white paper in big sheets."[67] In this spirit, Ryder produced a series of at least 129 8 x 10-inch photographs of tracks, trestles, stations, and locomotives, as well as the landscape and towns along the route [387, 388]. While Ryder spent months printing these views, their current rarity in America suggests that nearly all were sent overseas.

A vastly larger enterprise, the transcontinental railroad required that business look to the federal government for financing. In 1862, President Lincoln reaffirmed Washington's support for a transcontinental rail line by signing the Pacific Railroad Act. This officially established Sacramento as the western terminus of the proposed line. It also offered significant incentives to anyone willing to undertake the endeavor: loans of thirty-year government bonds at attractive rates, and land grants of 6,400 acres for each mile of track. A revision

of this legislation in 1864 doubled the land grant to 12,800 acres per mile of track.[68] Rail companies stood to profit twice from this arrangement: first, from the sale of these lands to farmers and settlers; and second, from the business generated by this new population living along their route.

With the end of the war, the quest for a transcontinental railroad was resumed in earnest.[69] Variations of two major plans, for southern and northern routes, were explored. Photographers were employed to document and promote both efforts.

In 1867, Alexander Gardner was one of two photographers hired by the Union Pacific Railway, Eastern Division (by 1869, officially the Kansas Pacific Railroad), as part of a publicity campaign to gain government backing for an extension of its line from Kansas to the Pacific. This proposed line, in direct competition with the northern route of the Central Pacific and Union Pacific railroads, had the advantage of running through some of the flattest country in the entire region. In the fall of 1867, Gardner photographed from Kansas City along the 35th parallel, at least as far west as Hays, Kansas.[70] Dr. William A. Bell, a British physician, made photographs at the same time on a more southerly route along the 32nd parallel.[71] Gardner made a variety of views: documents of rail lines and depots [c-123], as well as landscapes, ethnographic studies, and geological and botanical records. These were published under the series title "Across the Continent on the Union Pacific Railway, E. D."[72] Gardner's vision in these pictures is spare and functional; the land in most of these views is lonely and uninviting. Nonetheless, these photographs were disseminated as both stereographs and large-plate views to government officials, potential investors, and the general public. Twenty were also included in an official report.[73]

Soon after his return to Washington, Gardner again headed west, this time to record an important peace conference. As a result of the increasing penetration of the West, American Indian tribes were under great pressure to relinquish their claims to traditional lands and to move to reservations. To ensure the safety of whites in the region, official negotiations with tribal leaders had been going on for years. In 1857-58, for example, about ninety delegations from thirteen tribes came to Washington, D.C., to negotiate peace treaties.[74] As a natural part of this process, many of these delegates sat for portraits in the studios of Mathew B. Brady, James E. McClees, and others.

Gardner made at least two important group portraits of tribal leaders at this time.[75] With the end of the Civil War, the urgency of these negotiations increased. Indeed, in 1867, Washington was so full of Indian delegates that they had to be housed in army barracks.[76]

In the spring of 1868, Gardner traveled to Fort Laramie, Wyoming, to witness what was expected to be an important and concluding series of peace negotiations. Not coincidentally, Laramie was newly accessible: it had recently been reached by the tracks of the Union Pacific Railroad. On the way to Fort Laramie, Gardner stopped for a few days in Cheyenne, where he made a typically spare photograph of the officers' quarters at Fort David Russell [c-124]. He continued on in the company of General William T. Sherman.[77]

Upon his arrival at Fort Laramie in late April, Gardner found a large group gathered: a federal party led by the commissioner of Indian affairs, Nathaniel T. Taylor, and representatives of the Arapaho, Northern Cheyenne, Crow, and the Brule, Oglala, and Mineconjou Lakota.[78] The government's goal was to "establish peace, define tribal boundaries, and provide mechanisms for civilizing the Indians."[79] In reality, the Indians were invited not to negotiate, but to acquiesce. They were warned: "If you continue at war, your country will soon be overrun by white people; military posts will be located on all the rivers; your game and yourselves will be destroyed. This is the last effort of the President to make peace with you and save for you a country and home." Before signing, Iron Shell, chief spokesman for the Brule, observed sadly: "Our country is filling up with whites… Our great father is shutting up on us and making us a very small country… You come over here and get all our gold, minerals, and skins. I pass over it all and do not get mad. I have always given the whites more than they have given me."[80]

Gardner made a powerful series of photographs at Fort Laramie, working with cameras of unusually large size.[81] After witnessing talks with the Crow on May 6 and 7, he recorded the distribution of gifts by the government peace commissioners [389].[82] Gardner recorded Indians on the grounds of the fort [390] as well as scenes along the river [391] and in nearby encampments. Made in his characteristically laconic style, these views suggest the isolation and vulnerability of these proud but resigned people. The subjects of these photographs are in uncertain state, cut off from their past and deeply uncertain about the future. Gardner's visual approach—at once direct, respectful, and reserved—is in perfect accord with this mood. As it transpired, the U.S. government failed to live up to its own agreements, and conflict with a number of these tribes continued for years. On returning to Washington, Gardner issued a selection of these images under the series title "Scenes in Indian Country." Portfolios of these prints were apparently given to the members of the peace commission.[83] However, the current rarity of these views suggests that few were made.

Indian leaders were documented in the field by a number of other photographers in this period. For example, William S. Soule, the brother of Boston photographer John P. Soule, worked at Fort Sill, Oklahoma, between 1869 and 1874.[84] This fort served as the agency for several tribes, including the Kiowa, Wichita, and Comanche. Working with a traditional studio formality, Soule made a series of distinguished portraits of notable tribal figures [c-125]. When he returned to Boston in about 1874, these were copyrighted and sold by his brother.

With the Civil War over, the construction of the transcontinental railroad began in earnest. This was a story of epic drama and scale.

While several potential routes had been mapped, the northern path from Omaha to Sacramento was judged the most practical. The work was undertaken by two competing railroads: the Central Pacific worked eastward from Sacramento, while the Union Pacific laid track west from Omaha. These teams had significantly different tasks. Just outside of Sacramento, the Central Pacific crew—composed largely of Chinese laborers—faced the daunting challenge of crossing the Sierra Nevada Mountains, a 7,000-foot rise in a distance of only 100 miles.[85] This required nearly continuous digging, blasting, and tunneling. The Union Pacific team—composed primarily of Irish workers—had a far easier route: the long, gentle upgrade of the high plains of Nebraska and Wyoming, and then through the mountains of Utah. As a result, the Union Pacific line raced forward over nearly 1,100 miles: 305 miles of track were laid in 1866, followed by 233 and 446 in the next two seasons, and a final 102 in early 1869.[86]

Both railroads made extensive use of photography. Alfred A. Hart was hired in 1865 to document the progress of the Central Pacific Railroad.[87] Hart worked in the field every year from 1865 to 1869, creating an impressive series of stereographs. These were sold from Hart's studio in Sacramento and distributed nationally under the auspices of the railroad. In 1869, Hart lost his official status with the Central Pacific to Carleton E. Watkins. However, he made additional profit from this work by publishing a traveler's map and guidebook in 1869-70, both illustrated with wood engravings from his photographs.

The Union Pacific line was similarly well documented in both stereographs and large-plate views. This work served an explicitly promotional purpose. In October 1866, the Chicago photographer John Carbutt accompanied a Union Pacific publicity excursion along the length of track completed to that date.[88] Traveling with railroad executives and other dignitaries, Carbutt made stereo photographs of his party, and of the Indian encampments, landscapes, and new towns along the way. Upon returning to Chicago, Carbutt issued these under the series title "Union Pacific Railroad Excursion to the 100th Meridian, Oct. 1866."

In 1868, Andrew J. Russell was commissioned by the Union Pacific Railroad to document the company's entire line, from Omaha to the meeting point with the Central Pacific at Promontory Point, Utah. Fifty of these views were issued by the railroad in a lavish album titled *The Great West Illustrated* (1869).[89] The purpose of this album was stated clearly in its preface: "The information contained in this Volume…is calculated to interest all classes of people, and to excite the admiration of all reflecting minds as to the colossal grandeur of the Agricultural, Mineral, and Commercial resources of the West." As Russell's pictures made clear, this land was at once a spectacle and an economic resource; it was to be admired, inhabited, and exploited. Russell's images are correspondingly varied.[90] He recorded the line itself in views of warehouses, stations, construction crews, trestles, and tunnels. He also photographed the landscape from the tracks, moving from sweeping vistas of distant horizons to studies of unusual geological features [392, 393]. Russell's most scenic views seem intended to reassure potential settlers and visitors that the region had both fresh water and its own, spare, beauty.

Given his promotional agenda, it is not surprising that Russell photographed the West as an already inhabited landscape. He routinely placed one or more figures in the middle or far distance of his views. Too small to be read as specific individuals, these figures served factual and symbolic needs. They provided an indication of scale for the boulders and rock columns that they stood beside;

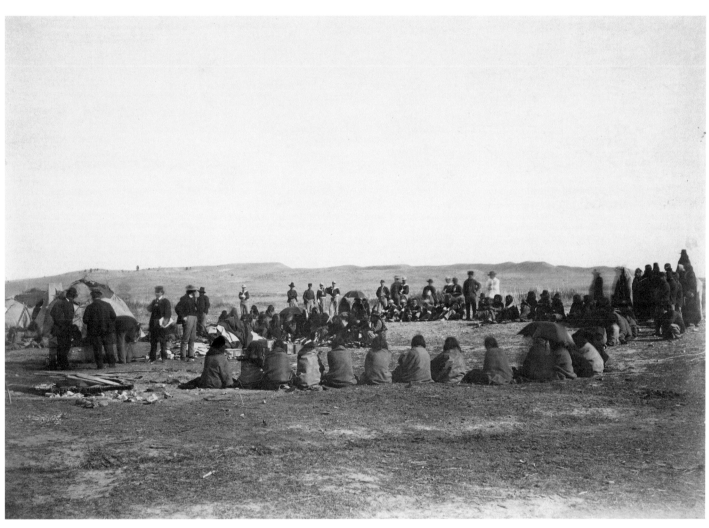

389 **Alexander Gardner**, *Indian Peace Commissioners Distributing Presents to the Crow Indians, Fort Laramie, Wyoming*, 1868

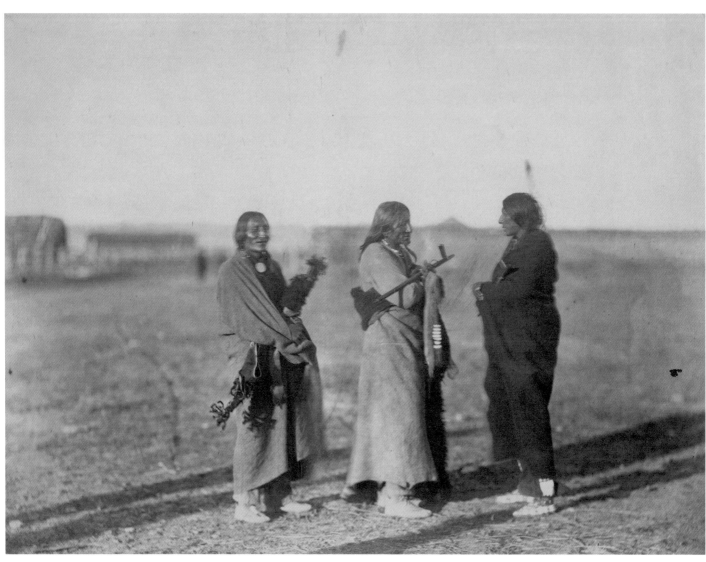

390 **Alexander Gardner**, *Three Chiefs, Fort Laramie, Wyoming*, 1868

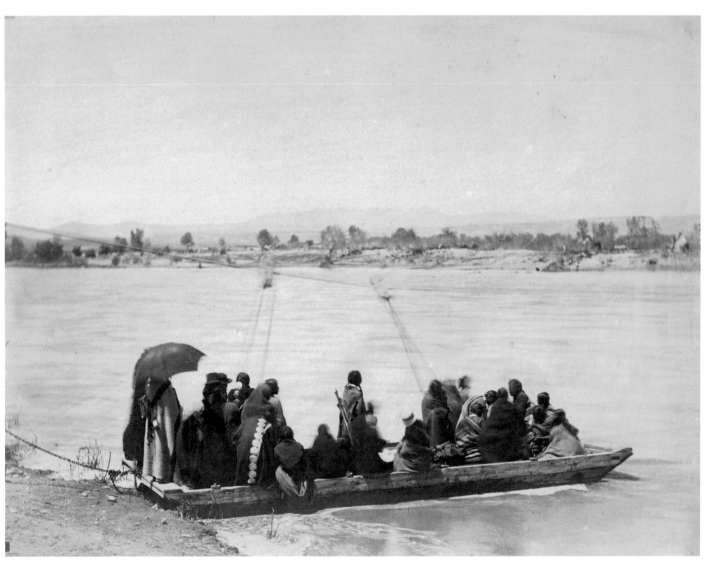

391 **Alexander Gardner**, *Indians Crossing the Platte, Fort Laramie, Wyoming*, 1868

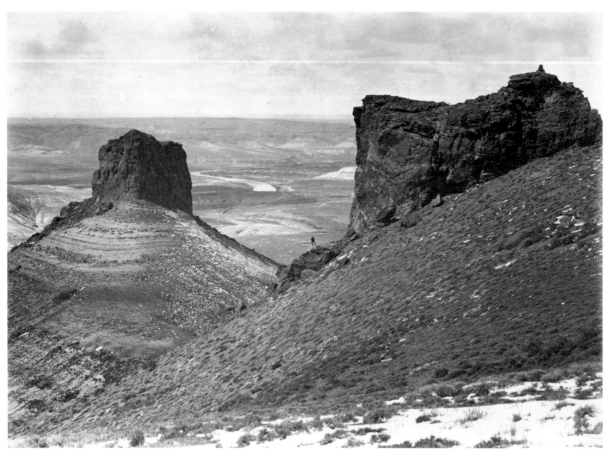

392 **Andrew J. Russell**, *On the Mountains of the Green River*, ca. 1868-69

393 **Andrew J. Russell**, *Skull Rock (Sherman Summit, Wyoming Territory)*, ca. 1868-69

however, as diminutive as they might appear in these views, Russell's ever-present figures convey a sense of strength and control. Posed in the very center of his composition [392] or perched triumphantly on a summit [393], these figures signify human authority and dominion. These photographs bear witness to a cultural triumph: the taming of a vast and formerly unknown land.

The historic joining of the rails took place on May 10, 1869, at Promontory Point. While the tracks had been built at a frenetic pace —and would require almost immediate repair and upgrading—the day carried enormous significance. For many, it marked the conquest of the West, a victory of technology over nature. A crowd of about 600 gathered for the occasion in the Utah desert.[91] This group included railroad workers and officials, a battalion of soldiers in transit to San Francisco, a military band from Fort Douglas, Wyoming, and a contingent of reporters. There were also three photographers: Andrew J. Russell, Alfred A. Hart, and Charles Savage, of Salt Lake City. The photographers all recorded the scene that Russell titled *East and West Shaking Hands* [394], the ceremonial linkage of the Central Pacific and Union Pacific lines.[92] The nation was now a continuous space from coast to coast. To signify this new connectedness, the sledge hammer and golden spike were rigged to an electrical circuit. At the moment of contact a telegraph signal would be sent to all the major cities of the nation—from Los Angeles to Boston—and even across the Atlantic to London. Leland Stanford missed the spike on his first swing, but the signal was sent around the world: "DONE!" It was a remarkable conjunction of the three greatest technological marvels of the nineteenth century: the railroad, the telegraph, and photography.

Timothy O'Sullivan and the King and Wheeler Surveys

The great postwar western surveys worked in parallel with the railroads. Survey personnel often rode the train to a convenient jumping-off point, proceeding from there into less-charted regions. The completion of the transcontinental line in 1869 increased the pace of settlement and tourism in the West. As a result, the "golden age" of the western survey was surprisingly brief: a dozen years between the start of the King and Powell surveys in 1867 to the consolidation of these individual efforts in 1879 under the auspices of the United States Geological Survey.

Timothy O'Sullivan was the first of the great postwar expeditionary photographers. He had overlapping tenures with two surveys, both administered by the Department of War: the King Survey in 1867-69 and 1872, and the Wheeler Survey in 1871 and 1873-74. O'Sullivan's photographs were included with official reports and issued in portfolios. Today, they are recognized as icons of the western expeditionary enterprise of the period.

The King Survey—officially the Geological Explorations of the Fortieth Parallel—was headed by a fascinating and persuasive man. Clarence King had the empirical vision of the scientist, the soul of an artist, and a deep passion for nature.[93] A graduate of Yale's Sheffield Scientific School, King had gone to California in 1863, where he joined a geological survey party under the direction of Professor Josiah D. Whitney. In January 1867, at the age of only twenty-five, King approached Secretary of War Edwin M. Stanton to propose a study of a vast section of land, 100 miles wide, from the Rocky Mountains to the Sierra Nevadas. King's immediate goals included

394 **Andrew J. Russell**, *East and West Shaking Hands, Promontory Point,* May 10, 1869

more accurate maps and, it was hoped, information on deposits of gold, silver, and coal. Stanton was convinced, Congress authorized the expenditure of $100,000, and King's survey was a reality. The team was quickly assembled and arrived in San Francisco (via the Isthmus of Darien, Panama) on June 3, 1867. Their fieldwork began a month later, when they struggled across the Sierra Nevada Range into Nevada.

Working with three cameras—in the stereo, 8 x 10-inch, and 9 x 12-inch formats—O'Sullivan produced hundreds of views, from the desert basin of Nevada into the present-day states of Utah, Idaho, and Wyoming. His primary focus was on the geology of the region; he recorded vistas of the most inhospitable deserts [364] as well as details of particularly interesting or characteristic features [395]. The first of these views is a deliberate self-portrait: his photographic wagon is parked in the mid-ground of the scene, and his footprints leading to the camera are visible in the sand. O'Sullivan's view of a geyser mouth includes both the shadow of his camera and the reclining figure of an assistant. The result, again, is a slyly self-aware document: a factual record that includes evidence of its own making.

Many of O'Sullivan's views were made under challenging conditions. In this regard, his most remarkable photographs were the ones he made hundreds of feet underground in the restricted passageways

395 **Timothy O'Sullivan**, *Geyser Mouth in Ruby Valley, Nevada,* 1868

231

396 Timothy O'Sullivan, *Virginia City Mine, Cave-in*, ca. 1867-68

of the Gould & Curry and Savage mines at Virginia City, Nevada.[94] In hot and dangerous conditions, O'Sullivan used a stereo camera and the light of burning ribbons of magnesium to record miners at work and the effects of a cave-in [396]. The resulting photographs, enlarged from relatively small stereo negatives, are memorably strange and claustrophobic images.

O'Sullivan's skill and adaptability made him eminently employable. When King's funding became uncertain in late 1869, O'Sullivan was hired as the first photographer for the navy's Darien Survey, in Panama.[95] He spent the spring and early summer of 1870 in the tropics before signing on with the survey of Lieutenant George M. Wheeler later that year. The Wheeler Survey—officially the Geological Surveys West of the One Hundreth Meridian—was organized to explore the vast arid region between Colorado and California. Wheeler was a military man rather than a scientist, a West Point graduate trained in military topography. His goals were straightforward: he sought to map the region and to collect information of benefit to travelers, miners, and farmers. The results of this enterprise were anything but simple, however. At the end of his 1874 season, Wheeler reported that his expedition had collected 9,000 botanical specimens; 20,155 specimens of mammals, fish, reptiles, and insects; 1,227 specimens of birds; and 497 lots of minerals and geologic samples.[96]

O'Sullivan covered a vast territory between 1871 and 1874. In 1871, he worked for Wheeler in California, Nevada, and Arizona. This trip included an arduous, month-long ascent of the Colorado River through the Grand Canyon. O'Sullivan rowed, towed, and carried his boat—christened *The Picture*—some 260 miles, with frequent stops to photograph. This famous image [398], like his 1868 view of his wagon in the desert sands, is slyly self-reflexive: a picture of the *Picture*, with one of his companions at work.

In 1872, once again in Clarence King's employ, O'Sullivan photographed in Utah, Wyoming, and Colorado. His replacement in the Wheeler party for the 1872 season—William Bell, formerly of the U.S. Army Medical Museum—worked primarily in the Grand Canyon [C-126, C-127].[97] In 1873, back with Wheeler, O'Sullivan photographed

in Arizona and New Mexico, producing some of his best-remembered views of Navajo life [397] and of Canyon de Chelly. His view of ancient cliff dwellings at Canyon de Chelly [399] is a remarkable work of pictorial imagination. The nominal subject of this view occupies a small fraction of the overall pictorial space. Instead of moving in more closely and treating the dwellings as a horizontal subject, O'Sullivan stepped well back to find his picture in a vertical composition. The resulting image is majestic: the sheer rock face and upsweeping striations combine to suggest both a primordial quality of endurance and a deep spiritual connection to place. In 1874, his last photographic season in the field, O'Sullivan worked in southern Colorado and northern New Mexico, again focusing on Indian life. When this work was completed, he traveled alone to Shoshone Falls, in southern Idaho, to make his final western views [400].

O'Sullivan's achievement of 1867-74 is genuinely remarkable. Except for 1870, when he went to Panama, he was in the West every year. By producing hundreds of views under the most challenging conditions, O'Sullivan established himself as the model western expeditionary photographer.

What continues to puzzle and challenge historians today is the matter of O'Sullivan's vision. Acknowledged as a master of the art of photography, the exact nature of his photographic artistry remains tantalizingly difficult to define. To begin with, there appears to be a stylistic difference between O'Sullivan's King and Wheeler photographs. The earlier views tend to be simpler in composition: many are bluntly direct records of individual geological or topographical features. There is a sort of existential nakedness in this work: it

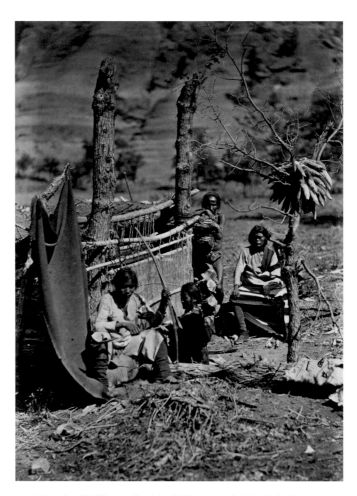

397 Timothy O'Sullivan, *Aboriginal Life Among the Navajo Indians, Near Old Fort Defiance, New Mexico*, 1873

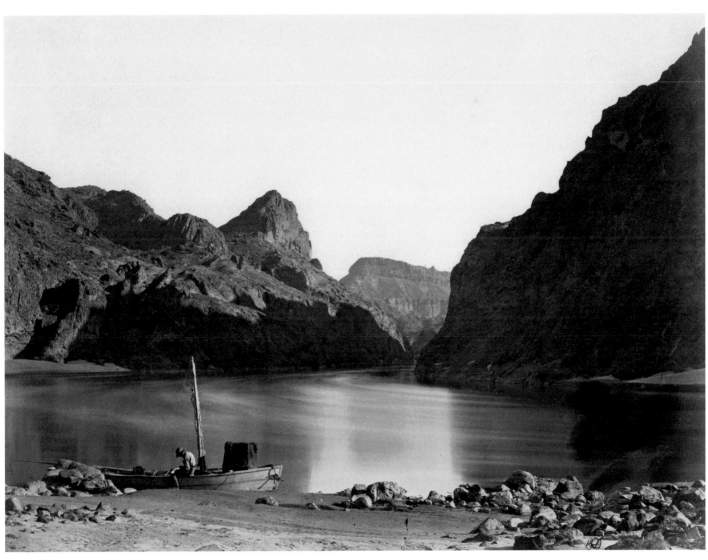

398 Timothy O'Sullivan, *Black Cañon, Colorado River, from Camp 8, Looking Above*, 1871

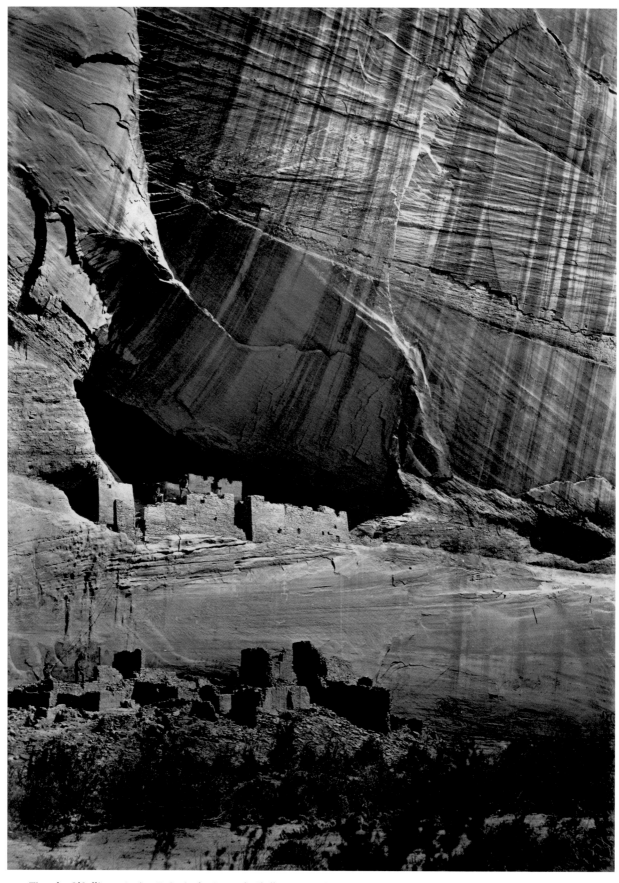

399 Timothy O'Sullivan, *Ancient Ruins in the Cañon de Chelle, New Mexico Territory*, 1873

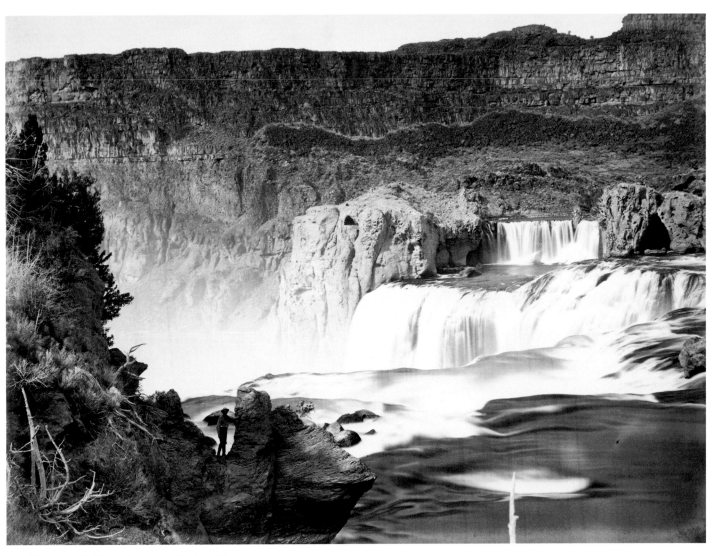

400 Timothy O'Sullivan, *Shoshone Falls, Snake River*, 1874

records a distinctly alien environment, a space that is neither nurturing nor uplifting. By contrast, many of O'Sullivan's Wheeler views are more artfully composed; while not traditionally picturesque, some are distinctly beautiful. Ultimately, both bodies of work elude easy categorization: aesthetics and utility are woven so tightly together as to be inseparable.

How may this distinction between the King and Wheeler photographs be explained? Perhaps what had begun as a visceral encounter evolved into a more nuanced process of conceptual engagement or negotiation. After a couple seasons in the field, O'Sullivan may well have developed the confidence not simply to accept this alien environment but to use it for his own (pictorial) purposes. In addition, the changing nature of both his subject matter and his leadership cannot be discounted. King and Wheeler were vastly different personalities and their direct influence on what and how O'Sullivan photographed is not clear. For example, Clarence King subscribed to the theory of "catastrophism": an attempt to marry science and theology that posited that some geologic change was sudden rather than gradual. Did this idea have any real effect on the way O'Sullivan made pictures?[98]

In addition to these questions, the intended use of O'Sullivan's photographs must be considered. Neither the King nor Wheeler photographs were offered for public sale in any significant quantity. They were intended primarily for scientific and promotional purposes. The key here appears to lie in the shifting balance between these uses: O'Sullivan's King Survey photographs served a largely scientific function, while his Wheeler images were used in a more consistently promotional manner. The first of these uses may be characterized as technical and internal; the second as fundamentally aesthetic and public.

While precise numbers are impossible to determine, far more photographs (as both full-plate views and as stereographs) were printed from Wheeler Survey negatives than from those of the King Survey. Accounting for full-plate views only, the difference may be about 6:1. There were roughly 2,500 King Survey prints in all, compared to more than 16,000 Wheeler prints.[99] Some King Survey views were converted into lithographs for inclusion in the survey's official reports. Other King Survey photographs were grouped in portfolios and given to military and government officials. These served a combined documentary and promotional function: they provided tangible evidence of the good work being done at public expense.

Survey funds became increasingly uncertain in later years, particularly after the depression of 1873. This resulted in a more focused effort to cultivate both official and public support. Between May 1874 and May 1876, Wheeler authorized the production of 15,000 large views and 70,000 stereographs from O'Sullivan's negatives. This massive production was intended primarily to win recognition of, and support for, the Department of War's valuable work. Groups of prints were given to influential figures. Prints were also exhibited internationally at the Vienna Exposition and the Louisville Industrial Exposition, both of 1873; the Centennial Exhibition in Philadelphia, in 1876; the Sydney Exhibition of 1877; and the Third International Geographical Congress in Venice, in 1881.[100] While some of O'Sullivan's Wheeler views were translated into lithographs for the official report, their greatest use was promotional.

This shift in use—from primarily technical and internal to more deliberately aesthetic and public—may explain some aspects of O'Sullivan's evolving vision between 1867 and 1874. Ultimately, however, his brilliance resists any easy explanation. He fulfilled the

401 **William Henry Jackson**, *Grand Canyon of the Yellowstone*, ca. 1872-73

needs of his employers while making photographs that remain alive today as *pictures*. That visual life must rest, in some measure, on O'Sullivan's purely individual melding of fact and point of view—his interest in what there was to see, and his equally deep concern for seeing itself.

William Henry Jackson and John K. Hillers: The Hayden and Powell Surveys

In the mid-1870s, federal money was tight and many viewed the government's western explorations as wastefully uncoordinated. There were four major expeditions in operation—the King, Wheeler, Hayden, and Powell surveys—and they sometimes overlapped in embarrassing ways. In 1873, for example, the Hayden and Wheeler groups ran into each other while surveying the same mountain in Colorado.[101] This led to congressional hearings in early 1874 and to calls for consolidation. From this point on, the Department of War played a decreasing role in western exploration, and surveys were put under the direction of civilians and scientists. Wheeler's survey continued for several years, but the winners of this encounter were the Hayden and Powell groups. Coincidentally or not, Wheeler employed no photographers after 1874, while the Hayden and Powell surveys generated photographs steadily through the end of the decade.

Ferdinand Vandeveer Hayden was an experienced explorer and geologist. His familiarity with the western Great Plains dated back to

402 **William Henry Jackson**, *Cañon of the Rio Las Animas*, ca. 1880

1853, when he accompanied his first party into the Nebraska Territory. After the Civil War, Hayden directed a series of expeditions under the auspices of the Department of Interior. The first of these, in 1867, was the Geological Survey of Nebraska. This was reorganized in 1869 as the Geological Survey of the Territories of the United States, and by 1873 had become the U.S. Geological and Geographical Survey of the Territories.[102] These were typically referred to in collective fashion as the "Hayden Survey." In his dozen years of fieldwork, Hayden covered a vast area, from Nebraska to the Idaho Territory.

Hayden had a deep interest in the educational and archival value of photographs. Shortly after the Civil War, he recommended to the American Philosophical Society and the Academy of Natural Sciences that they collect photographs of American Indians. Both institutions agreed and appointed him to head the effort to fund and oversee the project.[103] From the beginning of his official survey, in 1867, Hayden collected photographs from a variety of sources. In 1870, he published *Sun Pictures of Rocky Mountain Scenery*, a lively history of the geology and geography of the West. This volume was illustrated with thirty photographs culled from Andrew J. Russell's work for the Union Pacific Railroad.

As part of his continuing search for photographs, Hayden visited the Omaha studio of William Henry Jackson in early 1870. In short order, Jackson became Hayden's official photographer. Jackson was paid living expenses, but no salary; in exchange, he kept all his negatives and could sell prints as he chose. It was a mutually rewarding arrangement and Jackson worked for Hayden from 1870 through

1878. In these nine seasons, Jackson accompanied Hayden's team back and forth through the present-day states of Colorado, Utah, and Wyoming.[104] Jackson obviously loved the adventure and camaraderie of these years, and he made a number of photographs of his companions and their camps [C-128].

The Hayden Survey became best known for its study of Yellowstone. The first reports of this spectacular area had come from trappers in the 1830s. Later expeditions had passed through the region, but none had described it in detail. Hayden's team, which included landscape painter Thomas Moran, first entered Yellowstone in June 1871.[105] Jackson photographed subjects that would soon become iconic, including Mammoth Hot Springs, Old Faithful, Yellowstone Lake, and the Grand Canyon of the Yellowstone River [401]. Bound into albums and circulated around Washington, D.C., these images helped encourage congressmen and senators to declare the site a national park on March 1, 1872.[106]

Jackson's technical abilities improved steadily in these first few years. In addition to working routinely in the stereo format, he became adept with progressively larger view cameras. In 1871, he photographed with an 8 x 10-inch camera. In 1872, he moved up to an 11 x 14-inch model, and by 1875 he had acquired an ultra-mammoth-plate 20 x 24-inch camera. At the end of 1875, looking back over six years of work, Hayden noted that Jackson had produced "an average of 400 negatives each year, ranging in size from the stereoscopic up to plates 20 by 24 inches."[107] Not surprisingly, many of these photographs were produced in challenging conditions. Jackson often

403 **James Fennemore**, *Nan-Kun-To-Wip Valley, Grand Canyon*, 1872

404 **John K. Hillers**, *South Face of the East Peak of the "Three Patriarchs," Zion National Park, Utah*, ca. 1872-74

pitched his dark tent on the top of rocky, windswept ridges and had to melt snow for water to wash his plates.

Despite the adventure of these years, Jackson's most compelling work was accomplished in his early seasons with the survey. After 1873, the Hayden team spent most of its time retracing previous routes, and Jackson's photographs became increasingly scenic.[108] While aesthetically accomplished, they no longer conveyed the same excitement of discovery.

Given Hayden's enthusiasm for photography, it was natural that Jackson's photographs were used liberally in official publications and related promotional efforts. Hayden's annual reports included high-quality wood engravings based on these images. In 1873, Jackson created a portfolio of thirty-seven original prints of his most beautiful 11 x 14-inch views for public sale.[109] He also negotiated distribution deals for his stereo views, which sold in prodigious numbers. In addition, Jackson oversaw the assembly of a large Hayden survey exhibit at the 1876 Centennial Exhibition in Philadelphia. Many of his large photographs were included, as well as mineral specimens, Indian artifacts, and an elaborate scale model of the Mesa Verde ruins.

When the Hayden Survey ended in 1879, Jackson returned to private practice. Astute in matters of business and promotion, Jackson chose to live in Denver, which he had come to know in the course of his Hayden work. Denver was a booming city on the edge of a vast scenic region. Jackson built up a large and profitable commercial practice there, traveling to make views on his own initiative [c-129] and on assignment for the Denver and Rio Grande Railroad. Jackson's work of the 1880s is extraordinarily accomplished, but wholly scenic in nature: his many railroad images are explicitly about the West as tourist spectacle [402]. Jackson became perhaps the best known of a relatively small group of professionals—including Charles R. Savage, of Salt Lake City [c-130]—who specialized in large-format western views for tourists and elite collectors.[110]

The fourth great survey of the era was headed by John Wesley Powell. As a young man, Powell had developed an interest in geology, fossils, and Indian artifacts.[111] After serving as an officer on General Ulysses S. Grant's staff during the Civil War (and losing his right arm), he became a professor of natural history in Illinois. However, Powell quickly tired of teaching; he was restless to go west. In 1867, he secured small grants from various agencies in Illinois and the promise of a military escort from his former commander, General Grant. The first two Powell expeditions, in 1867 and 1868, were essentially family affairs composed of college students and Powell's friends and acquaintances.[112] However improvised, these expeditions gained him partial support from the Smithsonian Institution in 1869 for a daring descent of the Colorado River. Powell received further fame and financial support for this unprecedented, three-month, 1,500-mile journey. His surveys of the 1870s focused on this same region: the Colorado River system, and the surrounding canyon country and native peoples, from northwest Colorado through Utah to northern Arizona.

In 1871, Powell gained the official backing of the Smithsonian Institution. At their request, he hired his first photographer, E. O. Beaman, who had been recommended by the Anthony firm in New York.[113] Just before the party left Salt Lake City in May 1871 for a second descent of the Colorado River, Powell also hired John K. (Jack) Hillers as an oarsman. In addition to his general labors, Hillers took an interest in photography and began serving as Beaman's assistant. Beaman left in January 1872, following a dispute with Powell. He was

replaced temporarily by James Fennemore, a Salt Lake City photographer employed by Charles Savage. With the increasingly skilled assistance of Hillers, Fennemore produced some fine photographs [403] in his few months with the survey. When Fennemore left in the summer of 1872, Hillers took over as the survey's official photographer. He held this position for more than twenty years, through the remainder of Powell's field expeditions and in Washington, D.C., during Powell's tenure with the Bureau of Ethnology and the U.S. Geological Survey.[114]

In the beginning of this work, Hillers devoted most of his effort to landscape subjects. Using a variety of cameras—from stereo to 18 x 22-inch format—Hillers produced powerful views of the Grand Canyon, Zion National Park, and the surrounding region. This unusual circular image of Zion [404], cropped from a mammoth-plate negative, prominently includes one of Hillers other cameras in the left foreground. The image is cleverly self-reflexive: Hillers records the majestic landscape while, at the same time, indicating the fact of his own presence.

As time went on, Hillers devoted more effort to recording American Indians.[115] Powell had a longstanding interest in ethnology and approached Indians more seriously and sympathetically than the leaders of the rival surveys. As a recent biographer has noted, Powell "constantly sought the companionship of Indians and sat long hours in their midst, flat on the ground."[116] By 1874-75, anthropological research had become a top priority: he hired linguists to begin serious study of native languages and he collected a wide range of artifacts. In 1879, these efforts culminated in the establishment of the Bureau of Ethnology, under the auspices of the Smithsonian Institution. Directed by Powell, the Bureau became "one of the major centers of anthropological research in the country."[117] Powell's work effectively professionalized the field he described as "the general science of mankind."[118] As a recent historian has observed, "Powell brought methodological rigor to the emerging discipline of anthropology, creating a real science out of a motley set of practices."[119] In 1881, upon the retirement of Clarence King, Powell also became head of the U.S. Geological Survey. His authority and budgets expanded accordingly.

Hillers become the Bureau of Ethnology's photographer in 1879. He was moved to the payroll of the U.S. Geological Survey in 1881, and served double duty for these agencies in the following years. Hillers made hundreds of photographs of American Indians and dwellings in his trips to the southwest between 1879 and 1885. Powell ordered a systematic study of the Indian pueblos of north-central New Mexico and northeastern Arizona. Hillers was particularly active in this region between 1879 and 1882: he made overall views of the pueblo complexes, group and individual portraits of residents [405], and records of nearby archaeological sites [c-131]. After his last field trip in 1885, Hillers remained in Washington, D.C. In addition to overseeing the photographic lab for both the U.S. Geological Survey and the Bureau of Ethnology, he made portraits of the Indians who visited the city in the continuing peace negotiations.

The depth of the Bureau of Ethnology's work is suggested in the remarkable career of Hillers's associate Frank Hamilton Cushing. At an early age, Cushing dedicated himself to understanding American Indian life and artifacts. As a professional ethnologist, he became one of the first Americans to immerse himself completely in another culture. Cushing went to Zuni pueblo in 1879 with Hillers and the rest of Powell's team; unlike them, he stayed for most of the next five

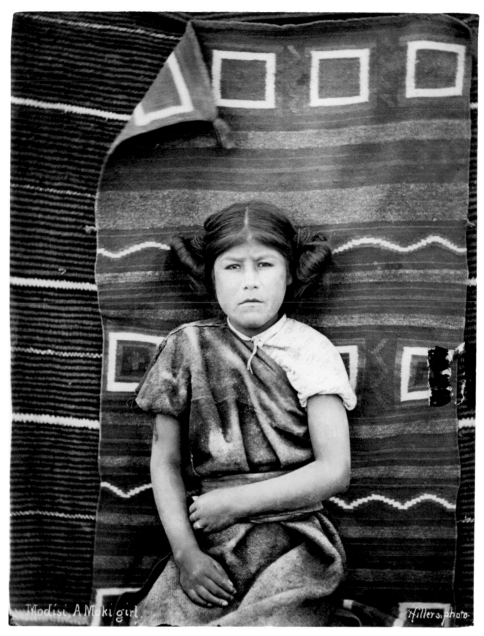

405 **John K. Hillers**, *Modisi, A Moki Girl (Walpi, Arizona)*, 1879

years.[120] After several tense confrontations, Cushing was accepted by the Zuni and gained an intimate knowledge of their lives, customs, and religious ceremonies. In 1881, he was initiated into the exclusive Bow Priesthood and was adopted as a son by the pueblo governor. In exchange for this privileged perspective on Zuni culture, Cushing led his Zuni "father" and fellow Bow Priests on a tour of the East in 1882. They traveled by railroad to Chicago, Washington, D.C., New York, and Boston, and were greeted as celebrities at every stop. In Washington, D.C., they met with President Chester A. Arthur and were entertained by the National Academy of Sciences.[121] Naturally, they were invited to several studios along the way to pose for group portraits [**C-132**]. Cushing's deep sympathy for Zuni values and beliefs pointed directly to the cultural relativism of twentieth-century anthropology.

It is one of the ironies of this overall endeavor, of course, that the quest to know the land and people of the West ensured that they both would be changed forever. Frank Hamilton Cushing had the best of intentions and motivations, but the exchange between Zuni and white cultures was not remotely equal. One was changed drasti-

cally—the other, scarcely at all. Similarly, Hillers's photographs may be seen as essentially commemorative in nature, records of ways of life that were disappearing or under threat.

The transformation of the West occurred with remarkable speed. When Ferdinand V. Hayden and William Henry Jackson first entered Yellowstone in the summer of 1871, it was an uncharted and otherworldly place. By the time of their last official visit, in 1878, it was radically changed. At this time, as a recent historian has noted, "They found it not an escape from civilization, but an escape into civilization: accommodations had been built on the site and tourists were ensconced, riding the trails, staring at the fountains, taking the waters, bathing in the pools."[122] Jackson's earlier views of the place, devoid of any people except for his fellow explorers, had seized the public imagination. Americans responded accordingly, turning the formerly remote site into a tourist destination. The success of Jackson's original photographs of Yellowstone contributed to making it impossible for him—or anyone else—to make truly comparable views ever again.

406 **Unknown Maker**, *General Ulysses S. Grant*, ca. 1863-68

CHAPTER VIII A World of Photographs

The Civil War marked a watershed in American history: the United States was one nation before the conflict and a very different one after it. When Henry Adams returned to Boston in 1868, after a ten-year stay in Europe, the culture that greeted him felt utterly alien. As he noted in his classic work, *The Education of Henry Adams,* "the last ten years had given to the great mechanical energies—coal, iron, steam—a distinct superiority in power over the old industrial elements—agriculture, handwork, and learning."[1] Adams's words underscored both quantitative and qualitative changes in American society. In acknowledging the nation's rapidly growing industrial might, Adams mourned what appeared to be lost: an organic connection to the land, the skilled and independent artisan, and a respect for the life of the mind.

The Gilded Age—from the end of the Civil War to the Panic of 1893—was characterized by an almost explosive process of urbanization, mechanization, and industrialization.[2] Between 1865 and 1885, the nation's population grew by nearly 60 percent, from approximately 36 million to 56 million. This new population was more urbanized than ever before. The residents of New York City proper (excluding Brooklyn) first exceeded 1 million in the early 1870s and by 1880 numbered 1.2 million. In 1880, the United States had twenty cities with more than 100,000 people, and thirty-five with populations over 50,000. After the Civil War, the nation's industrial production increased at an astonishing rate—growing by nearly 47 percent between 1865 and 1870 alone.[3] This growth was accompanied by a major change in the nature of American business, as small-scale, local enterprises gave way to giant corporations such as John D. Rockefeller's Standard Oil Company, founded in 1870.

As Adams sensed, the United States was changing from a nation of artisans and small businesses to one of heavy industries and monopolies. Significantly, the central attraction of the 1876 Centennial exhibition in Philadelphia was a potent symbol of industrial power: the immense Corliss steam engine. Through a complex system of shafts and belts, the Corliss engine provided the energy to run all the other mechanical devices on view in the thirteen-acre expanse of Machinery Hall. For many of the Centennial's nearly 8 million visitors, the Corliss engine had the mesmerizing sublimity an earlier generation had found in such natural wonders as Niagara Falls.[4] Thanks to Henry Bessemer's new process for refining pig iron into

steel, this new notion of the industrial sublime found expression in many other forms, from the daring expanse of the Brooklyn Bridge (completed in 1883) to the ever-higher "skyscrapers" of Chicago and New York.

Other technological marvels and innovations appeared in this period, many of them based on the newly harnessed power of electricity. After more than a decade of effort, the first transatlantic cable was laid in 1866, allowing instantaneous communication between New York and London. In 1876, Alexander Graham Bell received a patent for the telephone; a year later, Thomas Edison completed his first phonograph. Edison first demonstrated the incandescent light bulb at the end of 1879, and through his efforts the use of electric power and light spread rapidly in the 1880s.[5] In the West, patterns of land ownership and use were changed forever by another application of wire: the introduction of barbed wire fencing in the early 1870s.[6]

The rise of large corporations and the techniques of mass-production changed the nature of work and the social status of the working class. As enormous fortunes were amassed by a few, millions of laborers were subjected to unsafe working conditions and declining wages. The Panic of 1873, the worst economic depression in the nation's nearly 100-year history, lasted through 1877. It was followed by two decades of financial uncertainty: boom-and-bust economic cycles, tightening business credit, and bitter labor strikes.

For many Americans, this was an unsettling and disillusioning time.[7] As the phrase "Gilded Age" suggests, many felt that there was something hollow or fraudulent about their culture.[8] The 1873 novel of this title by Mark Twain and Charles Dudley Warner posed a sharp critique of the era's ills: a fever for sudden wealth, endless political scandals, and ruthless and dishonest business practices. The economic depression of the mid-1870s effectively ended the reformist energies of the 1860s and hopes of social reconstruction in the former Confederate states.[9] The political attempt to uproot the traditional ruling structure of the South was effectively ended; it would take almost another century to dismantle the racial and social inequalities that were given new official sanction in the 1870s.

This era's movement toward incorporation and centralized decision making included the formation of associations, institutions, and governing bodies of all kinds. In the cultural realm, this resulted in the founding of both art academies and public museums. The Yale

407 **W. H. Jacobi**, *Self-Portrait in Studio*, ca. 1875

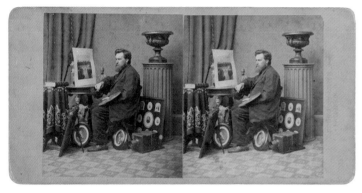

408 **J. Reid**, *Self-Portrait in Studio (hand-coloring a photograph)*, ca. 1870

409 **D. Appleton & Co.**, *Appleton's Stereoscopic Emporium*, ca. 1865

School of Art was begun in 1866, followed by the McMicken School of Art in Cincinnati (1867), and the San Francisco Art Institute (1871). The Metropolitan Art Museum and the Boston Museum of Fine Arts were both founded in 1870, and many others followed. While the terms of the debate had evolved from the antebellum era, art was still viewed as a force for individual and cultural betterment: a means of countering the coarse materialism of the age.

Surprisingly, given the social and economic turmoil of the period, the profession of photography enjoyed an unusual degree of stability in the late 1860s and 1870s. The Panic of 1873 served the Darwinian function of eliminating the weakest practitioners; otherwise, photographers appear to have done relatively well in this era. By this time, many had at least adapted to the severity of such boom-and-bust financial cycles. The pride that photographers took in their profession is suggested by the many self-portraits and views of studios and sales emporiums from this period [**407-409**].

The field's first broadly successful professional organization, the National Photographic Association, was founded in late 1868. Abraham Bogardus was elected the group's first president, and Edward L. Wilson, editor of the *Philadelphia Photographer,* was secretary. This group grew to over 1,000 members, and its national conventions, beginning with an 1869 meeting in Boston, were well attended.[10] Following internal disagreements in the late 1870s, the group was reorganized as the Photographers Association of America in 1880, with James F. Ryder as the first president. This latter group has continued, essentially uninterrupted, to the present.[11]

Contributing to the overall stability of this era was the fact that the technology of photography changed little between 1865 and 1880. The wet-collodion process completely dominated these years, although increasing effort was devoted to finding a workable dry technique for making negatives. The most significant technical innovations of this period may have been in photo-mechanical processes. These included the carbon and woodburytype processes (introduced in 1867 and 1869, respectively), and the collotype (1869), also called the Albertype or heliotype process.[12] All these techniques yielded permanent, continuous-tone prints in ink or pigment from photographic negatives. While all were capable of superb results, these processes were difficult and expensive, and thus never threatened to replace the albumen print as the standard printmaking technology.

The most popular innovations of the era included a new format, the cabinet card, and a new technique, the practice of retouching negatives. Together, these reinvigorated the business of portraiture.

By 1866, the once dominant carte-de-visite had fallen out of fashion. As Edward L. Wilson wrote: "Everyone is surfeited with them. All the albums are full of them, and everybody has exchanged with everybody." Noting "an inclination on the part of the public to sit for larger and better pictures than the carte de visite," Wilson concluded that "the adoption of a new size is what is wanted."[13] The cabinet card, first introduced in Britain, answered this desire. The cabinet card was a considerably larger version of the carte-de-visite: a print of about 5 ½ x 3 ¾ inches on a 6 ½ x 4 ¼-inch mount. This yielded an image area nearly three times the size of the earlier format. The leading photographers in New York met in late 1866 to approve this as an industry standard, and manufacturers immediately began producing mounts and albums in the new size. The public eagerly accepted the new format and sales soared.

While some photographers disdained the practice of retouching, nearly all of them practiced it. By 1868, it was discovered that the

410 **Mathew B. Brady**, *Brady Studio, 785 Broadway (at Tenth Street), New York City*, ca. 1864-65

collodion surface of a processed and dried negative could be abraded slightly so that it could be shaded with a special pencil. By means of careful handwork on the negative, wrinkles could be reduced or eliminated, facial blemishes removed, and hair smoothed. While this represented a further step away from the immediacy of the daguerreotype, customers happily embraced the practice.

After these years of relative professional stability, it became obvious in the late 1870s that a major technological change was on the horizon: the transition from the wet-plate collodion to the dry-plate process. This change was firmly in line with larger business and manufacturing trends. In the postwar years, American business witnessed a pronounced shift from hand-crafted to machine-made goods, from the independent artisan to the salaried factory worker, and from dispersed sites of manufacture to a centralized process of mass-production.

These contrasting terms describe the basic nature of the photographic technologies before 1880 and after 1885. In the daguerreotype and wet-collodion eras, photographers worked as skilled artisans: they purchased ready-made chemicals and supplies, but needed the skill and experience to prepare and process each plate or negative. The

dry-plate revolution of the years around 1880 made the technique of photography immensely easier: negatives were produced in factories, and could be exposed and processed at the photographer's leisure. Notably, however, the process of manufacturing dry plates was of such technical complexity that few photographers even considered doing it themselves. The daguerreotype and wet-plate processes were cottage-industry crafts; the dry plate was the result of high-industrial technology.

Napoleon Sarony and the New Art of Portraiture

Mass-produced celebrity photographs continued to find a ready market in this new era of money, materialism, and fame. Such photographs were made in greater number than ever before [406]. While the smaller carte-de-visite lasted well into the 1870s, most of these celebrity portraits were produced in the new cabinet-card size. With this change of physical format, a correspondingly new visual aesthetic gradually took shape.

Some of the leading studios of the 1850s survived into the 1870s and beyond. Brady's gallery at 785 Broadway [410] remained a popu-

411 **Mathew B. Brady**, *Lilliputian Souvenir*, ca. 1863

412 **Mathew B. Brady**, *Prof. T. A. Edison, and his Speaking Phonograph*, 1878

lar landmark until 1873, when he was forced to declare bankruptcy.[14] He relocated to Washington, D.C., where he continued to work at less lavish addresses into the early 1890s. While Brady's earlier photographs [411] were distinctly more fashionable and popular than most of his later works, he continued to attract noteworthy sitters through at least the late 1870s [412]. Other leaders of the prewar profession, such as Charles D. Fredricks [413, c-133] and Jeremiah Gurney [417], continued to produce fine work during the war and for years thereafter.

The celebrity portraits of this era comprise a familiar mix of entertainers and oddities [413, c-134 – c-136], artists [414], frontiersmen and adventurers [415], political and cultural leaders [416], and poets and writers [417]. Like the cartes-de-visite of a few years earlier, these cabinet cards were collected in albums which, displayed prominently in family parlors, represented portable galleries of "Illustrious Americans."

Though the subjects of these images changed little in this period, the visual style of this work was evolving. While Brady and his peers worked in familiar ways, William Kurtz and Napoleon Sarony were rewarded for newer and more expressive styles. Both were influenced by ideas derived from Europe and from their experiences in the graphic arts.

Although now little remembered, William Kurtz was regarded by many in the 1870s as the nation's leading photographer.[15] Born in Germany, Kurtz was employed in London as a lithographer and an art instructor before becoming a seaman. Shipwrecked on a voyage to California, he eventually made his way to New York City in the late 1850s, where he worked as an artist for photography studios. By 1865, he had taken up the camera himself. His first studio was at 872 Broadway; in 1874, he moved to larger quarters on Madison Square.

Kurtz was renowned for his innovations in lighting and posing. In fact, he was one of the first Americans to make portraits by artificial illumination: as early as the fall of 1882, Kurtz announced his specialty in "portraits taken by electric light."[16] Kurtz used his light in distinct and dramatic ways. His images were described as "Rembrandt" photographs or, in Kurtz's own words, as emphasizing "Shadow Effects."[17] Typically, Kurtz used a simple, directional light, allowing significant portions of his sitter's head to fall into shadow. He also paid great attention to the nuances of posture and expression. As a result, his portraits were distinguished not only by a new quality of dimensional modeling, but by a fresh intensity of emotion. The latter is apparent in Kurtz's unconventional portrait of Walt Whitman with closed and downcast eyes [418]. While Gurney recorded Whitman's public face, Kurtz sought a deeper and more personal identity: the poet as dreamer and visionary.

Napoleon Sarony was the Mathew B. Brady of his generation — not only a leader in the profession, but a celebrity in his own right [419]. Sarony was a man of uncommon experience and ambition.[18] Born in Quebec, Canada, to a French mother and an Austrian father, Sarony came to New York City as a child with his family. At the age of ten, he was apprenticed to a lithography firm. Showing considerable aptitude for this work, Sarony was employed in the following years as a freelance caricaturist, a political cartoonist, and a lithographer. In 1846, he started his own lithography business in partnership with Henry Major. This successful enterprise (later Sarony, Major, and Knapp) produced illustrations for books, government reports, music covers, and theatrical posters. Perhaps as a result of his expertise in drawing from photographs, Sarony began making daguerre-

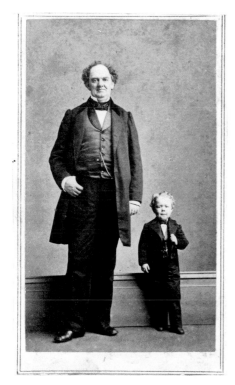

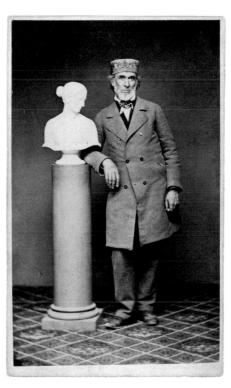

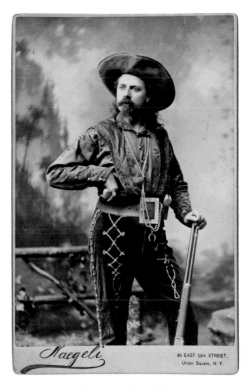

413 **Charles D. Fredricks**, *P.T. Barnum and Commodore Nutt*, ca. 1865

414 **Longworth Powers**, *Hiram Powers*, ca. 1865

415 **Naegeli**, *William "Buffalo Bill" Cody*, ca. 1880

otypes and ambrotypes himself in the late 1850s. In 1858, he dropped all these endeavors to go to Europe for artistic study and inspiration; his next six years were spent in Berlin, Paris, and London.

In 1864, prompted by the success of his brother, a portrait photographer in the English resort town of Scarborough, Sarony took up photography professionally. Like Brady, Sarony showed little interest in technical matters: he knew nothing of photographic chemistry and relied on skilled operators to prepare and process his negatives.[19] Instead, Sarony's genius lay in orchestrating the "perfor-

mance" of the portrait sitting—in lighting and posing his subjects. After operating a studio in Birmingham, England, for two years, he returned to New York in 1866. His first studio was at 630 Broadway. By 1871, his success allowed him to open a larger and more elaborate studio at 37 Union Square.

This new studio was in the heart of the city's theater district, and Sarony was in his element. In manner and dress, he was one of New York's most memorable and flamboyant characters.[20] Cultivating his reputation as a Bohemian and a *bon vivant*, Sarony dressed

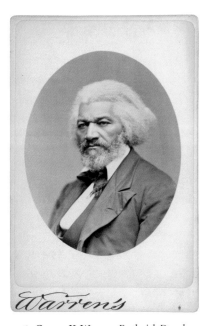

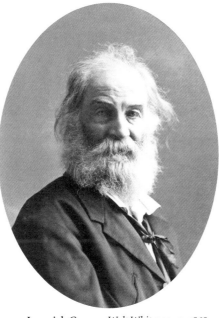

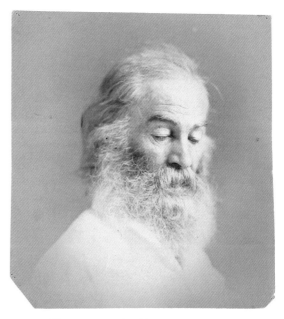

416 **George K. Warren**, *Frederick Douglass*, ca. 1870

417 **Jeremiah Gurney**, *Walt Whitman*, ca. 1868

418 **William Kurtz**, *Walt Whitman*, ca. 1870

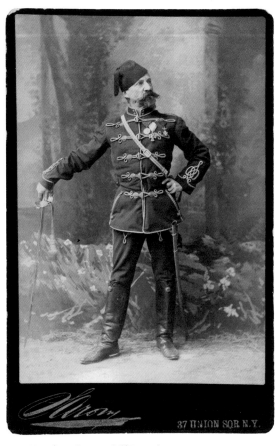

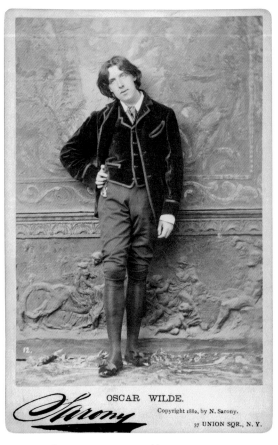

419 **Napoleon Sarony**, *Self-Portrait*, ca. 1875

420 **Napoleon Sarony**, *Oscar Wilde*, 1882

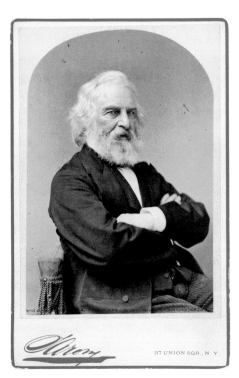

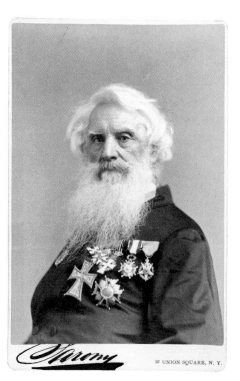

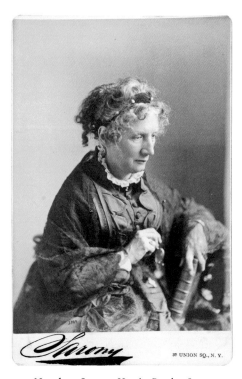

421 **Napoleon Sarony**, *Henry Wadsworth Longfellow*, ca. 1875-80

422 **Napoleon Sarony**, *Samuel F. B. Morse*, ca. 1870

423 **Napoleon Sarony**, *Harriet Beecher Stowe*, ca. 1880-85

like a Turkish count, complete with tasseled fez. His Union Square studio could have been a wing of Barnum's museum: "it was filled from wall to wall and floor to ceiling with Russian sleighs, Egyptian mummies, Indian pottery, Japanese armor, medieval arms, groups of statuary, and Eastern draperies."[21] A stuffed crocodile hung from the ceiling of his reception room.[22]

Many of the era's most renowned figures walked through this cabinet of curiosities on the way to Sarony's posing room. In addition to making publicity portraits of innumerable actors and entertainers, Sarony recorded the cultural and intellectual elite of his day. These subjects included the young Irish aesthete Oscar Wilde [420], as well as such venerable figures as the poet Henry Wadsworth Longfellow [421], inventor and artist Samuel F. B. Morse [422], and novelist Harriet Beecher Stowe [423].

All this work was informed by Sarony's skills as a caricaturist, his understanding of popular visual culture, and his devotion to fashion and theater. Sarony understood perfectly the relationship between artistic style and the construction of a public persona. His portraits of stage personalities are appropriately theatrical in nature: Sarony used elaborate backdrops and highly expressive gestures and poses.[23] On the other hand, his portraits of Longfellow, Morse, and Stowe—and figures of similar *gravitas*—are simpler and more dignified in approach. However varied, these images stemmed from Sarony's desire to make likenesses that were at once "picturesque" and emotionally vital.[24] A contemporary critic observed that Sarony's work "was all life and expression, only with far more abandon and intensity of action" than that of any other photographer in America.[25]

Sarony's interpretive eye found its perfect subject in Oscar Wilde. An Irish art critic and poet, Wilde was the world's most celebrated proponent of Aestheticism. With great intelligence and wit, Wilde encouraged a broader appreciation not only of art, but of the idea of the self as a kind of artistic creation. He cut an appropriately stylish —and sexually ambiguous—figure in his purple Hungarian smoking jacket, knee breeches, and black silk stockings. As the archetype of the modern aesthete or dandy, Wilde stood in direct opposition to what many perceived to be the stultifying pragmatism and materialism of the age.[26] This message had enormous appeal in the United States, where Wilde spent nearly all of 1882 delivering lectures on "The English Renaissance," "The House Beautiful," "The Decorative Arts," and similar subjects. Wilde traveled nearly continuously throughout that year, delivering some 140 lectures to large audiences across the country, from Boston to San Francisco, Minneapolis to San Antonio.[27]

At the start of this tour, Wilde went to Sarony's New York studio for a portrait session. By this time, celebrities had begun to charge photographers for the privilege of being recorded. This practice had started in 1867, when Charles Dickens—at the beginning of a tour of America—demanded a royalty from the sale of his likenesses.[28] Sarony was known to have paid enormous sums to secure celebrity sittings: $1,500 to Sarah Bernhardt, for example, and $5,000 to "the world's most beautiful woman," Lillie Langtry.[29] Notably, however, Wilde asked nothing from Sarony: he understood fully what could be gained from the public circulation of his likenesses and from the prestige attached to Sarony's name.

This portrait session, which took place in mid-January 1882, was enormously productive. Sarony made at least twenty-seven images of Wilde in a variety of costumes and poses.[30] One of the most memorable of these shots depicts the poet standing languidly in front of a decorative panel with one hand at his hip and his head tilted to the side [420]. It is an image of quietly revolutionary power: a new suggestion of what it might mean to be a man, an artist, and a public figure. As it happened, this portrait also played a significant role in the larger debate over the photograph's status as a work of art.

These portraits of Wilde were both popular and profitable. In addition to marketing cabinet cards of them under his gallery's imprint, Sarony sold the rights to make lithographic copies of this iconic pose (and perhaps a few others).[31] However, while Sarony was careful to copyright all the photographs in this series, at least one firm —the Burrow-Giles Lithographic Company—issued an unauthorized print of one of them. Sarony promptly sued. The case reached the United States Supreme Court in December 1883 and was decided in March 1884.

While there was some quibbling over the technical points of Sarony's copyright notice, the most interesting legal issue involved a larger question: did Sarony's photograph—and, by implication, *any* photograph—merit protection by copyright? The Burrow-Giles position was simple: as a "mere mechanical reproduction" of a chosen subject, the photograph involved "no originality of thought or any novelty in…intellectual operation."[32] By contrast, Sarony argued that his portrait of Wilde was "a useful, new, harmonious, characteristic, and graceful picture … made … entirely from [my] own original mental conception." Contesting the idea that photography was a "mere mechanical" operation, Sarony emphasized the imaginative labor that went into selecting and arranging the subject's costume and other accessories, the intricacies of posing and lighting, and the task of "suggesting and evoking the desired expression." By virtue of this creative process, Sarony claimed the legal right to be recognized as "author," "inventor," and "designer."

While the court acknowledged that a certain class of photograph was, in fact, the result of a purely mechanical operation—with "no place for novelty, invention or originality"—they upheld Sarony's argument.[33] In the court's judgment, when produced by someone of Sarony's talent and ambition, a photograph was legally "art"—not simply a mechanical product, but a work of the creative imagination. Of course, this decision did little to convince the general public that photography was equivalent in cultural prestige to the more established arts. However, this important legal principle helped set the stage for a larger battle, beginning about fifteen years later in the age of Pictorialist photography, over the medium's artistic credentials.

Reality in Focus

To most Gilded-Age Americans, photography's meaning remained simple: it was a familiar and endlessly useful workhorse. In these decades, it may have seemed that the camera was used to record nearly everything. Although made for the purpose of simple fact-gathering, many of these images retain a visual interest transcending their original use. The subjects of these views range from documents of buildings or businesses [424] to the complementary processes of construction and destruction [425, 426], celebrations of engineering achievements [427, 428], and records of entrepreneurship and enterprise [429].[34] Not surprisingly, the highly technical nature of some of these pursuits resulted in correspondingly unusual images [430, 431]. This photograph of a mechanical man may have been made as part of an attempt to patent the device. The study of an explosion of an underwater mine or "torpedo" is of interest, in part, for its stop-action

424 **Unknown Maker**, *Palmer's Mills*, 1860

425 **Lewis E. Walker**, *Construction of the Department of the Treasury*, 1861

426 **James W. Black**, *Trinity Church, Summer Street, Boston*, 1872

427 **Unknown Maker**, *Interior, Niagara Suspension Bridge*, ca. 1860

428 **J. P. Babbitt** (attrib.), *Kansas City Bridge: Lowering First Section of Curb, No. 1*, August 7, 1867

429 **John Mather,** *David Beatey Farm, Looking South from Saw Mill, West Hickory Creek, Pennsylvania,* ca. 1868

430 **George O. Bedford**, *Mechanical Man*, 1868

431 **Henry L. Abbot**, *Torpedo Explosion, Willet's Point, New York Harbor*, 1882

quality. In this "instantaneous" exposure, the momentary column of water is registered as a curiously permanent sculptural form.

The camera was also applied to a variety of scientific pursuits, including the study of astronomy. Lewis M. Rutherfurd, for example, made a celebrated series of photographs of the moon. A wealthy resident of New York City, Rutherfurd abandoned the practice of law in 1849 to devote himself to science.[35] In the mid-1850s, he constructed an observatory in the garden of his home at the corner of Second Avenue and Eleventh Street. After using a variety of telescopes, Rutherfurd built one specially adapted for photography with a highly corrected 11¼-inch lens.[36] Some of his finest photographs of the moon were made with this instrument on the night of March 6, 1865, through a perfectly clear and calm atmosphere [432]. Widely seen and celebrated, Rutherfurd's lunar photographs were the finest of their day.

Photographers were key members of the various eclipse and transit expeditions of the era. A solar eclipse on August 7, 1869, was recorded by scientific parties strategically located along its path. James W. Black was part of the team stationed in Springfield, Illinois, while his former partner, John A. Whipple, was a member of another group, in Shelbyville, Kentucky [433]. These and similar expeditions received consistent notice in the photographic press.[37] Photographers were also commissioned to record an even rarer event: the transit of Venus across the face of the sun [434]. The two such transits that occurred in this period—in 1874 and 1882—generated considerable public interest.[38] One of the scientific goals of these parties was to obtain a more accurate measure of the distance from Earth to the sun. This was done by triangulation: carefully recording and timing the passage of Venus across the solar disk from various locations on Earth. The slight parallax shift in the apparent position of the planet in relation to the edge of the sun was then used to calculate celestial distances.[39]

Photographers of this era flourished in a great variety of professional and social niches. College and university photography, for example, was a specialty of such noted figures as George K. Warren, William Notman, and Pach Brothers.[40] This work required a diverse set of skills, but had the virtue of occurring with unvarying regularity year after year. The commission from a college or university gave the photographer the "franchise" to make and sell individual portraits of students, faculty members, and even janitors and other support staff [c-137]; group portraits of societies, clubs, and teams [c-138]; views of the school's buildings and grounds; and other characteristic local scenes. These two images suggest something of the variety and aesthetic quality of this work. Warren's interior of the Williams College gymnasium [435] suggests a cathedral of physical culture. Gustavus Pach's elegantly minimal study of the champion Yale crew team plays the sleek form of the racing shell against the low horizon of the background marshes [436].

Photographers of the post-Civil War era continued to use the stereo format to make images of newsworthy, scenic, and anecdotal interest. The stereo camera's small size and portability allowed photographs to be made more candidly and quickly than with larger formats. The moderate cost of the finished images meant that a broad range of subjects could be profitably recorded: at the right price, a customer could be found for a good picture of almost anything. As a result of these factors, the stereographs of this period represent an almost endlessly rich pictorial realm of reportage and observation [437-444, c-139]. Equally varied subjects can be found

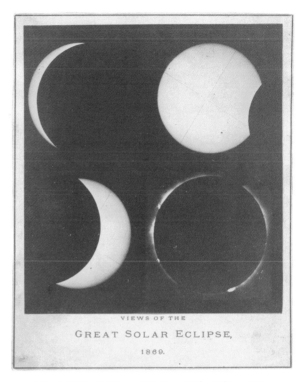

433 John A. Whipple, *Views of the Great Solar Eclipse*, 1869

432 Lewis M. Rutherfurd, *Moon*, March 6, 1865

434 **Unknown Maker**, *Astronomers (Transit of Venus Party), Washington, D.C.*, 1874

435 **George K. Warren**, *Gymnasium, Goodrich Hall, Williams College*, ca. 1866-67

436 **Gustavus W. Pach**, *Yale Crew Team*, ca. 1879-80

437　**E. Anthony**, *Specimen of New York Bill Posting, City Hall Park*, 1863

438　**Lawrence & Houseworth**, *Lumber Vessels in a Gale at Mendocino*, 1866

439　**Charles Waldack**, *View from "Bridge of Sighs," Mammoth Cave*, 1866

440　**M. A. Kleckner**, *Group of Coal Miners*, ca. 1869

441　**Charles Bierstadt**, *Professor King's Balloon at Rochester, N.Y.*, ca. 1872

442　**Unknown Maker**, *Cloud Study*, ca. 1870

443　**George Barker**, *Belleni Crossing Niagara on Tight-Rope*, ca. 1873

444　**Detlor & Waddell**, *Oil Fire Near Tarport, Pennsylvania*, ca. 1876

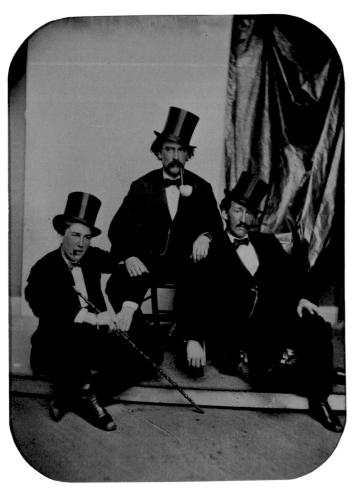

445 **Unknown Maker**, *Three Dandies*, ca. 1865-75

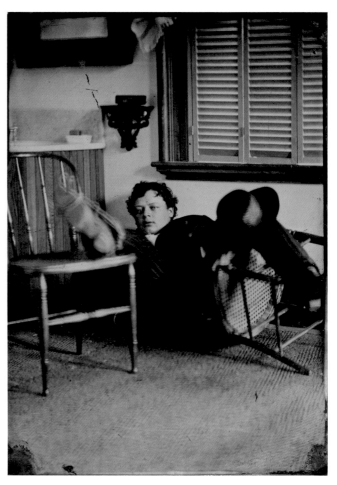

446 **Androscoggin Photographic Gallery**, *Man on Floor*, ca. 1885

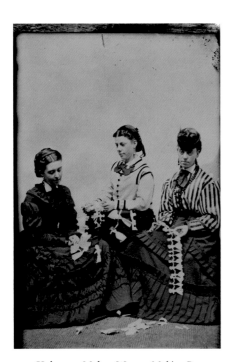

447 **Unknown Maker**, *Women Making Paper Dolls*, ca. 1870s

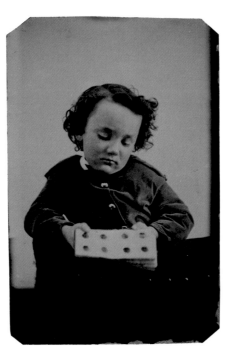

448 **Unknown Maker**, *Boy with Gem Tintype Album*, ca. 1870

449 **Unknown Maker**, *Smiling Man Behind Wall*, ca. 1880

in the cartes-de-visite of the period, as in this remarkable record of a river baptism [C-140]. Some of these views were produced in quantity and distributed nationally; others, intended for a strictly local audience, may have been issued in only a few examples.

The daring or playfulness of photographs in this period was closely correlated to the format and price of the image. With few exceptions, the most surprising or unconventional images were rendered in the most affordable techniques and sizes: occasionally as stereographs, but most commonly as cartes-de-visite or tintypes. The latter process—the simplest and most indestructible of all—was used for a uniquely wide range of work, from relatively large and elegant portraits [445] to the most personal and quirky pictures [446-449]. The nature of the tintype itself—a direct-positive image, made quickly and cheaply by the most anonymous of practitioners—encouraged subjects to "let their hair down" for the camera. These images are memorable, in part, because they so often violate accepted aesthetic standards for an exuberant new form of self-fashioning and self-expression.[41] In such instances, it is the creative vision of the subjects themselves that is dominant, rather than that of the camera operator. In this regard, the tintype represented an intriguing half-step in the direction of a genuinely amateur, vernacular photographic vision.

Art and Invention

As the anonymous "artistry" of these tintypes suggests, the creative currents of this era were lively and varied. From today's perspective, many of the most fascinating photographs of the period are the ones that are obviously orchestrated, fabricated, or manipulated. Such works were made for diverse purposes, by photographers of equally varied skills.

While the great majority of photographs before 1880 were made by professionals, there was—inevitably—some amateur activity. A now disassembled album of photo-collages by an unidentified artist stands as one of the era's most intriguing and whimsical photographic creations. Each plate of this work is a mass-produced engraving cut from the pages of the leading illustrated newspapers. These engravings were modified—by a careful and consistent hand—with albumen prints of the faces of family members [450]. Through these deft alterations, these unnamed people became virtual protagonists in an amusing series of pictorial adventures. In addition to their off-beat humor, these works represent a rich conceptual process of reclamation and transformation: these polite, mass-produced images were made to serve the most personal and playful ends.

Another one-of-a-kind album, credited to Amelia Bergner (about whom, unfortunately, little is now known), contained dozens of elegant photograms of botanical specimens [451]. These were produced without a camera: Bergner placed her selected leaves directly on sheets of photographic paper. The images were formed by exposure to sunlight, with the resulting shadow impressions then fixed and washed in a conventional manner. This work stemmed from a rich nineteenth-century tradition of both collecting botanical specimens and of making same-size impressions or images of them. Many volumes of dried flora were assembled in this period, and a handful of photographers (including Anna Atkins, in England) specialized in making photograms of such subjects.[42] Bergner's work is a rare example of this application of photography in the United

450 **Unknown Maker**, *Christmas Pudding at Sea*, ca. 1876

451 **Amelia Bergner**, *Untitled Photogram*, ca. 1870-75

452 **Unknown Maker**, *Plan of the Contemplated Murder of John Campbell*, 1871

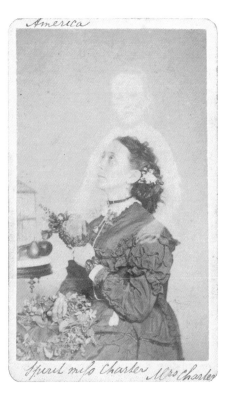
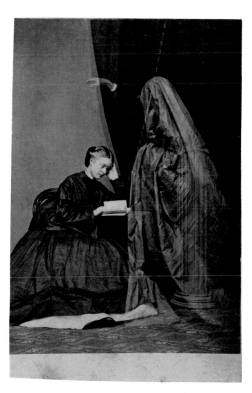
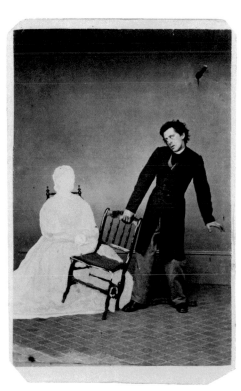

453 **William H. Mumler**, *Spirit Child and Mrs. Charter*, ca. 1870-75

454 **Unknown Maker**, *Spirit Photograph*, ca. 1870

455 **R. J. Hillier**, *Spirit Photograph*, ca. 1865

States. It is also distinguished by her visual intelligence: her confident sense of pictorial composition and structure.

In the studios of professional photographers, constructed or otherwise unconventional photographs were made of a great variety of subjects. One of the strangest "documentary" images of the period [452] was the result of a distinctly unusual approach: the period equivalent of a low-budget "docu-drama." In 1871, John A. Campbell, a leading figure in the North Carolina Republican party, was abducted and whipped by hooded members of the Ku Klux Klan. Just before he was about to be killed, Campbell was rescued by federal marshal Joseph G. Hester. The marshal was a man with a complex past: before becoming a government detective, Hester had been a member of the Klan. He also had an apparent hunger for publicity. Hester personally commissioned a photographer to record this reenactment of Campbell's ordeal. He then copyrighted the work in his own name and sent prints to the Northern press and to authorities in Washington, D.C.

Campbell played himself in this studio reenactment. Most remarkably, the visible hands of the "Klan" members (dressed in the actual outfits of the captured men) reveal that these roles were played by Campbell's African American friends. The black hands emerging from the sleeves of Klan outfits give this image a radically unexpected dimension of "documentary" interest.

Some of the era's most notorious examples of manipulated photographs were produced in the name of spiritualism. The modern spiritualist movement began in the United States in 1848, when two sisters in rural New York State first claimed the ability to communicate with the dead.[43] In the 1850s and 1860s, spiritualism gained numerous adherents as mediums, clairvoyants, and séances became part of mainstream culture. While many Americans viewed the matter with skepticism, spiritualism held a powerful emotional appeal. In a time of war and wrenching social change, believers took comfort in the possibility of some form of communion between the living and the dead.

"Spirit photography" arose in the early 1860s in response to this movement [453-455]. While a number of figures ultimately worked in this genre, the first and most prominent spirit photographer was William H. Mumler, of Boston. Mumler was well aware of how these images were produced: they were made by the simple technique of double-exposing negatives.[44] Nevertheless, the lucrative nature of this work—Mumler's clients were typically well-to-do and paid a premium for images of themselves with the ghosts of loved ones—prompted him to embark on a career in this field. While believers flocked to his studio, he was dogged by accusations of fakery. After losing the support of the spiritualist community in Boston, Mumler moved to New York in 1868. There, after a few months of highly profitable work, he was arrested on charges of larceny and fraud.

Mumler's court proceedings, from April 21 to May 4, 1869, were followed closely by the press.[45] The prosecution's case was aimed not simply at him, but at the spiritualist enterprise as a whole. Experts such as P. T. Barnum and the veteran photographer Abraham Bogardus described Mumler's techniques of deception. On the other hand, nearly all of Mumler's clients—including some of New York's most prominent citizens—testified to their confidence in his work. Mumler was ultimately acquitted, but the fad of spirit photography suffered irreparable damage. The presiding judge stated that he was "morally convinced that there had been trick and deception," but determined that the prosecution had failed to prove their case. Within weeks, the members of the photography section of the American Institute—a respected scientific group—officially denounced spirit photography as simple trickery. With his business in New York

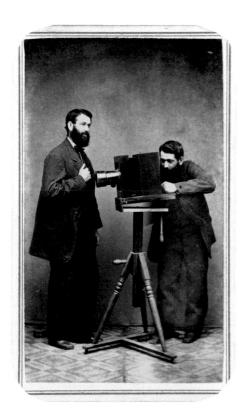

456 **J. Halstead**, *Double (Self?) Portrait with Camera*, ca. 1865-70

457 **A. M. Allen**, *Self-Portrait as Soldier and Civilian*, ca. 1865-70

458 **A. M. Allen**, *Self-Portrait with Camera and Seated*, ca. 1865-70

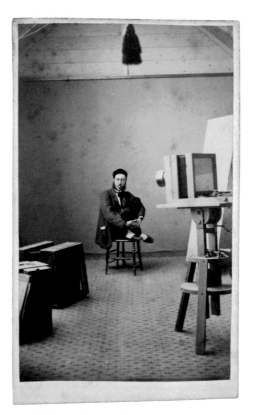

459 **Prescott & Gage**, *Woman with Opera Glasses*, ca. 1861

460 **Unknown Maker**, *Photographer in Studio Sticking Tongue Out*, ca. 1870

ruined, Mumler returned to Boston. He resumed work there in a small studio in his mother-in-law's parlor, conjuring spirits for a dwindling clientele through the 1870s.

Another form of photographic invention—double portraits— also became something of a fad in this period. In these amusing views, typically produced in the carte-de-visite format, a single subject was depicted twice in the same scene, as if talking to an identical twin.[46] These images were produced with an in-camera masking technique: two exposures were made on a single negative, with a carefully positioned mask shielding first one side of the negative, and then the other, from exposure. In its most skillful examples, this technique resulted in an apparently seamless studio scene with such subjects as a photographer posing for his own camera [456]. At least one operator, the otherwise little-known A. M. Allen, showed a particular inclination for this work. These two cartes-de-visite depict Allen dressed as a soldier and a civilian [457], and as both the maker and the subject of a portrait [458].

While such photographs were reasonably uncommon, they would have been known to—and understood by—most Americans. Their sly trickery undercuts any notions we might have today about "simple" nineteenth-century attitudes toward the truthfulness of photographs. Images such as these suggest that Americans easily accepted the idea that photographs could be made to represent imaginary beings and impossible events.

Another category of studio-made photographs eludes easy categorization: these cartes-de-visite [459, 460] were almost certainly not intended for general distribution or sale. Both are playfully self-reflexive images. In looking at each one, the viewer himself becomes the subject of a brazen, impudent gaze. In the first of these, a woman stares directly at us with a pair of opera glasses; curiously, her own identity is masked by the device she employs to see (us) more clearly. The second image, a wildly eccentric self-portrait of a photographer in his studio, turns polite standards of both pictorial composition and social decorum on their heads. Seated casually on a stool at the far end of his posing room, the photographer records himself sticking his tongue out at the camera (and at us). Like the earlier daguerreotype of the irreverent boy on the back of a chair [283], this carte-de-visite is something more than a mere comic exercise. By deliberately violating accepted photographic codes and assumptions, it highlights the artifice of normal studio practice. These remarkable works also emphasize the sometimes intrusive or aggressive nature of vision itself. While all photographs are looked *at*, these—memorably and somewhat uncomfortably—look *back*.

The work of other photographers of the period paid homage to more conventional artistic ideas and motifs. For example, James W. Black's portrait of Edward Everett Hale with his son [461] was modeled directly on a popular engraving of the day. In this richly narrative work, a kindly father instructs his young son in the ways of life, here represented by the art of tilling the land. This is an explicitly allegorical scene: the figures are cast in symbolic roles in order to illuminate universal human truths. For Hale—a renowned Unitarian pastor, newspaper editor, and author—this depiction confirmed basic virtues, while acknowledging the guiding influence of fine art.

George N. Barnard's stereograph *South Carolina Cherubs— After Raphael*, ca. 1874-75 [462], represents a knowing nod to one of history's most famous paintings, Raphael's *Sistine Madonna* of ca. 1512-13.[47] Raphael's work, which circulated widely in this period in reproduction, depicts the Madonna standing in a curiously theatrical

461 **James W. Black**, *Edward Everett Hale and Son*, 1869

462 George N. Barnard, *South Carolina Cherubs (After Raphael)*, ca. 1874-75

463 **Thomas Eakins** (or circle), *Woman in Empire Gown*, ca. 1881-85

trompe l'oeil space, holding the infant Christ. At the base of the picture, two winged cherubs—witnesses to the sacred allegory above—rest their arms on a pictorial "shelf" that seems to project the virtual space of the painting into the three-dimensional realm of the spectator.

This stereograph, made while Barnard was living and working in Charleston, South Carolina, is both a clever quotation of Raphael's painting and a work of real conceptual depth. By restaging this detail of Raphael's masterpiece, Barnard evoked the aura and importance of the original in the minds of his viewers. Raphael's central subjects —the Madonna and Christ child—in turn suggest the symbolic implications of Barnard's stereograph. Raphael's cherubs are honored witnesses to—and participants in—the greatest of sacred narratives: the redemption of mankind. Barnard, a Northerner and a fervent supporter of the abolitionist cause, deliberately chose two African American youths for these roles. As some of the first of their race to be born outside the shackles of slavery, these youths stand as both witnesses to—and central protagonists in—America's own great historical narrative of (racial) freedom and (national) redemption. Appropriately, Barnard's models are fresh-faced, thoughtful, patient, and serious—at once innocent of past injustice and aware of the moral and cultural importance of their lives to come. While the art-historical reference of this image marks it as distinctly unusual in Barnard's work, its intentionality cannot be doubted.

The camera was used in a very different way by the great American painter Thomas Eakins [C-141].[48] As a recent historian has observed, "Eakins grew up with photography."[49] Born in Philadelphia in 1844, Eakins came of age in a city with a distinguished community of photographers. He came to know several of them, including Coleman Sellers, his next-door neighbor, and the professional firm of Schreiber and Son.[50] Just as importantly, Eakins was an empiricist by nature: he was devoted to a scientifically exact mode of observation and analysis. As a result, his use of the camera may have been inevitable. As his teacher, the famous French painter Jean-Léon Gérôme, observed: "The photograph … has compelled artists to divest themselves of the old routine and to forget the old formulas. It has opened our eyes and forced us to gaze on that which [we] have never before seen, an important and inestimable service it has rendered to Art."[51] In the 1870s, Eakins applied this optically informed vision to his

paintings, making portraits with a new emotional and psychological depth, and recording such contemporary subjects as rowers, hunters, and baseball players.

Encouraged by the ease of the new dry-plate technology, Eakins purchased his first camera—a standard 4 x 5-inch amateur outfit—in 1880 or early 1881.[52] He used it to make portraits of friends and studies for his paintings. He also used the camera in his teaching at the Pennsylvania Academy of the Fine Arts, where his students frequently served as models. The resulting photographs are comprised predominantly of nudes, portraits, and clothed figure studies.[53] This photograph [463] is characteristic of the latter group: a woman in an Empire gown seated on the posing stand in Eakins's classroom at the Academy.[54] This image is related to Eakins's Arcadia series—photographic studies made to inspire and inform his paintings of pastoral and classical subjects. These Arcadia works speak to Eakins's artistic ambition: his desire to transform the oldest and most revered motifs into something distinctly his own. He made a number of photographs of female models in this dress (and similar ones), with a keen eye to the dynamics of the body and to the flow of fabric.[55]

Eakins made more consistent and thoughtful use of photography in the 1880s than any other American artist of remotely comparable stature. He used the camera to produce source images and studies for some of his most significant paintings of the period, including *Shad Fishing at Gloucester on the Delaware*, 1881; *Mending the Net*, 1881; and *The Swimming Hole*, 1883.[56] He also took a deep interest in the photographic analysis of motion and in the technologies that led to the development of moving pictures. However, Eakins was neither a professional photographer nor a typical amateur. He treated the process as a useful tool and rarely exerted any personal claim to authorship of the finished images. Since some of these photographs may well have been made by Eakins's wife, Susan, and by other associates, collective authorship is usually indicated by the phrase "Thomas Eakins (or circle)."

Instantaneous Vision

The most radical photographic work of this era was devoted to the high-speed analysis of human and animal motion. This began as a technical and scientific concern, but soon became a matter of considerable artistic interest.[57] From 1839 onward, photographers and researchers had labored to reduce exposure times. This effort began as a simple matter of commercial practicality—to shorten portrait exposures from minutes to seconds. However, as exposure times continued to drop, thanks to innovations in lenses and the sensitivity of emulsions, it was clear that something beyond mere convenience was involved. Faster exposures revealed a surprisingly new visual world. This was exciting, in part, because these "instantaneous" photographs were often distinctly at odds with ordinary perception. These photographs represented split-second fragments and slices of visual experience: instants plucked from the fluidity of lived reality. While these split seconds were unquestionably "real," they revealed unexpected—and previously unseen—complexities of posture, gait, and attitude. The apparently simple movement of pedestrians and vehicles in the street [313], for example, was revealed as an oddly intricate sequence of attitudes and relationships.

Beginning in the early 1870s, several international figures took up this quest with scientific rigor. The most important of these were Etienne-Jules Marey, in France, and Eadweard Muybridge, in the United States. Marey entered this field as early as 1859, using a variety of devices other than the camera to measure or graph the physiology of motion.[58] The results of this work were published in his 1873 book *La machine animale* (issued in English in 1874). This volume had a marked impact on Eadweard Muybridge, who had already begun exploring the application of photography to this problem.

Muybridge began his photographic studies of motion in 1872, with the sponsorship of former California governor Leland Stanford. According to legend, Stanford entered into a bet with friends as to whether a racehorse had all four feet off the ground at any point in its stride. Since this action took place much too rapidly to be determined by the unaided human eye, it was logical to call upon the camera's objective testimony. While the concept was simple, this work ended up taking several years. There were major technical hurdles to clear, and Muybridge's research was interrupted by his trial for murder and—after his acquittal—his temporary, self-imposed exile in Latin America.

By the time Muybridge returned to this effort in 1876, the goal had become even more ambitious: a photographic record of the full sequence of a running horse's stride. This required an elaborate arrangement—a bank of up to a dozen cameras connected by an electrical triggering mechanism—to ensure that photographs were made at precise and equal intervals. After months of experimentation, Muybridge achieved success in June 1878. To ensure maximum publicity—and, presumably, to guard against accusations of fraud—he invited the press to witness this work at Stanford's Palo Alto stock farm. Over a period of several days, Muybridge made dramatic sequential studies of several of Stanford's horses, including "Abe Edgington" on June 15, "Mahomet" on the 18th, and "Sallie Gardner" on the 19th [464]. All these images were accompanied by precise technical information. For example, "Sallie Gardner" was recorded in motion by eleven cameras, set 27 inches apart, and triggered at intervals of 1/25th of a second. The time of each exposure was astonishing: in Muybridge's own words, it was "less than the two-thousandth part of a second."

Six cabinet cards, all copyrighted by Muybridge, were issued from these sessions under the collective title "The Horse in Motion."[59] These images proved conclusively that a running horse lost contact with the ground on each stride. More importantly, they marked a revolution in seeing. Marey saw these photographs in Paris and was prodded to incorporate the camera into his own investigations. After viewing the photographs in Philadelphia, Eakins entered into a deepening engagement with both photography and the representation of motion. He corresponded with Muybridge and used the Palo Alto photographs in his teaching at the Pennsylvania Academy of the Fine Arts. By 1881, he had taken up the camera himself. In 1884, Eakins was instrumental in bringing Muybridge to the University of Pennsylvania to continue the work begun in California. Influenced by Muybridge's example, Eakins made his own photographic explorations of human motion in 1884-85.[60] Further, Muybridge's visual sequences of 1878 were designed to be transformed into "moving pictures" in the zoopraxiscope, a prototype of the film projector. This line of research led to the development of the modern motion picture in the mid-1890s.[61]

After the publication of his book *The Attitudes of the Horse in Motion* (1881) and a triumphant lecture tour of Europe, Muybridge began a vastly larger photographic study of motion at the University of Pennsylvania. Over a period of two years, from the spring of 1884

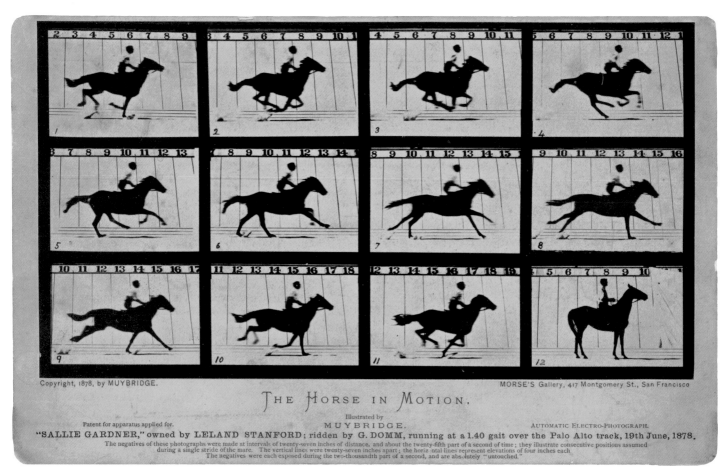

464　Eadweard Muybridge, *The Horse in Motion: "Sallie Gardner,"* June 19, 1878

to early 1886, he produced more than 20,000 plates of human and animal subjects. In an outdoor studio on the university grounds, he photographed men, women, and children—clothed and nude—engaged in a remarkable and sometimes bewildering variety of activities. He also took his apparatus to the Gentlemen's Driving Park to record running horses, and to the Philadelphia Zoological Garden to document more exotic animals. The result of this Herculean labor was published in 1887: an enormous folio of 781 collotype plates titled *Animal Locomotion*. The plates of this work are sequential views of simple individual actions, arranged systematically in grids. Most of these studies were made with two or three banks of a dozen cameras each, allowing each recorded action to be seen from a corresponding number of perspectives. The result is a curious kind of objectivity—at once scientifically correct, but alien to normal visual experience. By multiplying space and fracturing time, Muybridge emphasized the implicit strangeness of the most ordinary things. However subtly, the meaning of the world—and of human perception—was forever changed.[62]

The Dry-Plate Revolution

The quest for a practical dry negative process began with the rise to dominance of the wet-collodion technique. Notably, these experiments with dry emulsions were typically not conducted by full-time photographers. Work-a-day professionals happily accepted the wet-collodion process, fully aware of its advantages over earlier techniques. Instead, it was mostly amateur photographers or chemists who fussed with dry-plate recipes—only they had the time to devote to such speculative, trial-and-error work. The crux of the problem lay in making dry emulsions that were consistent and predictable in operation, with a sensitivity comparable to wet collodion. Various formulas were tried in the 1860s and early 1870s, but with little success: dry emulsions remained far less sensitive to light than wet ones.

In the mid-1870s, emulsions of dry collodion, albumen, and gelatin were tried in combination with preservatives such as tea, coffee, beer, tobacco, and other more exotic substances. As a result of this labor, however, the tide was finally turning: the photographic journals were full of articles on dry processes in 1877 and 1878. Indeed, by mid-1878, the ultimate dominance of the new technology seemed assured, although its timing was still uncertain. The remaining tasks—significant ones—were for manufacturers to make plates that were affordable, fast, and consistent.

Beginning in 1878, there was enough demand in the United States for the Anthony and Scovill companies to begin importing dry plates from Europe. Scovill began its own production in 1879, and Anthony followed a year later.[63] In this period, dry plates appealed primarily to the modest but growing number of amateurs. Professionals remained leery of them: not only were the new plates expensive, they required longer exposures and were less consistent in operation. The byword of professional practice was dependability: studio photographers needed to be sure that that they could make a good negative on the first try, without guesswork. Professionals of the day knew exactly how to do this with the wet-collodion technique, since they prepared those negatives themselves. In these years, store-bought dry-plates were a very different proposition; they were prone to inconsistency, which meant wasted time and money.

The risk of early dry plates is illustrated in a defining episode in the history of George Eastman's business.[64] In early 1882, Eastman's fledgling dry-plate company in Rochester, New York, was hit by a major crisis. In February of that year, photographers began returning Eastman's plates with the complaint that they came up fogged or registered no image at all. It soon became clear that his entire previous few months' production was flawed. Eastman shut his factory to devote all his energy to fixing the problem. After more than 450 experiments—tests of every conceivable variation of each step of the manufacturing process—the mystery remained unsolved. In early March, Eastman sailed to England to visit the firm that supplied most of his raw materials. After a few days, the answer was found in the gelatin used to bind the light-sensitive emulsion to the glass support. Eastman's faulty negatives had been made with gelatin from a new supplier. This new gelatin was slightly different in chemical composition from the previous supply, and it was this small variation that had ruined the most recent batch of negatives. Eastman corrected the problem, offered photographers a 25 percent discount to try his product again, and was back in the market by June. His dedication to resolving the matter as quickly and fairly as possible won the respect of his business partners and customers.

That year saw something of a sea-change in the acceptance of the new plates. Amateurs, who had always preferred the dry process for its convenience, were growing rapidly in number. Just as significantly, between about 1882 and 1885, most professionals dropped the wet-collodion process for the new technique. Thanks to steady improvements in the precision of manufacture, dry plates were now dependably consistent. They were also very fast—by one account, at least eight times more sensitive than wet-collodion negatives. This increased sensitivity was a great boon to professionals: portraits could now be made in any weather and of the youngest and most fidgety subjects. The only drawback to this new speed involved the potential for fogged negatives. Photographers had to be more careful about light leaks in their plate holders, camera bellows, and darkrooms. Finally, while professionals had originally resisted the relatively high cost of dry plates, prices came down as production volume rose and competition between manufacturers increased. In 1879, a few American businesses had produced dry plates in relatively small numbers and for primarily local markets. By the end of 1883, no fewer than twenty-eight American firms were in this business and were shipping plates to vendors as far away as India and China.[65]

The shift to dry plates profoundly changed the nature of photography. The dry plate separated forever the act of taking photographs from the technical skills required to prepare the original light-sensitive matrix (the daguerreotype plate or wet-collodion negative). This opened the medium to a vast new army of amateur enthusiasts. In 1881, the Anthony firm began marketing a 4 x 5-inch camera outfit for only $10 in the national ad campaign "Dry Plate Photography for the Million."[66] In early 1882, cameras were marketed in even smaller formats (2 ¼ x 3 ¼ inches), complete with lens, tripod, and other necessities. In 1883, the first truly hand-held model, William Schmid's 3 ¼ x 4 ¼-inch format Patent Detective Camera, was introduced by Anthony. By eliminating the need for a tripod, this simple camera allowed pictures to be made with unprecedented spontaneity.[67]

At the same time, great effort was devoted to an even cheaper and more democratic system: roll-film technology. This surprisingly difficult challenge was met in 1888 with the introduction of Eastman's Kodak, the first truly successful roll-film camera. The Kodak was radical both as a work of technology and as an idea. With dimensions of 6 ½ x 3 ½ x 3 ¼ inches, and a weight of only two pounds, the

Kodak was smaller and lighter than any other camera of the day. It sold for $25, already loaded with a 100-shot roll of film. Once this roll had been exposed, the entire camera was mailed back to Eastman's factory in Rochester. There, technicians developed the exposed film, made prints of each image, and installed a fresh 100-shot roll. The reloaded camera, negatives, and prints were then mailed back to the customer. Eastman's memorable advertising slogan, "You Press the Button—We Do the Rest," said it all. For the first time in history, all technical or craft barriers to the making of photographs had been removed. After spending the requisite money, all a photographer had to do now was simply to point and shoot.

This photographic revolution had many facets: it was at once technical, social, and aesthetic. It changed forever the business and the demographics of photography; it also made possible an entirely new kind of picture.

Until the late 1870s, photography had been a remarkably singular enterprise. Whatever their other differences (and there were many), nearly everyone who operated a camera did so as a professional. The implications of this shared professionalism were at least two-fold. All photographers sought to serve the needs of their consumers or employers. According to guild-based assumptions and practices, professionalism also implied a basic level of technical expertise. Thus, by the nature of the competitive market, it was nearly impossible to be either an inept (professional) photographer or to work in a purely self-expressive manner.

The dry-plate revolution altered these "rules" in fundamental ways. From a business standpoint, the production of key photographic materials changed from a craft-based enterprise to an industrial one. Photographers before 1880 used highly specialized skills to prepare their daguerreotype plates or wet-collodion negatives; after 1880, they purchased factory-made negatives in boxes. While some expertise was required to correctly expose and process these new dry plates, these skills were not remotely comparable to what had been demanded of earlier photographers. From a technical standpoint, the process was radically homogenized: individual experiences and techniques were replaced by standardized procedures and industrial products.[68] This was a strictly "one-way" paradigm shift. Once photographers became dependent on high-industrial processes and centralized sites of manufacture, there was no returning to the days of the independent artisan. What had typically been a unified creative process—beginning with an understanding of chemistry and the preparation of light-sensitive materials—was abbreviated and simplified by industrialization. Manufacturers of dry plates were not required to take the slightest interest in the images made from their negatives, and photographers gave no thought to such details as the chemical makeup of gelatin.

As a result of these changes, the field of photography was radically enlarged and diversified. What had been an essentially unified practice was split into two dramatically different classes: professionals and amateurs. Professionalism flourished with the introduction of the dry plate. There were more subjects to be photographed than ever before, and the demand for routine studio portraiture continued to grow. At the same time, photography was now a broadly popular pastime. American families had earlier kept carte-de-visite or cabinet-card albums in the parlor; now they made snapshots with their own cameras. The rapid rise of amateur photography had several professional implications. On one hand, professionals were no longer needed for the most routine photographs—simple records of babies, new houses, and similar subjects. On the other, the amateur demand for cameras and supplies vastly expanded existing networks of manufacturing and distribution and created new disciplines, such as photo-finishing. Far from threatening the domain of the professional, the amateur market redefined and expanded it.

Professional and amateur photographers thought about the medium in different ways. Professionals had specialized knowledge and skills and were expected to produce work of a certain quality and consistency. Many amateurs had no technical knowledge whatever and—we can guess—aimed simply to achieve recognizable likenesses of their chosen subjects. The social status of a professional photographer was connected, at least in part, to the quality of their work. For most amateurs, the camera was simply a useful tool or a pleasant amusement. Not surprisingly, there was a world of difference between the photographs produced by these two groups. Professional work was technically refined and of consistently "public" or commercial quality. Amateur snapshots were endearingly small, simple, and personal.

Significantly, however, this flood of untutored and unselfconscious photographs produced a new visual language. This aesthetic, embodied in the notion of the snapshot, was a product of both amateur informality and the new speed of cameras and films. As demonstrated in this 1885 photograph by J. G. Doughty [465], this was a vision of pure optical contingency: elements are both in and out of focus, and pictorial space is effectively collapsed by the odd conjunction of the foreground man and background balloon. Professional photographers before this time had typically worked to suppress such evidence of the camera's "raw" optical/mechanical nature. The makers of snapshots were not bound by the same ideals, constraints, or conventions. Their millions of photographs, lovingly and often playfully made, represented an entirely fresh way of seeing. This was a vision based not on borrowed notions of "art" or guild standards of competence, but on the syntactical peculiarities of the medium itself. This radical new vision was slow to be absorbed into anything approaching mainstream artistic discourse. It did, however, play a key role in various avant-garde twentieth-century photographic movements.

A critically important third category of photographer—the artistic amateur—began to take shape in the late 1880s and early 1890s. These photographers sought to occupy the ground between the realms of the work-a-day professional and the casual Kodaker. These artistic amateurs viewed professional work as technically accomplished but banal—an expression of utterly conventional ideas about the world and the medium. They saw snapshots as lively but trivial—embodying few, if any, creative ideas. While these judgments were far from entirely fair, they served to define a potent new set of photographic values and ambitions; they represented a rallying call to a cause. This new class of photographers took pride in their technical abilities, but disdained commerce; they worked for themselves, but aimed for something higher than simple records of the everyday world. Borrowing from the idealistic rhetoric of the 1850s daguerreotypists, these late nineteenth-century aesthetes sought to make pictures that were poetic and elevating. These sentiments, which crystallized as the Pictorialist movement around 1900, led to a pivotal chapter in the great historical debate about photography's artistic status. But that is another story, in another century.

465 **J.G. Doughty**, *Balloon Launch*, 1885

Notes

CHAPTER I
The Pioneering Generation: 1839-1843

[1] "New Discovery in the Fine Arts," *New-Yorker* 7:4 (April 13, 1839): 49-50. An abbreviated version of this text is reprinted in Merry A. Foresta and John Wood, *Secrets of the Dark Chamber: The Art of the American Daguerreotype* (Washington, D.C.: National Museum of American Art/Smithsonian Institution Press, 1995): 223-24. The *New-Yorker* text is derived from *Blackwood's Edinburgh Magazine* [New York: New American edition, vol. 8] 281:45 (March 1839): 383-90.

[2] For a broad overview of the use and importance of the camera obscura (and a host of other optical games and devices), see Martin Kemp, *The Science of Art: Optical Themes in Western Art from Brunelleschi to Seurat* (New Haven: Yale University Press, 1990); Barbara Maria Stafford and Frances Terpak, *Devices of Wonder: From the World in a Box to Images on a Screen* (Los Angeles: Getty Research Institute, 2001); and Laurent Mannoni et al., *Eyes, Lies, and Illusions* (London: Hayward Gallery, 2004). The many specialized studies include Arnaud Maillet, *The Claude Glass: Use and Meaning of the Black Mirror in Western Art* (New York: Zone Books, 2004); Philip Steadman, *Vermeer's Camera: Uncovering the Truth Behind the Masterpieces* (Oxford: Oxford University Press, 2001); and Jean-Luc Delsaute, "The Camera Obscura and Painting in the Sixteenth and Seventeenth Centuries," in Ivan Gaskell and Michiel Jonker, eds., *Vermeer Studies*, Studies in the History of Art 55 (Washington, D.C.: National Gallery of Art, 1998): 110-24.

[3] For a short summary of this history, see M. Susan Barger and William B. White, *The Daguerreotype: Nineteenth-Century Technology and Modern Science* (Washington, D.C.: Smithsonian Institution Press, 1991): 12-16. A considerably longer discussion is contained in Josef Maria Eder, *History of Photography*, trans. Edward Epstean (New York: Columbia University Press, 1945; repr. New York: Dover, 1978).

[4] Barger and White, *The Daguerreotype*, p. 14.

[5] The fifth halogen, astatine (atomic weight 85), is scarcely more than a theoretical element. First produced in a laboratory in 1940, it is highly radioactive and wildly unstable. A recent popular survey of the elements notes: "Total world production of astatine to date is estimated to be less than a millionth of a gram, and virtually all of this has now decayed away. A piece of this element has never been seen with the naked eye, and it is unlikely that enough will ever be made to make this possible." John Emsley, *Nature's Building Blocks: An A-Z Guide to the Elements* (New York: Oxford University Press, 2001): 48.

[6] The following is indebted to these essential works by Jean-Louis Marignier: *Nicéphore Niépce, 1765-1833, L'Invention de la Photographie* (Paris: Belin, 1999); "Heliography: The Photographic Process Invented by Nicéphore Niépce Before his Association with Daguerre. New Light on the Invention of Photography," *Daguerreian Annual 1996* (Pittsburgh: Daguerreian Society, 1997): 52-63; and "The Physautotype: The World's Second Photographic Process, Invented by Niépce and Daguerre in 1832," *Daguerreian Annual 2002-2003* (Pittsburgh: Daguerreian Society, 2004): 350-62.

[7] Barger and White, *The Daguerreotype*, p. 18.

[8] Conventional scholarship has speculated that Niépce's exposure was roughly a full day. More recent research by Jean-Louis Marignier suggests otherwise. See Marignier, "Heliography," p. 58.

[9] My thanks to Grant B. Romer for his insight on this point, and on many other aspects of this pivotal era.

[10] For the story of the rediscovery of this work in 1952, see Helmut Gernsheim, "The 150th Anniversary of Photography," *History of Photography* 1:1 (January 1977): 3-8. On Niépce's activities in England, see Marignier, *Niépce: L'Invention de la Photographie*, pp. 225-42.

[11] On Daguerre's early career, see the following essays by Barry V. Daniels: "Notes on the Panorama in Paris," *Theatre Survey* 19 (November 1978): 171-76; "Cicéri and Daguerre: Set Designers for the Paris Opera, 1820-1822," *Theatre Survey* 22 (May 1981): 69-90; "A Footnote to Daguerre's Career as a Stage Designer," *Theatre Survey* 24 (1983): 134-37; and "L. J. M. Daguerre: A Catalogue of his Stage Designs for the Ambigu-Comique Theatre," *Theatre Studies* 28-29 (1987-88): 5-40; as well as Stephen Christopher Pinson, *Speculating Daguerre* (Ph.D. dissertation, Harvard University, May 2002).

[12] For a contemporary account of the London Diorama, see Jeffreys Taylor, *A Month in London: Or, Some of its Modern Wonders Described* (London: Harvey and Darton, 1832[?]): 71-78. Courtesy Gary W. Ewer. For discussion of the Diorama in the larger context of the tradition of the panorama, see Stephan Oettermann, *The Panorama: History of a Mass Medium* (New York: Zone Books, 1997): 69-83.

[13] In addition to Marignier's work, I am indebted to Mark Osterman for showing me his own examples of the physautotype process and to Grant B. Romer for emphasizing the originality and collaborative nature of this discovery.

[14] See also Christopher Nisperos, "Rediscovering Niépce, Photography's Inventor," *Photo Techniques* 26:6 (November/December 2005): 16-19; and Peggy Ann Kusnerz, "'At First Light': A Conference Report," *History of Photography* 28:2 (Summer 2004): 165-72.

[15] The first published notice on his photographic process appears to be that in the September 27, 1835, issue of the *Journal des Artistes*; see Bates Lowry and Isabel Lowry, *The Silver Canvas: Daguerreotype Masterpieces from the J. Paul Getty Museum* (Los Angeles: J. Paul Getty Museum, 1998): 12.

[16] Helmut Gernsheim and Alison Gernsheim, *L. J. M. Daguerre: The History of the Diorama and the Daguerreotype*, 2nd revised edition (New York: Dover Publications, 1968): 74; and Helmut Gernsheim, *The Origins of Photography* (New York: Thames and Hudson, 1982): 42-43.

[17] Gernsheim and Gernsheim, *L. J. M. Daguerre*, pp. 78-79.

[18] As it turned out, the daguerreotype was covered by patent restrictions in England, hampering its popularity and development there.

[19] The scholarly literature on Talbot's life and work is superb. See, for example, H. J. P. Arnold, *William Henry Fox Talbot: Pioneer of Photography and Man of Science* (London: Hutchinson Benham, 1977); Gail Buckland, *Fox Talbot and the Invention of Photography* (Boston: David R. Godine, 1980); and the definitive works by Larry J. Schaaf, which include *Out of the Shadows: Herschel, Talbot & The Invention of Photography* (New Haven: Yale University Press, 1992); *Records of the Dawn of Photography: Talbot's Notebooks P & Q* (Cambridge: Cambridge University Press, 1996); and *The Photographic Art of William Henry Fox Talbot* (Princeton: Princeton University Press, 2000).

[20] Cited in Schaaf, *Out of the Shadows*, p. 75.

[21] Two other early first-hand accounts are worthy of mention. Robert Walsh, consul general of the United States in Paris, reported on his March 3, 1839, visit with Daguerre in the *New-York American* 21:7300 (May 22, 1839). John Robison, who likely accompanied Herschel as part of the "small party of English gentlemen who were lately invited to visit the studio of M. Daguerre," subsequently wrote: "Perfection of the Art, as stated in Notes on Daguerre's Photography," *American Journal of Science and Arts* [New Haven] 37:1 (July 1839): 183-85; repr. from "Edinb. Journ." Courtesy Gary W. Ewer.

[22] It appears that Daguerre's official manual may not have been available in Paris until September 7, 1839. See Pierre G. Harmant, "Daguerre's Manual: A Bibliographical Enigma," *History of Photography* 1:1 (January 1977): 79-83.

23 Beaumont Newhall, *The History of Photography* (New York: Museum of Modern Art, 1982): 23. For a full list of these variations, see Beaumont Newhall, *An Historical and Descriptive Account of the Various Processes of the Daguerreotype and the Diorama by Daguerre* (New York: Winter House, 1971): 267-77.

24 Considerable intellectual effort has been expended on the question of why photography arose when and where it did. The results of these speculative projects have been stimulating if ultimately less than fully convincing. See, for example, Peter Galassi, *Before Photography: Painting and the Invention of Photography* (New York: Museum of Modern Art, 1981); and Geoffrey Batchen, *Burning with Desire: The Conception of Photography* (Cambridge, Mass.: MIT Press, 1997). Jonathan Crary's *Techniques of the Observer: On Vision and Modernity in the Nineteenth Century* (Cambridge, Mass.: MIT Press, 1990) concerns itself with the visual culture of the 1830s and 1840s, rather than with photography itself. For a recent summary of the problems of this theoretical enterprise, see James Elkins, ed., *Photography Theory* (New York: Routledge, 2007). I agree in large measure with Joel Snyder's concluding remarks in his review of Batchen's book:

> One narrative of the period of photographic invention that remains to be told will be a rather untidy affair in which broad general principles and imputed inchoate desires will give way to detailed discussions of competing pictorial metaphors, an examination of prevailing pictorial standards, a review of the availability and use of "philosophical toys" (camera obscurae, kaleidoscopes, and mechanical models of the human eye), a patient recounting of partial experimental successes. These will constitute a story in which confusion and the repeated absence of clear, specifiable purposes will be seen to be the enabling conditions for the invention of the earliest practical photographic processes. The story will begin in chaos, without desire. We have read this story before. It is the details that will make it compelling.

Art Bulletin 81:3 (September 1999): 542. In this light, I would note Mike Ware's fascinating essay, "Luminescence and the Invention of Photography: 'a vibration in the phosphorus,'" *History of Photography* 26:1 (Spring 2002): 4-15; and Janet E. Buerger, "The Genius of Photography," in John Wood, ed., *The Daguerreotype: A Sesquicentennial Celebration* (Iowa City: University of Iowa Press, 1989): 43-59, a welcome reappraisal of the importance of Daguerre's Diorama.

25 Batchen, in *Burning with Desire* (p. 50), lists nineteen genuine and possible "proto-photographers" before 1839.

26 For an analysis of Talbot's conflicted attitudes toward capitalist enterprise, see Nancy Keeler, "Inventors and Entrepreneurs," *History of Photography* 26:1 (Spring 2002): 26-33.

27 William Welling, *Photography in America* (New York: Thomas Y. Crowell, 1978): 7.

28 The standard histories of early photography in America include Robert Taft, *Photography and the American Scene, A Social History 1839-1889* (New York: Macmillan, 1938); Beaumont Newhall, *The Daguerreotype in America* (1961; third revised edition, New York: Dover Publications, 1976); Richard Rudisill, *Mirror Image: The Influence of the Daguerreotype on American Society* (Albuquerque: University of New Mexico Press, 1971); Welling, *Photography in America*; and Floyd Rinhart and Marion Rinhart, *The American Daguerreotype* (Athens: University of Georgia Press, 1981).

29 Brief reports of Daguerre's process were published in late February: "Remarkable Invention," *Boston Daily Advertiser* (February 23, 1839), and "Extraordinary Chemical and Optical Discovery," *Boston Mercantile Journal* 4:441 (February 26, 1839). Other reports quickly followed: "Self-Operating Processes of Fine Art—The Daguerreotype," in *Museum of Foreign Literature, Science and Art* [Philadelphia] 35 (March 1839): 341-43 [repr. from the *Spectator* [London] (February 2, 1839)]; "Chemical and Optical Discovery," in the *Christian Register and Boston Observer* 18:10 (March 9, 1839): 40 ["from the Paris Constitutionnel"]; "The Daguerreotype," in the *Albion, or British, Colonial, and Foreign Weekly Gazette* [New York] 1:14 (April 6, 1839): 109; "The Pencil of Nature—A New Discovery," in the *Corsair: A Gazette of Literature, Art, Dramatic Criticism, Fashion and Novelty* [New York] 1:5 (April 13, 1839): 70-72; and issues of the *New-Yorker*: "Important Discovery," 7:1 (March 23, 1839): 8, "New Discovery in the Fine Arts," 7:4 (April 13, 1839): 49-50, and "New Discovery in the Fine Arts—The Daguerreotype," 7:5 (April 20, 1839): 70-71. My thanks to Gary W. Ewer for bringing several of these little-known references to my attention. Several of these texts are available in transcription on the Daguerreian Society web site: www.daguerre.org.

30 The following discussion is indebted to Geoffrey Batchen's article "'Some Experiments of Mine': The Early Photographic Experiments of Samuel Morse," *History of Photography* 15:1 (Spring 1991): 37-42. Another American proto-photographer may have been James M. Wattles, a young man from Indiana. Writing in 1849, Henry Hunt Snelling reported that Wattles had experimented with exposing sensitized paper in a camera obscura in 1828. See Henry Hunt Snelling, *The History and Practice of the Art of Photography* (New York: G. P. Putnam, 1849): 11-12.

31 From Morse's letter, "The Daguerreotipe [sic]," *New-York Observer* 17:16 (April 20, 1839): 62. Also cited in Taft, *Photography and the American Scene*, pp. 11-12. For a full transcription, see the Daguerreian Society web site, www.daguerre.org.

32 The Rinharts note that Morse's letter "was estimated to have been reprinted in more than two hundred newspapers and periodicals." Rinhart and Rinhart, *The American Daguerreotype*, p. 19.

33 Morse, "The Daguerrotipe."

34 "Notes of the Month: Photogenic Drawing," *United States Magazine and Democratic Review* 5:17 (May 1839): 517-19. The following month's issue contained another short report on the subject, with a mention of the experiments of Professor Locke in Cincinnati; 5:18 (June 1839): 611-12. Courtesy Gary W. Ewer.

35 In the intervening months, several fanciful reports on the process appeared in the popular press. See, for example, "Letter from an Idle Merchant," *New-York Mirror: A Weekly Journal of Literature and the Fine Arts* 17:4 (July 20, 1839): 31. Transcription on Daguerreian Society web site; courtesy Gary W. Ewer.

36 For a fascinating analysis of key aspects of this history (and for a critique of the standard accounts of Robert Taft and Beaumont Newhall), see R. Derek Wood, *Arrival of the Daguerreotype in New York* (New York: American Photographic Historical Society, 1994). In *Robert Cornelius: Portraits from the Dawn of Photography* (Washington, D.C.: National Portrait Gallery/Smithsonian Institution Press, 1983), William F. Stapp ventures (p. 27) that "the first detailed reports on Daguerre's process to reach the United States probably arrived on the steamship *Great Western*, which sailed from Bristol, England, on August 24, and docked in New York on September 10, 1839." Gary W. Ewer has reviewed the *New-York Evening Post* for this period, and found the *London Globe* account in the issue for September 23, 1839. This would appear to support the earlier accounts of Taft and Newhall, who both credit the *British Queen*, which arrived in New York on September 20, for bringing the first description of Daguerre's process to America. This was copied from a London paper of August 23, which appears to have arrived in New York on September 20 on board the steamship *British Queen*. The *Post* article was followed by "Principle of the Daguerreotype," *New-Yorker* 8:2 (September 28, 1839): 19-20; repr. from *Athenaeum: Journal of Literature, Science and the Fine Arts* [London] 617 (August 24, 1839): 636-37. Courtesy Gary W. Ewer.

37 Taft, *Photography and the American Scene*, p. 14.

38 "Principle of the Daguerotype [sic]," *Albion* [New York] 1:43 (October 26, 1839): 338. Courtesy Gary W. Ewer.

39 "The Daguerreotype," *New-York Observer* 17:44 (November 2, 1839): 176. This text was derived from the J. S. Memes translation of Daguerre's manual, as published in London. My thanks to Gary W. Ewer and Stephen White for this important reference.

40 "Practical description of the process called the Daguerreotype," *Journal of the Franklin Institute* [Philadelphia] 24:5 (November 1839): 303-11.

41 For the meager details of Seager's life, see Taft, *Photography and the American Scene*; and R. Derek Wood, *Arrival of the Daguerreotype*. The latter discusses Seager's claim of the period that his first daguerreotype was actually made on September 26, 1839, rather than on the 27th.

42 Samuel F. B. Morse, "Who Made the First Daguerreotype in this Country?" *Photographic and Fine Art Journal* 8:9 (September 1855): 280.

43 For a survey of Draper's career and photographic interests, see Deborah Jean Warner, "The Draper Family Material, National Museum of American History," *History of Photography* 24:1 (Spring 2000): 16-23. For a period biography/obituary, with a wood-engraved portrait, see "John William Draper," *Harper's Weekly* 26:1312 (February 11, 1882): 85. Also of interest is Howard R. McManus, "'It Was I Who Took the First': An Investigation into Professor Robert Taft's Assessment of Whether Dr. John William Draper Took the First Portrait," *Daguerreian Annual 1996* (Pittsburgh: Daguerreian Society, 1997): 70-100; "The Most Famous Daguerreian Portrait: Exploring the History of the Dorothy Catherine Draper Daguerreotype," *Daguerreian Annual 1995* (Pittsburgh: Daguerreian Society, 1995): 148-71; and McManus's web site, "Into the Light," www.historybroker.com/light/web/lighti.htm.

44 On West, see Evelyn Clark Morgan, "The First Camera Victim in America," *Photo Era* 4:1 (January 1900): 13; and Julius F. Sachse, "The Daguerreotype in America," *American Journal of Photography* (December 1896): 552-57. A number of others claimed to have made daguerreotypes in the fall of 1839. For the reminiscence of one of these, see J. B. Gardner, "The Daguerreotype Process," *Anthony's Photographic Bulletin* 20 (April 13, 1889): 214-16.

45 See "The First Photographic Gallery," *American Journal of Photography and the Allied Arts & Sciences* 4:2 (June 15, 1861): 41; and "The Bromine Discovery Question," *American Journal of Photography and the Allied Arts & Sciences* 6:15 (February 1, 1864): 343-47, 350-51, and 359-60. Johnson wrote a series of detailed articles on his early daguerreotype experiences for the journal *Eureka; or, The Journal of the National Association of Inventors*, from issue 1:1 (September 1846) through 1:6 (February 1847). Courtesy Gary W. Ewer.

46 Floyd Rinhart and Marion Rinhart, "Wolcott and Johnson; Their Camera and their Photography," *History of Photography* 1:2 (April 1977): 134.

47 Welling notes that this is extremely likely (*Photography in America*, p. 10). Wolcott was clearly a brilliant young man. His personality is suggested in a warm obituary notice, which includes the following:

> Mr. Wolcott's genius was not confined to one class of subjects, but embraced the whole range of mechanical skill. His inventions comprise improvements in the steam-engine, horology, engraving, &c., and the disease which terminated his life was contracted by too close application to some extremely valuable improvements in the manufacture of cotton. He delighted most, however, in those inventions which involved the application of Science. He possessed a fertility of invention,

and a knowledge of natural laws, rarely found united. The production of an ingenious mechanical contrivance, which always came from his hand, simple, perfect, and well adapted to the purpose for which it was intended, was often but the toy of a moment of relaxation, an impromptu suggested by a passing remark, or the embodiment of his genius for the entertainment of a friend; he sported with these things as the artist sports with his pencil…

"Obituary Notice of A. S. Wolcott, Esq.," *American Journal of Photography* 4:22 (April 15, 1862): 526 (repr. from a paper of 1844).

48 Wolcott's own report of this work is recorded in "The Daguerreotype," *Family Magazine* 7 (1840): 462-63. See also Taft, *Photography and the American Scene*, pp. 33-34; and Rinhart and Rinhart, "Wolcott and Johnson; Their Camera and their Photography," pp. 129-34.

49 *New-York Observer* (November 2, 1839), n.p.

50 "A Veteran Photographer," *Photographic Times* 25 (August 24, 1894): 134.

51 For Insley's own reminiscence of this early period, see "The Early Days," *Anthony's Photographic Bulletin* 14:19 (September 1883): 313-14.

52 For a later perspective on this subject, see Julius F. Sachse, "Philadelphia's Share in the Development of Photography," *Journal of the Franklin Institute* 135:4 (April 1893): 271-87.

53 This text was apparently published the same day (September 25, 1839) in the *United States Gazette*. See Stapp, *Robert Cornelius*, p. 28.

54 Marcus Aurelius Root, *The Camera and the Pencil; or The Heliographic Art* (Philadelphia: M. A. Root/Lippincott, 1864; repr. Pawlet, Vt.: Helios, 1971): 351. For information on Saxton's life and work, see "Biographical Memoir of Joseph Saxton," *Biographical Memoirs, Vol. I, National Academy of Sciences* (Washington, D.C.: Academy of Sciences, 1877): 289-316; Arthur H. Frazier, *Joseph Saxton and His Contributions to the Medal Ruling and Photographic Arts* (Washington, D.C.: Smithsonian Institution Press, 1975) and "Joseph Saxton's First Sojurn at Philadelphia," *Smithsonian Journal of History* 3:2 (Summer 1968): 45-76; and Albert M. Rung, "Joseph Saxton: Pennsylvania Inventor and Pioneer Photographer," *Pennsylvania History* 7:3 (July 1940): 153-58.

55 This has traditionally been dated to October 16, but Stapp makes an argument that it may have been taken as early as September 25. Stapp, *Robert Cornelius*, p. 29.

56 Root noted that "[Saxton's] heliographs naturally created no small excitement among the curious in such matters; and from this date many of our Philadelphia savants began cultivating the art." Root, *The Camera and the Pencil*, pp. 351-52.

57 Root, *The Camera and the Pencil*, pp. 354-55; and Rinhart and Rinhart, *The American Daguerreotype*, p. 29. See also William A. Cornelius, "Brief History of Robert Cornelius," *Papers Read before the Historical Society of Frankford* 3:5 (1937): 110-13; and Marian Sadtler Hornor, "Early Photography and the University of Pennsylvania," *General Magazine and Historical Chronicle* (January 1941): 3-12.

58 For an early report of Cornelius's skills—and his talents as a ventriloquist—see *Godey's Lady's Book* [Philadelphia] 20 (April 1840): 190. Transcription on Daguerreian Society web site. Courtesy Gary W. Ewer.

59 This plate is featured on the cover of Stapp, *Robert Cornelius*, and is now in the collection of the Library of Congress.

60 As Welling notes, this was made with the assistance of colleagues in the University of Pennsylvania's chemistry department, Dr. Hare and Dr. Martin Boyé. Welling, *Photography in America*, p. 13. The first use of bromine as an accelerator was a matter of considerable dispute in the nineteenth century. John Johnson's perspective on the matter is recorded in "The Bromine Discovery Question," *American Journal of Photography* 6:15 (February 1, 1864): 343-47.

61 One often-repeated story of early experiments with the daguerreotype—in Lexington, Kentucky, in late 1839 by Dr. James M. Bush and Dr. Robert Peter, of the Medical Department of Transylvania University—has been cast into serious doubt. See Taft, *Photography and the American Scene*, pp. 20-21; Rinhart and Rinhart, *The American Daguerreotype*, p. 30; and Gerald J. Munoff, "Dr. Robert Peter and the Legacy of Photography in Kentucky," *Register of the Kentucky Historical Society* 78:3 (Summer 1980): 208-13.

62 Root, *The Camera and the Pencil*, p. 353. This would suggest a date of late September or very early October, 1839.

63 Perkins's extant plates are in the collection of the Newburyport Historical Society, and I thank Jay Williamson and Scott Nason for the opportunity to view them. For basic information on Perkins and his plates, see John Wood, "News and Reviews," *Daguerreian Society Newsletter* 5:3 (May 1993): 2-3. As Wood notes, Perkins himself recalled beginning with the daguerreotype "about the first of Nov., 1839." However, two of his whole plates are marked in a nineteenth-century hand (but not that of Perkins) "Oct. 1839" and "Oct. 30, 1839." The first newspaper notice on Perkins's pictures was published in the November 8, 1839, issue of the Newburyport *Watchtower*. For a later biographical sketch, see Samuel J. Spalding, "Memoir of Henry Coit Perkins," *Historical Collections of the Essex Institute* 12 (1873): 1-34.

64 See William Salzillo, "Professor Charles Avery and Early Photography," *Hamilton Collects Photography: The First 100 Years* (Clinton, N.Y.: Emerson Gallery, Hamilton College, 2003): 33-41. Avery described his daguerreian activities in an unpublished manuscript, "Autobiography of Charles Avery" (1881), pp. 69-71;

65 Ross J. Kelbaugh, "Dawn of the Daguerreian Era in Baltimore, 1839-1849," *Maryland Historical Magazine* 84:2 (Summer 1989): 102.

66 Taft, *Photography and the American Scene*, p. 39.

67 On the early history of U.S. photographic patents, see Janice G. Schimmelman, *American Photographic Patents: The Daguerreotype & Wet Plate Era, 1840-1880* (Nevada City, Calif.: Carl Mautz, 2002). This camera is shown in use in a wood engraving accompanying the humorous poem "Photographic Phenomena, or the New School of Portrait-Making," *George Cruikshank's Omnibus* (London: Tilt & Bogue, 1842): 29-32. Courtesy Gary W. Ewer.

68 "The First Photographic Gallery," *American Journal of Photography* 4:2 (June 15, 1861): 41.

69 They were reported at this address by March 13, 1840; see Taft, *Photography and the American Scene*, p. 34. Johnson later stated that they first received money for a finished portrait on March 21, 1840. "Photography at the American Institute," *American Journal of Photography* 1:1 (June 1, 1858): 10.

70 Rinhart and Rinhart, "Wolcott and Johnson," p. 132.

71 The patent was applied for, in Beard's name, on June 13, 1840. See Arthur T. Gill, "Wolcott's Camera in England and the Bromine-Iodine Process," *History of Photography* 1:3 (July 1977): 215-20.

72 While this business always operated under Beard's name, there is considerable evidence that it was, in fact, a Wolcott and Johnson enterprise, with Beard as an investor-partner. See, for example, Johnson's reminiscence "The Bromine Discovery Question." My thanks to Grant B. Romer for his insights on this important matter. For details on Beard's operation, see Robert B. Fisher's essays "The Hogg Connection," *Daguerreian Annual 1990* (Lake Charles, La.: Daguerreian Society, 1990): 101-13; and "The Beard Photographic Franchise in England," *Daguerreian Annual 1992* (Lake Charles, La.: Daguerreian Society, 1992): 73-95.

73 See, for example, Wolcott's letters to Johnson of 1843, published in "Photography in its Infancy," *American Journal of Photography* 3:8 (September 15, 1860): 119-23; and 3:9 (October 1, 1860): 142-43.

74 Fisher, "The Beard Photographic Franchise in England," pp. 94-95.

75 Welling, *Photography in America*, p. 21.

76 From a letter of February 10, 1855; as published in the *Photographic and Fine Art Journal* 8:9 (September 1855): 280. See also "Correspondence Discovered between Samuel Morse and Marcus Root," *Daguerreian Society Newsletter* 12:3 (May/June 2000): 14.

77 John William Draper, M.D., "On the Process of the Daguerreotype, and its application to taking Portraits from Life," *London, Edinburgh, and Dublin Philosophical Magazine and Journal of Science* 17:109 (September 1840): 222-25. Courtesy Gary W. Ewer.

78 Welling, *Photography in America*, p. 21.

79 Morse later recalled: "I was left to pursue the *artistic* results of the process, as more in accordance with my own profession. My expenses had been great, and for some time, five or six months, I pursued the taking of portraits by the Daguerreotype, as a means of reimbursing these expenses. After this object had been attained, I abandoned the practice to give my exclusive attention to the telegraph…" Letter of February 10, 1855, published in the *Photographic and Fine Art Journal* 8:9 (September 1855): 280.

80 *Anthony's Photographic Bulletin* 14 (September 1883): 314.

81 *Photographic Times* 25 (August 24, 1894): 134.

82 Root, *The Camera and the Pencil*, p. 354.

83 For a good description of this operation, see "Daguerreotype," *Botanico-Medical Recorder* [Columbus, Ohio] 8:25 (September 5, 1840): 391. Courtesy Gary W. Ewer.

84 Stapp, *Robert Cornelius*, pp. 36, 54-55.

85 Several later daguerreotypes are credited to Cornelius, but these appear to have been made outside of his commercial practice. See Stapp, *Robert Cornelius*, pp. 39-40.

86 One of the best summaries of Gouraud's activities is found in Rinhart and Rinhart, *The American Daguerreotype*, pp. 30-36. I am also grateful to Chris Steele for sharing his extensive Gouraud file.

87 In a letter to the New York *Evening Star* 7:131 (February 27, 1840), Gouraud noted that, "excepting three or four by M. Colignon, the son-in-law of M. Daguerre, and the two by the great master himself, all the pieces in my collection were the fruits of my own labors." Courtesy Chris Steele and Gary W. Ewer.

88 For an account by one of those in attendance, see Bayard Tuckerman, *The Diary of Philip Hone 1828-1851* (New York: Dodd, Mead and Company, 1889): 391-92. For a transcript of Gouraud's invitation, see Thos. S. Cummings, *Historic Annals of the National Academy of Design* (Philadelphia: George W. Childs, 1865): 158. Curiously, as published here, this notice is signed "François Pamsel." Regarding the public viewing, see "The Daguerreotype," *New-Yorker* 8:13 (December 14, 1839): 205; and "The 'Daguerreotype'," *Knickerbocker* 14:6 (December 1839): 560-61. Courtesy Gary W. Ewer.

89 Letter published in the New York *Evening Star* 7:128 (February 24, 1840): n.p.

90 For information on Gouraud's activities in Boston and early photography in that city, see Ron Polito, "The Emergence of Commercial Photography in Boston: 1840-1841," *New England Journal of Photographic History* 164 (Spring 2005): 16-32.

91 *Boston Daily Evening Transcript* (June 2, 1840); quoted in Grant B. Romer and Brian Wallis, eds., *Young America: The Daguerreotypes of Southworth & Hawes* (Göttingen: Steidl/George Eastman House/International Center of Photography, 2005): 24.

92 The secret of this technique is revealed in Gouraud's book, *Phreno-Mnemotechny, or, The Art of Memory* (London: Wiley and Putnam, 1845).

93 "Death of Professor F. F. Gouraud," *Little's Living Age* 14 (July 10, 1847): 82. Courtesy Gary W. Ewer.

94 See, for example, Marjorie B. Cohn, "Francis Calley Gray and Early Boston Daguerreotype," *History of Photography* 9:2 (April-June, 1985): 155-57.

95 Lowry and Lowry, *The Silver Canvas*, pp. 36, 215. Additional biographical information is contained in "The Mountain Hermit," *White Mountain Echo* (July 2, 1881): 7; and Florence Morey, "Samuel A. Bemis," *Appalachia* (June 1958): 122-25.

96 Information provided in correspondence from Bates Lowry.

97 Margaret Denton Smith and Mary Louise Tucker, *Photography in New Orleans: The Early Years, 1840-1865* (Baton Rouge: Louisiana State University Press, 1982): 17-18.

98 Harvey S. Teal, *Partners with the Sun: South Carolina Photographers, 1840-1940* (Columbus: University of South Carolina Press, 2001): 7-9.

99 Thomas M. Weprich, "Dentists, Teachers & Milliners: The First Daguerreotypists in Pittsburgh, Pennsylvania," *Daguerreian Annual 2002-2003* (Pittsburgh: Daguerreian Society, 2004): 83-84.

100 Reese V. Jenkins, *Images and Enterprise: Technology and the American Photographic Industry, 1839 to 1925* (Baltimore: Johns Hopkins University Press, 1975): 13-16.

101 Welling, *Photography in America*, p. 17.

102 Teal, *Partners with the Sun*, p. 13.

103 A slender and obscure volume is illustrative of this evolution: Gilman & Mower, *The Photographer's Guide; in which the Daguerrean Art is Familiarly Explained* (Lowell, Mass.: Samuel O. Dearborn, 1842). Courtesy Gary W. Ewer.

104 On this overall matter, see Dennis A. Waters, "Dating American Daguerreotypes, 1839-1842," *Daguerreian Annual 2000* (Pittsburgh: Daguerreian Society, 2001): 33-57.

105 "From Our New York Correspondent," *Daily National Intelligencer* [Washington, D.C.] 31:9367 (February 24, 1843): n.p. Courtesy Gary W. Ewer.

106 The following summary is drawn largely from Grant B. Romer, "'A High Reputation with All True Artists and Connoisseurs': The Daguerreian Careers of A. S. Southworth and J. J. Hawes," in Romer and Wallis, eds., *Young America*, pp. 21-55; and the foundational work for all subsequent Southworth & Hawes scholarship: Charles LeRoy Moore, *Two Partners in Boston: The Careers and Daguerreian Artistry of Albert Southworth and Josiah Hawes* (Ph.D. dissertation, University of Michigan, 1975).

107 Cited in Romer, "A High Reputation," p. 21.

108 Ibid.

109 Pennell continued to practice the daguerreotype for a time, then taught at a school in the South, before returning to New England to work for the Scovill Manufacturing Company. Moore, *Two Partners in Boston*, p. 40.

110 While clouds were a highly unusual subject for daguerreotypists, T. B. Butler's book, *The Philosophy of the Weather and a Guide to its Changes* (New York: D. Appleton, 1856), is illustrated with engravings taken from daguerreotypes. The maker of these plates is not identified, and none of these original views is known to be extant. Courtesy Gary W. Ewer.

111 Cited in Romer, "A High Reputation," p. 41.

112 The following is drawn in part from Clifford Krainik, "National Vision, Local Enterprise: John Plumbe, Jr., and the Advent of Photography in Washington, D.C.," *Washington History* 9:2 (Fall/Winter 1997-98): 4-27, 92-93. I am also grateful to Chris Steele for sharing his Plumbe research.

113 *Boston Daily Evening Transcript* (January 4, 1841): 3. Courtesy Chris Steele.

114 This latter gallery, run by his younger brother, Richard Plumbe, was probably the first daguerreian gallery west of the Mississippi. Krainik, "National Vision," p. 9.

115 "Our First Photographers," *St. Louis and Canadian Photographer* 14:3 (March 1896): 114.

116 Krainik, "National Vision," p. 11.

117 John Doggett, Jr., *The Great Metropolis: or, Guide to New-York for 1846* (New York: John Doggett, Jr., 1846): 118. Courtesy Gary W. Ewer.

118 Two contemporary accounts of Plumbe's studios are worthy of mention: "Visit to Plumbe's Gallery," in *The Brooklyn Daily Eagle and Kings County Democrat* 5:160 (July 2, 1846): n.p. (generally assumed to have been written by the paper's editor at the time, Walt Whitman); and "Plumbe's National Daguerreian Gallery and Photographic Depots," in Doggett, *The Great Metropolis*, p. 118. Courtesy Gary W. Ewer.

119 Krainik, "National Vision," p. 22.

CHAPTER II
Leaders in the Profession: A Regional Survey

1 R. H. Vance, *Catalogue of Daguerreotype Panoramic Views in California* (New-York: Baker, Godwin & Co., 1851).

2 This work is discussed in numerous texts, including Robert Schlaer, *Sights Once Seen: Daguerreotyping Frémont's Last Expedition through the Rockies* (Santa Fe: Museum of New Mexico Press, 2000); Richard Rudisill, *Mirror Image: The Influence of the Daguerreotype on American Society* (Albuquerque: University of New Mexico Press, 1971): 105-06; and Martha A. Sandweiss, *Print the Legend: Photography and the American West* (New Haven: Yale University Press, 2002): 100-08. For his own narrative of this expedition, see Solomon Nunes Carvalho, *Incidents of Travel and Adventure in the Far West, with Colonel Frémont's Last Expedition* (New York: Derby & Jackson, 1858; repr. Lincoln: University of Nebraska Press, 2004).

3 See Francis L. Hawks, *A Narrative of the Expedition of an American Squadron to the China Seas and Japan: Performed in the Years 1852, 1853, and 1854, under the command of Commodore M. C. Perry, United States Navy, by order of the government of the United States* (Washington, D.C.: A. O. P. Nicholson, 1856). Volume 1 is of special interest for the numerous lithographs based on Brown's daguerreotypes. Courtesy Gary W. Ewer.

4 *Humphrey's Journal* 5:11 (September 15, 1853): 175.

5 However, the ease with which images may be placed into new mats or cases should give us pause over the absolute reliability of some of this evidence.

6 The collection of Matthew R. Isenburg includes a single leather sixth-plate case stamped "Southworth & Co FECIT [/] 5-1/2 Tremont Row Boston." Courtesy Matthew R. Isenburg.

7 See Grant B. Romer and Brian Wallis, eds., *Young America: The Daguerreotypes of Southworth & Hawes* (Göttingen: Steidl/George Eastman House/International Center of Photography, 2005); and Dolores A. Kilgo, *Likeness and Landscape: Thomas M. Easterly and the Art of the Daguerreotype* (St. Louis: Missouri Historical Society, 1994).

8 *Daguerreian Journal* 3:1 (November 15, 1851): 19. On this larger issue, see also Laurie A. Baty's discussion of Jenny Lind portraits in Baty, "'Proud of the Result of my Labor': Frederick DeBourg Richards (1822-1903)," *Daguerreian Annual 1995* (Pittsburgh: Daguerreian Society, 1995): 207-25, particularly pp. 209-15.

9 Advertisement, "Panorama of San Francisco—Gratuitous Exhibition," *Boston Daily Evening Transcript* (June 2, 1852): 3. Courtesy Gary W. Ewer.

10 See Romer and Wallis, eds., *Young America*, pp. 304-05; and Robert A. Sobieszek and Odette M. Appel, *The Spirit of Fact: The Daguerreoypes of Southworth & Hawes, 1843-1862* (Boston: David R. Godine/International Museum of Photography at George Eastman House, 1976): 19.

11 See Romer and Wallis, eds., *Yong America*, pp. 470-73; and Kenneth E. Nelson, "On Not Quite Reuniting a Grand Parlor Stereoscope Pair," *Daguerreian Annual 2002-2003* (Pittsburgh: Daguerreian Society, 2004): 10-23.

12 *Craig's Daguerreian Registry* represents a tireless and monumental effort to identify and preserve these names: John S. Craig, *Craig's Daguerreian Registry, Volume 2, Pioneers and Progress; Abbott to Lytle* and *Craig's Daguerreian Registry, Volume 3: Pioneers and Progress; MacDonald to Zuky* (Torrington, Conn.: John S. Craig, 1996); and the online version, www.daguerreotype.com.

13 Edward K. Spann, *The New Metropolis: New York City, 1840-1857* (New York: Columbia University Press, 1981): 322.

14 Ibid., p. 439, note 30.

15 Ron Polito, "The Emergence of Commercial Photography in Boston: 1840-1841," *New England Journal of Photographic History* 164 (Spring 2005): 28. Slightly variant numbers are cited in Grant B. Romer's essay, "'A High Reputation with All True Artists and Connoisseurs': The Daguerreian Careers of A. S. Southworth and J. J. Hawes," in Romer and Wallis, eds., *Young America*, p. 31. Chris Steele has been exceptionally generous in providing information on early photography in Boston and Massachusetts.

16 Romer, "'A High Reputation'," p. 28.

17 In 1854, it was noted with some amazement that "Southworth & Hawes, of Boston, Mass., take no Daguerreotype for less than *five dollars*." *Humphrey's Journal* 5:18 (January 1, 1854): 287.

18 Cited in Mike Robinson, "A Style Peculiar to Themselves: An Investigation into the Techniques of Southworth & Hawes," in Romer and Wallis, eds., *Young America*, p. 489. The following is indebted to Robinson's essay, and to his invaluable presentation at the 2005 Daguerreian Society meeting, Rochester, New York.

19 Cited in ibid., p. 490.

20 Ibid.

21 Ibid.; and Bates Lowry, "Secrets of the White Chamber," *Daguerreian Annual 2002-2003* (Pittsburgh: Daguerreian Society, 2004): 332-41.

22 Robinson, "A Style Peculiar to Themselves," pp. 492-93.

23 See Bates Lowry and Isabel Lowry, "Simultaneous Developments: Documentary

Photography and Painless Surgery," in Romer and Wallis, eds., *Young America*, pp. 75-88; and "Exposing Anesthesia: The First Operations under Ether," in Melissa Banta et al., *A Curious & Ingenious Art: Reflections on Daguerreotypes at Harvard* (Iowa City: University of Iowa Press, 2000): 52-59.

24 "Boston Daguerreotypists," *Daguerreian Journal* 2:4 (July 1, 1851): 114-15.

25 See, for example, Françoise Reynaud et al., eds., *Paris in 3D: From Stereoscopy to Virtual Reality 1850-2000* (Paris: Booth-Clibborn Editions, 2000).

26 Romer, "'A High Reputation'," p. 38.

27 Ibid., pp. 38-39.

28 This appears to have been achieved. As Romer notes, "Their business records indicate an increase in the purchasing of whole plates at this time, which had previously been relatively modest." Ibid., p. 38. It remains uncertain how many stereo views were originally made (or acquired) for the Grand Parlor and Gallery Stereoscope. A notable number of plates from the Southworth & Hawes studio collection have close "twins" that represent either nearly identical variant exposures or a full original stereoscopic pair. For example, a close variant of *Group of Young Women* is reproduced as plate 80 in Sobieszek and Appel, *The Spirit of Fact*.

29 See the catalogue for the April 27, 1999, sale, *The David Feigenbaum Collection of Southworth & Hawes and Other 19th-Century Photographs* (New York: Sotheby's, 1999); and Denise Bethel, "The David Feigenbaum Collection of Southworth & Hawes," in Romer and Wallis, eds., *Young America*, pp. 521-25.

30 Reproduced in Romer and Wallis, eds., *Young America*, p. 217.

31 Cited in Brooks Johnson, *Photography Speaks: 66 Photographers on Their Art* (Norfolk, Va.: Chrysler Museum/Aperture, 1989): 96.

32 J. W. Black, "Days Gone By," *St. Louis Practical Photographer* 1:7 (July 1877): 220-21.

33 See Ken Appollo, "Southworth & Hawes: The Studio Collection," in Romer and Wallis, eds., *Young America*, pp. 515-20.

34 An important milestone in this scholarship is Charles LeRoy Moore, *Two Partners in Boston: The Careers and Daguerreian Artistry of Albert Southworth and Josiah Hawes* (Ph.D. dissertation, University of Michigan, 1975).

35 The partnership with Litch lasted from 1845 to 1847. Black began working for Whipple in 1850, but the two only entered into partnership in 1856. William S. Johnson, "Chronology," in Sally Pierce, *Whipple and Black, Commercial Photographers in Boston* (Boston: Boston Athenaeum, 1987): 105-06.

36 Pierce, *Whipple and Black*, p. 8.

37 Ibid., pp. 8-13.

38 In an 1888 reminiscence on Whipple's career, H. H. Snelling noted: "Good artistic taste, a correct eye and a ready mind to correct difficulties and detect causes for defects, [Whipple] was enabled to put forth such uniformly perfect work that he was resorted to by the lovers of fine art and the most intelligent people of Boston. Mr. Whipple also commended himself by his urbanity and pleasing manners and made hosts of friends. From this time his success was assured." Snelling, "Looking Back: Or, The Olden Days in Photography," *Anthony's Photographic Bulletin* 19:18 (September 22, 1888): 560. For a delightful fictional tale describing what could only be Whipple's gallery see Anne E. (Gore) Guild [attrib.], *Grandmother Lee's Portfolio* (Boston: Whittemore, Niles, and Hall, 1857): 63-66. Courtesy Gary W. Ewer.

39 Pamela Hoyle, *The Development of Photography in Boston, 1840-1875* (Boston: Boston Athenaeum, 1979): 9 and note 13.

40 Pierce, *Whipple and Black*, p. 18. This began in late January 1850, and was reported or advertised in several newspapers of the period.

41 Advertisement in *Independent Democrat & Freeman* [Concord, N.H.] 4:4 (May 25, 1848). Courtesy Gary W. Ewer.

42 In its issue of April 26, 1851, the *Boston Daily Evening Transcript* commented on the success of Whipple's technique: "He has a new process, by which portraits are taken in the style of crayons. Some recent specimens we have seen are gems of art, and give great satisfaction. They are quite the rage now." Reproduced on Daguerreian Society web site. Courtesy Gary W. Ewer. For an insightful study of this technique, see Michael G. Jacob, "Vignetted Daguerreotypes: The Evolution of an Art," *Daguerreian Annual 1996* (Pittsburgh: Daguerreian Society, 1997): 8-21.

43 Whipple used the same technology that he had employed in his projected lantern slide shows—the so-called Drummond (calcium or lime) light, which was in common use at the time in the theater. For his own report on his microscopic work, see "Microscopic Daguerreotypes," *Photographic Art-Journal* 4:4 (October 1852): 227-28; and Snelling, "Looking Back," pp. 562-63. See also "Microscopic Daguerreotypes," *Boston Daily Evening Transcript* (January 11, 1847); reproduced on Daguerreian Society web site. Courtesy Gary W. Ewer.

44 These were made in collaboration with Professor William Cranch Bond and his son George Phillips Bond. Pierce, *Whipple and Black*, p. 25.

45 Even when discounted for the typical promotional puffery, a contemporary write-up of Whipple's style in the studio is revealing.

Mr. Whipple knows how to get a good picture out of any kind of face. His geniality oozes out so profusely that the subject finds himself within the sphere of his magnetic influence before he is aware; and no matter how morose and sour his disposition, his face must become bland and mild, if not actually radiant with smiles.

"A Visit to Boston," *American Journal of Photography and the Allied Arts and Sciences* 7:18 (March 15, 1865): 411.

46 *Photographic Art-Journal* 2:2 (August 1851): frontispiece, with accompanying text by M. Grant, "John A. Whipple and the Daguerrean Art," pp. 94-95.

47 While not maker marked, these plates have been identified as Whipple's work based on both physical and visual evidence. My thanks to Sally Pierce and Catharina Slautterback of the Massachusetts Historical Society for their invaluable assistance.

48 Polito, "The Emergence of Commercial Photography in Boston: 1840-1841," pp. 24-25.

49 *The Boston Directory…Almanac, From July, 1849, to July, 1850* (Boston: George Adams, 1849): 323. Courtesy Gary W. Ewer.

50 Hale was significant enough to be among the first daguerreotypists profiled in the photographic press. See "Luther Holman Hale and the Daguerreian Art," *Photographic Art-Journal* 1:6 (June 1851): 357-59.

51 *The Daguerreotype in Boston: Process, Practitioners, and Patrons* (Boston: Boston Athenaeum, 1994): 48-60. The definitive index of Massachusetts photographers is Chris Steele and Ron Polito, *A Directory of Massachusetts Photographers, 1839-1900* (Camden, Maine: Picton Press, 1993).

52 In an 1854 advertisement, Miller promoted his skills in the following terms:

Daguerreotypes taken in all the various styles, Crayons, Illuminated, Magic Backgrounds, &c.

Daguerreotypes copied and magnified to any size desired.

Old and infirm, sick and deceased persons, taken at their residences.

The public are invited to call and examine specimens, as I have some of the **Largest and best Daguerreotypes in the City.**

Massachusetts Register for the Year 1854 (Boston: George Adams, 1854): 13. Courtesy Gary W. Ewer.

53 Numerous specialized studies on this region have been published. For example, see John Monroe and Earle G. Shettleworth, Jr., *First Light: The Dawn of Photography in Maine* (Portland: Maine History Gallery/Maine Historical Society, 1999).

54 For a short history of the daguerreotype in Providence, see Maureen Taylor, "'Never Give Up; It is Better to Hope than once to Despair': Providence, Rhode Island, and the Daguerreotype," *Daguerreian Society Annual 1995* (Pittsburgh: Daguerreian Society, 1995): 1127-33. An earlier version of this paper was published as "'Nature Caught at the Twinkling of an Eye': The Daguerreotype in Providence," *Rhode Island History* 42:4 (November 1983): 110-21.

55 For a period perspective, see G. W. Baker, *A Review of the Relative Commercial Progress of the Cities of New-York & Philadelphia* (Philadelphia: Jackson, Printer, 1859).

56 Gary B. Nash, *First City: Philadelphia and the Forging of Historical Memory* (Philadelphia: University of Pennsylvania Press, 2006): 152.

57 Cited in ibid., p. 140.

58 New York City was also daguerreotyped extensively, but surprisingly few of these views are now extant. For an essential overview of this subject, see Arthur Krim, "Remarkable Legacy: Early Philadelphia Street Views," *Daguerreian Annual 2004* (Pittsburgh: Daguerreian Society, 2005): 168-97.

59 On McAllister as a collector, see Sandra Markham, "John A. McAllister Collects the Civil War," *Magazine Antiques* (August 2006): 102-07. For background on optometry in this era, and McAllister's place in the history of the American profession, see James R. Gregg, *The Story of Optometry* (New York: Ronald Press, 1965): 159-78; and Maxwell Miller, "Optometric Education and Public Health: The Philadelphia Story of Optometry," *American Journal of Optometry and Archives of American Academy of Optometry* 48:3 (March 1971): 270-80.

60 A close variant of this plate is held by the Free Library of Philadelphia; Krim, "Remarkable Legacy," p. 177.

61 Krim, "Remarkable Legacy," pp. 180-82.

62 While made considerably later, this view depicts the same buildings as the two plates reproduced in ibid., pp. 183-84.

63 The following is indebted to Rebecca Norris, "Samuel Broadbent, Daguerreian Artist," *Daguerreian Annual 2001* (Pittsburgh: Daguerreian Society, 2002): 135-47.

64 On Mayall, see Léonie L. Reynolds and Arthur T. Gill, "The Mayall Story," *History of Photography* 9:2 (April-June 1985): 89-107. Van Loan's early history is mentioned in Johnson, "The Bromine Discovery Question," *American Journal of Photography* 6:15 (February 1, 1864): 346.

65 Krim, "Remarkable Legacy," p. 193.

66 Simons's early work as a case maker is well documented. By 1844, however, he was also distributing a full range of daguerreian chemicals and supplies. See advertisement in the Philadelphia *Saturday Courier* 14:9 (May 11, 1844); reproduced on Daguerreian Society web site. Courtesy Gary W. Ewer. What follows is indebted to Laurie A. Baty, "'…and Simons.' Montgomery Pike Simons of Philadelphia (ca. 1816-1877)," *Daguerreian Annual 1993* (Green Bay: Daguerreian Society, 1993): 183-99.

67 Later in life, Simons mentioned being inspired by a visit to the studio of Robert Cornelius, which was in existence only into that year. M. P. Simons, "The Early Days of Daguerreotyping," *Anthony's Photographic Bulletin* 5 (September 1874): 309.

68 He also worked briefly in Charleston in 1849. See Harvey S. Teal, "Charleston & M. P. Simons," *Daguerreian Annual 1995* (Pittsburgh: Daguerreian Society, 1995): 41-47.

69 Baty, "…and Simons," pp. 192-93.

70 For an important if not entirely accurate early biographical sketch, see "Fortunes and Misfortunes of an Artist," *Scientific American* 6:6 (February 8, 1862): 87. A lithograph view of Root's Philadelphia gallery (as well as Broadbent & Co.) is seen in the three-color lithograph "Panorama of Philadelphia—Chestnut Street, East of Fifth," by Collins & Auterieth, 1856. A salt-print view of Root's New York gallery exterior, by Victor Prevost, is seen in George Gilbert, *Photography: The Early Years* (New York: Harper & Row, 1980): 43. Courtesy Gary W. Ewer.

71 "Daguerreotyping," *Dollar Newspaper* [Philadelphia] 6:25 (July 5, 1848): n.p. Courtesy Gary W. Ewer.

72 "Obituary," *Philadelphia Photographer* 25:321 (May 5, 1888): 284-85.

73 Cook's stature is indicated by the fact that works from this period are marked not only "Root Gallery Philadelphia," but also "Cook Artist."

74 Root advertisement in *Boston Evening Transcript* (September 21, 1847). *The Young Artist's First Effort* may be the same as the work reproduced as *The Young Artist* in *Peterson's Magazine* 22:5 (November 1852): 206. Courtesy Gary W. Ewer.

75 *Daguerreian Journal* 1:7 (February 15, 1851): 212; and 1:9 (March 15, 1851): 306. The eclipse daguerreotypes of 1854 were reported in several period accounts, including "Remarkable Works of Art," *New-York Daily Times* 3:840 (May 27, 1854): 8. Courtesy Gary W. Ewer.

76 See, for example, his essay "Moral Requisites of the Eminent Daguerrean Artist," *Photographic Art-Journal* 6:3 (September 1853): 187-90.

77 The following is indebted to Baty, "Proud of the Result of My Labor."

78 The following is indebted to Linda A. Ries, "Glenalvon J. Goodridge: Black Daguerreian," *Daguerreian Annual 1991* (Lake Charles, La.: Daguerreian Society, 1991): 38-41.

79 Ibid., p. 40.

80 The following is indebted to Jon M. Williams, "Daguerreotypists, Ambrotypists, and Photographers in Wilmington, Delaware, 1842-1859," *Delaware History* 18:3 (Spring-Summer 1979): 180-93. Williams notes (p. 181): "Wilmington was near one of the early centers of the daguerreotype at Philadelphia, and lived in its shadow for several years. Philadelphia daguerreotypists advertised in the Wilmington newspapers, and they obviously regarded the Delaware city as part of their market."

81 Spann, *New Metropolis*, p. 15.

82 Ibid., p. 403.

83 Ibid., pp. 283-84, 401.

84 Ibid., p. 315.

85 Ibid., pp. 205, 71.

86 As early as 1846, it was estimated that New York had 1,000 brothels and 10,000 prostitutes. In 1852, there were about 6,000 drinking establishments in the city. Ibid., pp. 482, note 17, and 249.

87 Ibid., p. 368.

88 *Daguerreian Journal* 1:2 (November 15, 1850): 49-50.

89 This extensive article, "Photography in the United States," was printed in all three publications of the *New-York Tribune*: the semi-weekly *New-York Tribune* 8:825 (April 22, 1853): 1; the weekly *New-York Tribune* 12:606 (April 23, 1853): 7; and as a two-part article in the daily *New-York Tribune* (April 29 and 30, 1853). It was reprinted in the *Photographic Art-Journal* 5:6 (June 1853): 334-41. Courtesy Gary W. Ewer.

90 Edwin G. Burrows and Mike Wallace, *Gotham: A History of New York City to 1898* (New York: Oxford University Press, 1999): 372.

91 Spann, *New Metropolis*, p. 97.

92 Burrows and Wallace, *Gotham*, pp. 667-68.

93 Ibid., p. 668. For a lively period description of the spectacle of the street, with mention of daguerreotype studios, see "Letters from New York," *National Era* [Washington, D.C.] 2:202 (November 14, 1850): 181. Courtesy Gary W. Ewer.

94 The prominence of daguerreotype galleries on Broadway is seen in the two-page wood-engraving illustration, "A Panoramic View of Broadway, New York City," in *Gleason's Pictorial Drawing-Room Companion* 6:11 (March 18, 1854): 168-69, 173. Included in this detailed illustration are the galleries of Meade Brothers (at 233), Plumbe (at 251), J. T. Barnes (at 262), Beckers & Piard (at 264), J. P. & E. B. Humphreys (at 264), Holmes (at 288), Dobyns, Richardson & Co. (at 303), Insley (at 311), Bayles & Bradley (at 315), and Thompson (at 315). Courtesy Gary W. Ewer.

95 More galleries were clustered around Chatham Square, a few blocks east from Broadway. See Arthur Krim, "A Window on the Manhattan Metropolis; the Chatham Square Daguerreotype," *Daguerreian Annual 1996* (Pittsburgh: Daguerreian Society, 1997): 22-35.

96 Quoted in Mary Panzer, *Mathew Brady and the Image of History* (Washington, D. C.: Smithsonian Institution Press/National Portrait Gallery, 1997): xvi.

97 "M. B. Brady," *American Phrenological Journal* 27:5 (May 1858): 65. Courtesy Gary W. Ewer.

98 Panzer, *Mathew Brady*, p. xv.

99 For information on Brady's work as a case maker, see James Szymanski, "M. B. Brady, Casemaker, N.Y.," *Daguerreian Annual 1996* (Pittsburgh: Daguerreian Society, 1997): 185-96; and Paul K. Berg, "Mathew Brady—Case Maker and a New Brady Label," *Daguerreian Society Newsletter* 18:5 (September-October, 2006): 14, 17.

100 A view of Brady's gallery interior accompanies the article "Photography—Brady's Daguerrean Saloon" in the *New-York Illustrated News* 1:24 (June 11, 1853): 384. An exterior view of this same gallery accompanies the article "Firemen's Annual Parade—Fire-Proof Buildings" in the *New-York Illustrated News* 2:46 (November 12, 1853): 267. Published views of other Brady studios include the advertisement in *Doggett's New York City Directory for 1850-51* (New York: John Doggett, Jr., 1850): 108; and "Brady's New Photographic Gallery, Broadway and Tenth Street," *Frank Leslie's Illustrated Newspaper* 11:267 (January 5, 1861): 106, 108. Courtesy Gary W. Ewer.

101 Panzer, *Mathew Brady*, p. 55.

102 C. Edwards Lester, "M. B. Brady and the Photographic Art," *Photographic Art-Journal* 1:1 (January 1850): 39.

103 *Humphrey's Journal* 5:10 (September 1853): 153-54; reprint of Brady ad from a New York daily paper.

104 Advertising bill, reproduced in Christian Peterson, *Chaining the Sun: Portraits by Jeremiah Gurney* (Minneapolis: Minneapolis Institute of Arts, 1999): 19.

105 Gurney's other operators included Albert Litch and William A. Perry. Ibid., p. 41.

106 Gurney appears to have been most active in this format beginning in early 1851. "Gurney has recently taken some of the finest large size Daguerreotypes ever produced. These wonderful specimens are on plates eleven by thirteen inches, called *mammoth plates*." *Daguerreian Journal* 1:8 (March 1, 1851): 243. A few months later, it was reported that a Gurney self-portrait in this format had been stolen from his doorway display. *Humphrey's Journal* 2:1 (May 15, 1851): 28.

107 *Daguerreian Journal* 2:11 (October 15, 1851): 340-42.

108 The extraordinary *Portrait of an American Youth*, in the collection of the J. Paul Getty Museum, is a notable exception. See Bates Lowry and Isabel Barrett Lowry, *The Silver Canvas: Daguerreotype Masterpieces from the J. Paul Getty Museum* (Los Angeles: J. Paul Getty Museum, 1998): 209.

109 The actual duration and degree of Marcus A. Root's involvement in the New York studio is less than clear. At the end of 1851, the photographic journals noted that M. A. Root was no longer involved in the M. A. and S. Root establishment, and that Samuel Root was in partnership with J. W. Thompson as Root & Co. However, the M. A. and S. Root studio name was still (or perhaps again?) in use in 1852.

110 *Daguerreian Journal* 2:4 (July 1, 1851): 117.

111 *Humphrey's Journal* 5:13 (October 15, 1853): 207.

112 "The Daguerrean Art—Its Origin and Present State," *Photographic Art-Journal* 1:3 (March 1851): 136-37.

113 For a brief summary of Beckers's career, see "Fifteen Years' Experience of a Daguerreotyper," a talk presented to the Society of Amateur Photographers of New York, on January 30, 1889. It was published in several photographic journals of the day, including the *Photographic Times and American Photographer* 19:391 (March 15, 1889): 131-32; and *Anthony's Photographic Bulletin* 20:5 (March 9, 1889): 144-46. It is reprinted in *Daguerreian Annual 1993* (Green Bay: Daguerreian Society, 1993): 117-18.

114 For a period biographic outline, see "The Brothers Meade and the Daguerrean Art" *Photographic Art-Journal* 3:5 (May 1852): 293-95. The brothers apparently came to a mutual division of labor at an early date. In 1851, it was noted that Henry "is always to be found in the stock room," while Charles "is more particularly engaged in the picture business." *Daguerreian Journal* 2:7 (August 15, 1851): 212.

115 For a study of this series, see Rita Ellen Bott, "Charles R. Meade and his Daguerre Pictures," *History of Photography* 8:1 (January 1984): 33-40. One of these was reproduced as a lithograph on the cover of the first issues of the *Daguerreian Journal* 1:1 (November 1, 1850).

116 *Photographic Art-Journal* 3:5 (May 1852): 295. An engraving of their reception room was published, with descriptive text, in *Gleason's Pictorial Drawing-Room Companion* (February 5, 1853); repr. *History of Photography* 1:4 (October 1977): 348.

117 "Martin M. Lawrence and the Daguerreian Art," *Photographic Art-Journal* 1:2 (February 1851): 103-06.

118 *Humphrey's Journal* 5:1 (April 15, 1853): 10-11.

119 *Photographic Art-Journal* 1:2 (February 1851): 106.

120 *Humphrey's Journal* 4:18 (January 1, 1853): 287.

121 *Humphrey's Journal* 6:20 (February 1, 1855): 327.

122 In 1869, Andrew Khrone was described as "the oldest man in the photographic business in this country, still making daguerreotypes for Bogardus." "Note," *Philadelphia Photographer* 6:65 (May 1869): 169. See also Abraham Bogardus, "The Lost Art of the Daguerreotype," *Century Magazine* 68:1 (May 1904): 83-91.

123 Later in life, Bogardus published more reminiscences on the daguerreotype than any of his peers. Other writings by Bogardus include: "Forty Years Behind the Camera," *Photographic Times and American Photographer* (November 19, 1886): 604-06 and (November 26, 1886): 614-15; "Trials and Tribulations of the Photographer," *British Journal of Photography* 35:1506 (March 15, 1889): 183-84 and 36:1507 (March 22, 1889): 200-01; "Experiences of a Photographer," *Lippincott's Magazine* 47 (May 1891): 574-82; "The Daguerreotype," *St. Louis and Canadian Photographer* 11:12 (December 1893): 534-38; "Leaves From the Diary of a Photographer," *St. Louis and Canadian Photographer* 13:1 (January 1895): 25-26; "The Days of the Daguerreotype," *Youth's Companion* (April 30, 1903; "May Special Number"); and "The Lost Art of the Daguerreotype." Courtesy Gary W. Ewer.

124 Abraham Bogardus, "Thirty-Seven Years Behind a Camera," *Photographic Times and American Photographer* 14:158 (February 1884): 74.

125 "Obituary," *Photographic Times* 4:47 (November 1874): 176.

126 Virginia Chandler, "Gabriel Harrison," in Henry Reed Stiles, ed., *History of Kings County* (Brooklyn: W. W. Munsell & Co., 1884): 1151. For more detailed biographies, see S. J. Burr, "Gabriel Harrison and the Daguerrean Art," *Photographic Art-Journal* 1:3 (March 1851): 169-77; and Grant B. Romer, "Gabriel Harrison—The Poetic Daguerrean," *Image* 22:3 (September 1979): 8-18.

127 Burr, "Gabriel Harrison and the Daguerrean Art," p. 175.

128 *Photographic and Fine Art Journal* 7:6 (June 1854): 192.

129 Gabriel Harrison, "The Dignity of Our Art," *Photographic Art-Journal* 3:4 (April 1852): 230-32.

130 *Fifth Avenue Journal* (June 15, 1872); cited in Romer, "Gabriel Harrison—The Poetic Daguerrean," p. 18.

131 Many short histories or checklists of photographers in individual communities have been done. For example, see: "A Bibliography of Early Syracuse Photographers," *Photographica* 13:8 (October 1981): 12-13; Jacob C. Vetter, "Early Photographers: Their Parlors and Galleries," *Chemung Historical Journal* [Elmira, N.Y.] (June 1961): 853-60; William Tei, "Early Photographers of Binghamton," *Broome County Historical Society Newsletter* (Spring 1989): 9-11; and Joseph R. Struble, "Captured Images: The Daguerreian Years in Rochester, 1840 to 1860," *Rochester History* 62:1 (Winter 2000, special issue).

132 Robert Sobieszek, "Samuel Walker," *American Photographer* 9:3 (September 1982): 80-84.

133 "S. L. Walker, of Poughkeepsie, has probably instructed more young men in the 'mystery and art' of daguerreotyping, than any other person in this country." *Humphrey's Journal* 6:11 (September 15, 1854): 175.

134 Cited in Robert A. Sobieszek, *Masterpieces of Photography: From the George Eastman House Collections* (New York: Abbeville, 1985): 36, 423.

135 In addition to several works by Churchill, the Hallmark Photographic Collection at the Nelson-Atkins Museum of Art includes daguerreotypes signed on the plate in the following way: "Stanbery [/] Brooklyn"; "M. E. Judd, 41 South Pearl St., Albany"; "J. S. Olds"; "N. B. Vars"; "Edwin Church Dgpst"; and "Durang March 5 1851" (two matching images in book-style case).

136 *Scientific Daguerrean: A Monthly Devoted to Photography, and Fine Arts Generally* (Utica, N.Y., 1853). Only one extant copy is currently known: 1:2 (February 1853); courtesy Rob McElroy. The full title of Davie's book is: *Secrets of the Dark Chamber, being Photographic Formulæ, at present practiced in the galleries of Messrs. Gurney, Fredricks, Bogardus, etc.* (New York: Joseph H. Ladd, 1870).

137 For a full description of these images, see Keith F. Davis, *George N. Barnard: Photographer of Sherman's Campaign* (Kansas City: Hallmark Cards, Inc., 1990): 28-29.

138 Frank Henry Goodyear, "Constructing a National Landscape: Photography and Tourism in Nineteenth-Century America," (Ph.D. dissertation., University of Texas at Austin, 1998): 26-27. See also John F. Sears, *Sacred Places: American Tourist Attractions in the Nineteenth Century* (New York: Oxford University Press, 1989): 12-30.

139 In some instances, McDonnell's name is mistakenly spelled "McDonell" in the photographic literature of the day. The Evans work reproduced here incorrectly spells his name "Evens" on the brass mat. For background on Evans, see Thomas Kailbourn and Graham Garrett, "Oliver B. Evans: Daguerreian Artist of the Niagara Frontier," *Daguerreian Annual 1992* (Lake Charles, La.: Daguerreian Society, 1992): 11-17.

140 "McDonnell's New Daguerrean Rooms," *Photographic and Fine Art Journal* 8:2 (February 1, 1855): 64.

141 For a good summary of Babbitt's background and work at Niagara Falls, see Goodyear, "Constructing a National Landscape," pp. 30-60.

142 Babbitt secured this right from General Peter B. Porter, who owned most of the land surrounding the American falls. See Anthony Bannon, *The Taking of Niagara: A History of the Falls in Photography* (Buffalo: MediaStudy/Buffalo, 1982): 14-15.

143 All three of these Niagara plates came from the Southworth & Hawes studio collection. The latter two are characteristic of the kind of work done in stereo by Babbitt for the Grand Parlor and Gallery Stereoscope. See Romer and Wallis, eds., *Young America*, pp. 470-73.

144 J. W. Kriner, *Journeys to the Brink of Doom* (Buffalo: J. & J. Publishing, 1997): 17-11; as summarized in *The David Feigenbaum Collection of Southworth & Hawes*, pp. 50-51.

145 "Avery. [Niagara, 1853]," was published in W. D. Howells, *Poems* (Boston: J. R. Osgood and Co., 1873): 143-47.

146 For a panoramic lithograph based on daguerreotypes by Langenheim, see J. De Tivoli, *A Guide to the Falls of Niagara, by J. De Tivoli, with a Splendid Lithographic View, by A. Vaudricourt, from a daguerreotype of F. Langenheim* (New-York: Burgess, Stringer and Co., 1846). Courtesy Gary W. Ewer.

147 The following is indebted to the publications of Ross J. Kelbaugh: "Dawn of the Daguerreian Era in Baltimore, 1839-1849," *Maryland Historical Magazine* 84:2 (Summer 1989): 101-18; *Directory of Maryland Photographers, 1839-1900* (Baltimore: Historic Graphics, 1988); and *Directory of Baltimore Daguerreotypists* (Baltimore: Historic Graphics, 1989).

148 See Carvalho, *Incidents of Travel and Adventure in the Far West*; and Shlaer, *Sights Once Seen*.

149 He also ran a gallery in Charleston, S.C., for a relatively short time in 1844. My thanks to Mark White for clarifying various details of Whitehurst's career.

150 *Forrest's Historical and Descriptive Sketches of Norfolk and Vicinity* (1851): 397. Courtesy Mark White.

151 *National Era* [Washington, D.C.] 5:13 (March 27, 1851): 51.

152 Ibid.

153 For an overview of this early history, see Clifford Krainik, "National Vision, Local Enterprise: John Plumbe, Jr., and the Advent of Photography in Washington, D.C.," *Washington History* 9:2 (Fall/Winter 1997-98): 4-27.

154 For example, see ibid., pp. 15-20; Lowry and Lowry, *The Silver Canvas*, pp. 187-92; Mike Kessler, "Once in a Lifetime: The True Story of the Plumbe Daguerreotypes," *Photographist* 99 (Fall 1993): 10-22; and Alan Fern and Milton Kaplan, "John Plumbe, Jr., and the First Architectural Photographs of the Nation's Capitol," *Quarterly Journal of the Library of Congress* 31 (January 1974): 3-20.

155 The following is indebted to Harvey S. Teal, *Partners with the Sun: South Carolina Photographers, 1840-1940* (Columbia: University of South Carolina Press, 2001): 6-36.

156 Ibid., pp. 19-22.

157 See, for example, Alan Trachtenberg, *Reading American Photographs: Images as History, Mathew Brady to Walker Evans* (New York: Hill and Wang, 1989): 53.

158 See ibid., pp. 52-60; and "Framed: The Slave Portraits of Louis Agassiz," in Banta et al., *A Curious & Ingenious Art*, pp. 42-51.

159 The following is indebted to Margaret Denton Smith and Mary Louise Tucker, *Photography in New Orleans: The Early Years, 1840-1865* (Baton Rouge: Louisiana State University Press, 1982): 3-52.

160 For a valuable survey of one facet of this general subject, see Frances Robb, "Shot in Alabama: Daguerreotypy in a Deep South State," *Daguerreian Annual 2004* (Pittsburgh: Daguerreian Society, 2004): 199-235; and Frances Osborn Robb, "Checklist of Photographers and Others Associated with Photography in Alabama, 1839-1861," *Daguerreian Annual 2004* (Pittsburgh: Daguerreian Society, 2004): 236-53.

161 For an overview of this process, see D. W. Meinig's magisterial volume, *The Shaping of America: A Geographical Perspective on 500 Years of History, Vol. 2, Continental America, 1800-1867* (New Haven: Yale University Press, 1993), particularly pp. 222-36, and 311-74.

162 Ibid., p. 222.

163 Ibid., p. 346.

164 For example, see the chapter "The Fine Arts," in Charles Cist, *Sketches and Statistics of Cincinnati in 1851* (Cincinnati: Wm. H. Moore & Co., 1851): 119-28.

165 The following is indebted to Diane VanSkiver Gagel, *Ohio Photographers, 1839-1900* (Nevada City: Carl Mautz, 1998); Mary Sayre Haverstock et al., *Artists in Ohio, 1787-1900* (Kent: Kent State University Press, 2000); and Peter Palmquist and Thomas R. Kailbourn *Pioneer Photographers from the Mississippi to the Continental Divide, A Biographical Dictionary, 1839-1865* (Stanford: Stanford University Press, 2005): 313.

166 Biographical outline, *Western Art Journal* (January 1855): 14; collection of the Cincinnati Historical Society.

167 *Humphrey's Journal* 2:8 (September 1, 1851): 242.

168 In 1851, Hawkins was involved in Earle's Daguerreian Institute, an establishment over Hawkins's gallery run by one Austin T. Earle.

> This Institute is designed for instruction in the Photogenic Arts in all their branches; and will present to students many advantages over what can usually be obtained elsewhere. The course of instruction will be thorough and systematic, combining the practical and the theoretical—imparting to the student, whilst he is acquiring manipulatory skill, the philosophy of his art. In the practical department, the proprietor will be assisted by E. C. Hawkins, the well-known and distinguished Daguerreotypist; and in the theoretical and chemical, by Prof. J. Milton Sanders, of the Eclectic Medical College.

Humphrey's Journal 2:8 (September 1, 1851): 250.

169 The Cincinnati Historical Society holds a companion to this image—a variant exposure in the same format, made from the same vantage point and at the same time—received from Strader family descendents. It is not maker marked.

170 Western Art Journal (January 1855): 14; collection of the Cincinnati Historical Society.

171 Gagel, Ohio Photographers, 1839-1900, p. 15. This work survives, in remarkably fine condition, in the collection of the Cincinnati Public Library.

172 A view of Ball's gallery interior accompanies the article "Daguerreian Gallery of the West," in Gleason's Pictorial Drawing-Room Companion 6:13 (April 1, 1854): 208.

173 Ryder's career was engagingly chronicled in his autobiography, Voigtländer and I: In Pursuit of Shadow Catching (Cleveland: Cleveland Printing & Publishing Co./ Imperial Press, 1902; repr. New York: Arno Press, 1973).

174 Ibid., pp. 23-24. The details of North's career are not entirely clear. See Craig, Craig's Daguerreian Registry, Volume 3: Pioneers and Progress, MacDonald to Zuky, pp. 421-22. Recently, North has been tentatively identified as the maker of the only extant daguerreotype of Emily Dickinson; see Mary Elizabeth Kromer Bernhard, "Lost and Found: Emily Dickinson's Unknown Daguerreotypist," New England Quarterly 72 (December 1999): 594-601.

175 A. Bisbee, The History and Practice of Daguerreotyping (Dayton, Ohio: L. F. Claflin & Co., 1853; repr. New York: Arno Press, 1973).

176 The numerous regional histories of this area include Richard W. Welch, Sun Pictures in Kalamazoo: A History of Daguerreotype Photography in Kalamazoo County, Michigan, 1839-1860 (Kalamazoo: Kalamazoo Public Museum, 1974), and "Sun Pictures in Kalamazoo," Daguerreian Annual 1999 (Pittsburgh: Daguerreian Society, 2000): 1-15; Bonnie G. Wilson, "Working the Light: Nineteenth-Century Professional Photographers in Minnesota," Minnesota History 52:2 (Summer 1990): 42-60; and the relevant entries in the essential Palmquist and Kailbourn, Pioneer Photographers from the Mississippi to the Continental Divide.

177 The following is indebted to Wilson, "Working the Light"; and Alan Woolworth, "Mini-biography: Sarah L. (Judd) Eldridge," Daguerreian Annual 1994 (Pittsburgh: Daguerreian Society, 1994): 233.

178 Wilson, "Working the Light," p. 45.

179 The following is indebted to Palmquist and Kailbourn, Pioneer Photographers from the Mississippi to the Continental Divide, pp. 319-20.

180 In a later reminiscence in the Photographic Times and American Photographer 19:391 (March 15, 1889): 130-31, Hesler recalled:

> In the early summer of 1851 I made a series of views for "Harpers' Travel Guide" of all the towns between Galena and St. Paul that were then settled on the Mississippi, from the pilot-house of the steamer "Nominee" while under full head-way, that were just as sharp as if taken from a fixed point. The pictures were taken on what we then called a half Daguerreotype plate…

Unfortunately, neither these original plates nor reproductions from them have been identified. Courtesy Gary W. Ewer.

181 Photographic Art-Journal 6:3 (September 1853): 191.

182 Humphrey's Journal 5:17 (December 15, 1853): 272.

183 Photographic Art-Journal 5:3 (March 1853): 184.

184 Photographic and Fine Art Journal 7:6 (June 1854): 192. For an early survey of this subject, see Charles Van Ravenswaay, "The Pioneer Photographers of St. Louis," Bulletin of the Missouri Historical Society 10:1 (October 1853): 48-71.

185 Palmquist and Kailbourn, Pioneer Photographers from the Mississippi to the Continental Divide, pp. 255, 470.

186 P. T. Barnum, Struggles and Triumphs: or, Forty Years' Recollections (Buffalo, N.Y.: Warren, Johnson, & Co., 1873): 270-354. Barnum detailed the locations and receipts proceeds of all ninety-five concerts on pp. 353-54.

187 For example, see "Daguerreotyping in the Backwoods," New York People's Organ: A Family Companion 14:16 (October 21, 1854): 123. This was also published, with additional text, as "The 'Arkansas Traveler' Daguerreotyped," Photographic and Fine Art Journal 7:11 (November 1854): 324-26. Courtesy Gary W. Ewer.

188 Dolores Kilgo, "Vance's Views in St. Louis: An Update," Daguerreian Annual 1994 (Pittsburgh: Daguerreian Society, 1994): 211-12.

189 Cited in Palmquist and Kailbourn, Pioneer Photographers from the Mississippi to the Continental Divide, p. 257. The photographic press made periodic mention of the most notable works added to the Fitzgibbon reception exhibition. For example, in early 1853, a local newspaper reported: "Fitzgibbon…has added to his already extensive collection of portraits of celebrities some excellent likenesses of the Chinese jugglers who lately visited the city. The pictures are fifteen in number, and represent the Celestials in their various costumes… Taken them all together, they are perhaps the best executed and most beautiful daguerreotypes we have seen." Cited in Humphrey's Journal 4:21 (February 15, 1853): 335-36.

190 From the Missouri Democrat; cited in Photographic and Fine Art Journal 7:6 (June 1854): 192.

191 If the portrait Kno-Shr, Kansas Chief (1853), in the former Gilman Paper Company Collection, is any indication, these daguerreotypes were of astonishing quality. Maria Morris Hambourg et al., The Waking Dream: Photography's First Century,

192 Palmquist and Kailbourn, Pioneer Photographers from the Mississippi to the Continental Divide, p. 257.

193 Ibid., pp. 257-58; and Sandweiss, Print the Legend, pp. 74-75.

194 The Long Brothers at first ran a single business; by 1850, they were listed at individual addresses. Palmquist and Kailbourn, Pioneer Photographers from the Mississippi to the Continental Divide, p. 403.

195 Ibid.

196 Ibid., pp. 220-22; and Kilgo, Likeness and Landscape, pp. 7-11.

197 Advertisement for "T. M. Easterly, Daguerrean Artist," in United States Commercial Register, containing sketches of the lives of distinguished merchants, manufacturers, and artisans, with an advertising directory at its close (New York: J. Belcher, 1851): [section for "St. Louis Advertisements"] 38. This obscure directory includes advertisements for a total of thirty-one daguerreian firms, from New York, Boston, Pittsburgh, Cincinnati, St. Louis, and New Orleans. Courtesy Gary W. Ewer.

198 Thirteen of these extraordinary plates are held by the Newberry Library in Chicago. The Missouri Historical Society holds the largest collection of Easterly's work: some 450 portraits and 160 city and landscape views.

199 In addition to Kilgo's discussion of these images in Likeness and Landscape, see Rachel Sailor, "Thomas Easterly's Big Mound Daguerreotypes: A Narrative of Community," Amerikastudien/American Studies 49:2 (2004): 141-57.

200 Kilgo, Likeness and Landscape, p. 110. On this overall subject, see Jennifer L. Mosier, "The Big Attraction: The Circus Elephant and American Culture," Journal of American Culture 22:2 (Summer 1999): 7-18.

201 This view has been previously attributed to Matthew K. Smith. See Thomas Robinson, Oregon Photographers; Biographical History and Directory, 1852-1917, second edition (Portland: Self Published, 1993): 5. On this larger subject, see also Robert O. Brown, Nineteenth Century Portland, Oregon Photographers: A Collector's Handbook (Portland: Robert O. Brown, 1991); and Theodosia Teel Goodman, "Early Oregon Daguerreotypers and Portrait Photographers," Oregon Historical Quarterly 49:1 (March 1948): 30-49; and the relevant entries in Peter E. Palmquist and Thomas R. Kailbourn, Pioneer Photographers of the Far West, A Biographical Dictionary, 1840-1865 (Stanford: Stanford University Press, 2000).

202 The following discussion is informed by Peter E. Palmquist, "The Daguerreotype in San Francisco," History of Photography 4:3 (July 1980): 207-38; individual entries in Palmquist and Kailbourn, Pioneer Photographers of the Far West; and Drew Heath Johnson and Marcia Eymann, eds., Silver & Gold: Cased Images of the California Gold Rush (Iowa City: University of Iowa Press, 1998). There are a number of more focused studies of this subject, including Ira H. Latour, Silver Shadows: A Directory and History, Early Photography in Chico and Twelve Counties of Northern California (Chico: Chico Museum Association, 1993).

203 Palmquist and Kailbourn, Pioneer Photographers of the Far West, pp. 181-82.

204 Ibid., pp. 182-83.

205 A quarter-plate daguerreotype of Baker and the Batchelder wagon is in the collection of the Oakland Museum, and is reproduced in Johnson and Eymann, eds., Silver & Gold, p. 124.

206 See Peter E. Palmquist, "The Stereo Daguerreotype in San Francisco: A Short and Unsuccessful Career," Stereo World 6:2 (May-June 1979): 12-16.

207 This plate's companion is in the collection of Matthew R. Isenburg; see Daguerreian Annual 1996 (Pittsburgh: Daguerreian Society, 1997): 220. My thanks to Mr. Isenburg for discovering the stereographic nature of these plates. The authorship of this work is uncertain. Its companion half was acquired in 1983, at an auction in Ravenna, Ohio, of items from the estate of Frank Ford. While the majority of these photographs were by Frank Ford, some were the work of his brother, James M. Ford. The present attribution is based on the fact that James M. Ford was known for his stereo daguerreotype portraits.

208 Palmquist and Kailbourn, Pioneer Photographers of the Far West, p. 328.

209 The following is indebted to ibid., pp. 559-66.

210 Advertisement, "Daguerrean Panoramic," New-York Daily Times 1:20 (October 10, 1851): n.p. Courtesy Gary W. Ewer.

211 See Peter E. Palmquist, "The Sad but True Story of a Daguerreian Holy Grail," in Johnson and Eymann, eds., Silver & Gold, pp. 43-73.

212 For a humorous commentary on the advertising wars between Vance and George H. Johnson, see Johnson and Eymann, eds., Silver & Gold, p. 329.

213 For example, a whole-plate view of Sacramento Street, looking in the opposite direction (in the collection of the Bancroft Library), appears to have been made from the same vantage point. See Johnson and Eymann, eds., Silver & Gold, p. 119.

214 A nearly identical plate, from the collection of the Gilman Paper Company, is now held by the Metropolitan Museum of Art. See Hambourg et al., The Waking Dream, pp. 311-12. My historical summary is based on these notes. See also Palmquist, "The Daguerreotype in San Francisco," p. 213; and Drew Heath Johnson, "Art & History," Daguerreian Annual 1994 (Pittsburgh: Daguerreian Society, 1994): 167-69.

Selections from the Gilman Paper Company Collection (New York: Metropolitan Museum/Harry N. Abrams, 1993): 118, 311.

CHAPTER III
Being a Daguerreotypist

1 James F. Ryder, *Voigtländer and I: In Pursuit of Shadow Catching* (Cleveland: Cleveland Printing & Publishing Co./Imperial Press, 1902; repr. New York: Arno Press, 1973): 14.

2 Ibid., p. 20.

3 Ibid., p. 22.

4 Ibid. For a recent evaluation of the details of Ryder's narrative, see William L. Camp, "J. F. Ryder's Ithaca Days," *Daguerreian Annual 1993* (Green Bay, Wis.: Daguerreian Society, 1993): 126-30. There is also at least one report of a part-time daguerreotypist, Judge Chas. H. Remmington, of Thomasville, Georgia, who spent most days sitting on the bench. *Photographic and Fine Art Journal* 7:3 (March 1854): 96.

5 John W. Bear, *The Life and Travels of John W. Bear, "The Buckeye Blacksmith"* (Baltimore: D. Binswanger & Co., 1873). Bear's daguerreian adventures, from 1845 to 1852, are described in chapter 7, pp. 138-52. Courtesy Gary W. Ewer.

6 L. L. Hill, *A Treatise on Heliochromy; or, The Production of Pictures by Means of Light, in Natural Colors* (New York: Robinson & Caswell, 1856; facsimile edition, State College, Pa.: Carnation Press, 1972, with introduction by William B. Becker). Commentary on this purported discovery filled the pages of American photographic journals through most of the 1850s.

7 Deservedly, Ball has received considerable scholarly attention. See, for example, Clyde H. Dilley, "Ball's Daguerreian Gallery of the West," *Daguerreian Annual 1991* (Lake Charles, La.: Daguerreian Society, 1991): 186-89; and Deborah Willis, ed., *J. P. Ball: Daguerrean and Studio Photographer* (New York: Garland Publishing, 1993).

8 Goodridge was later joined in the business by his brothers Wallace and William. See Linda A. Ries, "Glenalvon J. Goodridge: Black Daguerreian," *Daguerreian Annual 1991* (Lake Charles, La.: Daguerreian Society, 1991): 38-41. See also Deborah Willis, *Reflections in Black: A History of Black Photographers 1840 to the Present* (New York: W. W. Norton, 2000): 3-24. On Washington, see Carol Johnson, "Faces of Freedom: Portraits from the American Colonization Collection," *Daguerreian Annual 1996* (Pittsburgh: Daguerreian Society, 1997): 264-78.

9 A total of 33 women (of 1,567 total daguerreotypists, or 2.1%) are mentioned in Floyd Rinhart and Marion Rinhart, *The American Daguerreotype* (Athens: University of Georgia Press, 1981): 380-416. In his essay "…Pleasant Employment for Ladies…," *Daguerreian Annual 1995* (Pittsburgh: Daguerreian Society, 1995): 277-80, Roger C. Watson notes that this number "is by far the most generous figure I have found" in present-day scholarship.

10 "Woman was Houston's First Photographer," *Daguerreian Annual 1993* (Green Bay, Wis.: Daguerreian Society, 1993): 37-40.

11 Peter E. Palmquist and Thomas R. Kailbourn, *Pioneer Photographers of the Far West: A Biographical Dictionary, 1845-1865* (Stanford: Stanford University Press, 2000): 489.

12 Sarah J. Weatherwax, "Sally Hewes, Female Daguerreotypist," *Daguerreian Annual 2002-2003* (Pittsburgh: Daguerreian Society, 2004): 25-30.

13 Palmquist and Kailbourn, *Pioneer Photographers of the Far West*, pp. 463-64.

14 For engaging narratives of the sheer recalcitrance of the daguerreotype process see James Taylor Dunn, "The Diary of Tallmadge Elwell, Pioneer Daguerreotypist 1852," *Daguerreian Annual 1992* (Lake Charles, La.: Daguerreian Society, 1992): 59-72; and Gary W. Ewer, "'The Rise and Fall of the Daguerreotype,' by William H. Sherman," *Daguerreian Annual 1997* (Pittsburgh: Daguerreian Society, 1998): 209-25.

15 The best overview of the history and science of the daguerreotype is M. Susan Barger and William B. White, *The Daguerreotype: Nineteenth-Century Technology and Modern Science* (Washington, D.C.: Smithsonian Institution Press, 1991).

16 Much of what follows is indebted to Kenneth E. Nelson, "The Cutting Edge of Yesterday," *Daguerreian Annual 1990* (Lake Charles, La.: Daguerreian Society, 1990): 35-36.

17 For details, see "Practical Photography: Galvanizing Plates," *Photographic Art-Journal* 1:2 (February 1851): 112-14. This writer notes, "This process is much less used than it should be among our artists…"

18 "Daguerreotyping," *Dollar Newspaper* 6:25 (July 5, 1848): n.p. Courtesy Gary W. Ewer.

19 For example, see the notes submitted by the winning daguerreotypists in the Anthony Prize competition of 1853. *Photographic and Fine Art Journal* 7:1 (January 1854): 10.

20 Cited in Beaumont Newhall, *The Daguerreotype in America* (1961; third revised edition New York: Dover Publications, 1976): 120-21.

21 In conversation, the contemporary daguerreotype practitioner and scholar Mike Robinson has speculated that the sixth-plate format became ubiquitous in part because the first available portrait lens by Voigtländer covered a 4-inch image circle. An image of this diameter barely covered a quarter-plate, but was more than adequate for sixth-plates.

22 As Alexander Beckers noted, "The production of a chemically clean surface on silver, is a difficulty that increases four-fold with the size of the plate." Alexander Beckers, "Fifteen Years' Experience of a Daguerreotyper," *St. Louis and Canadian Photographer* (April 1889): 147-48; repr. *Daguerreian Annual 1993* (Green Bay, Wis.: Daguerreian Society, 1993): 117.

23 For a concise study of this subject, see Reece V. Jenkins, *Images and Enterprise: Technology and the American Photographic Industry, 1839 to 1925* (Baltimore: Johns Hopkins University Press, 1975): 13-26. Jenkins notes (p. 22) that Scovill rebuilt their manufacturing facilities in 1850 in order to make their plates more competitive with the French imports. He writes: "At this time the firm introduced the planishing and factory buffing of plates, and it is likely that electroplating was also adopted. The surface quality of the Scovill plates showed a marked improvement after the installation of the new facilities."

24 For an overview of standard techniques—with excellent illustrations—see Geo. M. Hopkins, "Reminiscences of Daguerrotypy," *Scientific American* 56:4 (January 22, 1887): 47, 52; repr. *St. Louis and Canadian Photographer* 14:5 (May 1896): 218-21.

25 S. D. Humphrey, *American Hand Book of the Daguerreotype*, fifth edition (New York: S. D. Humphrey, 1858; repr. New York: Arno Press, 1973): 14.

26 Ibid., p. 15.

27 Ibid., p. 17

28 He continued: "On the plate cleaned with clear alcohol a far inferior impression was obtained…while the one cleaned with water gave an impression…flat and cold, and destitute of character…" D. D. T. Davie, "Picture-Making—No. 1," *Photographic Art-Journal* 4:5 (November 1852): 299-300. See also A. Hesler, "Practical Photography—Cleaning and Coating the Plate," *Photographic Art-Journal* 2:1 (July 1851): 50-51.

29 For a detailed pictorial survey of daguerreian cameras and darkroom equipment, see Matthew R. Isenburg, "Early Equipment," *Daguerreian Annual 1993* (Green Bay, Wis.: Daguerreian Society, 1993): 201-54.

30 On wheel buffing devices, see "Buffing the Plate," *Photographic Art-Journal* 1:1 (January 1851): 59-60; and D. D. T. Davie, "Picture-Making—No. 2," *Photographic Art-Journal* 5:2 (February 1853): 103-04. Many daguerreotypists used machinery to clean and/or buff their plates by the early 1850s. In an 1889 reminiscence, Alexander Beckers stated: "In 1849…we succeeded in substituting machinery for cleaning our plates, and thus obtained cleaner and better plates in one-third the time required by hand." Beckers, "Fifteen Years' Experience of a Daguerreotyper," pp. 147-48; repr. *Daguerreian Annual 1993*, p. 118.

31 Humphrey, *American Hand Book*, p. 18.

32 Ibid., p. 20.

33 Ibid., p. 23. As Humphrey notes, a perfectly buffed plate "would produce a well-defined image in *one fourth* less time than the plate without the extra buffing."

34 "Mr. Hesler's New Process—Buffing Plates, &c.," *Photographic Art-Journal* 3:3 (March 1852): 154-55.

35 Nelson, "The Cutting Edge," p. 39.

36 Ibid., p. 126.

37 For a fascinating and detailed study of the nuances of sensitization, see Charlie Schreiner, "Iodine and Bromine: Part I: It takes Two to Tango," *Daguerreian Annual 1998* (Pittsburgh: Daguerreian Society, 1999): 165-74.

38 Kenneth E. Nelson, "An Introduction to the Modern Daguerreotype Process," in Grant Romer et al., *Daguerreotype Workbook: History, Modern Practice, Preservation* (Rochester: George Eastman House, 1996): 18.

39 Ibid.

40 I first had this experience in 1997, in a memorable daguerreotype workshop taught by Kenneth E. Nelson at the George Eastman House.

41 Humphrey, *American Hand Book,* pp. 24-25.

42 My understanding of what follows—and of much else in this section—has been informed by Mike Robinson.

43 Newhall, *The Daguerreotype in America*, p. 123.

44 This information from Mike Robinson, July 19, 2006. On this subject, see also Nelson, "An Introduction to the Modern Daguerreotype Process," p. 18. For related information, see John Hurlock's two articles: "The Light at the End of the Bromine: The Truth is Out There," *Daguerreian Annual 2000* (Pittsburgh: Daguerreian Society, 2001): 8-32; and "Unlocking the Secret: Hyper-sensitizing Daguerreotypes with Light, *Daguerreian Annual 2004* (Pittsburgh: Daguerreian Society, 2005): 91-105. In the latter essay, Hurlock uses the figure of ASA 0.07 for the base speed of the standard daguerreotype plate.

45 Alexander Hesler, "Some Practical Experiences of a Veteran Daguerreotypist," *Photographic Times* 19 (March 15, 1889): 130-31. While Hesler's words are slightly ambiguous, my understanding of this technique is indebted to Mike Robinson.

46 The following is indebted to Kenneth E. Nelson, "Mercury & the Daguerreotypist: A Modern Assessment," *Daguerreian Annual 1994* (Pittsburgh: Daguerreian Society, 1994): 119-46.

47 Humphrey, *American Hand Book*, p. 37.

48 Ibid., p. 38.

49 Ibid., p. 41.

50 Ibid., pp. 47-48.

51 For an overview of this subject, see Michael G. Jacob, "Color and the Daguerreotype: 'The Great Problem is Fairly Solved…'," *Daguerreian Annual 1997* (Pittsburgh: Daguerreian Society, 1998): 174-208.

[52] Newhall, *The Daguerreotype in America*, p. 96.

[53] Humphrey, *American Hand Book*, pp. 48-49.

[54] On daguerreotype cases see, for example, Floyd Rinhart and Marion Rinhart, *American Miniature Case Art* (South Brunswick and New York: A. S. Barnes & Co., 1969); Clifford Krainik and Michele Krainik with Carl Walvoord, *Union Cases: A Collector's Guide to the Art of America's First Plastics* (Grantsburg, Wis.: Centennial Photo Service, 1988); and the following works by Paul K. Berg: *Nineteenth Century Photographic Cases and Wall Frames* (Huntington Beach, Calif.: Huntington Valley Press, 1995); "Fancy Daguerreian Cases," *Daguerreian Annual 1996* (Pittsburgh: Daguerreian Society, 1996): 36-44; and "The Forgotten Leather and Paper Daguerreotype Case, Its Die Engravers and Manufacturers," *Daguerreian Annual 1997* (Pittsburgh: Daguerreian Society, 1997): 235-76.

[55] *Photographic Art-Journal* 3:5 (May 1852): 320.

[56] *Humphrey's Journal* 5:1 (April 15, 1853): 10-11.

[57] *Humphrey's Journal* 5:5 (June 15, 1853): 73-74.

[58] Dilley, "Ball's Daguerrian Gallery of the West," *Daguerreian Annual 1991*, pp. 187-88. A glowing article on Ball's gallery with a wood engraving of his reception room was published in *Gleason's Pictorial Drawing-Room Companion* 6:13 (April 1, 1854): 208.

[59] Marcus Aurelius Root, *The Camera and the Pencil; or, the Heliographic Art* (Philadelphia: M. A. Root/Lippincott, 1864): 46-48; and (an earlier, variant version of the same text) "Some Thoughts on the Fitting up of Daguerrean Rooms," *Photographic Art-Journal* 5:6 (June 1853): 361-64.

[60] Dunn, "The Diary of Tallmadge Elwell," pp. 66-68.

[61] Conversation with Mike Robinson, March 10, 2006.

[62] Studio handbill, collection of George Eastman House; reproduced in Keith F. Davis, *George N. Barnard: Photographer of Sherman's Campaign* (Kansas City: Hallmark Cards, 1990): 23.

[63] This discussion is informed by conversations with Mike Robinson, and by his superb lecture at the 2005 Daguerreian Society annual meeting, Rochester, New York, October 29, 2005.

[64] For a definitive history of this subject, see Larry J. West and Patricia A. Abbott, *Antique Photographic Jewelry: Tokens of Affection and Regard* (New York: West Companies, 2005).

[65] S. D. Humphrey and M. Finley, *A System of Photography; Containing an Explicit Detail of the Whole Process of Daguerreotype* (Canandaigua, N.Y.: Ontario Messenger, 1849); Henry Hunt Snelling, *The History and Practice of the Art of Photography* (New York: G. P. Putnam, 1849; repr. Hastings-on-Hudson, N.Y.: Morgan & Morgan, 1970); Levi L. Hill and W. McCartey, Jr., *A Treatise on Daguerreotype* (Lexington, N.Y.: Holman & Gray, 1850; repr. New York: Arno Press, 1973).

[66] This discussion is based on Jane Rohrschneider, "Samuel D. Humphrey, Journalist—Photographer: A New Perspective on His Contributions to American Photography," *Daguerreian Annual 1997* (Pittsburgh: Daguerreian Society, 1998): 63-86.

[67] A. J. Olmstead, "Snelling: The Father of Photographic Journalism," *Daguerreian Annual 1994* (Pittsburgh: Daguerreian Society, 1994): 220-23.

[68] *Daguerreian Journal* 1:1 (November 1, 1850): 15. Exact circulation figures are unclear. The circulation of the *Photographic Art-Journal*, as stated in its June 1851 issue (p. 380), was 1,000 copies per month. An 1853 article from the *New York Tribune*, reprinted in the *Photographic and Fine Art Journal* 5:6 (June 1853): 334-41, stated (p. 339) that the combined circulation of *Humphrey's* and the *Photographic and Fine Art Journal* was 5,000 copies. The rarity of these journals today suggests that these numbers might have been slightly optimistic.

[69] *Daguerreian Journal* 1:1 (November 1, 1850): 15.

[70] *Photographic Art-Journal* 1:1 (January 1851): 61.

[71] For example, see Snelling's series "Photographic Re-Unions," *Photographic Art-Journal* 1:2 (February 1851): 107-10; 1:3 (March 1851): 139-41; and 1:5 (May 1851): 266-68.

[72] One of the first of these, the Typographical Association of Journeymen Printers, was formed in 1831; many other craft unions were organized in the following years. For an overview of this general subject, see Sean Wilentz, *Chants Democratic: New York City and the Rise of the American Working Class, 1788-1850* (Oxford: Oxford University Press, 1984).

[73] The following is indebted to Joy Sperling, "'Art, Cheap and Good': The Art Union in England and the United States, 1840-1860," *Nineteenth-Century Art Worldwide: A Journal of Nineteenth-Century Visual Culture* 1:1 (Spring 2000); http://19thc-artworldwide.org; and Malcolm Goldstein, *Landscape with Figures: A History of Art Dealing in the United States* (New York: Oxford University Press, 2000): 20-28.

[74] *Humphrey's Journal* 1:6 (February 1, 1851): 176. The *Photographic and Fine Art Journal* reported on the Art-Union with great consistency; see, for example, 1:2 (February 1851): 101-03; 1:5 (May 1851): 287-94; 3:3 (March 1852): 165-69; and 3:4 (April 1852): 246-50.

[75] *Photographic Art-Journal* 2:2 (August 1851): 123-24.

[76] *Daguerreian Journal* 2:11 (October 15, 1851): 345.

[77] *Photographic Art-Journal* 3:5 (May 1852): 304.

[78] Ibid.

[79] *Daguerreian Journal* 2:11 (October 15, 1851): 345.

[80] *Photographic Art-Journal* 2:2 (August 1851): 124.

[81] *Photographic Art-Journal* 3:5 (May 1852): 317

[82] It is telling that an 1857 guide to "practical" success had this to say about the profession:

> The business of taking daguerreotypes, photographs, ambrotypes, and the thousand-and-one other "types" and "graphs," is now a very extensive one, employing many thousands of persons in the United States. It is not considered a healthful pursuit, and is, at present, over-crowded. The best artists, in this branch, in our large cities, sometimes do a very large business and accumulate fortunes, but the majority, we fear, barely gain a subsistence.

How to do Business: A Pocket Manual of Practical Affairs, and Guide to Success in Life (New York: Fowler and Wells, 1857): 87. Courtesy Gary W. Ewer.

[83] The risks of this entrepreneurial climate have been explored in a number of studies, including Scott A. Sandage, *Born Losers: A History of Failure in America* (Cambridge, Mass.: Harvard University Press, 2005).

[84] F. B. Gage, "Adaptation," *Humphrey's Journal* 10:3 (June 1, 1858): 36-37.

[85] Jack C. Ramsay, Jr., *Photographer…Under Fire: The Story of George S. Cook (1819-1902)* (Green Bay, Wis.: Historical Resources Press, 1994): 30-36. See also the series "The Peregrinations of a Daguerrean," in the July, November, and December 1851 issues of the *Photographic Art-Journal*, describing the wanderings through the South of an unnamed daguerreotypist.

[86] For an overview of this subject, see, for example, Peter Benes, ed., *Itinerancy in New England and New York*, vol. IX, Dublin Seminar for New England Folklife, Annual Proceedings (Boston: Boston University Press, 1984).

[87] On the sheer difficulties of moving about, see Jim Foster, "The Vexations of E. M. Wilson, Itinerant Daguerreotypist," *Daguerreian Annual 1992* (Lake Charles, La.: Daguerreian Society, 1992): 126-27.

[88] G. H. Loomis, "Gallery Biographic. No. 4: J. H. Fitzgibbon," *Anthony's Photographic Bulletin* 6:3 (March 1875): 81-82.

[89] Newhall, *The Daguerreotype in America*, p. 69.

[90] On this subject, see "Traveling Daguerreotype Wagon," *Photographic Art-Journal* 3:3 (March 1852): 194. The writer of this letter, "Helia," states that he has been traveling "for some time" in a large Daguerreotype saloon, but finds it "expensive…, heavy, and cumbersome." His letter requests advice or proposals from other daguerreotypists on a smaller, lighter vehicle.

[91] *Lockport Daily Courier* (July 19, 1853); as quoted in Newhall, *The Daguerreotype in America*, p. 71. The owners of this traveling studio were E. R. Graves and Henry Pruden. A whole-plate daguerreotype of Graves and Pruden's "Mammoth Daguerrean Saloon No. 2" is reproduced in Richard S. Field and Robin Jaffee Frank, *American Daguerreotypes from the Matthew R. Isenburg Collection* (New Haven: Yale University Art Gallery, 1989): 26.

[92] *St. Louis and Canadian Photographer* 13 (1899): 327; cited in Newhall, *The Daguerreotype in America*, p. 71.

[93] *Daguerreian Journal* 1:5 (January 15, 1851): 148.

[94] *Humphrey's Journal* 4:16 (December 1, 1852): 250. On Dobyns's career, see Beth Ouimet, "Dobyns & Company: River City Daguerreian Network," *Daguerreian Annual 1990* (Lake Charles, La.: Daguerreian Society, 1990): 42-50.

[95] *Photographic Art-Journal* 2:1 (July 1851): 63. On Haas's career, see William Marder and Estelle Marder with Sally Pierce, "Philip Haas: Lithographer, Print Publisher, and Daguerreotypist," *Daguerreian Annual 1995* (Pittsburgh: Daguerreian Society, 1995): 21-34.

[96] In contrast to the English preference for heavily hand-colored plates, the "American style" emphasized "fine, clear, and bright-toned impression[s]." For one view on the state of the art in London, see "Our Foreign Correspondent," *Humphrey's Journal* 4:20 (February 1, 1853): 313-20, followed by commentary by J. E. Mayall, "A Convenient Process for Photographs upon Paper and Glass," ibid., pp. 315-19.

[97] Isobel Crombie and Susan van Wyk, *Second Sight: Australian Photography in the National Gallery of Victoria* (Melbourne: National Gallery of Victoria, 2002): 20.

[98] Abel Alexander, "Robert H. Vance: Pioneer of the Daguerreotype in Chile," *Daguerreian Annual 1993* (Green Bay, Wis.: Daguerreian Society, 1993): 15.

[99] Sylvie Pénichon, "The History of the Daguerreotype in Brazil," *Daguerreian Annual 2002-2003* (Pittsburgh: Daguerreian Society, 2004): 319-20.

[100] After returning to New York, Morand subsequently made a long photographic journey West, spending an extended time "on the Mississippi, the Missouri and the Ohio Rivers…" For a period biographic sketch of Morand, see Rev. J. P. Kidder, "Augustus Morand and the Daguerrean Art," *Photographic Art-Journal* 1:4 (April 1851): 237-39.

[101] For a brief history of this activity, see Miguel Angel Cuarterolo, "Charles DeForest Fredricks: A Latin-American Adventure," *Daguerreian Annual 2002-2003* (Pittsburgh: Daguerreian Society, 2004): 298-314; and, in the same volume, Pénichon, "The History of the Daguerreotype in Brazil," pp. 316-31.

[102] On the larger history of the daguerreotype in Argentina, see Jeremy Adelman and Miguel Angel Cuarterolo, *Los Anos del Daguerrotyipo: Primeras Fotograpfias Argentinas, 1843-1870* (Buenos Aires: Fundacion Antorchas, 1995).

103 See Keith McElroy, "Benjamin Franklin Pease: An American Photographer in Lima, Peru," *History of Photography* 3:3 (July 1979): 195-209; and *Early Peruvian Photography: A Critical Case Study* (Ann Arbor, Mich.: UMI Research Press, 1985). This latter title, the definitive study of its kind, includes a particularly valuable chapter on "The Business of Photography," pp. 47-84.

104 McElroy, "Benjamin Franklin Pease," p. 199.

105 Alexander, "Robert H. Vance," pp. 11-30.

106 Enrique del Cid F., trans. David Haynes and Birgitta B. Riera, "First Photographers Who Worked in Guatemala," *Daguerreian Annual 1994* (Pittsburgh: Daguerreian Society, 1994): 38-41.

107 See William S. Johnson, *Nineteenth-Century Photography: An Annotated Bibliography, 1839-1879* (Boston: G. K. Hall, 1990): 693. On Whittemore's work in Bermuda, see A Field Officer, *Bermuda: A Colony, A Fortress, and a Prison; or, Eighteen Months in the Somers' Islands* (London: Longman, Brown, Gree, Longmans, & Roberts: 1857), with eight lithographic illustrations from daguerreotypes by Whittemore. Courtesy Gary W. Ewer.

108 Ron Polito, "The Emergence of Commercial Photography in Boston: 1840-1841," *New England Journal of Photographic History* 164 (Spring 2005): 28.

109 *Daguerreian Journal* 1:2 (November 15, 1850): 49.

110 *Photographic Art-Journal* 5:6 (June 1853): 339; "Photography in the United States," repr. from *New York Daily Tribune*.

111 *Photographic Art-Journal* 5:6 (June 1853): 339.

112 This subject is covered in the first chapter of Jenkins's *Images and Enterprise*. For a detailed report of the W. & W. H. Lewis factory, at the time the largest single producer of daguerreotype supplies, see "Daguerreville Manufactory," *Humphrey's Journal* 4:1 (April 15, 1852): 11-12.

113 Ibid.

114 *Photographic Art-Journal* 6:4 (October 1853): 258.

115 *Photographic Art-Journal* 6:1 (July 1853): 31-32.

116 Ibid., p. 32.

117 On November 13, 1852, Elwell reported: "Amount taken during the week $22.55." Dunn, "The Diary of Tallmadge Elwell," p. 67.

118 *Photographic Art-Journal* 3:1 (January 1852): 66.

119 *Humphrey's Journal* 4:18 (January 1, 1853): 287.

120 *Daguerreotype Directory, Reese & Co.'s German System of Photography and Picture Making* (New York: Charles R. Reese, 1854): 28. Courtesy Gary W. Ewer.

121 Ibid., p. 36.

122 *Humphrey's Journal* 6:20 (February 1, 1855): 327. At the time, two shillings was equal to about forty-eight cents.

123 *Humphrey's Journal* 6:18 (January 1, 1855): 296.

124 *Humphrey's Journal* 6:20 (February 1, 1855): 327.

125 Ibid.

126 Advertisements by Rafferty & Leask in the *New-York Daily Times* 2:619 (September 12, 1853): 4; and 4:976 (November 3, 1854): 4; courtesy Gary W. Ewer. This novelty was reported in *Humphrey's Journal* 5:17 (December 15, 1853): 265.

127 Cited in Newhall, *The Daguerreotype in America*, p. 63.

128 Ibid.

129 Cited in Richard Rudisill, *Mirror Image: The Influence of the Daguerreotype on American Society* (Albuquerque: University of New Mexico Press, 1971): 113; *Humphrey's Journal* 5:24 (March 1, 1854): 352.

130 The following is indebted to Julie K. Brown, *Making Culture Visible: The Public Display of Photography at Fairs, Expositions and Exhibitions in the United States, 1847-1900* (Amsterdam: Harwood Academic Publishers, 2001); and Ethan Robey, *The Utility of Art: Mechanics' Institute Fairs in New York City, 1828-1876* (Ph.D. dissertation, Columbia University, 2000).

131 Brown, *Making Culture Visible*, p. 5.

132 See, for example, Rev. H. W. Bellows, *The Moral Significance of the Crystal Palace: A Sermon* (New York: G. P. Putnam, 1853).

133 Brown, *Making Culture Visible*, p. 5.

134 *Official Catalogue of the New York Exhibition of the Industry of All Nations, 1853* (New York: George P. Putnam, 1853): 55-58.

135 "Report of the Seventeenth Exhibition of American Manufactures…by the Franklin Institute," *Journal of the Franklin Institute* (1847): 19-20.

136 J. J. Arnoux, "The World's Fair," *Photographic Art-Journal* 2:3 (September 1851): 153-56.

137 Rinhart and Rinhart, *The American Daguerreotype*, p. 121.

138 For a concise history and description, see Margot Gayle, "The New York Crystal Palace: America's Progress, Power, and Possibilities," *Nineteenth Century* 15:1 (1995): 10-15.

139 See, for example, Robert C. Post, "Reflections of American Science and Technology at the New York Crystal Palace Exhibition of 1853," *Journal of American Studies* 17:3 (1983): 337-56.

140 For a contemporary critique of these aspects of the fair, see "The Exhibition at the Crystal Palace," *Photographic Art-Journal* 6:2 (August 1853): 97-101; repr. from *New York Tribune*.

141 Horace Greeley, ed., *Art and Industry as Represented in the Exhibition at the Crystal Palace New York—1853-4* (New York: Redfield, 1853): 171.

142 *Official Catalogue of the New York Exhibition*, pp. 56-58.

143 This work was also known by the title *The Three Ages*.

144 *Photographic Art-Journal* 6:3 (September 1853): 195.

145 Greeley, ed., *Art and Industry as Represented in the Exhibition at the Crystal Palace*, p. 175. This text, which appears to be by Greeley, was reprinted (with strong comments on "the ignorance of its author") in *Photographic Art-Journal* 6:3 (September 1853): 191-94.

146 Root's submission is mentioned in Rinhart and Rinhart, *The American Daguerreotype*, p. 125.

147 *Photographic and Fine Art Journal* 7:2 (February 1854): 64.

148 *Photographic Art-Journal* 1:5 (May 1851): 315.

149 The *Photographic Art-Journal* was full of information on the evolution of this award. See, for example, 3:6 (June 1852): 384; and 4:5 (November 1852): 324.

150 The remaining three entrants were Joel E. Whitney, Preston M. Cary, and Masury & Silsbee. For a detailed summary of the results, see *Photographic and Fine Art Journal* 7:1 (January 1854): 6-11.

151 Ibid., pp. 6-7.

152 *Photographic and Fine Art Journal* 8:5 (May 1855): 158-59.

153 Oliver Wendell Holmes is credited with the oft-repeated phrase "mirror with a memory," in his article "The Stereoscope and the Stereograph," *Atlantic Monthly* 3:20 (June 1859): 738-48. The phrase "the tenacious mirror" appears in the review of James P. Ball's business, "Daguerrean Gallery of the West," *Gleason's Pictorial Drawing-Room Companion* (April 1, 1854): 208. Courtesy Gary W. Ewer. For an introduction to this rich subject, see Sabine Melchior-Bonnet, *The Mirror: A History* (New York: Routledge, 2001). On a related topic, see Alan MacFarlane and Gerry Martin, *Glass: A World History* (Chicago: University of Chicago Press, 2002). This motif is central to Alan Trachtenberg's "Mirror in the Marketplace: American Responses to the Daguerreotype, 1839-1851," in Wood, ed., *The Daguerreotype: A Sesquicentennial Celebration*, pp. 60-73.

154 Plato, *Republic*, 514a-518d, trans. Robin Waterfield (Oxford: Oxford University Press, 1993): 240-45.

155 The literature on the Enlightenment and Romantic thought is, of course, nearly endless. A basic inquiry into these critically important intellectual traditions might at least begin with the following volumes.

On the Enlightenment: Ernst Cassirer, *The Philosophy of the Enlightenment* (1951; Princeton: Princeton University Press, 1979); Peter Gay, *The Enlightenment, An Interpretation; vol. I: The Rise of Modern Paganism* (New York: W. W. Norton, 1966), and *The Enlightenment, An Interpretation; vol. II: The Science of Freedom* (New York: W. W. Norton, 1969); and Jonathan I. Israel, *Radical Enlightenment: Philosophy and the Making of Modernity, 1650-1750* (Oxford: Oxford University Press, 2001).

On Romanticism (with an emphasis on the German philosophic tradition): Duncan Wu, ed., *Romanticism: An Anthology*, second edition (Oxford: Blackwell, 1998); Karl Ameriks, ed., *The Cambridge Companion to German Idealism* (Cambridge: Cambridge University Press, 2000); Terry Pinkard, *German Philosophy 1760-1860: The Legacy of Idealism* (Cambridge: Cambridge University Press, 2002); Frederick C. Beiser, *The Fate of Reason: German Philosophy from Kant to Fichte* (Cambridge: Harvard University Press, 1987); and Andrew Bowie, *Aesthetics and Subjectivity: From Kant to Nietzsche*, second edition (Manchester: Manchester University Press, 2003).

156 Letter from "Junius" [pseudonym for Marcus A. Root], *Photographic Art-Journal* 4:4 (October 1852): 225.

157 John F. Kasson, *Civilizing the Machine: Technology and Republican Values in America, 1776-1900* (Harmondsworth: Penguin, 1977).

158 For a classic study of this subject, see John A. Kouwenhoven, *Made in America: The Arts in Modern Civilization* (New York: Doubleday, 1948).

159 "Development of Nationality in American Art," *Photographic Art-Journal* 3:1 (January 1852): 36, 37.

160 Ibid., p. 39.

161 On this overall subject, see Joshua C. Taylor, *The Fine Arts in America* (Chicago: University of Chicago Press, 1979); Neil Harris, *The Artist in American Society: The Formative Years, 1790-1860* (Chicago: University of Chicago Press, 1966); and Anne Farmer Meservey, "The Role of Art in American Life: Critics' Views on Native Art and Literature, 1830-1865," *American Art Journal* 10:1 (May 1978): 72-89. The numerous studies of the rise of artists' organizations, art galleries, and museums include: Eliot Clark, *History of the National Academy of Design, 1825-1953* (New York: Columbia University Press, 1954); Goldstein, *Landscape with Figures: A History of Art Dealing in the United States*; Leah Lipton, "The Boston Artists' Association, 1841-1851," *American Art Journal* 15:4 (Autumn 1983): 45-57; and William H. Gerdts, "'Good Tidings to the Lovers of the Beautiful': New York's Düsseldorf Gallery, 1849-1862," *American Art Journal* 30:1-2 (1999): 50-81.

The Face of a Nation

1 The following is informed by numerous sources, including: Peter Benes, ed., *Painting and Portrait Making in the American Northeast*, Dublin Seminar for New England Folklife Annual Proceedings (Boston: Boston University Press, 1994); Caroline F. Sloat, ed., *Meet Your Neighbors: New England Portraits, Painters, & Society, 1790-1850* (Sturbridge, Mass.: Old Sturbridge Village/University of Massachusetts Press, 1992); John Michael Vlach, *Plain Painters: Making Sense of American Folk Art* (Washington, D.C.: Smithsonian Institution Press, 1988); Dale T. Johnson, *American Portrait Miniatures in the Manney Collection* (New York: Metropolitan Museum of Art/Harry N. Abrams, 1990); David Jaffee, "'A Correct Likeness': Culture and Commerce in Nineteenth-Century Rural America," in Marianne Doezema and Elizabeth Milroy, eds., *Reading American Art* (New Haven: Yale University Press, 1998): 109-27; Jane Lee Aspinwall, *"Like a Bird Before a Snake": Nineteenth-Century Portraiture and its Relationship to the American Daguerreotype* (M.A. thesis, University of Missouri-Kansas City, 2001); and Robin Jaffee Frank, *Love and Loss: American Portrait and Mourning Miniatures* (New Haven: Yale University Press, 2000).

2 Carol Aiken, "The Emergence of the Portrait Miniature in New England," in Benes, ed., *Painting and Portrait Making in the American Northeast*, pp. 31-32, 37.

3 Jack Larkin, "The Faces of Change: Images of Self & Society in New England, 1790-1850," in Sloat, ed., *Meet Your Neighbors*, p. 18.

4 Cited in Elizabeth Mankin Kornhauser, "'Staring Likenesses': Portraiture in Rural New England, 1790-1850," in Sloat, ed., *Meet Your Neighbors*, p. 30.

5 Larkin, "The Faces of Change," p. 11.

6 Johnson, *American Portrait Miniatures*, pp. 13-14. For recent surveys of the British portrait miniature tradition, see Katherine Coombs, *The Portrait Miniature in England* (London: V&A Publications, 1998); Richard Walker, *Miniatures: 300 Years of the English Miniature Illustrated from the Collections of the National Portrait Gallery* (London: National Portrait Gallery, 1998); and Graham Reynolds, *British Portrait Miniatures* (Cambridge: Cambridge University Press, 1998).

7 Joyce Hill, "New England Itinerant Portraitists," in Peter Benes, ed., *Itinerancy in New England and New York*, Dublin Seminar for New England Folklife Annual Proceedings (Boston: Boston University Press, 1984): 160.

8 Itinerant limners attempted to appeal to a wide audience. In 1806, for example, one artist offered profiles in sixteen formats, from a quarter-inch in size on up, "cut on beautiful wove paper." In the early 1820s, an itinerant named Rufus Porter advertised "correct likenesses" ranging in price from twenty cents for "common profiles cut double" to $8 for "miniatures painted on ivory." Ibid.; and David Jaffee, "The Age of Democratic Portraiture: Artisan-Entrepreneurs and the Rise of Consumer Goods," in Sloat, ed., *Meet Your Neighbors*, p. 37.

9 See Ellen G. Miles, "1803—The Year of the Physiognotrace"; Peter Benes, "Machine-Assisted Portrait and Profile Imaging in New England after 1803" and Paul D. Schweizer, "William J. Weaver's Secret Art of Multiplying Pictures"; in Benes, ed., *Painting and Portrait Making in the American Northeast*, pp. 118-66; Ellen Miles, "Saint-Mémin, Valdenuit, Lemet: Federal Profiles," in Wendy Wick Reaves, ed., *American Portrait Prints* (Charlottesville: University Press of Virginia, 1984): 1-28; and Wendy Bellion, "Heads of State: Profiles and Politics in Jeffersonian America," in Lisa Gitelman and Geoffrey B. Pingree, eds., *New Media, 1740-1915* (Cambridge, Mass.: MIT Press, 2003): 31-59.

10 Benes, "Machine-Assisted Portrait and Profile Imaging in New England after 1803," p. 139.

11 Lydia Foy, "New England and New York Portrait Makers in Canada, 1760-1860," in Benes, ed., *Painting and Portrait Making in the American Northeast*, pp. 107-17; and Hill, "New England Itinerant Portraitists," pp. 150-71.

12 As a critic noted in 1856: "Among miniature painters, the photographic art has had the effect to benefit…the few, while it annihilates the many." New York *Home Journal* (February 9, 1856); quoted in Frank, *Love and Loss*, p. 302.

13 Harry B. Wehle, *American Miniatures, 1730-1850* (Garden City, N.Y.: Garden City Publishing, 1927): 69; cited in Frank, *Love and Loss*, p. 277.

14 See, for example, Lauren B. Hewes, "Horace Bundy: Portraits Painted from Daguerreotypes," in Benes, ed., *Painting and Portrait Making in the American Northeast*, pp. 247-54; and Frank, *Love and Loss*, pp. 277-303.

15 Frank, *Love and Loss*, pp. 296-97.

16 The following is indebted to Reaves, ed., *American Portrait Prints*.

17 Leo Braudy, *The Frenzy of Renown: Fame and its History* (New York: Oxford University Press, 1986): 452. Braudy's classic study provides a historical overview of this subject.

18 Scott E. Casper, *Constructing American Lives: Biography and Culture in Nineteenth-Century America* (Chapel Hill: University of North Carolina Press, 1999): 2. The following discussion is indebted to this important study.

19 Ibid., pp. 78-79.

20 Ibid., pp. 137-53.

21 Ralph Waldo Emerson, *Representative Men: Seven Lectures*, introduction by Andrew Delbanco (Cambridge, Mass.: Belknap Press, 1996): 3.

22 Casper, *Constructing American Lives*, pp. 91-94.

23 Mary Panzer, *Mathew Brady and the Image of History* (Washington, D.C.: Smithsonian Institution Press/National Portrait Gallery, 1997): 59.

24 See Gordon M. Marshall, "The Golden Age of Illustrated Biographies: Three Case Studies," in Reaves, ed., *American Portrait Prints*, pp. 29-82.

25 Wendy Wick Reaves, "Portraits for Every Parlor: Albert Newsman and American Portrait Lithography," in Reaves, ed., *American Portrait Prints*, pp. 83-134.

26 Ibid., p. 85.

27 The following is informed by several sources, including Panzer, *Mathew Brady*, pp. 55-69. For studies of this larger subject see, for example, Stephen Bann, *Parallel Lines: Printmakers, Painters and Photographers in Nineteenth-Century France* (New Haven: Yale University Press, 2001); and Kathleen Stewart Howe, ed., *Intersections: Lithography, Photography, and the Traditions of Printmaking*, vol. 17, Tamarind Papers (Albuquerque: University of New Mexico Press, 1998).

28 William Marder and Estelle Marder, *Anthony: The Man, The Company, The Cameras, An American Photographic Pioneer* (Amesbury, Mass.: Pine Ridge Publishing, 1982): 23-26. See also William Marder and Estelle Marder, "Miraculous Museum Find Leads to Remarkable Daguerreian Discoveries," *Daguerreian Annual 1992* (Lake Charles, La.: Daguerreian Society, 1992): 181-98, on this Anthony-Edwards work, and the discovery in 1990 of a cache of these plates at the Mead Art Museum, Amherst College.

29 Marder and Marder, *Anthony*, pp. 22-23. There also appears to have been an 1851 edition; see "A Splendid Monument of America," *Photographic Art-Journal* 1:5 (May 1851): 318-19. The print was documented as early as March 1845—before it was completed—in the *United States Magazine and Democratic Review* 16:81 (March 1845): 311; courtesy Gary W. Ewer.

30 *Humphrey's Journal* 4:1 (April 15, 1852): 12-13.

31 Clifford Krainik, "National Vision, Local Enterprise: John Plumbe, Jr., and the Advent of Photography in Washington, D.C.," *Washington History* 9:2 (Fall/Winter 1997-98): 22.

32 Panzer, *Mathew Brady*, p. 55.

33 This was first issued in monthly installments, beginning in late January 1850, with the paper wrapper providing the following: C. Edwards Lester [ed.], "assisted by an association of literary men," *The Gallery of Illustrious Americans, Containing the Portraits and Biographical Sketches of Twenty-four of the most Eminent Citizens of the Republic since the Death of Washington. Daguerreotypes by Brady—Engraved by D'Avignon* (New York: Published from Brady's Gallery, 205 Broadway. By G. P. Putnam, D. Appleton & Co., C. S. Francis & Co., 1850). Later issued as a bound volume: C. Edwards Lester, ed., *The Gallery of Illustrious Americans, Containing the Portraits and Biographical Sketches of Twenty-four of the most Eminent Citizens of the American Republic since the Death of Washington. From Daguerreotypes by Brady—Engraved by D'Avignon* (New York: M. B. Brady, F. D. Avignon, C. Edwards Lester, 1850). For a review of this work, see "Notices of New Works," *Southern Literary Messenger* [Richmond] 17:4 (April 1851): 254-55. Courtesy Gary W. Ewer.

34 William F. Stapp, "Daguerreotypes onto Stone: The Life and Work of Francis D'Avignon," in Reaves, ed., *American Portrait Prints*, pp. 201-03; and Panzer, *Mathew Brady*, pp. 62-65.

35 "Appendix: Preliminary Checklist of Newsam's Portrait Lithographs," in Reaves, *American Portrait Prints*, pp. 115-34. Newsam was a deaf-mute orphan who arrived in Philadelphia at the age of eleven. He survived at first on the coins from passersby for his chalk graffiti on the street. Kenneth Finkel, *Philadelphia ReVisions: The Print Department Collects* (Philadelphia: Library Company, 1983): 17-18.

36 Stapp, "Daguerreotypes onto Stone," pp. 194-231.

37 The first issue of the journal included a brief biographic sketch of D'Avignon and comments on his work with Brady. *Photographic Art-Journal* 1:1 (January 1851): 61.

38 *Photographic Art-Journal* 1:3 (March 1851): 189.

39 *Humphrey's Journal* 1:2 (November 15, 1850): 51.

40 *Humphrey's Journal* 2:8 (September 1, 1851): 251.

41 *Humphrey's Journal* 3:2 (December 1, 1851): 52.

42 See Harold Francis Pfister, *Facing the Light: Historic American Portrait Daguerreotypes* (Washington, D.C.: National Portrait Gallery/Smithsonian Institution Press, 1978): 74-79, 350-51. This plate appears to match "Other Unlocated Plates 'a,'" p. 351.

43 Ibid., pp. 281-85, 349. Four firmly attributed portraits of Sumner by Southworth & Hawes are known; see Grant B. Romer and Brian Wallis, eds., *Young America: The Daguerreotypes of Southworth & Hawes* (Göttingen: Steidl/George Eastman House/International Center of Photography, 2005): 304-05.

44 The following is indebted to John Stauffer, *The Black Hearts of Men: Radical Abolitionists and the Transformation of Race* (Cambridge, Mass.: Harvard University Press, 2002): 45-56.

45 Cited in ibid., p. 54.

46 Cited in Braudy, *Frenzy of Renown*, p. 453.

47 Philip B. Kunhardt, Jr., et al., *P. T. Barnum: America's Greatest Showman* (New York: Alfred A. Knopf, 1995): 36-37. For a larger perspective on this history, see Robert M. Lewis, ed., *From Traveling Show to Vaudeville: Theatrical Spectacle in America, 1830-1910* (Baltimore: Johns Hopkins University Press, 2003).

48 Kunhardt, *P. T. Barnum*, p. 39.

49 See Larry J. West and Patricia A. Abbott, *Antique Photographic Jewelry: Tokens of Affection and Regard* (New York: West Companies, 2005).

50 For one perspective on this subject, see Geoffrey Batchen, "Ere the Substance Fade: Photography and Hair Jewellery," in Elizabeth Edwards and Janice Hart, eds., *Photographs Objects Histories* (London: Routledge, 2004): 32-46.

51 Joanna Woodall, ed., *Portraiture: Facing the Subject* (Manchester: Manchester University Press, 1997): 2.

52 On this larger subject, see Donald R. Thayer, "Early Anatomy Instruction at the National Academy: The Tradition Behind It," *American Art Journal* 8:1 (May 1976): 38-51; and two essays by John Stephens Crawford: "The Classical Tradition in American Sculpture: Structure and Surface," *American Art Journal* 11:3 (July 1979): 38-52; and "The Classical Orator in Nineteenth Century American Sculpture," *American Art Journal* 6:2 (November 1994): 56-72.

53 Marcus Aurelius Root, *The Camera and the Pencil; or, The Heliographic Art* (Philadelphia: M. A. Root/Lippincott, 1864; repr. Pawlett, Vt.: Helios, 1971): 100-01.

54 Cited in Grant B. Romer, "'A High Reputation with All True Artists and Connoisseurs': The Daguerreian Careers of A. S. Southworth and J. J. Hawes," in Romer and Wallis, eds., *Young America,* p. 46.

55 For example, in analyzing a particular element of Southworth & Hawes's production, historian John Stauffer concludes, "In short, capturing the soul of sentimental women meant capturing nothing at all." Stauffer, "Daguerreotyping the National Soul: The Portraits of Southworth & Hawes, 1843-1860," in Romer and Wallis, eds., *Young America,* p. 60. For more generous—if distinctly contrarian—perspectives on the idea of the "sentimental," see Robert C. Solomon, "In Defense of Sentimentality," *Philosophy and Literature* 14 (1990): 304-23; and Deborah Knight, "Why We Enjoy Condemning Sentimentality: A Meta-Aesthetic Perspective," *Journal of Aesthetics and Art Criticism* 57:4 (Fall 1999): 411-20.

56 See, for example, Richard Jenkyns, *The Victorians and Ancient Greece* (Cambridge, Mass.: Harvard University Press, 1980); Wayne Craven, "The Grand Manner in Early Nineteenth-Century American Painting: Borrowings from Antiquity, the Renaissance, and the Baroque," *American Art Journal* 11:2 (April 1979): 5-43; and Caroline Winterer, "From Royal to Republican: The Classical Image in Early America," *Journal of American History* 91:4 (March 2005): 1264-90.

57 There are a number of recent studies of this larger subject, including Caroline Winterer, *The Culture of Classicism: Ancient Greece and Rome in American Intellectual Life, 1780-1910* (Baltimore: Johns Hopkins University Press, 2002).

58 The following quotes are drawn from "Johann Joachim Winckelmann (1717-1768) from *Reflections on the Imitation of Greek Works in Painting and Sculpture,*" in Charles Harrison, Paul Wood, and Jason Geiger, eds., *Art in Theory, 1648-1815, An Anthology of Changing Ideas* (London: Blackwell, 2000): 450-56. On this larger subject, see also Alex Potts, *Flesh and the Ideal: Winckelmann and the Origins of Art History* (New Haven: Yale University Press, 1994).

59 Anne L. Poulet et al., *Jean-Antoine Houdon: Sculptor of the Enlightenment* (Washington, D.C.: National Gallery of Art, 2003).

60 The many studies of this larger subject include Malcolm Baker, *Figured in Marble: The Making and Viewing of Eighteenth-Century Sculpture* (Los Angeles: J. Paul Getty Museum, 2000); Penelope Curtis et al., *Return to Life: A New Look at the Portrait Bust* (Leeds: Henry Moore Institute, 2001); Katharine Eustace, *Canova: Ideal Heads* (Oxford: Ashmolean Museum, 1997); Eric W. Baumgartner, *A Marvelous Repose: American Neo-Classical Sculpture, 1825-1876* (New York: Hirschl & Adler Galleries, 1996); H. Nichols B. Clark, *A Marble Quarry: The James H. Ricau Collection of Sculpture at the Chrysler Museum of Art* (New York: Hudson Hills Press, 1997); Joy S. Kasson, *Marble Queens & Captives: Women in Nineteenth-Century American Sculpture* (New Haven: Yale University Press, 1990); and Thayer Tolles, ed., *American Sculpture in the Metropolitan Museum of Art, Vol. I: A Catalogue of Works by Artists Born before 1865* (New York: Metropolitan Museum of Art, 1999).

61 See, for example, Vivien Green Fryd, "Hiram Powers's *America:* 'Triumphant as Liberty and in Unity,'" *American Art Journal* 18:2 (1986): 54-75; and Vivien M. Green, "Hiram Powers's *Greek Slave:* Emblem of Freedom," *American Art Journal* 14:4 (Autumn 1982): 31-39.

62 "Eighteenth Letter," in Friedrich Schiller, *On the Aesthetic Education of Man in a Series of Letters,* trans. with an introduction by Reginald Snell (New York: Frederick Ungar Publishing, 1965): 87.

63 Brooks Atkinson, ed., *The Selected Writings of Ralph Waldo Emerson* (New York: Modern Library, 1940): 15.

64 Jeffrey Sklansky, *The Soul's Economy: Market Society and Selfhood in American Thought, 1820-1920* (Chapel Hill: University of North Carolina Press, 2002): 38-52.

65 This is a central theme of E. Brooks Holifield's magisterial history, *Theology in America: Christian Thought from the Age of the Puritans to the Civil War* (New Haven: Yale University Press, 2003).

66 The following is informed by two definitive studies: Robert E. Norton, *The Beautiful Soul: Aesthetic Morality in the Eighteenth Century* (Ithaca, N.Y.: Cornell University Press, 1995); and Charles Colbert, *A Measure of Perfection: Phrenology and the Fine Arts in America* (Chapel Hill: University of North Carolina Press, 1997).

67 Colbert, *Measure of Perfection,* p. 199.

68 For Schiller, "this beauty of character…is merely an idea, to which one strives to conform with continuous vigilance." Cited in ibid., p. 243.

69 Norton, *The Beautiful Soul,* p. 283. For example, see publications such as D. H. Jacques, *Hints Toward Physical Perfection: or, the Philosophy of Human Beauty* (New York: Fowler and Wells, 1859). On the application of these ideas to American art, see John S. Crawford, "Physiognomy in Classical and American Portrait Busts," *American Art Journal* 9:1 (May 1977): 49-60.

70 As I have previously observed:

> In the end, an emphasis on the body [in late twentieth-century art] was perhaps an inevitable result of modern philosophy's relentless project of demystification. In this light, it is instructive to consider how our collective notions of the Western self have changed. In the last several centuries, I would suggest, the central concept of individual identity has shifted progressively from *soul* to *character* to *personality* to *body.* This movement represents a profound series of changes in our "foundational" frames of reference: from religion (the cosmos) to society (the world) to psychology (the mind) to simple existential presence (mere matter). It should go without saying that much has been lost in this intellectual trajectory.

Keith F. Davis, *An American Century of Photography: From Dry-Plate to Digital, The Hallmark Photographic Collection, Second Edition, Revised and Enlarged* (Kansas City: Hallmark Cards/Harry N. Abrams, 1999): 561, note 408.

The vast literature on this subject includes such notable works as Charles Taylor, *Sources of the Self: The Making of Modern Identity* Cambridge, Mass.: Harvard University Press, 1989); and Jerrold Seigel, *The Idea of the Self: Thought and Experience in Western Europe since the Seventeenth Century* (Cambridge: Cambridge University Press, 2005).

71 Angus Trumble, *A Brief History of the Smile* (New York: Basic Books, 2004): 1. This book provides a delightful introduction to this subject.

72 In addition to providing a magisterial history of the subject, Sean Wilentz's *Chants Democratic: New York City and the Rise of the American Working Class, 1788-1850* (New York: Oxford University Press, 1984) includes, as Table 9 (p. 403), a list of the twenty principal occupations in New York City in 1855.

73 For a valuable overview of this genre, see Matthew R. Isenburg, "Occupational, Tableaux, and Narrative Daguerreotypes," *Daguerreian Annual 1996* (Pittsburgh: Daguerreian Society, 1997): 200-51.

74 Brooks Johnson, "The Progress of Civilization: The American Occupational Daguerreotype," in John Wood, ed., *America and the Daguerreotype* (Iowa City: University of Iowa Press, 1991): 109. See also *Compilation of Works of Art and Other Objects in the United States Capitol* (Washington, D.C.: Government Printing Office, 1965): 380. For a related perspective on this theme, see Jeffrey F. Meyer, *Myths in Stone: Religious Dimensions of Washington, D.C.* (Berkeley: University of California Press, 2001).

75 The following draws from Keith F. Davis, "Reading Daguerreotypes," *Daguerreian Annual 1998* (Pittsburgh: Daguerreian Society, 1999): 19-53. The literature on this subject is large and growing. See, for example, James D. Hart, *The Popular Book: A History of America's Literary Taste* (Berkeley: University of California Press, 1950); Kenneth A. Lockridge, *Literacy in Colonial New England* (New York: W. W. Norton, 1974); Richard D. Brown, *Knowledge is Power: The Diffusion of Information in Early America, 1700-1865* (New York: Oxford University Press, 1989); as well as such specialized studies as Michael Schudson, *Discovering the News: A Social History of American Newspapers* (New York: Basic Books, 1978); John Tebbel and Mary Ellen Zuckerman, *The Magazine in America, 1741-1990* (New York: Oxford University Press, 1991); and Garry Apgar et al., *The Newspaper in Art* (Spokane, Wash.: New Media Ventures, 1996).

76 For example, see Michael Schudson, *The Good Citizen: A History of American Civic Life* (New York: Free Press, 1998): 116-28.

77 See Alison Winter, *Mesmerized: Powers of Mind in Victorian Britain* (Chicago: University of Chicago Press, 1998). On the spiritual implications of these ideas, see Ann Taves, *Fits, Trances & Visions: Experiencing Religion and Explaining Experience from Wesley to James* (Princeton: Princeton University Press, 1999). The origin of American spiritualism is discussed in Barbara Weisberg, *Talking to the Dead: Kate and Maggie Fox and the Rise of Spiritualism* (New York: HarperSanFrancisco, 2003).

78 On this subject, in addition to the literature on P. T. Barnum, see studies such as Robert M. Lewis, *From Traveling Show to Vaudeville: Theatrical Spectacle in America, 1830-1910* (Baltimore: Johns Hopkins University Press, 2003); and David Carlyon, *Dan Rice: The Most Famous Man You've Never Heard Of* (New York:

PublicAffairs, 2001). In recent years, much has been written on the history of blackface; see, for example, W. T. Lhamon, Jr., *Raising Cain: Blackface Performance from Jim Crow to Hip Hop* (Cambridge, Mass.: Harvard University Press, 1998).

79 There was a long tradition of free blacks in America, although their number grew rapidly after the Revolution. Most free blacks lived in the upper South and in the North. See Ira Berlin, *Slaves Without Masters: The Free Negro in the Antebellum South* (Oxford: Oxford University Press, 1974).

80 Specifically, the plates by Zealey described in "Framed: The Slave Portraits of Louis Agassiz," in Melissa Banta et al., *A Curious & Ingenious Art: Reflections on Daguerreotypes at Harvard* (Iowa City: University of Iowa Press, 2000): 42-51.

81 See Dolores A. Kilgo, *Likeness and Landscape: Thomas M. Easterly and the Art of the Daguerreotype* (St. Louis: Missouri Historical Society, 1994): 119-41; and Maria Morris Hambourg et al., *The Waking Dream: Photography's First Century, Selections from the Gilman Paper Company Collection* (New York: Metropolitan Museum/Harry N. Abrams, 1993): 118, 311.

82 Daniel Cornford, "'We all live more like brutes than humans': Labor and Capital in the Gold Rush," in James J. Rawls and Richard J. Orsi, eds., *A Golden State: Mining and Economic Development in Gold Rush California* (Berkeley: University of California Press, 1999): 84.

83 Martha V. Pike and Janice Gray Armstrong, *A Time to Mourn: Expressions of Grief in Nineteenth Century America* (Stony Brook, N.Y.: The Museums at Stony Brook, 1980): 11. This study provides a superb overview of the central themes of this subject. Other significant works include James Stevens Curl, *The Victorian Celebration of Death* (Gloucestershire: Sutton Publishing, 2000); Mary Louise Kete, *Sentimental Collaborations: Mourning and Middle Class Identity in Nineteenth-Century America* (Durham: Duke University Press, 2000); Robert V. Wells, *Facing the "King of Terrors": Death and Society in an American Community, 1750-1990* (Cambridge: Cambridge University Press, 2000); Gary Laderman, *The Sacred Remains: American Attitudes Toward Death, 1799-1883* (New Haven: Yale University Press, 1996); Stanley B. Burns, *Sleeping Beauty: Memorial Photography in America* (Altadena: Twelvetrees Press, 1990); Jay Ruby, *Secure the Shadow: Death and Photography in America* (Cambridge, Mass.: MIT Press, 1995); Deborah A. Smith, "'The Visage Once So Dear': Interpreting Memorial Photographs," in Benes, ed., *Painting and Portrait Making in the American Northeast*, pp. 255-68; and chapter 4, "'Not Lost But Gone Before,'" in Frank, *Love and Loss*, pp. 119-53.

84 This is the larger theme of studies such as Richard L. Bushman, *The Refinement of America: Persons, Houses, Cities* (New York: Vintage Books, 1992).

85 Cited in Pike and Armstrong, *A Time to Mourn*, p. 26.

86 See, for example, John Dizikes, *Sportsmen and Gamesmen* (Boston: Houghton Mifflin, 1981); John M. Findlay, *People of Chance: Gambling in American Society from Jamestown to Las Vegas* (New York: Oxford University Press, 1986); Robert Asbury, *Sucker's Progress: An Informal History of Gambling in America* (1938; repr. New York: Thunder's Mouth Press, 2003); and Ann Fabian, *Card Sharps and Bucket Shops: Gambling in Nineteenth-Century America* (New York: Routledge, 1999).

87 This era clearly had different ideas than our own about the display of physical contact between men. While these are often now interpreted as signs of sexuality, there is a danger in applying today's interpretations too directly to these images. For a recent anthology of such images, see David Deitcher, *Dear Friends: American Photographs of Men Together, 1840-1918* (New York: Abrams, 2001).

88 For a larger discussion of this topic, see John Wood, *The Scenic Daguerreotype: Romanticism & Early Photography* (Iowa City: University of Iowa Press, 1995).

89 Thomas Cole, "Essay on American Scenery," cited in Sue Rainey, *Creating Picturesque America: Monument to the Natural and Cultural Landscape* (Nashville: Vanderbilt University Press, 1994): 206.

90 The literature on this subject is large and growing. The standard historical works include J. S. Holliday, *The World Rushed In: The California Gold Rush Experience* (New York: Simon and Schuster, 1981); J. S. Holliday, *Rush for Riches: Gold Fever and the Making of California* (Berkeley: University of California Press, 1999); Malcolm J. Rohrbough, *Days of Gold: The California Gold Rush and the American Nation* (Berkeley: University of California Press, 1997); and Rawls and Orsi, eds., *A Golden State*. On the visual history of this era, see Janice T. Driesbach et al., *Art of the Gold Rush* (Berkeley: University of California Press, 1998); and Drew Heath Johnson and Marcia Eymann, *Silver & Gold: Cased Images of the California Gold Rush* (Iowa City: University of Iowa Press, 1998). A few of the many other specialized studies include Michael Kowalewski, ed., *Gold Rush: A Literary Exploration* (Berkeley: Heyday Books, 1997); John Boessenecker, *Gold Dust & Gunsmoke: Tales of Gold Rush Outlaws, Gunfighters, Lawmen, and Vigilantes* (New York: John Wiley & Sons, 1999); Leroy R. Hafen and Ann W. Hafen, eds., *Journals of Forty-Niners: Salt Lake to Los Angeles* (1954; Lincoln: University of Nebraska Press, 1998); and Susan Lee Johnson, *Roaring Camp: The Social World of the California Gold Rush* (New York: W. W. Norton, 2000).

91 Rohrbough, *Days of Gold*, p. 9.

92 Ibid., p. 27-28.

93 Ibid., p. 1.

94 Ibid., p. 3.

95 Cited in Larry Schweikart and Lynne Pierson Doti, "From Hard Money to Branch Banking: California Banking in the Gold-Rush Economy," in Rawls and Orsi, *A Golden State*, p. 211.

96 Cited in John Wood, "Theatrical Narratives and the Documents of Dream: California and the Great American Image," in Johnson and Eymann, *Silver & Gold*, p. 23.

97 Rohrbough, *Days of Gold*, p. 203.

98 For a colorful reminiscence by George D. Dornin, who opened a daguerreotype studio in Grass Valley in 1853, see George D. Dornin, *Thirty Years Ago: Gold Rush Memories of a Daguerreian Artist*, ed. Peter E. Palmquist (Nevada City: Carl Mautz, 1995).

99 For one of the numerous recent accounts of Murrieta's tale, see Boessenecker, *Gold Dust & Gunsmoke*, pp. 73-99.

100 *Humphrey's Journal* 21:5 (February 15, 1854): 329-30.

101 David S. Reynolds, *Beneath the American Renaissance: The Subversive Imagination in the Age of Emerson and Melville* (Cambridge, Mass.: Harvard University Press, 1988).

102 James W. Cook, *The Arts of Deception: Playing with Fraud in the Age of Barnum* (Cambridge, Mass.: Harvard University Press, 2001): 3.

103 The classic study of this subject is Constance Rourke, *American Humor: A Study of the National Character* (1931; New York: New York Review Books, 2004).

104 "The American Scholar"; cited in Reynolds, *Beneath the American Renaissance*, p. 484.

105 Ibid., p. 487.

106 For an exegesis of Barnard's work (written by a "friend by my side"), see *Photographic and Fine Art Journal* 7:1 (January 1854): 9-10; cited in Keith F. Davis, *George N. Barnard; Photographer of Sherman's Campaign* (Kansas City: Hallmark Cards, 1990): 35-36.

107 "Driving a Bargain," *Photographic and Fine Art Journal* 8:3 (September 1854): 278-79.

108 Ibid., p. 279. The "sympathy" or emotional identification that viewers of the day demanded from pictures is suggested in the following paragraph of this essay:

> In contemplating the picture, we behold in the face of the urchin that joyous hope which his innocence has led him to think his found treasure can purchase; in his imagination he already possesses the iron-shod sled for coasting—which acquisition will be the consummation of his joys. In the smiling and benevolent face of the powerful man who rests from his labor and with generous sympathy listens to his proposals, while his mind darts back to boyhood years; we plainly see that he has not forgotten to sympathize even with the lad before him.

109 The following is informed by Edward L. Widmer's *Young America: The Flowering of Democracy in New York City* (New York: Oxford University Press, 1999), particularly chapter 4, "Representation without Taxation: Art for the People," pp. 125-54.

110 Atkinson, ed., *The Selected Writings of Ralph Waldo Emerson*, p. 314.

111 On this larger subject, see Elizabeth Johns, *American Genre Painting: The Politics of Everyday Life* (New Haven: Yale University Press, 1991).

112 "Representation without Taxation," in Widmer, *Young America*, pp. 125-54; chapter 6, "The Washed, the Unwashed, and the Unterrified," in Johns, *American Genre Painting*, pp. 176-96; and chapter 4, "Ragamuffins," in Claire Perry, *Young America: Childhood in 19th-Century Art and Culture* (New Haven: Yale University Press, 2006): 111-45.

113 William Sidney Mount's painting *The Truant Gamblers* (1835) presents an upbeat view of young boys skipping both school and work to pitch pennies. Notably, however, this is set in a rural context. Perry, *Young America*, pp. 185-86.

114 On this larger theme, see Sarah Burns, "Barefoot Boys and Other Country Children: Sentiment and Ideology in Nineteenth-Century American Art," *American Art Journal* 20:1 (1988): 25-50.

115 The January 1855 issue of the *Photographic and Fine Art Journal* reported (p. 31): "There is an old saying that 'it is always darkest just before day,' and we trust the adage will hold good regarding the present general depression in the Daguerrean business."

116 S. D. Humphrey, "On the Daguerreotype," *Humphrey's Journal* 10:20 (February 15, 1859): 307.

117 Grant B. Romer, "The Daguerreotype in America and England after 1860," *History of Photography* 1:3 (July 1977): 203. This article remains the definitive study of this subject. On the halting revival of the process in the twentieth century, see Christopher Mahoney, "State of the Art: A Chronology of the Daguerreotype in the Twentieth Century," *Daguerreian Annual 1996* (Pittsburgh: Daguerreian Society, 1997): 170-84.

118 "Photography in Boston," *American Journal of Photography* 6:14 (January 15, 1864): 222.

119 Kilgo, *Likeness and Landscape*, pp. 35-36, 208-09.

120 Ibid., p. 36.

CHAPTER V
The Rise of Paper Photography

1 William Welling, *Photography in America: The Formative Years, 1839-1900* (New York: Thomas Y. Crowell, 1978): 117. Smith's patent for "Photographic pictures on japanned surfaces," number 14,300, was issued on February 19, 1856, and immediately assigned to William Neff and Peter Neff, Jr., of Cincinnati, Ohio. Janice G. Schimmelman, *American Photographic Patents: The Daguerreotype & Wet Plate Era, 1840-1880* (Nevada City, Calif.: Carl Mautz, 2002): 9. See also Janice G. Schimmelman, "Hamilton Smith & Peter Neff: The American Tintype Patent 19 February 1856," *Photogram* 33:4 (February-March 2006): 3-7; and Floyd Rinhart, Marion Rinhart, and Robert W. Wagner, *The American Tintype* (Columbus: Ohio State University Press, 1999).

2 For the English, it came as a "startling realization that…no one was allowed to take, demonstrate, exhibit, or sell daguerreotypes without a license from the patentee." Helmut Gernsheim and Alison Gernsheim, *L. J. M. Daguerre: The History of the Diorama and the Daguerreotype* (1956; New York: Dover Publications, 1968): 145. This volume devotes a chapter (pp. 143-70) to the fortunes of the daguerreotype in Britain.

3 On this complex subject, see, for example, Grace Seiberling, *Amateurs, Photography, and Mid-Victorian Imagination* (Chicago: University of Chicago Press, 1986); and Mike Weaver, ed., *British Photography in the Nineteenth Century, The Fine Art Tradition* (Cambridge: Cambridge University Press, 1989). Several of these photographers are the subject of monographic studies. See, for example, Martin Barnes, *Benjamin Brecknell Turner: Rural England through a Victorian Lens* (London: V&A Publications, 2001).

4 English amateurs were unconcerned with commerce. The leading French photographers engaged in a rather different, and notably complex, balance of art and business. See Elizabeth Anne McCauley, *Industrial Madness: Commercial Photography in Paris, 1848-1871* (New Haven: Yale University Press, 1994).

5 Andre Jammes and Eugenia Parry Janis, *The Art of the French Calotype* (Princeton: Princeton University Press, 1983): 28-30.

6 On the technique and aesthetic of the calotype, see ibid.; and William Crawford, *The Keepers of Light: A History & Working Guide to Early Photographic Processes* (Dobbs Ferry, N.Y.: Morgan & Morgan, 1979).

7 The following is informed by Crawford, *Keepers of Light*, pp. 41-43.

8 The following is indebted to James M. Reilly, *Care and Identification of 19th-Century Photographic Prints* (Rochester, N.Y.: Eastman Kodak, 1986): 2-5.

9 There was much overlap of these processes in the 1850s, as photographers explored their various attributes. See, for example, Seiberling, *Amateurs, Photography, and the Mid-Victorian Imagination*, pp. 24-38.

10 See, for example, "Calotypist Circles," in Michel Frizot, ed., *A New History of Photography* (Köln: Könemann, 1998): 70.

11 For a definitive study of early exhibitions in Britain, see Roger Taylor, *Photographs Exhibited in Britain, 1839-1865: A Compendium of Photographers and Their Works* (Ottawa: National Gallery of Canada, 2002).

12 See Jammes and Janis, *The Art of the French Calotype*, pp. 52-60; and Anne de Mondenard, *La Mission héliographique: Cinq photographes parcourent la France en 1851* (Paris: Monum, Editions du patrimonine, 2002).

13 Sylvie Aubenas, *Gustave Le Gray 1820-1884* (Los Angeles: J. Paul Getty Museum, 2002): 131-42.

14 Jammes and Janis, *The Art of the French Calotype*, p. 92. The following discussion is indebted to this volume, particularly pp. 91-101. For an overview of Blanquart-Evrard's career and work, see Jean-Claude Gautrand and Alain Buisine, *Blanquart-Evrard* (Centre Régional de la Photographie Nord Pas-de-Calais, 1999).

15 Cited in Jammes and Janis, *The Art of the French Calotype*, p. 98.

16 For studies of this overall subject, see Yeshayahu Nir, *The Bible and the Image: The History of Photography in the Holy Land, 1839-1899* (Philadelphia: University of Pennsylvania Press, 1985); Nissan Perez, *Focus East: Early Photography in the Near East (1839-1885)* (New York: Harry N. Abrams, 1988); Kathleen Stewart Howe, *Excursions Along the Nile: The Photographic Discovery of Ancient Egypt* (Santa Barbara: Santa Barbara Museum of Art, 1993), and *Revealing the Holy Land: The Photographic Exploration of Palestine* (Santa Barbara: Santa Barbara Museum of Art, 1997).

17 Mary R. Cabot, "Colonel Leavitt Hunt," *Annals of Brattleboro* vol. 2 (Brattleboro, Vt.: E. L. Hildreth, 1921-22): 728.

18 From Paul R. Baker, *Richard Morris Hunt* (Cambridge, Mass.: MIT Press, 1980): 49, 51, 473.

19 The following is based on Bruno Jammes, "John B. Greene, An American Calotypist," *History of Photography* 5:4 (October 1981): 305-24; Jammes and Janis, *The Art of the French Calotype*, pp. 121-22, note 186; and Rachel Topham, *John Beasly Greene* (M.A. thesis, Ryerson University, 2006).

20 Aubenas, *Gustave Le Gray*, p. 36.

21 Jammes, "John B. Greene," p. 307.

22 Variant copies of this album contain from ninety-two to ninety-six plates. Ibid., p. 309.

23 Greene's album *Fouilles executes à Thèbes* (1855) contains twelve photographs of Medinet-Habou. Ibid., p. 310. This work was also documented in a non-photographic publication: J. B. Greene, *Fouilles executes à Thèbes dans l'année 1855, texts hiéroglyphiques et documents inédits* (Paris: Librarie de Firmin Didot Frères, 1855).

24 Melissa Banta et al., *A Curious & Ingenious Art: Reflections on Daguerreotypes at Harvard* (Iowa City: University of Iowa Press, 2000): 9, 160, note 4. These are now in the collection of the Houghton Library at Harvard.

25 The following is indebted to Dolores A. Kilgo, "The Alternative Aesthetic: The Langenheim Brothers and the Introduction of the Calotype in America," in John Wood, ed., *America and the Daguerreotype* (Iowa City: University of Iowa Press, 1991): 27-57. It is worth noting that George Francis Schreiber—working either on his own or in concert with the Langenheims—made paper negatives as early as 1847. See Julius F. Sachse, "Philadelphia's Share in the Development of Photography," *Journal of the Franklin Institute* 135:4 (April 1893): 287.

26 Ibid., pp. 30-31.

27 "Communications: Mr. Whipple's Experiments," *Photographic Art-Journal* 6:3 (September 1853): 148-49.

28 See William F. Robinson, *A Certain Slant of Light: The First One Hundred Years of New England Photography* (Boston: New York Graphic Society, 1980): 47-49. The following is also indebted to Sally Pierce, *Whipple and Black, Commercial Photographers in Boston* (Boston: Boston Athenaeum, 1987): 19-24.

29 For details on Black's career, see ibid., and Chris Steele, "Recent Discoveries in the Career of James Wallace Black," *Daguerreian Annual 1998* (Pittsburgh: Daguerreian Society, 1999): 175-80.

30 *Photographic Art-Journal* 7:1 (January 1854): 31.

31 McClees obituary, *Philadelphia Photographer* 24:300 (June 18, 1887): 373; and William Marder and Estelle Marder, *Anthony: The Man, The Company, The Cameras, An American Photographic Pioneer* (Amesbury, Mass.: Pine Ridge Publishing, 1982): 62.

32 Welling, *Photography in America*, pp. 59-60. In 1855, it was reported that Hawkins's work with glass negatives had begun in 1846. *Western Art Journal* 1:1 (January 1855): 14; in holdings of the Cincinnati Historical Society.

33 It was reported that a fire in the summer of 1851 cost Hawkins a large number of glass negatives and all the specially prepared negative paper he had on hand. *Humphrey's Journal* 2:8 (September 1, 1851): 241.

34 *The Western Art Journal*. This publication was edited by P. Strickland and published by Joseph B. Babcock. This inaugural (and only?) issue includes a short biographical sketch of Hawkins (p. 14).

35 *Photographic Art-Journal* 4:1 (July 1852): 62.

36 *Photographic Art-Journal* 4:2 (August 1852): 106-13.

37 *Photographic Art-Journal* 4:6 (December 1852): 381.

38 *Humphrey's Journal* 5:8 (August 1, 1853): 128.

39 Ibid., p. 121.

40 "Fine specimens of the photographic art, both of the French and English school, can be purchased in New York at very reasonable prices, much cheaper than engravings of the same size. Some of these are very beautiful, and well worth the price asked for them. The Messrs. Trubner of London, our agents for the *Photographic Art-Journal* for Great Britain, are publishing a series of photographic prints, which commends itself to the lovers of fine pictures. Mr. Anthony, 308 Broadway, N.Y., is appointed to receive subscriptions." *Photographic Art-Journal* 6:5 (November 1853): 323-24.

41 Laurie A. Baty, "'Proud of the Result of my Labor.' Frederick De Bourg Richards (1822-1903)," *Daguerreian Annual 1995* (Pittsburgh: Daguerreian Society, 1995): 217.

42 J. Gurney, *Etchings on Photography* (New York: J. Gurney, 1856): 9. Courtesy Gary W. Ewer.

43 "Messrs. V. Prevost, C. Derchauchoir [sic.] & Co., of No. 627 Broadway, have done us the favor to present us with some very fine photographic views of scenes on the North River. These gentlemen are artists of fine taste and great ability, and their works will compare favorably with our best artists. The attractions of their room in photographic pictures are well deserving the attention of all lovers of art." *Photographic Art-Journal* 7:2 (February 1854): 64. The name of Prevost's partner was Peter C. Duchochois.

44 By the end of 1853, it was noted that Fredricks "has returned from Paris to establish himself in New York. He quite astonished us with his collodion photographs, and we cannot hesitate to say that for execution, tone, clearness, and life-like representations, they are the finest we have yet seen." *Photographic Art-Journal* 7:1 (January 1854): 31.

45 The following summary is drawn primarily from the *Photographic Art-Journal* 6:4 (October 1853): 254-58; the *Photographic Art-Journal* 7:3 (March 1854): 96; and Welling, *Photography in America*, p. 91.

46 Jas. E. McClees, *Elements of Photography* (Philadelphia: J. E. McClees, 1855): 20.

47 See, for example, *Humphrey's Journal* 7:15 (December 1, 1855); 7:16 (December 15, 1855); 7:17 (January 1, 1856); and 8:13 (November 1, 1856).

48 The spread of the process was hindered somewhat by the patent issued to James C. Cutting, of Boston, in July 1854, for a specific method of sealing the collodion

negative to a protective sheet of clear glass. The professional literature of the mid-1850s was full of commentary on the fairness of the Cutting patent.

49 For example, see his lengthy chronicle of an 1855 European excursion: F. De B. Richards, *Random Sketches, or What I Saw in Europe, from the Portfolio of an Artist* (Philadelphia: G. Collins, 1857).

50 "Samuel Masury," *Ballou's Pictorial Drawing-Room Companion* (March 26, 1859): 205.

51 The following is indebted to George Robinson Fardon, *San Francisco Album* (San Francisco: Chronicle Books/Fraenkel Gallery, 1999); and Peter Bacon Hales, *Silver Cities: Photographing American Urbanization, 1839-1939, Revised and Expanded* (Albuquerque: University of New Mexico, 2005): 77-87. The earliest known paper prints of San Francisco were made in May 1852; see Peter E. Palmquist, "George Robinson Fardon, Photographer," in Fardon, *San Francisco Album*, pp. 14-15. Fardon's prints average about 6¼ x 8¼-inches in size; ibid., p. 135.

52 For a detailed analysis of the social and political context of Fardon's album, see Rodger C. Birt, "The San Francisco Album and Its Historical Moment: Photography, Vigilantism, and Western Urbanization," in Fardon, *San Francisco Album*, pp. 99-125. Only eight sets of this work are now known, with no two identical. See Palmquist, "George Robinson Fardon, Photographer," p. 12.

53 See Jeff L. Rosenheim, "'A Palace for the Sun': Early Photography in New York City," in Catherine Hoover Voorsanger and John K. Howat, eds., *Art and the Empire City: New York, 1825-1861* (New York: Metropolitan Museum of Art/Yale University Press, 2000): 227-41, 490-94. The works attributed to Holmes or Fredricks are in the collection of the J. Paul Getty Museum, Los Angeles.

54 Hales, *Silver Cities*, pp. 71-77.

55 Ibid., p. 77.

56 Pierce, *Whipple and Black*, pp. 28-30.

57 See W. H. Helme, "Photographing from a Balloon," *Photographic and Fine Art Journal* (August 1860): 234-35.

58 The first advertisement we have located for Fredricks's business with the phrase "Photographic Temple of Art" was published in the March 27, 1857, issue of the *New York Times*, p. 8.

59 These dual entrances are indicated in a Fredricks's promotional flyer in the collection of Matthew Isenburg. My thanks to Mr. Isenburg for sharing this information.

60 These symbols were in general use by photographers. For example, Brady's studio façade was decorated with a large camera, while Whipple used the sun motif. For woodcuts of these scenes, see *Illustrated News* 2:46 (November 12, 1853): front page; and *Ballou's Pictorial* 12:8 (February 21, 1857): front page. Courtesy Gary W. Ewer.

61 Philip B. Kunhardt, Jr., et al., *Lincoln: An Illustrated Biography* (New York: Alfred A. Knopf, 1992): 100. On the evolution of Lincoln's public image, see the chapter "The Long 'Shadow' of Abraham Lincoln: A Living Symbol of Liberty & Freedom in the Camera's Eye," in David Hackett Fischer, *Liberty and Freedom* (New York: Oxford University Press, 2005): 341-48.

62 These were probably copied from original photographs purchased in Europe by Richards. See Baty, "Proud of the Result of my Labor," p. 217. It is not clear that all copies of this volume contained these photographs. This writer has a copy without photographs, which shows no visible evidence of pages having been removed.

63 Some of these prints appear to have been made with cameras of that dimension. In other cases, smaller images were enlarged with the use of the Woodward Solar Camera onto negatives of the requisite 21 x 17-inch format. See D. Mark Katz, *Witness to an Era: The Life and Photographs of Alexander Gardner* (New York: Viking, 1991): 15.

64 McClees, *Elements of Photography*, pp. 20-21.

65 The following is indebted to the entry in Mary Sayre Haverstock et al., *Artists in Ohio, 1787-1900* (Kent, Ohio: Kent State University Press, 2000): 461; to the biographical profile "John R. Johnston," *Cosmopolitan Art Journal* 3 (1859): 176-78; and to conversations with Alex Novak, Charles Isaacs, Stephen White, Graham Pilecki, and the late Janos Novomeszky.

66 Haverstock et al., *Artists in Ohio*, p. 461.

67 Johnston's position with Whitehurst was described in various ways, leading to some question as to whether he ever worked in the studio as a camera operator. The most detailed period reports appear to make that unlikely. For example:

> Col. John R. Johnson [sic] has painted many of the oil pictures of J. H. Whitehurst's. He is now painting for three or four of the galleries, and with the many orders he has for himself and the different galleries, he is kept busy nearly all the time. Col. J. has his studio in Carroll Hall corner Calvert and Baltimore Street, where a visit to him sometimes will pay all who go to see his many portraits.

"Baltimore Galleries," *Photographic and Fine-Art Journal* 10:11 (November 1857): 331.

68 The standard histories of this subject include William C. Darrah, *The World of Stereographs* (Gettysburg, Pa.: W. C. Darrah, 1977); and Edward W. Earle, ed., *Points of View: The Stereograph in America—A Cultural History* (Rochester, N.Y.: Visual Studies Workshop Press, 1979). Many other, more focused studies have been published, including Jim Crain, *California in Depth: A Stereoscopic History*

(San Francisco: Chronicle Books, 1994); and Bob Zeller's excellent two volumes on Civil War stereographs: *The Civil War in Depth, History in 3D* (San Francisco: Chronicle Books, 1997), and *The Civil War in Depth, Volume II, History in 3D* (San Francisco: Chronicle Books, 2000). For a superb study of the stereograph in France, see Françoise Reynaud et al., *Paris in 3D: From Stereoscopy to Virtual Reality 1850-2000* (Paris: Booth-Clibborn Editions, 2000).

69 Darrah's *World of Stereographs* gives two slightly varying dates for this: "no later than 1852, probably earlier" (p. 4), and "by 1853" (p. 21). *Photographic and Fine-Art Journal* 4:4 (October 1852): 254.

70 "Richards' Stereoscopes," *Humphrey's Journal* 4:16 (December 1, 1852): 253.

71 See for example, "New Inventions," *Scientific American* 8:37 (May 28, 1853): 292. Courtesy Gary W. Ewer.

72 Darrah, *World of Stereographs*, pp. 21-23.

73 The following is indebted to Laura Schiavo, *"A Collection of Endless Extent and Beauty": Stereographs, Vision, Taste and the American Middle Class, 1850-1880* (Ph.D. dissertation, George Washington University, 1999), particularly pp. 51-69; and Thomas L. Hankins and Robert J. Silverman, *Instruments and the Imagination* (Princeton: Princeton University Press, 1995), chapter 7, "The Giant Eyes of Science: The Stereoscope and Photographic Depiction in the Nineteenth Century," pp. 148-77.

74 This was reported promptly in the photographic press. See, for example, "The Stereoscope, Pseudoscope, and Solid Daguerreotypes," *Photographic Art-Journal* 3:3 (March 1852): 173-78.

75 Schiavo, *A Collection of Endless Extent and Beauty*, pp. 57, 59. See also Laura Burd Schiavo, "From Phantom Image to Perfect Vision: Physiological Optics, Commercial Photography, and the Popularization of the Stereoscope," in Lisa Gitelman and Geoffrey B. Pingree, eds., *New Media, 1740-1915* (Cambridge, Mass.: MIT Press, 2003): 113-37. The stereograph plays a central role in Jonathan Crary's often-cited text, *Techniques of the Observer: On Vision and Modernity in the Nineteenth Century* (Cambridge, Mass.: MIT Press, 1990). For a critique of Crary's approach (and, by implication, his model in the work of Michel Foucault), see Margaret Atherton, "How to Write the History of Vision: Understanding the Relationship between Berkeley and Descartes," in David Michael Levin, ed., *Sites of Vision: The Discursive Construction of Sight in the History of Philosophy* (Cambridge, Mass.: MIT Press, 1997): 139-65.

76 Hankins and Silverman, *Instruments and the Imagination*, p. 169. To achieve "naturalistic" results, photographers understood that the distance between the lenses of the stereo camera needed to be roughly matched to the distance of the desired subject. "The distance to be observed between [the lenses] is determined by the distance to the nearest object to be represented... If it be 50 feet, let the [lenses] be two feet apart; if 100 feet, 4 feet apart; 150 feet, 6 feet apart; and so on in the same proportion." "The Stereoscope," *Humphrey's Journal* 8:8 (August 15, 1856): 120.

77 The most definitive work on this subject remains William C. Darrah, *Cartes de Visite in Nineteenth Century Photography* (Gettysburg, Pa.: W. C. Darrah, 1981).

78 Ibid., p. 4.

79 Robert Taft, *Photography and the American Scene, A Social History 1839-1889* (New York: Macmillan, 1938): 141.

80 By 1862, *Humphrey's Journal* observed: "The ambrotype is indeed in little demand now, and we trust soon to hear that the last one has been taken." Cited in Beaumont Newhall, "Ambrotype: A Short and Unsuccessful History," *Image* 64 (October 1958): 171-77.

81 Cited in Taft, *Photography and the American Scene*, p. 143.

82 The following is indebted to Marder and Marder, *Anthony: The Man, The Company, The Cameras.*

83 Ibid., p. 20.

84 Ibid., p. 29.

85 There was a considerable public interest in views of fires. For example, see Margaret Sloane Patterson, "Nicolina Calyo and his Paintings of the Great Fire of New York, December 16th and 17th, 1835," *American Art Journal* 14:2 (Spring 1982): 4-22.

86 Marder and Marder, *Anthony: The Man, The Company, The Cameras*, pp. 116-21. For a fascinating study of the history of this photographic genre, see Phillip Prodger, *Time Stands Still: Muybridge and the Instantaneous Photography Movement* (New York: Oxford University Press/Iris and B. Gerald Cantor Center for Visual Arts at Stanford University, 2003).

87 Anthony was located at 308 Broadway until May 1860, when he moved to 501 Broadway.

88 George Washington Wilson, of Aberdeen, Scotland, also made stop-action stereographs of street scenes. William C. Darrah dates the start of this work by Wilson to 1857, but Phillip Prodger asserts that it was begun in 1859, "at nearly the same time" as Anthony's New York series. Darrah, *World of Stereographs*, p. 105; Prodger, *Time Stands Still*, p. 93.

89 Oliver Wendell Holmes, "The Human Wheel, Its Spokes and Felloes," *Atlantic Monthly* 11 (May 1863): 567-80; cited in Beaumont Newhall, *History of Photography* (New York: Museum of Modern Art, 1982): 117.

CHAPTER VI
"A Terrible Distinctness":
Photography of the Civil War Era, 1861-1865

1 The literature on this subject is almost endless. For a recent introduction to the written history of the war, see David J. Eicher, *The Civil War in Books: An Analytical Bibliography* (Urbana: University of Illinois Press, 1997).

2 E. B. Long with Barbara Long, *The Civil War Day by Day: An Almanac 1861-1865* (New York: Doubleday, 1971; repr. New York: DaCapo Press, 1985): 718-19.

3 Ibid., pp. 705-12.

4 See, for example, Edward Hagerman's *The American Civil War and the Origins of Modern Warfare* (Bloomington: Indiana University Press, 1988).

5 For example, see the following volumes by Ross J. Kelbaugh: *Directory of Civil War Photographers, Volume One: Maryland, Delaware, Washington, D.C., Northern Virginia, and West Virginia* (Baltimore: Historic Graphics, 1990); *Directory of Civil War Photographers, Volume Two: Pennsylvania, New Jersey* (Baltimore: Historic Graphics, 1991); *Directory of Civil War Photographers, Volume Three: Western States and Territories* (Baltimore: Historic Graphics, 1992); and *General Index, Volumes One-Three, Directory of Civil War Photographers* (Baltimore: Historic Graphics, 1992).

6 Jan Zita Grover, "The First Living-Room War: The Civil War in the Illustrated Press," *Afterimage* 11 (February 1984): 8-11.

7 See Bob Zeller, *The Civil War in Depth: History in 3-D* (San Francisco: Chronicle Books, 1997): 65-73, and *The Blue and Gray in Black and White: A History of Civil War Photography* (Westport, Conn.: Praeger, 2005): 91-99, 126.

8 Zeller, *The Blue and Gray in Black and White*, p. 86. See also William A. Frassanito, *Grant and Lee: The Virginia Campaigns 1864-1865* (New York: Charles Scribner's Sons, 1983): 342-43.

9 Margaret Denton Smith and Mary Louise Tucker, *Photography in New Orleans: The Early Years, 1840-1865* (Baton Rouge: Louisiana State University Press, 1982): 104-05.

10 Frederic E. Ray, "The Photographers of the War," in William C. Davis and Bell L. Wiley, eds., *Civil War Album: Complete Photographic History of the Civil War* (New York: Tess Press, 2000): 134. This volume is a reprint of an original six-volume set titled *The Image of War 1861-1865*.

11 Frassanito, *Grant and Lee*, pp. 286-93.

12 Census figures cited in Ray, "Photographers of the War," p. 130.

13 For discussions of Brady's business dealings with the Anthonys—by 1862, Edward had joined in partnership with his brother, Henry T. Anthony—see Josephine Cobb, "Mathew B. Brady's Photographic Gallery in Washington," *Records of the Columbia Historical Society* 53-56 (1953-1956): 28-69; William Marder and Estelle Marder, *Anthony: The Man, The Company, The Cameras, An American Photographic Pioneer* (Amesbury, Mass.: Pine Ridge Publishing, 1982): 169-83; and Frassanito, *Grant and Lee*, pp. 13-21.

14 William Welling, *Photography in America: The Formative Years 1839-1900* (New York: Thomas Y. Crowell, 1978): 150.

15 See Conley L. Edwards III, "The Photographer of the Confederacy," *Civil War Times Illustrated* 13 (June 1974): 27-33.

16 Welling, *Photography in America*, p. 150.

17 My thanks to Bob Zeller for this information. See his *Blue and Gray in Black and White*, pp. 42-44.

18 Coleman Sellers's letters of April 25, 1862, and May 11, 1862, published, respectively, in the *British Journal of Photography* 9 (May 15, 1862): 199; and 9 (June 2, 1862): 219.

19 *New Catalogue of Stereoscopes and Views, Manufactured and Published by E. Anthony* (October 1862), repr. in facsimile in Marder and Marder, *Anthony*.

20 William C. Darrah, *The World of Stereographs* (Gettysburg, Pa.: W. C. Darrah, 1977): 153.

21 *Catalogue of Card Photographs, Published and Sold by E. & H. T. Anthony*, (ca. 1865), in the collection of the George Eastman House, Rochester, New York.

22 William C. Darrah, *Cartes de Visite in Nineteenth Century Photography* (Gettysburg, Pa.: W. C. Darrah, 1981): 75.

23 There are many fine studies of this subject, including Peter C. Marzio, *The Democratic Art: Pictures for a 19th Century America, Chromolithography, 1840-1890* (Fort Worth: Amon Carter Museum, 1979); and Bryan F. Le Beau, *Currier & Ives: America Imagined* (Washington, D.C.: Smithsonian Institution Press, 2001).

24 See, for example, Sally Pierce and Temple D. Smith, *Citizens in Conflict: Prints and Photographs of the American Civil War* (Boston: Boston Athenaeum, 1981); Mark E. Neely, Jr., et al., *The Confederate Image: Prints of the Lost Cause* (Chapel Hill: University of North Carolina Press, 1987); Mark E. Neely, Jr., and Harold Holzer, *The Union Image: Popular Prints of the Civil War North* (Chapel Hill: University of North Carolina Press, 2000); and Frederic S. Voss, "Adalbert Bolck: The South's Answer to Thomas Nast," *Smithsonian Studies in American Art* 2 (Fall 1988): 67-87.

25 Neely and Holzer, *The Union Image*, pp. 51-55.

26 Sellers's letter of June 9, 1862; *British Journal of Photography* 9 (July 1, 1862): 260.

27 Sellers's letter of September 5, 1863; *British Journal of Photography* 10 (October 1, 1863): 395.

28 The following is indebted to Neely and Holzer, *The Union Image*, pp. 27-31.

29 Ibid., p. 28.

30 The following is indebted to Joshua Brown, *Beyond the Lines: Pictorial Reporting, Everyday Life, and the Crisis of Gilded Age America* (Berkeley: University of California Press, 2002), particularly chapters 1 and 2; and Budd Leslie Gambee, Jr., "*Frank Leslie's Illustrated Newspaper*, 1855-1860: Artistic and Technical Operations of a Pioneer Pictorial News Weekly in America" (Ph.D. dissertation, University of Michigan, 1963).

31 Philip Knightley, *The First Casualty, From the Crimea to Vietnam: The War Correspondent as Hero, Propagandist, and Myth Maker* (New York: Harcourt Brace Jovanovich, 1975): 20-23.

32 See W. Fletcher Thompson, Jr., *The Image of War: The Pictorial Reporting of the American Civil War* (New York: Thomas Yoseloff, 1959); and Frederic Ray, "With Pen and Palette: Artists of the Civil War," *Civil War Times Illustrated* 21 (April 1982): 18-31.

33 For inventories of published wartime images from Brady photographs, see James D. Horan, *Mathew Brady: Historian with a Camera* (New York: Bonanza Books, 1955): 235-38; and William S. Johnson, *Nineteenth-Century Photography: An Annotated Bibliography, 1839-1870* (Boston: G. K. Hall, 1990): 91-95.

34 *New York World* (April 12, 1891): 26.

35 "How Illustrated Newspapers Are Made," *Frank Leslie's Illustrated Newspaper* (August 2, 1856): 124-25; repr. in Gambee, "*Frank Leslie's Illustrated Newspaper*," p. 425.

36 *Photographic and Fine Art Journal* 10:10 (October 1857): 319, and 10:11 (November 1857): 347.

37 The following is indebted to Mary Panzer's essential study, *Mathew Brady and the Image of History* (Washington, D.C.: Smithsonian Institution Press/National Portrait Gallery, 1997).

38 For a listing of Brady's picture credits in both *Leslie's* and *Harper's Weekly*, see Johnson, *Nineteenth-Century Photography: An Annotated Bibliography*, pp. 87-98.

39 The following is indebted to several sources, including Josephine Cobb, "Alexander Gardner," *Image* 62 (June 1958): 124-36; D. Mark Katz, *Witness to an Era: The Life and Photographs of Alexander Gardner* (New York: Viking, 1991); and Brooks Johnson, ed., *An Enduring Interest: The Photographs of Alexander Gardner* (Norfolk, Va.: Chrysler Museum, 1991).

40 A revealing biographical sketch of Gardner was published in the *Philadelphia Photographer* 20 (January 1883): 92-95.

41 Katz, *Witness to an Era*, pp. 18-19.

42 Ibid., p. 21.

43 I appreciate Bob Zeller's insights on this matter.

44 See Keith F. Davis, *George N. Barnard: Photographer of Sherman's Campaign* (Kansas City: Hallmark Cards, 1990): 53-56.

45 William S. McFeely, *Memoirs of General William T. Sherman* (1875; repr. New York: DaCapo Press, 1984), vol. I, p. 176.

46 The members of the New York Seventh Regiment were mustered out of service on June 3, 1861. While many subsequently reenlisted in the regular army for a three-year stint, most were back at their jobs in New York City by the middle of June. See Davis, *George N. Barnard*, pp. 56 and 223, note 44.

47 While Brady used this series title repeatedly, the prints in question are copyrighted 1861 and are of a consistent and distinctive size, ranging from about 9 1/4 x 14 inches to 10 1/8 x 14 1/8 inches (trimmed).

48 The stylistic similarity to Roger Fenton's Crimean War views of 1855 is notable.

49 See Brady's recollection of this episode in George Townsend, "Still Taking Pictures," *New York World* (April 12, 1891): 26.

50 A fascinating and recently discovered photograph from this period, showing Brady with his photographic team at Berlin, Maryland, is published in Davis and Wiley, eds., *Civil War Album*, p. 135.

51 Panzer, *Mathew Brady*, p. 103.

52 The following is indebted to Frassanito, *Grant and Lee*, pp. 242-57.

53 For an extremely close variant of this view, see Panzer, *Mathew Brady*, p. 102.

54 *Philadelphia Photographer* 20 (January 1883): 92.

55 The precise timing of this break has never been firmly established. It is part of the legend of Civil War photography that Gardner and his team left Brady's employ over the matter of credit for their work. It is true that Brady—following standard business practices of the day—took official credit for all the work done by his studio employees. It is further true that Gardner was meticulous—and exceptional—in giving his individual photographers credit for their images. Ultimately, however, it is far more likely that Gardner and his fellow photographers left Brady's employ because of money: Brady was unable to pay them either at all or on time.

56 Frassanito, *Grant and Lee*, pp. 17-21.

57 For a recent analysis of the work done for Brady by the latter two men, see Susan E. Williams, "'Richmond Again Taken': Reappraising the Brady Legend through Photographs by Andrew J. Russell," *Virginia Magazine of History and Biography* 110:4 (2002): 437-60.

58 *Philadelphia Photographer* 20 (January 1883): 94.

59 *Catalogue of Photographic Incidents of the War from the Gallery of Alexander Gardner* (Washington, D.C.: H. Polkinhom, 1863).

60 Fenton's work was known to at least a few American photographers of the period. See Fenton's "Narrative of a Photographic Trip to the Seat of War in the Crimea," *Humphrey's Journal* 7:21 (March 1, 1856): 329-36.

61 See William A. Frassanito, *Antietam: The Photographic Legacy of America's Bloodiest Day* (New York: Charles Scribner's Sons, 1978); and William Stapp, "America and the Civil War," in Johnson, ed., *An Enduring Interest*. Stapp discusses the matter of Gardner's proximity to the battle on p. 117, note 8.

62 Frassanito observes: "More contemporary media attention was paid to the Antietam photographs than to any other single photographic series recorded during the entire four years of warfare." Frassanito, *Antietam*, p. 17.

63 The work reproduced here was one of the images included in the October 18, 1862, issue of *Harper's Weekly*. See William Stapp, "Subjects of Strange…and of Fearful Interest," in Marianne Fulton, ed., *Eyes of Time: Photojournalism in America* (Boston: New York Graphic Society, 1988): 18-19.

64 *New York Times* (October 20, 1862): 5.

65 *Harper's Weekly* 6 (October 18, 1862): 663.

66 The following is indebted to William A. Frassanito's pioneering studies *Gettysburg: A Journey in Time* (New York: Charles Scribner's Sons, 1975), and *Early Photography at Gettysburg* (Gettysburg, Pa.: Thomas Publications, 1995).

67 Frassanito, *Early Photography at Gettysburg*, pp. 20-25.

68 Frassanito, *Gettysburg*, pp. 222-29, and *Early Photography at Gettysburg*, pp. 315-18.

69 This discussion is wholly indebted to Frassanito's *Gettysburg*, pp. 187-92, and *Early Photography at Gettysburg*, pp. 268-73.

70 Frassanito himself has noted at least one earlier study of this subject: Frederic Ray's "The Case of the Rearranged Corpse," *Civil War Times* III (October 1961): 19.

71 In fact, while few of Gardner's other Gettysburg photographs reveal evidence of overt manipulation, some bear false or misleading caption data. *The Field Where General Reynolds Fell* does not actually depict the place where Reynolds was killed. Further, the Union bodies in this view are from the same group that is identified by Gardner in a variant view as Confederate. See Frassanito, *Gettysburg*, pp. 222-29; and Stapp, "Subjects of Strange…and of Fearful Interest," pp. 27-28.

72 For a very brief consideration of our changing appraisal of Civil War photographs, see Keith F. Davis, "Nuanced Truths: The Art of Civil War Photography," *New-York Journal of American History* 66:2 (Fall-Winter 2005): 96-119.

73 The following is indebted to Frassanito, *Gettysburg*, pp. 35-40, 225; and *Early Photography at Gettysburg*, pp. 26-28.

74 Frassanito, *Gettysburg*, p. 225.

75 See, for example, Thompson, *Image of War*.

76 Sellers's letter of February 1, 1862; *British Journal of Photography* 9 (March 1, 1862): 95.

77 Sellers's letter of May 25, 1862; *British Journal of Photography* 9 (June 16, 1862): 239.

78 Sellers's letter of September 8, 1862; *British Journal of Photography* 9 (October 1, 1862): 375.

79 Dorothy Meserve Kunhardt and Philip B. Kunhardt, Jr., *Mathew Brady and His World* (Alexandria, Va.: Time-Life Books, 1977): 56.

80 Davis and Wiley, eds., *Civil War Album*, p. 139.

81 See Zeller, *The Blue and Gray in Black and White*, p. 144. In personal correspondence, Mr. Zeller confirmed that the National Archives, Washington, D.C., holds many registers kept by the Army of the Potomac during the war. These provide detailed listings of prisoners, sutlers, and—in at least two individual registers—approved photographers. One of these was compiled while General Joseph Hooker was commander, in the winter and spring of 1863. The other, from 1864 or 1865, was kept during the command of General U. S. Grant.

82 Frassanito, *Grant and Lee*, pp. 28-29.

83 Davis and Wiley, eds., *Civil War Album*, pp. 798-805.

84 *British Journal of Photography* 11 (December 2, 1864): 489.

85 Quoted in Richard Wheeler, *Sword Over Richmond: An Eyewitness History of McClellan's Peninsular Campaign* (New York: Harper and Row, 1986): 67-68.

86 Sellers's letter of March 23, 1862; *British Journal of Photography* 9 (April 15, 1862): 157.

87 Sellers's letter of October 8, 1862; *British Journal of Photography* 9 (November 1, 1862): 418.

88 For years the Academy was the nation's leading source for formally trained engineers. Even when Harvard, Yale, and other schools began offering programs in civil engineering in the late 1840s, the instructors at these institutions were usually West Point graduates. See William H. Goetzmann, *Army Exploration in the American West 1803-1863* (New Haven: Yale University Press, 1959): 13-14. In private life, Academy graduates became leading civil engineers and occupied important positions in industry, transportation, and science.

89 See Henry P. Beers, "A History of the U.S. Topographical Engineers, 1813-1863," *Military Engineer* (June 1942): 287-91, and (July 1942): 348-52.

90 The Academy's curriculum is described in such sources as Stephen W. Sears, *George B. McClellan: The Young Napoleon* (New York: Ticknor and Fields, 1988): 4-10;

and Russell F. Weigley, *Quartermaster General of the Union Army: A Biography of Montgomery C. Meigs* (New York: Columbia University Press, 1959): 25-30.

91 Goetzmann, *Army Exploration*, pp. 15-16.

92 The West Point archives contain a large and impressive folio of Heintzelman's student drawings dated between 1823 and 1826. Meigs maintained his interest in sketching and watercolor painting at least through the 1850s.

93 Davis, *George N. Barnard*, pp. 63-65.

94 *Philadelphia Photographer* 6 (January 1869): 5. A letter in Walker's service file at the National Archives states that the photographer spent his time during the war "preparing important military maps for the various Union armies and copying important papers and drawings for the different Depts., in addition to the general work pertaining to the Architect's Office."

95 Sellers's letters of February 21, 1864, and November 28, 1863, published respectively in the *British Journal of Photography* 11 (March 15, 1864): 106; and 10 (December 15, 1863): 494. Photography was similarly used in the construction of railroad locomotives.

96 The following is drawn from Davis, *George N. Barnard*, pp. 63-94.

97 *Official Military Atlas of the Civil War* (1891-1895; repr. New York: Arno Press/ Crown Publishers, 1978): plates CXXVI-CXXIX.

98 Frank Abial Flower, "General Herman Haupt," in *Reminiscences of General Herman Haupt* (New York: John R. Anderson Co., 1901): xv. Analytical, practical, and forceful, with an immense ability to get things done, Haupt subsequently taught mathematics and engineering at the college level, published the widely used textbook *General Theory of Bridge Construction* (1852), served as General Superintendent of the Pennsylvania Railroad, and directed work on the controversial Hoosac Tunnel in Massachusetts, the second-longest underground rail passage in the world. See also Francis A. Lord, *Lincoln's Railroad Man: Herman Haupt* (Rutherford, N.J.: Fairleigh Dickinson University Press, 1969); and James A. Ward, *That Man Haupt: A Biography of Herman Haupt* (Baton Rouge: Louisiana State University Press, 1973).

99 One of the most celebrated achievements of Haupt's crew was a 400-foot span over the 90-foot-deep gorge at Potomac Creek, constructed in only twelve days. President Lincoln marveled at this bridge, calling it "the most remarkable structure that human eyes ever rested upon," particularly since it seemed to be composed of "nothing … but beanpoles and corn stalks." Ward, *That Man Haupt*, pp. 116-17.

100 The most recent study of the intricacies of Russell's wartime career is Williams, "Richmond Again Taken." A letter in Andrew J. Russell's file (National Archives, RG 92, Consolidated Correspondence) indicates that the order assigning the photographer to duty under Haupt was dated March 2, 1863.

101 Charles F. Cooney, "Andrew J. Russell: The Union Army's Forgotten Photographer," *Civil War Times Illustrated* 21 (April 1982): 34.

102 Williams, "Richmond Again Taken," p. 444. Russell's later request for reimbursement for these expenses was turned down by the Treasury Department.

103 The following is indebted to Zeller, *The Blue and Gray in Black and White*, pp. 91-99. See also Joe Buberger and Matthew Isenburg, *Russell's Civil War Photographs* (New York: Dover Publications, 1982), particularly plates 2-3. See also Thomas Weston Fels, *Destruction and Destiny, The Photographs of A. J. Russell: Directing American Energy in War and Peace, 1862-1869* (Pittsfield, Mass.: Berkshire Museum, 1987).

104 See Buberger and Isenburg, *Russell's Civil War Photographs*, plates 46-61, 65-68, etc.

105 See "Distribution of Photographs of Construction and Transportation Departments, as per order of Brig. Gen'l H. Haupt, Chief of Rail Roads, U.S.," in National Archives, RG 92, Box 815, "Photographs."

106 Much of the information in this section is drawn from Stanley B. Bums, "Early Medical Photography in America (1839-1883), VI: Civil War Medical Photography," *New York State Journal of Medicine* (August 1980): 1444-69.

107 Ibid., p. 1452.

108 Ibid., p. 1453.

109 *Philadelphia Photographer* 3 (July 1866): 214.

110 Bums, "Early Medical Photography," pp. 1453-59.

111 Ibid., p. 1463. On this subject, see, for example, Ransford E. Van Gieson, M.D., "The Application of Photography to Medical Science, including a Direct Process to photograph the Microscopic Field," *New York Journal of Medicine* 8, third series: 1 (January 1860): 17-30.

112 Weigley, *Quartermaster General of the Union Army*, pp. 72-73.

113 These photographs are held in the M. C. Meigs Collection, Library of Congress, Washington, D.C. In a letter of November 17, 1862, published in the *British Journal of Photography* 9 (December 15, 1862): 475, Sellers noted the prominent amateur photographers in Washington. These included "the minister from Brasil [sic] and his daughter… Mr. Titian R. Peale, who has charge of the class of fine arts in the Patent-Office," and Meigs. Sellers continued: "Before General M. C. Meigs was so much engrossed in his military duties, and while he was in charge of the extension of the Capitol and Post Office buildings, he, *too*, was an enthusiastic amateur, but now he can do but little at it." Meigs shared with Sellers and the Anthonys a background in civil engineering. The Anthonys had worked on the Croton Aqueduct in New York prior to entering the photographic profession, while Sellers—an amateur photographer and writer—earned his living as an engineer in Philadelphia.

114 James M. McPherson, *Battle Cry of Freedom: The Civil War* (New York: Oxford University Press, 1988): 324-25.

115 Herman Hattaway and Archer Jones, *How the North Won: A Military History of the Civil War* (Urbana: University of Illinois Press, 1983): 139.

116 Letter of April 20, 1864, from Meigs to Sherman; published in *The War of the Rebellion: A Compilation of the Official Records of the Union and Confederate Armies* (Washington, D.C.: Government Printing Office, 1891), series 1, vol. 32, part 3, p. 434.

117 The following is indebted to Zeller, *The Blue and Gray in Black and White*, pp. 150-51; and William Marvel, "The Andersonville Artist: The A. J. Riddle Photographs of August 1864," *Blue & Gray* (August 1993): 18-23.

118 Bob Zeller speculates that these may have been intended to help prod the Union to resume the practice of prisoner exchanges. Zeller, *The Blue and Gray in Black and White*, p. 151.

119 Ibid.

120 This subject has received considerable attention in recent years. See, for example, Dee Anne Blanton and Lauren M. Cook, *They Fought Like Demons: Women Soldiers in the Civil War* (New York: Vintage, 2003).

121 For a larger history of this movement, see Beverly Gordon, *Bazaars and Fair Ladies: The History of the American Fundraising Fair* (Knoxville: University of Tennessee Press, 1998).

122 The following is indebted to Kathleen Collins, "Portraits of Slave Children," *History of Photography* 9:3 (July-September 1985): 187-210. On this larger subject, see Claire Perry, *Young America: Childhood in 19th-Century Art and Culture* (New Haven: Yale University Press, 2006), chapter 3, "Children of Bondage," pp. 73-109.

123 This fund-raising effort appears to have been influenced by a slightly earlier set of photographs involving a "redeemed" slave child (also notably light-skinned) named Fannie Virginia Casseopia Lawrence. In May 1863, five-year-old Fannie was adopted by a wealthy Northern patron and baptized by Henry Ward Beecher in Plymouth Church in Brooklyn. Beecher's church had been active in the antislavery movement, and the publicity given to Fannie may have been part of an organized charitable effort. Fannie was taken to at least four studios (in Brooklyn, Hartford, and Boston) and commemorated in a dozen or more carte-de-visite portraits. Collins, "Portraits of Slave Children," pp. 203-09.

124 Ibid., p. 207.

125 Copyright records of the District Court of the District of Columbia, Library of Congress, Washington, D.C. Typically, only the most important and commercially valuable photographs were registered for copyright.

126 Sellers's letter of May 22, 1865; *British Journal of Photography* 12 (June 23, 1865): 333.

127 For a detailed discussion of the photographers and the photographs, see Katz, *Witness to an Era*, pp. 177-92; and James L. Swanson and Daniel R. Weinberg, *Lincoln's Assassins: Their Trial and Execution* (Santa Fe: Arena Editions, 2001).

128 Katz, *Witness to an Era*, p. 192.

129 Significantly, Gardner used a view of one of these monuments as the concluding plate in his *Photographic Sketch-Book of the War*.

130 See Albert Castel, "Comrades: A Story of Lasting Friendships," in William C. Davis, ed., *Touched by Fire* (Boston: Little, Brown, and Company, 1986): vol. I: 276-77, and vol. II: 301, 325.

131 Zeller, *The Blue and Gray in Black and White*, pp. 180-81. As Zeller notes, this premium market appears to have existed until the Depression of 1873.

132 *Gardner's Photographic Sketch Book*, text accompanying plate 48. This work has been reprinted several times, under slightly variant titles. See, for example, Alexander Gardner, *Gardner's Photographic Sketchbook of the American Civil War, 1861-1865* (New York: Delano Greenidge Editions, 2001).

133 Ibid., text accompanying plate 64.

134 Ibid., plate 41.

135 Ibid., text accompanying plate 41.

136 Alice Fahs, *The Imagined Civil War: Popular Literature of the North & South, 1861-1865* (Chapel Hill: University of North Carolina Press, 2001): 100. Lahs devotes an entire chapter, "The Sentimental Soldier," to this theme.

137 Information on Barnard is drawn from Davis, *George N. Barnard*.

138 Ibid., pp. 102-03.

139 Ibid., pp. 101-02. As a further twist on the matter of photographic credit, Barnard did not indicate the Brady studio's authorship of this work.

140 Ibid., pp. 88-89.

141 For a more extensive consideration of these themes, see ibid., pp. 170-77.

142 See ibid., pp. 78-80; and Keith F. Davis, "Death and Valor," *Register of the Spencer Museum of Art* VI:5 (Lawrence: University of Kansas, 1988): 12-25.

143 For example, see Horace Bushnell, "Our Obligations to the Dead," in Alan Trachtenberg, ed., *Democratic Vistas 1860-1880* (New York: George Braziller, 1970): 36-50.

144 *Atlantic Monthly* 12 (July 1863): 12.

145 *New York Times* (October 20, 1862): 5.

CHAPTER VII
Nature and Culture: Scenic, Topographic, and Promotional Views

1 Clyde A. Milner II, "National Initiatives," in Clyde A. Milner II, Carol A. O'Connor, and Martha A. Sandweiss, eds., *The Oxford History of the American West* (New York: Oxford University Press, 1994): 175.

2 There has been much written on this subject. See, for example, Gregory H. Nobles, *American Frontiers: Cultural Encounters and Continental Conquest* (New York: Hill and Wang, 1997), particularly pp. 209-42.

3 The literature on this subject is large and growing. Barbara Novak's pioneering study *Nature and Culture: American Landscape and Painting, 1825-1875* (New York: Oxford University Press, 1980) provides a valuable overview of the subject. More recent or more closely focused studies include John F. Sears, *Sacred Places: American Tourist Attractions in the Nineteenth Century* (New York: Oxford University Press, 1989); Stephan Oettermann, *The Panorama: History of a Mass Medium* (New York: Zone Books, 1997); Angela Miller, *The Empire of the Eye: Landscape Representation and American Cultural Politics, 1825-1875* (Ithaca, N.Y.: Cornell University Press, 1993); John K. Howat et al., *American Paradise: The World of the Hudson River School* (New York: Metropolitan Museum of Art/Harry N. Abrams, 1987); James F. Cooper, *Knights of the Brush: The Hudson River School and the Moral Landscape* (New York: Hudson Hills Press, 1999); Andrew Wilton and Tim Barringer, *American Sublime: Landscape Painting in the United States, 1820-1880* (Princeton: Princeton University Press, 2002); John Wilmerding et al., *American Light: The Luminist Movement, 1850-1875* (Washington, D.C.: National Gallery of Art, 1980); and Rebecca Bedell, *The Anatomy of Nature: Geology & American Landscape Painting, 1825-1875* (Princeton: Princeton University Press, 2001).

4 Novak, *Nature and Culture*, p. 4.

5 This essay is reprinted in John McCoubrey, *American Art, 1700-1960: Sources and Documents* (Englewood Cliffs, N.J.: Prentice-Hall, 1965): 109.

6 Diary entry of May 15, 1833; cited in Ellwood Parry, *The Art of Thomas Cole: Ambition and Imagination* (Newark: University of Delaware Press, 1988): 344.

7 Key studies of this subject include Franklin Kelly, *Frederic Edwin Church and the National Landscape* (Washington, D.C.: Smithsonian Institution Press, 1988); and Miller, *Empire of the Eye*.

8 Cited in Kelly, *Frederic Edwin Church*, p. 1.

9 In addition to the works already noted, many valuable individual studies of these artists have been published, including: Franklin Kelly et al., *Frederic Edwin Church* (Washington, D.C.: National Gallery of Art, 1989); Mishoe Brennecke, *Jasper F. Cropsey: Artist and Architect* (New York: New-York Historical Society, 1987); John Paul Driscoll and John K. Howat, *John Frederick Kensett: An American Master* (New York: W. W. Norton/Worcester Art Museum, 1985); Nancy K. Anderson and Linda S. Ferber, *Albert Bierstadt: Art and Enterprise* (New York: Hudson Hills, 1990); and Linda S. Ferber, ed., *Kindred Spirits: Asher B. Durand and the American Landscape* (Brooklyn: Brooklyn Museum, 2007). On the social and economic reception of this work, see the chapter "A Climate for Landscape Painters," in Howat et al., *American Paradise*, pp. 49-70.

10 See Theodore E. Stebbins, Jr., *Close Observation: Selected Oil Sketches by Frederic E. Church* (Washington, D.C.: Smithsonian Institution Press, 1978); and Eleanor Jones Harvey, *The Painted Sketch: American Impressions from Nature, 1830-1880* (Dallas: Dallas Museum of Art/Harry N. Abrams, 1998).

11 See, for example, Kelly, *Frederic Edwin Church*, pp. 56-58.

12 Richard C. Kugler, *William Bradford: Sailing Ships & Arctic Seas* (New Bedford, Mass.: New Bedford Whaling Museum, 2003): 21-23.

13 Cited in ibid., p. 15.

14 The following is particularly indebted to Adam Greenhalgh, "The Not So Truthful Lens: William Bradford's *Arctic Regions*," in Kugler, *William Bradford*, pp. 73-86.

15 See Dunmore's essay "The Camera Among the Icebergs," *Philadelphia Photographer* 6:72 (December 1869): 412-14; and "Mr. Bradford's Polar Regions. His Photographs Showing the Formation of Glaciers and Icebergs," *Frank Leslie's Illustrated Newspaper* 31:799 (January 21, 1871): 310-11.

16 Bradford actually supplemented the 1869 views of Dunmore and Critcherson with thirteen made by William H. Pierce in 1864. Greenhalgh, "The Not So Truthful Lens," p. 84, note 8.

17 William C. Darrah, *The World of Stereographs* (Gettysburg, Pa.: W. C. Darrah, 1977): 18.

18 Ibid., p. 21.

19 *New Catalogue of Stereoscopes and Views, Manufactured and Published by E. Anthony* (October 1862): 7-24; repr. in William Marder and Estelle Marder, *Anthony: The Man, The Company, The Cameras, An American Photographic Pioneer* (Amesbury, Mass.: Pine Ridge Publishing, 1982): 344-48.

20 See, for example, Thomas Southall, "White Mountain Stereographs and the Development of a Collective Vision," in Edward W. Earle, ed., *Points of View: The Stereograph in America—A Cultural History* (Rochester, N.Y.: Visual Studies Workshop Press, 1979): 97-108.

21 Quoted in Frank Henry Goodyear, *Constructing a National Landscape: Photography and Tourism in Nineteenth-Century America* (Ph.D. dissertation, University of Texas at Austin, 1998): 186.

22 The following is indebted to Sally Pierce, *Whipple and Black, Commercial Photographers in Boston* (Boston: Boston Athenaeum, 1987): 20.

23 See ibid., pp. 22-23; Wilmerding et al., *American Light*, pp. 269; John Szarkowski, *American Landscapes: Photographs from the Collection of the Museum of Modern Art* (New York: Museum of Modern Art, 1981): frontispiece; and Peter C. Bunnell et al., *Photography at Princeton: Celebrating Twenty-Five Years of Collecting and Teaching the History of Photography* (Princeton: Art Museum, Princeton University, 1998): 33.

24 *Photographic and Fine Art Journal* 7:11 (November 1854): 351.

25 The original print reproduced here appears to have been made from an albumen negative, or some similar "dry" process. In "Report of the Photographic Section of the American Institute," *Anthony's Photographic Bulletin* 8:5 (May 1877): 153, it is noted that "Some twenty-five years ago Mr. White, who photographed the White Mountain region, had a method of keeping his plates damp for two or three days…"

26 One of the most memorable of this group is reproduced in Merry A. Foresta, *American Photographs: The First Century, From the Isaacs Collection in the National Museum of American Art* (Washington, D.C.: National Museum of American Art/Smithsonian Institution Press, 1996): 62.

27 Anne Ehrenkranz et al., *Poetic Localities: Photographs of Adirondacks, Cambridge, Crete, Italy, Athens [by] William J. Stillman* (New York: Aperture/International Center of Photography, 1988): 17-19, 29-37.

28 F. W. Lander, *Maps and Reports of the Fort Kearney, South Pass, and Honey Lake Wagon Road*, House of Representatives Ex. Doc. No. 64 (Washington, D.C.: Government Printing Office, 1861): 5.

29 "Country Correspondence—Rocky Mountains," *Crayon* 6:9 (September 1859): 287.

30 Albert's artistic interest in this subject is outlined in Catherine H. Campbell, "Albert Bierstadt and the White Mountains," *Archives of American Art* 21:3 (1981): 14-20.

31 "Sketchings," *Crayon* 8:1 (January 1861): 22.

32 See Richard H. Goldman, *Charles Bierstadt, 1819-1903: American Stereograph Photographer* (M.A. thesis, Kent State University, 1974).

33 The complex intellectual currents in which Moran worked are outlined in Mary Caroline Panzer, *Romantic Origins of American Realism: Photography, Arts and Letters in Philadelphia, 1850-1875* (Ph.D. dissertation, Boston University, 1990). The following is indebted to this fine study.

34 On Ruskin's theories and influence, see, for example, Susan P. Casteras et al., *John Ruskin and the Victorian Eye* (New York: Abrams, 1993).

35 See Jeanne Winston Adler, *Early Days in the Adirondacks: The Photographs of Seneca Ray Stoddard* (New York: Abrams, 1997); Goodyear, *Constructing a National Landscape*, pp. 228-86; and John Fuller, "The Collective Vision and Beyond—Seneca Ray Stoddard's Photography," *History of Photography* 11:3 (July-September 1987): 217-27.

36 See, for example, John W. Reps, *Cities on Stone: Nineteenth-Century Lithograph Images of the Urban West* (Fort Worth: Amon Carter Museum, 1976).

37 Mark Neuzil, *Views on the Mississippi: The Photographs of Henry Peter Bosse* (Minneapolis: University of Minnesota Press, 2001): 8. My discussion of Bosse is indebted to this volume, and to Charles Wehrenberg, *Mississippi Blue: Henry P. Bosse and his Views on the Mississippi River Between Minneapolis and St. Louis, 1883-1891* (Santa Fe: Twin Palms, 2002).

38 The following is indebted to David Robertson, *West of Eden: A History of the Art and Literature of Yosemite* (Yosemite: Yosemite Natural History Association/ Wilderness Press, 1984); chapter 6, "Scenery as Art: Yosemite and the Big Trees," of Sears's *Sacred Places*; and Amy Scott, ed., *Yosemite: Art of an American Icon* (Berkeley: University of California Press/Autry National Center, 2006).

39 Sears, *Sacred Places*, p. 124.

40 Robertson, *West of Eden*, p. 8. See also Ron Tyler, *Prints of the West* (Golden, Colorado: Fulcrum Publishing, 1994): 133-40; and Martha A. Sandweiss, "The Public Life of Western Art," in Jules David Prown et al., *Discovered Lands Invented Pasts* (New Haven: Yale University Press, 1992): 117-33.

41 The following is indebted to Peter E. Palmquist, "California's Peripatetic Photographer: Charles Leander Weed," *California History* 58:3 (Fall 1979): 194-219; and Peter E. Palmquist and Thomas R. Kailbourn, *Pioneer Photographers of the Far West, A Biographical Dictionary, 1840-1865* (Stanford: Stanford University Press, 2000): 585-88.

42 This was a favorite motif for artists, beginning in 1855 with Thomas Ayres. See Scott, ed., *Yosemite: Art of an American Icon*, pp. 23-34.

43 Weston J. Naef and James N. Wood, *Era of Exploration: The Rise of Landscape Photography in the American West, 1860-1885* (Buffalo: Albright-Knox Art Gallery/ Metropolitan Museum of Art/New York Graphic Society, 1975): 35.

44 Palmquist, "California's Peripatetic Photographer," pp. 201-02.

45 While the date of this trip has not been precisely determined—and these views have sometimes been dated ca. 1865—Palmquist's research strongly suggests that they were made in 1864. Weed left San Francisco in "late February 1865" and was gone to Hawaii and Hong Kong into ca. 1867. Palmquist and Kailbourn, *Pioneer Photographers of the Far West*, p. 586.

46 Compare this to the 1859 work reproduced in Palmquist, "California's Peripatetic Photographer," pp. 202-03.

47 For example, see Scott, ed., *Yosemite: Art of an American Icon*, pp. 58-59.

48 Palmquist, "California's Peripatetic Photographer," p. 208.

49 Ibid., pp. 208, 211; and Palmquist and Kailbourn, *Pioneer Photographers of the Far West*, p. 587, note 9.

50 The following is particularly indebted to the numerous books and articles on Watkins by Peter E. Palmquist, including *Carleton E. Watkins: Photographer of the American West* (Albuquerque: University of New Mexico Press/Amon Carter Museum, 1983). The definitive short biography of Watkins is included in Palmquist and Kailbourn, *Pioneer Photographers of the Far West*, pp. 578-83.

51 Palmquist, *Carleton E. Watkins*, pp. 18-20.

52 Edward L. Wilson, "Views in the Yosemite Valley," *Philadelphia Photographer* 3:28 (April 1866): 107.

53 Palmquist and Kailbourn, *Pioneer Photographers of the Far West*, pp. 410-11.

54 In the early 1870s, both Weed and Watkins were associated with the same two San Francisco publishing firms: Thomas Housewort & Co. and Bradley & Rulofson. As a result of these professional intersections, Palmquist raises the possibility that Weed might have advised or assisted Muybridge in his 1872 series at Yosemite. Ibid., pp. 587-88, note 13.

55 Palmquist, *Carleton E. Watkins*, pp. 51-52.

56 Notably, Watkins is absent from both John Szarkowski's *The Photographer and the American Landscape* (New York: Museum of Modern Art, 1963), and the fourth edition of Beaumont Newhall's standard text, *The History of Photography* (New York: Museum of Modern Art, 1964). Szarkowski included a superb Watkins in his classic study *Looking at Photographs: 100 Pictures from the Collection of the Museum of Modern Art* (New York: Museum of Modern Art, 1973): 20-21. The full scope of Watkins's achievement was first suggested in Naef and Wood, *Era of Exploration* and in the 1975 exhibition of the same name. See also "Chronological Bibliography," in Amy Rule, ed., *Carleton Watkins: Selected Texts and Bibliography* (Boston: G. K. Hall & Co., 1993): 133-60.

57 William Goetzmann, *Army Exploration in the American West, 1803-1863* (New Haven: Yale University Press, 1959): 4.

58 The following is informed by numerous sources, including William Goetzmann's masterful triology: *Army Exploration in the American West, 1803-1863*; *Exploration and Empire: The Explorer and Scientist in the Winning of the American West* (New York: Alfred A. Knopf, 1966); and *New Lands, New Men: America and the Second Great Age of Discovery* (New York: Viking Penguin, 1986).

59 Eugene Ostroff, *Western Views and Eastern Visions* (Washington, D.C.: Smithsonian Institution Press, 1981): 8; Goetzmann, *Army Exploration in the American West*, p. 40. See also Howard Ensign Evans, *The Natural History of the Long Expedition to the Rocky Mountains, 1819-1820* (New York: Oxford University Press, 1997).

60 See Ron Tyler's *Prints of the West*, particularly pp. 69-107; and "Prints vs. Photographs, 1840-1860," in May Castleberry, ed., *Perpetual Mirage: Photographic Narratives of the Desert West* (New York: Whitney Museum of American Art, 1996): 41-47.

61 For a definitive overview of this subject, see Martha A. Sandweiss, *Print the Legend: Photography and the American West* (New Haven: Yale University Press, 2002): 48-120.

62 Goetzmann, *Army Exploration in the American West*, pp. 305-13.

63 Ibid., p. 313.

64 For a superb study of this overall subject, see James E. Vance, Jr., *The North American Railroad: Its Origin, Evolution, and Geography* (Baltimore: Johns Hopkins University Press, 1995).

65 For two recent studies of this subject, see Susan Danly and Leo Marx, *The Railroad in American Art: Representations of Technological Change* (Cambridge, Mass.: MIT Press, 1988); and Anne M. Lyden, *Railroad Vision: Photography, Travel, and Perception* (Los Angeles: J. Paul Getty Museum, 2003).

66 The following is drawn from the description for lot 2, *Photographs Sale 6684*, April 7-8, 1995 (New York: Sotheby's, 1995).

67 Ibid., quoted from James F. Ryder, "Photographing a Railroad," *American Annual of Photography and Photographic Times-Bulletin Almanac for 1904* (1904): 144-46.

68 Vance, *The North American Railroad*, pp. 170-72.

69 There are several fine recent studies of this enterprise, including David Haward Bain, *Empire Express: Building the First Transcontinental Railroad* (New York: Viking, 1999); and Stephen E. Ambrose, *Nothing Like It in the World: The Men Who Built the Transcontinental Railroad, 1863-1869* (New York: Simon & Schuster, 2000). More specialized studies include Robert G. Athearn, *Union Pacific Country* (Lincoln: University of Nebraska Press, 1971).

70 D. Mark Katz asserts that Gardner "stopped photographing in Hays, Kansas, in October 1867" and returned to Washington, D.C. Katz, *Witness to an Era: The Life and Photographs of Alexander Gardner* (New York: Viking, 1991): 220. On the other hand, Susan Danly cites stylistic consistencies as evidence that Gardner probably continued as far west as the California coast. Danly, "Across the Continent," in Brooks Johnson, ed., *An Enduring Interest: The Photographs of*

Alexander Gardner (Norfolk, Va.: Chrysler Museum, 1991): 86-87. See also Robert Taft, "Additional Notes on the Gardner Photographs of Kansas," *Kansas Historical Quarterly* 6:2 (May 1937): 175-77; and James E. Babbitt, "Surveyors Along the 35th Parallel: Alexander Gardner's Photographs of Northern Arizona, 1867-1868," *Journal of Arizona History* 22:3 (Autumn 1981): 325-48.

71 Katz, *Witness to an Era*, pp. 215, 220. For Bell's own story, see William A. Bell, *New Tracks in North America* (London: Chapman and Hall, 1870).

72 Apparently, some large-plate views were also issued with the series title "Across the Continent on the Kansas Pacific Railroad." Katz, *Witness to an Era*, p. 220.

73 William J. Palmer, *Report of the Surveys Across the Continent in 1867-68 on the 35th and 32nd Parallels for a route extending the Kansas Pacific Railroad to the Pacific Ocean in San Francisco and San Diego* (Philadelphia: n.p., 1869), cited in Danly, "Across the Continent," p. 119, note 4.

74 Paula Richardson Fleming, "The North American Indians," in Johnson, ed., *An Enduring Interest*: p. 99. See also Herman J. Viola, *Diplomats in Buckskins: A History of Indian Delegates in Washington City* (Washington, D.C.: Smithsonian Institution Press, 1981).

75 Alfred L. Bush and Lee Clark Mitchell, *The Photograph and the American Indian* (Princeton: Princeton University Press, 1994): 15-16. Works of the same period by the Vannerson, Shindler, and McClees studios are reproduced on pp. 17-19.

76 Fleming, "The North American Indians," p. 99.

77 Katz, *Witness to an Era*, p. 239.

78 Fleming, "The North American Indians," p. 102; Katz, *Witness to an Era*, pp. 235-39.

79 Katz, *Witness to an Era*, p. 238.

80 Ibid., p. 239.

81 Two of the works reproduced here—*Officers Quarters, Ft. David Russell, Wyoming* and *Indian Peace Commissioners Distributing Presents to the Crow Indians*—both have trimmed measurements of about 13 x 18¾ inches, suggesting that the original negatives might have been of 16 x 20-inch format.

82 For a recent philosophical perspective on the Crow's subsequent history, see Jonathan Lear, *Radical Hope: Ethics in the Face of Cultural Devastation* (Cambridge, Mass.: Harvard University Press, 2006).

83 Katz, *Witness to an Era*, p. 245.

84 See Russell E. Belous and Robert A. Weinstein, *Will Soule: Indian Photographer at Fort Still, Oklahoma, 1869-74* (Los Angeles: Ward Ritchie Press, 1972).

85 Vance, *The North American Railroad*, p. 184.

86 Ibid., pp. 179-81.

87 For background on Hart, see Peter E. Palmquist, "Alfred A. Hart and the Illustrated Traveler's Map of the Central Pacific Railroad," *Stereo World* 6:6 (January-February 1980): 14-17; and Glenn G. Willumson, "Alfred Hart: Photographer of the Central Pacific Railroad," *History of Photography* 12:1 (January-March 1988): 61-75.

88 Peter E. Palmquist and Thomas R. Kailbourn, *Pioneer Photographers from the Mississippi to the Continental Divide, A Biographical Dictionary, 1839-1865* (Stanford: Stanford University Press, 2005): 146.

89 A. J. Russell, *The Great West Illustrated in a series of Photographic Views Across the Continent; taken along the line of the Union Pacific Railroad, West from Omaha, Nebraska* (New York: Union Pacific Railroad, 1869). The following is informed by several sources, including the work of Susan Danly: "Andrew Joseph Russell's *The Great West Illustrated*," in Danly and Marx, *The Railroad in American Art*, pp. 93-112; and "Photography, Railroads, and Natural Resources in the Arid West: Photographs by Alexander Gardner and A. J. Russell," in Castleberry, ed., *Perpetual Mirage*, pp. 49-55. See also William D. Pattison, 'The Pacific Railroad Rediscovered," *Geographical Review* 52 (January 1962): 25-36; and Nancy Rich, "Politics and the Picturesque: A. J. Russell's Great West Illustrated," *Views* 11:1 (Summer/Fall 1989): 4-6, 24.

90 On this theme, see, for example, Nancy K. Anderson, "'The Kiss of Enterprise': The Western Landscape as Symbol and Resource," in Marianne Doezema and Elizabeth Milroy, eds., *Reading American Art* (New Haven: Yale University Press, 1998): 208-31.

91 Ambrose, *Nothing Like It in the World*, pp. 363-68.

92 For a summary of Savage's work that day, see Bradley W. Richards, *The Savage View: Charles Savage, Pioneer Mormon Photographer* (Nevada City, Calif.: Carl Mautz, 1995): 54-59.

93 The following is indebted to numerous sources, including Thurman Wilkins, *Clarence King: A Biography* (1958; repr.: Albuquerque: University of New Mexico Press, 1988); Joel Snyder, *American Frontiers: The Photographs of Timothy H. O'Sullivan, 1867-1874* (New York: Aperture, 1981); Rick Dingus, *The Photographic Artifacts of Timothy O'Sullivan* (Albuquerque: University of New Mexico Press, 1982); Alan Trachtenberg, "Naming the View," in Trachtenberg, *Reading American Photographs: Images as History, Mathew Brady to Walker Evans* (New York: Hill and Wang, 1989): 119-63; Robin Earle Kelsey, *Photography in the Field: Timothy O'Sullivan and the Wheeler Survey, 1871-1874* (Ph.D. dissertation, Harvard University, 2000); Robin E. Kelsey, "Viewing the Archive: Timothy O'Sullivan's Photographs for the Wheeler Survey, 1871-74," *Art Bulletin* 85:4 (December 2003): 702-23; Joel Snyder, *One/Many: Western American Survey Photographs by Bell and O'Sullivan* (Chicago: David and Alfred Smart Museum of Art, 2006); and Aaron Sachs, *The Humboldt Current: Nineteenth-Century Exploration and the Roots of American Environmentalism* (New York: Viking, 2006).

94 For a history of these operations, see Eliot Lord, *Comstock Mining and Miners* (1883; repr.: Berkeley, Calif.: Howell-North, 1959).

95 For a popular account of this region, see "The Secret of the Strait," *Harper's New Monthly Magazine* 47:282 (November 1873): 801-20.

96 George M. Wheeler et al., *Annual Report upon the Geographical Explorations and Surveys West of the One Hundredth Meridian* (Washington, D.C.: Government Printing Office, 1875): 5; cited in Kelsey, "Viewing the Archive," p. 706.

97 See William Bell, "Photography in the Grand Gulch of the Colorado River," *Philadelphia Photographer* 10:109 (January 1873): 10. For background on Bell, see "Death of William Bell," *Bulletin of Photography* 6:130 (February 2, 1910): 81; and Terence Randolph Pitts, *William Bell: Philadelphia Photographer* (M.A. thesis, University of Arizona, 1987).

98 This idea is central to Snyder's argument. However, he carefully hedges his bets: "O'Sullivan's photographs share the spirit of Clarence King's geology and theology. This is not to suggest that King influenced him, or that O'Sullivan worked consciously (or unconsciously, for that matter) to illustrate King's modified catastrophist views of geology… Yet a sympathetic resonance connects King's beliefs…to O'Sullivan's photographs." *American Frontiers*, p. 48. The historical debate over the artistic meaning of O'Sullivan's photographs provides the impetus for Kelsey's *Photography in the Field*, and is quickly summarized in his introduction, pp. 1-11.

99 See Jonathan Heller, "O'Sullivan Albumen Prints in Official Publications," in Snyder, *American Frontiers*, p. 117; and Kelsey's detailed discussion in *Photography in the Field*, pp. 33-46.

100 Kelsey, *Photography in the Field*, pp. 48-49.

101 Ibid., p. 17.

102 Mike Foster, *Strange Genius: The Life of Ferdinand Vandeveer Hayden* (Niwot, Co.: Roberts Rinehart, 1994): 154-55.

103 Ibid., p. 138.

104 The following is indebted to Peter Bacon Hales, *William Henry Jackson and the Transformation of the American Landscape* (Philadelphia: Temple University Press, 1988): 95-140; Diana E. Edkins, "Chronology," in Beaumont Newhall and Diana E. Edkins, *William H. Jackson* (Fort Worth: Amon Carter Museum of Art/Morgan & Morgan, 1974): 135-50; and Naef and Wood, *Era of Exploration*, pp. 219-50.

105 For an overview of Moran's activity in the West, see Nancy K. Anderson et al., *Thomas Moran* (Washington, D.C.: National Gallery of Art/Yale University Press, 1997): 46-117.

106 Hales provides a detailed and sober account of this process; Hales, *William Henry Jackson*, pp. 106-10.

107 Cited in Edkins, "Chronology," p. 138.

108 Hales, *William Henry Jackson*, pp. 113-19.

109 *Photographs of the Yellowstone National Park and Views in Montana and Wyoming Territories… W. H. Jackson, Photographer* (Washington, D.C.: 1873). Hales, *William Henry Jackson*, p. 122.

110 On this larger theme, see Peter Bacon Hales, "American Views and the Romance of Modernization," in Martha A. Sandweiss, ed., *Photography in Nineteenth-Century America* (Fort Worth: Amon Carter Museum/Harry N. Abrams, 1991): 205-57.

111 For full account of Powell's career, see Donald Worster, *A River Running West: The Life of John Wesley Powell* (New York: Oxford University Press, 2001).

112 Ibid., pp. 116-18, 135-36.

113 Ibid., p. 220.

114 Don D. Fowler, *The Western Photographs of John K. Hillers: Myself in the Water* (Washington, D.C.: Smithsonian Institution Press, 1989): 11.

115 See, for example, Julian H. Steward, "Notes on Hillers' Photographs of the Paiute and Ute Indians taken on the Powell Expedition of 1873," *Smithsonian Miscellaneous Collections* 98:18 (Washington, D.C.: Smithsonian Institution, 1939).

116 Worster, *A River Running West*, p. 261. For a suggestion of the views of Hayden, King, and Wheeler, see p. 208.

117 Steven Conn, *History's Shadow: Native Americans and Historical Consciousness in the Nineteenth Century* (Chicago: University of Chicago Press, 2004): 177.

118 Cited in ibid., p. 176.

119 Ibid., p. 178.

120 For general background, see Jesse Green, *Cushing at Zuni: The Correspondence and Journals of Frank Hamilton Cushing, 1879-1884* (Albuquerque: University of New Mexico Press, 1990); and Eliza McFeely, *The Zuni and the American Imagination* (New York: Hill and Wang, 2001).

121 Paula Richardson Fleming and Judith Luskey, *The North American Indians in Early Photographs* (New York: Dorset Press, 1986): 140.

122 Hales, *William Henry Jackson*, p. 135.

CHAPTER VIII
A World of Photographs

1 *The Education of Henry Adams: An Autobiography*, introduction by D. W. Brogan (1918; Boston: Houghton Mifflin, 1961): 238.

2 The following is informed by numerous sources, including Alan Trachtenberg, *The Incorporation of America: Culture & Society in the Gilded Age* (New York: Hill and Wang, 1982); Sean Dennis Cashman, *America in the Gilded Age: From the Death of Lincoln to the Rise of Theodore Roosevelt*, third edition (New York: New York University Press, 1993); and Robert Heilbroner and Aaron Singer, *The Economic Transformation of America: 1600 to the Present*, third edition (Fort Worth: Harcourt Brace, 1994).

3 Heilbroner and Singer, *The Economic Transformation of America*, p. 139.

4 Dee Brown, *The Year of the Century: 1876* (New York: Charles Scribner's Sons, 1966): 128-33.

5 On the electrification of New York City, see Edwin G. Burrows and Mike Wallace, *Gotham: A History of New York City to 1898* (New York: Oxford University Press, 1999): 1059-70.

6 Between 1874 and 1880, the annual production of barbed wire leaped from 5 tons to 20,000 tons. Gorton Carruth, *What Happened When: A Chronology of Life and Events in America* (New York: Harper & Row, 1989): 182.

7 The title of a recent book summarizes this point of view nicely: Jack Beatty, *Age of Betrayal: The Triumph of Money in America, 1865-1900* (New York: Alfred A. Knopf, 2007).

8 While this phrase has long been a conventional descriptive term for the era, it is worth noting that it was never embraced by people of the time. Ibid., p. 108 (note).

9 The many survey histories of this era include Eric Foner, *Reconstruction: America's Unfinished Revolution, 1863-1877* (New York: Harper Collins, 2002); and Nell Irvin Painter, *Standing at Armageddon: The United States, 1877-1919* (New York: W. W. Norton, 1987).

10 Robert Taft, *Photography and the American Scene: A Social History, 1839-1889* (1938; New York: Dover Publications, 1964): 331-34.

11 In 1958, the group's name was changed to the Professional Photographers of America (PPA), which currently has some 16,000 members.

12 William Welling, *Photography in America: The Formative Years, 1839-1900, A Documentary History* (New York: Thomas Y. Crowell, 1978): 189, 202, 223. For a superb overview of nineteenth-century photo-mechanical techniques, see David A. Hanson and Sidney Tillim, *Photographs in Ink* (Teaneck, N.J.: University College Art Gallery, Fairleigh Dickinson University, 1996). For a new definitive history of one of these processes, see Barret Oliver, *A History of the Woodburytype* (Nevada City, Calif.: Carl Mautz Publishing, 2007).

13 Edward Wilson, in *Philadelphia Photographer* (1866); cited in Welling, *Photography in America*, p. 185.

14 See, for example, Helena Zinkham, "Pungent Salt: Mathew Brady's 1866 Negotiations with the New-York Historical Society," *History of Photography* 10:1 (January-March 1986): 1-8.

15 Taft, *Photography and the American Scene*, p. 336. The following is informed by Taft's discussion on pp. 336-42, and 499, notes 357 and 358.

16 Ibid., p. 383.

17 See, for example, William Kurtz, "Rembrandt-ish," *Philadelphia Photographer* 8:85 (January 1871): 2-5; and "Kurtz's Art Gallery," *Frank Leslie's Illustrated Newspaper* 38:983 (August 1, 1874): 325, 327.

18 The following is indebted to Barbara McCandless, "The Portrait Studio and the Celebrity: Promoting the Art," in Martha A. Sandweiss, ed., *Photography in Nineteenth-Century America* (Fort Worth: Amon Carter Museum of Art/Harry N. Abrams, 1991): 63-72; and Ben L. Bassham, *The Theatrical Photographs of Napoleon Sarony* (Kent, Ohio: Kent State University Press, 1978).

19 "Highlights in Photography, No. 4: Napoleon Sarony," *Photo-American* 5:11 (September 1894): 323.

20 This strength of character is evident in a daguerreotype of Sarony, dated 1842, reproduced in a tribute essay, "Sarony," *Wilson's Photographic Magazine* 34:482 (February 1897): 66.

21 Cited in Bassham, *The Theatrical Photographs of Napoleon Sarony*, p. 13.

22 Taft, *Photography and the American Scene*, p. 340.

23 This work is surveyed in Bassham's book *The Theatrical Photographs of Napoleon Sarony*. See also the works reproduced in Taft, *Photography and the American Scene*, pp. 343-44; and in McCandless, "The Portrait Studio and the Celebrity: Promoting the Art," pp. 65-69.

24 As one critic of the time observed, Sarony "introduced into photography the employment of Hogarth's famous line of beauty and made photography picturesque." Cited in Taft, *Photography and the American Scene*, p. 345.

25 Ibid.

26 See Leo Braudy, *The Frenzy of Renown: Fame and Its History* (New York: Oxford University Press, 1986): 476-85.

27 For a concise history of this period, see Richard Ellmann, *Oscar Wilde* (New York: Alfred A. Knopf, 1988): 150-211. Wilde's itinerary is given on pp. 187-91.

28 Bassham, *The Theatrical Photographs of Napoleon Sarony*, p. 4.

29 Ibid.

30 Mitch Tuchman, "Supremely Wilde," *Smithsonian Magazine* (May 2004): 18; and Bassham, *The Theatrical Photographs of Napoleon Sarony*, pp. 168-69. Ellmann's *Oscar Wilde* reproduces seven images from this series in the illustrations following p. 204.

31 The following is indebted to William Allen, "Legal Tests of Photography-as-Art: Sarony and Others," *History of Photography* 10:3 (July-September 1986): 221-28. For reproductions of these two works, see pp. 223-24; this pose is here referred to as "Oscar Wilde, No. 12."

32 Ibid., p. 221.

33 Ibid., pp. 221-22.

34 There are numerous surveys of such themes. See, for example, Ralph Greenhill, *Engineer's Witness* (Toronto: Coach House Press/David R. Godine, 1985).

35 The following is indebted to Lewis M. Rutherfurd, "Astronomical Photography," *American Journal of Science and Arts* 2:39 (1865): 304-09; and John Krom Rees, *The Rutherfurd Photographic Measures, Contributions from the Observatory of Columbia University*, Nos. 1 and 2 (New York: Columbia University, 1906).

36 Much of this work was conducted with the assistance or advice of Henry Fitz, the lens maker and pioneering daguerreotypist who died in 1863.

37 For example, see "The Eclipse Expedition," *Philadelphia Photographer* 6:68 (August 1869): 271-72; "The Great Solar Eclipse," *Humphrey's Journal of Photography and the Allied Arts and Sciences* 20:24 (August 15, 1869): 382-84; and Edward L. Wilson, "Photographing the Eclipse," *Philadelphia Photographer* 6:69 (September 1869): 285-92.

38 From the photographic literature of the period see, for example, "The Transit of Venus," *Anthony's Photographic Bulletin* 5:6 (June 1874): 201-04; "The Expedition for the Observation of the Transit of Venus," *Photographic Times* 4:43 (July 1874): 97-98; "The Transit of Venus," *Philadelphia Photographer* 11:127 (July 1874): 213-14, and 11:132 (December 1874): 363-66; "Photographic Requisites and Apparatus for Expeditions," *Photographic Times* 4:44 (August 1874): 122-23; and Professor Simon Newcomb, "The Coming Transit of Venus," *Harper's Monthly* 50:295 (December 1874): 25-35. For a recent study of the history and significance of this subject, see Eli Maor, *June 8, 2004, Venus in Transit* (Princeton: Princeton University Press, 2000).

39 While it was hoped that photography would lend new accuracy to these measurements, the results were less than entirely satisfactory. See Maor, *June 8, 2004*, pp. 117-19. This quest for absolute precision resulted in a brief revival of the daguerreotype. In an attempt to avoid any potential distortion of the photographic image from the expansion or contraction of the wet-collodion emulsion, the scientific teams sent out by the French government chose to use the daguerreotype for the dimensional rigidity of its metal support. See Ann Thomas, "Capturing Light: Photographing the Universe," in Ann Thomas et al., *Beauty of Another Order: Photography in Science* (Ottawa: National Gallery of Canada/Yale University Press, 1997): 191-92.

40 "Class Photographs and Photographers," *Photographic Times* 8:86 (February 1878): 34-35. See also S. F. Spira et al., *The History of Photography as Seen Through the Spira Collection* (New York: Aperture, 2001): 86-87.

41 This rich subject has recently begun to receive the scholarly attention it deserves. See, for example, Floyd Rinhart, Marion Rinhart, and Robert W. Wagner, *The American Tintype* (Columbus: Ohio State University Press, 1999); and Stanley B. Burns, *Forgotten Marriage: The Painted Tintype & The Decorative Frame, 1860-1910, A Lost Chapter in American Portraiture* (New York: Burns Press, 1995). Janice Schimmelman's definitive work, *The Tintype in America, 1856-1880* (Philadelphia: American Philosophical Society), is scheduled to be published in about mid-2007.

42 For valuable perspectives on this overall subject, see Andrea DiNoto and David Winter, *The Pressed Plant: The Art of Botanical Specimens, Nature Prints, and Sun Pictures* (New York: Stewart, Tabori & Chang, 1999); Sue Ann Prince, ed., *Stuffing Birds, Pressing Plants, Shaping Knowledge: Natural History in North America, 1730-1860* (Philadelphia: American Philosophical Society, 2003); and Carol Armstrong and Catherine De Zegher, eds., *Ocean Flowers: Impressions From Nature* (Princeton: Princeton University Press/The Drawing Center, 2004). Atkins's work is surveyed in Larry J. Schaaf, *Sun Gardens: Victorian Photograms by Anna Atkins* (New York: Aperture, 1985).

43 Much has been written on this overall subject. Useful recent social histories include Barbara Weisberg, *Talking to the Dead: Kate and Maggie Fox and the Rise of Spiritualism* (New York: HarperSanFrancisco, 2004); and Barbara Goldsmith, *Other Powers: The Age of Suffrage, Spiritualism, and the Scandalous Victoria Woodhull* (New York: Alfred A. Knopf, 1998). The definitive photographic history of this genre is Clément Chéroux et al., *The Perfect Medium: Photography and the Occult* (New Haven: Yale University Press, 2005).

44 The following is indebted to Christa Cloutier, "Mumler's Ghosts," in Chéroux, et al., *The Perfect Medium*, pp. 20-23. For Mumler's own story, see William H. Mumler, *The Personal Experiences of William H. Mumler* (Boston: Colby and Rich, 1875).

45 See, for example, "Spiritual Photography," *Frank Leslie's Illustrated Newspaper* 28:710 (May 8, 1869): 119-20; "Spiritual Photography," *Harper's Weekly* 13:645 (May 8, 1869): 289; "Spirit Photographs," *Humphrey's Journal of Photography, and the Allied Arts and Sciences* 20:21 (May 15, 1869): 327-29; and C. Wager Hull, "New York Correspondence," *Philadelphia Photographer* 6:66 (June 1869): 199-203.

46 On this subject, see Professor Towler, "Card Pictures Representing the Same Person in Two Different Positions on the Same Card," *Humphrey's Journal* 16:18 (January 15, 1865): 273-75; and Peter E. Palmquist, "Seeing Double," *History of Photography* 5:3 July 1981): 265-67.

47 See Keith F. Davis, *George N. Barnard: Photographer of Sherman's Campaign* (Kansas City: Hallmark Cards, Inc., 1990): 190-91.

48 The following is indebted primarily to Susan Danly and Cheryl Leibold, eds., *Eakins and the Photograph: Works by Thomas Eakins and his Circle in the Collection of the Pennsylvania Academy of the Fine Arts* (Washington, D.C.: Smithsonian Institution Press/Pennsylvania Academy of the Fine Arts, 1994). The literature on Eakins is, of course, large and growing. Other valuable works include Helen A. Cooper at al., *Thomas Eakins: The Rowing Pictures* (New Haven: Yale University Press/Yale University Art Gallery, 1996); Kathleen A. Foster et al., *Thomas Eakins Rediscovered: Charles Bregler's Thomas Eakins Collection at the Pennsylvania Academy of the Fine Arts* (New Haven: Yale University Press/Pennyslvania Academy of the Fine Arts, 1997); and Darrel Sewell et al., *Thomas Eakins* (New Haven: Yale University Press/Philadelphia Museum of Art, 2002).

49 W. Douglass Paschall, "The Camera Artist," in Sewell et al., *Thomas Eakins*, p. 239.

50 Ibid., p. 240. Eakins's first known painting based on a photograph, from 1873, was a portrait of the dog of photographer Henry Schreiber. Kathleen Brown, "Chronology," in Sewell et al., *Thomas Eakins*, p. xxviii.

51 Cited in Paschall, "The Camera Artist," p. 255.

52 The date of 1880 is given in Paschall, "The Camera Artist," pp. 244-45, while a date of early 1881 is suggested in Foster et al., *Thomas Eakins Rediscovered*, p. 110.

53 Danly and Leibold, eds., *Eakins and the Photograph*, pp. 2-3.

54 This posing stand is visible in a number of other photographs. See, for example, figures 33 (p. 73), 250 (p. 176), 334 (p. 187), and 350 (p. 190), in ibid.

55 See, for example, fig. 51 (p. 107), pl. ii (p. 127), and pl. 12 (p. 128) in ibid.; and plates 64-67 (pp. 130-32) in Sewell et al., *Thomas Eakins*.

56 For example, see "Gloucester Landscapes: 'Camera Vision' and Impressionism," and "Nudes: The Camera in Arcadia," in Foster et al., *Thomas Eakins Rediscovered*, pp. 163-77, 178-88.

57 For a stimulating history of this theme, see Phillip Prodger, *Time Stands Still: Muybridge and the Instantaneous Photography Movement* (New York: Oxford University Press/Iris & B. Gerald Cantor Center for Visual Arts at Stanford University, 2003).

58 The essential study of Marey's life and work is Marta Braun, *Picturing Time: The Work of Etienne-Jules Marey (1830-1904)* (Chicago: University of Chicago Press, 1992).

59 Prodger, *Time Stands Still*, pp. 150-52.

60 Anne McCauley, "'The Most Beautiful of Nature's Works': Thomas Eakins's Photographic Nudes in their French and American Contexts," in Danly and Leibold, eds., *Eakins and the Photograph*, pp. 36-38; and Prodger, *Time Stands Still*, pp. 183-87.

61 Muybridge's role as the "father of the motion picture" is a matter of some debate and interpretation. See, for example, Tom Gunning, "Never Seen This Picture Before: Muybridge in Multiplicity," in Prodger, *Time Stands Still*, pp. 223-57, 263-72. On the origins of the American motion picture, see Charles Musser, *History of the American Cinema Volume 1. The Emergence of Cinema: The American Screen to 1907* (Berkeley: University of California Press, 1990): 1-105.

62 The influence of this work on later artists has received considerable attention beginning at least with Van Deren Coke's *The Painter and the Photograph, From Delacroix to Warhol* (Albuquerque: University of New Mexico Press), first published in 1964 and revised and enlarged in 1972.

63 Reese V. Jenkins, *Images & Enterprise: Technology and the American Photographic Industry, 1839 to 1925* (Baltimore: Johns Hopkins University Press, 1975): 69.

64 The following is drawn from Elizabeth Brayer, *George Eastman: A Biography* (Baltimore: Johns Hopkins University Press, 1996): 40-42.

65 *Philadelphia Photographer* 21 (February 1884): 49. This history is summarized in Jenkins, *Images & Enterprise*, pp. 66-80.

66 William Marder and Estelle Marder, *Anthony: The Man, the Company, the Cameras* (Amesbury, Mass.: Pine Ridge Publishing, 1982): 240-42.

67 Eaton S. Lothrop, Jr., *A Century of Cameras: From the Collection of the International Museum of Photography at George Eastman House* (Dobbs Ferry, N.Y.: Morgan & Morgan, 1973): 21-22, 26.

68 As Reese Jenkins notes, a similar change occurred a few years later in the production of photographic papers. See Jenkins, *Images & Enterprise*, pp. 80-95. As he observes (p. 81): "Before the early 1880s, photographic papers were not generally sensitized until immediately prior to printing. Consequently, as with the negative photosensitive materials, each photographer made his own photosensitive print material; however, unlike the negative materials, unsensitized photographic papers were prepared, prior to 1880, in centralized factories… The American photographer usually purchased albumen paper and then floated it on a silver nitrate bath for a short time prior to printing the paper."

Catalogue

This section provides information on the 606 original works reproduced in this volume—465 photographs in the main text and an additional 141 illustrated here. These two groups of works are indicated by distinct but overlapping numbering systems. The works reproduced in the primary text are numbered from 1 to 465. The photographs reproduced in this catalogue section bear "c" numbers, from c-1 to c-141. These are integrated with the text images to reflect the position of their references in the main narrative.

Unless otherwise noted, all works are from the Hallmark Photographic Collection at the Nelson-Atkins Museum of Art, Kansas City, Missouri. All such works are accompanied by their original Hallmark Photographic Collection accession numbers (e.g., 400-14-95). Works subsequently gifted to the collection by the Hall Family Foundation bear the prefix "HF" (e.g., HF556-15-05). Works gifted to the Museum by other donors are denoted by their Nelson-Atkins accession numbers (e.g., 2006.29.2). In all catalogue entries, "the collection" refers to the Hallmark Photographic Collection at The Nelson-Atkins Museum of Art.

While individual entries vary considerably in length, they contain basic information on the name and life dates of the artist (when known); the title and date of the photograph; and the work's process, size, and accession number. Some entries contain further information on the maker or subjects of the work in question, and bibliographic references. The names of photographers and businesses are typically given in original, nineteenth-century form. Unknown birth or death dates are indicated by a question mark ("?"). When neither birth nor death dates are known, "active" dates have been used (e.g., "active 1850s"). Additional data on the physical object—including maker marks, ink stamps, and hand-written inscriptions—is indicated in italic. In these descriptions, "[illeg.]" denotes illegible words and phrases, and "[?]" indicates a best-guess interpretation of handwriting. When a cased image or photograph has applied color, this is also noted.

Measurements for cased images (daguerreotypes and ambrotypes) are given as standard plate sizes; the exact dimensions of any individual object may vary slightly. These standard plate sizes are:

Whole plate:	8½ x 6½ in.
Half-plate:	5½ x 4½ in.
Quarter-plate:	4¼ x 3¼ in.
Sixth-plate:	3¼ x 2¾ in.
Ninth-plate:	2½ x 2 in.

Considerably less-common sizes include the three-quarter-plate format (7⅛ x 5½ in.) and oversize or mammoth plates, which were typically 8½ x 13 in. or larger.

The size of paper photographs is given for the print only, in inches, with height preceding width. Unless otherwise stated, all paper photographs reproduced here are presumed to be from wet-collodion glass-plate negatives.

1

Unknown Maker
Baby on Sofa, ca. 1855
Sixth-plate daguerreotype, 400-97-97

2

Unknown Maker
The Daguerreotypist, ca. 1850
Half-plate daguerreotype, 400-93-97

3

Unknown Maker
Woman Holding Half-Open Daguerreotype Case,
ca. 1850
Sixth-plate daguerreotype, 400-447-02

4

Unknown Maker
Portrait of Girl with Man to the Side with Letter,
ca. 1850
Sixth-plate daguerreotype, 400-70-96

CHAPTER I

The Pioneering Generation: 1839-1843

5

Henry E. Insley
1811-1894
Self-Portrait, ca. 1839
Sixth-plate daguerreotype, 576-1-97

An innovator as well as a pioneer, Henry Earle
Insley developed techniques that led to shorter
sitting times and cheaper prices; he claimed to
have taken the first stop-action photograph, was
the first to hand-tint plates, and received a patent
for his "illuminated daguerreotype." Henry E.
Insley, "The Early Days," *Anthony's Photographic
Bulletin* 14:19 (September 1883): 313-14; "Henry E.
Insley Dead," *New York Sun* (August 12, 1894): n.p.;
and Roy Blankenship, "The Art of the Insleys,"
*South of the Mountains: Historical Society of Rock-
land County* [New York] 29:1 (January-March
1985): 3-21.

A total of thirteen Insley family portraits ca. 1847-
1850 are held in the collection.

6

Henry E. Insley
George W. Prosch, ca. 1843-44
Quarter-plate daguerreotype, 576-3-97

7

Robert Cornelius
1809-1893
Portrait of a Woman, ca. 1840
Sixth-plate daguerreotype, 418-2-00

*In cast-brass frame, with Cornelius Studio yellow
label on reverse: "Daguerreotype / Miniatures, /
By R. Cornelius, / Eighth Street, above Chesnut
[sic], / Philadelphia."*

The rare cast-brass frame suggests this daguerre-
otype was made in May 1840. Other works of
similar style and presentation include a portrait
of Pierre Etienne Du Ponceau (gifted to the
American Philosophical Society by Paul Beck
Goddard in May 1840) and a portrait of Martin
Hans Boye (dated May 19, 1840). William F.

Stapp, *Robert Cornelius: Portraits from the Dawn
of Photography* (Washington, D.C.: Smithsonian
Institution Press/National Portrait Gallery, 1983);
"Editors' Table," *Godey's Lady's Book* 20 (April
1840): 190; and "Daguerreotype Miniatures,"
National Gazette (June 26, 1840): 2.

8

Robert Cornelius
Portrait of a Man, ca. 1841
Sixth-plate daguerreotype, 418-1-95

Stamped on mat: "R. Cornelius...Philada."

This plate appears to have been made prior to
June 1841, when Cornelius moved his studio
to 810 Market Street, Philadelphia.

9

Samuel Bemis
1789-1881
*Lafayette House, Franconia Notch, New
Hampshire*, ca. 1840
Whole-plate daguerreotype in original poplar
wood frame, 425-1-96

Samuel Bemis was the first American landscape
photographer. He made the White Mountains his
permanent home in 1840. Although somewhat
reclusive, he helped fellow daguerreotypists with
their apparatus while they were visiting the White
Mountains, including the noted botanist William
Oakes. There is little evidence that Bemis continued
to daguerreotype much beyond 1840. Bates Lowry
and Isabel Lowry, *The Silver Canvas: Daguerreotype
Masterpieces from the J. Paul Getty Museum* (Los
Angeles: J. Paul Getty Museum, 1998): 36-37, 215-16.

The subject of this view—the Lafayette House,
built in 1835—was one of the first hotels in the
region. It was located in Franconia Notch, a pop-
ular destination for tourists and artists. The hotel
burned down just after the start of the Civil War.
Frederick Kilbourne, *Chronicles of the White
Mountains* (Boston: Houghton Mifflin, 1916);
William Oakes and Isaac Sprague, *Scenery of the
White Mountains* (1848; repr. Somersworth, N.H.:
New Hampshire Publishing Co., 1971).

10

Smith & Hale
Active ca. 1841
Portrait of a Woman, ca. 1841
Ninth-plate daguerreotype, 400-26-95

*Note in back of case: "Made at Smith's, No. 2 Milk
Street, opposite old South [Church?], Boston."*

Ralph Smith, Jr., and Charles E. Hale (brother of
Luther Holman Hale) exhibited daguerreotypes at
the Third Annual Exhibition of the Massachusetts
Charitable Mechanics Association, in Boston,
on September 20, 1841. On October 16, 1841, an
ad appeared in the *American Traveller*, a Boston
weekly, announcing their studio at No. 2 Milk
Street. By November 1841, the advertisement
was for Hale only. *Photographic Art-Journal* 1:6
(June 1851): 357-59.

11

Hawkins & Todd
1808-1862; active ca. 1841
Portrait of a Man, September 16, 1841
Sixth-plate daguerreotype, 488-2-02

*Penciled inscription in back of case: "Taken by
Hawkins & Todd / Sept 16 1841 / Cincinnati." The
plate appears to bear the hallmark of the supplier,
"Wm. H. Butler / New York."*

After learning the daguerreotype process through
a letter from Samuel Morse, Ezekiel Hawkins
opened a temporary studio in Cincinnati, with a
partner known only as Todd, in August 1841. A
month later, they opened a permanent operation
at Fourth and Main. "Photography," *Western Art
Journal* 1:1 (January 1855): 14; Harry R. Stevens,
"Pioneer Photography," *Bulletin of the Historical
and Philosophical Society of Ohio* 10 (1952): 308-09.

12

W. & F. Langenheim
1807-1874; 1809-1879
Portrait of a Man, February 12, 1842
Ninth-plate daguerreotype, 401-12-01

*Handwritten inscription on case under plate: "for
a customer." Handwritten inscription on back of
plate: "The first daguerreotype / [illeg.] Langenheim
/ Feb 12, 1842."*

A former operator for William and Frederick
Langenheim recalled their studio in 1843: "Here
there was little to be seen of the things you see
nowadays in a photographic art gallery. A kind of
a hiding-place for a dark-room, and a spyglass-
like camera were all the indications of the mystery
I was to learn. The [Voigtländer] camera rested
on a candlestick-like tripod, with three set-screws
for adjustment, and was placed on an ordinary
table..." Alexander Beckers, "Fifteen Years' Expe-
rience of a Daguerreotyper," *Photographic Times
and American Photographer* 19:391 (March 15,
1889): 131.

13

Unknown Maker
Portrait of a Woman, ca. 1842
Sixth-plate daguerreotype, 400-339-01

14

Unknown Maker
Man with Clarinet, ca. 1842-43
Sixth-plate daguerreotype, 400-364-01

15

Unknown Maker
Rev. Charles Jones of Rome, New York,
ca. 1842-43
Sixth-plate daguerreotype, 400-111-97

Reverend Charles Jones, a Presbyterian minister,
became pastor of the Second Presbyterian Church
in Oswego, New York, in 1837. The church was
divided on the question of slavery; the older
congregation wanted to avoid the issue, while the
younger members favored abolition. An outspoken
opponent of slavery, Reverend Jones alienated
many of his congregation with his views. He was
dismissed after only five months, but the decision
was eventually reversed and he was re-installed as
pastor in 1844. *Oswego County Whig* (July 3, 1844);
Oswego Palladium (October 21, 1845), (January 13,
1846), (September 15, 1846), (September 29, 1846),
(October 15, 1846), and (October 20, 1846).

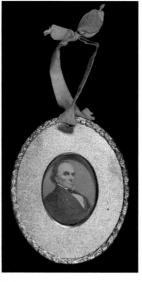

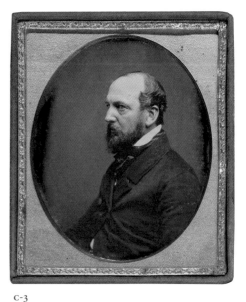

C-1 C-2 C-3

16
John Plumbe
1809-1857
Man Dressed in Fraternal Apron, ca. 1844
Half-plate daguerreotype, HF434-8-04

Stamped on mat: "Plumbe."

The subject is most likely an Odd Fellow. Visible on this man's apron are the three links representing Friendship, Love, and Truth, the official symbol of the Odd Fellows. Clifford Krainik, "National Vision, Local Enterprise: John Plumbe, Jr., and the Advent of Photography in Washington, D.C.," *Washington History-Magazine of the Historical Society of Washington D.C.* 9:2 (Fall/Winter 1997-98): 4-27, 92-93.

17
John Plumbe
Mexican War Officer, ca. 1846-48
Half-plate daguerreotype, 434-9-04

The subject is thought to be Major John H. Miller. Miller was born in Tennessee in 1821, served as a member of the Tennessee legislature, and earned the rank of major during the Mexican-American War. He moved to Corsicana, Texas, in 1852, married in 1855, and had several children. He moved to Rice, Texas, in 1858, and fought for the state in the Civil War. Miller died in Corsicana in 1907.

18
John Plumbe
The Raymond Triplets, ca. 1845-48
Half-plate daguerreotype, 434-1-96

Stamped on mat: "Plumbe."

Abraham, Isaac, and Jacob Raymond were born on July 6, 1826, the youngest of twelve children of George and Hannah Raymond, of Seneca County, Ohio. They were dubbed "the Buckeye Triplets" and were a sensation in the region and beyond. At about the age of four, the boys were presented to the "people of the east," in New York State. It is uncertain if these exhibitions continued in later life, but the triplets remained celebrities throughout their lives. Aaron Schuyler, *History and Sketches of the Raymond Family and Biographies of the Buckeye Triplets* (1907): n.p.; and Elizabeth Raymond, "The Diary of the Raymond Sisters," *The Crooked Lake Review* 103 (Spring 1997): n.p.

CHAPTER II

Leaders in the Profession: A Regional Survey

19
Southworth & Hawes
1811-1894; 1808-1901
Students from the Emerson School for Girls, ca. 1850-55
Whole-plate daguerreotype, 402-5-99

Albert Sands Southworth and Josiah Johnson Hawes were both introduced to the daguerreotype at lectures by François Gouraud. Southworth then took lessons from Samuel F. B. Morse, in New York, while Hawes probably studied with Gouraud. Grant B. Romer and Brian Wallis, eds., *Young America: The Daguerreotypes of Southworth & Hawes* (Göttingen: Steidl/George Eastman House/International Center of Photography, 2005).

A close variant of this plate is held by the Metropolitan Museum of Art.

20
Southworth & Hawes
Alice Mary Hawes, ca. 1853-55
Quarter-plate daguerreotype, 402-3-98

With hand-coloring by Nancy Southworth.

Alice Mary, born in 1850 (1880 census, Boston), was the oldest child of Nancy and Josiah Johnson Hawes.

21
Southworth & Hawes
Harriet Beecher Stowe, ca. 1843-45
Quarter-plate daguerreotype, 402-1-95

One of the most famous American writers of the nineteenth century, Harriet Beecher Stowe (1811-1896) was born in Connecticut but moved in 1832 to Ohio, where her father, Lyman Beecher, assumed the presidency of Lane Theological Seminary. She married Calvin Ellis Stowe, a professor at Lane, in 1836. In this period, she witnessed the brutality of the slave system; these experiences inspired her most famous novel, *Uncle Tom's Cabin* (1852). On meeting Stowe

in 1862, President Abraham Lincoln reportedly exclaimed, "So you are the little woman who wrote the book that started this great war."

A close variant of this plate is held by the Metropolitan Museum of Art.

22
Southworth & Hawes
The Letter, ca. 1850
Whole-plate daguerreotype, 402-4-99

A close variant of this plate is held by the National Gallery of Art. The George Eastman House has two variant portraits of the woman on the right in this pose.

23
Southworth & Hawes
Frost on a Window, ca. 1850
Sixth-plate daguerreotype, 402-6-99

Stamped on plate: "Scovill."

24
John A. Whipple
1822-1891
Self-Portrait, Reading Book in Lab Coat, ca. 1842-43
Sixth-plate daguerreotype, 399-19-98

Penciled on seal: "Great grandfather [illeg.] Whipple."

John Adams Whipple began working with photographic chemicals in 1840. In 1843, he was still listed in the Boston Directory as a chemist.

[C-1]
John A. Whipple
Family of Elizabeth Mann Whipple, ca. 1850
Mammoth-plate daguerreotype (10 x 12 in.) in period wall frame, 399-10-98

Whipple and his wife, the former Elizabeth Mann, had at least five children: Martha Elizabeth, Annie, Lucy, John, and William. Elizabeth is pictured here with her mother and father and at least two of her siblings. The collection includes thirty-five daguerreotypes from the Whipple family holdings.

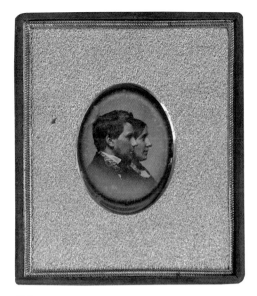

c-4

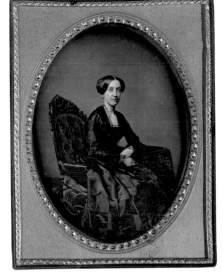

c-5

c-6

[c-2]
John A. Whipple
Daniel Webster Medallion, 1852
Ninth-plate daguerreotype in medallion with ribbon, 399-6-97

In original case, with ribbon fragment.

Daniel Webster was one of the greatest statesmen in American history. He was an attorney who argued important points to the Supreme Court, a senator who fought to preserve the Union prior to the Civil War, and secretary of state under three presidents. He twice ran unsuccessfully for president on the Whig party ticket, in 1848 and 1852. This daguerreotype was made for Webster's 1852 presidential campaign and is a copy of an original plate made by Whipple ca. 1848.

[c-3]
John A. Whipple
Horatio Greenough, ca. 1850
Sixth-plate daguerreotype, 399-3-95

Horatio Greenough was a leading American sculptor, perhaps best known for his controversial depiction of George Washington in classical style for the Capitol Rotunda. One of only a few known daguerreotypes of Greenough, this was made shortly before his death in 1852.

25
John A. Whipple
Self-Portrait with Brother, Frank Whipple, in Double Profile, ca. 1847
Sixth-plate daguerreotype, 399-2-95

26
John A. Whipple
Self-Portrait, ca. 1850
Half-plate daguerreotype, 399-1-95

This, or a variant, appears to have served as the source for Francis D'Avignon's lithograph of Whipple included as the frontispiece to the *Photographic Art-Journal* 2:2 (August 1851), accompanying the text by M. Grant, "John A. Whipple and the Daguerrean Art," pp. 94-95.

[c-4]
John A. Whipple
Self-Portrait with Wife, Elizabeth Mann Whipple, in Double Profile, 1849
Ninth-plate daguerreotype, 399-34-98

Scratched on back of plate: "John Whipple and wife Elizabeth 1849."

[c-5]
John A. Whipple
Ellen Harris Young, ca. 1849-52
Half-plate daguerreotype, 399-4-96

Ellen Harris Young (1812-1872) was the wife of New York governor John Young. Her husband served in Congress from 1840 to 1846 before being elected governor. He was the assistant U.S. treasurer before his untimely death of tuberculosis in 1852. It is possible that this daguerreotype was taken after John Young's death, as she appears to be wearing mourning clothes.

The identification of Whipple's authorship is based not only on stylistic qualities, but also on the carpet, wainscoting, and the chair visible in the scene, all of which have been matched to Whipple cartes-de-visite in the collection of the Boston Athenaeum.

27
John A. Whipple
Ellen Harris Young in Riding Clothes, with Rifle, ca. 1849
Half-plate daguerreotype, 399-5-96

Identified as Whipple's work by characteristic chair and case. This piece accompanied the one above.

[c-6]
Marcus Ormsbee
Active 1850s
Girl Resting Head on Table, ca. 1850
Sixth-plate daguerreotype, HF794-1-03

Stamped on mat: "Ormsbee."

[c-7]
Lorenzo G. Chase
1823-ca. 1891
Portrait of a Woman, ca. 1847-49
Half-plate daguerreotype, 727-1-00

Stamped on mat: "Chase."

28
George K. Warren
1824-1884
Lowell, Massachusetts, Market Day, ca. 1850
Quarter-plate daguerreotype, 556-7-00

29
Russell A. Miller
Active 1850s-1860s
Painter and Backdrop, ca. 1855
Half-plate daguerreotype, 450-1-96

Stamped on mat: "Miller Lowell."

The subject of this remarkable plate may be Frank Rowell (1832-1900). Rowell was trained as an ornamental painter but left this profession in 1855 to pursue photography. Rowell joined in partnership with Miller in 1863 and worked with him for at least two years in Lowell, Massachusetts. He then became a partner in the firm of Allen & Rowell. "Frank Rowell Dead," *Boston Evening Transcript* (May 10, 1900): 9.

[c-8]
Burnham
Active ca. 1850s
Girl Reclining on Couch with Doll, with Seated Man, ca. 1850
Quarter-plate daguerreotype, HF791-1-03

Stamped on mat: "Burnham."

This daguerreotype is thought to have been made by one of the Burnham brothers in Bangor, Maine: John Usher Parsons Burnham (b. 1823), Asa Marsh Burnham (b. 1825), or Thomas Rice Burnham (b. 1834).

30
William G. Mason (attrib.)
1803-ca. 1860
View of Northeast Corner of Chestnut and Second Streets, Philadelphia, ca. 1842-43
Sixth-plate daguerreotype, HF809-1-04

Label at lower rail in ink, on verso: "View of N.E. corner of Chestnut & 2nd Sts about 184[illeg.] by WGM."

C-7

C-8

C-9

31
William G. Mason (attrib.)
*View of North Side of Chestnut Street,
Philadelphia*, ca. 1843-45
Quarter-plate daguerreotype, HF809-2-04

*Label at lower rail in ink: "North Side of Chestnut
St." Label on reverse of case in ink: "The North Side
of Chestnut St. from Bank nearly to Strawberry
Alley about 1842 or 3 by W. G. Mason."*

32
William G. Mason (attrib.)
*View of Chestnut Street, Philadelphia (McAllister's
Optical Shop)*, ca. 1853
Half-plate daguerreotype, HF809-3-05

John A. McAllister, Jr., was a critically important
figure in both early Philadelphia photography
and the larger context of American photography.
The McAllister family store originally sold whips
and canes. In the 1780s, the senior McAllister
purchased a shipment of spectacles for sale and
from that point the McAllister business was
associated with optics and optometry. McAllister's
store on Chestnut Street was located near the
leading daguerreian studios and McAllister soon
became the premier source in Philadelphia for
daguerreian cameras, lenses, and chemicals. He was
photographed by a number of daguerreotypists.
Sandra Markham, "John A. McAllister Collects
the Civil War," *Magazine Antiques* (August 2006):
102-07; Maxwell Miller, "The Philadelphia Story
of Optometry," *American Journal of Optometry
and Archives of American Academy of Optometry*
48:3 (March 1971): 270-80; James Gregg, *The Story
of Optometry* (New York: Ronald Press Co., 1965):
161-62.

[C-9]
W. & F. Langenheim
1807-1874; 1809-1879
*William Langenheim with Son, William Paul
Langenheim*, 1856
Ninth-plate daguerreotype, 401-11-00

*Inscribed in ink on paper lining: "Paul Langenheim,
fecit Oct. 11th, 1856, aged 6 years, 9 months;"
numbered in ink on paper label on back of case: "78."*

Frederick and William Langenheim played a key
role in early American photography. In addition to
their fine daguerreotypes, the brothers pioneered
the introduction of paper photography in America
and the production of stereographs. Dolores A.
Kilgo, "The Alternative Aesthetic: The Langenheim
Brothers and the Introduction of the Calotype in
America," *America and the Daguerreotype* (Iowa
City: University of Iowa Press, 1991): 27-57; William
Brey, "The Langenheims of Philadelphia," *Stereo
World* 6:1 (March-April 1979): 4-20; Ellen NicKenzie
Lawson, "Fathers of Modern Photography: The
Brothers Langenheim," *Pennsylvania Heritage* 13:4
(Fall 1987): 16-23; Dolores Kilgo, "The Robyn
Collection of Langenheim Calotypes," *Gateway
Heritage* 6:2 (Fall 1985): 28-37; George S. Layne,
"The Langenheims of Philadelphia," *History of
Photography* 11:1 (January-March 1987): 39-52.

[C-10]
W. & F. Langenheim
Sophia Palmer Langenheim and Son, ca. 1848-50
Quarter-plate daguerreotype, HF401-16-03

*Impressed velvet liner reads: "W & F Langenheim /
Philadelphia / Exchange."*

In 1846, William Langenheim married Sophia
Palmer. They had three children, all of whom were
regularly photographed: Frederick David (b. 1847),
William Paul (b. 1850), and Sophia (d. 1853 or 1854).
Frederick never married.

At the time this daguerreotype was made, the
Langenheims were located at the Philadelphia
Exchange (1842-50).

33
W. & F. Langenheim
John Greenleaf Whittier, ca. 1843-45
Half-plate daguerreotype, 401-1-95

John Greenleaf Whittier (1807-1892) was a poet
who drew the early attentions of the abolitionist
William Lloyd Garrison. Whittier's early works,
such as *Barbara,* focused on patriotic and anti-
slavery themes. Whittier's popularity increased
in the 1850s and 1860s when his work ceased to
focus on political issues.

34
W. & F. Langenheim
Charles Calistus Burleigh, ca. 1843-45
Half-plate daguerreotype, 401-3-97

Charles Calistus Burleigh (1810-1878) was a
follower of abolitionist William Lloyd Garrison.
Burleigh became involved with the abolitionist
newspaper the *Unionist* and lectured for the
Middlesex Anti-Slavery Society of Massachusetts.
Burleigh also supported the causes of women's
rights, temperance, and capital punishment.

[C-11]
W. & F. Langenheim
Thomas Ustick Walter, ca. 1846
Quarter-plate daguerreotype, 401-2-95

*Impressed velvet liner reads: "W & F Langenheim /
Philadelphia / Exchange."*

Thomas Ustick Walter (1804-1887) was a promi-
nent architect known in his home city of Phila-
delphia for the Greek revival design of Girard
College (1833-48) and for his contribution to the
Philadelphia City Hall (1877). He was best known
for his design of the side wings and central dome
of the U.S. Capitol.

[C-12]
W. & F. Langenheim
Portrait of a Young Man, ca. 1845-50
Half-plate daguerreotype with unusual applied
color, 401-9-98

On January 30, 1846, William and Frederick
Langenheim were awarded U.S. Patent 4370 for
their process for coloring daguerreotypes. An
1846 advertisement in the Philadelphia *Public
Ledger* stated that "F. LANGENHEIM'S newly
invented and patent COLORING PROCESS,
with additional improvements" was available to
daguerreotype operators to learn for a fee. *Public
Ledger* [Philadelphia] 21:6 (May 7, 1846): n.p.

35
Samuel Broadbent
1810-1880
Lucretia Mott, ca. 1855
Quarter-plate daguerreotype, 584-1-98

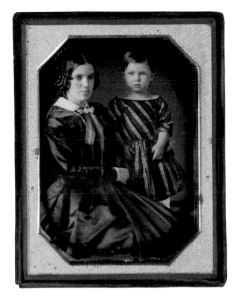

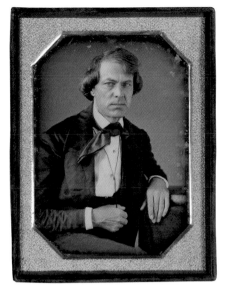

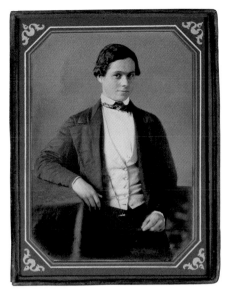

C-10 C-11 C-12

Lucretia Mott (1793-1880) was a Quaker minister and a leading abolitionist, social reformer, and advocate of women's rights. A resident of Philadelphia for many years, Mott traveled extensively to attend conferences and to lecture. She spoke at the International Anti-Slavery Convention in London in 1840 and was co-organizer of the famous Women's Rights Convention of 1848, in Seneca Falls, New York. She became particularly well known for her book *Discourse on Women* (1850), which detailed the restrictions on women in the United States at the time.

[C-13]
Samuel Broadbent
Portrait of a Woman, ca. 1853-55
Stereo daguerreotype (3¼ x 4¼ in., overall), 584-3-04

Label inside case behind stereo component: "From Broadbent's Daguerrean Rooms, No. 136 Chestnut Street, Philadelphia." Label on stereo component: "Mascher's Improved Stereoscope Philada., Patent March 8th 1853."

36
Van Loan & Mayall
Active 1840s-1850s; 1810-1901
Husband and Wife, ca. 1845-46
Half-plate daguerreotype, 423-3-96

Impressed velvet liner reads: "Van Loan & Mayall."

Samuel Van Loan and John Jabez Edwin Mayall were in partnership in Philadelphia from 1844 to 1846. Léonie L. Reynolds and Arthur T. Gill, "The Mayall Story," *History of Photography* 9:2 (April-June 1985): 89-107.

[C-14]
Samuel Van Loan
Peter Wagner, Ice Man, Philadelphia, ca. 1850
Sixth-plate daguerreotype, 423-1-95

Stamped on mat: "Van Loan;" note inside case: "Peter Wagner, Father of Mary E. Slackens, Early Days of his Ice Business, Schuykil River, Philadelphia, Pa., Grandfather—Ada Laura…"

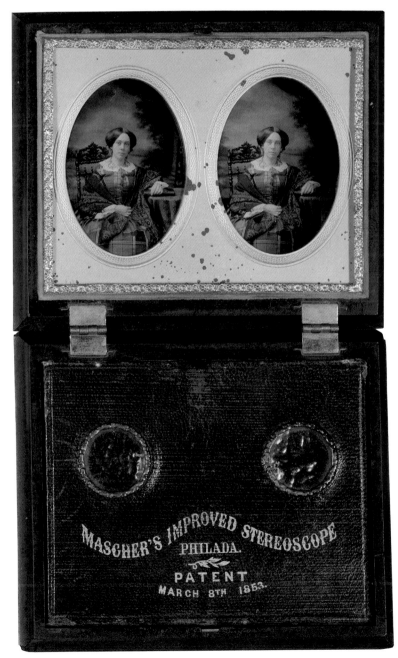

C-13

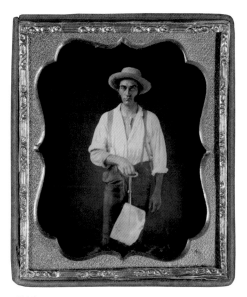

C-14

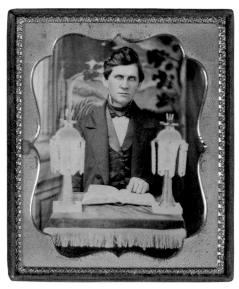

C-15

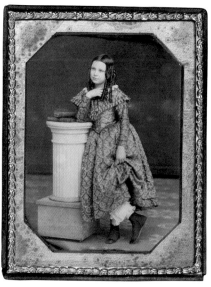

C-16

[c-15]
Van Loan & Chase
Lecturer at Podium with Two Lamps, ca. 1850
Sixth-plate daguerreotype, HF423-5-03

*Impressed velvet liner reads: "Van Loan & Chase's
Gallery / Cor.[illeg.] & Washington."*

[c-16]
David C. Collins (attrib.)
1825-?
Anne M. Collins, 1847
Sixth-plate daguerreotype, HF807-3-06

*Written in period hand on verso of plate: "11 years
old / Anne M. Collins / 1847."*

Little is known about David Chittenden Collins.
He started as a daguerreotypist in 1843 with his
father, Simeon Collins, working first in New Haven
and later in Philadelphia. He occasionally also
worked with his older brother, Thomas P. Collins.
In 1855, his business was dissolved. *Pennsylvania*,
Vol. 3, p. 183, R. G. Dun & Co. Collection, Baker
Library, Harvard Business School, Cambridge, Mass.

Anne (or Annie) Maria Collins, born in 1835, was
the youngest sister of David C. Collins.

37
David C. Collins (attrib.)
Dog "Albus," September 1842
Quarter-plate daguerreotype, in original wood
wall frame, HF807-1-04

*Inscribed on back: "Dog Albus daguerreotype Sept.
/ 1842" and "Charlie McCauley's[?] [illeg.] dog."*

[c-17]
Montgomery P. Simons
1817-1877
Smith Family, 1847
Three-quarter-plate daguerreotype, 551-3-00

*Embossed on back of case: "M.P. Simons, Phil'a;"
with a note in period hand: "Smith."*

[c-18]
McClees & Germon
1821-1887; 1823-1878
Girl with Bouquet of Flowers, ca. 1850
Sixth-plate daguerreotype, HF504-4-03

*Stamped on brass mat: "McClees & Germon Phila.
Cor. Chestnut & 8th."*

38
Washington L. Germon
The Ice Cream Party, ca. 1855
Sixth-plate daguerreotype, 751-1-01

*Stamped on brass mat: "W. L. Germon" "[illeg.]
8 Chest. St. PA."*

[c-19]
Marcus A. Root
1808-1888
*George Caleb Bingham's "Lighter Relieving a
Steamboat Aground,"* ca. 1847-49
Half-plate daguerreotype, HF598-5-03

*Impressed velvet liner reads: "Root's / Gallery /
140 / Chestnut St. / Philad. A."*

George Caleb Bingham painted *Lighter Relieving
a Steamboat Aground* in 1847. It is less a simple
genre scene than a political statement. Bingham
was very involved in politics, especially the
federal decisions regarding the Missouri and
Mississippi rivers in his home state of Missouri.
In the mid-1840s, several bills were put before
the House and the president for funds to ensure
unimpeded usage of the waterway. These bills
failed to pass or were vetoed. Bingham's depic-
tion of a steamboat run aground and the river
men apparently oblivious to its plight warned of
the danger he felt was inevitable. This painting
was originally intended to be sold through the
American Art Union's "lottery." Exhibited in
New York in October 1847, it was purchased by
a wealthy St. Louis businessman. Nancy Rash,
"George Caleb Bingham's *Lighter Relieving
A Steamboat Aground*," *Smithsonian Studies in
American Art* 2:2 (Spring 1988): 17-31.

David and Charlotte Gale, "A Study and Catalog
of 19th Century Photographic Tokens," *Photo-
graphic Historian* 6:2 (Summer 1985): 14-30;
"Obituary: Marcus A. Root," *Photographic Times
and American Photographer* 18:345 (April 27, 1888):
195; "Fortunes and Misfortunes of an Artist,"
Scientific American (February 8, 1862): 87; and
"Obituary," *Philadelphia Photographer* 25:321
(May 5, 1888): 284-85.

39
Frederick De Bourg Richards
1822-1903
Portrait of a Man, ca. 1850
Half-plate daguerreotype, HF466-5-05

Stamped on brass mat: "RICHARDS / PHILADA."

[c-20]
Frederick De Bourg Richards
Machine Model, ca. 1852-54
Stereo daguerreotype (3 1/8 x 6 13/16 in. overall),
466-3-00

*Label on back: "Stereoscopes, Made and for Sale by
Richards, Daguerreotypist, No. 179 Chestnut St.,
Phila. / Moran & Siekels, Prs."*

40
William Stroud
Active 1850s-1860s
Smiling Family, ca. 1855
Sixth-plate daguerreotype, HF793-1-03

*Impressed velvet liner reads: "Wm. Stroud's
Norristown, PA. / [illeg.] Light Gallery."*

[c-21]
Glenalvon J. Goodridge
1829-1867
Portrait of a Man, ca. 1855
Sixth-plate daguerreotype, 478-1-96

*Paper label: "G.J. Goodridge, Daguerreotypist,
York, PA."*

John V. Jezierski, "'Dangerous Opportunity':
Glenalvin J. Goodridge and Early Photography
in York, Pennsylvania," *Pennsylvania History* 64
(April 1997): 310-32; Linda A. Ries, "Glenalvon
J. Goodridge: Black Daguerreian," *Daguerreian
Annual 1991* (Lake Charles, La.: Daguerreian
Society, 1991): 39-41.

41
Mathew B. Brady
1823-1896
Portrait of a Boy, ca. 1850
Half-plate daguerreotype with hand-coloring,
428-13-98

*Impressed velvet liner reads: "Brady's Gallery /
205 & 207 / Broadway New York."*

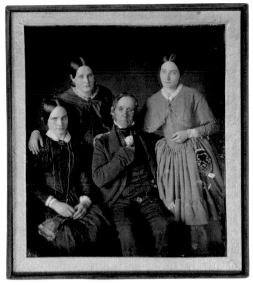

C-17

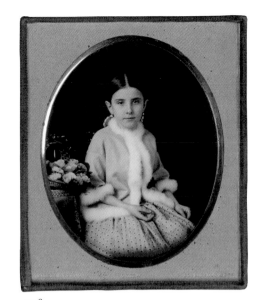

C-18

Soon after opening his studio at 205 Broadway, Brady commenced work on his *Gallery of Illustrious Americans*, a series of engravings based on his daguerreotypes. These were published by Francis D'Avignon in 1850. Mary Panzer, *Mathew Brady and the Image of History* (Washington, D.C.: Smithsonian Institution Press, 1997); and "Still Taking Pictures," *New York World* (April 12, 1891): n.p.

[C-22]
Unknown Maker
Portrait of Solomon N. Carvalho in Fraternal Apron, ca. 1853
Quarter-plate daguerreotype, HF400-567-06

Note inserted beneath plate: "Solomon Carvalho NYC."

Solomon Nunes Carvalho (1815-1897) was a daguerreotypist in Baltimore, Charleston, and New York City in the 1840s and 1850s. He is most recognized for having accompanied the Frémont expedition to the West, from September 1853 to June 1854. All the daguerreotypes taken on this expedition have been lost.

[C-23]
J. Gurney & C. D. Fredricks
1812-1886; 1823-1894
Two Seated Men, ca. 1853
Half-plate daguerreotype in period wall frame, HF424-11-03

Paper label on back of frame: "J. Gurney & C. D. Fredricks. / Photographists / 46 Rue Basse du Rempart, Paris, / and / No. 349 Broadway, New-York / Photographs taken from Miniature to SIZE OF LIFE, surpassing in accuracy, color, and finish, / the finest oil paintings on ivory or canvas."

Charles D. Fredricks ran a studio in Paris for less than a year, in 1853. His partnership with Gurney continued for several years upon his return to New York.

42
Jeremiah Gurney
Three Men in Aprons, ca. 1852-58
Half-plate daguerreotype, 424-10-02

Stamped on mat: "J. Gurney / 349 Broadway."

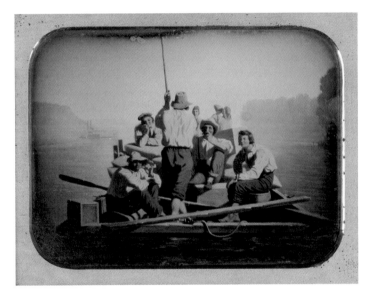

C-19

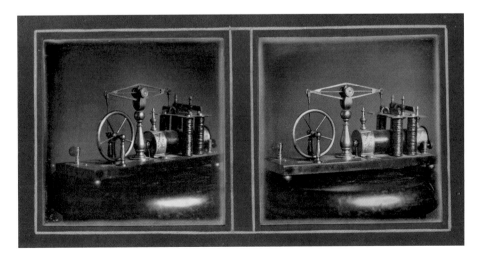

C-20

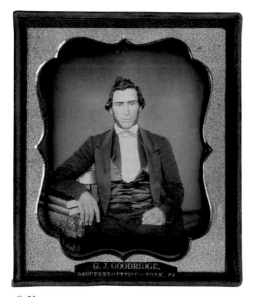

C-21

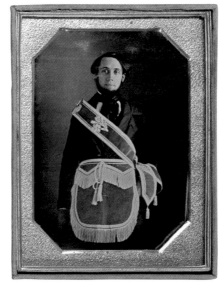

C-22

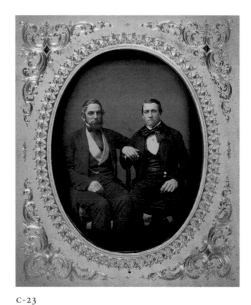

C-23

"Photographic Section of the American Institute," *Anthony's Photographic Bulletin* 17:10 (May 22, 1886): 312; J. T. Van Buren, "A Visit to Gurney's Palace of Art," *Cincinnati Daily Dispatch* (October 1, 1856): n.p.; Sandra Markham, "Painting with the Sunbeams of Heaven: Jeremiah Gurney, Photographist," *New York Journal of American History* (Fall 2004): 124-32; Christian Peterson, *Chaining the Sun: Portraits by Jeremiah Gurney* (Minneapolis: Minneapolis Institute of Arts, 1999).

43
Jeremiah Gurney
Family Group, ca. 1852-58
Whole-plate daguerreotype, 424-1-96

Stamped on mat: "J. Gurney / 349 Broadway."

44
Jeremiah Gurney
Young Girl with Arms Crossed, ca. 1852-58
Half-plate daguerreotype, HF424-12-06

Stamped on brass mat: "J. Gurney / 349 Broadway."

[C-24]
Jeremiah Gurney
Young Girl, ca. 1858-60
Sixth-plate daguerreotype with hand-coloring, 424-5-97

Stamped on mat: "J. Gurney 707 Broadway N.Y."

45
Samuel Root
1819-1889
The Doty Sisters, ca. 1852-54
Quarter-plate daguerreotype, 598-2-99

Stamped on mat: "S. Root / 363 Broadway NY."

Harriet (b. 1824) and Calista (b. 1828) Doty were members of a large New England family. Their brother, William Doty, was made notorious in the Edwin Forrest divorce trial of 1853. Catharine Forrest had accused her husband, the actor Edwin Forrest, of having an affair with Josephine Clifton in 1844. William Doty was a key witness, claiming to have seen the two together. Forrest's attorney later indicted Doty for lying. His perjury trial began in February 1853, and Harriet and Calista

Doty testified on their brother's behalf. He was found not guilty. "New-York City: Trial of Wm. M. Doty for Perjury," *New York Times* (February 16, 1853): 6; "The Doty Trial Concluded," *New York Times* (March 4, 1853): 8.

This daguerreotype appears to have been taken prior to 1855. Calista and Harriet's mother died in February 1855 and neither of these women appears to be dressed for mourning.

[C-25]
Marcus A. and Samuel Root
1808-1888; 1819-1889
The Drinker, ca. 1850
Sixth-plate daguerreotype, 598-6-00

[C-26]
Marcus A. and Samuel Root
Man Holding Whip (or Cane), ca. 1850
Sixth-plate daguerreotype, 598-4-01

Stamped on mat: "M.A & S. Root, 363 Broadway N.Y."

[C-27]
Rufus Anson
Active ca. 1850s
Marietta Alboni, Contralto, ca. 1852-53
Quarter-plate daguerreotype, HF663-9-03

Stamped on brass mat: "Anson, 589 Broadway."

The Italian opera singer Marietta Alboni became a sensation on her debut at La Scala, Milan, in 1843. After she toured the United States in 1852-53, her popularity rivaled that of Jenny Lind.

[C-28]
Rufus Anson
Woman in Mourning Costume, ca. 1855
Sixth-plate daguerreotype, 663-5-01

Impressed velvet liner reads: "Anson / 589 Broadway / N.Y." Stamped on brass mat: "Anson / 589 Broadway."

46
Rufus Anson
Family Group with Boy Holding Rooster, ca. 1853-55
Half-plate daguerreotype with hand-coloring, 663-3-01

Stamped on mat: "Anson / 589 Broadway."

47
Rufus Anson
Standing Man with Musket, ca. 1853-55
Half-plate daguerreotype, 663-4-01

Impressed velvet liner reads: "Anson / 589 Broadway / N.Y." Stamped on brass mat: "Anson / 589 Broadway."

[C-29]
Henry E. Insley
1811-1894
Insley Family, ca. 1848-49
Quarter-plate daguerreotype, 576-5-97

The Insley family: wife, Sarah Ann Fletcher Babb; son, Henry Aretas (b. 1840); daughter, Ella (b. 1845); daughter, Harriet (b. 1848); Henry E. Insley; and son, Albert Babb (b. 1842).

[C-30]
Henry E. Insley
Daughter of Henry Insley, ca. 1850
Sixth-plate daguerreotype, 576-6-97

[C-31]
Henry E. Insley
Self-Portrait, ca. 1850-55
Whole-plate daguerreotype, 576-2-97

48
Anthony, Edwards, & Co.
1819-1888; 1823-1847
Portrait of Jonas M. Edwards, ca. 1845
Quarter-plate daguerreotype, HF602-15-03

[C-32]
Beckers & Piard
Active 1840s-1850s
Standing Girl at Table with Book, ca. 1850
Half-plate daguerreotype, HF582-2-03

Stamped on mat: "Beckers & Piard, 264 Broadway."

Alexander Beckers was an early daguerreotypist, originally from Philadelphia. The first daguerreotype he ever saw was made by Robert Cornelius in 1840. Beckers studied with Frederick Langenheim in 1842, and by 1843 had joined him in business. In 1844, Beckers went to work for Edward White in New York City. By 1845, he had opened a studio in New York City in partnership with Langenheim

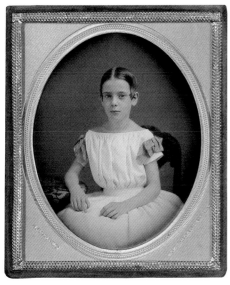

C-24

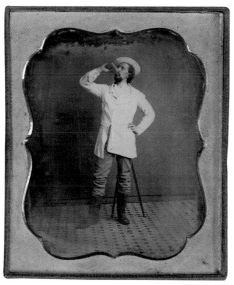

C-25

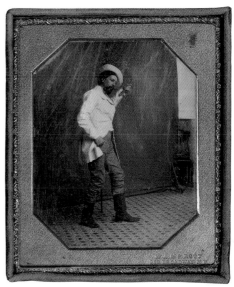

C-26

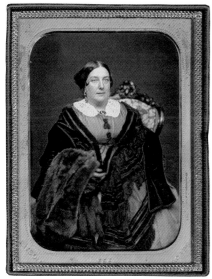

C-27

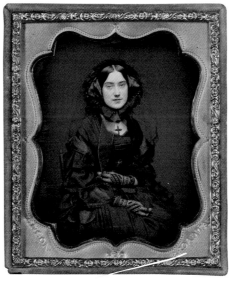

C-28

C-29

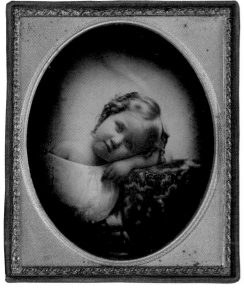

C-30

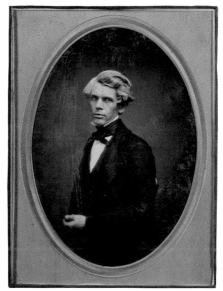

C-31

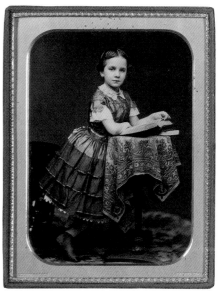

C-32

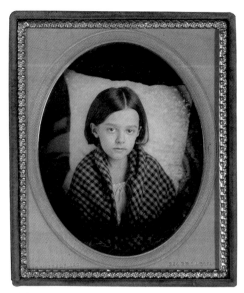

C-33

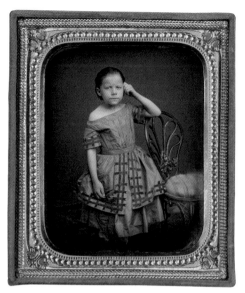

C-34

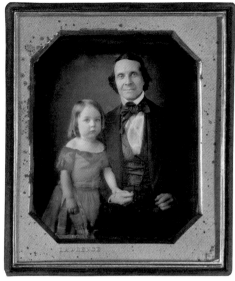

C-35

under the name Langenheim & Beckers. In 1849, he joined with Victor Piard under the firm name Beckers & Piard; they were partners until 1856. "Personal and Fine Art Intelligence," *Photographic and Fine Art Journal* 7:11 (November 1854): 351; Alexander Beckers, "Fifteen Years' Experience of a Daguerreotyper," *Photographic Times and American Photographer* 19:391 (March 15, 1889): 131-32; and "Photographic Section of the American Institute," *Anthony's Photographic Bulletin* 17:10 (May 22, 1886): 313.

[C-33]
Beckers & Piard
Sick Girl, ca. 1850
Sixth-plate daguerreotype, 582-1-98

Stamped on mat: "Beckers & Piard, 264 Broadway."

[C-34]
Meade Brothers
1826-1858; 1823-1865
Emma Buckingham Beach, ca. 1855
Sixth-plate daguerreotype, 444-2-96

Impressed velvet liner reads: "Meade Brothers / 9[illeg.]82 Broadway / New York." Accompanied by handwritten note: "Emma B. Beach mar. Abbott H. Thayer."

Charles R. (1826-1858) and Henry W. Meade (1823-1865) opened their first daguerreotype studio in Albany in 1842, followed by branch studios in Buffalo, Troy, and Saratoga. In about 1850, they relocated to 233 Broadway, in New York City. "The Brothers Meade and the Daguerrean Art," *Photographic Art-Journal* 3:5 (May 1852): 293-95; "Charles Richard Meade, Esq., Deceased," *Frank Leslie's Illustrated Newspaper* (March 27, 1858): 268-69; and Volina Valentine Lyons, "The Brothers Meade," *History of Photography* 14:2 (April-June 1990): 113-34.

Emma Buckingham Beach (b. 1849) was the second child of Chloe Buckingham Beach and Moses Sperry Beach, owner of the *New York Sun*.

[C-35]
Martin M. Lawrence
1808-?
Father and Daughter, ca. 1845
Quarter-plate daguerreotype, HF437-2-05

Stamped in lower left of plate: "Binsse & Co. N.Y." Stamped on brass mat: "LAWRENCE."

Binsse was a supplier of daguerreian goods in New York City from 1843 to 1845.

49
Abraham Bogardus
1822-1908
Man Reading, with Woman, ca. 1850
Sixth-plate daguerreotype, 609-1-98

Embossed on back of case: "Bogardus / Greenwich St. / Corner / Barclay / NY."

Abraham Bogardus operated his studio at the corner of Barclay and Greenwich in New York until 1862. In 1863, he bought Marcus A. Root's studio at Broadway and Franklin. In 1869, he relocated to 1153 Broadway, the address he kept until his retirement in 1887. This studio also included an American paintings gallery. "Our Picture: Abraham Bogardus," *Philadelphia Photographer* 8:94 (October 1871): 313-15. In addition, Bogardus himself wrote several anecdotal articles: "Thirty-Seven Years Behind a Camera," *Photographic Times and American Photographer* 14:158 (February 1884): 73-78; "Forty Years Behind the Camera," *Anthony's Photographic Bulletin* 17:22-23 (November 27-December 11, 1886): 714-16; "The Experiences of a Photographer," *Lippincott's Monthly Magazine* 47:5 (May 1891): 574-82; "Trials and Tribulations of the Photographer," *Anthony's Photographic Bulletin* 20:5-6 (March 9-23, 1889): 139-42, 178-81; and "Bogardusiana," *Photographic Times* 26:4 (April 1895): 252.

50
Charles H. Williamson
1826-1874
Young Woman in Blue Dress, ca. 1851
Ninth-plate daguerreotype in a sixth-plate case, 467-3-01

Stamped on brass mat: "C.H. Williamson, Brooklyn, NY."

"Obituary," *Photographic Times* 4:47 (November 1874): 176; "Brooklyn Photo. Art Association," *Anthony's Photographic Bulletin* (November 1873): 331-33.

51
Gabriel Harrison
1817-1902
Viola Harrison, ca. 1856-58
Sixth-plate daguerreotype, 527-2-98

Viola Harrison, Gabriel Harrison's oldest child, was born in 1850. In 1878, she debuted as Hester Prynne in her father's dramatization of *The Scarlet Letter*. Virginia Chandler, "Gabriel Harrison," in Henry Reed Stiles, ed., *History of Kings County Including the City of Brooklyn, N.Y.* (Brooklyn: W. W. Munsell & Co., 1884): 1151-58; Grant B. Romer, "Gabriel Harrison—The Poetic Daguerrean," *Image* 22:3 (September 1979): 8-18.

52
Samuel L. Walker
1802-1874
Man with Hat, ca. 1853
Ninth-plate daguerreotype, 417-1-95

Impressed velvet liner reads: "By Walker / Poughkeepsie, N.Y."

53
Rensselaer E. Churchill
1820-1892
Two Children, ca. 1850-55
Half-plate daguerreotype, 410-1-95

Signed in lower center of plate: "Churchill."

Rensselaer Emmett Churchill was born in upstate New York in 1820. He may have learned the daguerreotype technique in New York City. By 1848, he had opened a studio at 54 State Street in Albany. In 1863, Churchill formed a partnership with David Dennison, which lasted until 1870. He is last noted in a solo operation in 1881. "Colored Daguerreotypes," *Daily Albany Argus* (July 1, 1848); "Early Photography in Albany: Practitioners and Process," *Inside the Albany Institute of History & Art* (May/June 1998): 2.

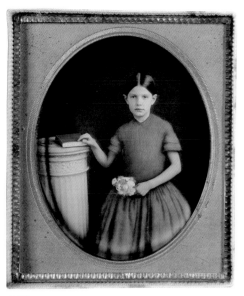

c-36

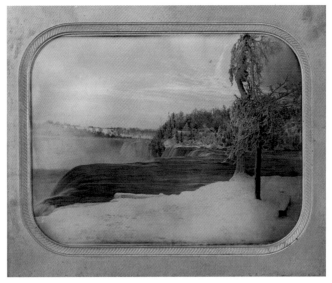

c-37

[c-36]
Rensselaer E. Churchill
Portrait of a Young Girl, ca. 1850-55
Sixth-plate daguerreotype, 410-4-98

Hand-colored; signed on plate, on side of book:
"Churchill."

54
Donald McDonnell
Active 1850s
Indian Chief Maungwudaus, Upper Canada,
ca. 1850-51
Half-plate daguerreotype, 654-1-99

Note pinned inside of case: "Indian Chief, Upper
Canada, 1850-1851." Black paper label attached to
brass mat at bottom: "By McDonell [sic] & Co.
Buffalo."

According to most nineteenth-century sources,
this daguerreotypist's last name was spelled
McDonnell. This daguerreotype has a black paper
label which reads: "By McDonell & Co. Buffalo."
The reason for this discrepancy is unknown.
"McDonnell's New Daguerrean Rooms," *Photo-*
graphic and Fine Art Journal 8:2 (February 1,
1855): 64.

Maungwudaus was born near Toronto, Ontario,
in 1811, a member of the Mississauga Indian band
of the Ojibwa tribe. He was raised in the Methodist
Church and took the Christian name George
Henry at his baptism in 1824. Maungwudaus left
the church in 1840 and from 1840 to 1845 worked
as a government interpreter with the St. Clair
Indians. In 1845, Maungwudaus assembled a troupe
of friends and family to perform abroad. Before
leaving for England, they first toured a few cities in
the upper eastern United States, including Detroit,
Cleveland, Buffalo, Utica, Albany, and New York.
They then toured Europe from 1845 to 1848,
followed by another tour of the United States. Rob
McElroy, "Two Exquisite Daguerreotypes Bring
Record Prices At Auction," *Daguerreian Society*
Newsletter 10:4 (July/August 1998): 3-4; and Graham
W. Garrett, "Maungwudaus," *Daguerreian Society*
Newsletter 8:1 (January/February 1996): 6.

Variant portraits of this subject are held by
the Chicago Historical Society and the George
Eastman House.

55
Oliver B. Evans
Active 1850s
Four Children in Costume, ca. 1853
Whole-plate daguerreotype, HF823-1-05

Hand-colored; stamped on mat: "EVENS [sic]
BUFFALO."

56
Platt D. Babbitt
1822-1879
Group at Niagara Falls, ca. 1853
Whole-plate daguerreotype, 426-4-00

Surprisingly little is known about Platt Babbitt's
life. He was born in Massachusetts and first
worked in the quarry business. It is unknown
where he learned the daguerreotype but, by 1853,
he was photographing at Niagara Falls. A crafty
businessman, Babbitt leased a pavilion and all the
land between it and the falls at Prospect Point.
From this vantage point, he had exclusive rights
to take "environmental portraits" of tourists
standing in front of the falls. According to legend,
if another photographer attempted to work at
this spot, Babbitt "and his forces would stand
between the camera and the falls, swinging
large-sized umbrellas to and fro thus preventing
[them] from getting a picture." Babbitt lost this
exclusive spot at some point prior to the 1860s.
Jacob J. Anthony, "Interesting Reminiscences,"
Niagara Falls Gazette (April 18, 1914): 5.

Babbitt later suffered from poor health, which
may have been caused by mercury vapor inhala-
tion. He committed suicide in 1879. "Suicide of
Platt D. Babbitt," *Niagara Falls Gazette* (August
27, 1879): n.p.

[c-37]
Platt D. Babbitt (attrib.)
Niagara in Winter, ca. 1855
Whole-plate daguerreotype, 426-1-96

From the Southworth & Hawes collection and
Holman's Book Shop; previously identified
in crayon on verso of plate: "Daguerreotype / by
Southworth / and Hawes, / Boston."

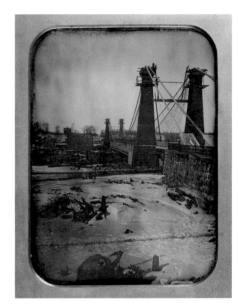

c-38

An article in the *Niagara Falls Gazette* (March 19,
1856) noted that Babbitt "has some of the most
beautiful views of the Falls, and points of interest
in this vicinity, that we have seen. As he resides here
he has been on hand to take winter views never
taken by any other artist. Mountains of ice, huge
icicles, trees borne down with their icy burden,
the foaming torrent, all and much more are
presented with the exactness of reality." Anthony
Bannon, *The Taking of Niagara: A History of the Falls*
in Photography (Buffalo: Media Study, 1982): 15.

[c-38]
Platt D. Babbitt (attrib.)
Niagara Suspension Bridge, ca. 1855
Whole-plate daguerreotype, 426-2-99

The Niagara Suspension Bridge was built in 1855
by John Roebling (1806-1869). This replaced a
temporary structure built in 1848 to accommodate
foot traffic. The new bridge was 825 feet long,
with two decks—an upper one for railway traffic
and a lower one for vehicles and pedestrians.

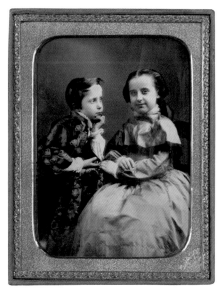

c-39

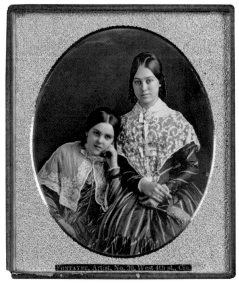

c-40

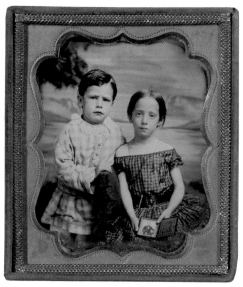

c-41

57
Platt D. Babbitt
Avery Stranded, Niagara, July 19, 1853
Quarter-plate daguerreotype, 426-3-99

In July 1853, Joseph Avery, a German immigrant, went drinking with two friends. The men were part of a crew that transported sand up and down the river in a flat-bottom boat. Inebriated, they set out in their boat and were swept into the rapids. The boat was thrown over the falls, killing two of them instantly. Avery was caught by a log in the center of the river, halfway between the bridge and the American Falls. After daybreak, as many as 3,000 people crowded the shore to watch the story unfold.

Several attempts were made to rescue Avery by means of a raft, but all failed. Two lifeboats were sent from Buffalo but they too were swamped by the rapids. It was during the second lifeboat attempt, after Avery had been in the water nearly twenty hours, that he lost his grip and was carried to his death. "The Bell-Ringer at Niagara: With An Episode on the Recent Tragedy," *New York Daily Times* (July 23, 1853): 3; John Werge, *The Evolution of Photography with a Chronological Record of Discoveries, Inventions, Etc., Contributions to Photographic Literature and Personal Reminiscences Extending over Forty Years* (London: Piper and Carter and John Werge, 1890): 143-44.

58
Jesse Whitehurst
1820-1875
Mother and Daughter, ca. 1850-55
Half-plate daguerreotype, 436-1-96

Stamped on mat: "Whitehurst."

See Whitehurst advertisement in *Daily National Intelligencer* [Washington, D.C.] 29:11915 (June 14, 1851): n.p.; "Obituary: Jesse H. Whitehurst," *Philadelphia Photographer* 12:142 (October 1875): 300-01; and "Obituary," *Norfolk Landmark* [Virginia] (September 28, 1875): n.p.

59
George S. Cook
1819-1902
Boy with Book, ca. 1849-50
Sixth-plate daguerreotype, 414-1-95

Hand-coloring; impressed velvet liner reads: "Geo. S. Cook / Artist / Charleston."

George S. Cook was one of the most experienced photographers of the era. After beginning as a portrait painter in New Orleans, in the late 1830s, he worked as a photographer from the early 1840s until his death in 1902. Peter E. Palmquist and Thomas R. Kailbourn, *Pioneer Photographers from the Mississippi to the Continental Divide, A Biographical Dictionary, 1839-1865* (Stanford: Stanford University Press, 2005): 172-74; A. Lawrence Kocher and Howard Dearstyne, *Shadows in Silver* (New York: Charles Scribner's Sons, 1954); and A.D. Cohen, "George S. Cook and the Daguerrean Art," *Photographic Art-Journal* 1:5 (May 1851): 285.

This image was probably taken during Cook's first years in Charleston, South Carolina.

60
J. T. Zealy
1812-1893
The Toast, ca. 1850
Quarter-plate daguerreotype, 676-1-00

Stamped on mat: "J.T. Zealy."

According to the R. G. Dun & Co. business records, by August 1855, J. T. Zealy had been in business about ten years and appears to have run a successful and respected practice. However, by 1860, the Dun records note that he "seems to be going downhill, drinks whisky no doubt; his real estate is encumbered, would not recommend him for credit." As of 1865, the records indicate that Zealy was "formerly a daguerreotypist here." *South Carolina*, Vol. 12, n.p. [internal index], R. G. Dun & Co. Collection, Baker Library, Harvard Business School, Cambridge, Mass.

See also: *Photographic and Fine Art Journal* (December 1851): 376; and Brian Wallis, "Black Bodies, White Science," *American Art* 9:2 (Summer 1995): 39-61.

[c-39]
Edward Jacobs
1813-1892
Two Children, ca. 1850-52
Quarter-plate daguerreotype, 778-1-01

Stamped on mat: "E. Jacobs N.O."

A native of England, Edward Jacobs set up a daguerreian business in New Orleans by 1844. In 1845, in partnership with Charles Johnson, he opened the Johnson and Jacob's Southern Daguerreotype Portrait Gallery on Camp Street. By 1849, he was in business by himself, and a year later he opened a lavish new studio. In 1852, he added a fine art gallery. According to the R. G. Dun & Co. business records, Jacobs did a large volume of business, but his spending habits and inability to pay creditors were a problem through the late 1850s. Jacobs's business failed at least twice in this period—in 1854 and 1859—but he appears to have reorganized and begun again each time. *Louisiana*, Vol. 10, p. 369, R. G. Dun & Co. Collection, Baker Library, Harvard Business School.

Jacobs operated through the Civil War, making portraits first of Confederate officers and then, after the capture of the city by Federal forces, of Union officers. In 1863, he entered into a partnership with George Brown and Walter Ogilvie, forming the National Art Union Photograph Gallery. He retired from photography in 1864. Palmquist and Kailbourn, *Pioneer Photographers from the Mississippi to the Continental Divide,* pp. 348-49; *New Orleans Daily Picayune* (January 2, 1851): n.p.

61
Ezekiel Hawkins (attrib.)
1808-1862
The Jacob Strader at Wharf, Cincinnati, ca. 1853
Half-plate daguerreotype, 488-1-97

In half case; accompanied by mismatched case top with impressed velvet liner: "Ezekiel Hawkins, Cincinnati."

This view has been attributed to Hawkins. He is known to have made a solograph (paper photograph) of the *Jacob Strader* ca. 1855 for the *Western Art Journal*. A variant daguerreotype, similar

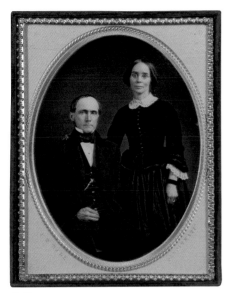

C-42

in size and viewpoint, but unfortunately also unmarked, is in the collection of the Cincinnati Historical Society.

Palmquist and Kailbourn, *Pioneer Photographers from the Mississippi to the Continental Divide*, p. 313; Samuel Stanton, *American Steam Vessels* (New York: Smith & Stanton, 1895): 124-25; Austin Earle, *Photographic Art-Journal* 2:5 (November 1851): 317; "Boat-Building on the Ohio," *Western Art Journal* 1:1 (January 1855): 14-15.

[c-40]
Charles H. Fontayne
1814-1901
Portrait of Two Women, 1846
Sixth-plate daguerreotype, 713-1-00

On printed strip in lower part of mat: "Fontayne, Artist, No. 30 West 4th St., Cin."

Charles H. Fontayne began daguerreotyping in 1841 and by 1844 was in partnership in Baltimore with William Porter. In 1846, Fontayne moved to Cincinnati, and Porter followed shortly later. In 1848, Fontayne & Porter made an eight-plate panoramic view of the Cincinnati waterfront, winning first prize at the Franklin Institute Fair in Philadelphia. Oddly, Fontayne continued to be listed alone in the business directories of 1848 and 1849, but the partnership was established by 1849, and continued at 30 West Fourth Street until 1854. Palmquist and Kailbourn, *Pioneer Photographers from the Mississippi to the Continental Divide*, pp. 298-99.

[c-41]
Thomas Faris
ca. 1814 - ?
Two Children with a Daguerreotype, ca. 1850
Sixth-plate daguerreotype, 439-1-96

Impressed velvet liner reads: "T. Faris, Melodeon Gallery, Cincinnati."

Thomas Faris was originally employed as an ornamental painter in 1836. By 1843, he was in business in Cincinnati with Ezekiel Hawkins. In 1844, he opened his own studio in the Melodeon Hall and remained there until 1857. Faris kept abreast of the latest photographic technologies and experimented

with the stereograph, ambrotype, and other formats and processes. Faris opened an additional studio in Cincinnati in 1855; in the following year he bought out Marcus A. Root's gallery in New York City. Mary Sayre Haverstock, Jeannette Mahoney Vance, and Brian L. Meggitt, eds., *Artists in Ohio, 1797-1900: A Biographical Dictionary* (Kent, Ohio: Kent State University Press, ca. 2000): 279-80.

62
James P. Ball
1825-1904
Two Men, ca. 1855
Half-plate daguerreotype, 459-1-96

Stamped on mat: "J.P. Ball Cincinnati."

James Presley Ball, Sr., was born in Virginia in 1825 and learned the daguerreotype process from John B. Bailey in 1846. Later that year, he opened a daguerreotype studio in Cincinnati. A year later, with his business a failure, Ball traveled to Richmond, Virginia, as an itinerate daguerreotypist. In 1849, Ball resumed his work in Cincinnati. He became one of the city's most successful daguerreotypists, and a role model for other African American businessmen. In 1851, Ball opened a second gallery in Cincinnati, encouraged by the immense success he had thus far enjoyed. Achilles Pugh noted, "Had Mr. Ball been a white man, this triumph would not be remarkable, but when we remember that in addition to his poverty, he has had to struggle against the prejudice of the American people, that degrades deeper, and more permanently, his rise is worthy of remark" (quoted in Haverstock et al., eds., *Artists in Ohio*, p. 41).

In 1856, Ball traveled to Europe to acquire a collection of European paintings to be shown in his gallery. Ball worked in Cincinnati until about 1870; he then moved to Minneapolis and later to Helena, Montana. "Daguerrian [sic] Gallery of the West," *Gleason's Pictorial Drawing-Room Companion* (April 1, 1854): 208; Martin Robison Delany, *The Condition, Elevation, Emigration, And Destiny of the Colored People of the United States* (Philadelphia: Published by the author, 1852): 118; J. P. Ball, *Ball's Splendid Mammoth Pictorial Tour of the United States…* (Cincinnati: Achilles Pugh, 1855): 7-10; and Haverstock et al., eds., *Artists in Ohio*, pp. 41-42.

[c-42]
James P. Ball
Portrait of a Couple, ca. 1855
Quarter-plate daguerreotype, HF459-2-03

Stamped on mat: "J.P. Ball / Cincinnati."

63
William C. North
1814-1890
Josephine and Eugene Gray, Children of Joseph W. Gray, ca. 1850
Quarter-plate daguerreotype, 683-2-01

Stamped on mat: "Wm. C. North / Cleveland, O."

William Case North was born in New York in 1814. It is unknown where he learned to daguerreotype, but he first surfaced as an itinerant in and around Oberlin, Ohio, in the late 1840s. He also traveled to Amherst, Massachusetts, where he daguerreotyped Emily Dickinson and other citizens of the

town. He was in Boston by 1848; a year later, he was operating two studios, one in Boston and one in New York City. In 1850, he moved to Cleveland; there, he worked with James F. Ryder before opening his own studio. He sold his studio to his nephew, Walter Crane North, in 1856, but bought it back the next year. In 1880, North gave up photography to concentrate on civic activities.

Joseph W. Gray was born in Vermont and came to Cleveland in 1839. He was the editor of the Cleveland *Plain Dealer* until his death in 1862. He had two children, Josephine and Eugene. Eugene was partly responsible for his father's untimely death. In 1858, Eugene was playing with a cap gun close to his father. A cap from Eugene's gun hit Gray in the eye, passed through the cornea, and lodged near Gray's brain. He was blinded in the one eye (Dr. Theodatus Garlick was called to extract the cap: see the following entry on North) and he died four years later as a result of complications from this injury. Haverstock et al., eds., *Artists in Ohio*, p. 646; Samuel Orth, *History of Cleveland, Ohio* (Chicago-Cleveland: S. J. Clarke Publishing Co., 1910): 320-23; Mary Elizabeth Kromer Bernhard, "Lost and Found: Emily Dickinson's Unknown Daguerreotypist," *New England Quarterly* 72 (December 1999): 594-601; and Gertrude Van Rensselaer Wickham, *The Pioneer Families of Cleveland, 1796-1840* (Cleveland: Evangelical Publishing House under the auspices of The Executive Committee of the Woman's Department of the Cleveland Centennial Commission, 1914): 606.

64
William C. North
The Fisherman, ca. 1850
Half-plate daguerreotype, 683-1-00

Impressed velvet liner reads: "North / Artist / Cleveland."

While full documentation is lacking, it is possible that the subject of this daguerreotype is Dr. Theodatus Garlick (1805-1884). Born in Vermont, Garlick was an athletic and outgoing young man. He was passionately fond of the outdoors, and of hunting and fishing. After earning enough money as a stonecutter to pay for medical school, Garlick entered the University of Maryland, graduating in 1834. In 1839-40, Garlick experimented with the daguerreotype and by 1841 had rented a room in Cleveland to take portraits. From 1850 to 1870, Garlick practiced medicine, while conducting extensive research on the propagation of fish. Theodatus Garlick, *A Treatise on the Artificial Propagation of Certain Kinds of Fish* (Cleveland: Thomas Brown, 1857); Haverstock et al., eds., *Artists in Ohio*, pp. 325-26; Maurice Joblin, *Cleveland Past and Present; Its Representative Men* (Cleveland: Fairbanks, Benedict, & Co., 1869): 375-78.

65
Lilbern W. Keen
1823-1907
Reverend W. M. Steel, ca. 1860
Half-plate daguerreotype, 665-1-00

Black label on brass mat at bottom: "L.W. Keen, Artist." Note in back of case: "Grand Pa Steel, W. M. Steel, Taken in Decatur, Il., He used to preach in a black gown."

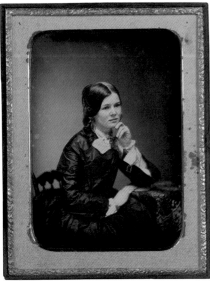
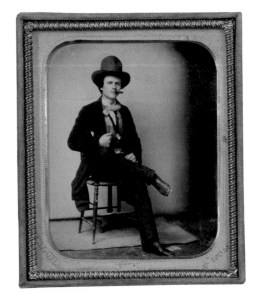
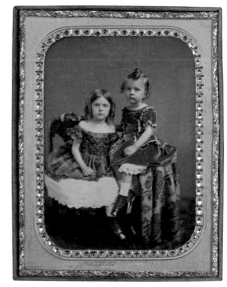

c-43 c-44 c-45

Lilbern Wilkerson Keen was born in Sullivan County, Tennessee, in 1823, and first worked as a carpenter. It is unknown how he learned photography. In 1847, Keen opened the first daguerreotype studio in Jonesborough, Tennessee, and he continued in the photographic business until 1900. Paul M. Fink, *Jonesborough: The First Century of Tennessee's First Town, 1776-1876* (Johnson City, Tenn.: Overmountain Press, 1989): 52-55.

Very little is known about Reverend William M. Steel. After apparently leaving the South, Reverend Steel became a pastor at St. John's Episcopal Church in Decatur, Illinois, from 1860 to 1863. Aaron Akins and Janice Akins, *The Living History of St. John's Episcopal Church: Decatur, Illinois, 1855-2000* (Decatur, Ill.: William Street Press, 1999): 3.

[c-43]
Alexander Hesler
1823-1895
Portrait of a Woman, ca. 1850-54
Half-plate daguerreotype, 563-4-00

Impressed velvet liner reads: "Hesler, Artist, Galena."

Alexander Hesler was born in Montreal, grew up in Vermont, and moved with his family to Racine, Wisconsin, in 1833. He learned the art of the daguerreotype in Buffalo, New York, in 1847, and set up his first studio in Madison, Wisconsin, in 1847-48. By 1850, Hesler had opened a studio in Galena, Illinois. Hesler moved to Chicago in 1854 and had a studio in the Metropolitan Block from 1855 to 1859. "Some Practical Experiences of a Veteran Daguerreotypist," *Photographic Times and American Photographer* 19:391 (March 15, 1889): 130-01; and Palmquist and Kailbourn, *Pioneer Photographers from the Mississippi to the Continental Divide*, pp. 319-20.

66
Alexander Hesler
Man and Woman, ca. 1855-59
Quarter-plate daguerreotype, 563-5-01

Impressed velvet liner reads: "Hesler's / Metropolitan Gallery / Laselle [sic] St. Chicago."

After his business in the Metropolitan Block, Hesler operated a studio in Chicago on Lake Street from 1859 to 1869; in Evanston, Illinois, from 1872 to 1880; and then back in Chicago at various addresses from 1880 to 1895.

67
Alexander Hesler
Quadruple Portrait of James Duncan Graham, Sr., ca. 1855-59
Sixth-plate daguerreotype, 563-6-04

Impressed velvet liner reads: "Hesler's / Metropolitan Gallery / Laselle [sic] St. Chicago."

James Duncan Graham, Sr., (1799-1865) was born in Virginia, graduated from the United States Military Academy in 1817, and joined the corps of topographical engineers. His projects included border surveys in the northeast, southern Texas, and along the Mason/Dixon line. From 1851 to 1861 he was in charge of harbor improvements for the northern lakes. James Grant Wilson and John Fiske, eds., "James Duncan Graham," *Appleton's Cyclopedia of American Biography* (New York: D. Appleton and Co., 1887-89): n.p.

[c-44]
John J. Outley
1815-1892
Seated Man with Hat and Cigar, ca. 1850
Sixth-plate daguerreotype, HF822-1-05

Stamped on mat: "J.J. OUTLEY, ARTIST, ST. LOUIS."

John Outley was born in Ireland in 1815. It is unknown when Outley arrived in the United States, but his daguerreotype gallery was established in St. Louis in 1849 in partnership with A.C. Dennison. This partnership was dissolved in 1850. Outley operated alone at various locations in St. Louis through 1858. In 1859, due to poor health, he entered into partnership with George Williams. They operated three St. Louis studios together and were awarded prizes at the 1859 St. Louis Fair. In 1860, Outley was listed as the solo proprietor of his studio and also as owner of a coal yard. From 1868 to 1871, he again worked in

partnership under the name Outley & Bell; this studio was destroyed by fire in 1871. Outley continued to photograph by himself until 1879. Palmquist and Kailbourn, *Pioneer Photographers from the Mississippi to the Continental Divide*, pp. 470-71.

[c-45]
William H. Tilford
?-1879
Two Children, ca. 1853-55
Half-plate daguerreotype, 435-1-96

Stamped on mat: "W.H. Tilford, St. Louis."

68
John H. Fitzgibbon
1817-1882
Jenny Lind, 1851
Half-plate daguerreotype, 673-1-00

Impressed velvet liner reads: "Fitzgibbon / Artist St. Louis." With accompanying note (translated here from Swedish): "In the month of March, 1851, Jenny Lind gave concerts in St. Louis, where I had gone to meet her from Chicago. One day after the end of a rehearsal to which she had invited me, she suggested that I come with her to a daguerreotype studio where she had this portrait made. This the great artist herself gave to me as a memento of her."

On Fitzgibbon, see Palmquist and Kailbourn, *Pioneer Photographers from the Mississippi to the Continental Divide*, pp. 254-59; "J.H. Fitzgibbon, of St. Louis," *Frank Leslie's Illustrated Newspaper* [New York] 4:92 (September 5, 1857): 213; G.H. Loomis, "Gallery Biographic, No. 4: J.H. Fitzgibbon," *Anthony's Photographic Bulletin* 6:3 (March 1875): 81-2; "The Late John H. Fitzgibbon," *Photographic Times and American Photographer* 12:140 (August 1882): 338-39; Bonnie Wright, "'This Perpetual Shadow-Taking': The Lively Art of John H. Fitzgibbon," *Missouri Historical Review* 76:1 (October 1981): 22-30; "Our Daguerreotypes," *Daguerreian Journal* 1:10 (April 1, 1851): 306.

Jenny Lind was born Johanna Maria Lind in 1820 in Sweden. At the age of sixteen, she debuted with the Royal Swedish Opera and was an instant

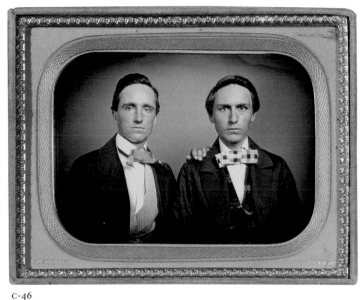

C-46

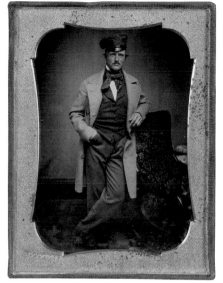

C-47

sensation. Her fame caught the attention of P. T. Barnum, who arranged her highly successful tour of the United States in 1850-51. This image was taken on or about March 22, 1851, when Lind was in St. Louis. According to the *Daguerreian Journal* (above), Fitzgibbon made three daguerreotypes of Lind.

69
Enoch Long
1823-1898
Three Girls, ca. 1850
Half-plate daguerreotype, 664-1-00

Stamped on mat: "E. Long."

Palmquist and Kailbourn, *Pioneer Photographers from the Mississippi to the Continental Divide*, pp. 403-04.

[C-46]
Thomas M. Easterly
1809-1882
Portrait of Two Men, ca. 1855
Quarter-plate daguerreotype, 415-4-05

Stamped on mat: "Easterly Artist;" with note identifying subjects as William and Thomas Thornton.

After an early career as an itinerant, Thomas Easterly established a studio in St. Louis in 1849. Because of his refusal to adopt new techniques, Easterly's business declined steadily from the mid-1860s. In 1865, he suffered a devastating fire at his studio. Although he reestablished his gallery and exhibited daguerreotypes at the 1868 and 1870 St. Louis fairs, he never fully recovered from the financial loss caused by the fire. Palmquist and Kailbourn, *Pioneer Photographers from the Mississippi to the Continental Divide*, pp. 220-22; Dolores A. Kilgo, *Likeness and Landscape: Thomas M. Easterly and the Art of the Daguerreotype* (St. Louis: Missouri Historical Society Press, 1994).

70
Thomas M. Easterly
Man with Elephant, ca. 1850
Quarter-plate daguerreotype, 415-1-95

Stamped on mat: "Easterly St. Louis."

Circuses and menagerie troupes were popular amusements in rural America. Conveyed by boats, circuses played in towns up and down the Missouri or Mississippi rivers. Inhabitants of this regioncould expect to see at least one circus each summer. Prior to the Civil War, there were some sixty-one circuses or menageries in rural Missouri. A number of these, including those of Dan Rice, P. T. Barnum, and Van Amburgh, were known to have had elephants. Elbert Bowen, *Theatrical Entertainments in Rural Missouri* (Columbia: University of Missouri Press, 1959): 17-36; Stuart Thayer, "The Elephant in America, 1840-1860," *Bandwagon* 35:3 (September-October 1991): 34-7; and David Carlyon, *Dan Rice: The Most Famous Man You've Never Heard Of* (New York: Public Affairs, 2001): 157-66, 435-36.

71
Joseph Buchtel (attrib.)
1830 - ?
Front Street, Portland, Oregon, ca. 1852
Half-plate daguerreotype, 644-1-99

Joseph Buchtel was born in Union Town, Ohio, in 1830 and moved to Urbana, Illinois, in 1837. While there, sometime in the 1840s, he learned the daguerreotype process. He moved to Portland, Oregon, in 1852. For five years he worked on a steamboat in the winter and took daguerreotypes during the summer. He began with equipment purchased from L. H. Wakefield in 1853. In 1857, Buchtel opened a studio in the Canton House in Portland, where he became a fulltime daguerreotypist. He worked as a photographer well into the 1880s. Elwood Evans, *History of the Pacific Northwest: Oregon and Washington…* (Portland: North Pacific History Co., 1889); and *Republican League Register of Oregon* (Portland: Register Publishing Co., 1896): 187.

[C-47]
Frederick Coombs
1803-1874
John B. Newton in Overcoat and Hat, ca. 1850-51
Quarter-plate daguerreotype, 479-1-96

Stamped on mat: "F. Coombs."

[C-48]
Frederick Coombs
The Statue of Wm. Penn Crowned by Fred'k Coombs, 1866
Albumen stereograph (3 ¼ x 6 ¾ in. overall), 479-3-01

Complete write-up on back of mount: "The city of Philadelphia has been honored with a visit from a gentleman whose dress resembles the old style of 1776. His carte-de-visite and mental resemblances to our Revolutionary fathers is very striking, and this very day is the anniversary of his advent in this city, twenty-seven years ago, when he was on a mission of benevolence…"

When Frederick Coombs first visited Philadelphia, in 1839, he was an inventor of sorts. In that year, he created a vehicle that ran on static-electricity, and in 1840, a version of the telegraph. He went to California in 1849 and opened a daguerreotype studio. After three devastating fires, he became a matrimonial promoter and the impresario of a traveling museum of curiosities. While on tour, Coombs returned to Philadelphia in 1866 dressed in Revolutionary costume, hoping to sell cartes-de-visite of himself to help recoup his losses. In his later years, Coombs strolled the streets of San Francisco dressed like George Washington. Peter Palmquist, "Gathering Nuts: Images of and by Frederick C. Coombs from the Peter E. Palmquist Collection," *Daguerreian Society Newsletter* 13:3 (May/June 2001): 13-21.

72
Jacob Shew
1826-1879
Portrait of a Standing Girl, ca. 1856-58
Half-plate daguerreotype, 438-1-96

Stamped on mat: "Jacob Shew / Sacramento."

Jacob Shew and his brothers, William, Myron, and Trueman, were taught to daguerreotype by Samuel F. B. Morse in 1841. In 1843, Shew was hired to run John Plumbe's Baltimore studio. By 1847, Shew was in a partnership with H. R. Marks. He then moved to California. By 1854, he was in business on Sacramento Street in San Francisco,

C-48

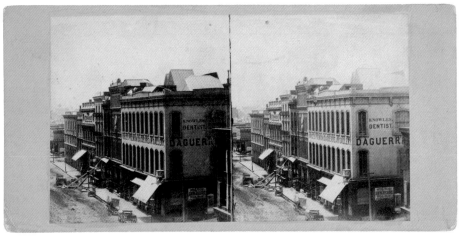

C-49

possibly in partnership with his brother William. Shew moved his business to Sacramento in 1856 but returned to San Francisco in 1861 to work with William Shew and then with Charles Hamilton. In 1878, Shew's studio was destroyed by fire, resulting in financial ruin, and his suicide. Wendy Calmenson, "'Likenesses Taken in the Most Approved Style': William Shew, Pioneer Daguerreotypist," *California Historical Quarterly* 56:1 (Spring 1977): 2-19; "Suicide of Jacob Shew," *Morning Call, San Francisco* (February 4, 1879): 4; and O. V. Lange, "William Shew: A Portrait Photographer For More Than Half a Century in San Francisco," *Daguerreian Annual* (1991): 15-25.

73
James M. Ford (attrib.)
1827-ca. 1877
Dentist and Patient, ca. 1852-54
Quarter-plate daguerreotype, 717-1-00

This plate is half of an original stereo pair. The companion quarter-plate, now in the collection of Matthew R. Isenburg, was acquired in 1983 from a sale of the work from the Ravenna, Ohio, studio of Frank Ford. Most of the items in this collection were the work of Frank Ford, but a few were clearly by his brother, James M. Ford, who worked in San Francisco. Our attribution is based on the fact that James M. Ford was noted for his work with stereo daguerreotypes, while Frank Ford was not. Our thanks to Mr. Isenburg for this information.

74
Robert H. Vance
1825-1876
Woman in Mourning with Child, ca. 1855
Quarter-plate daguerreotype, 407-3-97

Impressed velvet liner reads: "R.H. Vance's / Premium Daguerrean Galleries / San Francisco / Sacramento / Marysville."

Peter Palmquist, "Robert Vance: Pioneer in Western Landscape Photography," *American West* (September/October 1981): 22-27; Peter E. Palmquist and Thomas R. Kailbourn, *Pioneer Photographers of the Far West, A Biographical Dictionary, 1840-1865* (Stanford: Stanford University Press, 2000): 559-65.

75
Robert H. Vance
View of Sacramento Street, San Francisco,
ca. 1854-56 (detail)
Stereo daguerreotype (5 ½ x 4 ½ in. overall),
407-1-95

In original case with viewing device.

Robert H. Vance was one of the earliest daguerreotypists in San Francisco to work in stereo, beginning in 1853. He was also early to adopt the ambrotype and paper photography.

[C-49]

E. & H. T. Anthony & Co.
1819-1888; 1814-1884
Montgomery Street, San Francisco, ca. 1858-60
Albumen stereograph (3 ¼ x 6 ⅝ in. overall),
602-14-01

On verso: "California Views / No. 53 / Montgomery Street, San Francisco / Published by E. & H. T. Anthony & Co."

After starting as a civil engineer, Edward Anthony and later, his brother Henry became leading photographic suppliers and publishers of stereographs and cartes-de-visite. "Edward Anthony," *Photographic Times and American Photographer* 18:380 (December 28, 1888): 631-33.

76
Robert H. Vance
"The Great Man Has Fallen," San Francisco,
May 1856
Whole-plate daguerreotype, HF407-6-04

Impressed velvet liner reads: "R. H. Vance's / Premium Daguerrean Galleries / San Francisco / Sacramento / Marysville."

In the 1850s, San Francisco was a wild frontier town. Because of the rush to find gold in the hills of California, little thought was given to the establishment of local government or civic organizations. As a result, many city officers were corrupt and crime was rampant. In 1851, a Vigilance Committee was organized of merchants and other upstanding men. This committee, on its own initiative and the authorization of respectable citizens, undertook the task of rooting out the city's criminal element. However, it was soon disbanded, and the following years were full of corruption. On November 25, 1854, General Richardson, a respected citizen of San Francisco, was shot and killed by Charles Cora, a gambler. Although Cora was arrested and taken to jail, the sheriff was corrupt, and Cora's trial ended in a jury disagreement. This lack of justice enraged the good citizens of the city. In October 1855, a new newspaper, the *Evening Bulletin*, was started by James King of William. One of his goals was to expose the unlawful men who had taken control of San Francisco. To this end, King of William researched and published accounts of their past misdeeds. One official, James Casey, was exposed as an ex-convict who had served time in Sing Sing in New York. Furious at these revelations, Casey shot King of William on the street. Casey then ran to the jail, where he was protected by law enforcement friends. An outraged public demanded his immediate release. A reformed Vigilance Committee quietly recruited honest citizens for militia. On May 18, the committee and its army went to the jail and secured the release of both Cora and Casey. The two were taken to the Vigilance Committee headquarters and were put on trial. During the proceedings, King of William died, throwing the city into a state of mourning. Casey and Cora were found guilty of first-degree murder and were hanged on a temporary scaffolding just outside the window of the committee headquarters. This same day, May 22, was also the funeral of James King of William.

This image depicts the Smiley, Yerkes, and Company building at the corner of Sacramento and Montgomery streets. T. J. L. Smiley, the owner, had been a founding member of the 1851 Vigilance Committee. The building is draped with swags and banners; the large banner reads: "THE GREAT MAN HAS FALLEN. WE MOURN HIS LOSS." W. O. Ayres, "Personal Recollections of the Vigilance Committee," *Overland Monthly and Out West Magazine* 7:39 (March 1886): 161, 164-71; "Monthly Record of Current Events," *Harper's New Monthly Magazine* 13:75 (August 1856): 404; and "Monthly Record of Current Events," *Harper's New Monthly Magazine* 13:76 (September 1856): 552.

A nearly identical plate is held in the former Gilman Paper Company Collection at the Metropolitan Museum of Art. Maria Morris Hambourg et al., *The Waking Dream: Photography's First Century, Selections from the Gilman Paper Company Collection* (New York: Metropolitan Museum of Art/Harry N. Abrams, 1993): 311-12

CHAPTER III

Being a Daguerreotypist

77
Unknown Maker
Daguerreotypist in his Studio, ca. 1850
Sixth-plate daguerreotype, HF400-547-05

78
Unknown Maker
Woman Daguerreotypist with Camera and Sitter, ca. 1855
Sixth-plate ambrotype, 400-84-96

Professor John W. Draper, a pioneer of the daguerreotype, felt that the profession was one in which "the fairer sex may engage without compromising a single delicate quality of woman's nature" (Penny, *The Employments of Women*, p. 53). Nevertheless, images of female operators in this early period are extremely rare. Virginia Penny, *The Employments of Women: A Cyclopaedia of Woman's Work* (Boston: Walker, Wise, & Co., 1863): 53-55.

79
Charlotte Prosch
Active 1850s
Portrait of a Standing Child, ca. 1851
Sixth-plate daguerreotype, HF827-1-05

Paper label reads: "Miss C. Prosch, 259 Broad-St. Newark NJ."

In 1847, the *Newark Daily Advertiser* noted that Miss Prosch had opened a studio in that city at 259 Broad Street after previously working in New York City. Charlotte Prosch married a Mr. Day in 1853 and she is next mentioned in 1853, as "Mrs. Day, previously Miss Prosch," at 259 Broad Street. The 1854-58 city directories list her as a widow, and the rest of her career is unknown. "Notice," *Newark Daily Advertiser* 16:170 (July 19, 1847): n.p.; "Daguerreotype Notice," *Newark Daily Advertiser* 19:74 (March 29, 1850): n.p.; and "Mrs. Day," *Newark Daily Advertiser* 22:201 (August 29, 1853): n.p.

80
A. H. Boyce
1830 - ?
Self-Portrait with Cameras, August 30, 1855
Sixth-plate daguerreotype, 744-1-01

Paper note reads: "A.H. Boyce, D. Artist, Taken August 30th, 1855, in the 25 Year of his Age."

There is little written record of A. H. Boyce. In a review of the Ohio Mechanics Fair of 1851, Austin Earle notes that "Boyce had a few choice pictures." Austin Earle, "Ohio Mechanics Fair," *Photographic Art-Journal* 2:5 (November 1851): 317.

81
Unknown Maker
Traveling Daguerreian Studio, ca. 1850
Sixth-plate daguerreotype, 400-389-01

Selectively hand-colored in bright blue; engraved on back of plate and written in pencil in inside of case: "L.M. Moartrain [illeg.], house painter."

82
Joseph R. Gorgas
1829-1903
Gorgas's Floating Daguerreian Gallery, ca. 1856
Half-plate ambrotype, 723-1-00

According to an 1899 account in the *St. Louis and Canadian Photographer*, Gorgas started taking daguerreotypes in Pittsburgh, Pennsylvania, in 1847. After working as an itinerant daguerreotypist from about 1847-49, he temporarily left the business. In 1853, he opened a daguerreotype studio in Madison, Indiana, where he remained until at least 1899. Late in life, Gorgas felt that "there never was anything more beautiful than the good old Daguerreotype." J. R. Gorgas, "J.R. Gorgas," *St. Louis and Canadian Photographer* 23:7 (July 1899): 327.

83
Unknown Maker
Traveling Ambrotype Studio, ca. 1860
Half-plate daguerreotype, 400-403-01

84
Warren Thompson
Active 1840s-1850s
Portrait of a Boy with Toy Rifle, ca. 1854-56
Stereo daguerreotype (3¼ x 6¾ in. overall), 769-1-01

Stereo marked: "W. Thompson, Rue de Choiseul, 22."

Warren Thompson was active in Philadelphia in 1840-46. He obtained a patent in May 1843 (which he quickly assigned to M. P. Simons) for an electrolytic process for coloring daguerreotypes. Thompson left for Paris around 1847. He became such a prominent figure there that he was universally considered a French photographer. By 1853, he had opened his studio at 22 Rue de Choiseul, where he operated for the rest of his career in Paris. *Springfield Daily Republican* [Massachusetts] (March 22, 1851): n.p.; Janet E. Buerger, *French Daguerreotypes* (Chicago: University of Chicago Press, 1989): 108-14; and Bates Lowry and Isabel Lowry, *The Silver Canvas* (Los Angeles: J. Paul Getty Museum, 1998): 92-93, 220.

85
William Hardy Kent
1819-1907
Alice Abadam and Child, 1856
Stereo daguerreotype (3¼ x 6¾ in. overall), 765-1-01

Inscribed in lower area of left image: "Alice Abadam, 28 May 1856"; artist's label on back.

William Hardy Kent was born in England and spent his early years in Bedford, Massachusetts. In 1848, he opened his first daguerreotype studio in New York City. After realizing a small fortune, he returned to England in 1854 and opened three studios in London.

86
Fredricks & Weeks
1823-1894; active 1840s-1850s
Recife, Brazil, ca. 1853
Whole-plate daguerreotype, 390-2-95

Stamped on mat: "Electrotypo" and "Frederics É Weeks."

Charles D. Fredricks was sent to Havana as a child to learn Spanish. He continued his studies in the United States until the financial crash of 1837. Prompted by a letter from his brother, who lived in Venezuela, Fredricks set sail for that nation in 1843. Before departing, he learned the art of the daguerreotype from Jeremiah Gurney. When he reached Angostura, Venezuela, his daguerreotype services were called upon to record the deceased child of a prominent merchant. News soon spread of his skills, and Fredricks ultimately worked in South America as an itinerant daguerreotypist for the next nine years.

Little is known about Weeks. This appears to be Alexander B. Weeks, who worked in New York City between 1846 and 1854 and sometime later in Toledo, Ohio. At some point between 1848 and 1854, he was apparently employed by Jeremiah Gurney. In 1859, an operator by the name of Weeks was noted in the employment of C. D. Fredricks. "Our Illustration—How Fredricks Became a Photographer," *Anthony's Photographic Bulletin* 12:4 (April 1881): 110-12; "The Late Charles D. Fredricks," *Photographic Times* 24:664 (June 8, 1894): 355-56; and "Sketch of Charles D. Fredricks, Esq.," *Humphrey's Journal of Photography and the Allied Arts and Sciences* 20:27 (November 15, 1869): 429-31; John S. Craig, *Craig's Daguerreian Registry, Volume 3, Pioneers and Progress: MacDonald to Zuky* (Torrington: Conn.: John S. Craig, 1996): n.p.

87
Benjamin Franklin Pease
1822-1888
El Patroncito, ca. 1853-55
Half-plate daguerreotype, HF858-1-06

Keith McElroy, *Early Peruvian Photography* (Ann Arbor: UMI Research Press, 1985), fig. 61.

[C-50]
Silas A. Holmes
1820-1886
Self-Portrait, 1854
Ninth-plate daguerreotype, 740-1-01

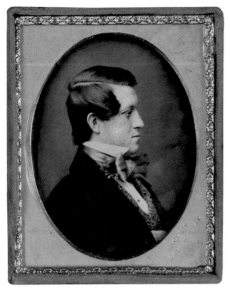

C-50

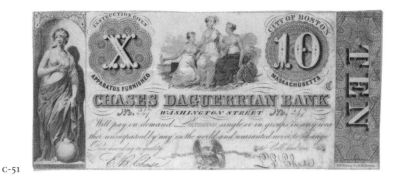

C-51

C-52

Written in red ink in bottom of case: "[illeg.] 1854 [illeg.], Self Portrait of Myself, Silas Holmes, Daguerreian Artist."

It is unknown where Silas Holmes learned to daguerreotype but by 1848 he was running a studio in New York City with C. C. Harrison. From 1850 into the 1860s, he owned his own studios, at various addresses on Broadway. In 1854, at about the time this daguerreotype was made, Holmes applied for a patent for his "double camera," used to take simultaneous views on two separate plate holders. William Welling, *Photography in America: The Formative Years, 1839-1900* (New York: Thomas Y. Crowell Company, 1978): 104, 115; *Photographic and Fine Arts Journal* 8 (December 1855): 384.

[c-51]
Ezra B. Chase
1818-1890
Chase Daguerreian Note, ca. 1848-49
Paper ephemera (3 x 6¾ in.), HF727-3-05

The daguerreian note was used much like a gift card, to be redeemed at the photographer's studio. Ezra Bailey Chase worked primarily in Massachusetts, though he started in Exeter, New Hampshire, with John Plumbe. He worked at the address on this note—247 Washington Street in Boston—in 1848 and 1849. "Another Daguerreotype Card Cheat," *Boston Daily Evening Transcript* (September 18, 1848): n.p.

CHAPTER IV

The Face of a Nation

88
Unknown Maker
Sarah Creighton, Julia Maria, and Harriet Cutler Peet, ca. 1846-48
Quarter-plate daguerreotype, HF400-480-03

Julia Maria (b. 1834), Sarah Creighton (b. 1837), and Harriet Cutler (b. 1839) were all born in Bridgeport, Connecticut, to Frederick Tomlinson and Elizabeth Roe Peet.

89
Unknown Maker
Sarah Creighton, Julia Maria, and Harriet Cutler Peet, ca. 1855
Quarter-plate daguerreotype, HF400-481-03

90
Unknown Maker
Family of Four, ca. 1847-50
Quarter-plate daguerreotype, 400-341-01

91
Unknown Maker
Portrait of Janet Mitchel Wilson, ca. 1845
Sixth-plate painted miniature in a quarter-plate case, 400-178-98

Painted miniature of the woman pictured in the Simons daguerreotype.

It is not known where or when this miniature was made. Janet Mitchel Wilson was originally from Warrenton, North Carolina, and attended Mrs. Meade's School in Richmond, Virginia, in the 1840s. It is thought that the miniature was probably painted during her time in Richmond. Alan Trachtenberg, "A Story of a Daguerreotype," (mss., n.d.).

92
Unknown Maker
Portrait of Thomas Epps Wilson, ca. 1845
Sixth-plate painted miniature in a quarter-plate case, 400-177-98

Painted miniature of the man pictured in the Simons daguerreotype.

While still living in his hometown county of Greensville, Virginia, at the age of twenty, Thomas Epps Wilson married his sweetheart, who died only a year later. After leaving Virginia for medical school at the University of Pennsylvania in Philadelphia, he maintained close ties with his deceased wife's family and had a miniature painted of himself there, which he sent to his sister-in-law. Trachtenberg, "A Story of a Daguerreotype."

93
Montgomery P. Simons
1817-1877
Thomas Epps Wilson and Janet Mitchel Wilson, ca. 1847
Three-quarter-plate daguerreotype, 551-2-98

Embossed on back of case: "M.P. Simons Phil'a."

After medical school, Thomas Epps Wilson bought a practice in prosperous Warrenton, North Carolina, in 1846. He then married Janet Mitchel (b. 1828), a wealthy plantation owner's daughter, in 1847 and proceeded to live the life of high society. The couple had hundreds of acres of fertile land and hundreds of slaves to work it. This daguerreotype may have been made during a stop in Philadelphia in the summer of 1847 during the couple's honeymoon trip to Niagara Falls. Trachtenberg, "A Story of a Daguerreotype."

94
Unknown Maker
Zachary Taylor, ca. 1847-48
Quarter-plate daguerreotype, 400-452-03

Zachary Taylor was a career military officer who gained fame for a series of early victories in the Mexican-American War. Taylor had no previous political experience; a rough-looking and rough-speaking man, Taylor was more at home on a remote frontier post than in the White House. He served as the 22nd President from 1849 until his death in 1850. Harold Pfister, *Facing the Light: Historic American Portrait Daguerreotypes* (Washington, D.C.: National Portrait Gallery/ Smithsonian Institution Press, 1978): 74-79, 350-51.

95
Unknown Maker
Charles Sumner, ca. 1854
Half-plate daguerreotype, 402-2-95

Charles Sumner was elected to the Senate by the State of Massachusetts in 1851 by antislavery Democrats. He was outspoken on the subject of slavery and vehemently opposed Stephen Douglas's Kansas-Nebraska Act (1854). In 1856, Sumner delivered a blistering speech on the floor of the

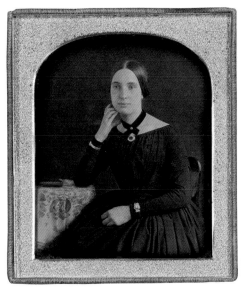

C-53

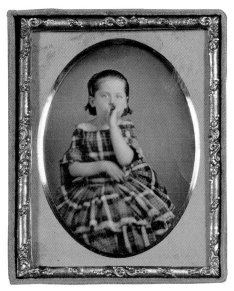

C-54

Senate, condemning Douglas and the act as well as Senator Andrew P. Butler of South Carolina. Defenders of slavery were enraged. Two days later, while Sumner was seated at his desk on the Senate floor, Representative Preston Brooks of South Carolina, a relative of Butler, beat Sumner severely on the head and shoulders with his walking cane. Sumner was critically injured and many doubted his recovery. After a long and difficult convalescence, Sumner eventually returned to politics.

This daguerreotype was taken before the attack by Preston Brooks. The beating took a toll on Sumner, and his appearance after May 1856 was dramatically changed. This daguerreotype has the same stylistic quality as the daguerreotypes of Sumner taken in 1854 by Southworth & Hawes. Grant B. Romer and Brian Wallis, eds., *Young America: The Daguerreotypes of Southworth & Hawes* (Göttingen: Steidl/George Eastman House/International Center of Photography, 2005): 281-85, 349.

96
Unknown Maker
Profile Portrait of Frederick Douglass, ca. 1858
Sixth-plate daguerreotype, 400-407-01

Frederick Douglass (1817-1895) was the son of a white slaveholder father and a black mother. He escaped slavery and fled north to Baltimore in 1838. There, he was discovered by William Lloyd Garrison and made a member of the Massachusetts Anti-Slavery Society. He toured the country, vividly recounting his experience with slavery and promoting the abolitionist cause. Pfister, *Facing the Light*, pp. 273-77.

This daguerreotype appears to be previously unpublished and unknown.

97
Unknown Maker
Elihu Burritt Reading, ca. 1845
Sixth-plate daguerreotype, 400-218-99

Elihu Burritt (1810-1879) was a self-educated scholar and lecturer. Because of his early career, he was dubbed the "Learned Blacksmith." He lectured throughout New England on the joy of learning. His later interests included the causes of abolition and world peace. Pfister, *Facing the Light*, pp. 250-54; Merle Curti, *The Learned Blacksmith: Letters and Journals of Elihu Burritt* (New York: Wilson-Erickson Inc., 1971).

98
Unknown Maker
Saunders K.G. Nellis, ca. 1850
Quarter-plate daguerreotype, HF400-568-06

Saunders K. G. Nellis was born without arms in 1817 in Stone Arabia, New York. According to the *National Intelligencer*, Nellis made his first public appearance in 1829 in Washington, D.C., with the billing of *Saunder's Circus & A. L. Nellis Armless Wonder*. From 1829 through the early 1860s, Nellis toured Canada, the United States, and abroad, amazing crowds with the dexterity of his feet. He died in 1865.

99
Unknown Maker
Tom Thumb and his Mother, ca. 1850-55
Quarter-plate daguerreotype, 400-192-98

Charles Sherwood Stratton (1838-1883) was born in Connecticut to average sized parents. In 1842, Stratton was discovered by P. T. Barnum, who taught him to sing and dance and began touring him in the United States and Europe. At the time of his death, in 1883, he was 3 feet, 4 inches tall. Philip B. Kunhardt, Jr., Philip B. Kunhardt III, and Peter W. Kunhardt, *P.T. Barnum: America's Greatest Showman* (New York: Alfred A. Knopf, 1995).

100
John A. Keenan
Active 1850s
Family Group with Wife Wearing Daguerreotype Pin of Husband, ca. 1855
Quarter-plate daguerreotype, HF825-1-05

Impressed velvet liner reads: "Keenan / 2d Ab South St / Philada."

[C-52]
Unknown Maker
Hair Bracelet with Daguerreotype Portrait, ca. 1850
Sixteenth-plate daguerreotype, 400-381-01

[C-53]
Unknown Maker
Woman Wearing Hair Jewelry Bracelet, ca. 1850
Sixth-plate daguerreotype, 400-397-01

101
Unknown Maker
Family Group (children with paintings of parents), ca. 1855
Quarter-plate daguerreotype, 400-17-95

102
Unknown Maker
Man Posed with Painting, ca. 1850
Sixth-plate daguerreotype, 400-210-99

103
Unknown Maker
Man and Woman Posed with Painting of Man, ca. 1850
Sixth-plate daguerreotype, HF400-548-05

104
Unknown Maker
Jerusha Forbes Holding a Daguerreotype, ca. 1848-50
Sixth-plate daguerreotype, 400-430-01

105
Unknown Maker
Woman with Daguerreotype of her Husband, ca. 1850
Sixth-plate daguerreotype, HF400-484-03

106
Unknown Maker
Father and Son with Postmortem Daguerreotype, ca. 1850
Quarter-plate daguerreotype, 400-294-00

107
Unknown Maker
Young Woman in Profile, ca. 1850
Sixth-plate daguerreotype, 400-274-00

108
Unknown Maker
Three Children at a Table, ca. 1843-45
Three-quarter-plate daguerreotype, 400-6-95

[C-54]
Unknown Maker
Girl Sucking her Thumb, ca. 1850
Ninth-plate daguerreotype, 400-331-01

109
Unknown Maker
Man in Casual Pose, ca. 1850
Sixth-plate daguerreotype, HF400-475-03

110
Unknown Maker
Woman with Two Shy Children, ca. 1850
Sixth-plate daguerreotype, HF400-544-05

111
Unknown Maker
Boy and Dog, ca. 1850
Sixth-plate daguerreotype, 400-402-01

112
Unknown Maker
Sleeping Baby, ca. 1855
Sixth-plate daguerreotype, HF400-502-03

C-55

C-56

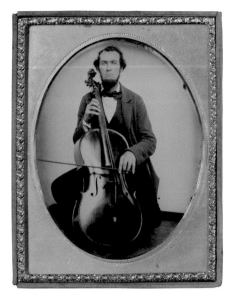

C-57

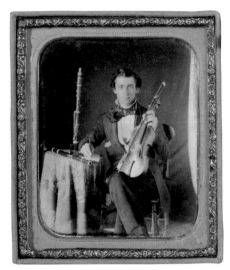

C-58

113
Unknown Maker
Twin Babies in Christening Gowns, ca. 1855
Sixth-plate daguerreotype, HF400-536-05

114
Unknown Maker
Child (father reaching into frame), ca. 1850
Sixth-plate daguerreotype, 400-229-99

115
Unknown Maker
Portrait of a Girl (father at edge of frame), ca. 1855
Sixth-plate daguerreotype, 400-307-00

116
Unknown Maker
The Human Head Clamp, ca. 1850
Sixth-plate daguerreotype, 400-302-00

117
Unknown Maker
Baby with Hiding Mother, ca. 1855
Sixth-plate daguerreotype, 400-414-01

118
Unknown Maker
Portrait of Obed Hussey, ca. 1850
Quarter-plate daguerreotype, HF400-500-03

Obed Hussey (1791-1860), of Cincinnati, Ohio, invented a horse-drawn reaper in 1833. This machine allowed farmers to harvest crops quickly and to plant more acreage. Six months after Hussey patented his machine, Cyrus McCormick placed a similar invention on the market. McCormick's machine soon outsold Hussey's, driving the latter out of business. Follett L. Greeno, *Obed Hussey, Who, Of All Inventors, Made Bread Cheap* (Rochester, N.Y.: Rochester Herald Pub. Co., 1912).

119
Unknown Maker
Dr. Rowland Greene, ca. 1850-55
Whole-plate daguerreotype, 400-50-96

Dr. Rowland Greene (1770-1859) was a respected physician in Rhode Island. He was a member of the Friends Society and traveled widely both as a physician and as a Quaker preacher. Devoted to improving the quality of local schools, he established the Plainfield Boarding School in 1817. He was distinguished by "the peculiarity of his dress; for he adhered to knee breeches and high stockings after all others had discarded them." Noah Arnold, "Biographical Reminiscences of the Pawtuxet Valley," *Narragansett Historical Register* 8:2 (July 1890): 102.

A variant of this daguerreotype can be found in Louise Brownell Clarke, *The Greenes of Rhode Island with Historical Records of English Ancestry* [sic] (New York: New York Genealogical and Biographical Society, 1903): 387. A whole-plate variant portrait is held in the collection of Matthew R. Isenburg.

120
Unknown Maker
Standing Artist, ca. 1850
Half-plate daguerreotype, 400-365-01

121
Unknown Maker
Girl Showing Pantaloons, ca. 1850-55
Half-plate daguerreotype with hand-coloring, HF400-488-03

122
Unknown Maker
Girl with Doll, ca. 1848-50
Sixth-plate daguerreotype, 400-409-01

123
Unknown Maker
Child with Building Blocks ("The Master Builder"), ca. 1850
Quarter-plate daguerreotype, HF400-540-05

124
Unknown Maker
Boy with Bow and Arrow, ca. 1846-48
Quarter-plate daguerreotype, HF400-509-03

125
Unknown Maker
Young Boy at Table with Marble Statue, ca. 1850
Sixth-plate daguerreotype, HF400-558-05

126
Unknown Maker
Man with Model Ship, ca. 1850
Sixth-plate daguerreotype, 400-384-01

127
Unknown Maker
Fitzhugh and Helen Ludlow, ca. 1846-48
Quarter-plate daguerreotype, 400-139-98

Note in period hand: "Fitzhugh and Helen Ludlow."

While full documentation is lacking, it appears likely that the subjects of this daguerreotype are Fitzhugh (b. 1836) and Helen Wilhemina Ludlow (b. 1839). They were born in Poughkeepsie, New York, the children of Presbyterian minister and abolitionist Henry G. Ludlow. Significantly, Henry was a friend of Samuel F. B. Morse, a member of his parish. As a child, Fitzhugh was often sickly, and he took to wearing glasses at the age of twelve (note the lack of glasses in this daguerreotype). While in college, he befriended a pharmacist and soon began experimenting with drugs. Ludlow wrote about his experiences with drugs in books and articles, and also published poetry and fiction. In 1859, he married Rosalie Osborne (they divorced in 1866). In 1863, he accompanied the artist

c-59

c-60

Albert Bierstadt on a journey west to California and Oregon. (Bierstadt would later marry Ludlow's ex-wife, Rosalie.) Ludlow's addiction to hashish and opiates continued until his death in 1870. Helen Ludlow is perhaps best remembered for her work with the Hampton Institute to document, preserve, and publish slave songs. Ralph Britsch, *Bierstadt and Ludlow: Painter and Writer in the West* (Salt Lake City: Brigham Young University, 1980); Donald Dulchinos, *Pioneer of Inner Space: The Life of Fitzhugh Ludlow* (Brooklyn: Autonomedia, 1998): 13-33.

128
Unknown Maker
Two Girls, ca. 1850-55
Quarter-plate daguerreotype, 400-180-98

[c-55]
Unknown Maker
Young Woman and Child, ca. 1855
Half-plate daguerreotype, 400-431-01

129
Unknown Maker
Two Girls on a Hobby Horse, ca. 1850
Half-plate daguerreotype, 400-42-96

130
Unknown Maker
Portrait of Two Girls, ca. 1855
Quarter-plate daguerreotype in thermoplastic wall frame, 400-326-00

In elaborately painted blue paper mat.

131
Unknown Maker
Six Women, ca. 1845
Quarter-plate daguerreotype, 400-43-96

132
Unknown Maker
The Phrenologist, ca. 1850-55
Quarter-plate daguerreotype, 400-138-98

[c-56]
Unknown Maker
Mrs. Fowler Wells with a Phrenology Book, ca. 1855
Quarter-plate daguerreotype, 400-197-99

Orson and Lorenzo Fowler, their sister Charlotte, her husband Samuel Roberts Wells, and Lorenzo's wife Lydia were all practicing phrenologists, providing readings for many celebrities of the era. As of 1842, the Phrenological Institute of New York City (founded by the Fowlers) included a Phrenological Cabinet, with a large collection of skulls as well as casts, charts, and other phrenological paraphernalia. The publishing house of Fowler and Wells issued the monthly *Phrenological Journal* as well as other self-improvement books. Matilda Joslyn Gage, "Woman in Newspapers," *The History of Woman Suffrage*, vol. 1 (New York: Arno Press, 1881): n.p.; L. N. Fowler, *Phrenological Reading of G. H. Clark*, March 1835, Harvard University Rare Books.

Charlotte Fowler Wells is pictured holding one of the firm's books, *The Illustrated Self-Instructor in Phrenology and Physiology with One Hundred Engravings and a Chart of the Character* (1855).

133
Unknown Maker
Smiling Child, ca. 1850
Sixth-plate daguerreotype, 400-169-98

134
Unknown Maker
Smiling Man, ca. 1845-48
Sixth-plate daguerreotype, HF400-550-05

[c-57]
Unknown Maker
Man with Cello, ca. 1855-60
Quarter-plate ambrotype, HF400-521-04

[c-58]
Unknown Maker
The Multi-Instrumentalist, ca. 1850
Sixth-plate daguerreotype, HF400-493-03

135
Unknown Maker
The Pianist, ca. 1850
Quarter-plate daguerreotype, HF400-497-03

136
Unknown Maker
Woman with Guitar, ca. 1850
Half-plate daguerreotype, 400-185-98

137
Unknown Maker
J. S. Boyd and Mr. Strandley with Flute and Sheet Music, ca. 1850
Sixth-plate daguerreotype, HF400-494-03

138
Unknown Maker
Cellist and Girl, ca. 1850
Sixth-plate daguerreotype, HF400-495-03

139
Unknown Makerr
Man with Quill Pen, ca. 1850
Half-plate daguerreotype, 400-56-96

140
Unknown Maker
Men Reading Newspaper, ca. 1843-45
Sixth-plate daguerreotype, 400-22-95

[c-59]
Unknown Maker
Moses Sperry Beach Holding a Copy of the New York Sun, ca. 1846-51
Sixth-plate daguerreotype, 400-48-96

Moses Sperry Beach (1822-1892) was the son of Moses Yale Beach, the proprietor of the *New York Sun* newspaper. Moses became employed in his father's business in 1836 and gained a financial interest in the paper in 1845. In 1851, he became the sole proprietor. His controlling interest in the paper made him a fairly wealthy man. "Moses Sperry Beach," *National Cyclopedia of American Biographies*, vol. 13 (New York: J. T. White, 1892): 329.

[c-60]
Unknown Maker
Editors of the University of North Carolina Magazine, ca. 1851-52
Sixth-plate daguerreotype, 400-406-01

Enclosed note provides names and data: "L. F. Siler, T. H. Gilliam, J. J. Slade, Wm. D. Barnes, Alex R. Smith, F. B. Burton, Editors, University Magazine, N. Carolina, Class of 1852."

c-61

c-62

c-63

141
Unknown Maker
Man with Books, ca. 1850
Quarter-plate daguerreotype, 400-308-00

[c-61]
Unknown Maker
Artillery Soldier, ca. 1855
Sixth-plate daguerreotype, HF400-464-03

According to Michael D. Medhurst, this uniform
was worn by Union troops early in the Civil War.
The red piping on the coat indicates the soldier
belonged to an artillery regiment.

142
Unknown Maker
Henry B. Webbert, November 20, 1855
Sixth-plate daguerreotype, 400-427-01

*Hand-colored; with pencil inscription inside case:
"Henry B. Webbert [illeg.], taken in Newburg,
November 20, 1855."*

According to Michael D. Medhurst, this soldier's
uniform indicates that he is an infantryman.

143
Unknown Maker
James Duncan Graham, Jr., Holding Telescope,
ca. 1857
Half-plate daguerreotype, HF400-527-04

James Duncan Graham, Jr. (1841-1900), was the
youngest son of James Duncan Graham, Sr., a
military topographer (see entry 67). The younger
Graham graduated from the Naval Academy
in Annapolis in 1857 as an acting midshipman.
After the start of the Civil War, in 1861, Graham
joined the crew of the *Roanoke* in the as part
of a blockade squadron. Later in the war, he
served in various capacities, including Ordnance
Inspector in the Washington Navy Yard, on
the gunboat *Delaware*, and commander of the
mortar schooner *S.C. Jones*. From 1862 to
1865, he served aboard the *Jamestown* in the
East India Squadron. He retired from naval
service in 1897.

144
Unknown Maker
*James Duncan Graham, Jr., with Outstretched
Telescope*, ca. 1857
Half-plate daguerreotype, HF400-528-04

[c-62]
Unknown Maker
New York City Policeman, ca. 1855
Sixth-plate daguerreotype, 400-424-01

145
Unknown Maker
Fireman, ca. 1855
Quarter-plate daguerreotype, 400-114-97

[c-63]
Unknown Maker
Mason, ca. 1855
Sixth-plate daguerreotype, HF400-466-03

146
Unknown Maker
Odd Fellow with Ceremonial Axe, ca. 1850
Sixth-plate daguerreotype, HF400-561-05

147
Benjamin F. Reimer
1826-1899
Odd Fellow Taking Oath, ca. 1855
Quarter-plate daguerreotype, HF828-1-05

*Impressed velvet liner reads: "REIMER'S GALLERY
/ 397 [illeg.] AB GREEN / PHILADELPHIA."*

148
Unknown Maker
Preacher, ca. 1855
Quarter-plate daguerreotype, 400-8-95

149
Unknown Maker
Reverend McKinney in his Pulpit, ca. 1850
Quarter-plate daguerreotype, 400-18-95

*Accompanying note: "Reverend McKinney, Christ
Reformed Church, Middleton, Md."*

Although no records were found for a Reverend
McKinney, there was a Reverend McCauley who
was pastor of the Christ Reformed Church in

Middleton, Maryland, from 1845 to 1855. Reverend
McCauley set up a school and a library for the
children of his parish; he also extended the privi-
leges of the Church to the black citizens of his
parish. Paul Fogle, *A History of Christ Reformed
Church, United Church of Christ, Middletown,
Md.* (Middletown, Md.: The Church, 1995): 45-48.

150
Robert H. Vance (**attrib.**)
1825-1876
Pharmacist (or Chemist), ca. 1850-55
Sixth-plate daguerreotype, 407-4-01

[c-64]
Unknown Maker
Dentist with Tools in Open Case, ca. 1850
Sixth-plate daguerreotype, HF400-471-03

151
Unknown Maker
Dentist with Tools and Set of False Teeth, ca. 1855
Half-plate daguerreotype, HF400-514a-04

152
Unknown Maker
Surgeon with Scalpel and Equipment, ca. 1850
Sixth-plate daguerreotype, HF400-470-03

153
Unknown Maker
Dr. Kenison, Chiropodist, ca. 1852-53
Sixth-plate daguerreotype, 400-39-96

*Accompanied by the subject's business card:
"Dr. P. Kenison, / Chiropodist. / Corns & Bad
Nails Extracted / Without Pain / 145 Tremont St. /
bet: West St. & Temple Place, Boston."*

154
Unknown Maker
Man with Skulls, ca. 1850
Sixth-plate daguerreotype, 400-191-98

155
Unknown Maker
The Mesmerist, ca. 1850
Sixth-plate daguerreotype, 400-38-96

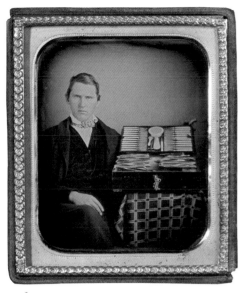

c-64

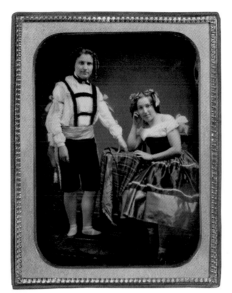

c-65

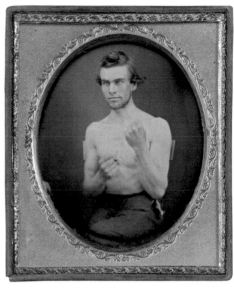

c-66

156
Unknown Maker
Artist with Palette Knife, Maul Stick, and Paint Brush, ca. 1850
Quarter-plate daguerreotype, 400-270-00

157
Unknown Maker
Man with Leopard Skin, ca. 1855
Quarter-plate daguerreotype, 400-232-99

158
Unknown Maker
Clown, ca. 1850-55
Sixth-plate daguerreotype, 400-28-95

159
Unknown Maker
Tightrope Walker, ca. 1855
Half-plate daguerreotype, HF400-451-03

[c-65]
Unknown Maker
Two Dancers in European Costume, ca. 1855
Half-plate daguerreotype, 400-441-02

160
Unknown Maker
Black-Face Minstrel, ca. 1850
Quarter-plate daguerreotype, 400-234-99

[c-66]
Unknown Maker
The Pugilist, ca. 1850
Sixth-plate daguerreotype, 400-168-98

161
Unknown Maker
Tailor Ironing, ca. 1848
Sixth-plate daguerreotype, 400-196-99

162
Unknown Maker
Blacksmith with Raised Hammer, ca. 1850
Sixth-plate daguerreotype, 400-433-01

163
Unknown Maker
Window Maker, ca. 1850
Sixth-plate daguerreotype, 400-129-97

164
Unknown Maker
Carpenter with T-Square and Saw, ca. 1850
Sixth-plate daguerreotype, 400-34-95

165
Unknown Maker
Baker with Basket of Buns, ca. 1850
Sixth-plate daguerreotype, 400-170-98

166
Unknown Maker
Delivery Boy with Parcel, ca. 1850
Sixth-plate daguerreotype, 400-53-96

167
Unknown Maker
Silversmith, ca. 1850
Sixth-plate daguerreotype, HF400-508-03

168
B. Barbour
Active 1850s
Jas. D. Robey, Calligrapher, Suncook, New Hampshire, 1854
Sixth-plate daguerreotype, 647-1-99

Scratched on back of plate: "Jas. D. Robey, 39 [illeg.] yrs., Feb. 1854, Suncook, N.H. by B. [illeg.] Barbour."

James D. Robey was born in 1816 in New Hampshire and was trained as a writing and calligraphy instructor. In 1851, he wrote a memorial poem for an infant, Sarah Elizabeth Webster, who had recently died. The poem was published in the local newspaper and indicated that Robey resided in North Chichester, New Hampshire. He later moved to Buda, Illinois, with his family and was residing there at the time of the 1880 census (1880 census, Buda, Illinois).

169
Unknown Maker
Surveyor, ca. 1855
Sixth-plate daguerreotype, 400-40-96

170
Unknown Maker
Two Musical Instrument Repairmen and Young Boy, ca. 1845-48
Sixth-plate daguerreotype, HF400-541-05

171
Unknown Maker
Man with Hammer and Nail, ca. 1850
Sixth-plate daguerreotype, 400-36-95

172
Unknown Maker
Woman Ironing, ca. 1850-55
Sixth-plate daguerreotype, 400-61-96

173
Unknown Maker
Fabric Salesman, ca. 1850
Quarter-plate daguerreotype, 400-83-96

[c-67]
Unknown Maker
Blacksmith, ca. 1850
Sixth-plate daguerreotype, HF400-478-03

[c-68]
Unknown Maker
Chimney Sweep, ca. 1850
Sixth-plate daguerreotype, 400-469-03

[c-69]
Unknown Maker
Cobbler, ca. 1848
Sixth-plate daguerreotype, 400-345-01

[c-70]
Unknown Maker
Man with Sewing Machine, ca. 1850-55
Sixth-plate daguerreotype, 400-24-95

Plate is hand-colored in bottom left.

The sewing machine model is unusual; it may be a prototype design not commercially manufactured.

[c-71]
Unknown Maker
Cigar Maker, ca. 1850
Sixth-plate daguerreotype, 400-276-00

[c-72]
Unknown Maker
Cartographer, ca. 1860
Sixth-plate ambrotype, 400-280-00

Title of map is: "The Middle States."

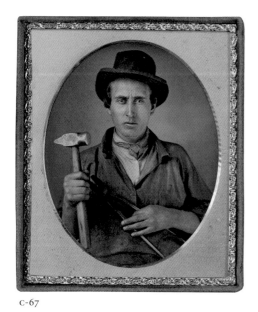

C-67

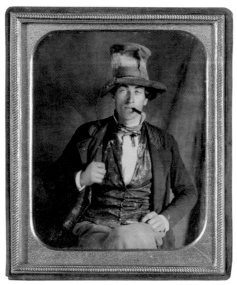

C-68

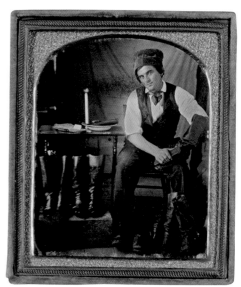

C-69

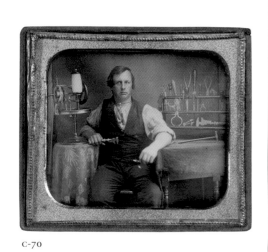

C-70

C-71

C-72

C-73

C-74

C-75

C-76

[C-73]
Unknown Maker
Man with Wheel, ca. 1855
Half-plate ambrotype, 400-121-97

174
Unknown Maker
Mountain Man with Rifle, ca. 1850
Sixth-plate daguerreotype, 400-148-98

175
Unknown Maker
Duck Hunters, ca. 1850
Half-plate daguerreotype, 400-160-98

[C-74]
Unknown Maker
The Hunters, ca. 1848-50
Half-plate daguerreotype, 400-436-01

This daguerreotype may have been made by Jacob
Byerly, who is reported to have had the only half-
plate camera in Fredrick, Maryland, at this time.
Byerly operated a studio in Fredrick from 1842 to
1860. This piece was originally bought at a small
estate sale in Fredrick.

176
Unknown Maker
The Frontiersman, ca. 1856
Half-plate ambrotype, HF400-539-05

177
Unknown Maker
Monmouth Inquirer, ca. 1855
Quarter-plate daguerreotype, 400-205-99

178
Unknown Maker
Man Picking Pears, ca. 1850
Quarter-plate daguerreotype, 400-27-95

179
Unknown Maker
Butcher Shop Interior, ca. 1850
Whole-plate daguerreotype, 400-96-97

According to information kindly provided by
Stephen Longmire, this daguerreotype may have
been made in Sag Harbor, New York.

180
Unknown Maker
Man Wearing Plumed Hat and Ethnic Dress,
ca. 1855
Sixth-plate daguerreotype, 400-534-04

181
Unknown Maker
Virginia Plantation Slave, ca. 1850
Sixth-plate daguerreotype, 400-115-97

This daguerreotype is reported to have
descended from the Reinhart family of Virginia.

182
Unknown Maker
Portrait of a Woman, ca. 1850
Sixth-plate daguerreotype, HF400-519-04

183
Unknown Maker
Man with Ball of String, ca. 1850
Quarter-plate daguerreotype, 400-82-96

184
Unknown Maker
Woman with Horse and Groom, ca. 1850
Half-plate daguerreotype, 400-172-98

185
Unknown Maker
Young Girl with Attendant, ca. 1850
Sixth-plate daguerreotype, HF400-562-05

186
Unknown Maker
Caretaker with Child, ca. 1850
Sixth-plate daguerreotype, 400-248-00

187
Unknown Maker
Attendant with Child, ca. 1855
Quarter-plate daguerreotype, 400-204-99

[C-75]
Unknown Maker
Caretaker with Child, ca. 1850
Sixth-plate daguerreotype, 400-62-96

[C-76]
Unknown Maker
Four Children, ca. 1848
Quarter-plate daguerreotype, 400-377-01

188
Unknown Maker
Unidentified Native Americans, ca. 1850
Quarter-plate daguerreotype, 400-437-01

189
Unknown Maker
General Rufus Ingalls with Son and Servant,
ca. 1850
Quarter-plate daguerreotype, 400-438-01

*With period note: "Rufus Ingalls / Brig. Genl. /
Chief Quartermaster."*

Brigadier General Rufus Ingalls (1819-1893) attended
the U.S. Military Academy; after graduation, he
was appointed to a regiment at Leavenworth,
Kansas. He fought in the war with Mexico. At
the outbreak of the Civil War, he was sent to
Washington to organize supplies for the Army of
the Potomac. He served as the Chief Quarter-
master for the Army of the Potomac from 1862 to
1864, and as Chief Quartermaster for the armies
around Richmond until the end of the war. Ingalls
is shown here with his adopted son, Blair. "Gen.
Rufus Ingall's [sic] Funeral," *New York Times*
(January 17, 1893): 6.

190
Unknown Maker
Seated Man with Servant, ca. 1855
Sixth-plate daguerreotype, HF400-462-03

191
Unknown Maker
Chinese Woman with Open Daguerreotype,
ca. 1850
Sixth-plate daguerreotype, HF400-457-03

192
Unknown Maker
Young Woman with Floral Necklace, ca. 1846-48
Sixth-plate daguerreotype, 400-334-01

C-77

C-78

193
Unknown Maker
Eugenia Nye Memorial, 1850
Ninth-plate daguerreotype portrait in framed text, 400-304-00

194
Unknown Maker
Girl with Dead Sister, ca. 1855
Sixth-plate daguerreotype with hand-coloring, 400-10-95

195
Unknown Maker
Mother with Dead Child, ca. 1850
Sixth-plate daguerreotype, HF400-518-04

196
Unknown Maker
Postmortem of Young Girl, ca. 1855
Sixth-plate daguerreotype with elaborate hand-coloring, 400-354-01

197
Unknown Maker
Postmortem of Child, ca. 1848
Quarter-plate daguerreotype, 400-206-99

[C-77]
Unknown Maker
Postmortem of Girl in Red Dress, ca. 1850
Sixth-plate daguerreotype, HF400-459-03

198
Unknown Maker
Undertakers and Grave Diggers in Cemetery, ca. 1850
Sixth-plate daguerreotype, 400-88-97
Handwritten on silk liner: "169 Gilmore [illeg.]."

199
Unknown Maker
Two Men Playing Cards, ca. 1848
Sixth-plate daguerreotype, 400-426-01

200
Unknown Maker
Two Men Playing Dominoes, ca. 1850
Sixth-plate daguerreotype, HF400-526-04

201
Unknown Maker
Three Men Playing Backgammon, ca. 1850
Sixth-plate daguerreotype, 400-256-00

202
Unknown Maker
Elizabeth Sewall Willis Wells and Mrs. Phineas Wells Playing Chess, ca. 1848-50
Half-plate daguerreotype with selective hand-coloring, 400-21-95
A period note identifies the subjects as sisters-in-law.

[C-78]
Unknown Maker
Chess Players, ca. 1846-48
Quarter-plate daguerreotype, 400-187-98

203
Unknown Maker
Man with Pitcher, ca. 1855
Sixth-plate daguerreotype, 400-291-00

204
Unknown Maker
The Temperance Pledge, ca. 1848-50
Sixth-plate daguerreotype, 400-422-01

205
Unknown Maker
Mother and Daughter with Print of George Washington, ca. 1845-48
Half-plate daguerreotype with hand-coloring, 400-348-01

206
Unknown Maker
Child with American Flag, ca. 1854-56
Quarter-plate daguerreotype with hand-coloring, 400-5-95

207
Unknown Maker
Child with Drum, ca. 1855
Sixth-plate daguerreotype, 400-420-01

208
Unknown Maker
Active 1850s
Girl Dressed as Little Red Riding Hood, ca. 1850
Sixth-plate daguerreotype, 663-1-00

209
Unknown Maker
Standing Boy with Powder Horn and Toy Sword, ca. 1855
Sixth-plate daguerreotype with hand-coloring, 400-318-00

210
Unknown Maker
Man in Colonial Costume, ca. 1850
Half-plate daguerreotype with hand-coloring, 400-312-00

211
Unknown Maker
Young Woman Adorned with Floral Garlands, ca. 1850
Half-plate daguerreotype with hand-coloring, 400-532-04

[C-79]
Unknown Maker
Girl in Firefighter Costume, ca. 1850
Quarter-plate daguerreotype, HF400-453-03

212
Unknown Maker
The Adlard Sisters, ca. 1855
Sixth-plate daguerreotype, HF400-485-03

[C-80]
Unknown Maker
Two Men, ca. 1855
Quarter-plate daguerreotype, HF400-516-04

213
Unknown Maker
Four Devilish Men, ca. 1850
Quarter-plate daguerreotype, HF400-551-05

214
Unknown Maker
Two Boys "Fighting," ca. 1850
Sixth-plate daguerreotype, 400-85-97

c-79

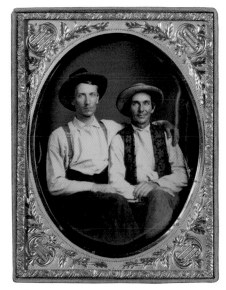

c-80

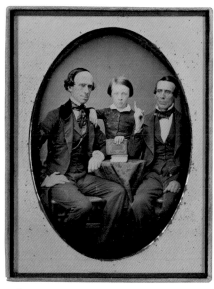

c-81

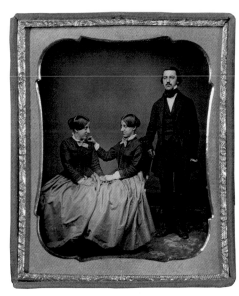

c-82

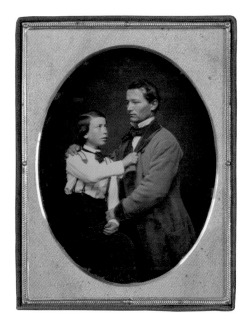

c-83

215 and **216**
Unknown Maker
Two Men Lighting Pipes, ca. 1850-55
Quarter-plate daguerreotype, 400-100-97

Two Men with Upraised Glasses, ca. 1850-55
Quarter-plate daguerreotype, 400-159-98

At some point in the past, these plates were separated. They were acquired by the collection from different sources in 1997 and 1998. They have been reunited in what appears to have been their original presentation: in one case.

217
Unknown Maker
Woman Brushing her Hair, ca. 1850-55
Sixth-plate daguerreotype, 400-30-95

218
Unknown Maker
Mother Nursing Baby, ca. 1850
Half-plate daguerreotype, 400-376-01

219
Unknown Maker
Man Pointing at Bouquet of Flowers, ca. 1850
Sixth-plate daguerreotype, 400-289-00

220
Unknown Maker
Woman with Love Token and Daguerreotype, ca. 1850
Sixth-plate daguerreotype, 400-99-97

221
Unknown Maker
Group of Four Reading a Letter, ca. 1850
Sixth-plate daguerreotype, 400-92-97

222
Unknown Maker
Women with Poem by Lord Byron, ca. 1848
Sixth-plate daguerreotype, 400-113-97

The text in the woman's hand is *The Hebrew Melodies* by Lord Byron.

223
Unknown Maker
Woman with Sheaf of Wheat, ca. 1855
Sixth-plate daguerreotype, 400-213-99

The wheat sheaf symbolized the bounty of the harvest, both earthly and divine.

224
Unknown Maker
Two Gold Miners, One Pointing, ca. 1855
Quarter-plate daguerreotype, 400-299-00

225
Unknown Maker
Two Men with Watches, ca. 1855
Sixth-plate daguerreotype, 400-203-99

226
Unknown Maker
Two Men Holding Hands, ca. 1850
Quarter-plate daguerreotype, 400-350-01

227
Unknown Makerr
Three Lively Women, ca. 1850
Quarter-plate daguerreotype with elaborate hand-coloring, 400-134-98

228
Unknown Maker
Man Seated Casually in Chair, ca. 1855
Stereo daguerreotype (7 x 4¼ in. overall) in Mascher case, 400-230-99

[c-81]
Unknown Maker
Trio (man with upraised finger), ca. 1850
Half-plate daguerreotype, 400-386-01

[c-82]
Unknown Maker
Man with Twin Sisters, ca. 1855
Sixth-plate daguerreotype, 400-124-97

[c-83]
Unknown Maker
Man and Boy, ca. 1850
Quarter-plate daguerreotype, 400-305-00

229
Unknown Maker
Cat by Window, ca. 1850
Sixth-plate daguerreotype, 400-95-97

c-84

c-85

c-86

230
Unknown Maker
Sleeping Cat on Table, ca. 1850-55
Sixth-plate daguerreotype, HF400-549-05

231
Unknown Maker
Dog on Wooden Bench, ca. 1850
Sixth-plate daguerreotype, 400-221-99

232
Unknown Maker
Two Dogs on Rug, ca. 1855
Sixth-plate daguerreotype, HF400-564-05

233
Unknown Maker
Seated Woman with Parrot, ca. 1850
Sixth-plate daguerreotype with hand-coloring,
400-530-04

*In book-style leather case with "Keepsake" printed
on spine.*

234
Unknown Maker
Lizzie Barber with her Bird, ca. 1850
Sixth-plate daguerreotype, 400-201-99

*Handwritten notes: "Lizzie Barber / New Haven /
Friend of Cornelia – Sarah – and Jennie Boston
[illeg.] – KrR.S."*

235
Unknown Maker
Girl with Lamb, ca. 1855
Half-plate daguerreotype with hand-coloring,
HF400-523-04

[c-84]
Unknown Maker
Boy with Donkey, ca. 1850
Sixth-plate daguerreotype, 400-190-98

[c-85]
Unknown Maker
Two Girls in Studio with Deer, ca. 1850
Half-plate daguerreotype, HF400-546-05

[c-86]
Unknown Maker
English Sailor with Monkey, ca. 1860
Sixth-plate ambrotype, 400-443-02

According to Tim Lindholm, this sea captain may
be Erasmus Ommanney (1814-1904), who had a
lifelong career with the navy. He was stationed in
ports of call all over the world, but most notably in
Nicaragua from 1857 to 1860. The monkey pictured
with the sea captain has been identified as a large
spider monkey, indigenous to South America.

236
Unknown Maker
Two Clocks, ca. 1850
Sixth-plate daguerreotype, 400-275-00

[c-87]
Unknown Maker
Document with John Hancock Signature, ca. 1850
Quarter-plate daguerreotype, 400-165-98

237
Unknown Maker
Howell, Michigan (quiet street with dog), ca. 1854
Quarter-plate daguerreotype, 400-98-97

This formerly unidentified view depicts Howell,
Michigan, a village just north of Ann Arbor.
"Hubbell & Gay," as indicated by the sign on the
store front, were attorneys and early settlers of
Howell. Sardis F. Hubbell moved to Michigan in
1835, began the study of law in 1840, and was
admitted to the bar in 1846. In 1854, he moved his
legal practice from Milford to Howell. He was
elected Circuit Court Commissioner, prosecuting
attorney for Livingston County, and president
of the village of Howell; he was also a leading
Mason. Mylo L. Gay moved to Michigan in 1837.
It is uncertain how long Hubbell and Gay prac-
ticed together in Howell. Franklin Ellis, *History
of Livingston County, Michigan* (Philadelphia:
Everts & Abbott, 1879).

238
Unknown Maker
Town in Snow, ca. 1850
Half-plate daguerreotype, 400-316-00

239
Unknown Maker
Cowing & Co., Seneca Falls, New York,
ca. 1850-55
Half-plate daguerreotype, 400-110-97

Cowing & Company, begun in 1840, specialized in
the manufacture of fire pumps. "Seneca Co., NY,"
History of Seneca Co., 1786-1876 (Philadelphia:
Ensign, Everts, Ensign, 1876; repr. W. E. Morrison
& Co., 1976): 48.

A close variant of this plate is included in the Isaacs
Collection, National Museum of American Art,
Smithsonian Institution. Merry A. Foresta,
*American Photographs: The First Century, From
the Isaacs Collection in the National Museum
of American Art* (Washington, D.C.: Smithsonian
Institution Press, 1996): 35.

240
Unknown Maker
New England Town Scene, ca. 1850
Half-plate daguerreotype, 400-267-00

[c-88]
Unknown Maker
Bird's-Eye View of Newport, Rhode Island, ca. 1850
Half-plate daguerreotype, 400-238-99

241
Unknown Maker
*Maiden Lane, New York City (in front of Mark
Levy's store)*, ca. 1843
Sixth-plate daguerreotype, 434-5-97

*The sign on the left in front of the store reads:
"Mark Levy's Circular Pointed Metallic Pens."*

According to the 1841-42 Manhattan business
directory, Mark Levy owned a stationery business
at 65 Maiden Lane, at the corner of Williams
Street. In the 1849 *New York Pictorial Business
Directory of Maiden Lane*, Mark Levy is listed as
owning a business in "Fancy Goods" at 49 Maiden
Lane, in the middle of the block about six doors
down from his last store. The building in the
pictorial directory appears to be the one pictured
here. Levy's store burned in 1852, and by 1868
he had filed for bankruptcy. *New York Pictorial
Business Directory of Maiden Lane* (New York:
Edward Jones, 1849): n.p.

c-87

c-88

242
Unknown Maker
Stagecoach, ca. 1850
Sixth-plate daguerreotype, HF400-513-04

243
Unknown Maker
Stagecoach Scene, ca. 1850
Sixth-plate daguerreotype, 400-271-00

[C-89]
Unknown Maker
Milan, Ohio, ca. 1848
Quarter-plate daguerreotype in original
wood wall frame, 400-78-96

[C-90]
Unknown Maker
Group Posed in Alley, ca. 1843-44
Quarter-plate daguerreotype, 400-440-02

244
Unknown Maker
Horse-Drawn Wagon, ca. 1855
Half-plate daguerreotype, 400-382-01

245
Unknown Maker
Three People in Carriage, ca. 1850
Quarter-plate daguerreotype, 400-349-01

246
Unknown Maker
Two Women on Horseback, ca. 1850-55
Half-plate daguerreotype, HF400-524-04

247
Unknown Maker
Barn Raising, ca. 1850
Half-plate daguerreotype, 400-19-95

248
Unknown Maker
House on Prairie, ca. 1855
Quarter-plate daguerreotype, 400-233-99

249
Unknown Maker
Rural Homestead, ca. 1855
Half-plate daguerreotype, 400-268-00

c-89

c-90

[c-91]
Unknown Maker
Farm Family Posed Outdoors, ca. 1850
Sixth-plate daguerreotype, 400-194-98

[c-92]
Unknown Maker
A Rural Picnic, ca. 1857
Half-plate daguerreotype, 400-122-97

Accompanied by note: "A rural picnic of the olden time. The gentleman in the foreground holding two small daughters is Mary Elizabeth Pidgeon's paternal grandfather (born 1815, died 1902)."

250
Unknown Maker
Locomotive (Adams Express), ca. 1850
Half-plate daguerreotype, 400-37-96

Adams & Co. was started in 1840 by Alvin Adams of Boston. The firm initially ran an express service between Boston and New York City, and for twenty-five years owned all the express lines between these cities. In 1854, with the expansion of additional lines, the company incorporated as the Adams Express Company. During the Civil War, the firm served as paymaster for both sides, with Adams Express in the North and the Southern Express in the South.

251
Unknown Maker
Locomotive, ca. 1855
Half-plate daguerreotype, 400-269-00

252
Unknown Maker
Bridge Construction, ca. 1850
Sixth-plate daguerreotype in center-opening case, 400-228-99

[c-93]
Unknown Maker
Survey Party Camp, ca. 1850
Sixth-plate daguerreotype, 400-243-99

This appears to be a copy daguerreotype made at or near the time of the original.

253
Unknown Maker
Niagara Falls in Winter, ca. 1850
Half-plate daguerreotype, HF400-449-03

254
Joel E. Whitney (attrib.)
1822-1886
Minnehaha Falls, ca. 1855
Sixth-plate daguerreotype, 626-6-05

255
Unknown Maker
St. Anthony's Falls, ca. 1850
Quarter-plate daguerreotype, 400-439-02

256
Unknown Maker
Gold Miner, ca. 1850
Quarter-plate daguerreotype, 400-231-99

[c-94]
Unknown Maker
Seth Boyden in Miner's Dress, ca. 1850
Quarter-plate daguerreotype, 400-120-97

C-91

C-92

Seth Boyden (1788-1870) was a noted inventor. His inventions included improvements to machines for cutting metal (1809) and leather (1812), the creation of patent leather (1820s) and malleable iron (1830s), a cut-off valve for steam engines (1835), and the design of railroad locomotives (1835-48). In 1849, Boyden was caught up in the excitement of the California Gold Rush and by February 1850 was on his way to California. After an unprofitable time in the gold fields, he returned home in March 1851. Boyden was also an early practitioner of the daguerreotype and a known acquaintance of Samuel F. B. Morse. In an article in the *Photographic Times*, E. T. Whitney states: "My earliest recollections of the daguerreotype date from 1840. I was visiting a friend in Newark who showed me a daguerreotype case… it was taken by Seth Boyden, the great inventor." E. T. Whitney, "Reminiscences," *Photographic Times* 14:159 (March 1884): 122. See also: O. Henry Mace, "The Boyden Daguerreotype Camera," *Daguerreian Annual* (Pittsburgh: The Daguerreian Society, 2005): 134-43. Theodore Runyon, *Address for the Erection of a Statue to Seth Boyden* (Newark: Ward & Tichnor Printers, 1880).

257
James M. Ford
1827-1878
Miner with Gold Ore, ca. 1855
Quarter-plate daguerreotype, 684-1-00

Impressed velvet liner reads: "From / Ford's / Daguerrean Gallery / Clay St / San Francisco / and / J. St Sacramento City."

258
Unknown Maker
Gold Miner in Front of Tent, ca. 1850
Sixth-plate daguerreotype, 400-51-96

259 and **260**
Unknown Maker
Gold Mining Scene (camp), ca. 1850-55
Half-plate daguerreotype, 400-31-95

Gold Mining Scene (landscape view), ca. 1850-55
Half-plate daguerreotype, 400-32-95

Two half-plates in one case.

261
Unknown Maker
Gold Miners with Sluice, ca. 1850
Quarter-plate daguerreotype, 400-94-97

262
Unknown Maker
Gold Mining, North Fork, American River, ca. 1850-55
Half-plate daguerreotype, 400-23-95

An engraving of a variant of this daguerreotype was published in *Gleason's* to illustrate the technical advances in mining operations. "The view…is on the north fork of the American River —showing a claim on Horse Shoe Bar. The wheel is for pumping out water on back claims…The 'Milk Punch' house is seen in the background." "Scenes in California," *Gleason's Pictorial Drawing-Room Companion* 6:12 (March 25, 1854): 184.

263
Unknown Maker
Gold Mining Landscape, ca. 1855
Quarter-plate daguerreotype, 400-166-98

264
William Shew
1820-1903
Michigan Bluff, Placer County, California, ca. 1855
Whole-plate daguerreotype, 416-1-95

Note on back of plate gives title and notes: "Signed (stamped) in the plate by Wm. Shew."

265
Unknown Maker
El Dorado County, California, ca. 1855
Half-plate daguerreotype, 400-399-01

Label inside case: "Mountain House [Norris?] El Dorado Co. Cal 1855."

266
George H. Johnson
Active 1850s
Johnson's Studio, Sacramento, California, ca. 1850-55
Half-plate daguerreotype, 625-2-99

Stamped on mat: "G. H. Johnson."

c-93

c-94

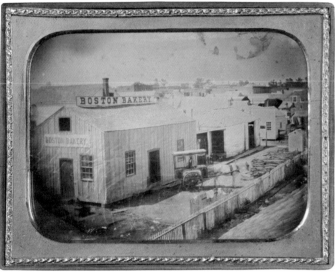

c-95

c-96

George Howard Johnson arrived in San Francisco in 1849; by July 1850, he had established a studio in Sacramento on J Street, between Third and Fourth. After a fire destroyed his Sacramento gallery in 1852, he opened a studio in San Francisco at 197 Montgomery Street in partnership with S. L. Shaw. In 1854, Johnson relocated to 142 Montgomery Street. Peter E. Palmquist, "The Pioneers: Landscape and Studio," in *Capturing Light: Masterpieces of California Photography 1850 to the Present* (New York: W. W. Norton & Company, 2001): 3-20.

267
George H. Johnson
Mining Town, ca. 1850-52
Half-plate daguerreotype, 625-1-98

Impressed velvet liner reads: "Geo. H. Johnson / 33 J St. / Sacramento / Cal."

[c-95]
Unknown Maker
Boston Bakery, Sacramento, California, ca. 1850-55
Half-plate daguerreotype, hf400-450-03

[c-96]
Unknown Maker
Mercantile Building with Freight Cars, ca. 1850
Sixth-plate daguerreotype, hf400-506-03

268
Unknown Maker
Lumber Town, ca. 1850-55
Half-plate daguerreotype, 400-162-98

269
Unknown Maker
Logging Scene, ca. 1850-55
Half-plate daguerreotype, 400-71-96

270
Unknown Maker
Captain Harry Love and California Rangers, ca. 1853
Quarter-plate daguerreotype, hf400-566-06

Joaquin Murrieta was a miner caught up in the aftermath of the Mexican-American war. Stripped of his claims in a territorial dispute, Murrieta retaliated in a spree of robbery and murder. The California Rangers were formed in 1853 in response to the lawlessness in the region. Captain

Harry Love, an army veteran and rugged Texas explorer, was put in charge of the group. In 1853, Love and his rangers located Murrieta and his gang and killed them. As proof of their deed, the head of Murrieta and the hand of his lieutenant, Three Fingered Jack, were cut off and preserved in jars. The *Daily Alta California* reported that these relics were displayed in San Francisco in August 1853. In this previously unknown group portrait, Captain Harry Love is shown in the middle; William T. Henderson, the actual killer of Murrieta, is on his right. William B. Secrest, *The Man From the Rio Grande: A Biography of Harry Love, Leader of the California Rangers Who Tracked Down Joaquin Murrieta* (Spokane: Arthur H. Clark Co., 2005).

271
Unknown Maker
Double Portrait, ca. 1846-50
Quarter-plate daguerreotype, 400-4-95

272
Unknown Maker
"Two-Headed" Man, ca. 1855
Sixth-plate daguerreotype, 400-137-98

273

Unknown Maker

Man with Violin Wearing Woman's Hat, ca. 1850

Sixth-plate daguerreotype, 400-227-99

274

Unknown Maker

Comic Dentist, ca. 1850

Sixth-plate daguerreotype with hand-coloring, 400-15-95

275

Unknown Maker

Child with Brush and Palette, ca. 1850

Quarter-plate daguerreotype, 400-44-96

276

Unknown Maker

Chester Lunn, Jr., as Cupid, ca. 1850

Quarter-plate daguerreotype, HF400-474-03

Written on back of plate: "Chester Lunn Jr., at the age of 3 yrs."

277

George N. Barnard

1819-1902

Woodsawyer, Nooning, 1853

Albumen carte-de-visite (2 ⅛ x 3 ¼ in.), 196-104-96

On C. D. Fredricks & Co. mount; in pencil on back: "Wood Sawyer." This appears to be a copy of the Whipple crystalotype of the original daguerreotype.

This is a slightly cropped copy of the whole-plate daguerreotype awarded an honorable mention in the 1853 Anthony Prize competition. A crystalotype paper-print facsimile (by John A. Whipple) of *Woodsawyer, Nooning* was used as the frontispiece for the *Photographic and Fine Art Journal* 7:1 (January 1854).

278

Alexander Hesler

1823-1895

Driving a Bargain, 1853

Salt print (8 x 5 7/8 in.), 563-2-98

This is a crystalotype by Whipple of the original daguerreotype by Hesler; similar prints were included as the frontispiece in the Photographic and Fine Art Journal *in September 1854.*

The man (named Park) depicted in this photograph was born in Massachusetts and became apprenticed to a blacksmith at an early age. After learning the trade, he traveled to Missouri to attend college. He then settled in Galena, Illinois. In addition to resuming his trade as a blacksmith, he was later elected justice of the peace. "Driving a Bargain," *Photographic and Fine Art Journal* 8:3 (September 1854): 278-79.

279

Unknown Maker

Boys Playing Marbles, ca. 1850-52

Half-plate daguerreotype, 400-247-00

280

Unknown Maker

Boy on Bench with Book, ca. 1843-47

Sixth-plate daguerreotype, 400-25-95

With note bearing the inscription: "Ellery Miller – [Books?] / 1840[?] [Study?]"

281

Unknown Maker

Boy with Hammer and Books, ca. 1843-46

Quarter-plate daguerreotype, 400-16-95

282

Unknown Maker

Painting of Young Girl with Chess Board (surreal still life), ca. 1848-50

Sixth-plate daguerreotype, HF400-563-05

283

Unknown Maker

Young Man on Chair Back, ca. 1850

Sixth-plate daguerreotype, 400-136-98

284

Unknown Maker

Hunters with Owl, ca. 1850

Sixth-plate daguerreotype, 400-245-99

285

Unknown Maker

Preparing for the Camera, ca. 1850

Sixth-plate daguerreotype, 400-246-00

Note in back: "Beardslee Van Alystine standing; Nan Hess Swarthart in center; Helen Augusta Beardslee at left; Helen Beardslee (mother of Guy Beardslee)."

Little is known of this group. Helen Augusta Beardslee is known to have later owned a rural electrification (hydroelectric) plant with her son, Guy Beardslee (1858-1937).

286

Unknown Maker

A Showing of Daguerreotypes, ca. 1850

Quarter-plate daguerreotype, 400-394-01

CHAPTER V

The Rise of Paper Photography

287

Charles D. Fredricks

1823-1894

Fredricks's Photographic Temple of Art, Broadway, New York, 1857

Salt print (16 ⅛ x 13 ¾ in., irreg.), 390-1-95

On back: "Collection – Albert Gilles" ink stamp; and "(Calotype) Temple de l'art Photographique, New-York en 1853" in pencil.

This view, taken before September 1857, establishes the success and prominence of Charles D. Fredricks's studio in New York City. According to *Frank Leslie's Illustrated Newspaper* (6:145 [September 11, 1858]: 230), the words "Photographic Temple of Art" were formed by hundreds of lamps covering a 60-foot semicircular arch. This print is unique and was formerly in the collection of André Jammes, Paris. A single extant print of a variant view, also formerly owned by Jammes, is now held by the J. Paul Getty Museum, Los Angeles. See Beaumont Newhall, *The History of Photography* (Boston: Little, Brown, & Co., 1982): 58.

288

Leavitt Hunt

1830-1907

Grand Hall and Obelisk, Karnak, 1851

Salt print from calotype (paper) negative (7 ⅛ x 8 in.), 480-1-96

After completing his education in Europe, Leavitt Hunt embarked on a tour of the Near East with his friend Nathan Baker, a sculptor. They arrived in Rome in the fall of 1851 and took considerable interest in the photographic work being done there. After two weeks of instruction and practice, Hunt and Baker set off for Egypt, arriving in Alexandria in November 1851. They traveled up the Nile from Cairo to Philae and on to the First Cataract, proceeding then to the St. Catherine monastery in Sinai, and to Petra in March 1852. Hunt also made a few images of Jerusalem and at Baalbek before the conclusion of his trip in Athens. Hunt made a total of 75 to 80 paper negatives. Upon his return to Berlin, he made salt prints from about 60 of these. He included 55 salt prints in a personal album titled *Souvenir de l'Orient*. Once Hunt returned to the United States, he seems to have given up photography.

David Hanlon, "Souvenir de l'Orient: Leavitt Hunt's Album of Wonders," in *Exploration, Vision, and Influence: The Art World of Brattleboro's Hunt Family* (Bennington, Vt.: Bennington Museum, 2005): 14-17; Paul R. Baker, *Richard Morris Hunt* (Cambridge, Mass.: MIT Press, 1980); Mary R. Cabot, "Colonel Leavitt Hunt," *Annals of Brattleboro, 1681-1895*, vol. 2 (Brattleboro, Vt.: Press of E. L. Hildreth & Co., 1921-22): 728.

289

John B. Greene

1832-1856

Medinet Habou, Entrée de la Seconde Cour, 1854

Salt print from calotype negative (9 ¼ x 11 ⅞ in.), 394-1-95

This appears to be a "red" Greene print—made by him before he signed the negative and had subsequent prints produced for public sale. Blind stamp in upper right of mount reads: "Bristol Français."

John Beasly Greene was fascinated with archaeology and Egyptology and had a remarkable aptitude for photography. He worked primarily with the waxed-paper negative process of Gustave Le Gray. During a trip to Egypt in 1853-54, he took a total of 330 negatives, which he divided into three groups: "Inscriptions" (102), "Monuments" (46), and "Paysages" (56). More than 100 other negatives were made apart from these series; they are primarily documents of his paper maché technique for making casts of hieroglyphics.

In 1854, Greene delivered his negatives to the Blanquart-Evrard printing house in Lille. Some historians believe that Greene's album *Le Nil* was published at this time. This work exists in distinctly varied examples. A copy at the Bibliothèque Nationale features prints from the Monuments and Paysages groups. There are several other bound compilations of Greene's work: the Institut de France has two albums, one of Inscriptions and one with Monuments and Paysages; the Société Française has an album of Monuments and

Paysages, all inscribed by Greene. Another album —from which this print is assumed to have come—has been nicknamed "the Red Album" because of the color of the prints; these were thought to have been printed by Greene himself.

Greene returned to Egypt in 1855 with a permit to excavate at Medinet Habou. This archaeological work resulted in a book comprising twelve pages of text and eleven pages of lithographic renderings of hieroglyphs and sculptures. He also put together an album of twelve photographs made on this trip. Greene traveled to Algeria in December 1855 or January 1856. He returned to Egypt later in 1856, where he died—at only twenty-four—in November.

Rachel Topham, *John Beasly Greene* (M.A. thesis, Ryerson University, 2006); Bruno Jammes, "John B. Greene, An American Calotypist," *History of Photography* 5:4 (October 1981): 305-24; Kathleen Stewart Howe, *Excursions Along the Nile: The Photographic Discovery of Ancient Egypt* (Santa Barbara: Santa Barbara Museum of Art, 1993): 28-29, 45, 64; "Notice by Greene," *Photographic and Fine Art Journal* 7:10 (October 1854): 320.

290
John B. Greene
Abu Simbel, ca. 1854-56
Salt print from calotype negative (9 x 12 in.), 394-3-01

Signature in negative, bottom right.

The temple of Abu Simbel was built for Ramses II to commemorate a battle victory. Since it was located close to the Nile River, photographers found it necessary to cross to the right (opposite) bank to capture general views. This dramatically close view was taken on the left bank of the river.

291
John B. Greene
Vue du Portique de Luxor, 1854
Salt print from calotype negative (9 ¼ x 11 ½ in.), 394-2-95

Signature in negative. This appears to be a "Le Gray" Greene print—rich gray in tone and made by Greene in Le Gray's studio for public sale. Numbered ("44") and titled on mount, apparently in Greene's hand.

This photograph is number 44 from Greene's "Paysages" series and is titled *Portique de Lougsor [sic]*. Here, Greene records the ruins of the Temple of Amon at Thebes, Egypt, built by King Amenhotep III, who reigned from 1390 to 1353 B.C. At the left is a lone palm tree; at the right, the remains of an elaborate peristyle court. Topham, *John Beasly Greene*, pp. 44, 48.

[C-97]
John A. Whipple
1822-1891
Portrait of Josiah Parsons Cooke, ca. 1854-56
Salt print (4 ¹⁄₁₆ x 3 ⅛ in.), 2006.29.2. Gift of George R. Rinhart.

In the early 1840s, while a student at Harvard, Cooke made perhaps the first calotype photographs in the United States. He went on to found the department of chemistry at Harvard and enjoyed a distinguished career teaching mathematics.

292
Whipple & Black
1822-1891; 1825-1896
Dartmouth Crew, Connecticut River, Hanover, New Hampshire, ca. 1859
Salt print (5 ¼ x 7 ⅜ in.), HF399-65-05

James Wallace Black was born in Francestown, New Hampshire, and moved to Boston as a young man. He learned photography in Boston from John A. Lerow in 1846; he then worked for L.H. Hale, 1848-50; Loyal M. Ives, 1850-51; and, finally, with John A. Whipple, beginning in 1851. Black worked in partnership with Whipple from 1856 to 1859 under the name Whipple & Black. "In Memoriam," *Wilson's Photographic Magazine* 33: 471 (March 1896), 120-21; Sally Pierce, *Whipple and Black: Commercial Photographers in Boston* (Boston: Boston Athenæum, 1987).

Another print of this image exists in the Rauner Special Collections Library at Dartmouth College. The photograph appears in the Dartmouth College Class of 1860 book. It depicts the crew of the Naiad Queen, including Frederick Chase on the far right.

293
Victor Prevost
1820-1881
The Commonwealth, ca. 1854
Salt print (9 x 13 ⅛ in.), 605-1-98

Signed in pencil on mount and in original negative.

The *Commonwealth* was built in 1854 for the Norwich and New London Steamboat Company; it ran between New York and New London. At the time of its construction, the *Commonwealth* "was not surpassed in strength, beauty of model or magnificence of interior embellishment by any then afloat" (Samuel Stanton, *American Steam Vessels* [New York: Smith and Stanton, 1895]: 137). The *Photographic Art-Journal* (72 [February 1854]: 64) made an editorial mention of Prevost: "Messrs. V. Prevost, C. Derchauchoir & Co., of No. 627 Broadway, have done us the favor to present us with some very fine photographic views of scenes on the North River," where the *Commonwealth* would have been located.

W. I. Scandlin, *Victor Prevost, Photographer, Artist, Chemist* (New York: Press of Evening Post Job Print, 1901): 3-8.

294
Richards & Betts
1822-1903; active 1850s
Old Barley Mill, Brandywine River, June 1854
Salt print (5 ⅝ x 7 ¼ in.), 504-1-97

In pencil on back of mount: "Old Barley Mill, Brandywine, June 1854."

Both a photographer and a landscape painter, Frederick De Bourg Richards was an early proponent of the use of the camera as an aid for artists. An 1865 article in the *Delaware Republican* refers to one of Richards's photographs (made with his partner of 1854-57, John Betts) of an old mill on the Brandywine River that was used as a model for a painting by Henry Price in 1857. According to Kara A. Briggs Green, Curator of Collections at the Historical Society of Delaware, the barley mill depicted in this photograph was built in 1728 on the

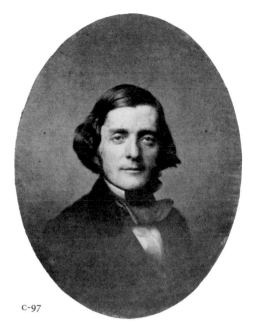

C-97

right bank of the Brandywine River at what is now the foot of Adams Street in downtown Wilmington. It was destroyed by fire in January 1857.

A variant of this photograph was included as the frontispiece of the *Photographic and Fine Art Journal*, October 1854. This was accompanied by a text written by Richards: "The Old Barley Mill—which forms the subject of our present illustration—is situated upon the Brandywine, near Wilmington, Delaware. It is fast falling to decay, yet it is one of the links connecting the present with the past . . . But all this has passed away, and, in a few short years, the old mill will exist but in its pictured views, made lasting by that wonderful Art, the Art Photographic! By whose aid posterity shall know all things hereafter. The beautiful and grand shall be rescued from oblivion and handed down to millions yet unborn!" Frederick De Bourg Richards, "Old Mill on the Brandywine," *Photographic and Fine Art Journal* 7 (October 1854): 316, frontispiece; "The Old Barley Mill," *Delaware Republican* (January 26, 1865): 3.

295
Samuel Masury
1818-1874
On the Loring Estate, ca. 1856
Albumenized salt print (10 ¼ x 13 in.), 389-1-95

Blind stamp on mount: "MASURY'S PHOTO-GRAPH BOSTON." Names of horses and cows inscribed in pencil on mount.

Samuel Masury originally studied with John Plumbe in Boston, in 1842; he then ran his own studio in Salem from 1843 to 1850. By 1852, Masury had moved his business to Boston and added George Silsbee as a partner. By 1854, they began working with the collodion and paper processes. In March 1854, Masury was seriously injured in an explosion in his studio. In 1856, John G. Case was added as a partner to the studio, with the business name changed to Masury, Silsbee, and Case. By 1858, Masury was in business by himself in Boston and he continued to make photographs well into the 1860s.

Masury was commissioned by Charles Greely Loring, a prominent lawyer and the first director

c-98

c-99

of the Museum of Fine Art, Boston, to photograph his estate in Beverly, Massachusetts. Born into a family of privilege, Loring was educated at Harvard, traveled frequently in Europe, dabbled in Egyptology, and enjoyed a gentleman's life in Beverly.

"Daguerreotype Miniatures," *Salem Gazette* [Massachusetts] (July 21, 1843): 3; *Boston Directory* (Boston: George Adams, 1852): 35; "Gas Explosion on Washington Street," *Boston Daily Evening Transcript* (March 10, 1854): 2; Joseph Garland, *Boston's North Shore* (Boston: Little, Brown, & Co., 1978): 92-93, 293, 296.

296
Unknown Maker
Stump-Pulling Scene, ca. 1857
Salt print (10 ¼ x 13 ⅝ in.), 400-255-00

Two oval salt-print portraits—presumably of the stump pullers depicted here—are affixed to the mount above the upper right and left corners of the larger view.

297
Unknown Maker
Lyceum of Natural History of Williams College (Florida Expedition Group), 1857
Salt print (5 ⁹⁄₁₆ x 7 ⅜ in.), HF400-476-03

Caption printed beneath image: "Photographed with their trophies, including Spanish moss, on their return to Williamstown."

The Lyceum of Natural History of Williams College was the first American college- and student-run organization to sponsor scientific expeditions. The Florida expedition, led by Professor Paul Ansel Chadbourne, comprised a group of twenty. Their schooner, the *Dew Drop,* sailed from New York City on February 19, 1857, and arrived at Amelia Island, Florida, on March 8. The group explored the region south to the Florida Keys, gathering many bird, reptile, and plant specimens. They returned to New York City at the end of April. The group is shown here on the Williams College campus, probably in front of Jackson Hall, the home of the Lyceum of Natural History. At least three variants of this image are known and can be found in the Williams College Archives.

Frederick Rudolph, *Mark Hopkins and the Log, Williams College, 1836-1872* (New Haven: Yale University Press, 1956); "Editor's Table," *Williams Quarterly* 4:2 (December 1856): 191.

298
George R. Fardon
1807-1886
Kearny Street, San Francisco, ca. 1855-56
Salt print (6 ¼ x 8 in.), 619-1-98

George R. Fardon was born in Birmingham, England, and emigrated to the United States ca. 1850-54. It appears likely that he learned photography shortly after his arrival in California. Between 1855 and 1858, he operated a successful studio in San Francisco and had a number of partners or operators. This photograph was part of a series taken ca. 1854-56 and published in *San Francisco Album: Photographs of the Most Beautiful Views and Public Buildings of San Francisco, Photographed by G. R. Fardon* (1856).

Kearny Street was one of the major arteries in the commercial heart of San Francisco. James M. Ford opened his studio in September 1854 at Clay and Kearny streets; his sign is clearly visible in this view.

Peter Palmquist, "George Robinson Fardon, Photographer," *San Francisco Album: Photographs of the Most Beautiful Views and Public Buildings, George Robinson Fardon* (San Francisco: Fraenkel Gallery, 1999): 11-32.

[c-98]
Unknown Maker
View of Tremont Street, Boston, ca. 1858
Salt print (16 ⅞ x 13 ⅛ in.), HF400-552-05

299
Frederick De Bourg Richards
1822-1903
Customs House (formerly Second Bank of the United States), Philadelphia, 1859
Salt print (6 x 8 ⅛ in.), 466-2-00

[c-99]
Frederick De Bourg Richards
Congress Hall (Independence Hall), Philadelphia, ca. 1857-59
Salt print (8 x 6 ⅛ in.), HF466-4-05

300
James E. McClees (attrib.)
1821-1887
Theater, Chestnut Street, Philadelphia, ca. 1854
Salt print (8 ⅜ x 6 ½ in.), HF504-5-06

In ink at bottom of mount: "Theatre – Chestnut Street; view taken on the day of the last performance previous to its being torn down."

The structure pictured here is the Chestnut Street Theatre, at Sixth and Chestnut in Philadelphia. Built in 1820, it was known in theater history as "the Old Drury." The last opera here was performed in September 1854 by Julia Daly, and the theater was torn down in 1855.

Struthers Burt, *Philadelphia: Holy Experiment* (New York: Doubleday, Doran & Co., 1945): 189-90; Kenneth Finkel, *Nineteenth Century Photography in Philadelphia* (New York: Library Company of Philadelphia and Dover Publications, 1980): 70, 218; Robert Looney, *Old Philadelphia in Early Photographs 1839-1914* (New York: Free Library Company of Philadelphia and Dover Publications, 1976): 130.

[c-100]
Unknown Maker
Fifth Street, Cincinnati, ca. 1857
Salt print (4 x 5 ⅛ in.), 400-117-97

In pencil on mount: "fifth st. Cin[ti] – Ohio."
From the John R. Johnston album.

301
Williams & Outley
1822-?; 1815-1892
Street Scene, St. Louis, ca. 1859-60
Salt print (11 x 14 ³⁄₁₆ in.), HF818-1-05

In pencil on bottom right of mount: "WILLIAMS [illeg.]."

George L. Williams was first identified as a daguerreian in Alton, Illinois, in partnership with George T. Cornwell. In 1859, Williams opened a studio in St. Louis with John J. Outley. Although they won prizes at the St. Louis Fair in 1860, Williams left Outley and began a partnership with Nicholas Brown.

Freeman A. Durgin and Thomas H. Burtt were flat silver and hollowware manufacturers located at 78 Pine Street, St. Louis, in 1859. After 1860, Burtt disappeared from the firm name; this suggests that this photograph was made ca. 1859-60. In the 1860 St. Louis directory, John J. Outley is listed as owning a coal yard at 81 Chestnut, next door to Durgin and Burtt, facing the opposite end of the block. A close inspection of this photograph reveals a figure holding a top hat directly below the "Wood & Coal Yard" sign. This resembles a known daguerreotype of Outley of 1856 (reproduced in Peter E. Palmquist and Thomas R. Kailbourn, *Pioneer Photographers from the Mississippi to the Continental Divide: A Biographical Dictionary, 1839-1865* [Stanford: Stanford University Press, 2005]: 471).

Palmquist and Kailbourn, *Pioneer Photographers from the Mississippi to the Continental Divide,* pp. 636-37.

02
J. D. Edwards
1831-1900
Steamships at Cotton Wharf, New Orleans,
ca. 1857-60
Salt print (5¼ x 7⅞ in.), 761-1-01

James Dearborn Edwards worked in New Orleans ca. 1857-60. This photograph depicts the Chartres Street wharf. A variant of this view is held by the Historic New Orleans Collection.

303
Black & Batchelder
1825-1896; 1818-1891
Boston as the Eagle and Wild Goose See It, 1860
Albumen print (9½ x 7⅝ in.), 429-4-00

Printed on mount: "Black and Batchelder, Photo.;" "King and Allen, Aeronauts;" and copyright registration data.

James Wallace Black's first effort to make photographs from a balloon—over Providence, Rhode Island, on August 16, 1860—was hampered by inclement weather. His next attempt was on October 13, 1860, over Boston, between 1:00 and 4:00 p.m. Samuel King was the aeronaut, and the balloon, called *The Queen of the Air,* was tethered at an altitude of 1,200 feet above Boston Common. Black exposed a total of six negatives. This image was described by Oliver Wendell Holmes in the *Atlantic Monthly* in 1863: "Boston, as the eagle and wild goose see it, is a very different object from the same place as the solid citizen looks up at its eaves and chimneys. The old South and Trinity Church are two landmarks not to be mistaken. Washington Street slants across the picture as a narrow cleft. Milk Street winds as if the old cow path which gave it a name had been followed by the builders of its commercial palaces. Windows, chimneys and skylights attract the eye in the central parts of the view, exquisitely defined, bewildering in numbers. Towards the circumference, it grows darker, becoming clouded and confused, and at one end a black expanse of waveless water is whitened by the nebulous outline of flitting sails."

Perez M. Batchelder was an itinerant daguerreotypist who traveled throughout the east. After Whipple & Black dissolved their partnership in 1859, Black worked with Batchelder from 1859 to 1862.

This image was first published in "Aerial Photography," *Photo-Miniature* 5:52 (July 1903): 144. Similar prints are held by the Massachusetts Institute of Technology and the Boston Public Library.

William Robinson, *A Certain Slant of Light* (Boston: New York Graphic Society, 1980): 53-59; Samuel A. King, "The Late Balloon Photographing Experiment," *American Journal of Photography and the Allied Arts and Sciences* 3:12 (November 15, 1860): 188-90; "Photographing From a Balloon," *Boston Herald* (October 13, 1860): 4; "In Memoriam," *Wilson's Photographic Magazine* 33:471 (March 1896): 120-21; "Photography in Boston," *American Journal of Photography* 6:14 (January 15, 1864): 222; Oliver Wendell Holmes, "Doings of the Sunbeam," *Atlantic Monthly* 12 (July 1863): 12; Sally Pierce, *Whipple & Black,* 28-30.

C-100

304
Jesse Whitehurst (attrib.)
1820-1875
James Buchanan, 1856
Salt print (7⅜ x 5⅜ in.), 436-3-97

In pencil on front of mount: "Buchanan – 1856."

James Buchanan (1791-1868) was the fifteenth president of the United States. Elected in 1856, he served in a period bitterly divided by the issue of slavery. The Civil War began only weeks after he was succeeded by Abraham Lincoln in early 1861.

305
Alexander Hesler
1823-1895
Abraham Lincoln, 1857
Albumen print (8¼ x 6⅛ in.), 563-1-97

Hesler's blindstamp on mount: "Hesler Artist, 113 Lake St., Chicago." Lincoln autograph fixed to bottom center of image.

Alexander Hesler operated a studio at 113 Lake Street in Chicago from 1857 to 1869.

In 1857, Lincoln was challenging the incumbent, Stephen Douglas, for a Senate seat. Because Illinois was a frontier state, Lincoln wanted to represent himself as a common man rather than as the rather successful attorney he actually was. He chose the clothes he wore to the studio and gave his hair an orchestrated tousle before sitting for this portrait. The resulting image was of a rough-and-tumble character in a plain shirt and rumpled suit. Lincoln encouraged his campaign supporters to use this portrait to underscore his frontier image. In 1860, Lincoln again used photography to help construct a public image—this time of a neat and distinguished man suited for the presidency.

David Hackett Fischer, *Liberty and Freedom* (New York: Oxford University Press, 2005): 341-44.

306
Jesse Whitehurst
Jefferson Davis, ca. 1857
Salt print (6 x 4⅞ in.), 436-5-01

From the John R. Johnston album. Fragment of original album page inscribed "Hon. Jeff Davis."

Jefferson Davis, a military man, first entered politics as a delegate to the Democratic National Convention in 1843. In 1845, he was elected to the House of Representatives. Davis was a founding member of the State Rights Party. After commanding a regiment of volunteers in the Mexican-American War in 1846, he was elected to the Senate, where he was an early proponent of Southern succession. In 1851, he gave up his seat in the Senate partially in protest of the Missouri Compromise. He became secretary of war in 1853 and was instrumental in training the U.S. military in European tactics. Re-elected to the Senate in 1857, he resigned in 1861 at the formation of the Confederate States of America, of which he became the first and only president. Davis was indicted by the U.S. government for treason in 1866 and imprisoned. Later released, he died in 1889.

A full-length portrait of Davis was reproduced on the front page of *Harper's Weekly* on January 9, 1858; the caption reads: "Hon. Jefferson Davis, United States Senator from Mississippi—(Photographed by Whitehurst, Washington D.C.)."

"Jefferson Davis's Life: Career of the Leader of the Confederacy," *New York Times* (December 6, 1889): 2; "Hon. Jefferson Davis," *Harper's Weekly* 2:54 (January 9, 1858): 1.

[C-101]
Unknown Maker
Preston Brooks, ca. 1856
Salt print (7¼ x 5¼ in. oval), 400-404-01

Preston Brooks was a U.S. Representative from South Carolina. In 1856, Senator Charles Sumner of Massachusetts made an antislavery speech verbally abusing Senator Andrew P. Butler of South Carolina, Brooks's relative. Several days later, Brooks walked up to Sumner on the Senate floor and beat him severely about the head and shoulders with a cane. Sumner collapsed and many doubted he would survive. After a lengthy and painful recovery, Sumner returned to work but his health was affected for the rest of his life. Brooks died soon afterward in January 1857.

C-101

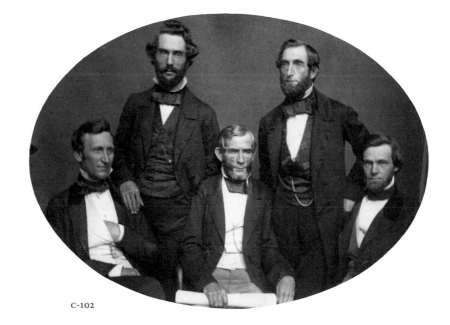

C-102

Grant B. Romer and Brian Wallis, eds., *Young America: The Daguerreotypes of Southworth & Hawes* (Göttingen: Steidl/George Eastman House/International Center of Photography, 2005): 284.

[C-102]
Unknown Maker
Kansas Investigating Committee, 1856
Salt print (5 ⅛ x 7 ⅛ in.), 400-161-98

From the John R. Johnston album. With handwritten caption: "Kansas Investigating Committee / Mordecai Oliver / Wm. A. Howard / John Sherman."

In 1856, the State of Kansas was at the center of the slavery debate. "After the passage of the Kansas bill we had reports in the newspapers of gross frauds at pretended elections of rival legislatures, of murder and other crimes, in short, of actual civil war in Kansas; but the accounts were contradictory." John Sherman, *John Sherman's Recollections of Forty Years in The House, Senate, and Cabinet: An Autobiography, Vol. 1* (New York and Chicago: Werner Company, 1895): 113.

In January 1856, President Pierce requested that the House of Representatives look into these matters. Formed in March 1856, the Kansas Investigating Committee consisted of three House members: John Sherman of Ohio, William Howard of Michigan, and Mordecai Oliver of Missouri. Also included in this group portrait are William Lord, stenographer, and John Upton, sergeant-at-arms. The committee left Washington in April 1856 for an investigation of about two months. Their report confirmed the suspicions of the president.

Sherman, *John Sherman's Recollections, Vol. 1*; J. J. Nicolay and John Hay, "Abraham Lincoln: A History, The Border Conflict," *Century Magazine* 34:1 (May 1887): 90; Mary Sherman-Wills, "The Fight for Kansas," *Archipelago* 6:3 (2003): n.p.

307
Samuel Root
1819-1889
John C. Frémont, 1856
Salt print (7 ¼ x 5 ¼ in.), 598-1-98

John C. Frémont (1813-1890) began his career as a surveyor, charting undocumented lands of the central and western United States. In 1837, he assisted in an army survey of the southern Appalachian Mountains. After the Army Corps of Engineers was formed in 1838, Frémont became a leading explorer, surveying the territory between the upper Mississippi and Missouri rivers. He led explorations of the Oregon Trail in 1842; the Oregon Territory in 1844; and the Great Basin and Sierra Mountains in 1845. In 1846, he fought in the Mexican-American War in California. He was made one of the first senators from California and served from 1850 to 1852. In 1856, at about the time this photograph was taken, he made an unsuccessful run for president. He served in the early years of the Civil War, but with little success: he was stripped of his command by Lincoln for his uncompromising attitude toward emancipation in Missouri (he was later reinstated). From 1878 to 1881, he was governor of the Arizona Territory.

Robert Shlaer, *Sights Once Seen: Daguerreotyping Frémont's Last Expedition through the Rockies* (Santa Fe: Museum of New Mexico, 2000); Tom Chaffin, *Pathfinder: John Charles Fremont and the Course of American Empire* (New York: Hill and Wang, 2002).

[C-103]
Masury, Silsbee, & Case
Active ca. 1856-1858
Rembrandt Peale, 1857
Salt print (6 ¼ x 5 ⅛ in.), 389-2-97

The October 17, 1857, issue of *Ballou's Pictorial* reproduced a wood engraving of a variant image from this portrait session, noted as "taken expressly for the Pictorial by Messrs. Masury, Silsbee, & Case" of Boston. "Rembrandt Peale, The Artist," *Ballou's Pictorial Drawing-Room Companion* 13:16 (October 17, 1857): 241.

Rembrandt Peale (1778-1860) was a painter best known for his portraits of George Washington and Thomas Jefferson.

308
Charles D. Fredricks
Tateishi Onojirō Noriyuki, 1860
Salt print (8 x 6 in. oval), 490-4-97

Subject's name written in script on mount in what appears to be Japanese characters. Previously titled The Japanese Envoy.

In 1860, the Japanese government sent a seventy-seven-member delegation to the United States to exchange ratifications of the Perry treaty made in 1853. The emissaries arrived in San Francisco in March 1860 and toured many major northeastern cities, all to great public interest. There were three senior members of this group, eleven lesser officials, and their support staff. Of particular interest to the American public was a junior interpreter, Tateishi Onojirō. "Tommy" as he was dubbed by the American press, was a "light, good-natured lad, showing more signs of [our] common human nature than his grave, dignified superiors…" ("The Scandal of 'Tommy'," *New York Times* [June 22, 1860]: 4). He quickly became a favorite of the public; he was especially sought after by the ladies. The delegates left New York on June 29, 1860.

"The Scandal of 'Tommy'," *New York Times* (June 22, 1860): 4; W. G. Beasley, *Japan Encounters the Barbarian* (New Haven: Yale University Press, 1995): 56-67; Masao Miyoshi, *As We Saw Them: The First Japanese Embassy to the United States (1860)* (Berkeley: University of California Press, 1979): viii-ix, 43-45.

309
Frederick Gutekunst
1831-1917
Dumb-Bell Charts in Background (Group at Pennsylvania Training School for Feeble-Minded Children), ca. 1858
Salt print (4 ¹⁵⁄₁₆ x 3 ⁶⁄₁₆ in.), 597-5-99

From the book by Isaac Newton Kerlin, The Mind Unveiled *(Philadelphia: U. Hunt & Son, 1858): n.p.*

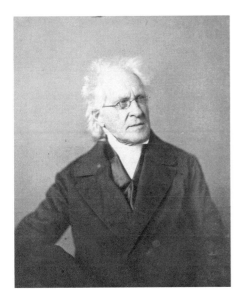

C-103

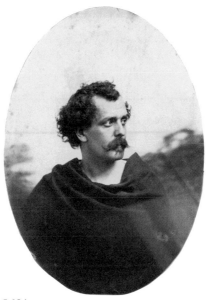

C-104

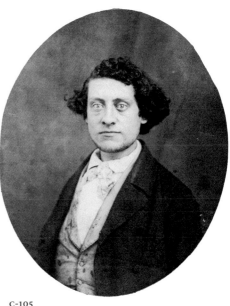

C-105

310
Mathew B. Brady
1823-1896
Moses H. Grinnell, ca. 1858
Salt print (18 x 14¼ in.), 428-3-96

Moses H. Grinnell (1803-1877) was a wealthy businessman who began his professional life as a seaman. After spending time in Europe, he came to New York City to join a firm of shipping merchants, where his brother, Joseph, was a junior partner. In 1829, after his brother left the firm, Grinnell was made a partner and the firm changed its name to Grinnell, Minturn, & Co. Grinnell served in Congress from 1839 to 1841 and remained influential in politics for the rest of his life.

"The Late Moses H. Grinnell," *New York Times* (November 26, 1877): 8.

311
Unknown Maker
Susan M. Davis, 1865
Hand-colored salt print (14 x 10½ in.),
HF400-556-05

Hand-colored; handwritten inscription on mount: "Susan M. Davis / Peoria, Illinois / Spring of 1865."

[C-104]
Albert G. Park
1824-?
Self-Portrait, ca. 1855-56
Salt print (7⅛ x 5⅛ in.), 845-1-97

From the John R. Johnston album. With script title: "Mr. Parker [or Parkes?], Daguerotypest [sic] Parker."

Albert George Park learned to daguerreotype from Chauncy Barnes of Mobile, Alabama. He traveled as an itinerant daguerreotypist throughout Alabama before settling in Montgomery. He was institutionalized in the lunatic asylum of Orleans Parish in Louisiana in 1846 for a manic condition. He then worked in Charleston, South Carolina, for George S. Cook, and in New York City for Mathew B. Brady. He learned the art of paper photography from Charles W. Rhea in Philadelphia and as of 1856 was associated with F. H. Clark and Co. in Memphis.

Original prints of this portrait were included as the frontispiece to the *Photographic and Fine Art Journal* in February 1856, with a brief biography of Park. The editor noted: "The blending of the shadows are seen to be remarkably strong and the base of the background enveloped in clouds, presents at least a totally distinct feature from most other photographs. The perfect outlines so nearly resembling the finest engraving—without any retouching—precisely as it came from the printing frame." N.G. Burgess, "Albert G. Park," *Photographic and Fine Art Journal* 9:2 (February 1856): 59, frontispiece.

[C-105]
Unknown Maker
Charles Waldack, ca. 1856-58
Salt print (6 x 4⅞ in.), 400-105-97

From the John R. Johnston album. Title written in script: "Mr. Waldack, Photographist."

Charles Waldack was a Cincinnati photographer and photo-chemist. He is perhaps best known for the two trips he made to Mammoth Cave in Kentucky (in June and July 1866), using the light of burning magnesium to photograph underground scenes.

Charles Waldack, "Photographing in Mammoth Cave," *Philadelphia Photographer* 3:32 (August 1866): 241-44; and "Photographing in the Mammoth Cave," *Philadelphia Photographer* 3:36 (December 1866): 359-63.

312
E. Anthony
1819-1888
The Burning of Cyrus W. Field's Warehouse in New York, 1859
Albumen stereograph (3¼ x 6¾ in.), 602-8-00

Cyrus W. Field (1819-1892) was an American businessman and financier. After making a fortune at a relatively young age, Field went on to head the Atlantic Telegraph Company, which made several attempts to lay an Atlantic cable. This project finally succeeded in 1866.

313
E. Anthony
Looking up Broadway from the Corner of Grand Street, ca. 1860
Albumen stereograph (3¼ x 6¾ in.), 602-13-01

"A Terrible Distinctness": Photography of the Civil War Era, 1861-1865

314
Andrew J. Russell
1830-1902
Fredericksburg: Rebel Caisson Destroyed by Federal Shells, May 3, 1863
Albumen print (9⅛ x 12⅜ in.), 395-9-03

On December 13, 1862, the Union movement toward the Confederate capitol of Richmond, Virginia, was stopped at Fredericksburg. Federal forces suffered terrible causalities in a futile assault on entrenched Confederate positions. The two armies met again on the same ground on May 3, 1863. This time, Union troops managed to take the Confederate positions on Marye's Heights. Russell made this photograph only hours after the end of fighting that day.

315
David Knox
Active 1860s
The Mortar Dictator, *Front of Petersburg, Virginia*, October 1864
Albumen print (7½ x 9½ in.), HF819-1-05

"The Dictator is a 13-inch mortar, firing a shell weighing two hundred pounds, with a charge of twenty pounds of powder. At an angle of elevation of forty-five degrees the range is set down in the Ordnance Manual at 4,235 yards . . . The bursting of the shell was described as terrific, an immense crater being formed in the ground where it fell, and earth, stones, and sod being scattered in every direction, much to the consternation of the inhabitants of the place." Caption from *Gardner's Photographic Sketch Book of the War*, vol. II (Washington, D.C.: Philp & Solomons, 1865-66): pl. 75.

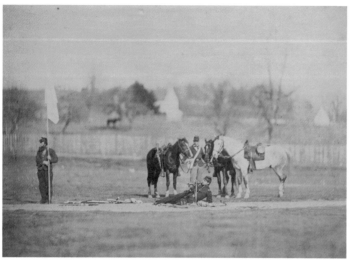

C-106

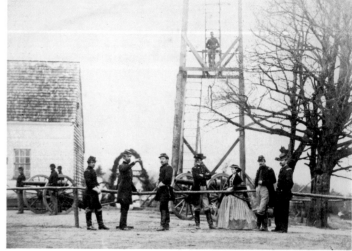

C-107

316

Alma A. Pelot

Active ca. 1860-1900

Floating Battery, Sullivan's Island, Charleston Harbor, April 16, 1861

Salt print (6 ¼ x 7 ⅜ in.), 844-1-99

The Floating Battery, or Iron Battery, was one of several Confederate defensive works in the harbor around Fort Sumter. This battery was located on Morris Island, directly across from the fort. It was constructed of palmetto fiber timber, was covered with plate iron, and contained four cannons of large caliber. Although there were no Confederate casualties in the shelling of Fort Sumter, the Floating Battery did sustain some damage. The day after the fort was evacuated by Federal forces, Alma Pelot, an assistant to Jesse H. Bolles, was allowed to photograph the interior and close surrounding areas. For more on this battery, see "A Visit to Morris Island Batteries and Fort Sumter," *Charleston Daily Courier* [South Carolina] (April 18, 1861): 1; "Fort Sumter," *Charleston Daily Courier* (April 16, 1861): 1; "Forts Sumter and Moultrie and The Floating Battery!" *Charleston Daily Courier* (April 25, 1861): 1; E. A. Pollard, *Southern History of the War* (New York: Charles B. Richardson, 1866).

Alma A. Pelot, a native of Charleston, is documented as a daguerreotypist in that city in 1859, in the employ of photographer Jesse Bolles in 1860, and in the Confederate army in 1862. After his military service, he opened a studio in Augusta, Georgia, which he ran for over 40 years. Bob Zeller, *The Blue and Gray in Black and White: A History of Civil War Photography* (Westport, Conn.: Praeger, 2005): 42.

317

Mathew B. Brady

1823-1896

Abraham Lincoln, 1863

Albumen carte-de-visite (3 ⅜ x 2 ⅛ in.), 428-31-01

Back mark by Anthony.

This portrait is generally assumed to have been made in Brady's Washington, D.C., studio by operator Thomas Le Mere on April 17, 1863. James Mellon, ed., *The Face of Lincoln* (1979; New York:

Bonanza Books, 1982): 122-23; Philip B. Kunhardt, Jr. et al., *Lincoln: An Illustrated Biography* (New York: Knopf, 1992): 209 (here significantly cropped); and Stefan Lorant, *Lincoln: A Picture Story of His Life, Revised and Enlarged Edition* (New York: Bonanza Books, 1969): 150.

318

Mathew B. Brady / E. Anthony & Co.

Ellsworth Memorial, 1861

Two cartes-de-visite flanking circular albumen print (10 ½ x 13 ⅝ in. overall), HF428-35-05

Printed below photograph on mount: "The Marshall House, / Alexandria, VA / Published by E. Anthony, 501 Broadway, N.Y." Also, "Entered according to act of Congress in the year 1861, by M.B. Brady, in the Clerk's office of the District Court of the United States for the Southern District of New York."

"Highly Important News: Col. Ellsworth Assassinated by a Rebel," *New York Times* (May 25, 1861): 1; "Colonel Ellsworth, of the Fire Zouaves," *Harper's Weekly* 5:228 (May 11, 1861): 1.

319

Mathew B. Brady

Camp Sprague, 1st Rhode Island Regiment, 1861

Albumen print (9 ¼ x 14 ⅛ in.), 428-33-03

On "Brady's Incidents of the War" mount.

After the surrender of Fort Sumter, President Lincoln issued a call for 75,000 men to serve a three-month stint in the Union army to suppress the rebellion. Governor Sprague of Rhode Island responded by organizing the 1st Rhode Island Regiment. The two divisions of the regiment, one under the command of Colonel Ambrose E. Burnside, left for Washington, D.C., on April 20, 1861. Frederick H. Dyer, *A Compendium of the War of the Rebellion* (Des Moines: Dyer Publishing Co., 1908).

Surprisingly little scholarly attention has been devoted to Brady's 1861 "Incidents of the War" series. In mid-1862, a reporter for the *New York Times* noted that these photographs filled Brady's studio. This writer observed that they presented "a panorama of the war" that would enable the

"historian to gather material for his pages: for the embrasures of earthworks and the walls of fortresses will crumble…while the colors of their photographic counterparts will only have deepened." "Photographic Phases," *New York Times* (July 21, 1862): 5.

[C-106]

Mathew B. Brady

Signal Corps, Georgetown, 1861

Albumen print (10 x 14 ¼ in.), HF428-34-03

In August 1861, the signal corps was organized to ensure the accurate exchange of information between divisions of the army. In September 1861, the central camp of instruction was established at Georgetown. Here, officers were taught flag signals as well as the use of colored lights and rockets.

[C-107]

Mathew B. Brady

Headquarters, Gen. Morell's Brigade, Minor's Hill, Virginia, 1861

Albumen print (10 ⅛ x 14 ⅛ in.), 428-12-97

On "Brady's Incidents of the War" mount; copyright 1861 by Brady.

Minor's Hill was one of the Union's defensive areas outside Washington, D.C. In 1861, Minor's Hill was used as a winter encampment for intense military training under the leadership of General George McClellan.

320

Mathew B. Brady

Maj. Gen. Burnside and Brady the Artist, Head Quarters of the Army of the Potomac, Near Richmond, Virginia, 1863

Albumen stereograph (3 ⅜ x 6 ⅞ in.), 428-26-00

Published by Anthony.

321

Mathew B. Brady

Jones's 11th Massachusetts Battery, before Petersburg, June 21, 1864

Albumen print (4 ¼ x 7 ⅝ in.), 428-5-96

Inscribed on back of mount: "Before Petersberg [sic], v. similar Vol. I p. 22-23 Miller."

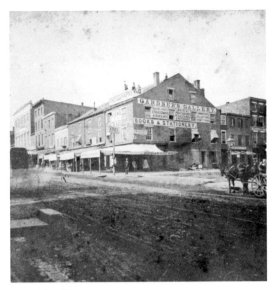

c-108 (detail)

c-109

Captain Edward J. Jones of the 11th Massachusetts was in command of the light artillery brigade. On June 21, 1864, the Union attempted to sever one of the South's major railroad supply lines into Petersburg in an effort to put pressure on the Confederate capitol of Richmond. While this larger mission was not immediately accomplished, the Union improved its strategic position.

William A. Frassanito, *Grant and Lee: The Virginia Campaigns, 1864-1865* (New York: Charles Scribner's Sons, 1983): 252-54.

322
Mathew B. Brady
Brady's Photographic Wagon, ca. 1862
Albumen print (4⅝ x 6⅝ in.), 428-7-96

Inscribed on back of mount: "WE / F5627 #65 Brady vol. 8 p. 27 Miller."

Brady's "What-is-it wagon" was described by George Rockwood as an "ordinary delivery wagon of the period, much like the butcher's cart of today . . . a strong step attached at the rear and below the level of the wagon floor. A door was put on at the back, carefully hung so as to be lightproof. The door came down over the step, which was boxed in at the sides, making it a sort of well within the body of the wagon rather than a true step . . . The work of coating or sensitizing the plates and that of developing them was done from this well in which there was just room enough to work. As the operator stood there the collodion was within reach of his right hand, in a special receptacle. On his left also was the holder of one of the baths. The chief developing bath was in front, with the tanks of various liquids stored in front of it again, and the space between it and the floor filled with plates." "Reminiscences of War Time Photographers," *Anthony's Photographic Bulletin* 2 (1882): n.p.

[c-108]
Alexander Gardner
1821-1882
Gardner's Gallery, Washington, D.C., ca. 1863-64
Albumen stereograph (3¼ x 6¾ in.), 432-22-01

[c-109]
Alexander Gardner
Union Soldier and Horse, ca. 1862-65
Albumen print (6⅞ x 8⅞ in.), HF432-25-05

Printed on mount below photograph: "Gardner Photographer" and "Washington."

323
Alexander Gardner
President Lincoln and General McClellan at Antietam, 1862
Albumen print (6⅞ x 8⅞ in.), 432-17-01

In ink on back of mount: "Interview between President Lincoln and Genl. McClellan."

The battle of Antietam represented the first attempt by Confederate General Robert E. Lee to take the war to the North. On September 17, 1862, Union and Confederate forces met just outside Antietam, Maryland, for what would be the bloodiest battle of the entire conflict. The hard-won Union victory set the stage for Lincoln's preliminary Emancipation Proclamation on September 22, 1862. Lincoln visited the Antietam battlefield on October 2-4, 1862, to congratulate McClellan and his troops.

324
Mathew B. Brady (attrib.)
Winter Camp, Army of the Potomac, ca. 1862
Albumen print (5⅛ x 9 in.), 428-6-96

325
Unknown Maker
Camp near Darnestown, Maryland; General Banks's Division; Best's Battery, 1862
Salt print (5⅝ x 7⅞ in.), 400-41-96

Title in pen on mount.

General Nathaniel Prentiss Banks was put in charge of the 5th Corps of the Army of the Potomac in 1861. Banks's division was located in Darnestown, Maryland, during the battle of Ball's Bluff in October 1861. Captain Clermont L. Best was in charge of Company F, 4th Artillery unit in 1862. Frank Moore, ed., *Anecdotes, Poetry, and Incidents of the War: North and South, 1860-1865* (New York: Publication Office, 1867): 43.

326
David Woodbury
Active 1860s
Military Bridge across the Chickahominy, Virginia, 1862
Albumen print (6¾ x 8⅞ in.), 596-1-98

Plate 17 from Gardner's Sketch Book of the War.

In his accompanying text, Alexander Gardner described the Union effort to construct a bridge through Virginia swamp land. "The picture is taken at a point where the accumulated waters most presented the character of a stream, the swamp being in some places all of a mile in width, and supporting on its treacherous surface a luxuriant growth. In the depths of this morass, the home of almost every variety of Virginia reptiles, the soldiers worked several weeks . . ." Gardner, *Sketch Book of the War*, pl. 17.

327
Egbert Guy Fowx (attrib.)
1821 - ?
On the James River, ca. 1862
Albumen print (5 x 8⅛ in.), 474-3-96

Inscribed on back of mount: "F178 James River Harvey NC 9/14/61."

[c-110]
Egbert Guy Fowx
Butler's Canal, Dutch Gap, James River, Virginia, 1864
Albumen print (5¾ x 8⅛ in.), 474-5-03

About fifteen miles from Richmond, at an area known as Dutch Gap, the James River doubles back on itself in a large loop. By digging a canal through a small peninsula of land, seven miles could be saved on a trip down the river. General Butler and his African American troops worked on this canal from August 1864 to January 1865 under constant attack by Confederate forces. "The Dutch Gap Canal," *Harper's Weekly* 9:421 (January 21, 1865): 38.

[c-111]
Mathew B. Brady
Telegraph Station, Wilcox's Landing, ca. 1864
Albumen stereograph (3¼ x 7 in.), 428-32-01

C-110

C-111

328
Timothy O'Sullivan
1842-1882
Canvas Pontoon Boat, ca. 1864
Albumen print (6¾ x 8½ in.), 391-49-97
Printed title on mount.

The 50th New York Engineers was a regiment of construction workers and canal boat men. Organized in the summer of 1861, they began active duty in March 1862, rebuilding the bridges across the Chickahominy. In fall of 1862, after the battle of Antietam, the regiment laid two pontoon bridges across the Potomac; they later laid pontoon bridges across the Rappahannock at Fredricksburg. The 50th New York Engineers had their headquarters at Rappahannock Station in March 1864, when O'Sullivan documented their encampment and apparatus. "50th New York Engineers," *Military Images* (March/April 2001): n.p.

329
Alexander Gardner and **James F. Gibson**
1821-1882; active 1860s
A Contrast! Federal Buried, Rebel Unburied, Antietam, 1862
Albumen print (3¼ x 4¼ in.), 432-13-00
"Brady's Album Gallery" series, No. 551.

330
Timothy O'Sullivan
The Field Where General Reynolds Fell, Gettysburg, 1863
Albumen print (6¾ x 8⅞ in.), 391-48-97
On Gardner "Incidents of the War" mount.

John Fulton Reynolds was the Union commander of the left wing of the Army of the Potomac. He was loved by his troops and respected by his peers. On July 1, 1863, while marching through the town of Gettysburg, Reynolds's troops were attacked by a large Confederate contingent. While riding to the front to scout for an area in which to set up artillery, he was killed by a sharpshooter. "The Late Gen. Reynolds," *Harper's Weekly* (July 18, 1863): 453.

331
Timothy O'Sullivan
Home of a Rebel Sharp-Shooter at Battle of Gettysburg, 1863
Albumen print (6¾ x 8⅞ in.), 391-47-96
On Gardner "Incidents of the War" mount.

Lee's second attempt to invade the North ended with the battle of Gettysburg on July 1-4, 1863. Gardner, O'Sullivan, and Gibson began to document the battlefield on about July 6. Zeller, *The Blue and Gray in Black and White,* pp. 106-07; William A. Frassanito, *Gettysburg: A Journey in Time* (Gettysburg, Penn.: Thomas Publications, 1975); William A. Frassanito, *Early Photography at Gettysburg* (Gettysburg, Penn.: Thomas Publications, 1995).

332
Mathew B. Brady
Rebel Prisoners, Gettysburg, 1863
Albumen stereograph (3¼ x 7 in.), 428-28-01

These Confederate prisoners were photographed on July 15, 1863, on Seminary Ridge two weeks after the battle of Gettysburg. They were probably found on one of the main retreat routes of Lee's army and were being taken to a prison camp in the North. Frassanito, *Gettysburg: A Journey in Time,* pp. 70-71.

333
Henry P. Moore
1835-1911
"Gwine to da Field," (Hopkinson Plantation, Edisto Island, South Carolina), 1862
Albumen print (5¼ x 7⅛ in.), 433-1-96

At the end of the war, photographs of former slaves in what had been their everyday environments were recognized as surprisingly uncommon. This led to a resurgence of interest in Moore's work from three years earlier. The editors of the *Philadelphia Photographer* included a print of *"Gwine to da Field"* as a frontispiece to its issue of September 1865, with the following commentary: "[the photograph] we present in this issue can never more be taken. It is called 'Gwine to the Field.' The jaded donkey and the sable field-hands

with their implements all explain themselves. When they were taken, they were *slaves*; now they are *free* men and women. The view was made (in 1862) with a single Jamin View lens, by Henry P. Moore, of Concord, N.H., on Edisto Island, S.C., at the plantation of James Hopkinson." "Our Picture," *Philadelphia Photographer* 2:21 (September 1865): 152-53, frontispiece.

A similar image in the New Hampshire Historical Society's collection is titled *Negro Cabin, Hopkinson's Edisto Island, S.C.*, April-May 1862.

334
F. S. Keeler
Active 1860s
Union Officer, ca. 1861-65
Hand-colored salt print (10⅛ x 8¼ in.), 502-1-97
Stamped on back of mount: "F. S. Keeler, S. E. cor. 8th & Market Sts., Phila."

335
Unknown Maker
Confederate Private with '49 Colt Pistol and Sword Bayonet, ca. 1861-64
Sixth-plate tintype, HF400-535-05

336
L. Seebohm & Co.
Active 1860s
Civil War Soldiers in "Combat," ca. 1865
Albumen carte-de-visite (3⅞ x 2⅜ in.), 772-1-01
Studio backmark and 2-cent orange tax stamp on verso.

337
Alexander Gardner
Making Maps, Photographic Establishment, Headquarters, Army of the Potomac, ca. 1863
Albumen print (7¾ x 9¾ in.), 432-4-97
Title written in pencil on back of print.

This view documents Gardner's arrangement to photographically copy maps and other official documents. While technically mundane, this work served a critical military function. Gardner's work addressed a chronic problem outlined in a letter of October 1862 from Major-General Rosecrans to

C-112

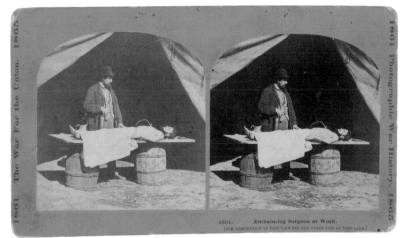

C-113

Secretary of War Stanton: "Destitute of engineers or topographical engineers, groping our way through an unknown wooded and hostile country, we have been obliged to resort to every possible device to obtain and diffuse information among commanders of troops. Having no copyists, when we get a map we have to resort to an improvised photographer, who, taking likenesses, was required to provide himself with the means of copying maps as the tax for the privilege of staying in camp." *Official Records of the Union and Confederate Armies*, Series 1, Vol. 17, Part 2, p. 286.

338
George N. Barnard
1819-1902
View from Rebel Works Southeast of Atlanta, 1864
Albumen print, (10 3/8 x 14 1/2 in.), 196-105-97

339
George N. Barnard
General Sherman's Men Destroying the Railroad, Before the Evacuation of Atlanta, Georgia, 1864
Albumen stereograph (3 1/4 x 7 in.), 196-75-89

Anthony's "War Views" series, No. 3630.

340
Andrew J. Russell
U.S. Military Railroad Wood Yard, April 1863
Salt print (7 1/8 x 9 5/8 in.), HF395-11-06

Ink inscription on board, below image: "U.S. Military Rail Roads / Wood Yard / Alexandria, VA., April 1863."

[C-112]
Andrew J. Russell
Falls of the Potomac, ca. 1863
Albumen print (10 3/8 x 13 7/8 in.), 395-8-03

341
Andrew J. Russell
Locomotive on Trestle, ca. 1863
Albumen print (6 x 8 in.), 395-6-97

Railroads played an unprecedented military role in the Civil War. The Orange & Alexandria Railroad—the only rail link between Washington, D.C., and Richmond, Virginia—ran through some critical battle locations, including Bull Run.

The Bull Run Bridge was destroyed and rebuilt many times in the course of the war. This photograph records the locomotive Firefly, part of the United States Military Railroad (U.S.M.R.R.), on Bull Run Bridge just after it was repaired by the Army Corps of Engineers under the direction of General Herman Haupt. Vincent Virga et al., *Eyes of the Nation: A Visual History of the United States* (New York: Knopf, 1997): 174.

342
William Bell
1830-1910
Successful Excision of the Head of the Humerus, 1864
Albumen print (8 x 6 in.), 392-5-97

On Army Medical Museum mount; a carte-de-visite portrait of the subject is included on back of mount.

When the war began, medical practitioners and institutions had little experience with gunshot wounds and other war injuries. In an effort to address this need, William Hammond, founder of the Army Medical Museum and head of the Union army's medical department, sent a request to all medical personnel "to collect, and to forward to the office of the Surgeon General, all specimens of morbid anatomy, surgical or medical, which may be regarded as valuable; together with projectiles and foreign bodies removed, and such other matters as may prove of interest in the study of military medicine or surgery." William Hammond, *Circular No. 2* (Washington, D.C.: Surgeon General's Office, May 21, 1862): n.p. Each of these specimens, with accompanying contextual information, was recorded in an immense volume, *Medical and Surgical History of the War of the Rebellion*. Many of the Museum's own photographs were taken by William Bell.

The text accompanying this photograph provides information on the circumstance of the injury and a history of its treatment. The soldier, Private R. Jones, of the 67th New York, was wounded in his left shoulder by a conoidal musket ball. The full title of this work is "PHOTOGRAPH NO. 17

—Successful Excision of the Head of the Left Humerus and Coracoid Process of the Scapula." George A. Otis, *Photographs of Surgical Cases and Specimens, prepared by direction of the Surgeon General* (Washington, D.C.: Surgeon General's Office, 1871): 15.

343
William Bell
Recovery After a Penetrating Gunshot Wound of the Abdomen…, 1865
Albumen print (7 1/2 x 6 in.), 392-3-96

Major Henry A. Barnum, 12th New York Infantry, was wounded at Malvern Hill, on July 1, 1862, by a musket ball that entered his stomach and exited through his back. Despite medical complications, repeated surgical operations, and at least two subsequent wounds, Barnum continued his service in the army. He accompanied Sherman's forces in the occupation of Atlanta in 1864, the March to the Sea, and the occupation of Savannah. The complete title of this work is: "PHOTOGRAPH NO. 93—Recovery after a Penetrating Gunshot Wound of the Abdomen, with perforation of the Left Ilium." Otis, *Photographs of Surgical Cases and Specimens*, p. 81.

[C-113]
Unknown Maker
Embalming Surgeon at Work, ca. 1863-65
Albumen stereograph (3 1/4 x 7 in.), HF400-512-03

[C-114]
J. J. Woodward
1833-1884
Photomicrograph of a Crab Louse, ca. 1864-65
Albumen print (6 1/8 x 6 1/4 in.), HF764-3-05

Printed and handwritten in lower center of mount: "WAR DEPARTMENT, / Surgeon General's Office, Army Medical Museum."

The material collected by the Army Medical Museum for the *Medical and Surgical History of the War of the Rebellion* was grouped into two categories: surgical and medical. Dr. John Hill Brinton was in charge of the surgical section, which focused on wounds and related injuries;

C-114 C-115 C-116

Dr. Joseph J. Woodward was in charge of the medical section, devoted to war-related diseases. Dr. Woodward was considered a pioneer in early photomicrographic techniques.

344
Andrew Jackson Riddle
Active 1860s
Andersonville Prison, Georgia. Bird's Eye View; Gathering Roots to Boil Coffee; 33,000 Prisoners in Bastille, August 17, 1864
Albumen print (3¼ x 4¾ in.), 443-1-96

Full title printed on mount.

Opened in February 1864 in rural Georgia, Andersonville was the most notorious of the Confederate prisoner-of-war facilities. Designed for some 10,000 prisoners, the 26-acre camp held as many as 32,000 men at a time in conditions of shocking squalor. Of the total of 45,000 men imprisoned there, nearly 13,000 died. After the war, the commander of Andersonville, Captain Henry Wirtz, was tried as a war criminal, found guilty, and hanged on November 10, 1865. Zeller, *The Blue and Gray in Black and White,* pp. 150-51.

345
Albert J. Beals
1821 - ?
Dictator, Under Construction, 1863
Albumen print (11⅞ x 15¾ in.), 694-1-00

In pen on mount: "Dictator;" in pencil on mount: "Brady & Co."

"The ocean Monitor Dictator is an iron-clad ram, 3033 tons, and carrying two guns. Her length is 321 feet, breadth 52, and depth 22 . . . an attempt to launch her on the 28th of November, 1863, failed. A month afterward she was successfully launched. She is the largest of our iron-clads, except the Dunderberg, and takes part in the second attempt against Fort Fisher." "The Dictator," *Harper's Weekly* 9:422 (January 28, 1865): 1.

Albert Beals entered the daguerreian trade in 1844 in Charleston, South Carolina. He operated a gallery in New York City from about 1846-47

to at least 1854. Subsequently, Beals worked as an operator for Brady in New York City. In November 1863, Beals moved to Nevada, where he practiced as a photographer and as a dentist into the 1880s. Peter E. Palmquist and Thomas R. Kailbourn, *Pioneer Photographers of the Far West: A Biographical Dictionary, 1840-1865* (Stanford: Stanford University Press, 2000): 103.

The attribution of this image is based on information on the mount of an identical print in the New-York Historical Society collection.

[C-115]
Unknown Maker
Young Girl Dressed as Liberty with Crown and Sword, ca. 1863-65
Albumen carte-de-visite (3⅝ x 2⅛ in.), HF400-557-05

The girl is standing on a Confederate volunteer unit flag.

346
Samuel Masury
1818-1874
Frances L. Clayton Dressed as Cavalryman, ca. 1865
Albumen carte-de-visite (3¾ x 2⅜ in.), HF389-3-05

Disguised as a man, Frances Clayton fought alongside her husband in the Civil War. She was wounded at Fort Donelson and her husband killed at Stones River. Upon being discovered to be a woman, she was discharged in 1863. DeAnne Blanton and Lauren M. Cook, *They Fought Like Demons: Women Soldiers in the American Civil War* (Baton Rouge: Louisiana State University Press, 2002): 130-31, 149-50.

347
Samuel Masury
Frances L. Clayton, ca. 1865
Albumen carte-de-visite (3¾ x 2⅜ in.), HF389-4-05

Handwritten inscriptions on verso: "Frances L. Clayton 4 mo / heavy artilery [sic] Co. I 13 mo. Cavalry Co. A / 22 months" and Wi[illeg.] / So. Strong Rd. / Framington, Me."

348
Mathew B. Brady
Major Pauline Cushman Souvenir, ca. 1865
Albumen print (11½ x 6¾ in.), 428-2-96

Original maquette for mass-produced carte-de-visite issued by Anthony.

While performing in Louisville, Kentucky, shortly after the start of the Civil War, the actress Pauline Cushman was arrested by the Union army on suspicion over her Southern roots. When it was determined she was not a Confederate, she was asked to become an agent for the North. She accepted and was employed by General Rosecrans of the Army of the Cumberland, delivering messages throughout the South. Captured by Confederate forces, she was tried and sentenced to death. However, Union troops captured the city in which she was imprisoned and she was freed. "A Thrilling Narrative: Miss Maj. Pauline Cushman, the Federal Scout and Spy," *New York Times* (May 28, 1864): 9.

349
John Carbutt
1832-1905
The Brave Defenders of Our Country, 1863
Albumen carte-de-visite (3 9/16 x 2 5/16 in.), 503-2-99

Printed on front: "The Brave Defenders of Our Country / Photographed and Donated by / J. Carbutt, 131 Lake St., Chicago;" on back of mount in script: "Sp — Th Surling [?]. Presented by her father / As a memento of the Great Ladies Fair held at Chicago, Nov. 1863, for the Soldiers."

[C-116]
Churchill & Denison
1820-1892; 1814-1899
Oriental Booth Groupe, at Army Relief Fair, Albany, New York, 1864
Albumen print (5⅝ x 7½ in.), 410-2-96

Full title at bottom: "Oriental Booth Groupe, at Army Relief Fair, Albany, N.Y., 1864." Names of subjects in pencil on back of mount.

Rensselaer E. Churchill and his partner D. Dension were daguerreotypists in Albany, New York, in the 1850s. In the 1860s, they opened a studio specializing in photographs of school and other groups.

The United States Sanitary Commission was organized to provide the Union army with supplies not available from the government and for "the relief of the sick and wounded of the National Army." The commission held fund-raising fairs in cities throughout the North, to which "every branch of agriculture, trade, industry, and art will be invited to contribute its choicest and costliest products for exhibition and sale." Henry Bellows, Elisha Harris, J. Harsen, W. H. Van Buren, "U.S. Sanitary Commission Report No. 1: An Address to the Secretary of War, May 18, 1861," in United States Sanitary Commission and J. S. Newberry, *The U. S. Sanitary Commission in the Valley of the Mississippi, During the War of the Rebellion, 1861-1866* (Cleveland: Fairbanks, Benedict & Co., 1871): n.p.

350
Unknown Maker
Sojourner Truth, 1864
Albumen carte-de-visite (4 x 2¾ in.),
HF400-570-07

Printed caption: "I sell the shadow to support the substance. / Sojourner Truth." The back of the carte has a copyright date of 1864 and a 2-cent revenue stamp.

351
Myron H. Kimball
1825 - ?
Wilson Chinn, a Branded Slave from Louisiana, 1863
Albumen carte-de-visite (3½ x 2⅛ in.), 662-1-99

Caption: "WILSON CHINN, A Branded Slave From Louisiana. / Photographed by KIMBALL, 477 Broadway, N.Y. / Entered according to Act of Congress, In the year 1863, by Geo. H. Hanks, in the Clerk's office of the United States for the Southern District of New York."

In December 1863, eleven emancipated slaves (eight students and three adults) were brought to New York and Philadelphia for the purpose of being photographed, both singly and in groups. These photographs (usually cartes-de-visite) were then sold to Northern abolitionists to raise funds for New Orleans schools. The most widely distributed photographs were of the "white" ex-slave children, a choice designed not to offend the prejudices of anyone willing to give money to the cause. Although nearly all Northerners were opposed to any form of Negro persecution, few were in favor of true social equality. Maria Morris Hambourg, *The Waking Dream: Photography's First Century* (New York: Harry N. Abrams, 1993): 317; Kathleen Collins, "Portrait of Slave Children," *History of Photography* 9:3 (July-September 1985): 187-210.

Harper's Weekly described Wilson Chinn as follows: "about 60 years old, he was 'raised' by Isaac Howard of Woodford County, Kentucky. When 21 years old he was taken down the river and sold to Volsey B. Marmillion . . . and Wilson has on his forehead the letters 'V.B.M.'" C. C. Leigh, "White and Colored Slaves," *Harper's Weekly* (January 30, 1864): 71. Chinn is pictured with several instruments of torture, including a slave collar around his neck. This instrument was a burden during the day and prevented him from lying down at night. "An Instrument of Torture Used by Slaveholders," *Harper's Weekly* (February 15, 1862): 108.

352
Charles Paxson
1841-1880
Our Protection: Rosa, Charley, Rebecca, 1864
Albumen carte-de-visite (3¼ x 2⅛ in.), 661-3-01

Caption on front of card: "Our Protection. / Rosa, Charley, Rebecca. / Slave Children From New Orleans."

Harper's Weekly described Charles Taylor, Rebecca Huger and Rosina Downs as follows: "Charles Taylor is eight years old. His complexion is very fair, his hair light and silky. Three out of five boys in any school in New York are darker than he. Yet this white boy, with his mother, as he declares, has been twice sold as a slave . . . The boy is decidedly intelligent, and though he has been at school less than a year he reads and writes very well . . . Rebecca Huger is eleven years old, and was a slave in her father's house, the special attendant of a girl a little older than herself. To all appearance she is perfectly white. Her complexion, hair, and features show not the slightest trace of negro blood. In the few months during which she has been at school she has learned to read well, and writes as neatly as most children of her age . . . Rosina Downs is not quite seven years old. She is a fair child, with blonde complexion and silky hair. Her father is in the rebel army." C. C. Leigh, "White and Colored Slaves," *Harper's Weekly* (January 30, 1864): 71.

353
Unknown Maker
Abraham Lincoln's Second Inauguration,
March 4, 1865
Albumen stereograph (3¼ x 6¾ in.), 400-372-01

This appears to be a previously unknown and unpublished view.

354
Unknown Maker
Lincoln's Catafalque, New York, 1865
Albumen stereograph (3¼ x 6¾ in.), 400-370-01

A train bearing the remains of Lincoln from Washington, D.C., entered New York City on April 24, 1865. Following a day of ceremonies, the funeral procession continued to Albany on April 26. "The Remains in New York," *New York Times* (April 25, 1865): 1.

355
Alexander Gardner
Scaffold for Lincoln Conspirators, 1865
Albumen print (7 x 8⅞ in.), 432-18-01

One of five in a series. Gardner credit/copyright on mount.

The assassination of Lincoln was the result of a conspiracy involving more than a dozen people and sanctioned by the president of the Confederacy, Jefferson Davis. In addition to Lincoln, it was planned that Vice President Johnson, Secretary of War Stanton, Secretary of State Seward, and General Grant would be assassinated, leaving the Union devoid of leaders. On April 14, 1865, John Wilkes Booth shot and killed Lincoln at Ford's Theatre. Injured in this act, Booth's escape was aided by Ed Spangler. At approximately the same time, Lewis Payne (a.k.a. Powell or Paine) entered

Seward's house and, after clubbing and stabbing several people, stabbed the Secretary of State. David Herold waited outside with Payne's horse. Other conspirators included Mary Surratt, the owner of the inn where conspirators stayed while in Washington; Dr. Samuel Mudd, who treated Booth's injuries; Michael O'Laughlen, who was supposed to kill Secretary of War Stanton; George Atzerodt, who was to kill Vice President Johnson; Samuel Arnold; and John Surratt.

Booth was killed while eluding capture and John Surratt escaped to Europe. The other eight were tried in a military court for conspiracy and treason. Spangler received a six-year sentence; Dr. Mudd, O'Laughlen, and Arnold all received life sentences; and Mary Surratt, Herold, Atzerodt, and Payne were condemned to death by hanging. The execution took place on July 7, 1865. "The Assassination," *New York Times* (April 19, 1865): 1.

356
Alexander Gardner
Reading the Death Warrant, 1865
Albumen print (6⅞ x 8⅞ in.), 432-20-01

No. 2 in a series of five; Gardner credit/copyright on mount.

357
Alexander Gardner
Hanging of the Lincoln Conspirators, 1865
Albumen print (6⅞ x 8⅞ in.), 432-15-01

One in a series of five; Gardner credit/copyright on mount. In ink on mount: "Sic Semper Sicariis [Thus be it ever with assassins]."

358
M. Witt
Active 1860s
The Soldier's Return, 1865
Albumen carte-de-visite (2¼ x 3¾ in.), 691-1-00

Maker's mark on back of card: "M. Witt, Columbus, Ohio." Handwritten on card: "James / [?] / Webster / India / George."

359
John Carbutt
William T. Sherman and Son, 1865
Albumen print (7⅝ x 7¼ in.), 503-1-97

Lithographed credit on mount: "J. Carbutt, 131 Lake St., Chicago." In pencil on front of mount: "Gen. Wm. T. Sherman / from life." On back of mount: "To Hon. Ginery Twichell, with regards of E.W.W."

A little-known view of Gen. William T. Sherman with his second son, Thomas Ewing (b. 1856), two years after the death of his favorite and oldest son, William Tecumseh Sherman II. His first son, "Willy," died after being exposed to yellow fever while visiting his father's camp. Some scholars believe that Sherman's vengeance in the war was a result of his uncontrollable grief from the loss of his eldest son. James Horan, *Mathew Brady: Historian with a Camera* (New York: Bonanza Books, 1955): 63.

Hon. Ginery Twichell was a Republican member of Congress from the State of Massachusetts from 1867 to 1873.

360
Alexander Gardner
While Judge Olin was Delivering the Address,
June 11, 1865
Albumen print (7 ¼ x 9 ¾ in.), 432-3-97

In pen on face of print: "While Judge Olin was delivering the address." In pencil on back: "Inauguration of a monument at 2nd Bull Run battlefield, 1865 or 6" and "Heintzelman." Ex: Alfred W. Waud collection.

Monuments at Bull Run were erected on June 10, 1865, with dedication ceremonies the following day. These ceremonies included troop maneuvers, the performance of a military band, recitation of a prayer, singing of a hymn, a gun salute, and addresses by various generals and by Judge Olin. Two monuments were erected, the first near the Bull Run Bridge and the second just outside Groveton. It is at this second location that this photograph was taken. "The Bull Run Monuments," *Harper's Weekly* 9:444 (July 1, 1865): 1.

361
George N. Barnard
Rebel Works in Front of Atlanta, No. 2, 1864
Albumen print (10 x 14 ⅛ in.), 196-40-88

Plate 40 from George N. Barnard's album, Photographic Views of Sherman's Campaign *(New York: Wynkoop & Hallenbeck, 1866).*

362
George N. Barnard
Scene of General McPherson's Death, 1864 or 1866
Albumen print (10 x 14 ⅛ in.), 196-35-88

Plate 35 from album Photographic Views of Sherman's Campaign.

The beloved Union general James Birdseye McPherson was killed by Confederate troops while on a routine inspection of the Union line outside Atlanta on July 22, 1864. Barnard photographed the scene shortly after his arrival in Atlanta in September 1864. By that time, fellow officers had erected a sign on the tree near where McPherson had died and had also carved the same text into the tree itself. There was considerable battle debris —cannonballs, wagon wheels, a horse carcass, and other rubbish—littering the spot. Barnard returned in the fall of 1864 or in early 1866 to make another, more considered, view. By this time, much of the battle debris, and the sign on the central tree, had been removed. Barnard carefully organized the elements of the composition and painted over the inscription on the tree. Keith F. Davis, *George N. Barnard: Photographer of Sherman's Campaign* (Kansas City: Hallmark Cards, 1990): 79-80.

363
George N. Barnard
Battleground of Resaca, No. 2, 1866
Albumen print (10 x 14 in.), 196-20-88

Plate 20 from album Photographic Views of Sherman's Campaign.

Sherman's campaign to take Atlanta, begun in the spring of 1864, involved both head-to-head battles (as at Resaca) and a series of flanking moves that forced Confederate forces to fall progressively back toward the city. Davis, *George N. Barnard*, p. 99.

C-117

CHAPTER VII

Nature and Culture: Scenic, Topographic, and Promotional Views

364
Timothy O'Sullivan
1842-1882
Desert Sand Hills near Sink of Carson, Nevada, 1868
Albumen print (7 ⅞ x 10 ⅝ in.), 391-11-96

On U.S. Engineer Department, Geological Exploration, Fortieth Parallel King Survey mount.

After his work during the Civil War, Timothy O'Sullivan was the photographer for the first great postwar Western expedition: the U.S. Geological Survey of the Fortieth Parallel, under the command of Clarence King. From 1867 to 1869, and again in 1872, O'Sullivan worked for King in harsh conditions across Nevada and Utah.

Rick Dingus, *The Photographic Artifacts of Timothy O'Sullivan* (Albuquerque: University of New Mexico Press, 1982); Joel Snyder, *American Frontiers: The Photographs of Timothy O'Sullivan, 1867-1874* (New York: Aperture, 1981); Robin Earle Kelsey, *Photography in the Field: Timothy O'Sullivan and the Wheeler Survey, 1871-1874* (Ph.D. dissertation, Harvard University, 2000).

365
Dunmore & Critcherson
1831-1902; 1823-1892
No. 98. Castle Berg in Melville Bay over two hundred feet high. The Figure, which is some seventy-five feet from the Base, gives an object to compare with the Berg. The Ice in the foreground is about eighteen inches in thickness, 1869
Albumen print (10 ⅞ x 15 ⅛ in.); on page from William Bradford's *The Arctic Regions: Illustrated with photographs taken on an art expedition to Greenland* (London: Sampson, Low, Marston, Low, and Searle, 1873), HF430-003-05

Plate after page 74 of The Arctic Regions.

366
Dunmore & Critcherson
No. 83. Hunting by Steam in Melville Bay, The Party After a Day's Sport Killing Six Polar Bears Within the Twenty-four Hours, 1869

C-118

Albumen print (10 ¾ x 16 ¼ in.), on page from William Bradford's *The Arctic Regions,* HF430-003-05

Plate between pages 64 and 65 of The Arctic Regions.

While sketching one night, Bradford was the first to view a mother bear and her cubs crossing the ice. In the early morning hours, he quietly alerted the crew, who assembled on the deck with their guns. By the end of the day, as recorded here, the hunters in Bradford's party had killed six bears.

[C-117]
Franklin White
1813-?
White Mountains, New Hampshire, 1859
Salt print (6 ⅞ x 5 ⅝ in.), HF817-1-05

Franklin White was a self-taught photographer from Springfield, Massachusetts. He was listed in the 1849 business directory as F. White & Co. He moved to Lancaster, New Hampshire, in 1855 and photographed there through 1868. He was an early enthusiast of paper photography and published rare early views of the White Mountains in 1859-60.

Merry A. Foresta, *American Photographs: The First Century* (Washington, D.C.: Smithsonian Institution Press, 1996): 165; "Personal and Fine Art Intelligence," *Photographic and Fine Art Journal* 7:11 (November 1854): 351.

367
William James Stillman
1828-1901
Eastern Portico of the Parthenon, View Looking Northward and Showing Mount Parnes in the Extreme Distance, ca. 1869
Carbon print (9 ½ x 7 ½ in.), 447-18-01

Plate 15 from Stillman's portfolio The Acropolis of Athens Illustrated Picturesquely and Architecturally in Photography *(London: F. S. Ellis, 1870).*

William James Stillman was originally trained as a painter. He moved to New York City in 1854 where, after a brief time as an art critic, he joined with John Durand to start the weekly art journal *The Crayon.* He learned to photograph in 1858

C-119

C-120

and, in 1859, he published a small volume of photographs taken in the Adirondacks. After extensive travel in Europe, Stillman was appointed the American counsel in Rome in 1861. He was transferred to the American counsel in Crete and moved to Athens in 1868. After the death of his wife, Stillman found solace in his photographic project to document the Acropolis. In 1870, he issued a portfolio of twenty-five of these views. Several variants of this image are known, in both carbon and albumen, with and without a seated figure. (Collection of the Avery Architectural and Fine Arts Library, Columbia University, New York).

Andrew Szegdy-Maszak, "An American on the Acropolis: William James Stillman," *History of Photography* 29:1 (Spring 2005): 1-34; Anne Ehrenkranz, *Poetic Localities: Photographs of Adirondacks, Cambridge, Crete, Italy, Athens* (New York: Aperture, 1988); Elizabeth Lindquist-Cock, "Stillman, Ruskin, and Rossetti: The Struggle Between Nature and Art," *History of Photography* 3:1 (January 1979): 1-14; W. J. Stillman, "Retrospect," *American Annual of Photography* [New York: Scovill Publishing Company] 5 (1891): 156-61.

368
Bierstadt Brothers
Charles, Edward, and Albert Bierstadt
1819-1903; 1824-1907; 1830-1902
The Cathedral, White Mountains, New Hampshire,
ca. 1860
Albumen print (8 1/8 x 6 1/8 in.), 421-4-99

Albert Bierstadt first visited the White Mountains of New Hampshire around 1852. He returned in 1858 to make several paintings. In 1859, Albert and his brothers Charles and Edward were part of a team of artists and photographers that traveled west with Colonel Frederick W. Lander on his exploration of the Overland Trail. Albert continued on to California, but Edward and Charles returned to Massachusetts to open a photography business.

This photograph is described in an excerpt from *Gems of American Scenery consisting of stereoscopic views among the White Mountains* (New York: Harroun and Bierstadt, 1878): 94-95: "About three miles from the Kiarsarge House ... is a large

cavity in the rocks, about forty feet deep and sixty feet high, called the Cathedral. It has a smooth, level floor, and the trees ranged round the opening resemble columns supporting the Gothic arches formed by the boughs."

Crayon (January 1862): 22, repr. in Catherine Campbell, "Albert Bierstadt and the White Mountains," *Archives of American Art Journal* 21:3 (1981): 14-19; Bierstadt Brothers, *Gems of American Scenery*, pp. 94-95.

[c-118]
Bierstadt Brothers
Charles, Edward, and Albert Bierstadt
Below the Flume Looking Down, Franconia Notch, New Hampshire, 1860
Albumen print (15 7/8 x 12 7/8 in.), 421-1-95

Written on mount: "Below the Flume Looking Down." Registered for copyright in 1860.

Campbell, "Albert Bierstadt and the White Mountains," pp. 14-19.

[c-119]
John Moran
1831-1903
A Glimpse of the Schuylkill, from Laurel Hill Cemetery, Philadelphia, ca. 1871-72
Woodburytype (4 3/4 x 6 5/8 in.), 482-1-97

Printed title and credit on mount.

John Moran photographed scenic regions around Philadelphia as well as prominent buildings in the city itself. This photograph was included in the *Philadelphia Photographer* in 1872, but its exact date is in question. The note by the editor of the *Philadelphia Photographer* that accompanied the publication of this photograph ("we have long coveted this charming picture for our magazine") suggests that it may have been made a few years earlier. *Philadelphia Photographer* 9:100 (April 1872): n.p.

John Moran, "The Relation of Photography to the Fine Arts," *Philadelphia Photographer* 2:15 (March 1865): 33-35; Bernard F. Reilly, "The Early Work of John Moran, Landscape Photographer," *American Art Journal* 11:1 (January 1979): 65-75.

369
John Moran
Tropical Scenery, Isthmus of Darien, Panama, 1871
Albumen print (11 1/8 x 8 in.), 482-4-99

On Darien Survey mount.

The Isthmus of Darien was thoroughly explored and mapped to determine whether a ship canal could be built across it. John Moran and Timothy O'Sullivan were hired as photographers, joining a team of engineers, geologists, and botanists. An exploring party under the command of Commander Thomas O. Selfridge left the United States in December 1870. His group navigated the rivers of the isthmus, traversed its dense jungle, and climbed through difficult terrain. G. A. Maack, "The Secret of the Strait," *Harper's New Monthly Magazine* 47:282 (November 1873): 801-20.

[c-120]
Joel E. Whitney
1822-1886
St. Anthony Falls, ca. 1865
Albumen print (6 1/8 x 8 1/8 in. oval), 626-3-99

In pencil on back, factual inscription by D. H. Meredith: "May 23, 1866 / Falls at St. Anthony / Minn. / 10 miles from St. Paul." [Refers to visit to the site by original owner of print.]

Joel Emmons Whitney moved from Maine to St. Paul, Minnesota, in 1850 and opened a daguerreotype studio. When Alexander Hesler visited St. Paul from his studio in Galena, Illinois, Whitney gained additional expertise from him. They photographed together in the summer of 1851 and again in 1852, documenting the landscape around St. Paul, with particular attention given to St. Anthony Falls and Minnehaha Falls. At first, Whitney acted as Hesler's apprentice; after Hesler returned to Galena, Whitney continued to record the local scenery on his own.

Peter E. Palmquist and Thomas R. Kailbourn, *Pioneer Photographers from the Mississippi to the Continental Divide, A Biographical Dictionary, 1839-1865* (Stanford: Stanford University Press, 2005): 629-32.

C-121

C-122

370

Joel E. Whitney

Minnehaha Falls in Summer, ca. 1865

Albumen print (8 ¼ x 6 ⅛ in. oval), 626-1-99

Written in pencil on back: "D. H. Meredith, Falls of Minnie-Ha-Ha, May 23, 1866, Minn. 4 Miles from Minneapolis." [Refers to visit to the site by original owner of print.]

Minnehaha Falls, located just outside Minneapolis, was a popular tourist attraction in the nineteenth century. It was also the inspiration for Henry Wadsworth Longfellow's poem, "The Song of Hiawatha." Whitney photographed the falls repeatedly over the years, in all seasons.

371

Joel E. Whitney

Minnehaha Falls in Winter, ca. 1865

Albumen print (8 ¼ x 6 ⅛ in. oval), 626-2-99

Written in pencil on back: "D. H. Meredith, Falls of Minnie-Ha-Ha, May 23, 1866, Minn. 4 Miles from Minneapolis." [Refers to visit to the site by original owner of print.]

372

Seneca Ray Stoddard

1843-1917

Untitled (Adirondacks Landscape), ca. 1870

Albumen print (10 ½ x 13 ½ in.), 431-1-96

Originally an ornamental painter, Seneca Ray Stoddard moved to Glen Falls, New York, in 1864, where he began a career as a landscape photographer. Stoddard's early photographs were taken in and around Glen Falls and Saratoga Springs, and along the outskirts of the Adirondacks. He made his first trip into the heart of the Adirondacks in the fall of 1870.

William Crowley, *Seneca Ray Stoddard: Adirondack Illustrator* (Rome, New York: Adirondack Museum, 1982); John Fuller, "The Collective Vision and Beyond – Seneca Ray Stoddard's Photography," *History of Photography* 11:3 (July-September 1987): 217-27; John Fuller, "Seneca Stoddard and Alfred Stieglitz: The Lake George Connection," *History of Photography* 19:2 (Summer 1995): 150-58.

373

Herman F. Nielson

1859 - ?

Niagara Falls, ca. 1880

Albumen print (18 ⅝ x 15 ⅝ in.), 475-1-96

Photographer's logo on back: "H.F. Nielson, Manuf. of all kinds of / Paper & Glass Views / Niagara Falls."

Herman F. Nielson lived in Niagara, New York, for much of his life. His father was the president of Prospect Park Company, a local lumber firm. Nielson was first noted as a photographer in the 1880 census; his work at Niagara Falls may have begun in about 1883. His gallery specialized in the "manufacture of all kinds of glass and stereoscopic views, panels, and all the different sized photographs of scenery now in the market … Mr. Nielson … who is senior member of the firm, has had much experience and his pictures are pronounced among the best on the market. With its increased facilities, the firm will be able to supply the demand." "New View Manufactory," *Niagara Falls Gazette* 30:16 (October 10, 1883): n.p.

This view depicts the American Falls, also known as Luna Falls and Bridal Veil Falls. The large rock was named the Rock of Ages. This view, or a very close variant, was reproduced in the popular guidebook *Niagara Falls* (Buffalo: Matthews, Northrup & Co., 1890): 17.

[C-121]

David Butterfield

Active 1880s

The Jefferson Land Slide, 1885

Albumen print (17 ½ x 22 ¼ in.), 487-2-99

Imprinted on mount: "The Jefferson Landslide / July 10, 1885. / Reached only by way of the Boston and Lowell and Whitefield and Jefferson R.R.s.;" photo copyrighted July 21, 1885.

Little is known about David W. Butterfield. He was a photographer and publisher in Cambridgeport, Massachusetts, in the 1880s.

The Jefferson Landslide occurred on July 10, 1885, when a massive quantity of soil and rock slid two miles, from the peak of Cherry Mountain into the valley below. The mudslide obliterated a home,

a barn, cattle, and crops. The landslide occurred inside the White Mountain National Forest and excursion trips were organized for tourists to view the damage.

374

Thomas H. Johnson

Active 1870s

Honesdale, Pennsylvania (panorama, sections 1-4), ca. 1870

Albumen prints (12 x 16 in. each); 620-1/2/3/4-98

Imprinted on mount: "Johnson, Photographer, Scranton, Pa." From series "Views of the Delaware and Hudson Canal and Gravity Railroad."

The series "Views of the Delaware and Hudson Canal and Gravity Railroad" consisted of large-format landscape and industrial views of this firm's facilities and operations in Pennsylvania. It was composed of views in Providence, Carbondale, Honesdale, Archibald, Waymart, Dickson, Scranton, and Olyphant; scenes in the Moosic Mountains; breakers, inclined planes, shafts, bridges, and machine shops; and the Scranton Terminus.

375

Henry P. Bosse

1844-1903

From Bluff at Fountain City, Wisconsin, Looking Downstream, 1885

Cyanotype (10 ⅜ x 13 ⅛ in.), 604-1-98

No. 82a from series "Views on the Mississippi River."

Henry P. Bosse was born in Prussia and came to the United States in the early 1870s. Trained as an engineer, he entered the U.S. Corps of Engineers in 1874 and was head draftsman by 1887. Bosse produced photographs and drawings of various engineering projects along the Mississippi River. He often printed his photographs as cyanotypes ("blueprints"), an easy and inexpensive process.

Mark Neuzil, *Views on the Mississippi: The Photographs of Henry Peter Bosse* (Minneapolis: University of Minnesota Press, 2001); Charles Wehrenberg, *Mississippi Blue: Henry P. Bosse and his Views on the Mississippi River Between Minneapolis and St. Louis, 1883-1891* (Santa Fe: Twin Palms, 2002).

376
Henry P. Bosse
Riverfront, Burlington, Iowa, 1885
Cyanotype (10 ½ x 13 ½ in. oval), 604-2-99

No. 130 in series "Views on the Mississippi River."

377
Charles L. Weed
1824-1903
*The Yo-semite Fall, 2634 Feet High, Yosemite
Valley, Mariposa County, California*, ca. 1864
Albumen print (20 ¼ x 15 ¾ in.), 397-1-95

*On Thomas Houseworth mount. Full title as printed
on mount: "The Yo-semite Fall, 2634 feet high,
Yosemite Valley, Mariposa County, Cal."*

Charles Leander Weed is noted as early as 1855
in the Sacramento directories as operating a
daguerreotype studio. By 1858, Weed was in part-
nership with Robert H. Vance in Sacramento. In
October 1858, he took a series of mining pictures
on the Middle Fork and American River for
Vance. He became the first photographer in
Yosemite in 1859, and he returned there to work
again in 1864. The prints from this latter series
were sold by Thomas Houseworth. These pictures
had wide appeal and were apparently issued over
a period of years; the mount of this print indi-
cates that it was made in the early 1870s. Prints
from Weed's 1864 trip were also used to illustrate
an article for *Harper's New Monthly Magazine*
in May 1866.

Mary Jessup Hood, "Charles L. Weed, Yosemite's
First Photographer," *Yosemite Nature Notes* 38:6
(June 1959): 76-87; "The Yosemite Valley," *Harper's
New Monthly Magazine* 32:152 (May 1866): 697-
708; Peter E. Palmquist, "California's Peripatetic
Photographer: Charles Leander Weed," *California
History* 58:3 (Fall 1979): 194-219; Peter E. Palmquist,
*Points of Interest: California Views, 1860-1870:
The Lawrence and Houseworth Albums* (San
Francisco: Society of California Pioneers, 2002);
Peter E. Palmquist and Thomas R. Kailbourn,
*Pioneer Photographers of the Far West, A Biograph-
ical Dictionary, 1840-1865* (Stanford: Stanford
University Press, 2000): 585-88.

378
Carleton E. Watkins
1829-1916
View from Camp Grove, Yosemite, 1861
Albumen print (15 ¼ x 20 ¾ in.), 406-2-95

Titled in artist's hand; signed in ink on mount.

Carleton E. Watkins learned to daguerreotype in
California in 1854. By 1856, he was operating
James M. Ford's studio and was also producing
large-format wet-collodion landscape photo-
graphs. After the manufacture of his 18 x 22-inch
mammoth-plate camera, Watkins went to Yosemite
in 1861. Many of his resulting views were shown
at the Goupil Art Gallery in New York City in
1862. These photographs were instrumental to
the 1864 designation of Yosemite as "inviolate,"
paving the way for a future national park system.

Palmquist and Kailbourn, *Pioneer Photographers
of the Far West*, pp. 578-83.

[c-122]
Carleton E. Watkins
The Three Brothers, 4480 Feet, Yosemite, ca. 1865-75
Albumen print from wet-collodion negative
(15 ¾ x 20 ¼ in.), HF406-17-05

Credit to Isaiah Taber, publisher, in negative.

379
Carleton E. Watkins
View on the Merced, Yosemite, ca. 1872
Albumen print (15 ⅛ x 20 ⅜ in.), 406-6-97

*In lower left corner of print: "Taber Photo, San
Francisco."*

380
Carleton E. Watkins
Cathedral Rocks, Yosemite, 1861
Albumen print (16 ⅛ x 21 5/16 in.), HF406-19-06

Titled in artist's hand; signed in ink on mount.

381
Eadweard Muybridge
1830-1904
*Cathedral Rocks, Valley of the Yosemite, 2600 Feet
High*, 1872
Albumen print (16 ½ x 21 ¼ in.), HF27-11-05

*Left edge of mount has remnant of red binding.
Printed on mount: "Cathedral Rocks, Valley of the
Yosemite, 2600 feet high, No. 7;" Bradley & Rulofson
credit.*

Born in England, Eadweard Muybridge arrived
in California about 1855. His first serious work in
photography occurred in 1867, with a trip to
Yosemite. He returned there in 1872 with a camera
of 17 x 21-inch format. These views were published
by Bradley & Rulofson, a leading photographic
gallery and supplier in San Francisco.

Mary V. Jessup Hood and Robert Bartlett Haas,
"Eadweard Muybridge's Yosemite Valley Photo-
graphs, 1867-1872," *California Historical Society
Quarterly* 42 (March 1963): 5-26; Mary Jessup
Hood, "Charles L. Weed, Yosemite's First Photog-
rapher," *Yosemite Nature Notes* 38:6 (June 1959):
76-87; Bradley & Rulofson, *Catalogue of Photo-
graphic Views Illustrating Yosemite, Mammoth
Trees, Geyser Springs, and other remarkable and
interesting scenery of the Far West, by Muybridge*
(San Francisco: Francis & Valentine, 1873).

382
Eadweard Muybridge
Pi-Wi-Ack, Valley of the Yosemite, 1872
Albumen print (16 ⅞ x 21 ⅝ in.), 27-10-01

*Title and credit on mount; also, "Shower of Stars,
Vernall Fall, 400 feet fall, No. 28;" Bradley &
Rulofson credit.*

383
Carleton E. Watkins
*The First View of the Mine, View Looking South,
New Almaden*, 1863
Albumen print (15 ¾ x 20 ⅜ in.), 406-1-95

Titled in artist's hand; signed in ink on mount.

This view depicts the New Almaden Quicksilver
Mine outside San Jose, California. The mine pro-
duced mercury, the primary reduction agent in the
processing of gold and silver. Watkins's commission
to record this site came as a result of a legal dispute.

"The Quicksilver Mines of New Almaden," *Harper's
New Monthly Magazine* 27:157 (June 1863): 33;
Peter E. Palmquist, *Carleton E. Watkins, Photographs
1861-1874* (San Francisco: Fraenkel Gallery, 1989).

384
Carleton E. Watkins
Dalles City from Rockland, Columbia River, 1867
Albumen print (15 ¾ x 20 ⅝ in.), 406-3-95

In 1867, Watkins photographed in various parts
of Oregon, including Portland, the area around
Mount Hood, and the Columbia River.

385
Unknown Maker
Pennsylvania Railroad Engine, 1868
Albumen print (10 ¾ x 17 ⅛ in.), HF400-554-05

386
William T. Purviance
1831 - ?
Emigrant Train, West Philadelphia, ca. 1870
Albumen print (9 ¾ x 12 ⅞ in.), 498-1-97

*On lithographed mount; printed on mount:
"Pennsylvania Railroad Scenery; Purviance, Photo.
Philadelphia."*

William T. Purviance operated a daguerreian
studio in Pittsburgh, Pennsylvania, from 1857 to
at least 1860. He was included in the Pittsburgh
business directories as a photographer until 1869.
After 1870, he primarily recorded Pennsylvania
scenery in the stereograph format.

387
James F. Ryder
1826-1904
Station, Atlantic & Great Western Railway, 1862
Albumen print (7 ⅜ x 9 5/16 in.), 398-47-95

Plate 47 from album Photographic Views of the
Atlantic & Great Western RR, *vol. 2 (Cleveland:
J.F. Ryder, 1862).*

The Atlantic & Great Western Railway was formed
in 1857 from smaller rail companies in New York,
Pennsylvania, and Ohio. The owners hoped to
expand to St. Louis, but the start of the Civil War
put them in financial peril. As part of an effort to
attract investment from England, James Ryder
was commissioned to make a series of views in
early 1862. He produced a two-volume set of 129
original photographs. This is the earliest known
photographic survey of a railroad in America: it
predates the work of Alexander Gardner for the
Kansas Pacific Railroad (in 1867) and of Andrew J.
Russell for the Union Pacific Railroad (1867-68).

James F. Ryder, *Voigtländer and I: In Pursuit of
Shadow Catching* (Cleveland, Ohio: Cleveland
Printing & Publishing Co., 1902; repr. New York:
Arno Press, 1973).

388
James F. Ryder
Bridge, Atlantic & Great Western Railway, 1862
Albumen print (7 ⅜ x 9 5/16 in.), 398-41-95

Plate 41 from album Photographic Views of the
Atlantic and Great Western RR, *vol. 2.*

C-123

C-124

[C-123]
Alexander Gardner
1821-1882
Railroad Station, Wamego, Kansas, 1867
Albumen print (7 x 9 1/8 in.), 432-1-96

In 1867, Alexander Gardner was appointed chief photographer for the Union Pacific Railroad, Eastern Division. In September 1867, Gardner left Washington, D.C., for Kansas, where he photographed along the route of the railroad until at least mid-October. Gardner made views not only of the railroad, but also of the surrounding towns, stockyards, and encampments. He published his photographs in the series "Across the Continent on the Kansas Pacific Railroad" (1868).

D. Mark Katz, *Witness to an Era: The Life and Photographs of Alexander Gardner* (New York: Viking, 1991).

[C-124]
Alexander Gardner
Officers Quarters, Ft. David Russell, Wyoming, 1868
Albumen print (13 x 18 3/4 in.), HF432-29-06

In early 1868, Gardner traveled to Cheyenne and Laramie, Wyoming, to record official treaty ceremonies with a number of American Indian tribes. He also photographed Fort David Russell, established as a frontier cavalry post in 1867 in part to protect transcontinental railroad construction crews.

Susan Danly Walther, *The Landscape Photographs of Alexander Gardner and Andrew Joseph Russell* (Ph.D. dissertation, Brown University, 1983).

389
Alexander Gardner
Indian Peace Commissioners Distributing Presents to the Crow Indians, Fort Laramie, Wyoming, 1868
Albumen print (12 7/8 x 18 9/16 in.), HF432-28-06

At Fort Laramie in 1868, Gardner recorded peace commission meetings with various regional tribes, including the Arapaho, Northern Cheyenne, and Crow peoples.

390
Alexander Gardner
Three Chiefs, Fort Laramie, Wyoming, 1868
Albumen print (9 5/8 x 12 3/4 in.), 432-10-99

Names of subjects in pencil on mount: "Fire Thunder, Man afraid of his horses, Pipe;" series title "Scenes in Indian Country" printed on mount.

Gardner published a number of his 1867 and 1868 views, including this one, under the series title "Scenes in Indian Country."

391
Alexander Gardner
Indians Crossing the Platte, Fort Laramie, Wyoming, 1868
Albumen print (9 1/2 x 12 3/4 in.), 432-9-99

Title in pencil on mount; series title "Scenes in Indian Country" printed on mount.

[C-125]
William S. Soule
1836-1908
Pacer's Son, Kiowa-Apache, Fort Still, Oklahoma, ca. 1869
Albumen print (5 1/2 x 4 in.), 438-1-96

392
Andrew J. Russell
1830-1902
On the Mountains of the Green River, ca. 1868-69
Albumen print (8 1/16 x 11 3/8 in.), 395-4-96

Plate 23 from album Great West Illustrated in a Series of Photographic Views from Across the Continent; Taken along the Line of the Union Pacific Railroad, West from Omaha, Nebraska, *vol. 1, (New York: Union Pacific Railroad, 1869).*

After his service in the Civil War, Andrew Joseph Russell became the official photographer of the Union Pacific Railroad. In 1868-69, he recorded the construction of the eastern half of the transcontinental line, from Omaha westward across the high plains of Wyoming and through the mountains of Utah. Original prints from fifty of Russell's negatives were assembled in an album published by the Union Pacific Railroad. These views were intended to help gain financial support for the enterprise and to promote Western tourism.

Nancy Rich, "Politics and the Picturesque: A. J. Russell's Great West Illustrated," *Views* 11:1 (Summer/Fall 1989): 4-6, 24; William D. Pattison, "The Pacific Railroad Rediscovered," *Geographical Review* 52 (January 1962): 25-36; Walther, *The Landscape Photographs of Alexander Gardner and Andrew Joseph Russell.*

393
Andrew J. Russell
Skull Rock (Sherman Summit, Wyoming Territory), ca. 1868-69
Albumen print (8 3/4 x 11 5/8 in.), HF395-10-05

Plate 6 from album Great West Illustrated in a Series of Photographic Views from Across the Continent; Taken along the Line of the Union Pacific Railroad, West from Omaha, Nebraska, *vol. 1; title across bottom reads: "Plate 6, Skull Rock."*

394
Andrew J. Russell
East and West Shaking Hands, Promontory Point, May 10, 1869
Albumen print (9 x 12 1/8 in.), 395-7-98

Title in pen on back of mount; in pencil on back of mount: "5-10-1869."

This photograph documents the completion of the first transcontinental rail line: the joining of the rails constructed by the Union Pacific and the Central Pacific teams. The tracks (1,800 miles in total) stretched westward from Omaha and eastward from Sacramento, uniting at Promontory Point, Utah, on May 10, 1869.

395
Timothy O'Sullivan
Geyser Mouth in Ruby Valley, Nevada, 1868
Albumen print (7 7/8 x 10 5/8 in.), 391-10-96

On U.S. Engineer Department, Geological Exploration, Fortieth Parallel King Survey mount.

396
Timothy O'Sullivan
Virginia City Mine, Cave-in, ca. 1867-68
Albumen print (7 x 7 1/2 in.), 391-56-99

On U.S. Engineer Department, Geological Exploration, Fortieth Parallel King Survey mount; No. 84 in series; ex: Horan collection.

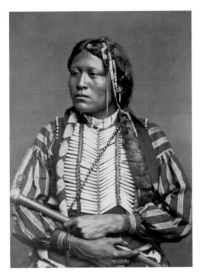

C-125

C-126

C-127

The Comstock Lode in Virginia City, Nevada, was perhaps the richest mineral vein in the world in 1868. About 3 miles long by 600 yards wide, it yielded $12 million annually. The Gould & Curry operation, which went into production in 1859, was one of many mines in this region. In the 1860s, the Gould & Curry mine penetrated to the remarkable depth of 821 feet. As this image suggests, mine cave-ins were not unusual.

C. L. B., "The Pacific Coast: Virginia City and the Silver Mines," *New York Times* (February 11, 1868): 2.

397
Timothy O'Sullivan
Aboriginal Life among the Navajo Indians, Near Old Fort Defiance, New Mexico, 1873
Albumen print (10 7⁄8 x 8 in.), 391-63-99

On Geographical Explorations and Surveys, West of the 100th Meridian, War Department, Corps of Engineers, U.S. Army Wheeler Survey mount.

In addition to his work for Clarence King, Timothy O'Sullivan was the photographer for Lieutenant George M. Wheeler's U.S. Geological Survey of the 100th Meridian in 1871 and 1873. The 100th Meridian—which runs north-south from the middle of North Dakota into Texas—was considered the boundary between the moist East and the arid West. O'Sullivan focused on landscape views, river scenes, military forts, and American Indians.

Robin E. Kelsey, "Viewing the Archive: Timothy O'Sullivan's Photographs for the Wheeler Survey, 1871-74," *Art Bulletin* 85:4 (December 2003): 702-23.

[C-126]
William Bell
1830-1910
Cañon of Kanab Wash, Colorado River, Looking South, 1872
Albumen print (10 3⁄4 x 8 in.), 392-1-95

On Explorations and Surveys West of the 100th Meridian, War Department Corps of Engineers U.S. Army Wheeler Survey mount; No. 4 in series.

William Bell was born in England and moved to Philadelphia at a young age. He fought in the Mexican-American War in 1846. Around 1848, Bell learned to daguerreotype while working in the studio of John Keenan in Philadelphia. By 1851, Bell had his own studio and showed several of his daguerreotypes in the exhibition of the Institute of American Manufacturers. Between 1854 and 1857, he worked in partnership with Lybrand Clayton. He had another partnership, with D. Biderman, in 1858 and 1859. At some point in this period, Bell was briefly employed by James E. McClees. In 1862, he volunteered for military service. After serving in the field for three years, he went to work for the Army Medical Museum in Washington, D.C. (see previous Bell entries). In 1867, he purchased the McClees studio in Philadelphia, which he operated until 1875. Bell spent the summer of 1872 working in Utah and Colorado for the survey of Lieutenant George M. Wheeler. In 1878, Bell did some work for the Pennsylvania Railroad. He was part of the 1882 Transit of Venus expedition, and in 1884, he photographed for the Kentucky State Geological Survey. Bell continued working until his death in 1910. Terence Pitts, *William Bell: Philadelphia Photographer* (MA thesis, University of Arizona, 1987).

[C-127]
William Bell
Looking South into the Grand Canyon, Colorado River, Sheavwitz Crossing, 1872
Albumen print (10 7⁄8 x 8 in.), 392-2-95

On Explorations and Surveys West of the 100th Meridian, War Department Corps of Engineers U.S. Army Wheeler Survey mount; printed on mount: "W. Bell Phot." and "No. 9."

This photograph was taken from a notable vantage point. "Two parties during the season have visited at special points the lower of the main grand cañons of the Colorado River. These points... [afford views of] some of the most striking topographical details that are known in the world, [but which can be only] partially

delineated upon a map, no matter what its scale may be. Photography assists us somewhat in gathering ideas of land forms..." George M. Wheeler, *Progress Report Upon Geographical and Geological Explorations and Surveys West of the One Hundredth Meridian in 1872 under the direction of Brig. Gen. A.A. Humphreys* (Washington, D.C.: Government Printing Office, 1874): 38.

398
Timothy O'Sullivan
Black Cañon, Colorado River, from Camp 8, Looking Above, 1871
Albumen print (8 x 10 3⁄4 in.), 391-2-95

On Geographical Explorations and Surveys, West of the 100th Meridian, War Department, Corps of Engineers, U.S. Army Wheeler Survey mount; No. 8 in series.

399
Timothy O'Sullivan
Ancient Ruins in the Cañon de Chelle, New Mexico Territory, 1873
Albumen print (10 3⁄4 x 7 7⁄8 in.), 391-1-95

On Geographical Explorations and Surveys, West of the 100th Meridian, War Department, Corps of Engineers, U.S. Army Wheeler Survey mount; full title on mount: "Cañon de Chelle, Ancient Ruins in the Canon de Chelle, N.M. In a niche 50 feet above present Canon bed. No. 11."

This iconic view of ancient Anasazi cliff dwellings was made at Canyon de Chelly, in what is now northeast Arizona.

400
Timothy O'Sullivan
Shoshone Falls, Snake River, 1874
Albumen print (7 7⁄8 x 10 3⁄4 in.), 391-5-95

On Geographical Explorations and Surveys, West of the 100th Meridian, War Department, Corps of Engineers, U.S. Army Wheeler Survey mount with original text page. Full title on mount: "Shoshone Falls, Snake River, Idaho. Midday view. Adjacent walls about 1000 feet in height."

C-128

C-129

[C-128]
William Henry Jackson
1843-1942
Hayden Survey Party, ca. 1875
Albumen print (6¾ x 8¾ in.), 499-4-99

*On Department of the Interior, U.S. Geological
Survey of the Territories Hayden Survey mount;
printed on mount: "W.H. Jackson, Photo."*

William Henry Jackson turned to photography in
1867, when he and his brother opened the Jackson
Brothers Studio in Omaha, Nebraska. Jackson
enjoyed outdoor work and became known for his
images of the Indians living outside Omaha. By
1869, he was traveling along the Union Pacific
Railroad west of Omaha, photographing scenery.

The U.S. Geological and Geographical Survey of
the Territories was first organized in 1867 under
the direction of geologist Ferdinand V. Hayden.
The survey covered a vast area, including the
states of Colorado, Utah, and Wyoming. Jackson
was the survey's official photographer from 1870
to 1878.

401
William Henry Jackson
Grand Canyon of the Yellowstone, ca. 1872-73
Albumen print (12⅜ x 9½ in.), 499-5-99

*On Department of the Interior, U.S. Geological
Survey of the Territories Hayden Survey mount.*

[C-129]
William Henry Jackson
*Navajo Church, near Fort Wingate, Arizona
Territory*, ca. 1880
Albumen print (21¼ x 16¾ in.), 499-1-97

*Printed in negative: "1063. Navajo Church, near
Fort Wingate, A.T. W.H. Jackson & Co., Denver."*

After gaining invaluable experience with the
Hayden survey, Jackson returned to private
practice in 1879. He opened his own business in
Denver and became renowned for his views of
landscape and railroad subjects.

402
William Henry Jackson
Cañon of the Rio Las Animas, ca. 1880
Albumen print (16¾ x 21⅛ in.), HF499-9-03

[C-130]
Charles R. Savage
1832-1909
Yucca Brevifolia, Mojave Desert, California, ca. 1870
Albumen print (8½ x 10¼ in.), 464-1-96

*On original mount; titled in negative; variant title
in French on mount: "Forêt de yuccas du désert
de Mojave sur l'Atlantic & Pacific U.S. California."*

Charles Roscoe Savage emigrated from England
to the U.S. in 1856, after adopting the Mormon
faith. On assignment for the church, he established
a daguerreotype studio in Council Bluffs, Iowa.
He moved to Salt Lake City in 1860, where he
opened a studio in partnership with Marsena
Cannon, and later with George Ottinger. By 1869,
he was in business by himself. Savage documented
the joining of the transcontinental rail lines at
Promontory Point, on May 10, 1869. A prolific
landscape photographer, Savage recorded scenery
throughout the West. Around 1870, he opened
his Pioneer Art Gallery, later renamed the Art
Bazaar. This gallery burned to the ground in 1883,
resulting in the loss of most of his negatives.

The figure under the central yucca in this photo-
graph has been identified as Savage.

Bradley W. Richards, *The Savage View: Charles
Savage, Pioneer Mormon Photographer* (Nevada
City, Calif.: Carl Mautz Publishing, 1995); MSS
P 24, *C.R. (Charles Roscoe) Savage Photograph
Collection*, Photo Archives, L. Tom Perry Special
Collections, Harold B. Lee Library, Brigham
Young University.

403
James Fennemore
1849-1941
Nan-Kun-To-Wip Valley, Grand Canyon, 1872
Albumen print (13 x 9¾ in.), 525-1-97

On Smithsonian mount.

The second Powell Expedition (1871-72) explored
the Grand Canyon. In January 1872, Salt Lake
City photographer James Fennemore was hired
to replace the expedition's original photographer,
E. O. Beaman. In the summer of 1872, Fennemore
became too sick to continue and was replaced by
John K. Hillers.

Robert Cahn and Robert Glenn Ketchum, *American
Photographers and the National Parks* (New York:
Viking Press, 1981); F. S. Dellenbaugh, "The Great
Walled River," *Journal of the American Geographical
Society of New York* 19 (1887): 113-63.

404
John K. Hillers
1843-1925
*South Face of the East Peak of the "Three
Patriarchs," Zion National Park, Utah*, ca. 1872-74
Albumen print (16½ in. diameter), 393-4-95

John K. Hillers began with the Powell Survey as an
oarsman. He learned photography as an assistant
to both Beaman and Fennemore. In mid-1872,
when Fennemore was unable to complete his
work, Hillers took over as the expedition's official
photographer.

Don Fowler, *The Western Photographs of John K.
Hillers: Myself in the Water* (Washington, D.C.:
Smithsonian Institution Press, 1989).

405
John K. Hillers
Modisi, a Moki Girl (Walpi, Arizona), 1879
Albumen print (9 ⅛ x 7 ¼ in.), 393-3-95

On gray Smithsonian mount; photographer's credit and title in negative.

In 1879, Congress rolled all the Western surveys into one organization—the U.S. Geological Survey—and created the Bureau of American Ethnology to continue the study of the native peoples of the West. John K. Hillers made many ethnographic studies of American Indian tribes in the Southwest, including the Hopi, Zuni, Navaho, Ute, and Paiute. After John Wesley Powell became the head of the U.S. Geological Survey in 1881, Hillers became the organization's chief photographer. He spent much of his time in Washington, D.C., with periodic trips to the West.

Paula Richardson Fleming, *Native American Photography at the Smithsonian* (Washington, D.C.: Smithsonian Books, 2003); Julian H. Steward, *Notes on Hillers' Photographs of the Paiute and Ute Indians Taken on the Powell Expedition of 1873* (Washington, D.C.: Smithsonian Institution Press, 1939).

[C-131]
John K. Hillers
Ruins in Mummy Cave, Canyon del Muerto, Arizona, ca. 1879
Albumen print (9 ¾ x 13 in.), 393-6-96

Title and credit in negative; written in pen on mount: "Ruins in Mummy Cave, Canones, N.M."

[C-132]
James Wallace Black
1825-1896
Frank Cushing with Zuni Bow Priests and a Hopi, Boston, 1882
Albumen print (6 ½ x 8 ⅝ in.), 429-2-97

Frank Cushing was commissioned by the Smithsonian Institution to document the lives and traditions of Pueblo Indians in New Mexico. After immersing himself in Zuni culture, he learned that the Zuni required sea water from the Atlantic for ritual purposes. Cushing offered to take five elders to Boston to obtain the salt water, provided they made him a member of their tribe. Pictured here are Lai-in-ah-tsai-lun-kia, second priest of the tribe and Cushing's "father;" Nai-in-tchi, first priest of war; Ki-a-si, second priest of war; Pa-lo-wah-ti-wa, Head Chief of the Nation; Na-na-he, a native Moqui Indian admitted to the Zuni tribe; and Frank Cushing.

Jesse Green, ed. *Cushing at Zuni: The Correspondence and Journals of Frank Hamilton Cushing, 1879-1884* (Albuquerque: University of New Mexico Press, 1990): 218-23, 228-33, 398-401; Sylvester Baxter, "The Father of the Pueblos," *Harper's Monthly Magazine* 65:385 (June 1882): 72-91; "A Boston Revival," *New York Times* (March 31, 1882): 4.

C-130

C-131

C-132

A World of Photographs

406

Unknown Maker

General Ulysses S. Grant, ca. 1863-68

Albumen print (7 5/8 x 6 1/4 in.), 400-14-95

Uncut sheet of stamp photos.

Ulysses S. Grant (1822-1885) was responsible for the first Union victories in the Civil War, in 1862. The following year, he gained federal control of the Mississippi River, and in 1864 was appointed the general-in-chief of all Union armies. He received the Republican nomination for president in 1868 and was elected to two terms (1869-77).

Another example of this uncut sheet resides in the George Eastman House collection. The exact date and use of these images is uncertain. They may have been copy images of a slightly earlier, wartime portrait intended for campaign buttons in 1868.

407

W. H. Jacobi

Active 1870s

Self-Portrait in Studio, ca. 1875

Albumen stereograph (3 7/8 x 6 7/8 in.), 782-1-01

W. H. Jacobi may have been located in Minneapolis, Minnesota.

408

J. Reid

Active 1870s

Self-Portrait in Studio (hand-coloring a photograph), ca. 1870

Albumen stereograph (3 3/8 x 6 7/8 in.), 784-1-01

J. Jefferson Reid was located in Patterson, New Jersey, in the 1870s. He exhibited work at the National Photographic Association in 1871 and 1874, and at the Centennial Exhibition in Philadelphia in 1876.

409

D. Appleton & Co.

Active 1850s-1860s

Appleton's Stereoscopic Emporium, ca. 1865

Albumen stereograph (3 1/4 x 6 7/8 in.), 671-1-00

Hand-colored.

D. Appleton & Co. was the first firm to sell stereographs in the U.S., first by importing views from Europe and later, in 1856, by publishing their own.

410

Mathew B. Brady

1823-1896

Brady Studio, 785 Broadway (at Tenth Street), New York City, ca. 1864-65

Albumen print (8 x 9 3/4 in.), 428-15-99

Back of mount shows Brady Gallery imprint.

In 1860, Mathew B. Brady opened the National Portrait Gallery, a new studio at 785 Broadway. During the Civil War, Brady exhibited his war views in this space. He occupied this prestigious address through the early 1870s. Mary Panzer, *Mathew Brady and the Image of History* (Washington, D.C.: Smithsonian Institution Press/National Portrait Gallery, 1997).

411

Mathew B. Brady

Lilliputian Souvenir, ca. 1863

Albumen cartes-de-visite (13 3/4 x 8 1/4 in. overall), 428-1-96

Original maquette for mass-produced carte-de-visite by E & H. T. Anthony.

Charles Sherwood Stratton (1838-1883), or Tom Thumb, was discovered by P. T. Barnum in 1842, and quickly became an international sensation. In 1863, he married Lavinia Warren (1841-1919) in a highly publicized "Fairy Wedding." The photographs of that event reproduced here also include Lavinia's sister, Minnie Warren (1848-1875), and George Washington Nutt (1844-1881). Philip B. Kunhardt, Jr., Philip B. Kunhardt III, and Peter W. Kunhardt, *P.T. Barnum: America's Greatest Showman* (New York: Knopf, 1995).

412

Mathew B. Brady

Professor T. A. Edison, and his Speaking Phonograph, 1878

Albumen cabinet card (5 1/2 x 4 in.), 428-14-98

Thomas A. Edison (1847-1931) applied for a patent for his phonograph in February 1878.

413

Charles D. Fredricks

1823-1894

P.T. Barnum and Commodore Nutt, ca. 1865

Albumen carte-de-visite (4 x 2 3/8 in.), 390-9-01

Fredricks & Co. backmark and (in pencil) "Barnum and Nutt."

In 1862, P. T. Barnum discovered another little person, George Washington Nutt (1844-1881), to add to his Lilliputian show. Commodore Nutt, as he was called, was even smaller than Tom Thumb: he stood 29 inches tall at the age of eighteen. Nutt served as best man at Tom Thumb's 1863 wedding. "Barnum's American Museum. Commodore Nutt," *Harper's Weekly* (February 22, 1862): 128.

[c-133]

Charles D. Fredricks

Self-Portrait, 1873

Albumen cabinet card (6 1/4 x 2 7/8 in.), 390-7-01

414

Longworth Powers

1835-1904

Hiram Powers, ca. 1865

Albumen carte-de-visite (3 3/4 x 2 1/4 in.), 585-1-98

Longworth Powers was the son of Hiram Powers (1805-1873), an American neoclassical sculptor best known for his *Greek Slave* of 1843.

415

Naegeli

Active 1880s

William "Buffalo Bill" Cody, ca. 1880

Albumen cabinet card (5 7/8 x 4 in.), 575-1-97

William Frederick Cody (1846-1917) served in the 7th Kansas Calvary Regiment and was a scout for the U.S. Army at Fort Laramie. In 1883, he created "Buffalo Bill's Wild West," a touring show of

frontier and Native American performers. For other portraits of Cody—and a catalogue of the ephemera stemming from his celebrity—see James W. Wojtowicz, *The W. F. Cody Buffalo Bill Collector's Guide with Values* (Paducah, Kentucky: Collector Books, 1998).

416

George K. Warren

1824-1884

Frederick Douglass, ca. 1870

Albumen cabinet card (4 1/2 x 3 1/2 in.), 556-3-98

417

Jeremiah Gurney

1812-1886

Walt Whitman, ca. 1868

Albumen print (8 x 6 in. oval), 424-6-98

Rejected at first as rude and offensive, the poems of Walt Whitman (1819–1892) are now recognized as some of the greatest achievements in nineteenth-century American literature. His book *Leaves of Grass* first appeared in 1855.

418

William Kurtz

1834-1904

Walt Whitman, ca. 1870

Albumen print (6 x 5 1/2 in.), 522-1-97

[c-134]

Unknown Maker

Millie and Christine McCoy, Siamese Twins, ca. 1865

Albumen carte-de-visite (4 x 2 3/8 in.), 400-421-01

Removed from original backing and affixed to a new carte mount without a back mark.

Conjoined twins Millie and Christine McCoy (1851-1912) were born into slavery in North Carolina. They were sold at birth to showman J. P. Smith, who taught them to sing and perform. They toured the United States and Europe into the 1880s. Joanne Martell, *Millie-Christine: Fearfully and Wonderfully Made* (Winston-Salem, N.C.: John F. Blair, 2000).

[c-135]

Jas. W. Turner

Active 1870s

Half-Man, Half-Woman, ca. 1870

Albumen carte-de-visite (4 1/8 x 2 3/8 in.), 586-1-98

[c-136]

Miller & Rowell

Active 1850s-1860s; 1832-1900

Madame Young, ca. 1860-65

Albumen carte-de-visite (3 1/2 x 2 1/4 in.), 693-1-00

Originally trained as an ornamental painter, Frank Rowell (1832-1900) left this profession in 1855 to pursue photography. Rowell worked with Russell A. Miller from 1863 until at least 1865. He then became a partner in the firm of Allen & Rowell, which eventually entered the business of manufacturing dry plates and films. "Frank Rowell Dead," *Boston Evening Transcript* (May 10, 1900): 9.

C-133

C-134

C-135

C-136

419
Napoleon Sarony
1821-1896
Self-Portrait, ca. 1875
Albumen cabinet card (5 5/8 x 3 7/8 in.), 574-7-98

Napoleon Sarony was born in Canada and moved to New York as a child. Originally trained as a lithographer, he opened his own lithography firm in 1848 under the name Sarony, Major & Knapp. Soon after, Sarony left for Europe where he learned to photograph and opened his first studio, in Birmingham, England. Sarony returned to the United States after the Civil War and opened a gallery on Broadway in New York City. He was soon one of the most acclaimed and influential figures in the field. "Sarony," *Wilson's Photographic Magazine* 34:482 (February 1897): 64-75; Ben L. Bassham, *The Theatrical Photographs of Napoleon Sarony* (Kent, Ohio: Kent State University Press, 1978).

420
Napoleon Sarony
Oscar Wilde, 1882
Albumen cabinet card (5 5/8 x 3 7/8 in.), 574-4-97

Oscar Wilde (1854-1900) was an Irish playwright, novelist, and poet, best known for works such as *The Importance of Being Earnest*. This photograph was taken shortly after Wilde's arrival in the United States in January 1882.

421
Napoleon Sarony
Henry Wadsworth Longfellow, ca. 1875-80
Albumen cabinet card (5 1/4 x 3 5/8 in.), 574-6-97

Henry Wadsworth Longfellow (1807-1882) was one of America's most beloved poets. His most popular works included *Evangeline* and *The Song of Hiawatha* (the latter inspired by a daguerreotype of Minnehaha Falls by Alexander Hesler). Longfellow was one of the Fireside Poets, an elite group that included William Cullen Bryant, John Greenleaf Whittier, James Russell Lowell, and Oliver Wendell Holmes.

422
Napoleon Sarony
Samuel F. B. Morse, ca. 1870
Albumen cabinet card (5 7/8 x 4 1/8 in.), 574-3-97

After graduating from Yale, Samuel F. B. Morse (1791-1872) became a portrait and history painter. In 1832, Morse began work on the telegraph—an invention later hailed as one of the technological marvels of the age. He was also a key figure in the early history of American photography. Morse published the first American description of the daguerreotype process and, in 1839-40, instructed a number of notable figures in the process.

423
Napoleon Sarony
Harriet Beecher Stowe, ca. 1880-85
Albumen cabinet card (5 3/4 x 4 1/8 in.), 574-5-97

This photograph served as the basis for an engraving by T. Johnson in the October 1887 issue of *Century Magazine*. James Lane Allen, "'Uncle Tom' At Home in Kentucky," *Century Magazine* 34:6 (October 1887): 802.

424
Unknown Maker
Palmer's Mills, ca. 1860
Albumen print (6 1/2 x 8 1/2 in.), 400-311-00

In original lithographed mat; title in pencil on back of mount.

While full documentation is lacking, it appears that the subject of this photograph is the flour and saw mill complex of T. Chalkley Palmer (1804-1876). The mills, located in Delaware County, Pennsylvania, along the bank of Crum Creek, were acquired by Palmer in 1834. Palmer was an active member and one-time president of the Delaware County Institute of Science. An amateur biologist all his life, he published many papers on botany. Henry Graham Ashmead, *History of Delaware County* (Philadelphia: L. H. Everts & Co., 1884): 672.

425
Lewis E. Walker
1822-1880
Construction of the Department of the Treasury, 1861
Albumen print (9 5/8 x 13 1/2 in.), 483-1-97

Dated in negative: Sept. 3, 1861.

Lewis Emory Walker first entered the field of photography in 1856 as an ambrotypist at Brady's studio in New York City; he then held a similar position in C.D. Fredricks's gallery. By June 1857, Walker was in charge of the photographic section, Office of the Supervising Architect, Department of the Treasury. During the Civil War, he copied drawings for this office, and maps and surveys for the Army. *Philadelphia Photographer* 7:1 (January 1876): 13.

426
James W. Black
1825-1896
Trinity Church, Summer Street, Boston, 1872
Albumen print (13 5/8 x 12 5/8 in.), 429-3-98

Title and "Black Pht." in pen on mount.

427
Unknown Maker
Interior, Niagara Suspension Bridge, ca. 1860
Albumen print (6 x 8 1/8 in.), 400-393-01

428
J. P. Babbitt (attrib.)
1830-?
Kansas City Bridge: Lowering First Section of Curb, No. 1, August 7, 1867
Albumen print (5 x 7 in. oval), 419-4-95

Exact date given as August 7, 1867; numbered on mount #1.

Joseph P. Babbitt was born in Ohio in 1830. He is listed in several Kansas City directories: 1868-69, as J. P. Babbitt; 1869-70, as Babbitt and G. L. Gause Photographic Gallery; 1871, as J. P. Babbitt; 1872-73, as Babbitt and P. Shannon; and 1874-75, as J. P. Babbitt. As of 1880, he was living in Abilene, Kansas, making a living as a photographer. David Boutros, "A Preliminary Survey of Photographers and Artists in Kansas City, Missouri, 1850 to 1882," (mss., 2004).

The Kansas City Bridge (also known as the Hannibal Bridge) was begun in January 1867; in February of that year, it was placed under the supervision of chief engineer Octave Chanute. Heavy flooding in the spring halted construction until August 1867, when this photograph was taken. The piers were numbered 1 to 8, starting from the south bank, and were designed to withstand the strong current of the Missouri River. This photograph shows the timber section that was to rest on one of the early piers. The bridge was completed in July 1869.

A limited-edition book by Octave Chanute, *The Kansas City Bridge, with an account of the regimen of the Missouri River, and a description of methods used for founding in that river* (New York: D. Van Nostrand, 1870), documented the project. This volume exists in several variations: one illustrated with engravings based on photographs and one with original photographic prints. An example of the latter (Chanute's personal copy), provides no record of the photographer. The photographs in this volume are different in format from the one illustrated here: the written script of the captions is different and the photographs are not trimmed to the oval format. The plate opposite p. 70 of this copy of *The Kansas City Bridge* shows a photographer's wagon in the background with the firm name of Ragan and Winans. Further, the photographs in *The Kansas City Bridge* were all taken in 1869 when the bridge was nearing completion. Engravings of the Kansas City Bridge were used in *Harper's Weekly* as illustrations of the event; these engravings were made from photographs taken by Ragan and Winans. *Harper's Weekly* (August 9, 1869): 500.

429
John Mather
1829-1915
David Beatey Farm, Looking South from Saw Mill, West Hickory Creek, Pennsylvania, ca. 1868
Albumen print (10 1/8 x 13 5/8 in.), 501-1-97

In pen on mount: "David Beatey Farm, looking South from Saw Mill, West Hickory Creek, Penn. Photo by Mather, Titusville, Penn."

John Aked Mather was born in England and was trained as a papermaker. After immigrating to the United States in 1856, he assisted an itinerant photographer throughout the east before settling in Painesville, Ohio, in 1860. The oil boom took him to Titusville, Pennsylvania, where he opened a studio; he remained there for almost fifty years. Ernest C. Miller and T. K. Stratton, "Photographer to Oildom," *American Heritage* 17:6 (October 1966): 38-45; William C. Darrah, *The World of Stereographs* (Gettysburg, Penn.: Darrah, 1977).

David Beatey was a farmer and lumberjack from Warren County, Pennsylvania. When oil was discovered, Beatey started a petroleum operation in Oil Creek, near Titusville. He became rich and in 1873 moved from his residence on West Hickory to a 170-acre farm in Warren County. J. S. Schenck, ed., *History of Warren County, Pennsylvania* (Syracuse: D. Mason & Co., 1887): n.p.

430

George O. Bedford

Active 1860s

Mechanical Man, 1868

Albumen carte-de-visite (3 ⅝ x 2 ⅛ in.), 449-1-96

Registered copyright in 1868 by the inventor, Zadoc P. Dederick.

George O. Bedford was located in Newark, New Jersey. In January 1868, Zadoc Dederick of New Jersey received a patent for his automated steam man. The man stood 7 feet, 9 inches tall, weighed 500 pounds, and was powered by a three-horse-power steam engine. Joseph Rainone, *Art & History of American Popular Fiction* (Baldwin, N.Y.: Almond Press, 2005).

431

Henry L. Abbot

1831-1927

Torpedo Explosion, Willet's Point, New York Harbor, 1882

Albumen print (9 ⅞ x 7 ⅛ in.), 572-1-97

Detailed caption printed on front of mount: "School of Submarine Mining – Willet's Point, N.Y.H. / No. 63, June 12, 1882, Iron Torpedo resting on bottom. Charge, 276 lbs. of mortar powder; distance, 300 feet; submergence, 10 feet; height of jet on plate, 157 feet; probable total height, 180 feet."

Henry L. Abbot was an army engineer in charge of the Engineer Battalion at Willet's Point, New York, after the Civil War. His group investigated various problems of military engineering, including the use of high explosives for a coastal defense system of submarine mines. This photograph is one of thirty-nine that accompanied a two-volume report titled *Report upon Experiments and Investigations to Develop a System of Submarine Mines for the Defending the Harbors of the United States, Parts I and II* (Washington, D.C.: Government Printing Office, 1881). *Photographs* (New York: Sothebys, October 8, 1997): 39, lot 52.

432

Lewis M. Rutherfurd

1816-1892

Moon, March 6, 1865

Albumen print (22 ⅜ x 16 ⅝ in.), 510-1-97

In negative: full signature, "Lewis M. Rutherfurd" and "N.Y., March 6, 1865."

Lewis Morris Rutherfurd was born in Morrisania, New York, in 1816 to a prominent family. He studied chemistry and physics at Williams College and later studied law. After marrying a wealthy woman, Rutherfurd left the practice of law to concentrate on his scientific interests. In 1849, he traveled abroad to study optics. After returning to New York, Rutherfurd erected an observatory in the garden of his residence. He made many observations that contributed to the astronomical scholarship of the day. In 1864, he had a large refractor telescope, 15 feet long with an 11 ¼-inch objective, made by Henry Fitz. This instrument was designed for photography rather than for visual observation. With this telescope, Rutherfurd produced the finest photographs of the moon made to that time. John Krom Rees, *The Rutherfurd Photographic Measures* (New York: New York Academy of Sciences, 1906): 5-15.

Some of Rutherfurd's best negatives were taken on the night of March 6, 1865. In his own words: "Since the completion of the photographic objective, but one night has occurred, (the 6th of March), with a fine atmosphere, and on that occasion the instrument was occupied with the moon…On the 6th of March, the negatives of the moon were remarkably fine, being superior in sharpness to any I have yet seen. The exposure for that phase, three days after the first quarter, is from two to three seconds, and for the full moon about one-quarter of a second." Lewis M. Rutherfurd, "Astronomical Photography," *American Journal of Science and Arts* 39 (May 1865): 304-09 (quoted material from p. 309). Rutherfurd continued to make astronomical photographs and calculations and to publish his findings in scientific journals until 1878. He then donated his equipment and photographic plates to the observatory at Columbia University.

433

John A. Whipple

1822-1891

Views of the Great Solar Eclipse, 1869

Albumen print (5 ¼ x 4 ⅞ in.), 399-51-98

Inscribed on back of mount: "Grandfather John A. Whipple. He went to Shelbyville, Ky., to take this eclipse for Harvard."

This was acquired in a group of Whipple family photographs.

434

Unknown Maker

Astronomers (Transit of Venus Party), Washington, D.C., 1874

Albumen print (7 ½ x 9 ¾ in.), 400-173-98

Full title in German written on mount under photograph.

The Transit of Venus in 1874 was anticipated as "probably the most important astronomical event of the century" (George Forbes, *The Transit of Venus* [London: Macmillan & Co., 1874]: n.p.). Venus passed across the face of the sun twice in the nineteenth century—in 1874 and 1882—and both events were recorded by viewing stations around the world. Steven J. Dick, *Sky and Ocean Joined: U.S. Naval Observatory, 1830-2000* (Cambridge: Cambridge University Press, 2003): n.p.

435

George K. Warren

Gymnasium, Goodrich Hall, Williams College, ca. 1866-67

Albumen print (7 ¾ x 5 ¾ in. oval), HF556-16-05

Although George K. Warren began making daguerreotypes in Lowell, Massachusetts, in the 1850s, he is best known today for his work for Harvard, Yale, Williams, and other schools and universities. In addition to student portraits, Warren took photographs of campus buildings, notable characters, and local scenery. Students then bought the images they desired for their personal albums. Goodrich Hall, built in 1865 in an early English style, had the best facilities for gymnastic exercise and training according to the 1866-67 college catalog.

436

Gustavus W. Pach

1848-1904

Yale Crew Team, ca. 1879-80

Albumen print (6 ⅝ x 8 ⅝ in.), 512-3-97

From the 1880 Yale College Yearbook.

Gustavus Pach immigrated to the United States from Germany with his brothers at a young age. All the boys were interested in photography and by the 1860s, Gustavus was listed in the New York City business directory as a photographer in business with his brother, Morris. Pach also operated studios near various universities, including Yale, Princeton, and Harvard. The Pach studio operated at varying addresses in New York City until 1894.

Pictured here is the winning Yale crew team of 1880: John Burnett Collins, bow, 1881; Nathaniel T. Gurnsey, 1881; Louis K. Hull, 1883; Philo C. Fuller, 1881; Frederick W. Rogers, 1883; George B. Rogers, captain, 1880; Henry T. Folsom, stroke, 1883; and Mun Yew Chung, coxswain, 1883. Mun Yew Chung was part of the Chinese Educational Mission, an organization devoted to bringing at least thirty Chinese students a year to the United States. A popular student, Chung was coxswain of the crew team in 1880 and 1881. The *Hartford Courant* reported in 1912: "Famous in Yale annals as the coxswain of the Yale shell which distanced Harvard in the race of 1880, Chung was a favorite among his classmates. He was a bright student who never lost his temper and who was never known to swear, except on one occasion. That was during the race with Harvard in 1880. Toward the finish, the little coxswain broke out with 'Damn it boys, pull!' The boys did and Yale won the race." Judith Ann Schiff, "When East Meets West," *Yale Alumni Magazine* (November/December 2004): n.p.

The identity of each crew member is based on a variant group portrait held in the Yale University Archives, Yale University Library.

[C-137]

George K. Warren

George W. Smith, Custodian, Yale University, ca. 1868

Albumen print (7 ⅞ x 5 ¾ in.), HF556-15-05

On stiff board (a detached yearbook page), backed with a similar study.

George K. Warren was the class photographer for Yale University from at least 1865 to 1869. This photograph depicts custodian George W. Smith. Additional images of Smith are included in the Yale University Archives, Yale University Library.

The Yale Pot-pourri. Yale College: 1865-1866 (New Haven: Tuttle, Morehoufe, & Taylor, 1865): 56; 1867-1868 (1867): 68; 1871-1872 (1871): 25; 1872-1873 (1872): 92; 1873-1874 (1873): 88.

[C-138]

John A. Whipple

Harvard Natural History Society, ca. 1867

Albumen print (6 x 8 in.), 399-66-05

This photograph is from the 1867 Harvard class album. Whipple's authorship of these views is indicated in the Secretary's Report No. 1 of the Harvard College, Class of 1867. Another print of this photograph is held by the Boston Athenaeum.

C-137

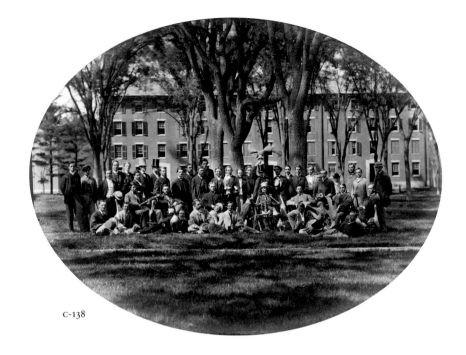

C-138

437
E. Anthony
1819-1888
Specimen of New York Bill Posting, City Hall Park,
1863
Albumen stereograph (3¼ x 6¾ in.), 602-7-00

Printed on mount: "Anthony No. 896."

438
Lawrence & Houseworth
Active 1860s-1870s
Lumber Vessels in a Gale at Mendocino, 1866
Albumen stereograph (3¼ x 6¾ in.), 437-2-00

Copyright by Lawrence & Houseworth in 1866.

It is likely that Lawrence & Houseworth's
Mendocino coast negatives were made by M. M.
Hazeltine (1827-1903), who lived near the area
in the 1860s. Peter E. Palmquist, *Lawrence &
Houseworth / Thomas Houseworth & Co.: A Unique
View of the West, 1860-1886* (Columbus, Ohio:
National Stereoscopic Association, 1980): 91.

439
Charles Waldack
1828-1882
*View From "Bridge of Sighs;" from series
"Magnesium Light Views in Mammoth Cave,"* 1866
Albumen stereograph (3⅜ x 6⅞ in.), 600-1-98

*Printed on card: "Magnesium Light Views in
Mammoth Cave;" copyright by Proctor and
O'Shaughnessy in 1866.*

Charles Waldack was a Cincinnati photographer
and photochemist. He is best known for two
trips to Mammoth Cave in June and July 1866 to
photograph underground scenes by the light of
burning magnesium flares. His trips resulted in a
series of over eighty stereo views published both
by Waldack and by E. Anthony & Co. In a letter to
the *Philadelphia Photographer,* Waldack explained
his fascination with photographing in the dark:
"Ever since the introduction of the magnesium
light as a photographic agent, it has been one

of my pet projects to test its capabilities as such
in the celebrated Mammoth Cave...the object
was not so much to make pictures ...as to test
the capabilities of the magnesium light and the
quantity of the metal to be used...The lenses used
were a pair of T. Ross's No. 2 carte-de-visite lenses
...mounted on a French stereoscopic camera...
The American Magnesium Company had fur-
nished half a pound of tapers...composed of two
ribbons and one wire around which had been
twisted a double iron wire...A third trial being
made with about twenty-five tapers...I obtained a
negative with which I was quite satisfied...The
difficulty of burning a large quantity of magnesium
without being inconvenienced by the smoke...
compelled me to use always large diaphragms."
Charles Waldack, "Photography in the Mammoth
Cave by Magnesium Light," *Philadelphia Photog-
rapher* 3 (August 1866): 241-43; and 3 (December
1866): 359-63. See also "General Notes," *Photographic
Times and American Photographer* 13:146 (February
1883): 57; Charles Waldack, *Treatise on Photography*
(Cincinnati: H. Watkin, 1865); and Chris Howes,
*To Photograph Darkness: The History of Under-
ground and Flash Photography* (Carbondale, Ill.:
Southern Illinois University Press, 1989): 48-71,
300-02.

440
M. A. Kleckner
Active 1870s
Group of Coal Miners, ca. 1869
Albumen stereograph (3⅜ x 7 in.), 672-1-00

From about 1868 to 1876, M. A. Kleckner operated
a winter studio in the Allentown/Bethlehem area
and another, in the summer, in Mauch Chunk,
Pennsylvania. In 1869, he photographed the
anthracite mining chutes and navigation canal in
Mauch Chunk. Darrah, *The World of Stereographs,*
pp. 79-80.

441
Charles Bierstadt
1819-1903
Professor King's Balloon at Rochester, New York,
ca. 1872
Albumen stereograph (3⅜ x 6⅞ in.), 421-6-01

It appears that the purpose of this balloon assent
on September 3, 1872, was to obtain a "more
definite knowledge of the upper currents of air
and the laws governing them." Professor King and
a member of the Signal Service, Mr. Schaeffer,
were the passengers. "The Balloon Ascension by
Prof. King and an Officer of the Signal Service –
Its Object," *New York Times* (September 6, 1872): 2.

442
Unknown Maker
Cloud Study, ca. 1870
Albumen stereograph (3⅜ x 6⅞ in.), 400-283-00

*From "Beauties of the Brandywine, Delaware"
series; No. 270.*

443
George Barker
1844-1894
Belleni Crossing Niagara on a Tight-Rope, ca. 1873
Albumen stereograph (4¼ x 7 in.), 608-2-00

*Printed title: "Belleni Crossing Niagara on a
Tight-Rope on line of N.Y.C. and H.R.R.R. Gems
of American Scenery."*

George Barker arrived at Niagara Falls in 1862.
He became the area's best-known photographer,
winning eleven international awards between
1871 and 1890. In 1880, his photographs were
instrumental in the creation of a state reservation
around the falls. Anthony Bannon, *Taking of
Niagara: A History of the Falls in Photography*
(Buffalo: Media Study, 1982): 18-19; "Mr. George
Barker," *Wilson's Photographic Magazine* 32:457
(January 1895): 45; James Gardner, *Special Report
of New York State Survey on the Preservation of
the Scenery of Niagara Falls* (Albany: Charles Van
Benthuysen & Sons, 1880): n.p.

Henry Bellini made his first attempt to cross Niagara by tightrope on August 25, 1873; by the end of that year, he had accomplished the feat three times.

444
Detlor & Waddell
Active 1880s
Oil Fire Near Tarport, Pennsylvania, ca. 1876
Albumen stereograph (4½ x 7 in.), 704-1-00

Oil was first drilled in Pennsylvania in 1859 and the area was soon filled with prospectors and oil wells. In June 1876, a large oil fire was started by lightning just outside the town of Bradford. The fire began at a well and then spread along a pipeline, igniting a series of storage tanks. The damage was estimated at $90,000. J. H. Beers, *History of McKean, from History of the Counties of McKean, Elk, Cameron, and Potter, Pennsylvania* (Chicago: J. H. Beers & Co., 1890), n.p.

[c-139]
Carleton E. Watkins
1829–1916
California Buckeye, Belmont, 1867
Albumen stereograph (3⅜ x 7 in.), 406-14-00

Printed on card: "Watkins' Pacific Coast / 429 Montgomery Street, San Francisco."

[c-140]
Washington Gallery
Active 1860s
Negroes Being Baptized at Vicksburg, ca. 1865
Albumen carte-de-visite (2¼ x 3¾ in.), 766-1-01

With gallery backmark, and pencil title.

This was not taken by the African American photographer Augustus Washington, of Hartford, Connecticut. Washington left the United States for Liberia in 1854 and did not return.

445
Unknown Maker
Three Dandies, ca. 1865-75
Whole-plate tintype, 400-143-98

446
Androscoggin Photographic Gallery
Active 1880s
Man on Floor, ca. 1885
Three-quarter-plate tintype, HF814-1-05

Remnants of labels on verso.

The Androscoggin Photographic Company was located in Lewiston, Maine.

447
Unknown Maker
Women Making Paper Dolls, ca. 1870s
Sixth-plate tintype, HF400-467-03

448
Unknown Maker
Boy with Gem Tintype Album, ca. 1870
Sixth-plate tintype, 400-396-01

Gem tintypes are only about ¾ to 1 inch wide. These were made with a multi-lens camera that produced a grid of exposures on a single plate. Very inexpensive to make, the gem tintype's miniature size made it appropriate for use in jewelry. Floyd Rinhart, Marion Rinhart, and Robert Wagner, *The American Tintype* (Columbus: Ohio State University Press, 1999).

C-139

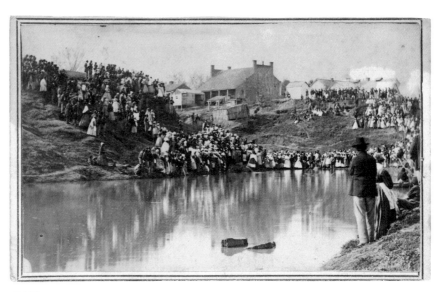

C-140

449

Unknown Maker

Smiling Man Behind Wall, ca. 1880

Sixth-plate tintype, 400-344-01

450

Unknown Maker

Christmas Pudding at Sea, ca. 1876

Albumen prints collaged on wood engraving (11¾ x 8¾ in.), 400-133-97

This wood engraving, by J. Nash, was originally published in the January 1, 1876 issue of *Harper's Weekly* and was captioned "Christmas Pudding at Sea—The Pride of the Ship's Cook." The accompanying article gave a brief history of the English plum-pudding. "Plum-Pudding at Sea," *Harper's Weekly* 20:992 (January 1, 1876): 12.

451

Amelia Bergner

Active 1870s

Untitled Photogram, ca. 1870-75

Toned cyanotype (11⅜ x 9 in. irregular), 441-1-96

Nothing is known about Amelia Bergner. This is one page from an album of similar photograms that surfaced in the mid-1990s. The technique of this print, resulting in its green color, remains uncertain.

452

Unknown Maker

Plan of the Contemplated Murder of John Campbell, 1871

Albumen print (7⅝ x 9⅝ in.), HF400-538-05

Inscriptions in ink on bottom margin of mount: "Entered according to the act of Congress in the year 1871 / in the District Court of the United States for the Pamlico District of North Carolina by Joseph G. Hester" and "Plan of the contemplated murder of John Campbell / which was interrupted by U.S. Detective Jos. G. Hester / on the Night of the 10th of August 1871."

The era of Southern Reconstruction was a time of great civil unrest. In Moore County, North Carolina, as in many counties in the region, elections belonged to the antislavery Republican Party, but the local offices continued to be controlled by pro-slavery Democrats. It became necessary for the governor of North Carolina to declare marshal law and to bring federal officials into the area. Of particular concern were the activities of the Ku Klux Klan, which terrorized and killed both recently emancipated blacks and their white supporters. Anti-Klan laws were enacted in 1871, making it illegal for anyone to be disguised after dark.

Joseph G. Hester was one of the federal marshals brought into Moore County, North Carolina. A man of questionable character, Hester had served in the Confederate Army before being dishonorably discharged. He then joined the Ku Klux Klan but soon denounced the organization and went to work for the government. Because of Hester's previous connection with the Klan, he was able to infiltrate the group.

In this photograph, John A. Campbell, a prominent Moore County Republican, is shown in the hands of hooded Klan members with a noose around his neck. The incident being reenacted here took place in the summer of 1871, when "a party of robed, masked riders dismounted in front of Campbell's grocery, dragged him out with a noose around his neck and soundly flogged him." Manly Wade Wellman, *The County of Moore, 1847-1947: A North Carolina Regions Second Hundred Years* (Southern Pines, N.C.: Moore County Historical Association, 1962): 77-80; Luke Poland, *Report of the Joint Select committee to Inquire into the Condition of Affairs in the late Insurrectionary States* (Washington, D.C.: Government Printing Office, 1872): 13-19.

Hester later captured the Klan members responsible for this crime, along with their elaborate disguises. These were put to use in the photographer's studio. "Their captured costumes were donned by acquaintances of Hester to pose for a photograph, with John Campbell in person, to show Ku Klux methods. The picture was sent to the Secretary of War in Washington and was widely circulated and reproduced in the North" (Wellman, *The County of Moore, 1847-1947*: 80). An engraving of this photograph was reproduced as a broadside and as a book illustration in *The Existing Conflict Between Republican Government and Southern Oligarchy* by Green B. Raum (Washington D.C.: Charles M. Green, 1884): 157 and *A Documentary History of Reconstruction* by W.L. Fleming (Cleveland: Arthur H. Clark, 1907): 365.

453

William H. Mumler

1832-1884

Spirit Child and Mrs. Charter, ca. 1870-75

Albumen carte-de-visite (3¾ x 2¼ in.), HF826-2-05

Photographer's credit stamp on verso; label on verso: "No. 12 / Mrs. Charter, / E. Boston, / MASS. / SPIRIT CHILD. / This is a very excellent / picture, the lady being a me- / dium. The articles belong- / ing to the child were placed / on the table while the sitter / held in one hand a bouquet / of flowers, requesting men- / tally that the spirit would / rest its hand on it. As will / be seen, the request was / granted."

Handwritten on verso: "Mrs. Charter [illeg.] a per / fect [illeg.] to the photo / graph - / Upon a [illeg.] nature / Dec. [illeg.] p. 515- / Were / M's process is to be found."

William H. Mumler was a jeweler in Boston who also experimented with photography. Around 1860, while working in Mrs. H. F. Stuart's studio, Mumler accidentally produced his first "spirit" photograph. These could be made in several ways, including the simple technique of double-exposing negatives. Spirit photography caused a sensation and spiritualists from all over the country came to Mumler's studio to be recorded with their own ghostly companions. His success in Boston prompted Mumler to move to New York. There, in 1869, he was charged with fraud. The prosecution proved that the same "spirit" appeared repeatedly in some of his images and, further, that the apparition was actually a living

person. Expert photographers were called to explain the possible methods used to create spirit photographs. After days of testimony, the charges were dropped for lack of evidence. However, while spirit photographs were made after 1869, the heyday of the practice was over. Mumler, left destitute by his $3,000 defense fee, died in 1884. John Dobran, "The Spirits of Mumler," *Northlight: The Journal of the Photographic Historical Society of America* 5:2-3 (Summer-Fall 1978): 4-7, 10-14; "The Spirit Photographs," *Journal of Photography* 5:14 (January 15, 1863): 329-30.

Another example of this carte-de-visite is held by the College of Psychic Studies, London. It is published in Crista Cloutier, "Mumler's Ghosts," in Clément Chéroux et al., *The Perfect Medium: Photography and the Occult* (New Haven: Yale University Press, 2004): 20-28, with the title *Fanny Conant and the spirit of her brother Chas. H. Crowell (recognized by all who knew him)*.

454

Unknown Maker

Spirit Photograph, ca. 1870

Albumen carte-de-visite (3⅜ x 2⅜ in.), 400-358-01

455

R. J. Hillier

Active 1860s

Spirit Photograph, ca. 1865

Albumen carte-de-visite (3¾ x 2½ in.), 770-1-01

Printed on back of card: "R.J. Hillier's / Photographic Rooms, / N.E. Cor. Eighth and Green, Philadelphia."

456

J. Halstead

Active 1860s

Double (Self?) Portrait with Camera, ca. 1865-70

Albumen carte-de-visite (3⅝ x 2⅛ in.), 680-1-00

Printed on back of card: "J. Halstead / Artist / Milton, PA."

457

A. M. Allen

1823-1900

Self-Portrait as Soldier and Civilian, ca. 1865-70

Albumen carte-de-visite (3½ x 2⅛ in.), HF824-2-05

Printed on back of card: "A.M. Allen / Photographer, / Pottsville, Pa."

Amos M. Allen, originally from Deerfield, Massachusetts, practiced photography in Pottsville, Pennsylvania, from 1852 to 1894.

458

A. M. Allen

Double Self-Portrait with Camera and Seated, ca. 1865-70

Albumen carte-de-visite (3½ x 2⅛ in.), HF824-1-05

Printed on back of card: "A.M. Allen / Photographer, / Pottsville, Pa."

459

Prescott & Gage

Active 1860s

Woman with Opera Glasses, ca. 1861

Albumen carte-de-visite (3½ x 2⅛ in.), 719-1-00

D. K. Prescott and Edwin P. Gage, of Hartford, Connecticut, specialized in cartes-de-visite.

460

Unknown Maker

Photographer in Studio Sticking Tongue Out,
ca. 1870

Albumen carte-de-visite (3⅝ x 2⅛ in.), 400-368-01

461

James W. Black

Edward Everett Hale and Son, 1869

Albumen print (8 x 5⅞ in.), 429-1-96

Sticker with "100" in bottom right of front of mount

This print was shown in the Mechanics' Exhibition in Philadelphia in 1868. "The photographic part of the later Mechanics' Exhibition…there were some good things there, among which I must mention a 7 x 9 of Edward Everett Hale and his little boy, made in imitation of the engraving where a father is teaching his son to plough, and which pleased me more than anything else I saw, from its close resemblance to the engraving." E.L. Allen, "Old Times," *Philadelphia Photographer* 7:74 (February 1870): 46-48.

462

George N. Barnard

1819-1902

South Carolina Cherubs (After Raphael), ca. 1874-75

Albumen stereograph (3⅜ x 6⅞ in.), 196-113-00

Printed on card: "Barnard's Specialties No. 263 King St., Charleston, S.C."

George N. Barnard relocated to Charleston, South Carolina, from New York City around 1868, and worked in partnership with Charles J. Quinby through 1871. He operated a gallery in Chicago from 1871 to 1873, but then returned to Charleston. Keith F. Davis, *George N. Barnard: Photographer of Sherman's Campaign* (Kansas City: Hallmark Cards, Inc., 1990): 180-92.

463

Thomas Eakins (or circle)

1844-1916

Woman in Empire Gown, ca. 1881-85

Albumen print (4¾ x 3⅝ in.), 616-1-98

[C-141]

Frederick Gutekunst

1831-1917

Thomas Eakins, 1878

Albumen print (4 x 3 in.), 597-1-98

This image was reproduced in an 1878 *Harper's Weekly* magazine issue.

464

Eadweard Muybridge

1830-1904

The Horse in Motion: "Sallie Gardner," June 19, 1878

Albumen print (4⅛ x 7⅞ in.), 27-8-98

In 1872, Muybridge was commissioned by former California governor Leland Stanford to photograph a racehorse in motion. Although the results were inconclusive, Muybridge became devoted to stop-action photography. After other projects and distractions—including his trial for murder, acquittal, and subsequent visit to Central America—Muybridge continued this work from 1877 to 1881 at Stanford's Palo Alto ranch, and then from

1884 to 1886 at the University of Pennsylvania. Mary V. Jessup Hood and Robert Bartlett Haas, "Eadweard Muybridge's Yosemite Valley Photographs, 1867-1872," *California Historical Society Quarterly* 42:1 (March 1963): 5-26; "California," *New York Times* (November 1, 1874): 2; "An Accused Murderer Acquitted," *New York Times* (February 18, 1875): 1; and Phillip Prodger, *Time Stands Still: Muybridge and the Instantaneous Photography Movement* (New York: Oxford University Press/ Iris & B. Gerald Cantor Center for Visual Arts at Stanford University, 2003).

465

J. G. Doughty

Active 1880s

Balloon Launch, 1885

Albumen print from gelatin dry-plate negative (7½ x 4⅝ in.), 509-4-00

Stamped on front of mount: "J.G. Doughty, Winsted, Ct."

John G. Doughty was the son of Winsted, Connecticut, photographer T. M. V. Doughty and a relative of Thomas Doughty, the Hudson River School landscape painter. In 1886 he worked at a Winsted electrical plant and in 1901 he helped organize the short-lived Flexible Rubber Company, which attempted to manufacture and market rubber-soled athletic shoes. William F. Robinson, *A Certain Slant of Light* (Boston: New York Graphic Society, 1980): 110.

John Doughty made his first balloon ascent with aeronaut Alfred E. Moore in September 1885. This flight was a photographic failure: lift-off was postponed until after 5:00 pm and the resulting light was too low for photographing. On their next flight, in October 1885, the pair soared from Winsted to Windsor, Connecticut, and Doughty made successful photographs of the landscape and the clouds. He used a "five-by-eight-inch plate [camera], which size seems best suited to our purpose, as it allows a considerable extent of country to be included in the view, while the apparatus need not be unduly bulky or heavy." John G. Doughty, "Balloon Experiences of a Timid Photographer," *Century Magazine* 32:5 (September 1886): 684. Doughty and Moore later published a series of fourteen views from these negatives, including the inflation of the balloon (probably the scene represented here), the balloon on the ground, aerial views of the landscape, and the landing scene.

C-141

Index